T S IGN

D0229512

LEEDS COL IGN

Mischa Kuball

...in progress

Projekte | Projects 1980–2007

...in progress

Mischa Kuball

Projekte | Projects 1980–2007

Herausgegeben von
Edited by
FLORIAN MATZNER

Mit Texten von
With texts by
WALTER GRASSKAMP
BORIS GROYS
IHOR HOLUBIZKY
NINA HÜLSMEIER
DORIS KRYSTOF
FLORIAN MATZNER
YUKIKO SHIKATA
PETER SLOTERDIJK
PETER WEIBEL
ARMIN ZWEITE

KUNSTSTIFTUNG ⟶ NRW

HATJE
CANTZ

///// ZKM Zentrum für Kunst und
Medientechnologie Karlsruhe /

INHALT
CONTENTS

GRUSSWORT
FOREWORD

Stets sind bei der geistesgeschichtlichen Erfassung des Phänomens »Licht« Begriffe wie Wahrnehmung und Erkenntnis präsent. Auf selbstverständliche Weise verstehen wir uns als »Lichtgestalten« und formen unsere Erkenntnis immer schon dank des natürlichen Sonnenlichts und seit geraumer Zeit auch mit Hilfe des artifiziellen, elektrischen Lichts. Auch wenn das sichtbare Licht nur einen winzig kleinen Bereich im Gesamtspektrum der Wellenlängen zwischen 1 und 10^{24} Hertz umfasst, sind wir mehr als fasziniert, dass das Licht zwischen Welle und Teilchen zudem einen wesentlichen funktionalen Bestandteil wie etwa im Fotoapparat, im Bildschirm ausmacht oder aber Grundlage und Medium künstlerischer Problemstellungen bildet. Zum Tragen kommen dann oft Gedanken an Gesamtkunstwerke und synästhetische Utopien, die den Weltgrund im Lichte (Gottes) reflektiert und interpretiert haben. Platon hatte nicht von ungefähr Angst vor den gleißenden Strahlen der Sonne, die die Wahrheit offenbarten.

Die Utopie vom Gesamtkunstwerk innerhalb eines Diskurses über die Lebenskunstwerke oder einer erneuerten Verschmelzung von Kunst und Leben scheinen ausgeträumt. Zu wenig Raum ist inmitten einer Ortlosigkeit der Kunst nach dem Fenstersturz aus dem Elfenbeinturm, dessen Inneres marode dahindämmerte. Der Sprung war somit kein

The concepts of perception and enlightenment are constants in the history of human efforts to comprehend the phenomenon of "light." We see ourselves quite naturally as "figures of light" and have always developed our knowledge from the revelations of natural sunlight and, for many years now, of artificial, electric light. Although visible light covers only a tiny segment of the wavelength spectrum from one to 10^{24} Hertz, we are more than fascinated by the fact that light, as wave or particle, is also a key functional component—in cameras or computer screens, for instance—or serves as the basis and the medium for issues of concern to artists. Often equally important are the concepts of the *Gesamtkunstwerk* and synaesthetic utopias that have reflected and interpreted the essence of the world in the light (of God). It was with good reason that Plato feared the glaring rays of the sun, which revealed truth.

The utopian dream of the *Gesamtkunstwerk* within a discourse on the work of the art of living or a renewed unity of art and life appears to have faded. Too little space is left in the midst of a non-locality of art after the defenestration from the ivory tower, whose core was slumbering in infirmity. Thus the plunge was not a compulsive suicidal act but rather a daring stunt in which the mystification of the ordinary achieved a striking effect. Utopias and their real settings characterize the oeuvre of the Düsseldorf sculptor and media and installation artist Mischa Kuball. The utopian pathos of renewal evident in many projects realized during the heyday of the modernist program in the early years of

zwanghafter Selbstmord, sondern eher ein abenteuerlicher Stunt, da die Mystifizierung des Alltäglichen eine einschlägige Wirkung erreichte.

Utopien und ihre wahren Orte indessen kennzeichnen das Werk des Düsseldorfer Bildhauers, Medien- und Installationskünstlers Mischa Kuball. Das utopische Aufbruchpathos vieler Projekte zu Beginn des 20. Jahrhunderts in der Blüte des Programms der Moderne sind charakteristisch für sein immer gegenwärtiges und zeitbasiertes Wirken im Raum, welches häufig in Serien oder – wie er es nennt – »Blöcken« geschieht.

Blitzlichtgewitter allerorten, rote Teppiche als scheinbare Ehrerbietungen, Aufmerksamkeitssteigerungen potenziert, Rauschgelüste ohne Nebenwirkungen – die Welt ist ein Paradies des Individuums geworden. »They can be heroes, just for one day« (David Bowie) oder auch »everybody will be famous for 15 minutes« (Andy Warhol). Visionäre Sentenzen wie diese haben sich im Low and High der immer populärer avancierten Kultur und Kunstszene durch alle Lebensbereiche bewahrheitet. Auf ihre Virtualität hin geeicht ist die Aneignung von echter Liebe im Spiegel des anderen meist eingeschränkt und begrenzt. Nur im zarten Anreiz eines Hauchs von Realität entwickelt sich das Begehren als eine Art Ausgleichshandlung und Schlüsselreizfunktion. Gleichwohl erkennen wir innerhalb der medialen Präsenz den Verlust von Tiefe, Nachhaltigkeit und Bedeutung. Die Anwesenheit und Aufmerksamkeit in den Medien ist eine durch das Licht als Träger der Information wahr gewordene Heilsmission der Moderne und ihrer Post-Stadien, der sich viele Künstler seit Beginn der Elektrifizierung widmeten.

the twentieth century is typical of his ever-present, time-based work in space, which is often accomplished in series or—as he refers to them—in "blocks."

Bolts of lightning everywhere, red carpets as apparent gestures of reverence, potentiated intensifications of attention, ecstatic outpourings of desire without side-effects— the world has become a paradise for the individual. "They can be heroes, just for one day" (David Bowie) or "everybody will be famous for fifteen minutes" (Andy Warhol). Visionary scenarios like these have come true in the ebb and flow of the increasingly popularized culture and art scene in all areas of life. Tuned to their virtual character, the appropriation of true love in the mirror of the other is usually limited and restricted. Only in the tender appeal of a hint of reality does desire develop as a kind of compensatory activity and key stimulus. At the same time, we recognize in the presence of the media a loss of depth, permanence, and meaning. Presence and awareness in the media is a mission of salvation of modernism and its derivative phases that has been made true through light as the bearer of information, and many artists have devoted themselves to it since the outset of the era of electrification.

One spokesman of this current who has created outstanding, attention-getting works, often with critical intent, is the media artist Mischa Kuball. Efforts to woo the consumer have become more aggressive, more massively visible and palpable than we would have dared to dream only a few years ago in the age of progressive modernism and the

Ein Exponent mit herausragenden, aufmerksam machenden und kritisch intendierten Exponaten ist der Medienkünstler Mischa Kuball. Das Werben um den Verbraucher, den Konsumenten ist aggressiver, massiver sichtbar und spürbar geworden als wir es uns noch vor einigen Jahren im Zeitalter der fortschrittsgläubigen Moderne und konsumorientierten Hedonismus-Dekade der 1980er-Jahre haben träumen lassen. Zu dieser Zeit begann Kuball seine Interventionen im halb-öffentlichen Raum zu realisieren. *Dia-Cut* lautete der Titel seiner ersten Einzelausstellung in der Städtischen Galerie Düsseldorf. 1994, zehn Jahre später war es die lichtgeflutete Synagoge in Stommeln bei Köln, weitere zehn Jahre später ist es ein ebenso gesellschaftspolitisch motiviertes Werk, das im öffentlichen Raum positioniert, seine Zeitbasiertheit mehr noch als das Schlagwort der »Projektion« deutlich machte.

Abb. S. 38–39, 338–339
Abb. S. 358–359

Public Entrance heißt die Arbeit von Mischa Kuball, die zuerst 2004 auf der *Art Cologne* im Rahmen eines kommerziellen Events und dann im November 2005 im Lichthof 3 des Hallenbaus A des ZKM in Karlsruhe präsentiert wurde. Die Installation vermittelte perfekt verschiedene Bereiche, denn sie verband nicht nur Forschung, Lehre und Präsentation in der Hochschule für Gestaltung, an der Mischa Kuball seit 2004 ein leuchtendes Beispiel professoralen Engagements abgibt, sondern bildete zugleich Eingang und Ouvertüre zum ZKM | Museum für Neue Kunst, wo damals gerade die Ausstellung »Lichtkunst aus Kunstlicht« zu sehen war. Die Installation *Public Entrance* stellte den alltäglichen Vorgang des Ankommens (und Weggehens) zentral dar. Eingeführte Elemente – der rote Teppich, kopfgesteuerte Scheinwerfer – ahmten die Attribute öffentlicher Inszenierung von Macht und

decade of consumer-oriented hedonism in the eighties. It was then that Kuball realized the first of his interventions in semipublic space. *Dia-Cut* was the title of his first solo exhibition at the Städtische Galerie Düsseldorf in 1994. Ten years later, he exhibited at the light-bathed synagogue in Stommeln near Cologne, and ten years after that it was an equally political work positioned in public space that underscored the time-based character of his work even more than the fashionable term "projection."

Figs. pp. 38–39, 338–339
Figs. pp. 358–359

Public Entrance is the title of a work by Mischa Kuball that was first presented in 2004 at *Art Cologne* within the scope of a commercial event and then again in Lichthof 3 in Building A of the ZKM | Center for Art and Media in Karlsruhe in November 2005. The installation conveyed a perfect sense of different fields, for it not only unites research, teaching, and presentation at the Staatliche Hochschule für Gestaltung (State College of Design), where Mischa Kuball has served as a shining example of professorial commitment since 2004, but also serves as both an introduction and an overture to the ZKM | Museum of Contemporary Art, at which the exhibition "Light Art from Artificial Light" was being shown at the time. *Public Entrance* focuses on the everyday act of arriving (and leaving). Injected elements— the red carpet, visitor-controlled spotlights—imitated the attributes of public presentations of power and media presence. In this way, the entrance installation at this exhibition stands for the concepts of perception and enlightenment as the leitmotifs of this publication and the touring exhibition of Mischa Kuball's art that begins at the ZKM.

Medienpräsenz nach. Die Eingangsinstallation zu dieser Ausstellung sollte somit als Passage programmatisch für die Begriffe Wahrnehmung und Erkenntnis (Enlightenment) als Leitmotive der vorliegenden Publikation und für die im ZKM | Zentrum für Kunst und Medientechnologie beginnende Ausstellungstournee von Mischa Kuball stehen.

Es ist uns somit eine große Freude, das häufig ortsgebundene oder ortsspezifische, gesellschaftsrelevante Werk von Mischa Kuball auf Reisen zu sehen und als Gastgeber der verschiedensten Orte und Institutionen auf der Welt eine urbane und institutionelle Sonderstellung abseits des Elfenbeinturmes aufzeigen zu können. Dies war nur möglich dank des Engagements von vielen Personen, die im Umfeld des Künstlers tätig sind und im öffentlichen Raum und sozialen Leben vernetzt sind. Namentlich seien hervorgehoben Florian Matzner, der die Herausgabe des Œuvre-Kataloges übernahm, und Nina Hülsmeier, Kuballs Düsseldorfer Assistentin, die in allen Belangen für das Gelingen der Unternehmung Sorge trug.

Ganz herzlich ist Regina Wyrwoll von der Kunststiftung NRW für deren großzügige Unterstützung zu danken und natürlich nicht zuletzt dem Künstler selbst. Nur durch dieses Zusammenwirken konnte eine Ausstellungstournee realisierbar sowie mit utopischen Hoffnungszügen durchsetzt werden, die aber zuvorderst dem Publikum gewidmet sein soll.

GREGOR JANSEN für die beteiligten Ausstellungsinstitutionen
Karlsruhe, im März 2007

It is a source of great joy for us to see the site-specific, socially relevant work of Mischa Kuball begin its journey and, as hosts at many locations and institutions around the world, to present a unique urban and institutional position beyond the pale of the ivory tower. This has been made possible by the commitment of many people associated with the artist and his work who are networked in public space and social life. Worthy of special note in this context are Florian Matzner, editor of the catalogue raisonné, and Nina Hülsmeier, Kuball's assistant in Düsseldorf, who contributed to the success of this project in many ways.

Thanks are due as well to Regina Wyrwoll of the Kunststiftung NRW for her generous support, and of course to the artist himself. This collaboration has made it possible to realize an exhibition tour that is permeated with utopian hopes and dreams and dedicated above all to the public.

GREGOR JANSEN for the participating exhibition institutions
Karlsruhe, March 2007

GREGOR JANSEN & PETER WEIBEL
ZKM | Museum für Neue Kunst Karlsruhe

THORSTEN SADOWSKY
Kunstbygning/Kunsthal Århus

ELISABETH FIEDLER & CHRISTA STEINLE
Neue Galerie am Landesmuseum Joanneum, Graz

STEPHAN BERG
Kunstverein Hannover

CHRISTOPH BROCKHAUS
Stiftung Wilhelm Lehmbruck Museum, Duisburg

ZORAN ERIC
Museum of Contemporary Art Belgrade

DUNJA BLAŽEVIĆ
Sarajevo Center for Contemporary Art

WOLF GUENTER THIEL
Beijing Royal Art Museum

TOMOAKI KITAGAWA
Toyota Municipal Museum of Art, Toyota

ESKO NUMMELIN & LAURA SELIN
Pori Art Museum, Pori

EVA SCHMIDT
Museum für Gegenwartskunst Siegen

PHILIPPE PIROTTE
Kunsthalle Bern

XIAO HUI WANG
Tong JI University, Shanghai

ULRIKE KREMEIER
Centre d'Art Contemporain Passerelle, Brest

»Ich gehe in den meisten Fällen über die Analyse des Ortes an ein Projekt heran. Da habe ich nicht das mögliche Medium im Kopf, sondern die Frage, was kann man hier machen: Oft sind ja die Orte mehrfach determiniert – im Museum durch die bisher gezeigte Kunst, die Geschichte des Museums. Im öffentlichen Raum kommen dagegen Aspekte des Urbanen, Sozialen und Politischen hinzu [...] Ich bin am Prozess interessiert – oder wie ich es einmal formulierte, an der ›Öffentlichkeit als Labor‹ [...].«

Mit diesen Worten hat Mischa Kuball in einem Interview seine künstlerischen Strategien beschrieben, die er seit nahezu dreißig Jahren unbeirrt verfolgt: Dabei ist die Konzentration auf einen Ort oder einen Menschen und seine Geschichte die zentrale Motivation seiner Arbeit: Dass Kuball des öfteren die Austragungsorte wechselt und den »white cube« des Innenraums gegen den »dirty space« des Außenraums eintauscht, ist gleichfalls ein wichtiger Aspekt dieser Strategie, die sich damit bewusst der schnelllebigen Mode des Zeitgeists wie des Kunstmarkts entzieht. Eine weitere Konstante in seinem Werk ist das Medium, das Licht in direkter oder projizierter oder reflektierter Form, denn – um mit Peter Weibel zu sprechen – »Mischa Kuball hat es verstanden, dass Licht immer eine Inszenierung und Dramatisierung bedeutet und dass dort, wo inszeniert und konstruiert wird, das

"In most cases I start a project by analyzing the site first. When I do this, I don't have a particular medium in mind, but instead ask myself what can be done here: after all, the sites are often determined by several factors—in the museum by the art that has been shown there previously, the history of the museum. In public space, on the other hand, there are additional aspects, such as the urban, the social, and the political. . . . I'm interested in the process—or as I once called it, the 'public as laboratory. . . .'" Mischa Kuball used these words in an interview to describe the artistic strategies he has been unerringly pursuing for almost thirty years. The central motivation for his work is the concentration upon a place or a person and their history: another important aspect of this strategy is that Kuball frequently changes the sites, exchanging the "white cube" of the indoors for the "dirty space" of the outdoors. This also allows him to consciously avoid the short-lived trends of the zeitgeist as well as those of the art market. Yet another constant in his work is the medium: light in projected or reflected form, for, to use Peter Weibel's words, "Kuball understands that light always implies staging, dramatization; and that wherever things are staged and constructed, life itself becomes a stage. When illuminated, all of life becomes a public stage, more so than ever in the media age. . . ."

Mischa Kuball and I developed the concept for this publication over the course of long conversations. Conceived as a monograph, it is also a companion catalogue for the international tour of exhibitions that will take place over the next few years. The Kunststiftung NRW in Düsseldorf, its President Dr. Fritz Schaumann, and General Secretary

Leben zur Bühne wird. Im Raum des Lichts wird das gesamte Leben zu einer öffentlichen Bühne, im Zeitalter der Medien mehr denn je.«

Die Konzeption der vorliegenden Publikation haben Mischa Kuball und ich gemeinsam in langen Gesprächen entwickelt: Als Monografie konzipiert, begleitet sie wie ein Katalog-buch die internationale Ausstellungstournee in den nächsten Jahren. Mit der Kunststiftung NRW in Düsseldorf und dem Präsidenten Dr. Fritz Schaumann und der engagierten Gene-ralsekretärin Regina Wyrwoll haben wir Partner gefunden, die dieses einmalige Buchpro-jekt großzügig unterstützt haben. Ihnen gilt unser herzlicher Dank ebenso wie Peter Weibel und Gregor Jansen vom Zentrum für Kunst und Medientechnologie in Karlsruhe, die die vorliegende Publikation in die Schriftenreihe des ZKM aufgenommen haben und zugleich die weltweite Ausstellungsreihe eröffnen. Das umfangreiche Bild- und Textmaterial hat das Atelier Kuball in Düsseldorf mit Nina Hülsmeier, Sebastian Freytag und Michèle Kuball umfassend bearbeitet, geordnet und bereitgestellt. Im Verlag Hatje Cantz haben Annette Kulenkampff mit ihrem Team aus Tas Skorupa und Birgit Sonna das Gesamtmaterial in eine druckfähige Form gebracht, das die Münchner Grafikerin Saskia Helena Kruse in ein besonders schönes Buch »verpackt« hat. Ihnen allen sei an dieser Stelle herzlich gedankt und vor allem auch Mischa Kuball für die außergewöhnliche Zusammenarbeit.

FLORIAN MATZNER, im März 2007

Regina Wyrwoll have generously supported this unique book project. Hearty thanks go out to them as well as to Peter Weibel and Gregor Jansen from the ZKM Center for Art and Media Karlsruhe. This publication has been included in the ZKM series, and it will be the first venue for Kuball's series of international exhibitions. All of the many visual and writ-ten materials have been carefully organized and prepared with the help of Nina Hüls-meier, Sebastian Freytag, and Michèle Kuball of the Kuball Studio in Düsseldorf. At Hatje Cantz, Annette Kulenkampff and her copyediting team, Tas Skorupa and Birgit Sonna, shaped all of the material into publishable form, which Munich graphic designer Saskia Helena Kruse has "packaged" as an exceptionally beautiful book. Here, gratitude due to everyone involved—in particular to Mischa Kuball for his extraordinary cooperation.

FLORIAN MATZNER, March 2007

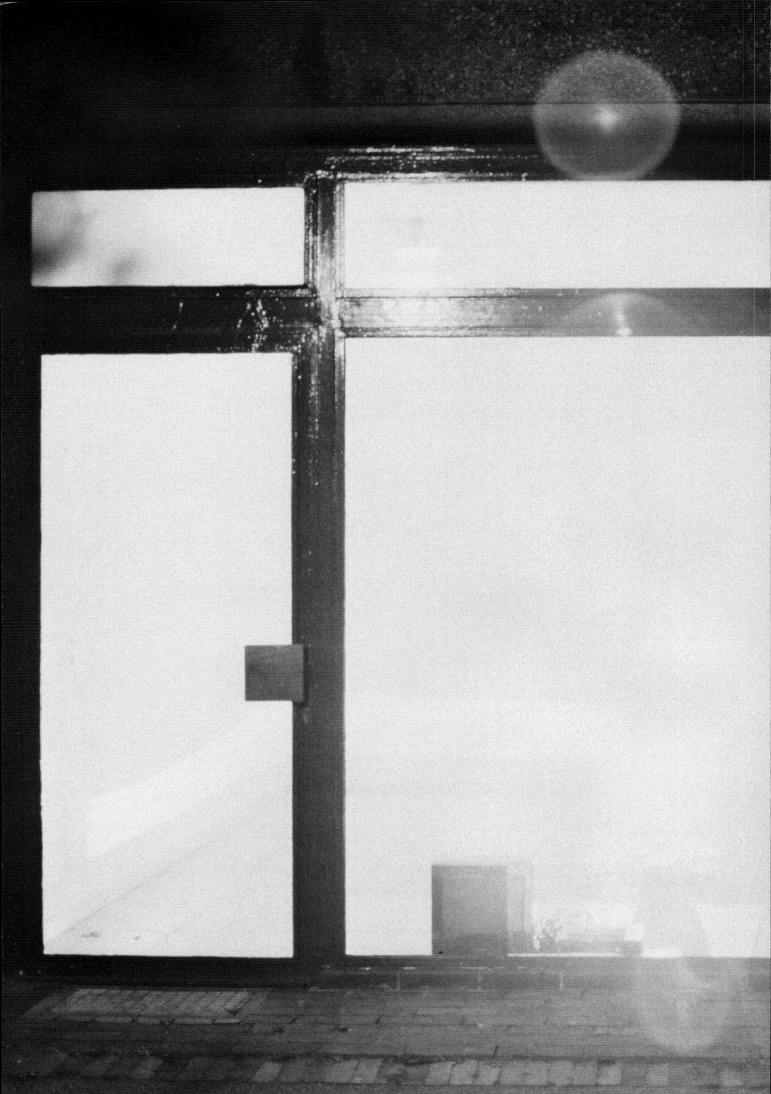

PETER SLOTERDIJK

LICHTUNG UND BELEUCHTUNG
LIGHT AND ILLUMINATION

ANMERKUNGEN ZUR METAPHYSIK, MYSTIK UND POLITIK DES LICHTS
Omnia quae sunt lumina sunt
SCOTUS ERIUGENA

METAPHYSIK ALS METAOPTIK

Der Mensch, das nachdenkliche Tier, kann über sein Dasein im Licht und Klang der Welt Rechenschaft ablegen, weil er an der Front einer kosmischen Entwicklung steht, die sich ihrem vorherrschenden Wesenszug nach als ein audiovisueller »Augen«-Aufschlag zum Sein interpretieren lässt. Der Intelligenzkomplex, der in der Gattung Homo sapiens prozessiert, inkarniert das Resultat einer biologisch-kognitiven Evolution von abenteuerlicher Unwahrscheinlichkeit. Diese spitzt sich zu in der Hervorbringung von Lebewesen, deren Umweltbezug durch eine zerebral gesteuerte komplexe Integration von Auge, Ohr, Hand und Sprache zustande kommt. Die Sonderstellung des Menschen im Kosmos ist somit ein Sachverhalt, der nicht mehr nur den Theologen ins Auge springt, sondern mehr noch den Biologen, die sich über die Rätsel sensorischer Weltoffenheit beim Menschen beugen. Der kognitive Primat der Gattung Mensch im Ensemble der natürlichen Arten scheint mit dem sensorischen Primat des Audiovisuellen beim Menschen zusammenzuhängen.

NOTES ON THE METAPHYSICS, MYSTICISM, AND POLITICS OF LIGHT
Omnia quae sunt lumina sunt.
JOHN DUNS SCOTUS

METAPHYSICS AS METAOPTICS

The human being, the contemplative animal, can call upon the world to account for his existence in light and sound, because he is on the front lines of a cosmic development, which, according to its dominant natural trait, can be interpreted as an audiovisual "eye"-opener to the state of being. The complex of knowledge that is processed within the species Homo sapiens incarnates the result of a biological, cognitive evolution of adventurous improbability. This is intensified in the production of living things whose relationship to the environment is created by a cerebrally guided, complex integration of eye, ear, hand, and language. The special position of the human being in the cosmos is hence a fact that no longer draws only the attention of theologians, but even more from biologists, who bow before the riddle of the human being's sensory receptiveness to the world. The cognitive primacy of the human genus among the ensemble of natural species seems to have something to do with the sensory primacy of the audiovisual in humans, in a way that we do not yet completely understand.

Project Rooms/Kabinett für aktuelle
Kunst (Detail), 1998,
Kabinett für aktuelle Kunst,
Bremerhaven
(Foto: Jürgen Wesseler, Bremerhaven)

15

Der Harvard-Ökologe Edward O. Wilson illustriert diese Überlegungen anhand der Vorstellung, wir befänden uns in tiefer Nacht inmitten des brasilianischen Regenwaldes: »Der Wald ist nachts meist ein riesiges Experiment über sensorische Deprivation, schwarz und still wie eine mitternächtliche Höhle. Wie erwartet gibt es Leben hier draußen in Überfülle, der Dschungel schwirrt, aber in einer Weise, die zum größten Teil außerhalb unserer Wahrnehmung liegt. Neunundneunzig Prozent der Tiere finden ihren Weg durch chemische Spuren an der Oberfläche, Duftwolken, die in Luft und Wasser ausgestoßen werden, und durch Gerüche, die aus kleinen verborgenen Drüsen mit dem Wind ausgesetzt werden. Tiere sind Meister dieses chemischen Kanals, auf dem wir Idioten sind. Wir hingegen sind Genies des audiovisuellen Kanals, denen in dieser Hinsicht nur einige exzentrische Tiergruppen wie Wale, Affen und Vögel gleichkommen. Daher warten wir auf die Morgendämmerung, während sie auf den Einbruch der Dunkelheit warten; und weil Sicht und Klang die evolutionären Prämissen von Intelligenz sind, haben wir allein es dahin gebracht, über Nächte im Amazonas und die Organisation der Sinne nachzudenken.«[1]

In Fortführung solcher Betrachtungen lässt sich sagen, dass die menschliche Intelligenz, besonders in ihren kontemplativen und wissenschaftlichen Formierungen, eine Ekstase der Audiovisualität bedeutet. Die Darstellbarkeit von Welt überhaupt in menschlichen Wissensformen gründet in dem Sonderweg der Sehkraft – von der auditiven Komponente unserer Weltoffenheit wird im Folgenden abstrahiert –, der sich beim Ausscheren des Menschen aus dem Gang der nur biologischen Evolution eröffnete. Nicht umsonst haben die

Harvard ecologist Edward O. Wilson illustrated these ideas with the following imaginary scenario. We find ourselves in the heart of the Brazilian rain forest in the middle of a dark night: "The forest at night is an experience in sensory deprivation most of the time, black and silent as the midnight zone of a cave. Life is out there in expected abundance. The jungle teems, but in a manner mostly beyond the reach of the human senses. Ninety-nine percent of the animals find their way by chemical trails laid over the surface, puffs of odor released into the air or water, and scents diffused out of little hidden glands and into the air downwind. Animals are masters of this chemical channel, where we are idiots. But we are geniuses of the audiovisual channel, equaled in this modality only by a few odd groups (whales, monkeys, birds). So we wait for the dawn, while they wait for the fall of darkness; and because sight and sound are the evolutionary prerequisites of intelligence, we alone have come to reflect on such matters as Amazon nights and sensory modalities."[1]

Continuing with these observations, it can be said that human intelligence, especially in its contemplative and scientific formations, signifies a rich endowment of audiovisual faculties. The ability to depict the world at all in terms of human knowledge is based in the special provisions of the power of sight—the auditory components of our perceptions of the world will be abstracted from the following—which opened up when human beings left the path of pure biological evolution. It is not without reason that a great majority of Western philosophers made optical analogies in order to express the

Philosophen des Westens in ihrer großen Mehrheit optische Analogien vorgebracht, um das Wesen der Erkenntnis und den Grund der Erkennbarkeit der Welt auf den Begriff zu bringen. Welt, Intellekt und Erkenntnis sollen miteinander einen ähnlichen Zusammenhang bilden wie Leuchtkörper, Auge und Licht in der physischen Sphäre. Ja, auch der »Weltgrund« selbst, Gott oder eine schöpferische Zentralintelligenz, wurde nicht selten als eine aktive intelligible Sonne vorgestellt, die mit ihrem Strahlen Weltformen, Dinge und Intellekte hervorbringt – gleichsam wie ein allumfassendes Selbstanschauungstheater der absoluten Intelligenz, für welche Anschauen und Schaffen eins wären. Daher ist die Behauptung gut begründet, dass die abendländische Metaphysik – ihrer durchgehenden Faszination durch okulare Motive wegen – in der Sache eine Metaoptik gewesen sei. Nachmetaphysisches Philosophieren wäre dann der Versuch, den optischen Idealismus zu überwinden und der »Condition humaine« die wirkliche Breite ihrer Weltoffenheit zurückzugeben.

LICHTUNG

Im »Lichte« einer nachmetaphysischen Auslegung der menschlichen Weltbefindlichkeit zeigt sich, dass Menschen adventische Tiere sind: Wesen, die im Kommen sind. Dies ist ein zugleich klassischer und noch nicht zu Ende gedachter Gedanke, dessen bisherige Formulierungen das Bedürfnis des zeitgenössischen Denkens nicht mehr befriedigen. In der jüdisch-christlichen Tradition wurde die menschliche Grundbewegtheit des »Zur-Welt-Kommens« mit dem Begriff der Geschöpflichkeit erfasst, die das »Im-Kommen-Sein« als

nature of insight and describe the foundations of our recognizability of the world. Together, world, intellect, and insight were supposed to form a context similar to the one shaped by illuminated objects, eye, and light in the physical sphere. Yes, even the "foundation of the world" itself, God, or another central creative intelligence, was often presented as an active, intelligible sun whose rays produced the forms of the world, things, and intellects, much like an all-encompassing, self-observing theater of absolute intelligence, as it were, to whom seeing and creating would be one and the same. Hence, there is a good foundation for the assertion that, in this regard, occidental metaphysics—due to its continual fascination with optical motifs—is a kind of metaoptics. Postmetaphysical philosophers would then have to attempt to overcome optical idealism and restore to the condition humaine the actual range of its receptivity to the world.

GLADES OF LIGHT

In "light" of a post-metaphysical interpretation of human sensitivity to the world, it can be seen that people are advent animals: creatures about to arrive. This is simultaneously a classic concept and one that has not yet been thought out completely, whose previous formulations up to the present day no longer satisfy the requirements of contemporary thought. In Judeo-Christian tradition the basic movedness of human beings as they "come into the world" is comprehended in the concept of creation, which interprets "com-

Spur einer göttlichen Urzeugung interpretierte – daraus ergab sich, dass das menschliche »Im-Kommen-Sein« hinter dem urpassiven »In-die-Welt-hineingestellt-Sein« in die zweite Reihe treten musste. Tatsächlich ist die christlich-mittelalterliche Welt mehr an Ordnung und Bestand als an Ereignis und Ankunft des Neuen interessiert. Die nachchristliche Neuzeit hingegen machte die aktiven und innovativen Momente im menschlichen Weltverhältnis stark. Sie verschob den Akzent vom Geschaffensein des Menschen auf seine eigene Schöpferkraft – zur Welt kommen bedeutet daher in neuzeitlicher Perspektive vor allem: die Welt, in welche »der Mensch« zu kommen sich vornimmt, aus eigener Vollmacht herstellen; es zu einer Welt bringen, in der sich Träume vom menschenwürdigen Leben allgemein verwirklichen. In beiden Anthropologien – in der christlichen Deutung des Menschen als Kreatur und Vasall Gottes und in der neuzeitlichen Auffassung vom Menschen als Weltingenieur und Selbsterzeuger – prägen sich verkürzte Sichten der menschlichen Grundbewegtheit aus. Noch hat das adventische Gattungsabenteuer nicht zu seiner angemessenen Selbstbeschreibung gefunden.

Als ein Wesen, das im Kommen ist, ist der Mensch wesenhaft ein Tier, das von innen kommt. »Innen« bedeutet hier: Fötalität, Nicht-Manifestation beziehungsweise Latenz, Verborgenheit, Wasser, Familiarität, Schoßhaftigkeit und Häuslichkeit. »Zur-Welt-Kommen« muss demnach fünffach verstanden werden: gynäkologisch als Geburt, ontologisch als Welteröffnung, anthropologisch als Elementwechsel vom Flüssigen ins Feste, psychologisch als Erwachsenwerden, politisch als Einrücken in Machtfelder. Wo Menschen sind,

ing into being" as the mark of an ancient, divine creation. The result of this was that the human process of "coming into being" took second place to the ancient, passive process of "being placed into the world." In fact, the medieval Christian world was more interested in hierarchy and perpetual life than in the experience and advent of the new. The post-Christian modern era, on the other hand, strengthened the active, innovative aspects of the human relationship to the world. It shifted the emphasis from the creation of human being to his own powers of creation. From a modern perspective, therefore, coming into the world primarily means using one's own authority to make a world into which "the human being" intends to come: a kind of world in which the dream of a dignified life can be universally realized. Both kinds of anthropology—the Christian interpretation of the human being as the creature and vassal of God, and the modern concept of the human being as the engineer of the world and the creator of himself—are marked by shortsighted views of basic human movedness. Humankind's adventure of advent has not yet been adequately defined.

As a creature still coming into being, the human being is by nature an animal who comes from inside. Here, "inside" means: a fetality, non-manifestation or latency, security, water, familiarity, the desire for safety, and domesticity. "Coming into the world" therefore must be understood in five ways: in the gynecological sense as birth; ontologically, as receptivity to the world; anthropologically, as the transformation of elements—

dort tummelt sich nicht eine Gattung wie alle anderen im Licht der Sonne, sondern dort geschieht die Lichtung, für deren Bewohner erst davon die Rede sein kann, dass »es eine Welt gibt«. Daher gehören Ankunft und Lichtung radikal zusammen. Das Licht über allem, was der Fall ist, ist nicht eine Gegebenheit unter anderen. Es ist vielmehr das Kommen des Menschen als Zugehen auf die Welt, welches den Weltaufgang ermöglicht. Die Ankunft des Menschen ist selbst der »Augen«-Aufschlag zum Sein, in dem das Seiende sich lichtet. In dieser Sicht ließe sich der Gattungsadvent im Ganzen – samt seiner epistemisch-technischen Spitze – als ein luziferisch-kosmisches Abenteuer verstehen. Die Menschheitsgeschichte wäre dann die Zeit der Lichtung; Menschheitszeit ist die Zeit des weltbildenden Blitzes, den wir als solchen nicht sehen, weil wir, indem wir in der Welt sind, im Blitz sind.

LICHT ALS GARANT DER ERKENNBARKEIT DES SEIENDEN
Gleichwohl schöpfen Menschen ihre Gewissheit, sich an ihrem Ort hinlänglich auszukennen, aus der Erfahrung einer stabilen Sichtbarkeit der Welt – und als tagaktive Lebewesen neigen sie dazu, den Sinn von Sein als »Bei-Tage-Sein« auszulegen. Somit wird schon für die frühen Metaphysiker und Naturphilosophen des Westens die Welt zu allem, was bei Tageslicht der Fall ist – man hat sogar mit einem Moment von Berechtigung sagen können, die okzidentale Philosophie sei ihrem Wesen nach Heliologie, das heißt Sonnenmetaphysik oder Photologie – Lichtmetaphysik. Dass bei den Ägyptern erste Versuche über den Mono-

from liquid into solid; psychologically, as the process of becoming an adult; and, politically, as the process of taking over areas of power. Wherever people are found, we as a genus do not simply frolic in the light of the sun, as all of the others do. Instead, that is where the glade of light can also be found, and its existence is what makes it possible for its inhabitants to say that "there is a world." And so advent and glade of light cleave together. Light shining over everything, which is the case, is not one of many other preconditions. Rather, it is the advent of the human being, an approach to the world, which makes the dawning of the world possible. The arrival of the human being is itself the "eye"-opener to existence, in which being is illuminated. From this point of view, the advent of the genus as a whole—including its epistemological, technological tip—can be understood as a luciferous, cosmic adventure. In this case, the history of humanity would be the era of the glade of light; the era of humanity is the era of lightning that forms the world, which we do not perceive as such, because we who are in the world are inside the lightning.

LIGHT AS THE GUARANTEE OF THE ABILITY TO KNOW BEING
People nevertheless derive their certainty that they are sufficiently familiar with their location from their experience of the world as a place whose visibility is stable—and as living beings who are active by day, they tend to explain their sense of existence as "existing during the day." Therefore, even for the earliest Western metaphysicians and philoso-

theismus als Monarchie des Sonnengottes unternommen wurden, entspricht dieser ratio-
nalisierten metaphysischen Lichtauffassung. Deren Spuren reichen religionsgeschichtlich
vorwärts bis in die römischen kaiserzeitlichen Kulte des »Sol invictus« und der Mithras-
Verehrung, philosophisch bis in die christlich-mittelalterlichen Metamorphosen des Plato-
nismus. Plato hatte in dem berühmten Sonnengleichnis aus dem 6. Buch der *Politeia*, wel-
ches das Höhlengleichnis vorbereitet, das Grundmotiv für alle spätere Lichtmetaphysik
vorgegeben. Er führt dort aus, dass neben Auge und sichtbarem Ding ein Drittes vonnöten
sei, damit erfolgreiches Sehen zustande komme: das Licht. Licht ist die Gabe des Helios,
des Himmelsgottes, der als Herr des Lichts uns Menschen den Gesichtssinn und den Din-
gen die Sichtbarkeit gewährt. Der Gesichtssinn ist seiner Natur nach Sonne in ihrem ande-
ren Zustand – Sonnenausfluss und Sonnenkraft – und deswegen Grund der Offenheit des
sonnenhaften Auges für die Sonne. Sehen bedeutet im Grunde eine Fortführung des Strah-
lens der Sonne mit anderen Mitteln: Sonnenhafte Augen strahlen sichtbare Dinge an und
»erkennen« sie kraft dieser Anstrahlung. Nun ist Denken seinerseits nur ein anderes
Sehen – nämlich Sehen im Bereich der unsichtbaren Dinge, der Ideen. Wie Helios für das
Sichtbare Lichtgeber ist, so wirkt in der Welt der Ideen »agathon«, das Gute, als die alles
durchwaltende Zentralsonne; von ihr her gewinnen Menschen Denkkraft, während zugleich
die Ideen Denkbarkeit erhalten. Mit dem klaren Denkstrahl wahre Ideen anzudenken, ist
analogisch dasselbe wie mit dem (heliomorphen) Sehstrahl gut beleuchtete sichtbare
Dinge anzusehen. Und so wie das Letztere bei Nacht misslingt, wo man nur Schemen und

phers of nature, everything about the world that existed during the daylight hours—one
might even be somewhat justified in saying that occidental philosophy is in its very nature
heliology, meaning sun metaphysics or photology—became part of the metaphysics of
light. The fact that the Egyptians made some attempts at monotheism, considered a
monarchy of the sun god, corresponds to this rationalized, metaphysical understanding of
light. In terms of religious history, the Egyptians can be traced forward into the Roman
Empire, to the cult of *sol invictus* and Mithraism. Philosophically, they can be traced as far
as the medieval Christian metamorphoses of Platonism. In the famous image of the sun
from the sixth volume of his *Politeia,* which preceded the Allegory of the Cave, Plato pro-
vided the basic motif for all later metaphysics of light. Here, he explains that besides the
eyes and a visible item, a third thing is needed in order to see successfully: light. Light is
the gift of Helios, the god of the heavens, who, as lord of light, not only gives human
beings their sense of sight but also makes things visible. By its very nature, the sense of
sight is the sun in its other state—the rays and energy of the sun—and therefore the rea-
son why the sun-like eye is receptive to the sun. Basically, to see means to continue to
convey the rays of the sun through other means: sun-like eyes beam at visible things and
"recognize" them by virtue of these beams. Now, for its part, thinking itself is just another
way of seeing—namely, seeing in the territory of invisible things, ideas. Just as Helios
provides light to visible things, *agathon*, goodness, functions in the world of ideas as the

dunkle Nichtse wahrnimmt, so schlägt auch das Denken fehl, wenn es sich auf Gegen-
stände richtet, denen die Finsternis des bloßen Meinens beigemischt ist. Richtiges (»aga-
thomorphes«) Denken ist Sehen im ewigen Tag der vom Guten ausgeleuchteten Ideenwelt.
Man erkennt hier, wie der optische Idealismus zu seinem entscheidenden Coup ansetzt,
indem er das sehende Denken dem sinnlichen Sehen überordnet. Helios nämlich, so Plato,
ist seinerseits das Abbild des Guten, das aus der Ideensphäre in die Sinnenwelt herüber-
fließt. Aus der Analogie von Sonne und Gottheit (Gutheit) wird eine ontologische Hierarchie
mit dem intelligiblen Gottesprinzip an der Spitze. Damit hat die neuere Geistmetaphysik der
archaischen Naturphilosophie den Rang abgelaufen – auch das sichtbare Licht ist jetzt
»nur ein Gleichnis«, wenngleich ein majestätisches, naturtheologisch immer noch virulen-
tes. Nicht umsonst hat die mittelalterliche Metaphysik das »fiat lux« der Genesis in platoni-
schem Sinne deuten können – denn Licht- und Sonnenschöpfung sind glaubhafte Erst-
handlungen des Gottes, der bei seiner Schöpfungs-Äußerung nicht anders kann, als in der
Stofflichkeit das seinem Wesen Ähnlichste, Beste darzustellen. In einer zu schaffenden
Welt von höchster Güte muss das Vornehmste zuerst geschaffen werden – als wäre Licht
ein Geist- und Gottesanalogon unter den Kreaturen, ein erhabenes Band und Medium der
Natur, das von erlösten Menschenaugen als »Evangelium corporale« angeschaut werden
kann. Der in der positiven Theologie zwingende Schluss von der Bestheit des Gottes auf die
Optimalität der Schöpfung zieht eine dreifache Grundbestimmung der Schöpfung nach
sich: Sie muss kugelgestaltig sein, weil die Sphäre das morphologische Optimum vorstellt;

central sun that reigns over everything; it is from this that people derive their power to
think, while at the same time, ideas are given the ability to be thought. Using clear rays of
thought to think real ideas is, analogously, the same thing as looking at well-lit, visible
things using (heliomorphic) rays of vision. And just as the latter is not possible at night,
when one can only perceive silhouettes and dark nothings, thought also fails if it is
directed toward things mixed together with the darkness of pure opinion. Right (agatho-
morphic) thought is seeing by the light of eternal day the world of ideas as it is illumi-
nated by goodness. One can see here how optical idealism prepared for its decisive coup
by subordinating sensory vision to visual thought. According to Plato, Helios is the image
of goodness, which flows out of the sphere of ideas into the world of the senses. From the
analogy of sun and the divine (goodness) comes an ontological hierarchy with the princi-
ple of the intelligible god at the top. Thus modern intellectual metaphysics surpassed
archaic natural philosophy in rank—visible light, too, became "just a likeness," although
still a majestic, virulent one in terms of natural theology. There is a reason why medieval
metaphysics interpreted the *fiat lux* of Genesis in the Platonic sense—for light and the
creations of the sun plausibly represent the first deeds of the god who, in articulating his
creations, could do nothing but represent in materiality what most resembled his nature:
goodness. In an as-yet-to-be-created world of greatest good, the most noble must be cre-
ated first—as if, among the creatures, light were analogous to the spirit and the divine, a

sie muss lichtdurchflutet sein, weil Licht das physikalische Optimum ist; sie muss rational vollkommen transparent sein, weil Durchsichtigkeit das kognitive Optimum bedeutet. Alle drei Optima fallen in einer Schöpfung zusammen, die als eine aus dem absoluten Licht-punkt Gott ausstrahlende Lichtkugel gedacht wird – jene »sphaera lucis«, die zugleich mit dem Modell der Welt eine Begründung für deren Erkennbarkeit liefert; die Welt verstehen, heißt die Ausstrahlung der Kategorien aus der einen unbedingten Licht-, Seins- und Ver-ständlichkeitsquelle nachvollziehen.[2] Zu den chronischen Verlegenheiten der Lichtmeta-physik gehört freilich, im Platonismus wie in den von ihm abhängigen christlichen Theolo-gien, die Frage nach Herkunft und Rang der Materie, über die das Licht, als Erstausgeburt Gottes, erst leuchten soll. Ähnlich muss die christliche Lesung der jüdischen Genesis die Frage umgehen, welcher Art die Wasser gewesen sein könnten, über denen der Geist Got-tes ursprünglich geschwebt haben soll.

Mit der Absolutsetzung des Lichts in den monotheistischen Metaphysiken kommt ein Zug zur Überbelichtung des Seins zum Tragen – bis hin zum Untergang der Materie am Licht; das gnostische Motiv von der Weltfremdheit des Lichts kündigt sich hierin ebenso an wie die eschatologische Idee, dass am Ende der Zeiten Welt und Leben in einer endgültigen innergöttlichen Licht-Symphonie aufgehoben werden; dann wäre das Licht allein alles, was der Fall ist – vielmehr: alles, was erlöst vom Fall, in ewiger Schwebe bleibt. Das sublimste Monument dieser Vorstellungsart sind die Gesänge des Paradiso aus Dantes *Göttlicher Komödie*; dort tut sich eine ganz aus Licht im Licht modellierte Über-Welt seliger Intelli-

sublime natural body and medium, which can be seen by the human eye redeemed by Christianity as the *evangelium corporale*. The necessary conclusion of positive theology, that what was best about God manifested in optimal creation, results in three basic deter-minants of the creation: it has to be round, because the sphere represents the morpho-logical optimum; it has to be flooded with light, because light is the physical optimum; it has to be perfectly transparent in logic, because transparency means the cognitive opti-mum. All three optima coincide together in one creation, which is imagined as a sphere of light emanating from the absolute point of light, God—that *sphaera lucis,* which along with the model of the world provides the foundation for its ability to be recognized. Under-standing the world means imagining the categories emanating from the one uncondi-tional source of light, being, and comprehensibility.[2] Admittedly, one of the chronic, awk-ward situations in light metaphysics—in both Plato and Christian theologies—is dependent upon the matter of the origin and rank of the material above which light, as the first of God's productions, was supposed to shine. In a similar way, the Christian interpre-tation of Genesis in the Old Testament has to deal with the issue of what kind of water the spirit of God originally floated above.

When light gained an absolute position in monotheistic metaphysics, an aspect of the light that shines above all that exists came to fruition—all the way to the annihilation of matter exposed to light. This heralds the Gnostic motif of light's unworldliness as well as

genzen auf, allesamt teilnehmend an der sich ungehindert »teilgebenden« und in sich selbst zurückflutenden Strömung des Urlichtes. Dantes Visionen antworten auf die Schlussbilder der Johannes-Apokalypse, in denen das Ende des Wechsels von Tag und Nacht und die Herrschaft des Ewigen Lichts prophezeit wird; im Himmlischen Jerusalem werden alle Lampen, die astralen wie die menschengemachten, überflüssig geworden sein.

»(21,23) Die Stadt braucht weder Sonne noch Mond, die ihr leuchten. Denn die Herrlichkeit Gottes erleuchtet sie, und ihre Leuchte ist das Lamm [. . .] (22.5) Es wird keine Nacht mehr geben, und sie brauchen weder das Licht einer Lampe noch das Licht der Sonne. Denn der Herr, ihr Gott, wird über ihnen leuchten [. . .]«.

Es spricht für den engen Zusammenhang zwischen Monotheismus und Lichtmetaphysik, dass auch die islamische Kultur des Mittelalters eine Fülle von hochrangigen lichtphilosophischen Abhandlungen hervorgebracht hat – gemischt aus platonischen, plotinischen, aristotelischen, jüdischen und arabischen Komponenten, unter gelegentlichem Hinzutretens iranisch-dualistischer Motive.[3] In Wendungen, die dem Kenner der platonischen Tradition vertraut sind, spricht der arabische Philosoph Abu-Hamid Muhammad al-Ghazali (1059–1111) in seinem Traktat *Die Nische der Lichter* (*Miskat al-anwar*, verfasst circa 1100) über den Lichtsinn der Prophetenworte: »So haben die Koranischen Verse für das Auge der Vernunft die gleiche Bedeutung wie das Sonnenlicht für das physische [wörtlich: sichtbare] Auge, weil dadurch das Sehen vollkommen wird. Deshalb ist es angemessen, dass der

the eschatological idea that at the end of all time, the world and life will dissolve into a final, inwardly divine light symphony. Then light alone will be all that exists, or rather, everything that is saved from annihilation will remain in a state of eternal suspension. The most sublime monument to this kind of thinking consists of the cantos in the *Paradiso* of Dante's *Divine Comedy*. In them can be found a kind of world beyond of blissful, intelligent beings modeled entirely out of light, all of whom are part of the stream of "participatory" original light that flows back unhindered to itself. Dante's visions respond to the final images in the Revelations of John, which prophesy the end of day and night and the rule of eternal light. In heavenly Jerusalem, all lights, both astral as well as those made by humans, will have become superfluous.

"(21:23) And the city had no need of sun or moon to shine upon it; for the glory of God gave it light, and its lamp was the lamb. (22.5) There shall be no more night, nor will they need the light of lamp or sun, for the Lord God will give them light. . . ."

Evidence of the close relationship between monotheism and the metaphysics of light is that medieval Islamic culture also produced a cornucopia of highly esteemed treatises on the philosophy of light— mixtures of Platonic, Plotinian, Aristotelian, Jewish, and Arabic components, with the occasional addition of Iranian dualist motifs.[3] Using phrases that are familiar to those who know the Platonic tradition, the Arabian philosopher Abu-Hamid Muhammad al-Ghazali (1059–1111) speaks in his tract, *The Niche of Lights* (*Miskat*

Koran wie das Sonnenlicht ›Licht‹ genannt wird. Das Symbol des Korans ist das Sonnen-
licht und das Symbol der Vernunft das Augenlicht. Deshalb können wir den Sinn jenes
Koranischen Verses begreifen: ›Glaubt an Gott und seinen Gesandten und an das Licht, das
wir (zu euch) hinabgesandt haben‹.«[4]

BLENDUNG

Wo viel Licht ist, ist viel Schatten, wo zu viel des Lichts ist, dort herrscht Dunkelheit. Es
gehört zur Eigendynamik metaphysischer Monismen, dass ihre Radikalisierung in Mystik
ausmünden muss. Wer vorbehaltlos auf das »Eine« setzt, hebt zu guter oder schlechter
Letzt alle Verschiedenheiten im Abgrund des »Erst-Letzten« auf. Dies gilt auch dann, wenn
das absolute Erste als Licht, Urlicht oder Überlicht gedacht wird. Soll dieser letzte Licht-
Abgrund in irgendeiner Weise für die menschlichen Erfahrung aufgehen, so nur, wenn der
Erkennende in ihm zugrunde geht – so lautet die Regel radikalisierter Monismen. Das
Zugrundegehen im »Einen« setzt die Unterschiedenheit von Licht, Sehkraft und beleuchte-
tem Gegenstand außer Kraft: Der Sehende ertrinkt im primordialen Lichtmeer, welches
zugleich aufhört, als Helligkeit erfahren zu werden – sofern Helligkeit noch zur nicht-
abgründigen Zone der Hell-Dunkel-Differenz gehört. So bildet unter monistischen Prämis-
sen die Lichtmystik das notwendige Schlussstück der Lichtmetaphysik – gleichsam deren
Überlauf oder Exzessfunktion. Schon Plato hatte den Aufstieg des aus der Höhle Befreiten
ans offene Licht des »Einen« als Blendung gedacht – als Katastrophe der Sehkraft ange-

al-anwar, written around 1100), about the meaning of light in the words of the prophets.
"Thus, for the eye of reason, the verses of the Qur'an have the same meaning as the sun-
light has for the physical [literally: visible] eye, because through it, vision is perfected.
Therefore it is appropriate to call both the Qur'an and the sun 'light.' The symbol of the
Qur'an is the sunlight, and the symbol of reason is the light of the eye. Thus we can
understand the meaning of this verse in the Qur'an: 'Believe in God and his messengers
and in the light, which we have sent down (to you).'"[4]

BLINDING

Where there is much light, there is also much shadow; where there is too much light,
darkness reigns. It is part of the unique dynamics of metaphysical monisms that when
they are taken to extremes, they must end in mysticism. Anyone who relies without reser-
vation on the "one" must ultimately, for good or bad, see all differences removed in the
abyss of the "first-last." This is also true when the absolute first is regarded as light, orig-
inal light, or super-light. If, in some way, this last abyss of light is, in human experience,
to dissolve, it will only occur when the person realizing it is destroyed by it: this is the rule
of radical monism. Being destroyed in the "one" negates the difference among light, the
power of vision, and the illuminated object: the person seeing drowns in the primordial
sea of light, which at the same time ceases to be experienced as brightness, insofar as

sichts des himmlischen Lichtgrundes. Über Plotin und Pseudo-Dionysius Areopagita wandern diese Konzepte in die mittelalterliche Theologie und formen deren mystische Kulminationsfiguren mit. Auf dem »apex theoriae«, dem Gipfel der Schau, schlägt das hellste Sehen in Blindheit, das absolute Licht in Dunkelheit, das vollkommene Wissen in Unwissenheit um. Der heilige Bonaventura (†1274) denkt die letzte Stufe des »itinerarium mentis in deum« – der Reise der Seele in Gott – als vernichtend-verwandelnden »transitus«, das heißt als Überschritt ins Dunkel (»caligo«) und als beseligende Blendung. Im Sprachspiel der Lichtmystik heißt diese letzte Verschmelzung des Meditierers mit dem Absoluten »Sterben«. So kennt auch die klassische Metaphysik einen »Tod des Subjekts«: den durch Überbelichtung. Was das Mittelalter Erleuchtung nannte, ist das lichtmystische Mittelglied der Vergottungsübung, die sich durch die Triade »Reinigung-Erleuchtung-Einung« (lateinisch: »purificatio-illuminatio-unio«; griechisch: »katharsis-photismos-henosis«) vollzieht. So konnte die deutsche Mystik zu klingenden Formeln wie »überliehte dunkle vinsterheit« (Heinrich Seuse, *Vita*) gelangen, die weniger poetisch kühn als logisch folgerichtig sind.

PASSION DES LICHTS

Wo die Mystik des Lichts religiösen Motiven am nächsten kommt, dort geht es weniger um Optik oder Logik als um die Selbsterfassung des bewussten Lebens. Lichttheorie war über lange Zeit das Feld, auf dem die abendländische Menschheit Reden über Subjektivität pro-

brightness still belongs to the non-abyss zone of the light-dark difference. Thus, under monist premises, light mysticism is the necessary key to the metaphysics of light—their superfluity or excessive function, as it were. Even Plato regarded the ascension of those freed from the cave to the open light of the "one" as a kind of blinding—a catastrophe affecting the power of vision when faced with the fundamental heavenly light. Through Plotin and Pseudo-Dionysius Areopagita these concepts moved into medieval theology to form a portion of its culminative mystical figures. At the *apex theoriae*, the peak of vision, the brightest vision is transformed into blindness, absolute light into darkness, perfect wisdom into unknowing. St. Bonaventura (†1274) thought of the last phase of the *itinerarium mentis in deum*—the journey of the soul in God—as destructive-transformative, *transitus*, meaning the transition into darkness *(caligo)*, a process resulting in blissful blinding. In the language of light mysticism, the person meditating and then melding with the absolute is said to be "dying." Thus, classic metaphysics also recognizes the "death of the subject" via excessive illumination. What was known in the Middle Ages as enlightenment is the intermediate stage of divine practice in light mysticism, which is completed in the triad of "catharsis-enlightenment-unity" (Latin: *purificatio-illuminatio-unio;* Greek: *katharsis-photismos-henosi).* Thus, German mystics came to such resounding formulations as *überliehte dunkle vinsterheit* (luminous yet somber darkness) (Heinrich Seuse, *Vita),* which are less poetically bold than they are logically consistent.

ben konnte. Nicht das Licht der Physiker ist es, was Menschen bei der Frage nach Gott, Welt und Selbst zu denken gibt, sondern das personale Licht, das als Metapher für Selbstgefühl und Beseeltheit steht. Wie kommt es, dass inmitten der Dinge, deren Aggregat das Weltganze bildet, Seelen vorkommen, gleichsam Ich-Lichter und innere Funken, deren Leuchten nicht nach der Art eines Dingbestandes oder einer natürlichen Reaktion aufgefasst werden kann? Lichtphilosophie begleitet die Geschichte des Rätsels, das die sich selbst entdeckende »Subjektivität« für sich selbst darstellt. Immer schon impliziert das menschliche Selbstsein ein Moment von Licht- oder Funke-Sein, von dem sich fragen lässt, ob es nicht von anderer Herkunft sei als die dingliche Welt. Von einem erlebten inneren Licht reden, heißt – mutatis mutandis – teilhaben an der Erfahrung des Moses vor dem brennenden Dornbusch, aus dem, gewissermaßen im Geist der Flamme, eine Stimme spricht: »Ich bin, der ich bin« – anders übersetzt: »Ich bin der ›Ich-bin-da‹« (*Exodus* 3,14). So verwundert es nicht, wenn in der Hochreligion, jenseits von Optik und Logik, eine Wendung zur Personalisierung des Lichts vollzogen wurde. Nicht nur das Licht, das scheint und das Licht, das erkennen macht, gehen Menschen von Grund auf an, sondern mehr noch das Licht, das lebt, das Licht, das erheitert und heilt. Darum ist Lichtmetaphysik an ihrem Ursprung ebenso sehr Soteriologie wie philosophische Optik, ebenso sehr metaphysische Therapeutik wie Logik. Den Tenor solcher Heilslicht-Geschichten gibt der Prolog des Johannes-Evangeliums vor.

PASSION OF THE LIGHT

Wherever the mysticism of light most closely approaches religious themes, it has less to do with optics or logic than with the way the self comprehends conscious existence. For a long time, the only field in which Westerners could attempt to discuss subjectivity dealt with the theory of light. It is not the light of the physicists that gives people something to think about when considering the matter of God, the world, and the self, but the personal light, which is a metaphor for one's feeling about oneself and bliss. How is it that in the midst of things, whose aggregate is the entire world, there are souls, self-lights and internal sparks, as it were, whose light cannot be understood as if it were an object-state or a natural reaction? The philosophy of light accompanies the history of the riddle which says that the "subjectivity" that discovers itself represents itself. The existence of the human self has always implied the existence of a light or spark, which allows us to ask if it does not originate somewhere else besides the material world. To speak of the experience of an inner light means—*mutatis mutandis*—to participate in Moses's experience in front of the burning bush, from whence, in the spirit of the flame as it were, a voice said: "I am; that is who I am"—or otherwise translated: "I am who 'I-am-there'" (Exodus 3:14). So it is not surprising when, in high religion, beyond optics and logic, there is a turn to the personalization of light. People are not only basically concerned with the light that shines and the light that makes it possible to see, but even more with the light that lives, the light

»1,3 In ihm war das Leben, und das Leben war das Licht der Menschen.

4 Und das Licht leuchtet in der Finsternis, und die Finsternis hat es nicht erfasst.

9 Das wahre Licht, das jeden Menschen erleuchtet, kam in die Welt.

10 Er war in der Welt, und die Welt ist durch ihn geworden, aber die Welt erkannte ihn nicht.«

Dieses Licht, als »Leben des Lebens« verstanden, teilt mit dem Lebendigen überhaupt die Nötigung zum Leiden. »Wie ein Sterblicher« kommt diese »lux vivens« (Augustinus) zur Welt und kehrt nach einem exemplarischen welt- und todüberwindenden Leidensweg an seine überhimmlische Quelle zurück. Die Welt ist ihm das Theater seiner Passion. Unter den kanonischen Evangelien kommt das des Johannes den Vorstellungen der Gnosis am nächsten, nach welcher die Seelen mancher Menschen – der Pneumatiker – gefallene Lichtfunken seien, die durch das Erscheinen eines Rufers und Retters an ihre wahre Natur erinnert und aus dem Gefängnis der Materie befreit werden können. Die gnostische Dramaturgie des zur Welt gekommenen Lichts kulminiert in der Religion Manis, die den Weltlauf als Passionsgeschichte des leidenden Lichtes deutet. Jede lichthafte Einzelseele ist einbezogen in ein dreiphasiges kosmisches Drama: In diesem sinkt das Licht aus seinem ursprünglichen Zustand der Abgetrenntheit in den der Vermischung und des Leidens ab, um zuletzt durch eine reinigende Entmischung und Neuabtrennung erlöst zu werden.[5] Solche erzählerischen Lichtpassionen bieten die logische Möglichkeit einer Antwort auf die philosophisch ansonsten unlösbare Frage nach dem Grund des Nicht-Lichts, der Materie

that cheers and heals. That is why the origins of the metaphysics of light are just as much soteriology as philosophical optics, just as much metaphysical therapy as logic. The tone of this kind of healing light story is given by the prologue of John the Evangelist.

1:3–4 All that came to be was alive with his life, and that life was the light of men.

5 The light shines on in the dark, and the darkness has never mastered it.

8–9 The real light which enlightens every man was even then coming into the world.

10 He was in the world; but the world, though it owed its being to him, did not recognize him.

This light, regarded as the "light of life," shares with those who are alive the compulsion to suffer. "Like a mortal," this *"lux vivens"* (St. Augustine) comes into the world, and after following an exemplary path of suffering to overcome the world and death, returns to its source beyond heaven. For it, the world is the theater in which its passion play takes place. Among the canonized Evangelists, John's ideas are the closest to those of the Gnostics, according to whom the souls of some people—the pneumatics—are fallen sparks of light who are reminded of their true nature by the appearance of someone who calls them, a savior who can liberate them from the prison of the material world. The Gnostic drama concerning the arrival of light in the world culminates in the religion of Manes, who interpreted the course taken by the world as a passion play of suffering light. Each individual light-clad soul is included in three phases of a cosmic drama: in it, the

und des Bösen. Weil Licht zunächst nur Expansion aus sich ist, braucht es die Brechung am Weltwiderstand, um sich an diesem zu reflektieren und um aus der Selbstferne zu sich selbst zurückzukehren. Die Leidensgeschichte des weltfremden Lichts im Nicht-Licht ist – von den spätantiken Gnostikern bis zu Hegel – die Bedingung dafür, dass das heimgekehrte Licht sich »zuletzt« in sich selbst reflektiert und weiß.

AUFKLÄRUNG

Mit dem Beginn der Neuzeit verschieben sich die lichtmetaphysischen Einstellungen der westlichen Rationalität von Grund auf. Die reale Welt liegt nun nicht mehr unter dem wie auch immer verschleierten ewigen Licht einer göttlichen Überwelt, sie enthüllt sich progressiv im Laufe eines Ausleuchtungsprozesses, dessen epistemologischer Titel »Forschung« und dessen politisches Programmwort »Aufklärung« lautet. Dies hat seine Motivation in einer Neufassung der Vorstellung vom Weltgrund selbst. An die Stelle einer autoritativen Ureinrichtung der Welt auf dem Grund einer Schöpfungsordnung tritt nun die Selbsteinrichtung der Welt durch die menschliche Praxis. Dessen Folgen für die Auffassung des Lichts reichen weit. Wo die altabendländische Ontologie – kaum anders als die orientalische Metaphysik – sich von einem sich gebenden oder offenbarenden Licht Gott, Welt und Seele zeigen lässt, dort setzt die neu-europäische Vernunft auf die eigene erhellende Tat. Damit wird das Licht (wie der Intellekt und das Handeln) entontologisiert – es wird zum Medium und zum Instrument einer Praxis, die sich selbst hinreichende Aufklä-

light descends from its original state of detachment into the confusion and suffering, in order to ultimately be saved through a process of purification involving detachment and re-separation.[5] These kinds of narrative passion plays about light offer a logical opportunity to answer the otherwise insoluble philosophical question of the source of non-light, the material world, and evil. Since light is, at first, simply an expansion of itself, it needs to be broken by the resistance of the world in order to reflect upon the world and then return to itself from across the distance. From the early Gnostics to Hegel, the passion play of light not of this world as it suffers in non-light is the perquisite needed so that the light that has returned to itself can "finally" be reflected in itself and know.

ENLIGHTENMENT

As the modern era began, the ideas of light metaphysics fundamentally shifted in the direction of Western rationalism. The real world no longer lay underneath the mysterious eternal light of a divine world beyond. It progressively revealed itself over the course of a process of illumination, known by the epistemological title of "research," whose political program was "enlightenment." The motivation for this lay in a new understanding of the concept of the foundation of the world itself. Instead of an authoritative original creation of the world based on a hierarchy of creation, there appeared the notion that people themselves set up the world as it was. The consequences for the understanding of light

rung verschafft. »Aufklärung« ist der Prozess, den die moderne Vernunft anstrengt, um Licht in die gesellschaftlichen und naturalen Zusammenhänge zu bringen. Man könnte sagen, das Licht wird aktiviert und zu einer Sonde der technischen und politischen Weltdurchdringung gemacht. Der ontologisch-religiöse Habitus der partizipativen Andacht vor dem Geheimnis wandelt sich in den Willen zur Entzauberung und Entlarvung. Der gemeinsame Grund von neuzeitlicher Politik und Technik liegt in dem alles durchdringenden Motiv, Licht ins bisher Dunkle oder Verdunkelte zu bringen. Aufklärung ist das Zeitalter der Licht-Penetranz. Nun soll niemand mehr im Namen einer höheren Einsicht von privilegierten Priesterintellektuellen hinters Licht geführt werden können. Darum werden Dunkelmänner vor die Schranken der Öffentlichkeit zitiert, Geheimpolitik wird durch Transparenzpolitik ersetzt, unbewusste Motive werden ans Licht des Bewusstseins gehoben, neue Energiequellen werden zur künstlichen Beleuchtung der Häuser und Städte erschlossen. Ein luziferischer – »lichtbringerischer« – Aktivismus kennzeichnet die Epoche, die aus dem »Siècle des lumières« hervorging. Laternenanzünder und Philosophen, Ingenieure und Psychologen, Journalisten und Chirurgen, Detektive und Astrophysiker sind allesamt Teilnehmer an jener großen Koalition der offensiven Durchleuchtung aller Dinge, als die sich die industrielle, elektrische und elektronische Neuzeit versteht. Ihre natürlichen Gegner erkennen die Partisanen der demokratisch-technokratischen Licht-Kampagne in den Verteidigern vormoderner Verhältnisse – den »Obskurantisten« und Sympathisanten des abgelösten Agrarzeitalters mit seinen übernatürlichen Lichtern und seinen privilegierten

were far-reaching. Whereas the old Western ontology—which could barely be differentiated from Eastern metaphysics—saw God, the world, and souls through a giving or revealing light, the new European method of reasoning bet on its own enlightening deeds: hence, the de-ontologization of light (as well as the mind and the deed). Light became the medium and instrument of a praxis that created its own, perfectly adequate explanation. "Enlightenment" is the process that challenges modern reason in order to cast light on social and natural interrelations. One could say that light was activated and turned into a probe that would technologically and politically penetrate the mysteries of the world. The ontological, religious habit of participatory worship of the mystery was transformed into the will to de-mystify and reveal. Modern politics and technology shared the idea of bringing light to what had been dark or shadowy. The Enlightenment was the age of light penetration. Nobody would ever again have the wool pulled over his eyes, in the name of more elevated insight, by a privileged, intellectual priesthood. So shadowy figures were brought before the public, transparency replaced the practice of politics behind closed doors, subconscious motifs were elevated to the light of the conscious mind, new sources of energy provided artificial lighting for houses and cities. A luciferous—"light-bringing"—activism marked the epoch that emerged from the *siècle des lumières.* Lamplighters and philosophers, engineers and psychologists, journalists and surgeons, detectives and astrophysicists all participated in the great coalition to aggressively illuminate everything, as it

Erleuchtungen. Das »luziferische« Licht der emanzipierten Selbsttätigkeit, die sich neuzeitlich in die Position des Grundes aller Gründe gesetzt hat, kann keine andere Lichtquelle – zumal kein »Licht von oben« – neben sich dulden.

KÜNSTLICHE BELEUCHTUNG – POSTMODERNES ZWIELICHT

Auch das Licht der Aufklärung macht Erfahrungen mit seinem Schatten. Es charakterisiert die Selbsterfahrung moderner Menschen, dass sie die Welt infolge von Aufklärung und Fortschritt nicht nur heller, sondern auch zwielichtiger sehen werden. Die politischen Lernprozesse des 19. und 20. Jahrhunderts haben einen zivilisationsweiten Umschwung von Aufklärungsoptimismus zu Geschichtspessimismus nach sich gezogen. Beim Versuch, zweihundert Jahre »aufklärerische« Politik und Technik zu bilanzieren, entdecken die meisten Kommentatoren die Notwendigkeit einer »Abklärung der Aufklärung« beziehungsweise einer Kritik der lichtbringerischen Vernunft. Was landläufig Postmoderne genannt wird, hat eines seiner überzeugendsten Motive in dieser Nachuntersuchung von Aufklärungsfolgen[6]: Reflexion in der Abenddämmerung eines großen Experiments. Die Addition von Sowjetmacht und Elektrizität hat weder einen roten Morgen für die ganze Menschheit noch einen strahlenden Tag für die Teilnehmer an dem sozialistischen Großversuch heraufgeführt, sondern eine schwere Eintrübung der Lebensaussichten fast aller Beteiligten nach sich gezogen. Aus der Synthese von Marktkapitalismus und Wohlfahrtsstaat, die den »Way of Life« der »aufgeklärten« westlichen Industrienationen charakteri-

understood the industrial, electrical, and electronic modern era. The partisans of the democratic, technocratic campaign of light recognized their natural opponents in the defenders of premodern conditions—the "obscurantists" and sympathizers of the arcane agrarian age with its supernatural lights and privileged enlightenment. The "luciferous" light of emancipated preoccupation with the self, which has, in the modern age, become the foundation of all foundations, cannot tolerate any other source of light—especially a "light from above"—apart from itself.

ARTIFICIAL ILLUMINATION—POSTMODERN TWILIGHT

Even the light of Enlightenment experiences its shadows. This characterizes modern man's experience of himself, as he sees the world not in a better light, but, as a result of the Enlightenment and progress, in a worse one. The political education processes of the nineteenth and twentieth centuries have consequently brought about a transition from the optimism of enlightenment to a historical pessimism, affecting all areas of civilization. In the attempt to balance two hundred years of "enlightened" politics and technology, most commentators discover the need for a "clarification of the Enlightenment" or a critique of enlightening reason. One of the most persuasive themes of what is commonly called the postmodern is this investigation, after the fact, of the results of the Enlightenment:[6] reflection in the twilight of a great experiment. The addition of the Soviet powers

siert, entspringt gleichfalls kein Zustand allgemeiner Genugtuung, sondern eine Kultur der murrischen Zweideutigkeit, der die großen Perspektiven und Projektionen abhanden gekommen zu sein scheinen. Über dem Leben der Konsum- und Arbeitsgesellschaften liegt das graue Licht nachgeschichtlicher Aperspektivik. Die Epoche artikuliert ihr Lichtbewusstsein nicht mehr mit massiven solaren Symbolen, sondern in dem Arrangement diskreter künstlicher Lichtquellen wie Spotlights und Flutern. Beim höchsten Stand der Kunstlichttechnologie, die gelegentlich eine »neue« genannt wird, breitet sich gleichwohl ein Bewusstsein allgemeiner Perspektivenverwirrung und Unübersichtlichkeit aus. In dem Etikett verrät sich die Enttäuschung der Aufklärung angesichts des Scheiterns ihrer optischen Verheißungen. Im Unübersichtlichwerden der Welt verrät sich die Krise jener panoptischen Rationalität, durch die sich die neuzeitliche Aufklärung als pragmatische Erbin der alteuropäischen Lichtmetaphysik erweist. Im Rückblick auf die Geschichte des optischen Idealismus – in seinen religiösen wie seinen politischen Formen – zeigt sich, dass inzwischen die gesamte verwestlichte Hemisphäre der Welt zu einem »Abend«-Land geworden ist.

SCHLUSSLICHT

Ist nun in Reaktion auf das Unbehagen am Zwielicht mit einer postmodernen Wiederkehr der Lichtreligionen zu rechnen? Gewisse Indizien sprechen hierfür. Zunächst bringen die aktuellen weltweiten Offensiven der monotheistischen Religionen starke Züge licht-meta-

and electricity did not lead to a red dawn for all of humanity, or to a bright day for the participants in the great attempt at socialism, but rather to the obscuring of life's perspectives for almost everyone involved. Out of the synthesis of free-market capitalism and the welfare state, which characterizes the "way of life" of the "enlightened" Western industrial nations, there has not sprung a state of general satisfaction, but a culture of sullen ambivalence, which seems to have lost sight of grand perspectives and projections. Above the life led by working consumer societies shines the gray light of the posthistorical nonperspective. The epoch no longer articulates its consciousness of light through massive solar symbols, but through the arrangement of discrete artificial sources of light, such as spotlights and floodlights. At the apex of artificial lighting technology, which, upon occasion, is called "new," there is a consciousness of a widespread, general confusion in perspective and an inability to grasp the big picture. Its tag betrays the disappointment of the Enlightenment in the face of the failure to live up to its optical promises. In the inability to understand the world can be seen the crisis of that panoptical rationality which was supposed to have proved the modern Enlightenment to be the pragmatic heir to the old European metaphysics of light. Looking back at the history of optical idealism—in its religious as well as political forms—it can be seen that in the meanwhile, the entire westernized hemisphere of the world has become the land of the setting sun.

physischer Restauration ins Spiel mitsamt panoptischen Sichten aufs große Ganze und welt-»anschaulichen« Gewissheiten, die für die labilisierten Massen der drei »Welten« von nicht zu unterschätzender Attraktivität sind. Obendrein entspringen aus den spekulativen Nebentrieben moderner Naturwissenschaft eine Fülle von weltanschaulich suggestiven Evolutionsmodellen, in denen lichtmetaphysische Ideen in gewandelter Form erneut die Bühne betreten. Den Auftakt hierzu gaben in der Mitte unseres Jahrhunderts die Ideen des heterodoxen Jesuiten Teilhard de Chardin, der lichtmetaphysische, kosmologische und christologische Motive zu einer eschatologischen Vision von dantescher Spannweite zusammenfasste. Nach ihm läuft der gesamte Weltprozess auf eine totale Verlichtung aller Wesen hinaus. Im Zeichen moderner Hypernaturwissenschaft kehren die Ideen der anti-kosmischen Gnosis gleichsam in den Kosmos heim. Dies kennzeichnet unter anderem auch das System des Natur- und Bewusstseinswissenschaftlers Arthur Young, der in *The Reflexive Universe* (1976) die Gegenwart als Scheitelpunkt einer Licht-Evolutionskurve darstellt. Diese ist nach dem Abstieg des Lichts über die Teilchenwelt, die Molekülwelt, das Pflanzen-reich, das Tierreich und das Menschenreich an den Punkt gelangt, wo ein Wiederaufstieg mit dem Ziel der Rückkehr ins Licht in Aussicht genommen werden kann. Mit diesem Schleifen- oder Bogenmodell der Evolution kopiert Young auf eine eher symptomatische als originelle Weise die spätantiken Emanationslehren, nach denen der Kosmos durch Aus-strömungen aus dem »Über-Einen« entsteht. Asiatische und europäisch-mittelalterliche Vorstellungen von »Erleuchtung« als letztem Ziel der Seele kehren in szientistischen Ton-

TAIL LIGHT

Must we now anticipate a return of the religions that worship light as a reaction to the dis-content with this twilight state? There are certain indications of this. First of all, current worldwide offensives launched by the monotheistic religions include strong characteris-tics of a restoration of light metaphysics, together with panoptical views of the big picture and ideological certainties about the world, whose attraction for the easily swayed masses of the three "worlds" should not be underestimated. On top of this, from the speculative activities of modern scientists emerges a multiplicity of ideologically sugges-tive models of evolution, in which ideas from light metaphysics once again appear in a dif-ferent shape. This was begun in the middle of the twentieth century, with the ideas of the heterodox Jesuit Teilhard de Chardin, who summed up motifs of light metaphysics, cos-mology, and Christology in an eschatological vision of Dantean range. According to him, the entire world process is moving toward the total enlightenment of all creatures. Under the auspices of modern hyper-science the ideas of the anti-cosmic Gnostics return home, as it were, to the cosmos. Among other things, this is a mark of the system developed by scientist and psychologist Arthur Young, who, in *The Reflexive Universe* (1976), depicts the present time as the vertex of a curve in the evolution of light. After the fall of light via the world of atomic particles, the molecular world, the plant and animal kingdoms, and the realm of humanity, this has gotten to the point where there is hope for its re-ascension,

arten wieder, meistens mit evolutionstheoretischem Akzent. Die neuen Licht-Schleifen-Evolutionisten möchten es für wahrscheinlich hinstellen, dass eine Menschheit, die ihren Status quo als Zwischenergebnis der kosmischen Entwicklung nach einer initialen Hyper-licht-Katastrophe (»Big Bang«) begreifen muss, ebenso gut über künftige weite Spannungsbögen in eine allgemeine Erleuchtung einmünden könnte. Mit erleuchtungsevolutionistischen Ideen hat sich unter anderen Ken Wilber einen Namen gemacht (zum Beispiel: *Up From Eden*, 1981[7]). Wo Spekulationen dieses Typs milieubildend wirken, wie in gewissen kalifornischen Subkulturen, dort kann es zur Proklamation eines neuen Licht-Zeitalters oder »Light-Age« kommen – mit Widerhall in gewissen Zirkeln mitteleuropäischer Neosophistik und Beratungsphilosophie.

Auf vielfältige Weise bleiben alte Fragen nach dem, was zuletzt zu sehen sein wird, auch für die moderne Menschheit von Belang. Ist die letzte Sicht nichts anderes als das ewige Blinzeln der letzten Menschen, die in die glutlose Abendsonne schauen? Entspricht sie der Erfahrung der Sterbenden gemäß dem Tibetanischen Totenbuch, das von einem Übergang in das weiße Licht des Erlöschens spricht? Oder wird die letzte Sicht in einem nuklearen Lichtorkan erblinden – gleichsam in technologischer Realisation des lichtmystischen Transitus? Wenn zutrifft, dass nichts in der Technologie ist, was nicht zuvor in der Metaphysik gewesen war, dann hat eine lichtmetaphysisch vorgeformte Menschheit Aussicht darauf, zuletzt in ein selbstgemachtes großes Licht zu blicken – »heller als tausend Sonnen«. Oder macht es das Wesen des Zivilisationsprozesses aus, die Schlussansicht

with the goal of returning to the light. With this loop or arch model of evolution, Young copies, in a very symptomatic and original way, ancient theories of emanation, according to which the cosmos was created by rays from the "über-one." Asian and medieval European concepts of "enlightenment" as the ultimate goal of the soul return in his scientist tones, usually with a touch of evolutionary theory. The new light-loop evolutionists might believe it probable that people who have to regard their status quo as the interim result of cosmic development after an initial hyper-light catastrophe (The Big Bang) could via future expansive arches of tension just as well end up in a general enlightenment. People like Ken Wilber have made a name for themselves with revolutionary ideas of enlightenment (for example, *Up From Eden*, 1981).[7] Where speculations of this sort have the effect of forming milieus, as in certain subcultures in California, a new "Light Age" can be proclaimed—with echoes in particular circles of central European neosophists and the philosophies practiced by consultants.

In many ways, old questions of what will be seen last of all are still important to modern humanity. Will the last vision be nothing more than the eternal blink of the last human being looking into a fading evening sun? Does it correspond to the experience of the dying, as the *Tibetan Book of the Dead* says when it speaks of a transition into the white light of extinction? Or will the last vision be blinded by a nuclear hurricane—the technological realization of mystical transition via light, as it were? If it is true that technology

aller Dinge in immer neuen Aufschüben offenzuhalten? Gegenstandslos wird der Unterschied zwischen letzten und vorletzten Sichten, wenn die Welt den Augen der Künstler offensteht. »Das Auge vollbringt das Wunder, der Seele das zu öffnen, was nicht Seele ist, die glückselige Welt der Dinge und ihren Gott, die Sonne.«[8]

will never invent anything that has not previously existed in metaphysics, then humanity, preformed by the metaphysics of light, has a good chance of ultimately seeing a great, self-made light, "brighter than a thousand suns." Or does the nature of the civilization process consist of keeping the last vision of all things open through constant postponements? The difference between the ultimate and the penultimate visions will be void of objects, if the world is open to the eyes of artists. "The eye creates the miracle of opening up the soul to that which is not soul, the blissful world of things and their god, the sun."[8]

ANMERKUNGEN

Zuerst erschienen in: Willfried Baatz (Hrsg.),
Gestaltung mit Licht, Ravensburg 1994,
S. 14–39, ebenfalls erschienen in: *Lichtkunst
aus Kunstlicht. Licht als Medium im 20. und
21. Jahrhundert,* hrsg. von Peter Weibel und
Gregor Jansen, Ausst.-Kat. ZKM | Museum
für Neue Kunst Karlsruhe, Ostfildern 2006,
S. 44–55.

1 Edward O. Wilson, *The Diversity of Life*,
Cambridge 1992, zit. n. *The New York Review
of Books*, 39, 18, 5. November 1992, S. 3.
2 Vgl. hierzu: Klaus Hedwig, *Sphaera Lucis.
Studien zur Intelligibilität des Seienden im Kon-
text der mittelalterlichen Lichtspekulation*,
Münster 1980, bes. das Kapitel über den
Optik-Philosophen und Theologen Robert
Grosseteste (1168–1253), S. 119 ff.
3 Über arabische Optik und Lichtphiloso-
phie, namentlich Alkindi und Alhazen infor-
miert das Standardwerk von David C. Lind-
berg, *Auge und Licht im Mittelalter. Die
Entwicklung der Optik von Alkindi bis Kepler*,
Frankfurt am Main 1987; Henri Corbin ver-
dankt der heutige Westen einen guten Teil
seiner eventuellen Kenntnisse islamischen
Denkens durch seine *Histoire de la philosophie
islamique*, Paris 1986, bes. das Kapitel:
»Sohravardi et la philosophie de la lumière«,
S. 285–305; s. ders., *L' homme de lumière
dans le soufisme iranien*, Paris 1971.
4 Abu-Hamid Muhammad al-Ghazali, *Die
Nische der Lichter [Miskat al-anwar]*, Hamburg
1987, S. 15.
5 Zu Mani vgl. Amin Maalouf, *Les jardins
de lumière*, Paris 1992; zur manichäischen
Religion vgl. Karl Matthäus Woschitz, Man-
fred Hutter, Karl Prenner, *Das manichäische
Urdrama des Lichts. Studien zu koptischen,
mitteliranischen und arabischen Texten*, Wien
1989.
6 Vgl. Peter Sloterdijk, *Kritik der zynischen
Vernunft*, 2 Bde., 11. Aufl., Frankfurt am Main
1990, vor allem die Abschnitte: »Nach den
Entlarvungen: Zynisches Zwielicht«, S. 159
sowie: »Historisches Hauptstück – Das Wei-
marer Symptom. Bewusstseinsmodelle der
deutschen Moderne«, S. 697 ff.
7 Ken Wilber, *Halbzeit der Evolution. Der
Mensch auf dem Weg vom animalischen zum
kosmischen Bewusstsein*, Bern u. a. 1984.
8 Maurice Merleau-Ponty, *Das Auge und der
Geist. Philosophische Essays*, Hamburg 2003.

NOTES

This essay was first published in *Gestaltung
mit Licht,* ed. Willfried Baatz (Ravensburg,
1994), pp. 14–39; republished in *Light Art from
Arificial Light. Light as a Medium in 20th and
21st Century Art,* eds. Peter Weibel and Gregor
Jansen, exh. cat. ZKM | Museum für Neue
Kunst Karlsruhe (Ostfildern 2006), pp. 44–55.

1 Edward O. Wilson, *The Diversity of Life*
(Cambridge, MA, 1992), cited in *The New York
Review of Books* 39, no. 18 (November 5, 1992),
p. 3.
2 See Klaus Hedwig, *Sphaera Lucis: Studien
zur Intelligibilität des Seienden im Kontext der
mittelalterlichen Lichtspekulation* (Münster,
1980), especially the chapter on optical
philosopher and theologian Robert Gros-
seteste (1168–1253), pp. 119 ff.
3 For more on Arabian optics and philosophy
of light, specifically *alkindi* and *alhazen,* see
David C. Lindberg's standard work, *Theories of
Vision from Al-Kindi to Kepler* (Chicago, 1996,
reprint); the West today owes a good portion
of its knowledge of Islamic thought to Henri
Corbin's *Histoire de la philosophie islamique*
(Paris, 1986), especially the chapter entitled
"Sohravardi et la philosophie de la lumière,"
pp. 285–305; also see Corbin, *L'homme de
lumière dans le soufisme iranien* (Paris, 1971).
4 Abu-Hamid Muhammad al-Ghazali, *Die
Nische der Lichter [Miskat al-anwar]* (Ham-
burg, 1987), p. 15.
5 For more on Manes see Amin Maalouf, *Les
jardins de lumière* (Paris, 1992); for more on
the Manichaean religion see Karl Matthäus
Woschitz, Manfred Hutter, and Karl Prenner,
*Das manichäische Urdrama des Lichts: Studien
zu koptischen, mitteliranischen und arabischen
Texten* (Vienna, 1989).
6 See Peter Sloterdijk, *Kritik der zynischen
Vernunft,* vol. 2, 11th ed. (Frankfurt am Main,
1990), especially the sections "Nach den Ent-
larvungen: Zynisches Zwielicht," p. 159, and
"Historisches Hauptstück—Das Weimarer
Symptom. Bewusstseinsmodelle der
deutschen Moderne," pp. 697 ff.
7 Ken Wilber, *Halbzeit der Evolution: Der
Mensch auf dem Weg vom animalischen zum
kosmischen Bewusstsein* (Bern, 1984).
8 Maurice Merleau-Ponty, *Das Auge und der
Geist: Philosophische Essays* (Hamburg, 2003).

HISTORY | MODERNISM

GESCHICHTE | MODERNE

<<
Urban Context (Detail), 2000,
Projektion Bunker Lüneburg
(Foto: Kwan Ho Yuh-Zwingmann,
Hannover), Vgl. Abb. S. 40–41 /
See fig. pp. 40–41

Refraction House, 1994,
Synagoge Stommeln; 16 x 1 kW
Scheinwerfer, 3 Gerüste, je 5 x 3 m
(Fotos: Hubertus Birkner, Köln, und
Archiv Mischa Kuball, Düsseldorf)

Die Synagoge in Stommeln am
Niederrhein ist von der Hauptstraße
aus kaum zu sehen und liegt zurück-
gesetzt in einem Hinterhof. Acht
Wochen lang wurde das Bauwerk
verschlossen und im Inneren mit
intensivem Licht geflutet, sodass die
Architektur wie eine Lichtskulptur
in der Umgebung leuchtete und ein
weithin sichtbares Zeichen setzte.
S. S. 338–339

Refraction House, 1994,
Stommeln Synagogue; 16 1-kW
spotlights, 3 scaffolds, each 5 x 3 m
(photographs: Hubertus Birkner,
Cologne, and Mischa Kuball Archive,
Düsseldorf)

The synagogue in Stommeln on the
Lower Rhine can barely be seen from
the main street and is set back in
a courtyard. For a period of eight
weeks, the building was closed and
lit from the inside with intense light,
so that the building illuminated the
surrounding area like a light sculp-
ture, becoming a symbol that could
be seen from afar.
See pp. 338–339

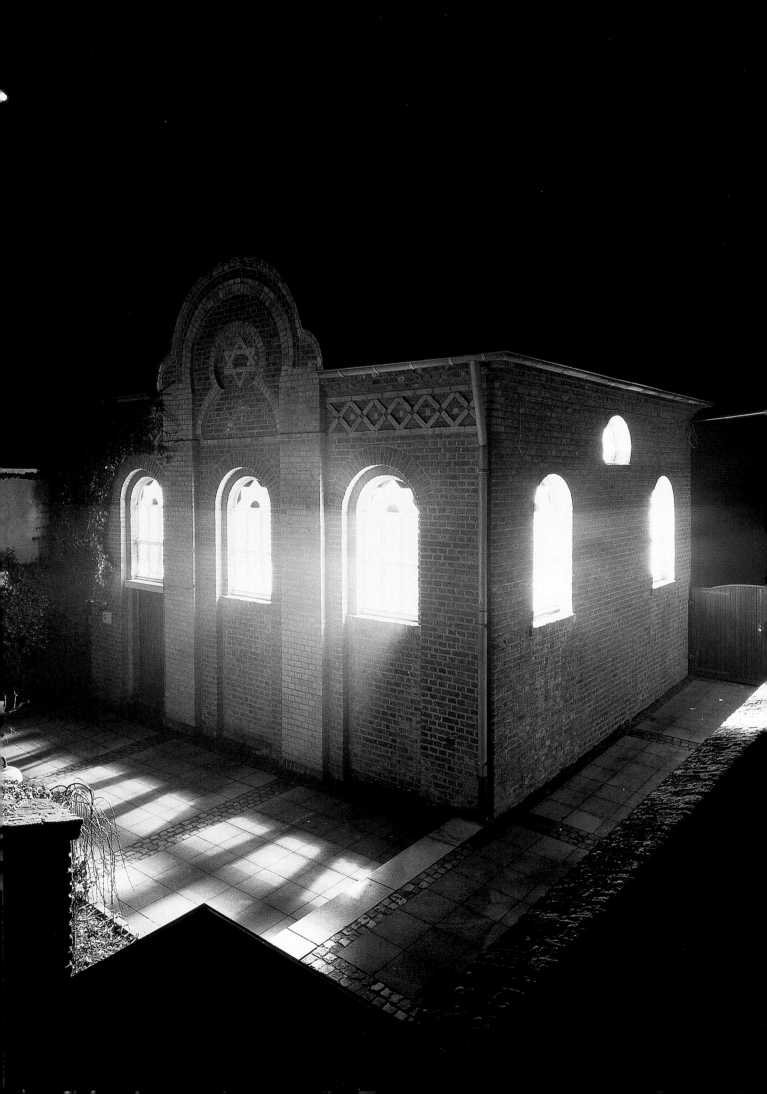

Urban Context, 2000,
Projektion Bunker Lüneburg;
Stahlgerüst ca. 5 x 30 m,
11 x 2 kW Scheinwerfer
(Foto: Kwan Ho Yuh-Zwingmann,
Hannover)

Nach fünfjähriger Diskussion zwi-
schen Studenten der Universität
Lüneburg und Mischa Kuball konnte
dieses ortsspezifische Projekt rea-
lisiert werden. Die an dem Gerüst
befestigten Scheinwerfer zeichneten
mit ihrem Licht quer zur Schieß-
grabenstraße in Lüneburg die unter-
irdische Lage eines ehemaligen
Gauleiterbunkers nach.

Urban Context, 2000,
projection at the Lüneburg bunker;
steel scaffolding approximately
5 x 30 m, 11 2-kW spotlights
(photograph: Kwan Ho Yuh-Zwing-
mann, Hanover)

After five years of discussion between
students at the University of Lüne-
burg and the artist, this site-specific
project was finally realized. The light
from the spotlight attached to the
scaffolding shone directly across to
Schiessgrabenstrasse in Lüneburg,
marking the subterranean location
of a former gauleiter bunker.

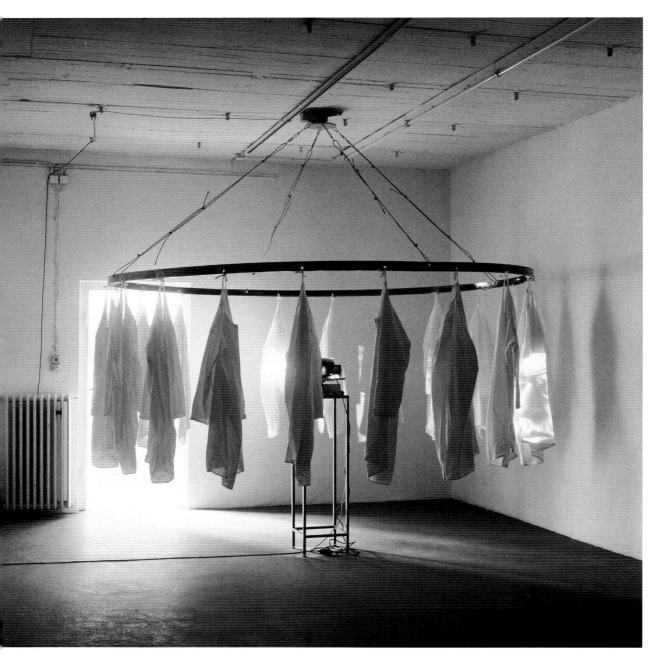

Die Welt in mir/ich in der Welt, 1994/96,
Konrad Fischer Galerie, Düsseldorf;
3 projectors, each with 81 slides,
32 laboratory coats, steel rack:
measurements dependent upon room
size, ceiling motor
(photograph: Dorothee Fischer,
Düsseldorf)

Die Welt in mir/ich in der Welt, 1994/96,
Konrad Fischer Galerie, Düsseldorf;
3 Projektoren, je 81 Dias, 32 Labor-
kittel, Stahlgerüst: Maße raumab-
hängig, Deckenmotor
(Foto: Dorothee Fischer, Düsseldorf)

Auf sich an einem Gerüst drehenden
Laborkitteln werden Dias histori-
scher Persönlichkeiten projiziert,
die in der Mitte des 20. Jahrhunderts
von Paul Swiridoff fotografiert wor-
den waren und somit als Dokumente
ihrer Zeit und Geschichte stehen.

Slides of historical figures were
projected onto lab coats that revolved
as they hung from a circular rack.
The slides were taken in the mid-
twentieth century by Paul Swiridoff
and thus represent documents of
their time and history.

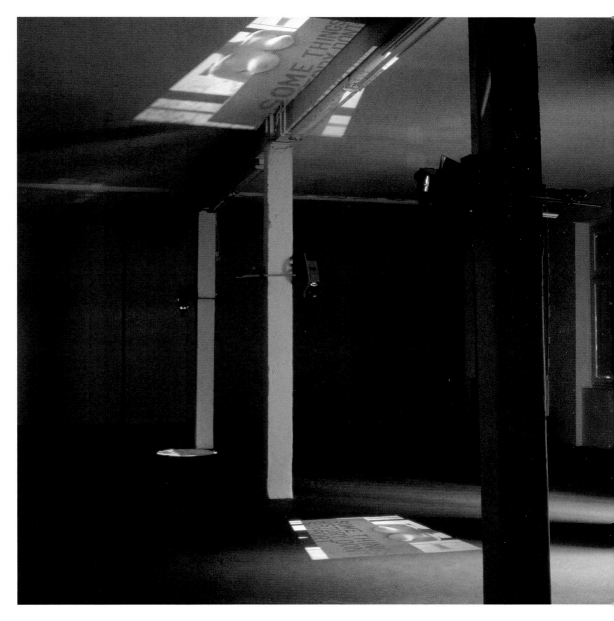

Rotoren (Participation by Lawrence
Weiner: *SOME THINGS HISTORY DONT
SUPPORT*
© Foto: Betsy Kaufmann, New York)
1995/96, Konrad Fischer Galerie,
Düsseldorf; 3 Diaprojektoren,
je 2 Dias, Maße raumabhängig
(Foto: Dorothee Fischer, Düsseldorf)

Die 6 von Lawrence Weiner entwor-
fenen und zur Verfügung gestellten
Diamotive werden an die Decke und
den Boden der Galerie projiziert.
Der Diawechsel vollzieht sich aus
gravitatorischen Gründen in der
Rotation. Lawrence Weiner kannte
die Installationsidee und steuerte
*SOME THINGS HISTORY DONT SUP-
PORT* bei.

Rotoren (Participation by Lawrence
Weiner: *SOME THINGS HISTORY DONT
SUPPORT*
© photograph: Betsy Kaufmann,
New York) 1995/96, Konrad Fischer
Galerie, Düsseldorf; 3 slide projec-
tors, each containing 2 slides,
measurements dependent upon room
size (photograph: Dorothee Fischer,
Düsseldorf)

The motifs on the six slides, designed
and provided by Lawrence Weiner,
are projected onto the ceiling and the
floors of the gallery. For gravitational
reasons, the slides change as they
revolve. Weiner was familiar with the
idea for the installation and con-
tributed *SOME THINGS HISTORY DONT
SUPPORT*.

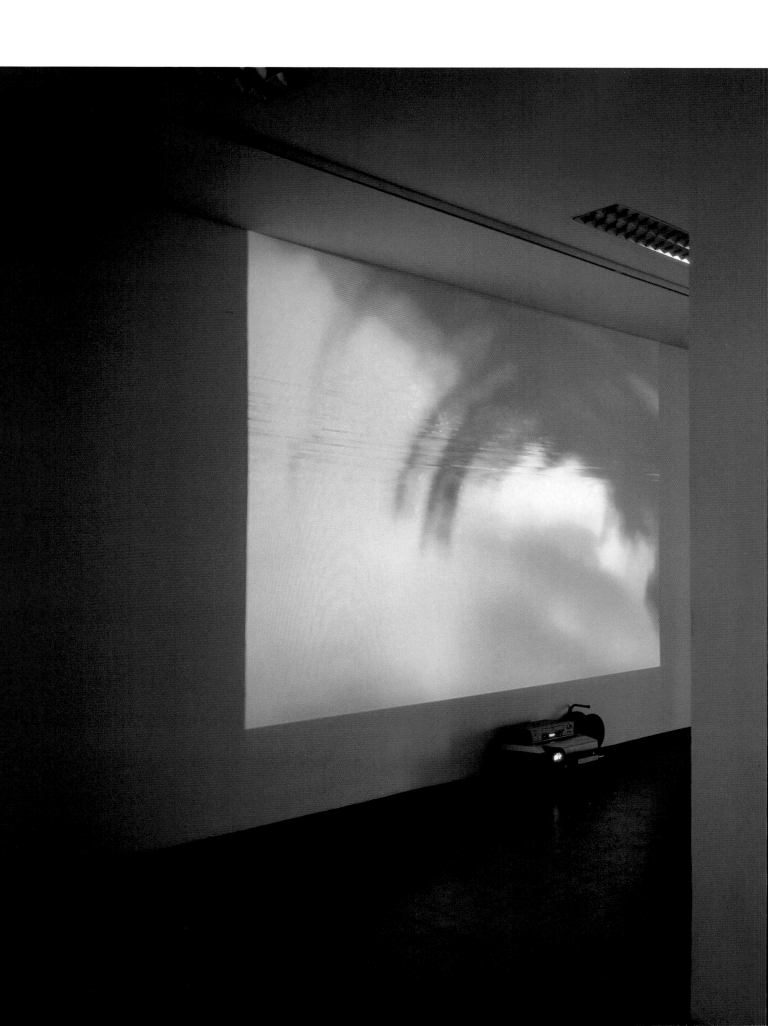

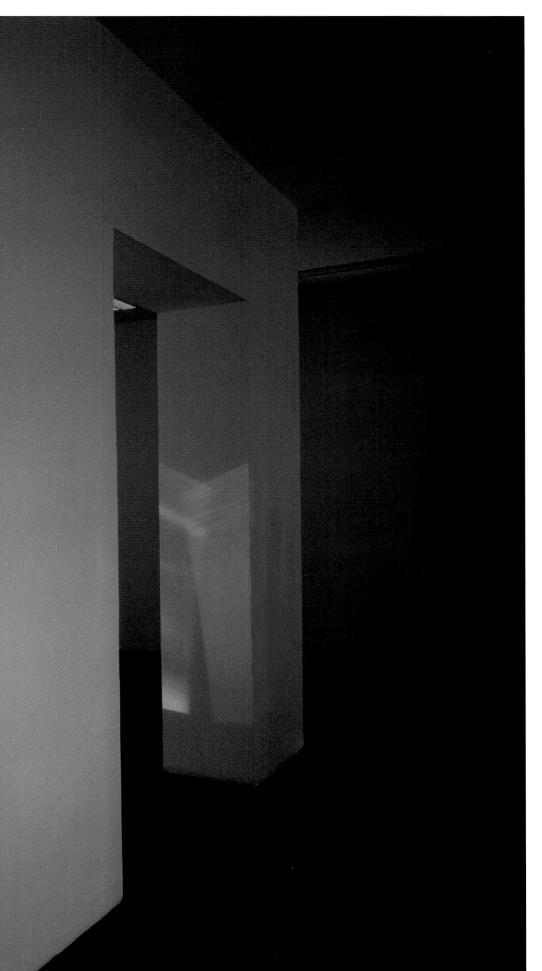

Schleudertrauma, 2000,
Kunstverein Ruhr, Essen; 2 Beamer,
2 DVDs, 8' (Loop) mit Audio
(Foto: Werner Hannappel, Essen)

In der Essener Synagoge schleuderte
Mischa Kuball eine Filmkamera hori-
zontal und vertikal herum. Vor dem
Gebäude ließ er sie vertikal kreisen.
Die Aufnahmen montierte er schließ-
lich zu einem »Endlosband« zusam-
men, welches über zwei Beamer an
die Seitenwände des leeren Kunst-
vereins, der sich in den Räumen
unterhalb der Synagoge befindet,
projiziert wurde. Eine bis dahin in
einer Tapete verborgene Tür im
Kunstverein wurde zum ersten Mal
wieder geöffnet, so ergab sich eine
räumliche Beziehung zum Thora-
Schrein.

Schleudertrauma, 2000,
Kunstverein Ruhr, Essen; 2 projec-
tors, 2 DVDs, 8' (loop) with sound
(photograph: Werner Hannappel,
Essen)

Kuball made a film camera glide
horizontally and vertically around
the former synagogue in Essen. In
front of the building, it moved in ver-
tical circles. Finally, he edited the
takes into an endless loop that was
projected by two DVD projectors onto
the sides of the Kunstverein's empty
gallery space located beneath the
synagogue. A door that had previ-
ously been concealed by wallpaper
was opened again for the first time,
creating a spatial relationship to
the Torah altar.

Kompressor, 2004,
Museum für Gegenwartskunst Sie-
gen; 2 Diaprojektoren, je 81 Dias,
4 Glasscheiben, Maße variabel;
Courtesy Sammlung Rheingold
(Foto: Roman Mensing/artdoc.de)

Auf den Dias befindet sich eine
Auswahl von 81 Gesichtern und 81
Gebäuden. Dieser Querschnitt durch
die Kultur des 20. Jahrhunderts
wird in den Glasscheiben mehrfach
reflektiert und an die Wände des
Ausstellungsraums geworfen.

Kompressor, 2004,
Museum für Gegenwartskunst
Siegen; 2 slide projectors, each
containing 81 slides, 4 glass plates,
dimensions variable; Courtesy
Rheingold Collection
(photograph: Roman Mensing/
artdoc.de)

The slides feature a selection of
81 faces and 81 buildings. This visual
cross-section of twentieth-century
culture is reflected several times
through the glass plates and pro-
jected onto the walls of the exhibition
space.

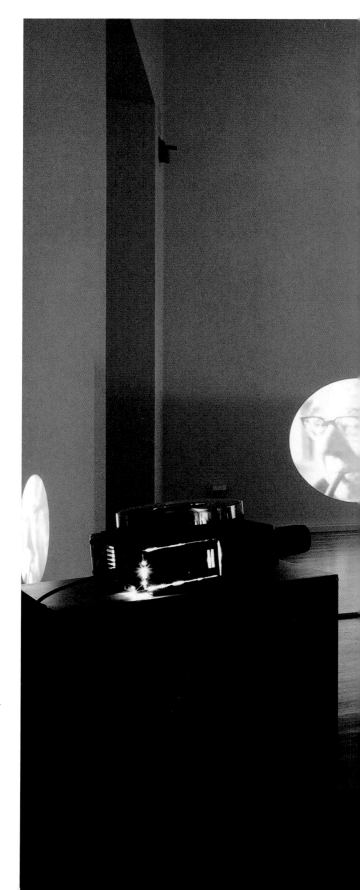

Folgende Doppelseite
Metaphases, 2004,
Museum für Gegenwartskunst
Siegen; Diaprojektor, 81 Dias,
Vergrößerungsschirm 60 x 120 cm
(Foto: Roman Mensing/artdoc.de)

Den Dias liegen die 81 Porträts von
Paul Swiridoff aus Mischa Kuballs
Arbeit *Kompressor* zugrunde. Die
Projektionen werden durch einen
von der Decke herabhängenden,
rotierenden, konvex-konkav geform-
ten Vergrößerungsschirm einerseits
präzise abgebildet, dann wiederum
verzerrt oder dekonstruiert.

Following double-page spread
Metaphases, 2004,
Museum für Gegenwartskunst
Siegen; slide projector, 81 slides,
magnifying screen, 60 x 120 cm
(photograph: Roman Mensing/
artdoc.de)

The slides are based on 81 portraits
by Paul Swiridoff used in Mischa
Kuball's work *Kompressor*. A revolv-
ing, convex-concave-shaped magnify-
ing screen hanging from the ceiling
first creates exact reproductions
of the projections and then distorts
or deconstructs them.

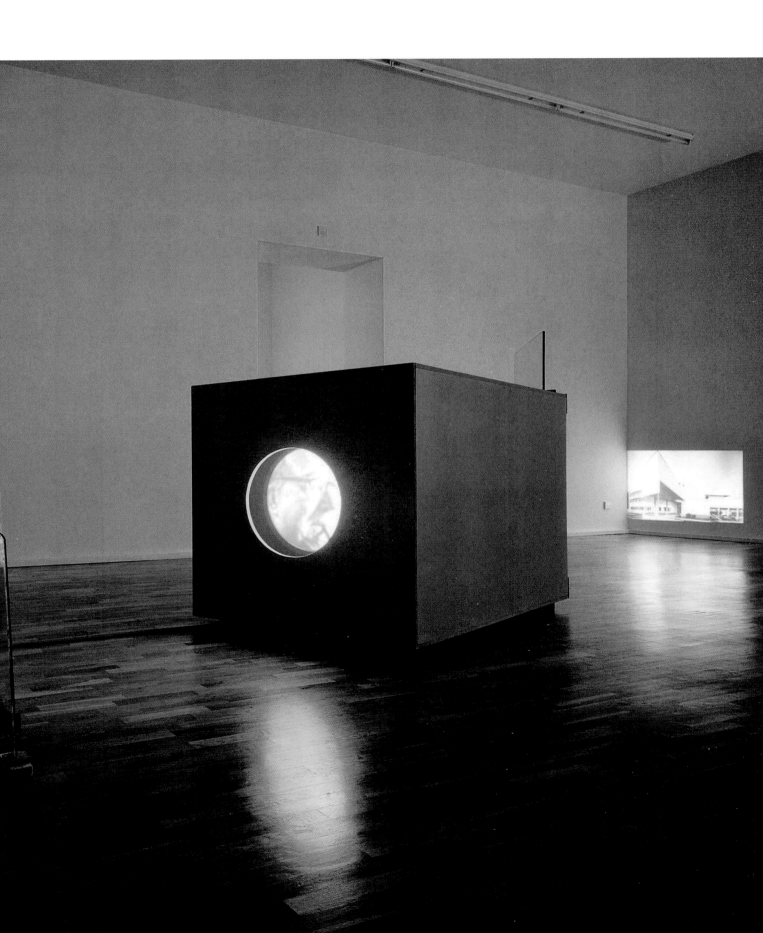

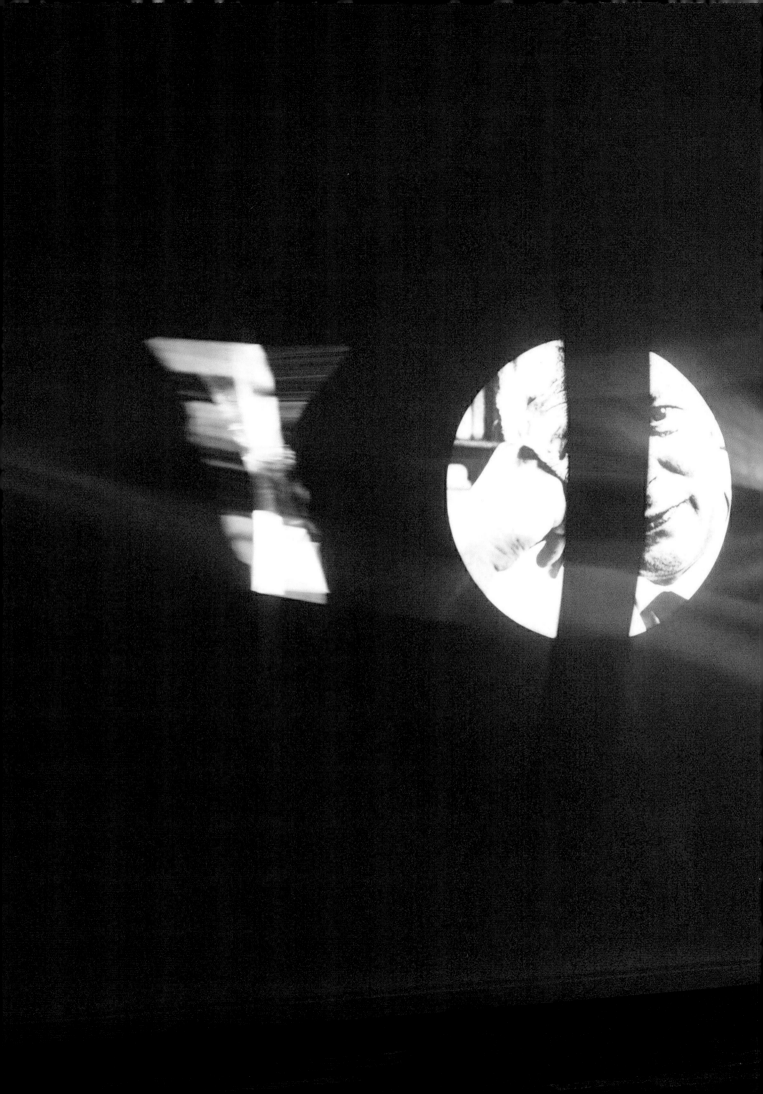

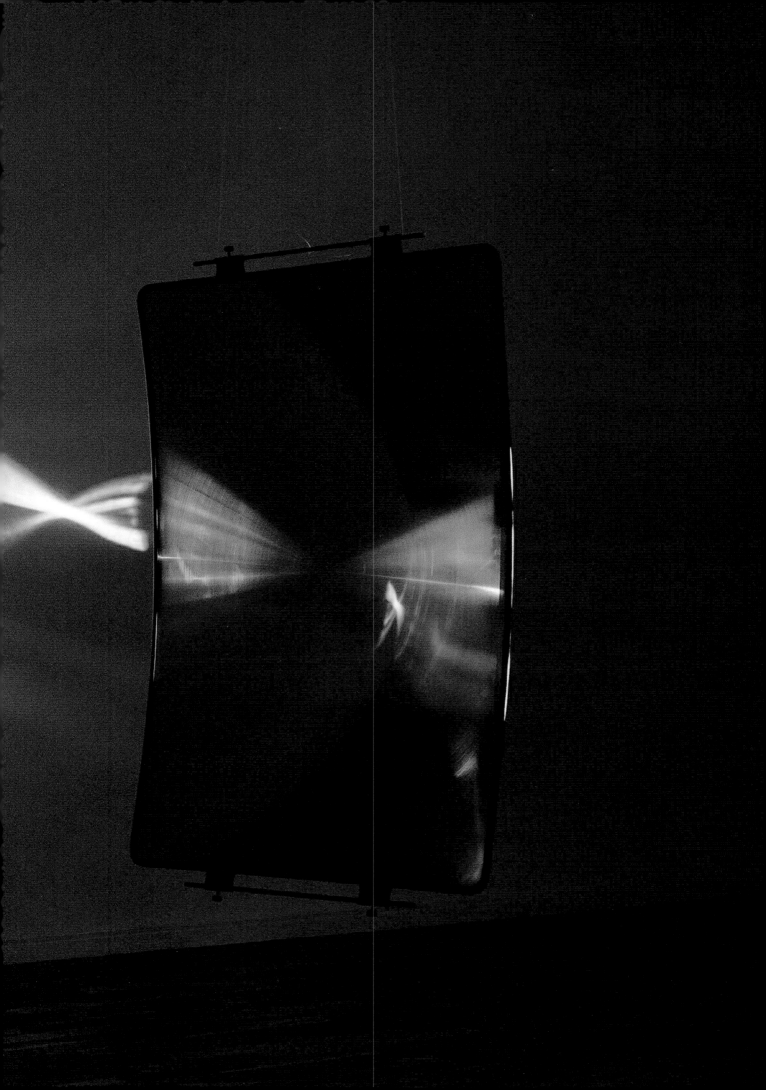

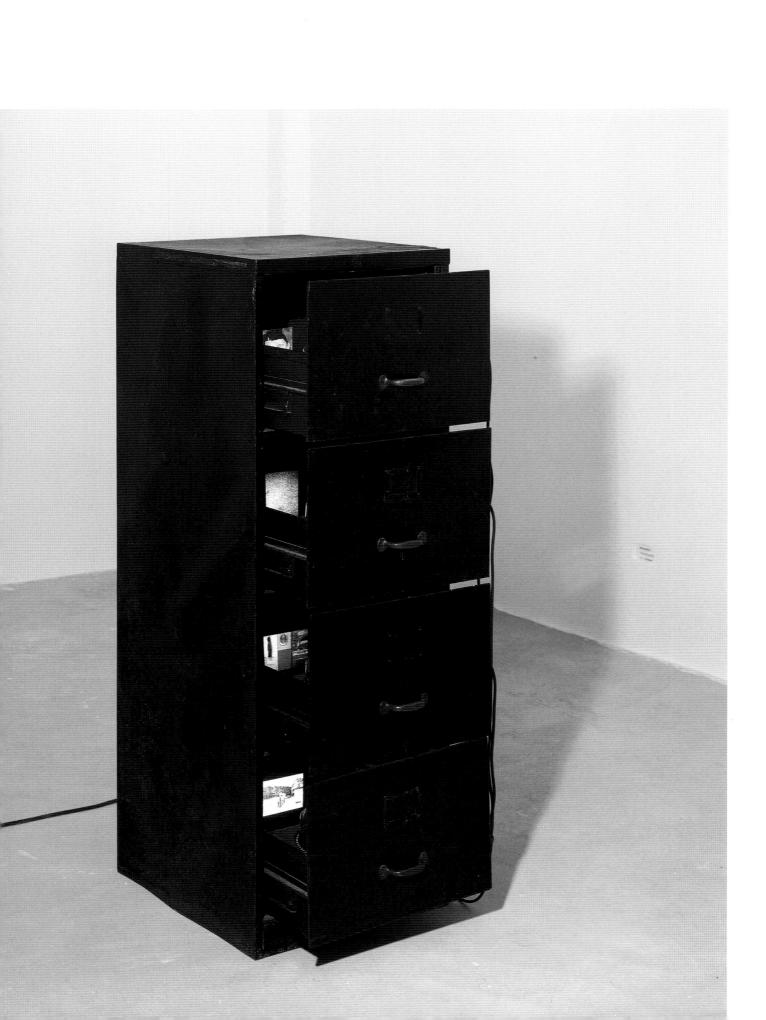

Magazin des 20. Jahrhunderts,
1989/90, Kunsthalle Köln; Metall-
schrank mit 4 Schubladen, 4 Dia-
projektoren, je 81 Dias; Sammlung
Gottfried Hafemann, Wiesbaden
(Foto: Norbert Faehling, Düsseldorf)

Die 4 Diaprojektoren in den geöff-
neten Schubladen des Schrankes
zeigen Kunstwerke aus den Archiven
berühmter Museen. Durch die
unregelmäßig wechselnden Bilder
ergeben sich immer neue Konstel-
lationen, die an Ausstellungen
angelehnt sind.

Magazin des 20. Jahrhunderts, 1989/90,
Kunsthalle Köln; metal filing cabinet
with 4 drawers, 4 slide projectors,
each containing 81 slides; Gottfried
Hafemann Collection, Wiesbaden
(photograph: Norbert Faehling,
Düsseldorf)

The four slide projectors in the open
drawers of the filing cabinet show
works of art from the archives of
famous museums. Thanks to the
asynchronous change of images, new
constellations of images constantly
appear, which are allusions to exhibi-
tions.

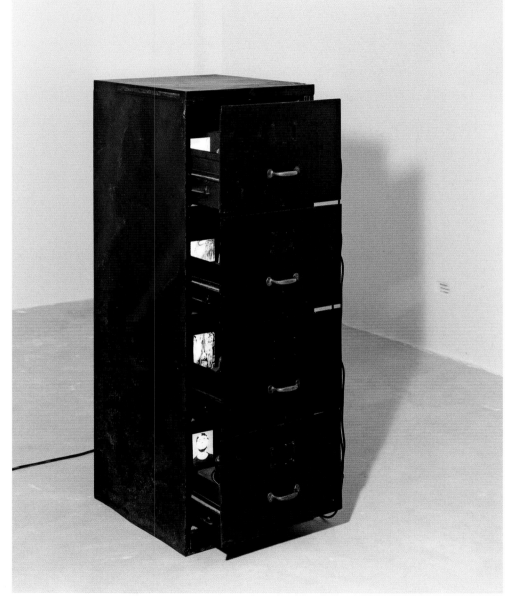

Hitler's Cabinet, 1990,
The Jewish Museum, New York;
Holzkonstruktion, 4 Diaprojektoren,
je 81 Dias, 40,6 x 400,7 x 400,7 cm;
The Jewish Museum, New York,
Purchase: Fine Arts Acquisitions
Committee Fund, 2001-78a-w
Zu sehen war die Arbeit in der von
Norman L. Kleeblatt kuratierten
Ausstellung *Mirroring Evil. Nazi
Imagery/Recent Art*
(Foto: © The Jewish Museum,
New York, Sheldan Collins)

Durch die aus den Enden der Kreuz-
form tretenden Projektionsstrahlen
erinnert die entstandene Form an
ein Hakenkreuz. Die verzerrten Licht-
bilder sind Standfotos aus expres-
sionistischen Filmen der 1910er- und
1920er-Jahre und folgen beispielhaft
einer kritischen Analyse von Sieg-
fried Kracauer.

Hitler's Cabinet, 1990,
Wood, 4 projectors, containing
81 slides each, 40.6 x 400.7 x 400.7 cm;
The Jewish Museum, New York,
Purchase: Fine Arts Acquisitions
Committee Fund, 2001-78a-w
This work was shown in the exhibi-
tion *Mirroring Evil. Nazi Imagery/
Recent Art*, curated by Norman L.
Kleeblatt.
(photograph: © The Jewish Museum,
New York, Sheldan Collins)

Rays emanating from the ends of
the cross-shaped construction are
reminiscent of a swastika. The dis-
torted light images are still photo-
graphs from Expressionist films of
the 1910s and 1920s, and in an exem-
plary manner follow in the footsteps
of a critical analysis by Siegfried
Kracauer.

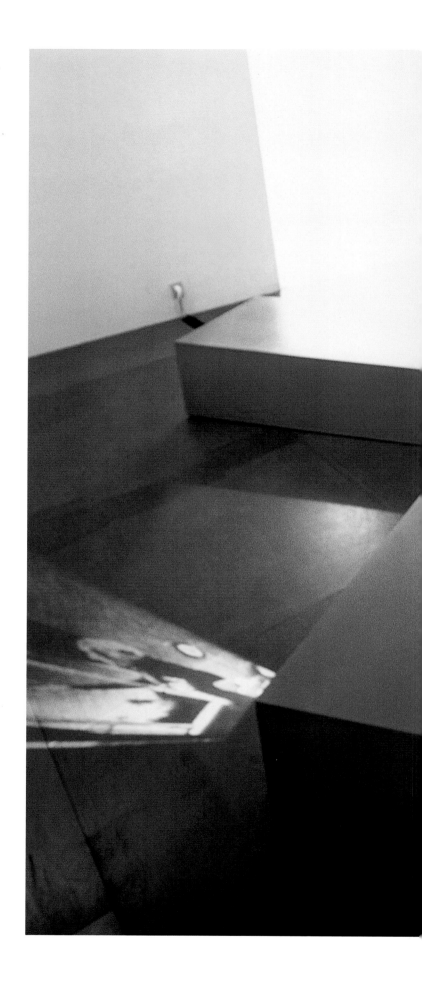

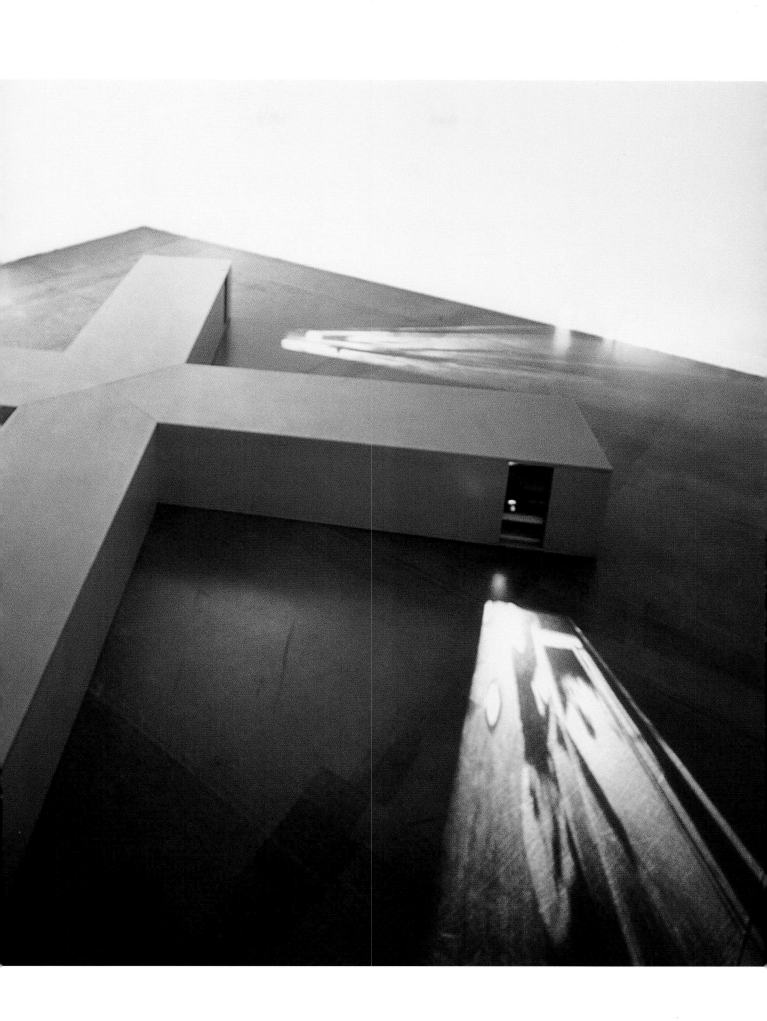

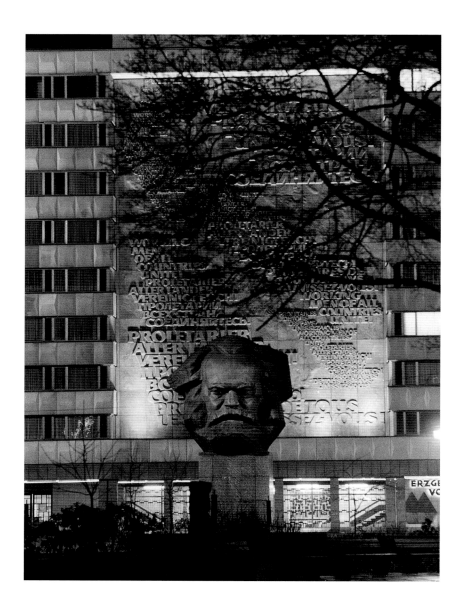

Ostung, Karl Marx Kopf, 1998,
nicht realisiert, Chemnitz (Projekt-
entwurf: Archiv Mischa Kuball,
Düsseldorf)

Mischa Kuball plante, die monumen-
tale Bronzeplastik *Karl Marx Kopf*
vor der ideologisierenden Architektur
eines Wohnkomplexes auf dem zen-
tralen Platz von Chemnitz (ehemals
Karl-Marx-Stadt) um 90° in östliche
Richtung zu drehen. Die formale
und politische Verhältnismäßigkeit

zwischen Architektur und Plastik
sollte anhand der künstlerischen
Intervention neu markiert und disku-
tiert werden. Der damalige Stadt-
baudezernent erteilte den beteiligten
Künstlern Jenny Holzer, Lawrence
Weiner und Mischa Kuball eine
Absage – ohne Angabe von Gründen.

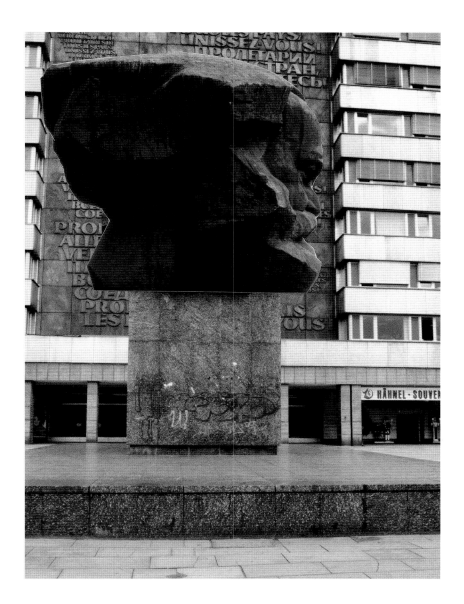

Ostung, Karl Marx Kopf, 1998,
not realized, Chemnitz
(project design: Mischa Kuball
Archive, Düsseldorf)

Mischa Kuball planned to turn a
monumental bronze sculpture, *Karl
Marx Kopf*, which stood in front of an
ideologically based apartment com-
plex on the central square in Chem-
nitz (formerly Karl Marx City), ninety
degrees to face east. This artistic
intervention was meant to mark the
formal and political relationship

between architecture and sculpture,
opening up a new discussion on the
topic. However, the city planning
commissioner at the time refused to
grant the participating artists, Jenny
Holzer, Lawrence Weiner, and Mischa
Kuball, permission for the project,
and did not provide any grounds for
his rejection of the proposal.

Utopie/Black Square 2001 ff., 2003,
Kunstsammlungen der Ruhr-Univer-
sität, Bochum; 107 Fotografien
21 x 21 cm, 7 Fotografien 1 x 1 m;
Kunstsammlungen der Ruhr-
Universität Bochum
(Foto: Thorsten Koch, Bochum)

Mischa Kuball hat Abbildungen aus
dem Ausstellungskatalog der 1992
in der Schirn Kunsthalle in Frankfurt
gezeigten Suprematismus-Ausstel-
lung *Die große Utopie* zusammen mit
seinen Fingerspitzen abfotografiert.
Die Hängung der insgesamt 114 qua-
dratischen Arbeiten orientiert sich
an dem historischen Konzept der
Ausstellung und verläuft in einer
imaginären Linie oberhalb der Expo-
nate der Kunstsammlungen der
Ruhr-Universität als Metakommen-
tar. Gleichzeitig reflektiert Kuball
durch die Auswahl seiner Motive die
Bildsprache der Sammlung und
untersucht die Bedeutung des Kon-
struktivismus heute.

Utopie/Black Square 2001 ff., 2003,
Kunstsammlungen der Ruhr Uni-
versität Bochum; 107 21-x-21-cm
photographs, 7 1-x-1-m photographs;
Kunstsammlungen der Ruhr
Universität Bochum
(photograph: Thorsten Koch,
Bochum)

Kuball photographed images from
the exhibition catalogue of the 1992
Suprematist exhibition at the Schirn
Kunsthalle in Frankfurt, *Die Grosse
Utopie*, so that the tips of his fingers
were also visible on the photos. The
idea for hanging the 114 rectangular
works was founded on the historical
concept of the exhibition; the works
ran in an imaginary line as a meta-
commentary above artworks from
the Ruhr University. At the same
time, in selecting particular motifs,
Kuball reflected the pictorial lan-
guage of the collection and explored
the meaning of Constructivism today.

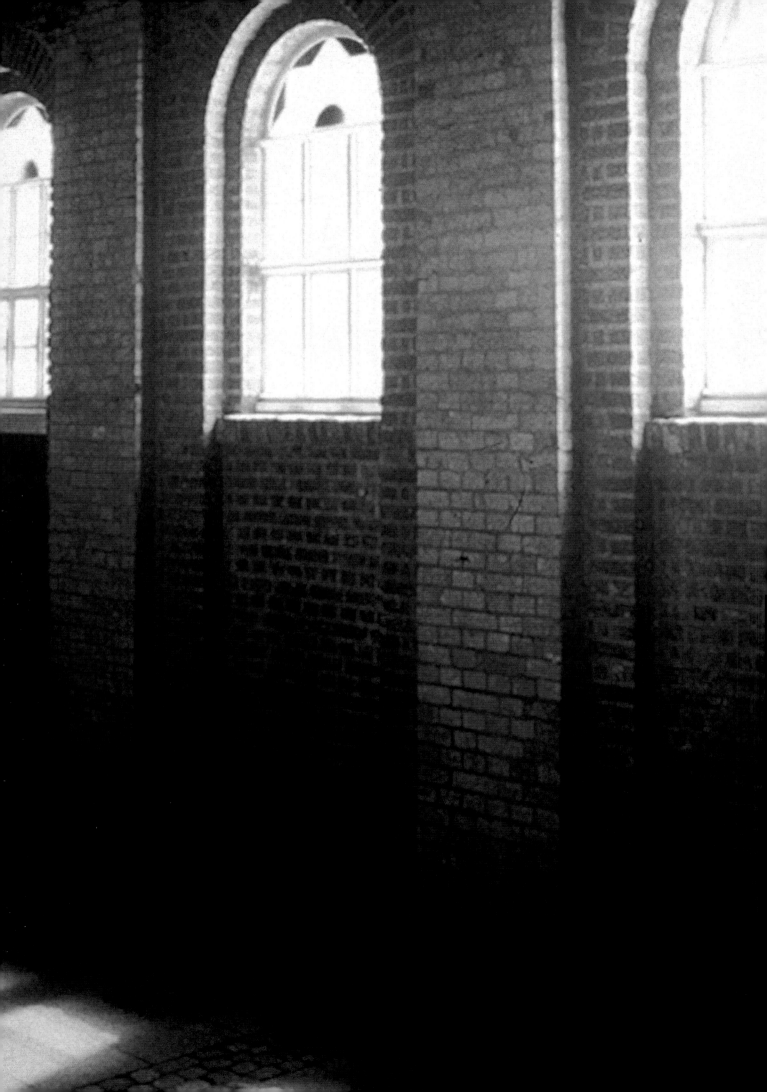

ARMIN ZWEITE

REFRACTION HOUSE

Abb. S. 38–39, 338–339

Die Arbeit gehört zweifellos zu den wichtigsten, die Kuball bisher realisieren konnte. Bereits der Ort seiner Intervention hat einen derart spezifischen Charakter, dass in diesem Zusammenhang kurz auf die Vorgeschichte von *Refraction House* einzugehen ist.

Stommeln, nordwestlich von Köln im Erftkreis gelegen und inzwischen zur Stadt Pulheim gehörend, hatte lange Zeit eine jüdische Gemeinde, die sich im frühen 19. Jahrhundert bemühte, ein eigenes Gebetshaus zu errichten. War es zunächst ein einfaches Fachwerkgebäude, so folgte 1882 ein schlichter neoromanischer Ziegelbau mit plastisch ausgebildeter Schauseite. Ein in gelben Steinen ausgeführter Davidstern ziert im Zentrum die dreiachsige Fassade mit Rundbogenfenstern, während ein aus Rauten gebildetes Zierband unter der Traufe den herausgehobenen Mittelrisalit mit Giebelaufsatz flankiert. Unter dem Druck des auch hier grassierenden Antisemitismus löste sich die jüdische Gemeinde bereits vor 1933 auf. Die Synagoge, wie so oft aus der Straßenflucht zurückversetzt und in einer zweiten Häuserzeile liegend, verkaufte man 1937 an einen Bauern, der sie dann als Scheune, Abstellraum und Stall nutzte. So wurde sie anders als die meisten Synagogen in der Pogromnacht nicht niedergebrannt, verfiel jedoch allmählich aufgrund der veränderten Nutzung, wobei die ursprüngliche Funktion und Bedeutung nach dem Zweiten Weltkrieg völlig in Vergessenheit geriet.

Figs. pp. 38–39, 338–339

Refraction House is undoubtedly one of the most significant works Kuball has realized to date. The site of his intervention is in itself so singular that a closer look at the background of the work is appropriate in this context.

Situated northwest of Cologne in the county of Erft and now a part of the city of Pulheim, Stommeln once had an established Jewish community, which erected its first synagogue in the early nineteenth century. This simple half-timbered structure was replaced in 1882 by a plain, Neoclassical brick building with a sculpturally designed front façade. A Star of David composed of yellow stones is positioned in the center of the three-axis façade with arched windows, while a decorative band of diamond-shaped elements flanks the gabled central pavilion beneath the eaves. Succumbing to the pressure of increasingly rampant anti-Semitism, the Jewish community dissolved even before 1933. Set back from the street in a second row of buildings, as was so often the case, the synagogue was sold to a farmer in 1937 and used as a barn, storage area, and stable. Thus unlike most synagogues, it was not burned to the ground during the Night of Broken Glass but simply fell gradually into disrepair. Its original function and importance were completely forgotten by the end of the World War Two.

Refraction House (Detail), 1994, Synagoge Stommeln (Foto: Archiv Mischa Kuball, Düsseldorf), Vgl. Abb. S. 38–39 / See figs. pp. 38–39

59

Das änderte sich erst, als Ende der Siebzigerjahre der Geschichts- und Heimatverein begann, das Schicksal der Stommelner Juden zu erforschen. Schließlich erwarb die Stadt Pulheim das Anwesen und machte das Haus 1983 nach einer durchgreifenden Restaurierung der Öffentlichkeit zugänglich. Ein gemischtes Programm von kulturellen Veranstaltungen regionalen Zuschnitts konnte auf Dauer nicht wirklich überzeugen, schließlich sollte die wiederhergestellte Synagoge an den Holocaust und damit an den unvergleichlichen Zivilisationsbruch erinnern, den Nazideutschland begangen hatte. Einzelne Lesungen und kleine Konzerte konnten dem Anspruch an das Haus, als Denkmal und Mahnmal zu fungieren, nicht gerecht werden.

Den bald neu einsetzenden konzeptuellen Überlegungen gab der in Köln lebende Maler W. Gies eine entscheidende Anregung, die insbesondere von Gerhard Dornseifer, dem zu früh verstorbenen Kulturdezernenten Pulheims, in die Tat umgesetzt wurde. So sollten sich bedeutende, international renommierte Künstlerinnen und Künstler mit dem Ort und seiner verschütteten Geschichte auseinandersetzen und mit einer spezifischen, auf das Innere der Architektur bezogenen künstlerischen Arbeit einen Dialog anstoßen. Eine derartige programmatische Neuorientierung zielte auf die Verknüpfung des Symbolischen mit dem Funktionalen, das heißt: auf die Verschwisterung von ästhetischer Erfahrung mit historischer Reflexion. Der künstlerische Impuls, so die hoffnungsvollen Überlegungen, würde über das jeweilige Werk hinausweisen und – wenn auch vermutlich nur indirekt – die Diskriminierung der jüdischen Mitbürger und die Shoah in Erinnerung bringen. Architektur,

That did not change until the late 1970s, when the local historical society began to research the destinies of the Jews of Stommeln. The City of Pulheim eventually bought the building and grounds, which were completely restored and opened to the public in 1983. In the long run, the mixed program of cultural events failed to achieve the desired effect. The reconstructed synagogue was meant to serve as a reminder of the Holocaust and thus of the unparalleled crimes against civilization committed by Nazi Germany. Sporadic events such as readings and small concerts were not enough to support the building's intended function as a monument and a memorial.

Cologne-based artist W. Gies provided the decisive impulse for efforts to develop a new concept for the site that soon followed. His idea was pursued primarily by Gerhard Dornseifer, Director of Culture of the City of Pulheim, who unfortunately died too early to witness its realization. Gies proposed inviting important, internationally renowned artists to explore the site and its buried history and develop works of art relating specifically to the interior of the building as a means of engendering dialogue. Such a programmatic reorientation aimed to forge a link between the symbolic and the functional—that is, to unite aesthetic experience with historical reflection. It was hoped that the aesthetic impulse would point beyond the work itself and would commemorate—though presumably only in an indirect way—the persecution of Jewish citizens and the Shoah. Architecture, history, and art would interact and thus set themselves apart from an overheated

Geschichte und Kunst würden sich wechselweise aufeinander beziehen und sich damit von einem überhitzten Kulturbetrieb absetzen, der durch sein ständiges Überangebot einer allgemeinen Relativierung Vorschub leistete. Die als »Kunstraum« apostrophierte Synagoge verwies man auf den Weg der Reduktion: ein Ort – ein Raum – eine Arbeit. Und zudem beschränkte man jede Manifestation auf einen zeitlich begrenzten Rahmen von wenigen Wochen.

Überblickt man das seit Dezember 1991 verwirklichte Programm, dann stößt man in der Tat auf überwiegend weltberühmte Namen wie zum Beispiel Jannis Kounellis, Eduardo Chillida, Carl Andre, Rebecca Horn, Sol LeWitt und andere. Man sah in den zurückliegenden 15 Jahren eindrucksvolle Werke, in Ausnahmefällen jedoch auch Arbeiten, die in diesem Kontext wenig Sinn machten und evident werden ließen, dass es nicht immer zu einer genuinen Auseinandersetzung mit den besonderen Vorgaben und Erwartungen gekommen war. Ja, es kam im März 2006 sogar dazu, dass die Stadt ein vor allem skandalöses und auf Provokation angelegtes Projekt von Santiago Sierra nach vielen Protesten abbrechen musste. Der als »Agent provocateur« bekannte Künstler beabsichtigte mit seinem Vorschlag der »Banalisierung der Erinnerung an den Holocaust« Einhalt zu gebieten. Aus diesem Grund verwandelte er das Innere der Synagoge buchstäblich in eine Gaskammer, die Besucher nur in Begleitung eines Feuerwehrmanns und mit Gasmaske betreten konnten. Doppelt gesichert, sollte so die Angst, ermordet zu werden, im Horizont einer partiell simulierten, partiell realen Gefährdung nachvollziehbar werden. Ein Einzelfall von extremer

culture scene which, by virtue of its constant surplus, had promoted to a general tendency to view everything as relative. Apostrophized as "art space," the synagogue was described through reduction: a place—a space—a work of art. Furthermore, every presentation was limited to a relatively short period of a few weeks.

In reviewing the program realized since December 1991, we encounter primarily world-renowned names such as Jannis Kounellis, Eduardo Chillida, Carl Andre, Rebecca Horn, Sol LeWitt, and others. During the past fifteen years, we have seen impressive works but also, in isolated cases, works that made little sense in this context and made it clear that a genuine effort to come to terms with the specific requirements and expectations had not been made. Indeed, in March 2006, the city was compelled in the wake of vociferous protests to cancel a scandalous project by Santiago Sierra that was obviously intended as a provocation. Known as an "agent provocateur," the artist aimed to put an end to the "banalization of memories of the Holocaust." In pursuit of that objective, he literally transformed the interior of the synagogue into a gas chamber, which visitors could enter only accompanied by specially trained personnel and equipped with a respirator. Thus doubly protected, visitors were supposed to experience the fear of being murdered within the framework of a partially simulated, partially real threatening situation. In view of this isolated case of extreme overstatement, the question arose as to whether to continue to pursue an aesthetic approach that glossed over the historical facts or opt instead

Zuspitzung, der indessen die Frage aufwarf, ob man wie bisher weiter ästhetisch verbrämend verfahren soll oder besser einer anderen Konzeption den Vorzug gibt, die auf Irritation oder Evokation unvergleichlicher Erfahrungen abheben könnte. Wie auch immer die Antwort letztlich ausfallen wird, rückblickend bleibt festzuhalten, dass vor allem in der Anfangszeit die programmatischen, speziell für die Synagoge konzipierten Projekte eine breite Resonanz fanden. Mischa Kuballs Arbeit *Refraction House*, Ende Februar 1994 realisiert und für zwei Monate gezeigt, gehört ohne Zweifel zu den herausragenden Werken der bis jetzt verwirklichten Werkreihe. Und es ist hinzuzufügen, dass die Arbeit in einem engen Zeitfenster und unter besonderen Vorgaben sowie in einem spezifischen Kontext auf den Weg gebracht und realisiert werden musste. Es spricht für den Künstler, dass er mit sicherem Gespür beziehungsweise mit einer klaren Konfiguration seines Vorhabens darauf reagiert hat.

Rekapituliert man in aller Kürze die Ausgangssituation, dann ist zu vergegenwärtigen, dass sich Mischa Kuball nicht nur mit der Geschichte der Örtlichkeit, dem Bau, der Umgebung und der Geschichte der jüdischen Mitbürger und den an ihnen begangenen Verbrechen bis hin zum Völkermord zu beschäftigen hatte, sondern eben auch mit den unmittelbar vorangegangenen Installationen. Richard Serras Skulptur, die von Ende April bis Mitte September 1992 zu sehen war, trug den Titel *The Drowned and the Saved*. Der Künstler spielte damit ganz unmittelbar auf Primo Levis unter dem gleichen Titel erschienenen, 1986 verfassten Bericht seiner traumatischen Erfahrungen in den Konzentrationslagern

for a different concept that would irritate or evoke incomparable experiences. Regardless of how the question is ultimately answered, it is evident in retrospect that, especially in the early years, these programmatic projects conceived specifically for the synagogue attracted considerable public attention. Mischa Kuball's *Refraction House*, realized in late February 1994 and exhibited for two months, is undoubtedly one of the most outstanding works in the series to date. And one should add that the work had to be initiated and realized within a very narrow time frame under very restrictive conditions and in a very specific context. It is to the artist's credit that he responded to the challenge with a clear sense of purpose and a clearly configured project.

In recapitulating the original situation in brief, it should be noted that Mischa Kuball was compelled to respond not only to the setting, the building, its surroundings, the history of the Jewish people, and the crimes perpetrated upon them, and ultimately the fact of genocide, but also to the installation that immediately preceded him: Richard Serra's sculpture, which was exhibited from late April until mid-September 1992, was entitled *The Drowned and the Saved*. With this title, the artist alluded directly to Primo Levi's account of his traumatic experience in the concentration camps, which was published under the same title in 1986. Serra found no adequate form of expression for such unimaginable suffering, and his work remained entirely self-referential and comprehensible above all as a striking manifestation of emptiness and silence.

an. Für das unvorstellbare Leiden gab es auch bei Serra keinen adäquaten Ausdruck, und so blieb Serras Arbeit ganz auf sich bezogen und wurde vor allem als Manifestation vergegenwärtigter Leere und Stille verständlich.

Zwei massive stählerne Winkel formten in *The Drowned and the Saved* ein breitgelagertes Tor, wobei keines der Teile für sich stehen konnte. Nur indem sie sich gegenseitig stützten, bildeten sie eine skulpturale Analogie zu Levis Bild der Lebenden und der Toten, die aufeinander verwiesen und doch voneinander getrennt sind. Die abstrakte Arbeit wirkte hermetisch, entbehrte jeder konkreten Anspielung auf Trauer und Verlust, und veranlasste gerade deshalb den Betrachter, sich die Situation zu vergegenwärtigen, in der er die Skulptur wahrnahm. Es war eine Form der Selbstvergewisserung, wenn der Betrachter die sich aufdrängenden Fragen zu beantworten suchte: Wo bin ich? Wer war hier? Was geschah? Wer bin ich selbst? Es war die Mutter Serras, die dem Fünfjährigen 1944 seine jüdische Identität offenbarte. »So wuchs ich in einer Atmosphäre von Furcht und bewusster Täuschung, von Verlegenheit und Verwirrung, von Selbstverleugnung auf. Ich wurde gelehrt, nicht zuzugeben, wer ich war, nicht zuzugeben, was ich war.« Die Plastik sprach an ihrem Ort nicht von Täuschung, Verwirrung oder Selbstverleugnung, sondern im Gegenteil von Wahrhaftigkeit, von Offenheit und Autonomie. Das stählerne Tor, durch das man nicht gehen und das man nicht übersteigen konnte, stimulierte eine geschichtliche Erinnerung, die an Form und Materialität der Skulptur gebunden erschien, vor allem jedoch vom Verhältnis von Skulptur und Raum und von der Örtlichkeit selbst ausgelöst wurde.

In *The Drowned and the Saved,* two solid steel L-beams formed a wide gate. Neither of the two elements could stand alone. Only by supporting each other could they present a sculptural analogy to Levi's image of the living and the dead, who allude to but are separated from each other. The abstract sculpture evoked the impression of a self-enclosed structure devoid of reference to grief and loss, and for that very reason it prompted viewers to reflect upon the situation in which they viewed the work. In a kind of self-analysis, viewers sought to answer the insistent questions that arose: "Where am I? Who was here? What happened here? Who am I?" It was Serra's mother who revealed Serra's Jewish identity to her five-year-old son in 1944. "And so I grew up in an atmosphere of fear and deliberate deception, of shame and confusion, of self-denial. I was taught not to admit who I was, not to admit what I was." In its place, the sculpture did not speak of deception, confusion, or self-denial but instead of honesty, openness, and autonomy. The steel gate through which no one could pass and over which no one could climb prompted very individual aesthetic experience and stimulated a historical recollection that appeared bound to the form and material character of the sculpture but was above all generated by the relationship between sculpture and space and by the setting itself.

The work by Georg Baselitz achieved an entirely different effect. *Das Bein,* a body fragment of rough-hewn wood dyed yellow and mounted on a pedestal, stood in the middle of the room from late March to late July 1993 as a symbol of the vulnerability and mor-

Ganz anders wirkte die Arbeit von Georg Baselitz: *Das Bein*, ein gelb eingefärbtes, auf einen Sockel montiertes, roh aus Holz gehauenes Körperfragment, stand von Ende März bis Ende Juli 1993 in der Raummitte und verwies auf die Verletzlichkeit des menschlichen Körpers und seine Hinfälligkeit. Schwankend zwischen Zeichenfunktion und expressivem Duktus, wie er sich vor allem in der rissigen Oberfläche, der kaum differenzierten Gestalt von Unter- und Oberschenkel und dem offensichtlich sehr kleinen Fuß aussprach, machte diese autonomen Skulptur nicht den Eindruck, der Künstler habe sich explizit auf die besondere Örtlichkeit einlassen wollen oder können. Baselitz' delirierendes »Nein«, das ein entsprechendes Statement prägte, musste man damals als kongruent zu seiner Plastik empfinden, so als wollte er deutlich machen, dass die Kunst auf eine solche Situation nicht angemessen zu reagieren vermag. Man hatte indessen in der Synagoge kein Zeichen der Ohnmacht vor sich, sondern eines, das kraftvoll und selbstbewusst die absolute Autonomie des Künstlerischen signalisierte und jeglichen Verweis auf die historische Bedeutung des Ortes seiner Aufstellung negierte.

The Drowned and the Saved von Serra bezog sich in Material, Charakter, Form, Proportion und Position auf die Situation in Stommeln, war indessen nicht ortsspezifisch und knüpfte eine relativ lockere Verbindung zwischen der Plastik und dem Raum der Synagoge. Aufgestellt in einem neutralen Ambiente, dürfte die Arbeit freilich nur eine begrenzte Geltung und Wirkung entfalten. Ob dem so ist, wird sich zeigen, wenn sie im Kolumba, dem Diözesan-Museum in Köln, gezeigt wird. Beim *Bein* von Baselitz liegen die Verhältnisse

tality of the human body. Vacillating between symbolic function and expressive impulse, as was evident above all in the cracked surface and the scarcely differentiated form of the thigh and lower leg and the remarkably small foot, this autonomous sculpture did not evoke the impression that the artist had explicitly intended or been able to involve himself with the specific setting. There seemed little choice at the time but to interpret Baselitz's delirious "no," which formed a corresponding statement, as congruent with his sculpture, as if he wanted to show that art cannot respond adequately to such a situation. What one encountered in the synagogue was not a symbol of powerlessness but a powerful and self-confident symbol of the autonomy of art that negated all references to the historical significance of the place.

Serra's *The Drowned and the Saved* alluded in all respects—in terms of material, character, and form—to the situation in Stommeln, yet it was not site-specific and forged a relatively loose link between the sculpture and the space inside the synagogue. Placed in neutral surroundings, the work would probably have only limited relevance and impact. Whether that is true or not will be revealed when it is shown at the Kolumba, the museum of the diocese of Cologne. Baselitz's *Bein* is another case entirely. Structurally speaking, the sculpture asserted its independence, referred only to itself, and lost nothing of its quality, either in the synagogue or elsewhere. Ultimately, its function as an instrument within the context of a memorial setting remained in the foreground. And because that is

grundsätzlich anders. Die Plastik behauptete strukturell jedenfalls ihre Unabhängigkeit, verwies nur auf sich selbst und büßte nichts von ihrer Qualität ein, weder in der Synagoge noch andernorts. Die Instrumentalisierung im Rahmen einer Mahn- und Gedenkstätte blieb letztlich vordergründig. Genau das hatte offenbar auch Baselitz empfunden, sodass man seinen Kommentar als Ablehnung jeder historischen Konnotierung zu verstehen hat.

Baselitz und Serra sind etwa gleichaltrig und waren am Ende des Zweiten Weltkriegs 7 beziehungsweise 6 Jahre alt. Von allen sonstigen Unterschieden der Herkunft, der Ausbildung und persönlicher Erfahrungen einmal abgesehen, gehören sie doch einer Generation an. Mischa Kuball ist 20 Jahre später geboren und in den 1960er- und 1970er-Jahren aufgewachsen. Seine Lebenserfahrung ist eine andere und auch seine Einstellung gegenüber der Kunst ist offensichtlich nicht mit der von Serra und Baselitz zu vergleichen. Und diese fundamentalen Unterschiede zeichnen sich auch in seiner Arbeit für die Synagoge in Stommeln ab.

In einer brieflichen Mitteilung an den Verfasser vom Juli 1992 – Serras Skulptur war damals in Stommeln zu sehen – skizzierte Kuball sein Konzept, und auch der Titel *Refraction House* stand bereits fest. Mit dem Terminus »refraction« wird bekanntlich eine Brechung, eine Richtungsänderung bezeichnet, die eine Welle erfährt, wenn sie von einem Stoff in einen anderen übertritt. Licht, das durch Glas fällt oder auf eine Mauer trifft, ändert seine Richtung beziehungsweise wird reflektiert. Es handelt sich um ein optisches Phänomen, wobei Kuball den Begriff von Anfang an auch metaphorisch verstanden wissen wollte.

evidently precisely what Baselitz thought, his commentary must be understood as a rejection of all historical connotations.

Baselitz and Serra are roughly the same age and were seven and six years of age, respectively, when World War Two ended. Despite their different origins, education, and personal backgrounds, they belong to the same generation. Mischa Kuball was born twenty years later and grew up during the 1960s and 1970s. He has experienced life differently, and his attitude toward art cannot be compared with that of Serra or Baselitz. These fundamental differences become apparent in his work for the synagogue in Stommeln.

Kuball outlined his concept in a letter to the author written in July 1992 (Serra's sculpture was on exhibit in Stommeln at the time), and he had already decided on the title of *Refraction House* by that time. The word "refraction" denotes a kind of deflection, the change in direction of a wave of light as it moves from one material to another. Light passing through glass or striking a wall is reflected or changes its direction. Refraction is an optical phenomenon, although Kuball also intended it to be understood in a metaphorical sense as well from the very beginning. Thus he speaks with respect to his early proposal of 1992 of "the light radiating from the synagogue that strikes the concealing buildings like a hidden accusation. . . ." The work sought to bring about a change of consciousness, of our consciousness, of the consciousness of those who experienced Kuball's installation

So ist bereits im Entwurf von 1992 vom »überstrahlenden Licht der Synagoge« die Rede, »das auf die umliegenden, die Synagoge verdeckenden Häuser trifft wie eine verdeckte Anklage [...]« Die Arbeit zielte auf Änderung des Bewusstseins, unseres Bewusstseins, des Bewusstseins derjenigen, die Kuballs Installation erlebten und sich mit ihr auseinandersetzten. Im Juli 1993 war das definitive Konzept ausformuliert:

»Die Synagoge in Stommeln in gleißendem Licht – Konturen auflösend, nahe einer Ent-Materialisierung, hin zu einer Vergeistigung, weckt per Licht/Architekturplastik den spirituellen Geist; die Synagoge bleibt für den Zeitraum des Projekts (Monate Februar/März bevorzugt) verschlossen, nicht betretbar und nicht nutzbar, existiert nur noch als gedanklicher ›Körper‹, ohne funktionsgebundene Architektur; das überstrahlende Licht der Synagoge – erzeugt mit Hochleistungsscheinwerfern – trifft aus der Synagoge auf die umliegenden Häuser, die das Gebäude eng umschließen, verdecken, schützen, wie eine Anklage auf potent. Mitwisser- und Mittäterschaft.

Als das Konzept im Juli 1992 entwickelt wurde, war die öffentliche Präsenz von politischer, gesellschaftlicher Gewalt noch nicht abzusehen, die sich interessanterweise vermehrt der Lichtmetaphorik bedient – Licht als Erkenntnis, wie beim Hl. Augustinus oder als Symbol der Zerstörung, in den Pogromen, den Bücherverbrennungen; *Refraction House* versucht der verrohenden Verunsicherung durch Utopieverlust nicht mit Objekten oder neuen Bildern zu begegnen, sondern an die geistigen, immateriellen und ideellen Potenziale unserer gemeinsamen Kultur anzuknüpfen.«

Abb. S. 38–39, 338–339

and made an effort to grasp its meaning. In July 1993, he described the definitive concept:

"The synagogue in Stommeln in glaring light—dissolving outlines, approaching dematerialization to the point of spiritualization—awakens the spiritual mind through light/architectural sculpture; the synagogue will remain closed for the duration of the project (preferably the months of February/March); it will not be entered or used and will exist only as a 'body' without thoughts, without functional architecture; the light radiating from the synagogue—generated by high-powered spotlights—falls on the nearby houses that closely surround the building, concealing and protecting it, like an accusation of potent[ial] conspiracy and complicity.

"In July 1992, when the concept was first developed, the public presence of political, social violence, which interestingly enough makes increasing use of the metaphorical aspect of light (light as insight in the spirit of Saint Augustine or as a symbol of destruction in the pogroms and the book-burnings). *Refraction House* does not attempt to oppose the debilitating effects of uncertainty caused by the loss of utopias with objects or new images but instead to address the spiritual, immaterial, and ideal potential of our common culture."

Kuball made several revisions of this text for the version printed in the accompanying publication of 1994. The most important of these changes is his deletion of the reference

Figs. pp. 38–39, 338–339

Für die gedruckte Form, wie sie dann in der begleitenden Publikation von 1994 zu finden ist, hat Kuball an diesem Text einige Modifikationen vorgenommen. Die wichtigste ist darin zu sehen, dass er das aus der Synagoge hervorbrechende und die umliegenden Gebäude anstrahlende Licht nun nicht mehr »wie eine Anklage auf potent. Mitwisser- und Mittäterschaft« verstanden wissen wollte. Der moralische Aspekt seiner Arbeit konnte, soviel wurde dem Künstler klar, nicht mit der Lichtwirkung allein verbunden werden. Bekanntlich hat das Licht als Energieform und objektive Erscheinung der Natur weit über seine sichtbare Erscheinung hinaus grundlegende Bedeutung für alles Leben auf der Erde. Seit alters her wurde es als Metapher für die Intelligibilität von Sein und Wirklichkeit beziehungsweise Wahrheit und für die Erfahrung der Evidenz verstanden. Und so konnte man Erkenntnis als Weg aus der Dunkelheit ins Licht begreifen. Das natürliche Licht der Sonne wurde über Jahrtausende hinweg durch künstlich geschaffene Derivate des Feuers in Gestalt von Fackeln, Kerzen, Öl- und Gaslampen ergänzt, bevor mit Erzeugung und Nutzung von Elektrizität eine neue Stufe der Erhellung der Lebenswelt möglich wurde. Die Doppelpoligkeit von Leuchten und Brennen, von Aufklären und Zerstören, auf die Kuball explizit anspielt, war zu Beginn der Neunzigerjahre besonders virulent, nachdem an verschiedenen Orten Deutschlands Asylantenheime und Häuser und Wohnungen ausländischer Mitbürger durch Brandstiftung in Flammen aufgingen. Dass hier vielfach rechtsradikales Gedankengut solche Verbrechen mit Todesfolge entscheidend motiviert hatte, lag auf der Hand. Die künstlerischen Arbeiten für Stommeln wurden auch in diesem tagesaktuel-

to the light that emerges from the synagogue and illuminates the surrounding buildings "like an accusation of potent[ial] conspiracy and complicity." The moral aspect of his work, as the artist clearly realized, could not be associated with the effect of the light alone. It is generally understood that the importance of light as a form of energy and an objective phenomenon of nature to life on earth goes far beyond its visible manifestation. Light has always been regarded as a metaphor for the intelligibility of being, reality, and truth and for the experience of evident presence. In this sense, knowledge may be understood as the path from darkness into light. For thousands of years, the natural light of the sun was supplemented by artificial derivatives of fire in the form of torches, candles, oil- and gas-burning lamps before the discovery of technologies capable of generating and harnessing electricity introduced a new stage in the illumination of our living environment. The dual poles of illumination and burning, of enlightenment and destruction, to which Kuball explicitly alludes were made painfully clear in the early 1990s, when arsonists set fire to homes for asylum-seekers and the houses and apartments of foreign residents in Germany. The motivating influence of radical right-wing ideology on the perpetrators of these lethal crimes was impossible to overlook. The works of art created for Stommeln were also viewed and discussed in light of these current developments. Kuball was well aware of this, of course, but the fact that he did not attempt to associate his installation directly with moral precepts in his statement says a great deal about his sen-

len Kontext wahrgenommen und erörtert. Kuball war das selbstverständlich bewusst, aber es spricht für sein Augenmaß, dass er in seinem Statement von einer direkten Koppelung seiner Installation mit moralischen Vorhaltungen Abstand nahm. Um Anklage zu erheben, reichte offenbar der metaphorische Einsatz des Lichts nicht aus. Nur eindeutige Motive, Zeichen und Symbole hätten eine solche Zielrichtung seiner Arbeit evident machen können.

Mit seiner Erinnerungsarbeit über das Denkmal der Synagoge Stommeln bewegte sich Mischa Kuball im sozialen Bereich unserer Lebenswelt. Wie schon im Herbst 1990 bei der frappierenden Umwandlung des Mannesmann-Hochhauses in ein *Megazeichen* oder wie bei der 2 Jahre später realisierten *Lichtbrücke* am Bauhaus handelte es sich auch in diesem Fall um eine temporäre Installation. Während sich in Düsseldorf die Architektur vorübergehend in eine mächtige Lichtskulptur verwandelte, die die nächtliche Stadtsilhouette dominierte und zu einem großen urbanen Zeichen wurde, das viele Menschen vor allem von den Rheinbrücken und vom Oberkasseler Ufer aus wahrnahmen, diente in Dessau eine Außenwand der Inkunabel modernen Bauens für etliche Abende als Projektionsfläche geometrischer Zeichen. Auf sinnfällige Weise gelang es Kuball, einerseits zwar den Denkmalanspruch des Bauhauses zu untergraben, andererseits aber dessen utopische Programmatik hervorzukehren. Es ist diese so pointiert ausgespielte Ambivalenz, die beide Arbeiten aus dem Bannkreis des nur Abstrakten und nur Konzeptuellen herauslöst und ihnen einen spezifischen Stellenwert verleiht. Und im Spannungsfeld dieser beiden bemerkenswerten Arbeiten Kuballs ist auch sein *Refraction House* anzusiedeln.

Abb. S. 166–171, 128

sitivity. Apparently, the metaphorical use of light alone was not sufficient to support the weight of accusation. Only clearly defined motifs, signs, and symbols could have made such an intention in his work evident to viewers.

Mischa Kuball entered the social sphere of our daily living environment with his work of memory devoted to the memorial of the synagogue in Stommeln. As was the case with the striking transformation of the Mannesmann building into a *Megazeichen* (Mega-Sign) in the fall of 1990 and the *Lichtbrücke* (Light Bridge) realized at the Bauhaus two years later, this work was a temporary installation. While the architecture in Düsseldorf was temporarily transformed into a massive light sculpture that dominated the natural silhouette of the city and appeared as a huge urban symbol which could be seen by many people, especially from the Rhine bridges and the riverbank of Oberkassel, an outside wall of the incunabulum of modern architecture in Dessau served as a projection screen for geometric forms on many evenings in succession. Kuball succeeded to a remarkable degree in undermining the Bauhaus claim to monumental stature while at the same time emphasizing its utopian program. It is this succinctly articulated ambiguity that removes these two works from the realm of purely abstract and purely conceptual and imbues them with specific significance. And his *Refraction House* must also be seen within the context of the tensions generated by these two remarkable works by Kuball.

Figs. pp. 166–171, 128

Abb. S. 176–177

Abb. S. 180–181

Abb. S. 356

Abb. S. 44–45, 260–261

Spätere Arbeiten nahmen unmittelbar Bezug auf seine Installation in der Synagoge. Bei *Projektion/Reflektion*, im Herbst 1995 für die Kunststation St. Peter in Köln verwirklicht, verlegte Kuball die Lichtquellen von innen nach außen, sodass das künstliche Licht in Ergänzung zum Sonnenlicht durch die bemalten Glasfenster ins Innere drang und dort teilweise durch große Spiegel unter den Fensterbänken reflektiert wurde. Das Licht bekam hier die Fähigkeit zur säkularen Epiphanie. Auch *Greenlight*, 1999 in Montevideo realisiert und das Verlöschen der Spuren jüdischer Einwanderung und jüdischen Lebens in der Calle de la Democracia aufzeigend, müsste in diesem Zusammenhang erörtert werden. Das gilt auch für den leider nicht verwirklichten Entwurf *Sprach Platz Sprache*, den der Künstler 1999 für das ehemalige Gauforum in Weimar vorgesehen hatte. Und in die Betrachtung wäre last but not least *Schleudertrauma* einzubeziehen, eine komplexe Arbeit mit rotierenden, Schwindel erregenden und desorientierenden Bildern, die Kuball für den Kunstverein Ruhr entwickelte und die im Jahre 2000 in dem entsprechenden Ausstellungsraum der Essener Synagoge unter dem leeren Thoraschrein gezeigt wurde.

Alle diese Arbeiten beziehen sich auf die deutsche Geschichte der Nazi-Zeit, und sie erinnern an die Verbrechen an den jüdischen Mitbürgern. Es ist das deutsche Trauma, das sich in diesen Werken auf unterschiedliche Weise artikuliert, wobei Kuball jedoch stets ein abstraktes Formenvokabular und eine konzeptuelle Arbeitsstrategie zugrunde gelegt hat. Es gibt keine narrativen Aspekte, nur wenige emotionale Komponenten, kaum dokumentarische Verweise in unmittelbarem Zusammenhang mit der Arbeit selbst oder gar die Evo-

Figs. pp. 176–177

Figs. pp. 180–181

Fig. p. 356

Figs. pp. 44–45, 260–261

Later works alluded directly to his installation in the synagogue. In *Projektion/Reflektion*, realized for the Kunststation St. Peter in Cologne in the fall of 1995, Kuball moved the sources of light from the inside to the outside, so that the artificial light penetrated into the interior through the painted glass windows, supplementing the natural sunlight, and was reflected in part by the large mirror beneath the window sills. In this case, light was given the capacity to evoke a kind of secular epiphany. *Greenlight*, a work realized in Montevideo in 1999 which illustrated the eradication of the traces of Jewish immigration and Jewish life in the Calle de la Democracia, is also worthy of note in this context. And that applies as well to *Sprach Platz Sprache* (Language Space Language), a regrettably unrealized work the artist had conceived for the former Gauforum in Weimar in 1999. Also relevant, last but not least, to this discussion is *Schleudertrauma*, a complex work comprising rotating, dizzying, disorienting images developed by Kuball for the Kunstverein Ruhr and exhibited in the corresponding exhibition space at the synagogue in Essen beneath an empty Torah shrine in 2000.

All these works relate in some way to the history of the Nazi era in Germany, and they recall the crimes committed against Jewish citizens. It is the German trauma that is articulated in various ways in these works, although Kuball consistently employed an abstract formal vocabulary and conceptual working strategy. There are no narrative aspects, very few emotional components, hardly any documentary references that relate

kationen von Unmittelbarkeit. Alles bleibt auf Distanz, ein kühles Arrangement bestimmt den anschaulichen Charakter dieser Werke. Das limbische System wird nicht stimuliert, eine Verankerung der ästhetischen Erfahrung im Gefühl bleibt weitgehend ausgeblendet. Aber so rational die Konfiguration jeweils auch erscheinen mag, die Arbeiten bestechen durch ihre Qualität und innere Konsequenz und ihren distanzierenden und zugleich aufklärerischen Impuls. Es ist erstaunlich, wie jemand der lange nach Ende des Zweiten Weltkriegs geboren wurde, der 5 Jahre alt war, als in Frankfurt die Auschwitz-Prozesse begannen, der den Historikerstreit als Student mitbekommen haben mag, sich derart konsequent und wiederholt mit dem deutschen Thema, mit der engen Verquickung von Kultur und Barbarei befasst hat. Und dass die Dialektik der Aufklärung viele seiner Überlegungen grundiert, erscheint ohnehin evident. Die Thematik des Holocaust durchzieht das Œuvre von Mischa Kuball jedenfalls und lässt es in Zeiten der Postmoderne den von Amnesie befallenen Zeitgenossen als obsolet erscheinen. Im Hintergrund aller genannten Werke und auch etlicher anderer steht die Frage, wie und an was man sich jetzt und zukünftig in Deutschland erinnern wird. Bei aller ästhetischen Zuspitzung geht es Kuball um die Verifikation einer Ethik des Gedenkens, die die Deutschen annehmen und die auch die Juden respektieren können. Im Nachhinein lässt sich daher sagen, dass *Refraction House* in mehrfacher Hinsicht als eines der Schlüsselwerke im Schaffen Mischa Kuballs zu betrachten ist. Abgesehen davon ist es eine der aufschlussreichsten Arbeiten, die in den Neunzigerjahren zu diesem thematischen Komplex geschaffen wurden, vergleichbar eigentlich

directly to the work itself or even evoke a sense of immediate presence. Everything remains at a distance; the work draws its visual power from a cool, detached arrangement. The limbic system is not stimulated; there is virtually no evidence of an anchoring of aesthetic experience in the realm of feeling. But as rational as each individual configuration may appear, the most striking aspects of these works are their quality and inner consistency, their distancing yet enlightening impulse. One is astonished at the rigor and tenacity with which a person who was born long after the end of World War Two, who was five years old when the Auschwitz trials began in Frankfurt, who may well have followed the Historians' Dispute as a student, approached the German theme—the intimate relationship between culture and barbarity. And it is evident in any case that the dialectic of enlightenment underlies many of his ideas. The theme of the Holocaust is a constant in Mischa Kuball's oeuvre, and it makes it appear obsolete in the eyes of contemporaries who lapsed into amnesia during the postmodern period. Behind all of the works mentioned here and many others stands the question of what will be remembered in what ways, now and in the future. Despite his aesthetic emphasis, Kuball is concerned with the verification of an ethics of commemoration that Germans can accept and Jews can respect. Thus in retrospect one may safely say that *Refraction House* is in many ways one of the most important works in Mischa Kuball's oeuvre. And quite apart from that, it is also one of the most revealing works devoted to this thematic complex created in the

nur mit Hans Haackes Intervention von 1993 im deutschen Pavillon der *Biennale* von Venedig.

Wie seinerzeit das Mannesmann-Hochhaus in Düsseldorf erstrahlte 1994 das Gebäude der Synagoge in Stommeln von innen, hier allerdings sehr viel intensiver, so als sollte das Zeichen sich selbst überblenden. Und ähnlich wie in Dessau traf das Licht benachbarte Häuser, war indessen so gestreut, dass Mauern und Zäune, Bäume und Büsche lange Schatten warfen. Bezeichnenderweise legte die Einladungskarte zur Betrachtung der Installation in Stommeln die technischen Voraussetzungen der Intervention offen. Diese Doppelkarte war die erste Information, die potenzielle Interessenten erhielten. Und sie erschien einigermaßen irreführend, da man zu einer »Ausstellung« eingeladen wurde. Das Bild auf der Vorderseite zeigte jedenfalls einen Innenraum, von dem man annehmen musste, dass es sich um den Ausstellungsraum handelte. Zu sehen war Folgendes: Am Gestänge eines im Inneren der Synagoge stehenden Baugerüsts waren jeweils 3 starke HQI-Strahler auf die 5 Rundbogenfenster gerichtet, während sich Kuball für die Lünette über dem Thoraschrein mit einem solchen Scheinwerfer begnügte. War die Arbeit ursprünglich auf 180 000 Lumen hin konzipiert, so musste sich Kuball aus technischen Gründen mit »nur« 33 000 Lumen zufrieden geben. Das hatte zur Folge, dass man bei Dämmerung in die Synagoge hineinsehen konnte, was der Künstler eigentlich vermeiden wollte. Die Silhouette aus Stangen und Kabeln, Lampen und Transformator vor den beiden ganz in Helligkeit ertrinkenden Wänden, wie sie die Einladungskarte zeigt, blieb

1990s—comparable in fact only to Hans Haacke's intervention at the German pavilion for the *Biennale* in Venice in 1993.

Like the Mannesmann building in Düsseldorf, the synagogue building in Stommeln cast its radiant light from within in 1994, although with much greater intensity, as if the symbol were meant to dissolve into itself. And as in Dessau, the light fell on neighboring buildings, dispersing over such a wide area that walls and fences, trees and bushes cast long shadows. Quite appropriately, the invitation card issued to prospective viewers of the installation in Stommeln disclosed the technical details of the intervention. This fold-out card was the first information provided to potential visitors. And it appeared to be somewhat misleading, as it invited people to an "exhibition." The photograph on the front of the card showed a room inside a building, a space one would have assumed to be an exhibition venue. The work itself comprised three bright HQI spotlights mounted on the bars of a construction scaffold erected inside the synagogue and pointed toward the five arched windows, whereas Kuball used only one spotlight for the lunette above the Torah shrine. Having originally planned for 180,000 lumen, for technical reasons Kuball was compelled to work with "only" 33,000. Consequently, it was possible to look into the synagogue at dusk, which the artist had actually hoped to avoid. The silhouette composed of bars and cables, lamps, and a transformer arranged in front of the two walls bathed in bright light, as shown on the invitation card, remained inaccessible to the gazes of viewers, however,

jedoch den Blicken der Betrachter entzogen, denn die Synagoge war während der Laufzeit des Projektes nicht zu betreten. Das Innere des Baus war somit von der ästhetischen Erfahrung des Außenraums abgekoppelt, aber der Künstler machte durch die bildliche Information seiner Einladung deutlich, wie er den vor allem nachts überwältigenden Effekt erzeugt hatte.

Fotos vermitteln von der Suggestion der aus dem Inneren brechenden Strahlkraft nur einen unzureichenden Eindruck. Vor allem den enormen Kontrast von Blendung und Finsternis kann keine Aufnahme auch nur annähernd wiedergeben. Was man nämlich in situ unmittelbar wahrnahm, war ein Doppeltes: einerseits die Entkörperlichung der Architektur und die gleißende Emanation weißen Lichts, andererseits grelle Beleuchtung und tiefe Verschattung der Umgebung. Die Erfahrung konkreter Dinglichkeit verschränkte sich mit dem Eindruck des Unwirklichen. Wege, Bäume, Mauern, Dächer, Fenster schienen ganz gegenwärtig und zugleich merkwürdig distanziert, fremd und substanzlos. Ende Februar und Anfang März erschien ohnehin alles in dunklen, unfarbigen Tönen. Räumliche Zusammenhänge zerrissen in fragmentarische Eindrücke. Die so intensive Ausleuchtung schien alles zu zerlegen und optisch in disparate Details zu zersprengen. Nur das Bewusstsein des physischen Kontinuums und die Erinnerung an den tagsüber schon oft beschrittenen Weg von der Hauptstraße zur Synagoge minderten den Eindruck des Aufgelösten und gegeneinander Isolierten. Weil man manchmal nicht sah und nicht wusste, wohin man trat, war man verunsichert. Weil man in dem wenigen – ein unzugänglicher, überhell erleuchteter Innen-

since the synagogue was closed for the duration of the project. Thus the inside of the building was disconnected from the aesthetic experience of the surrounding outdoor space, although the artist revealed in the photograph on his invitation how he had created this overwhelming effect, particularly at night.

Photographs convey only a vague impression of the suggestive power of the radiant light bursting forth from the interior. And no photograph can come close to replicating the enormous contrast between blinding light and total darkness. What viewers perceived immediately in situ was a double effect: the dematerialization of the architecture and the glaring emanation of white light, on the one hand, and bright light and deep, dark shadows, on the other. The perception of concrete physical objectivity merged with an impression of the unreal. Paths, trees, walls, roofs, and windows seemed entirely present yet strangely distant, alien and devoid of substance. As it was, everything appeared in dark, colorless tones anyway in late February and early March. Spatial relationships collapsed, leaving nothing but fragmentary impressions. The intense light seemed to break everything apart, visually blasting the whole into a collection of disparate details. Only the knowledge of the physical continuum and the memory of the path from the main street to the synagogue walked so often during the day softened the impression of dissolution and isolation. Visitors sometimes became uncertain because they could not see at all and did not know where to walk. They were irritated because they found no evident message in

raum – keine manifeste Botschaft fand, war man irritiert. Weil die Intervention nichts über den Künstler verriet und sein schöpferisches Talent sich nicht in Gesten und spontan anmutenden Formen manifestierte, fühlte sich mancher Besucher ernüchtert. War das etwa alles? Verunsicherung, Irritation und vielleicht sogar latente Enttäuschung verwiesen den Betrachter von Synagoge und ihrer Umgebung auf sich selbst. Hatte diese Konfiguration aus Gegensätzen überhaupt einen Sinn oder erschöpfte sie sich in einer auf grellen Effekt angelegten Inszenierung ephemeren Charakters?

Vilém Flusser hat in seinem phänomenologischen Essay »Wände« auf einen indogermanischen Wortstamm »h...l« hingewiesen, dessen Bedeutung beide Extreme des sakralen Komplexes umfasse: »Heil und Hölle«, »Helle und Höhle«, »whole und hole«. Wände, so Flusser, würden uns vor die Wahl stellen, entweder aus ihnen heraus zu schreiten, um die Welt zu erobern und sich dabei zu verlieren, oder in ihnen auszuharren, um sich selbst zu finden und so der Welt verlustig zu gehen. Für Flusser wird die Undurchsichtigkeit der Wände geradezu zur Bedingung des Menschen beziehungsweise zur Voraussetzung, unter denen das Religiöse überhaupt erst zur Entfaltung kommen könne.

Auch wenn man Flusser nicht bis ins Detail zustimmen mag, Kuballs Eingriff, der sich vor allem nachts zur vollen Wirksamkeit steigerte, machte deutlich, wie die gleichsam entstofflichten Wände aus Licht und Schatten die paradoxe Illusion nährten, als wären innen und außen vertauscht. *Refraction House* nämlich machte seine Umgebung zur Bühne, auf der uns eine doppelte Identität zufiel: Als Passanten und angereiste Kunstliebhaber waren

the small, inaccessible, excessively brightly illuminated room. Some visitors were disappointed because the intervention betrayed nothing about the artist and because his creative talent was not revealed in gestures and spontaneously appealing forms. Was that all? Uncertainty, irritation and perhaps even latent disappointment diverted the thoughts of the viewers of the synagogue and its surroundings to themselves. Did this configuration of opposites make any sense at all, or was it exhausted in the staging of an ephemeral scene designed to evoke glaring effects?

In his phenomenological essay entitled "Wände" (Walls), Vilém Flusser cites the Indo-Germanic sememe "h...l", whose meanings encompass both extremes of the religious complex of "Heil und Hölle" (salvation and hell), "Helle und Höhle" (lightness and cave), "whole und hole." Walls, according to Flusser, force us to choose between walking out of them in order to conquer the world and losing sight of ourselves in the process or remaining within them in order to discover ourselves only to lose sight of the world. Flusser regards the opaqueness of walls as the defining condition of human life and the precondition for the development of religion.

Although I do not agree with Flusser in every detail, Kuball's intervention, which achieves its most powerful effect at night, clearly shows how "dematerialized" walls consisting of light and shadow nourish the paradoxical illusion that inside and outside have changed places. *Refraction House* turned its surroundings into a stage on which we

wir Akteure und Beobachter in einem. Wir standen im Hellen und warfen Schatten, wir sahen und wurden gesehen. Und mit zunehmender Dunkelheit traf das Licht nun immer stärker auch die Anwohner: passive Mitakteure, ohne deren Bereitschaft, sich dem grellen Schein auszusetzen, das Projekt nur eine unverbindliche Idee geblieben wäre. Anders nämlich als in Dessau brach die intensive Strahlung nicht in unbelebte Arbeitsräume, sondern teilweise in die Zimmer der Anwohner und verwandelte deren private Sphäre buchstäblich in eine halböffentliche. Den lebenden Bildern der Nacht würde während des Tages der Austausch in Form eines Dialogs mit den Anwohnern folgen, so die unausgesprochene Hoffnung. Was im urbanen Umfeld einer Metropole zu einer lebendigen Resonanz hätte führen können, rief freilich in Stommeln erwartungsgemäß nur ein begrenztes Echo hervor.

Dass die Reaktion so verhalten ausfiel, hat möglicherweise noch einen anderen Grund. Die Mauern, die die Bürger in ihren Häusern schützen, waren aufgrund der Fensteröffnungen partiell durchlässig. Infolge von Kuballs Intervention war aber das Fenster kein Instrument mehr für den Blick von innen nach außen, sondern für den Blick von außen nach innen. Für die Betroffenen sicherlich eine unangenehme Erfahrung, sich derart angestrahlt und quasi durchleuchtet zu finden, aber vielleicht war es in den Augen Kuballs so etwas wie ein erster Vorgriff auf ein schöpferisches Haus als Knoten des zwischenmenschlichen Netzes, von dem Vilém Flusser schwärmte. Eine dach- und mauerlose Architektur würde, so Flusser, weltweit offen stehen und das Dasein verändern. Die Leute müssten sich nirgends mehr ducken und es bliebe ihnen nichts übrig als einander die Hände zu reichen.

<div style="text-align: right">Abb. S. 38–39, 338–339</div>

acquired a dual identity: as passers-by and visiting art-lovers we were actors and observers in one. We stood in the light and cast shadows; we saw and were seen. As darkness increased, the light fell even more intensely on the people in the neighborhood—passive players in the drama without whose willingness to expose themselves to the glaring light the project would have remained nothing but an inconsequential idea. For unlike the installation in Dessau, the intensive illumination did not penetrate into unoccupied working areas but in some cases into the homes of neighbors, literally transforming their private spheres into semi-public ones. The unexpressed hope was that the living images of the night would be followed during the day by a dialogue with the neighbors. As could be expected, of course, what might have triggered animated resonance in the urban environment of a big city evoked only a weak echo in Stommeln.

There may well be another reason for this mild reaction. The walls that protect people inside their homes were not entirely impermeable due to the presence of windows. Yet after Kuball's intervention, the window was no longer an instrument that allowed people to look from the inside out but rather one that was used to look from the outside in. Being illuminated and "exposed" in this way was surely an unpleasant experience for the people involved, but perhaps Kuball may have seen this as a first approach to the creative house as a node within a network of interpersonal relationships of which Vilém Flusser dreamed. According to Flusser, an architecture without roofs or walls would stand open

<div style="text-align: right">Figs. pp. 38–39, 338–339</div>

Was wie eine surreale Phantasterei anmutet, erweist sich so als Ausfluss einer herrschaftsfreien Sozialutopie, von der höchst zweifelhaft ist, ob sie denn wünschenswert wäre. Dass Flusser Wände und Mauern unterschiedlich konnotiert, macht seine Reflexionen nicht plausibler. Diese Anmerkung ist selbstverständlich nicht als Einwand gegen die Konzeption des Künstlers zu werten – das versteht sich wohl von selbst. Immerhin wirft der kleine Exkurs die Frage auf, ob ein überaus starkes Licht die Transmission vom Metaphorischen ins Funktionale wirklich zu leisten vermag, und wenn dem so ist, ob das auch in einem so kleinstädtischen, ja beinahe dörflichen Ambiente wie in Stommeln manifest werden kann.

Kuball dürfte die Einsichten Flussers, den er persönlich kannte und dessen Schriften er gelesen hat, zumindest in einer Hinsicht teilen: Wenn nämlich das Licht der Synagoge in die Wohnungen dringt und so das Denkmal beziehungsweise Mahnmal mit der Sphäre des Privaten über Wochen hin in Beziehung setzt, dann ist darin ein Versuch zu sehen, die ästhetische Intervention, wie sie Kuball mit *Refraction House* vorgenommen hatte, aus ihrem praxisfernen und unpolitischen Ghetto zu befreien. Als restlos ausdifferenzierte hat die Kunst kaum Möglichkeiten, auf unser Verhalten zu wirken. Kuball möchte ja nicht nur etwas zeigen und das Gezeigte im Unverbindlichen belassen, sondern er möchte über das Moment der Aufklärung auf das Verhalten der Rezipienten einwirken, möchte die Betrachter nicht nur motivieren, sich zu erinnern, sondern auch dazu bewegen, toleranter zu werden, engagierter und offener, moralischer und couragierter. Ein solches Anliegen liest sich bei Flusser dann so: »Da Ästhetik (Erleben) und Ethik (Verhalten) niemals unabhängig von-

to the whole world and change our entire way of life. People would no longer have to duck, and they would have no choice but to reach out to one another. What appears to us at first glance as surreal fantasizing turns out to be the product of a utopian vision of a society without rulers, which one seriously doubts would be desirable. Flusser applies different connotations to walls, and that does not make his reflections any more plausible. Of course this remark is not to be understood as criticism of the artist's concept—that goes without saying. In any event, this brief digression leads to the question of whether an extraordinarily intense light is truly capable of transposing the metaphorical into the functional, and if it is, whether that can be visualized at all in a small-town, indeed almost village-like setting like that in Stommeln.

Kuball may agree with Flusser, whom he knew personally and whose writing he has read, in at least one sense. If the light from the synagogue penetrates into people's homes and thus establishes a relationship between the memorial and the private sphere for a period of weeks, then this must be interpreted as an attempt to liberate the aesthetic intervention, as Kuball tried to do with *Refraction House,* from its apolitical ghetto removed from reality. Art, in its omnifariousness, has hardly any way of influencing our behavior. Kuball does not simply want to show something without encouraging commitment, he wants to go beyond enlightenment and influence the behavior of viewers, motivating them not only to remember but also to become more tolerant, more involved and

einander sind, müssen Kunstwerke, gerade weil sie unser Erleben zu modellieren vermö-
gen, wieder nach der Jahrhunderte langen Kastrationsperiode auch zu Verhaltensmodellen
werden [...] Das Kunstmachen muss technisiert und theoretisiert, und die Technik ästheti-
siert, also erlebnisnah werden.«

Für einen begrenzten Zeitraum suchte Kuball mit seiner Arbeit *Refraction House* die
soziale Situation in Stommeln neu zu definieren. Indem er ein Spannungsfeld um das Denk-
mal schuf, artikulierte er den Widerspruch zwischen der Banalität des Alltags und der his-
torischen Bedeutung dieses besonderen Ortes, zwang indirekt Normalität und Schrecken
zusammen, ließ unmittelbar Gewohntes in Lästiges übergehen, verschränkte aber auch,
wenngleich indirekt, die Gewalttaten gegen Minderheiten im Gefolge der barbarische
Ereignisse von Mölln, Rostock, Hoyerswerda und Solingen mit der Erinnerung an die histo-
rische Schuld der Deutschen, wie sie sich im Verlöschen einer jüdischen Gemeinde und der
banalisierenden Zweckentfremdung der Synagoge manifestiert.

Es entbehrt dabei nicht pointierter Zuspitzung, wenn sich der Künstler bei seiner
Installation eines Mittels bedient, das in Form speerscher *Lichtdome* während des Dritten
Reiches zum Synonym für die Ästhetisierung von Gewalt wurde. Aber es versteht sich von
selbst und bedarf keines weiteren Kommentars, dass Kuball völlig anders vorgeht und
absolut konträre Absichten verfolgt. Weder senkrecht gebündelt noch parallel in den Him-
mel ausgerichtet, kann das Licht hier nicht als Verherrlichung von Macht missverstanden
werden. Im Gegenteil: Durch mehr oder minder horizontale Ausrichtung, durch Brechung

open, more moral, and more courageous. Flusser expresses a similar interest in the fol-
lowing way: "Because aesthetics (experience) and ethics (behavior) are never completely
independent of one another, works of art must become models for behavior once again
after centuries of castration—precisely because they have the capacity to shape our expe-
rience. The production of art must become more technical and theoretical and tech-
nology more aesthetic, more closely bound to experience."

With *Refraction House*, Kuball attempted for a limited period of time to redefine
the social situation in Stommeln. By creating a field of tension around the memorial,
he articulated the contradiction between the banality of everyday life and the historical
significance of this unique place, indirectly forcing normality and terror to merge, turn-
ing something that was immediately familiar into something disturbing. At the same
time, although indirectly, he blended the acts of violence committed against minorities
in the course of the barbaric events in Mölln, Rostock, Hoyerswerda, and Solingen with
memories of the historical guilt of the German people, as manifested in the eradi-
cation of a Jewish community and banalizing conversion of the synagogue for secular
use.

It is not without deliberate intensification that the artist used a medium in his instal-
lation that became a synonym for the aestheticization of violence during the Third Reich in
the form of Speer's *Lichtdom*. But that Kuball proceeds in a very different way and pur-

und Beugung fungiert das Licht als Mittel der Aufklärung und geistigen Durchdringung. Nicht die Suggestion des Erhabenen, das den Einzelnen klein und ohnmächtig macht, wird hier zelebriert, sondern vielmehr ein Licht verwendet, in das man sich buchstäblich stellen kann und das einen zum Objekt der Beleuchtung, vielleicht sogar der Erleuchtung, jedenfalls zu einem Subjekt des Fragens macht.

Kuball realisierte seine Arbeit nur für einige Wochen. Im ephemeren Charakter und in der Tatsache, dass von *Refraction House* kein materielles Substrat in Holz, Stein oder Stahl übrig blieb und zum Handelsobjekt mutierte, lagen konträr zum Augenschein Chancen für das immaterielle Überdauern eines ortspezifisches Kunstwerks als fotografisches Dokument. Widerstand gegen visuelle Entropie und Arbeit an der Geschichte kristallieren sich für Kuball zumeist nicht in stabilen Formen traditioneller Gattungen. Das gilt zumal für die Arbeit *Refraction House*, die einen Dialog mit einem bereits bestehenden Denk- und Mahnmal intendierte. Nicht inhaltliche Verdoppelung, emotionale Intensivierung oder ästhetische Kommentierung jener Momente von Trauer und Reue, Mahnung und Gedenken, die der Synagoge eingeschrieben sind, hatte der Künstler beabsichtigt, sondern Intensivierung einer Botschaft aus Verzweiflung und Hoffnung bei gleichzeitiger Versachlichung, intellektueller Durchdringung und reflektierter Aneignung mit latenter emotionaler Verankerung.

Statt der Wendung nach innen, wie sie auf jeweils unterschiedliche Weise Jannis Kounellis, Richard Serra, Georg Baselitz, Rebecca Horn und andere vollzogen, indem sie museale Präsentationsformen wählten, begegnet uns bei Mischa Kuball der entschiedene

sues entirely contrary intentions goes without saying and requires no further comment. Neither bundled in vertical columns nor directed in parallel arrangement toward the heavens, the light in this work cannot be misconstrued as a glorification of power. On the contrary, by virtue of its more or less horizontal orientation and the processes of refraction and diffraction, light serves here as an instrument of enlightenment and spiritual perceptivity. It is not the suggestion of the sublime which makes the individual small and powerless that is celebrated here. Instead, the light used in this work is a light in which one can literally stand, a light that makes one an object of illumination, perhaps even of enlightenment, but at the very least subject of inquiry.

Kuball's work was only on display for several weeks. Contrary to what one would normally expect, its ephemeral character and the fact the *Refraction House* left behind no material substrate of wood, stone, or steel and did not mutate into a commercial object represented an opportunity for the immaterial survival of a site-specific work of art as a photographic document. In Kuball's view, resistance to visual entropy and work with history ordinarily do not crystallize into stable forms of traditional genres. That is especially applicable to *Refraction House,* a work meant to engage in dialogue with an existing memorial. The artist was not striving for substantive replication, emotional intensification, or aesthetic commentary with regard to the aspects of grief and regret, warning and commemoration that are embodied in the memorial, but rather his intention was to lend

Schritt nach außen ohne vordergründige Aktualisierungen. Das immateriellste Medium, über das die bildende Kunst verfügt, nutzte er für den temporären und vor allem nachts wirksamen Versuch, den wiederhergestellten, freilich säkularisierten jüdischen Kultraum in seine gebaute und belebte Umgebung einzubinden und gleichzeitig zu isolieren. Im gebrochenen Licht rückte das prosaische Ambiente in eine Perspektive, die es mit der Geschichte verknüpft, und zwar einer sowohl ortspezifischen als auch einer nationalen, die mit dem Stigma des Versagens, Wegsehens und Verdrängens gezeichnet ist.

So wendet sich bei Kuball die Kunst nicht zu sich selbst zurück, bleibt nicht abstrakt und distanziert sich auch nicht vom empirischen Leben. Statt subjektivistischer Selbstbespiegelung transzendiert seine Arbeit *Refraction House* die Bedingungen ihrer historischen Möglichkeiten. In zeitlich begrenztem Rahmen weitet sich die Arbeit zwar latent ins Soziale aus, ohne indessen konkrete Vorgaben zu machen, besondere Tatbestände zu akzentuieren oder auch nur im Entferntesten eine Anklage erheben zu wollen. Bezeichnenderweise unterscheidet sich das gedruckte Konzept, wie wir sahen, von seiner ursprünglichen Fassung durch den Wegfall der implizierten Anklage gegen Mitwisser und potenzielle Mittäter. Das Licht, so wie Kuball es in diesem Fall einsetzt, ist Bezeichnendes und Bezeichnetes zugleich. Es leuchtet nicht etwas aus oder an, sondern dient – ganz traditionell im Übrigen – als Metapher für Wahrheit. Einerseits ist es selbstreferentiell, andererseits hat es Verweischarakter.

greater intensity to a message of despair and hope while uniting detachment, intellectual involvement, and reflected appropriation with a latent emotional foundation.

Instead of an inward turn of the kind as Jannis Kounellis, Richard Serra, Georg Baselitz, Rebecca Horn, and others accomplished in different ways by choosing forms of presentation in the museum context, we encounter in the work of Mischa Kuball a decisive step outward without ostensible attempts to achieve currency. He used the most immaterial medium available to visual art for his temporary experiment, which achieved its most striking effect at night, in order to integrate the restored yet secularized Jewish cultural space into its constructed and human environment while isolating it at the same time.In the refracted light, the prosaic ambience shifted into a perspective that linked it with a history that is both site-specific and national and is marked by the stigma of failure, deliberate ignorance, and repression.

Thus art does not turn to itself in Kuball's work. It does not cling to abstraction or distance itself from the empirical facts of life. Instead of wallowing in subjective self-reflection, *Refraction House* transcends the conditions of its own historical possibilities. Within a limited time frame, the work expands into the social sphere, albeit without posing concrete demands, accentuating specific circumstances, or articulating even a hint of accusation. It is significant that the printed concept, as we noted, differs from its original version in that the implicit condemnation of co-conspirators and accomplices has been

»Wo Kunst«, so notierte Adorno in seiner *Ästhetischen Theorie*, »die gesellschaftlichen Zwänge reflektiert, in die sie eingespannt ist, und dadurch den Horizont von Versöhnung freilegt, ist sie Vergeistigung.« Darin, so meine ich, könnte das utopische oder sagen wir einfach positive Potenzial von *Refraction House* liegen. Als sich Kuballs Konzeption in situ einlöste, wurden durchaus Antworten auf Fragen möglich, inwieweit ein der Bildlichkeit beraubtes Licht, dessen Quelle und Sujet die Synagoge war, den von Adorno zitierten »Horizont von Versöhnung« in unserem Bewusstsein zu verankern vermag. Und auch eine Antwort auf die Frage schien möglich, inwieweit die Ästhetik des Immateriellen die ubiquitären Strategien des Vergessens und Verdrängens konterkarieren kann. So waren Anstöße gegeben und positive Reaktionen ließen nicht auf sich warten, aber Nachhaltigkeit blieb auch in diesem Fall an ständige Präsenz gebunden. Dennoch überdauern ephemere Werke wie *Refraction House* in der Erinnerung und bewahren in der Vergegenwärtigung des zeitlich begrenzten Ereignisses jenes suggestive Moment, in welchem sich das Ästhetische gleichsam als Potenzialität manifestiert. Denn darum geht es hier: eine erfahrbare Situation auf Zeit zu schaffen, die vor allem auch im Nachhinein, das heißt in der Erinnerung zu einem starken und herausfordernden Bild gerinnt, auf Dauer im Gedächtnis wirksam ist und sich nicht verbraucht, weil im ephemeren Charakter der Arbeit die Gefahr gebannt erscheint, sich durch Gewöhnung und Dauer rasch zu erschöpfen.

Refraction House ist eine kühle Arbeit, eine Arbeit, die mit einfachen Mitteln eine Richtungsänderung des Denkens auslöste und die zugleich die Bedingungen ihres Entstehens

deleted. The light as Kuball uses it in this case is both the signifier and the signified. It does not expose or illuminate something but serves instead—in a very traditional way—as a metaphor for truth. It is self-referential but also refers to something beyond itself.

"Wherever art reflects the social constraints by which it is bound," notes Adorno in his *Ästhetische Theorie,* "and in doing so exposes the horizon of reconciliation, it is a process of spiritualization." It is there, it seems to me, that the utopian, or let us simply say the positive potential of *Refraction House* may be found. When Kuball's concept was realized in situ, it became possible to answer such questions as how a light robbed of pictorial character, whose source and subject was the synagogue, might fix Adorno's "horizon of reconciliation" in our consciousness. And it also seemed possible to find an answer to the question of how the aesthetics of the immaterial and ubiquitous strategies of forgetting and repression can be counteracted. Impulses were offered, and positive reactions were not long in coming, although sustained effect remained bound to constant presence in this case as well. Yet such ephemeral works as *Refraction House* endure in the memory and, by shifting a past event of brief duration into the present, preserve the suggestive moment in which the aesthetic dimension manifests itself as a potential. For that is precisely the point here: to create a situation that can be experienced for a limited period of time, a situation above all that congeals in retrospect, in the memory, to form a powerful, challenging image that retains an enduring effect in the memory and does not

an einem der Kunst fremden Ort thematisierte. Die Einladungskarte machte das nachvoll-ziehbar und offenbarte zugleich, was das gleißende Licht verbarg. Der Raum der ehemali-gen Synagoge erschien nicht wie ein Ort kultischer Restitution, sondern wie eine nach außen gekehrte Erinnerungswerkstatt. So basierte die temporäre Realisierung von *Refraction House* auf einer bestechenden Konzeption. Die Erfahrungen vor Ort bestätigten, dass sich Mischa Kuballs Erwartungen einlösten. Der besondere Rang dieser wichtigen Arbeit, die in Fotos und Texten überliefert ist, hat in den letzten Jahren noch an Prägnanz und Evidenz gewonnen und das scheint für ihr Überdauern in zukünftiger Vergangenheit zu sprechen. Die Verschränkung von Zeitgebundenheit und Zeitlosigkeit, von historischer Reminiszenz und fortdauernder Wirksamkeit ist dem Künstler mit *Refraction House* auf überzeugende Weise gelungen. Das war 1994 vielleicht so noch nicht absehbar, bestätigt sich indessen 13 Jahre später sehr nachdrücklich.

consume itself because the danger of exhausting itself through familiarity and duration is banished by the ephemeral character of the work.

Refraction House is a cool, detached work, a work that triggered a change in thinking with simple resources and addressed the subject of the conditions of its creation in a set-ting that is unfamiliar to art. The invitation card made that understandable and revealed at the same time what the glaring light concealed. The room in the former synagogue did not appear as a setting for religious restitution but as a workshop of memory turned inside out. And thus the temporary realization of *Refraction House* was based on an imposing concept. Experience at the site confirmed that Mischa Kuball's expectations were fulfilled. The outstanding quality of this important work, which is preserved in pho-tographs and texts, has gained increasing succinctness and presence over the past sev-eral years and appears to speak in favor of its survival in the future past. In *Refraction House*, the artist achieved a convincing blend of the time-bound and the timelessness, of historical reminiscence and enduring impact. That may not have been evident in 1994, but it has been confirmed emphatically in the thirteen years that have passed since then.

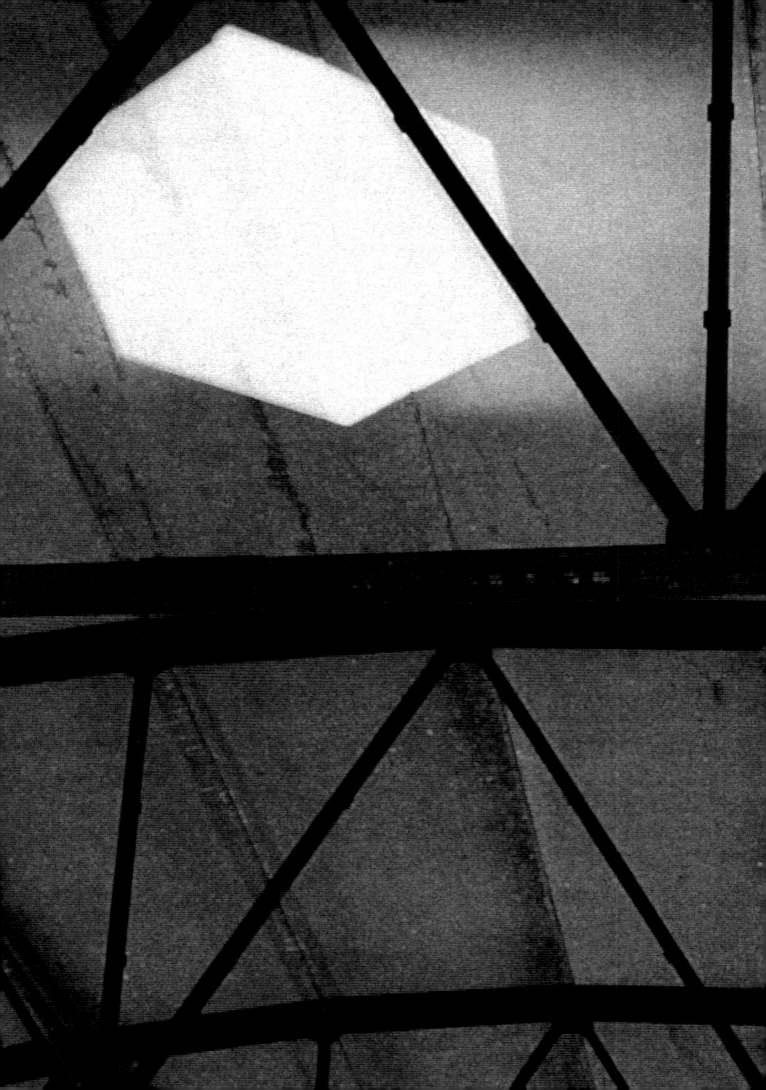

CUTS | PROJEKTIONEN | BAUHAUS

CUTS
PROJECTIONS
BAUHAUS

<<
Manifest (Detail), 1990/91,
Städtisches Museum Mülheim an der
Ruhr (Foto: Olaf Bergmann, Witten),
Vgl. Abb. S. 124 / See fig. p. 124

Schnitt X/83 (linke Seite),
Schnitt XVIII/83 (oben),
Schnitt IX/83 (links), 1983,
63 x 96 x 7 cm, 3 von 18 Collagen;
Schnitt XVIII/83 Sammlung Meikel
Vogt, London
(Foto: Norbert Faehling, Düsseldorf)

Schnitte in weißem Karton, zum Teil
auch montiert: Mischa Kuball reflek-
tiert seit 1980 architektonische und
urbane Modelle in seinen Schnitt-
Bildern. Sie sind die Grundlage für
raumgreifende Installationen und
Raum-Schnitte.

Schnitt X/83 (left page),
Schnitt XVIII/83 (above),
Schnitt IX/83 (left), 1983,
63 x 96 x 7 cm, 3 of 18 collages;
Schnitt XVIII/83 Meikel Vogt Collection,
London
(photograph: Norbert Faehling,
Düsseldorf)

Cuts in white cardboard, some
mounted: in 1980, Mischa Kuball
began reflecting on architectural and
urban models in his Schnittbildern.
They serve as the basis for his large-
scale installations and spatial cuts.

Doppelprojektion auf Skulptur, 1987,
Museum Folkwang, Essen;
Diaprojektor, 81 handgeschnittene
Dias, 5 schwarze Holzstäbe
(Foto: Norbert Faehling, Düsseldorf)

Ein Projektor überträgt Diaschnitte
und -risse auf eine reliefartige Skulp-
tur aus Holzstäben an der Wand.

Doppelprojektion auf Skulptur, 1987,
Museum Folkwang, Essen;
slide projector, 81 hand-cut slides,
5 black wooden stakes
(photograph: Norbert Faehling,
Düsseldorf)

A projector projects cut and torn
slides onto a relief-type sculpture
made of wooden stakes on the wall.

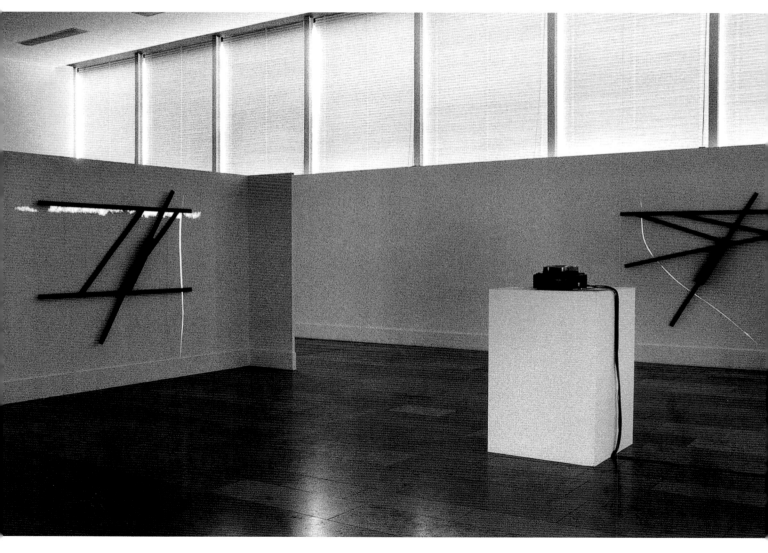

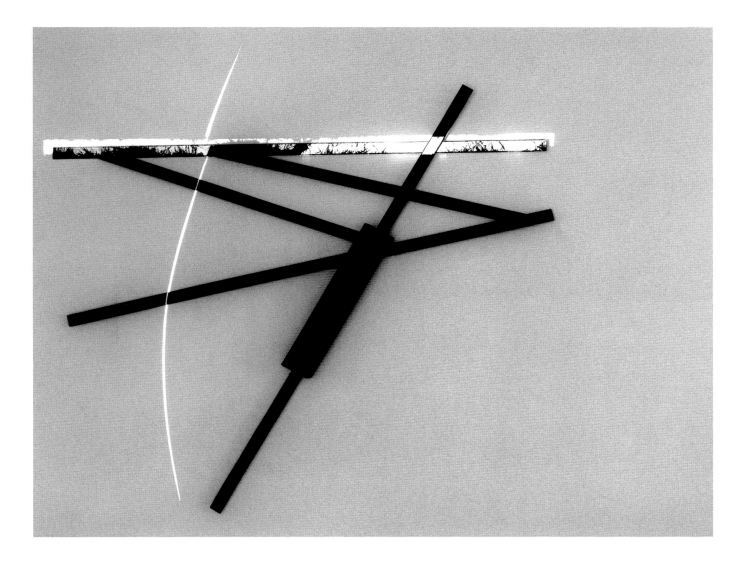

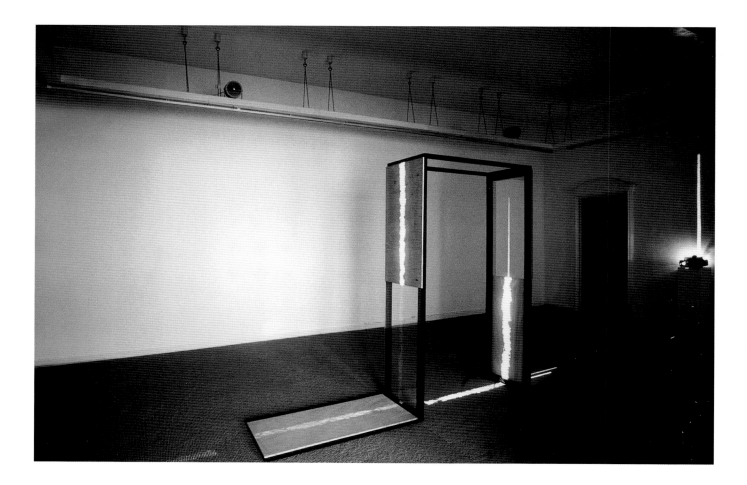

Tor, 1988,
Neuer Berliner Kunstverein, Berlin;
2 Diaprojektoren, je 81 Dias, Torkon-
struktion aus Glas und Holz
400 x 240 x 60 cm
(Foto: Ulrich Sauerwein, Berlin)

Die Projektoren wurden rechts und
links vom Tor aufgestellt, das alter-
nierend aus Holz- und Glasflächen
bestand. Die Projektoren sendeten
durch Schnitte und Risse in den Dias
strukturierte Lichtstrahlen auf die
Torkonstruktion und ihre Umgebung.

Tor, 1988,
Neuer Berliner Kunstverein, Berlin;
2 slide projectors, each containing
81 slides, gate constructed of glass
and wood 400 x 240 x 60 cm
(photograph: Ulrich Sauerwein,
Berlin)

Projectors were set up to the right
and left of the gate made of alternat-
ing pieces of wood and glass.
Through cuts and tears in the slides,
the projectors beamed rays of light
onto the gate and its surroundings.

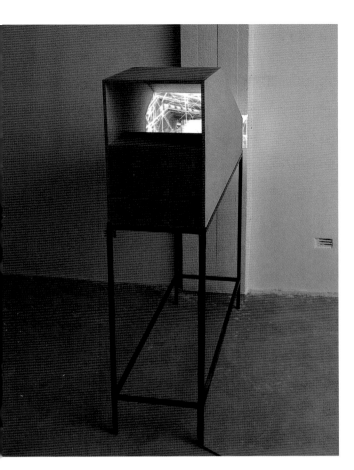

Deutscher Pavillon I, 1989,
Städtische Galerie im Museum
Würzburg; Diaprojektor, 81 Dias,
Gehäuse aus Pressspan, Metall
150 x 160 x 40 cm;
Sammlung Gottfried Hafemann,
Wiesbaden
(Foto: Norbert Faehling, Düsseldorf)

Die Dias zeigen Beispiele der Welt-
architektur, die als rechteckiger Aus-
schnitt auf die Wand projiziert wer-
den. Ein Großteil der hier fokus-
sierten Architektur sollte im Dritten
Reich für die nazi-ideologische Idee
vereinnahmt werden.

Deutscher Pavillon I, 1989,
Städtische Galerie im Museum
Würzburg; slide projector, 81 slides,
press-board housing, metal
150 x 160 x 40 cm;
Gottfried Hafemann Collection,
Wiesbaden
(photograph: Norbert Faehling,
Düsseldorf)

The slides feature examples of archi-
tecture from around the world pro-
jected in rectangular sections onto
the wall. Much of the architecture
here was supposed to have been
appropriated by the Third Reich and
used to promote Nazi ideology.

Deutscher Pavillon III, 1988/89, 1990,
Kunsthalle Köln; Diaprojektor,
81 Dias, Gehäuse aus Pressspan
150 x 160 x 40 cm
(Foto: Norbert Faehling, Düsseldorf)

Deutscher Pavillon III, 1988/89, 1990,
Kunsthalle Köln; slide projector,
81 slides, press-board housing
150 x 160 x 40 cm
(photograph: Norbert Faehling,
Düsseldorf)

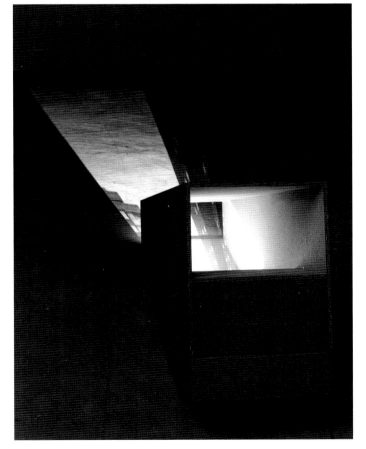

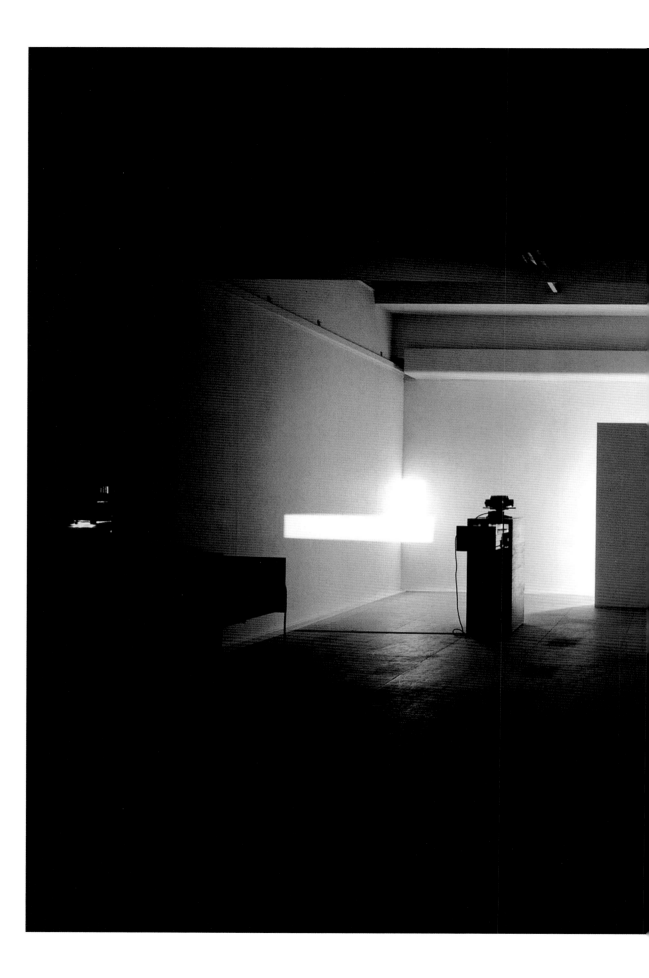

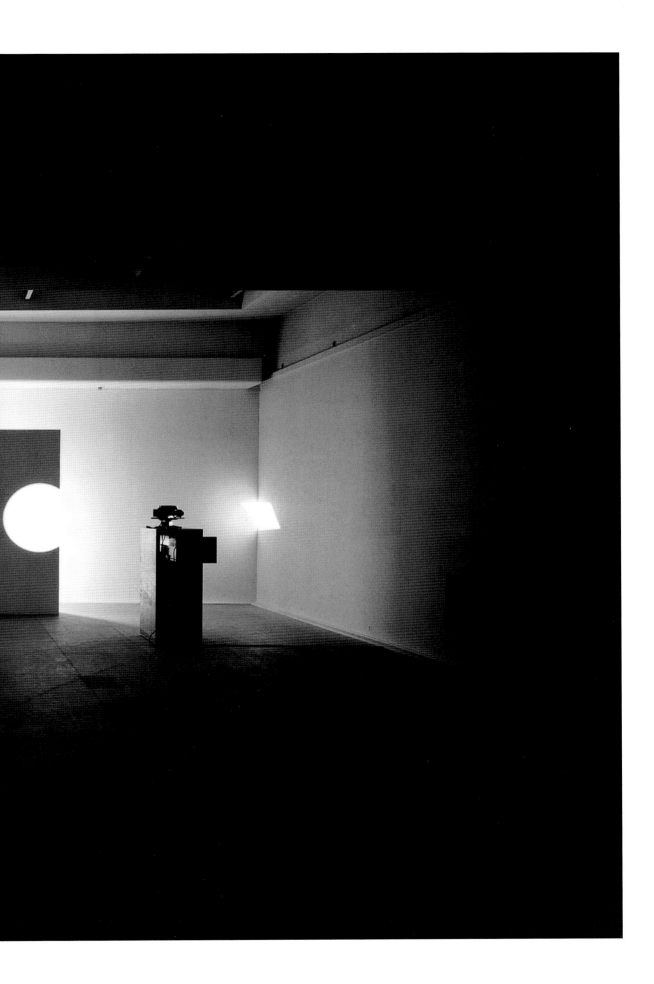

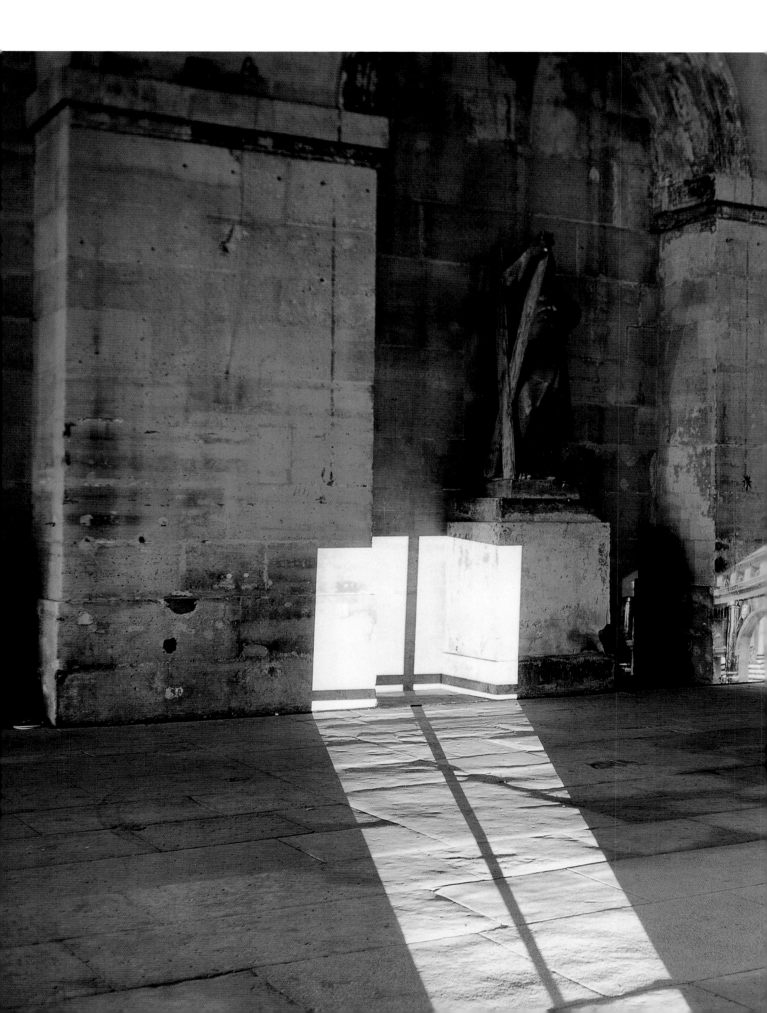

Vorhergehende Doppelseite
Moderne, rundum II, 1994,
Kunstverein für die Rheinlande und
Westfalen, Düsseldorf; 8 Diaprojek-
toren, 4 Drehteller, 4 Schubladen-
schränke, Diamasken, je 81 Dias
(Fotos: Nic Tenwiggenhorn, Düssel-
dorf)

Geometrische Lichtprojektionen
tauchten auf horizontalen Flächen
des Raums auf. In den obersten
Schubladen der Schränke wurden
Dias einer Architektur gezeigt,
die der Postmoderne zugerechnet
wird. In der Projektion erschienen
sie wie »archiviert«.

Previous double-page spread
Moderne, rundum II, 1994,
Kunstverein für die Rheinlande und
Westfalen, Düsseldorf; 8 slide
projectors, each containing 81 slides,
4 turntables, 4 filing cabinets,
slide masks
(photographs: Nic Tenwiggenhorn,
Düsseldorf)

Geometric light projections appear
on horizontal surfaces of the space.
In the topmost drawer of the filing
cabinets, slides of a building ascribed
to the postmodern are shown. In the
projection they seem to be "archived."

Moderne, rundum I, 1996,
Chapelle de Salpetrière, Paris;
4 Diaprojektoren, 4 Drehteller,
je 81 Dias
(Foto: Dennis Bouchard, Paris)

Geometrische Lichtformen und Bei-
spiele historischer Bauwerke wurden
in die Kirchenarchitektur projiziert.

Moderne, rundum I, 1996,
Chapelle de Salpetrière, Paris;
4 slide projectors, each containing
81 slides, 4 turntables
(photograph: Dennis Bouchard, Paris)

Geometric light shapes and examples
of historical structures are projected
onto the church architecture.

Moderne, rundum. Vienna Version,
1996, Museum Moderner Kunst
Stiftung Ludwig, Wien; 8 Diaprojek-
toren, 4 Drehteller, 4 Schubladen-
schränke, je 81 Dias
(Foto: Museum Moderner Kunst
Stiftung Ludwig, Wien)

Geometrische Lichtformen wurden
auf die barocke Architektur des
Herkulessaals im Palais Liechten-
stein projiziert.

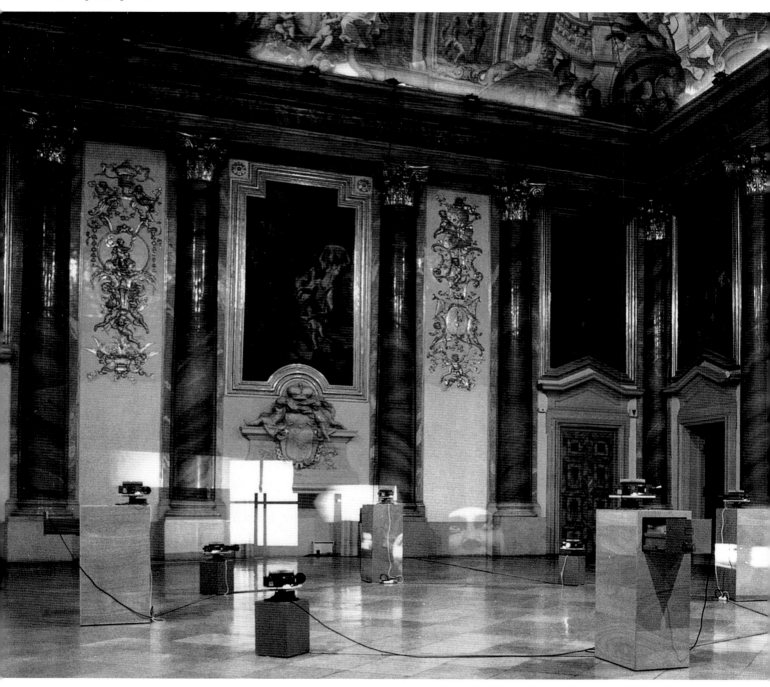

Moderne, rundum: Vienna Version,
1996, Museum Moderner Kunst
Stiftung Ludwig, Vienna; 8 slide pro-
jectors, each containing 81 slides,
4 turntables, 4 filing cabinets
(photograph: Museum Moderner
Kunst Stiftung Ludwig, Vienna)

Geometric light shapes were pro-
jected onto the Baroque architecture
of the Hercules Room in the Palais
Liechtenstein.

Moderne, rundum. No. 3 und No. 18,
1994/2002, 18 Motive, Unikatfotogra-
fie in Schwarz-Weiß, 100 x 150 cm;
No. 18 Sammlung Katrin und Dr.
Barthold Albrecht, Budapest
(Foto: Archiv Mischa Kuball, Düssel-
dorf)

Geometrische Lichtformen über-
lagern projizierte Abbildungen
berühmter Architekturen der klas-
sischen Moderne, hier zum ersten
Mal als »statisches« Bild.

Moderne, rundum: No. 3 und No. 18,
1994/2002, 18 motifs, signature b/w
photographic print, 100 x 150 cm;
No. 18 Katrin and Dr. Barthold
Albrecht Collection, Budapest
(photograph: Mischa Kuball Archive,
Düsseldorf)

Geometric light shapes overlap
other projected images of famous
classic modern architecture, forming
a ¨static¨ image for the first time.

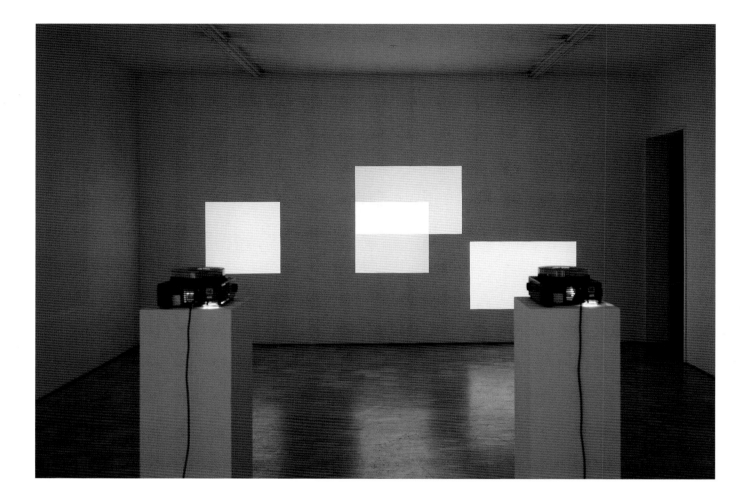

Projektionsraum 1:1:1, 1991/92,
Konrad Fischer Galerie, Düsseldorf;
2 Diaprojektoren, je 81 Dias;
Städtische Galerie im Lenbachhaus,
München
(Foto: Hubertus Birkner, Köln)

Geometrische Lichtformen wurden
in zufälliger Reihenfolge an eine
Wand der Galerie projiziert und bil-
deten so neue Formkonstellationen,
die zusammen mit der Architektur
ein definiertes Relationsverhältnis
beschrieben.

Projektionsraum 1:1:1, 1991/92,
Konrad Fischer Galerie, Düsseldorf;
2 slide projectors, each containing
81 slides; Städtische Galerie im
Lenbachhaus, Munich
(photograph: Hubertus Birkner,
Cologne)

Geometric light shapes were pro-
jected in random order onto the wall
of the gallery, thus forming new
constellations of shapes, which,
along with the architecture, described
a defined relationship ratio.

Außenansicht der Konrad Fischer
Galerie in Düsseldorf mit der Projek-
tion Mischa Kuballs. Die Galerie
war auf seinen Wunsch hin geschlos-
sen, die Installation nur von außen
einsehbar.

External view of the Konrad Fischer
Galerie in Düsseldorf with Mischa
Kuball's projection. At his request,
the gallery was closed and the instal-
lation could only be seen from the
outside.

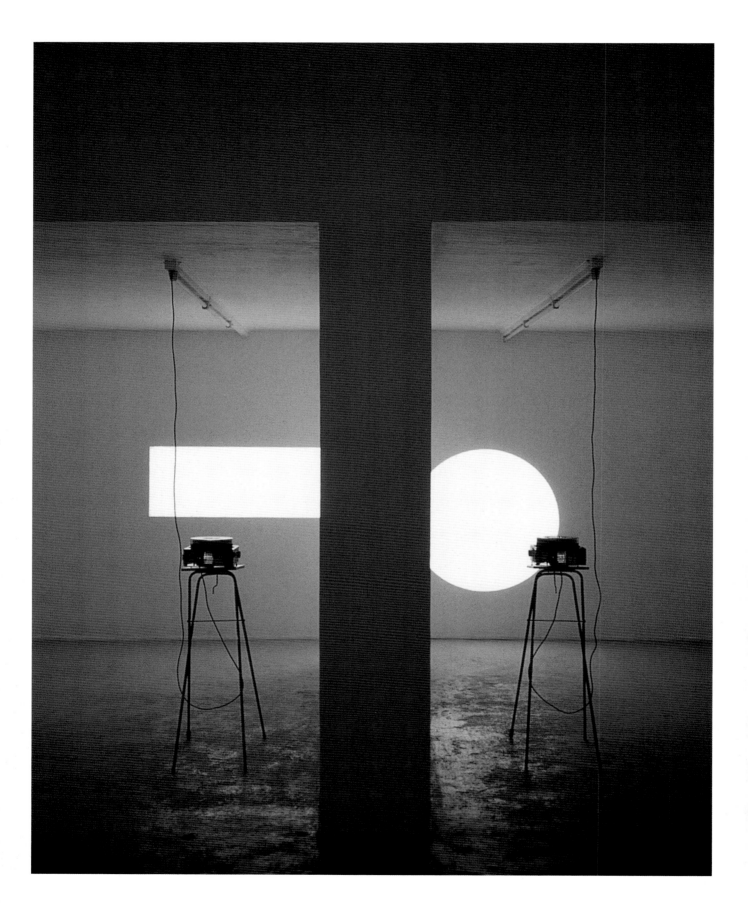

Projektionsraum 1:1:1, 1993,
Stichting de Appel, Amsterdam;
2 Diaprojektoren, je 81 Dias
(Foto: Hubertus Birkner, Köln)

Projektionsraum 1:1:1, 1993,
Stichting de Appel, Amsterdam;
2 slide projectors, each containing
81 slides
(photograph: Hubertus Birkner,
Cologne)

**Projektionsraum 1:1:1/Spinning
Version**, 1995, Kunsthalle, Bielefeld;
2 Diaprojektoren, je 81 Dias, 2 Glas-
scheiben 50 x 50 cm, 2 Decken-
motoren; Stiftung museum kunst
palast, Düsseldorf
(Foto: Archiv Mischa Kuball, Düssel-
dorf)

Geometrische Lichtformen wurden
in zufälliger Reihenfolge durch die
rotierenden Glasscheiben an eine
Wand der Kunsthalle projiziert. Die
sich ergebenden Formkonstellatio-
nen waren überdies mehrfach reflek-
tiert. Die Arbeit versteht Mischa
Kuball als Referenz an seine frühen
Arbeiten und an den *Licht-Raum-
Modulator* von László Moholy-Nagy.

**Projektionsraum 1:1:1/Spinning
Version**, 1995, Kunsthalle Bielefeld;
2 slide projectors, each containing
81 slides, 2 glass plates 50 x 50 cm,
2 ceiling motors; Stiftung museum
kunst palast, Düsseldorf
(photograph: Mischa Kuball Archives,
Düsseldorf)

Geometric light shapes were pro-
jected in random order through the
revolving glass plates onto a wall
of the Kunsthalle. The resulting con-
stellations of shapes were also
reflected several times. Mischa
Kuball regards this work as both
a reflection upon and a reference to
earlier works and to the *Light-Space
Modulator* by László Moholy-Nagy.

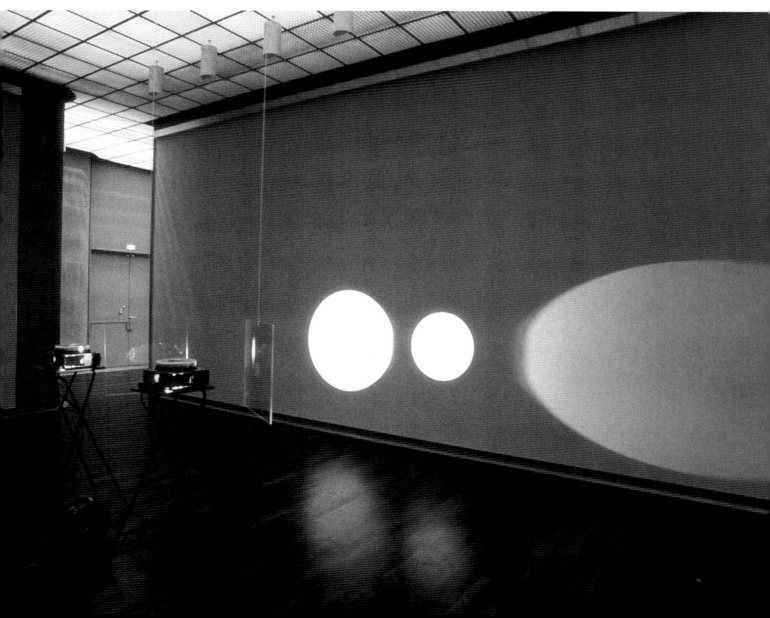

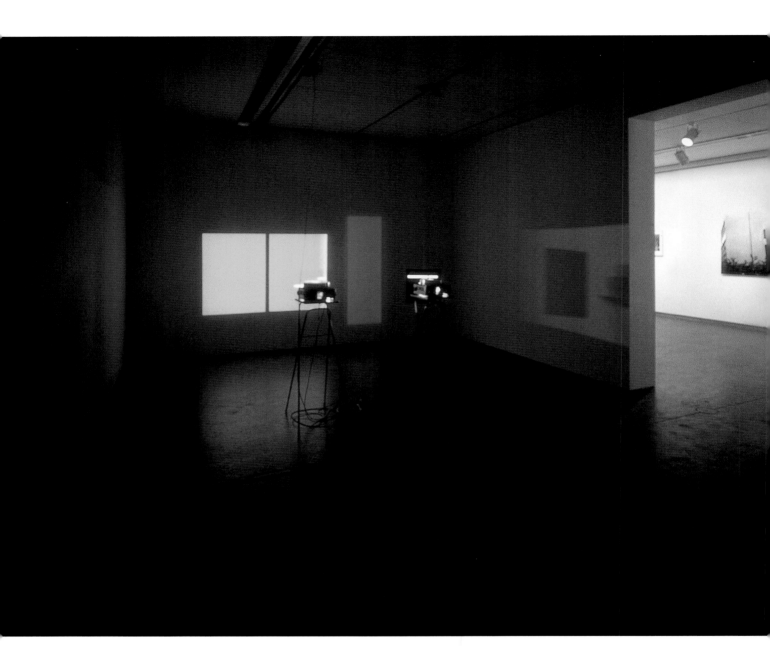

Projektionsraum 1:1:1. Farbraum, 1999,
Museum Ludwig, Köln; 2 Projektoren,
je 81 Dias, 2 Farbplatten 50 x 50 cm,
2 Deckenmotoren; Museum Folkwang,
Essen
(Foto: Rheinisches Bildarchiv/Marion
Mennicken, Köln)

Geometrische Lichtformen wurden
in zufälliger Reihenfolge durch Farb-
platten an eine Wand des Museums
geworfen und spiegelten rotierend
im Raum farbig gefiltertes sowie
weißes Licht.

Projektionsraum 1:1:1. Farbraum, 1999,
Museum Ludwig, Cologne; 2 slide
projectors, each containing 81 slides,
2 colored glass plates 50 x 50 cm,
2 ceiling motors; Museum Folkwang,
Essen
(photograph: Rheinisches Bildarchiv/
Marion Mennicken, Cologne)

Geometric light shapes were pro-
jected in random order through
colored glass plates onto a wall of
the museum, so that they reflected
revolutions of both filtered color
and white light in the space.

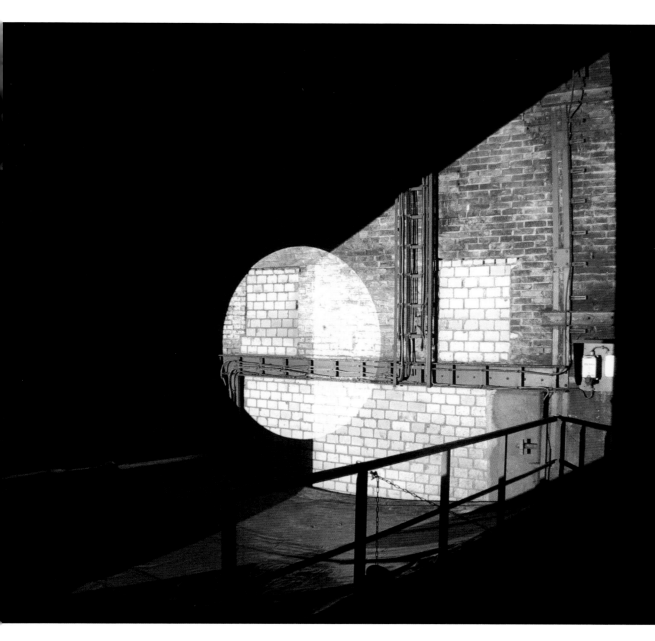

**Projektionsraum 1:1:1. Spinning
Version**, 2005, Ostpol Förderturm
Bönen; 2 Diaprojektoren, je 81 Dias,
2 Glasscheiben 50 x 50 cm,
2 Deckenmotoren
(Foto: Peter Pothmann, Bönen)

Geometrische Lichtformen wurden
in zufälliger Reihenfolge durch rotie-
rende Glasscheiben an die Wände
des Förderturms projiziert. Die sich
ergebenden Formkonstellationen
waren überdies mehrfach reflektiert.
Die Installation wurde zum ersten
Mal außerhalb eines »White Cube«-
Kontextes gezeigt. Im Förderturm
bildeten die horizontalen Linien ein
Gegengewicht zur Vertikalität des
Raumes.

Projektionsraum 1:1:1: Spinning
Version, 2005, Ostpol shaft tower,
Bönen; 2 slide projectors, each
containing 81 slides, 2 glass plates
50 x 50 cm, 2 ceiling motors
(photograph: Peter Pothmann,
Bönen)

Geometric light shapes were pro-
jected in random order through
revolving glass plates onto the walls
of the shaft tower. The resulting
constellations of shapes were also
reflected many times. This was the
first time the installation was shown
outside the context of a "white cube."
The horizontal lines of the shaft
tower balanced the vertical direction
of the space.

Doppelhaus I–V, 1996,
5 Zeichnungen 68 x 97 cm, Filzstift
auf Papier; Sammlung Caren und
Rüdiger Czermin, Bad Homburg
(Foto: Archiv Mischa Kuball, Düssel-
dorf)

Zeichnungen in Schwarz-Weiß von
insgesamt 10 öffentlichen Arbeiten
Mischa Kuballs, die sich gegenseitig
überlagern.

Doppelhaus I–V, 1996,
5 drawings 68 x 97 cm, felt marker
on paper; Caren and Rüdiger Czermin
Collection, Bad Homburg
(photograph: Mischa Kuball Archive,
Düsseldorf)

Black-and-white overlapping draw-
ings of a total of ten public works
by Mischa Kuball.

**Le Passage I/94 (für W. B.).
Interventionen 1,**1994,
Sprengel Museum Hannover;
4 Diaprojektoren, 4 Drehteller,
je 81 Dias
(Foto: Michael Herling, Hannover)

Vier Projektoren warfen Dias mit
Architekturbildern und geometri-
schen Formen auf die Fassaden des
Übergangs zwischen Neu- und Alt-
bau des Sprengel Museums und ver-
wiesen auf das berühmte *Passagen*-
Werk von Walter Benjamin. Der
Zwischenraum – eine Fuge – wurde
zum ersten Mal als Ausstellungs-
raum genutzt. Mischa Kuball startete
damit *Interventionen 1* – mittlerweile
gibt es mehr als 40 Arbeiten von
internationalen Künstlern für die
Museumspassage.

**Le Passage I/94 (für W. B.).
Interventionen 1,** 1994,
Sprengel Museum Hannover; 4 slide
projectors, each containing 81 slides,
4 turntables
(photograph: Michael Herling,
Hanover)

In reference to Walter Benjamin's
famous *Arcades Project*, four projec-
tors showed slides of architectural
images and geometrical shapes on
the façades of the transition between
the new and old wings of the Spren-
gel Museum. The transitional space—
a kind of structure—was used as an
exhibition space for the first time.
This was the start of Mischa Kuball's
Interventionen 1; more than forty
works have been created by interna-
tional artists for the museum's
passageway since.

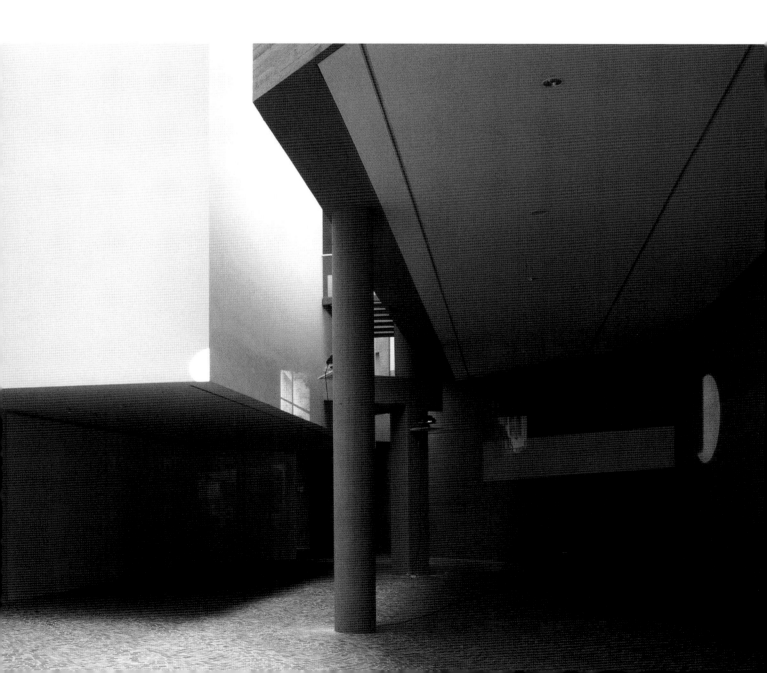

Le Passage I/94 (für W. B.).
Interventionen 1, 1994,
Sprengel Museum Hannover; 4 slide
projectors, each containing 81 slides,
4 turntables

Projektionsskulptur I, 1993,
Konrad Fischer Galerie, Düsseldorf;
3 Diaprojektoren, 3 Dias, Podest 120
x 40 x 40 cm
(Foto: Dorothee Fischer, Düsseldorf)

Die auf einem Podest aufeinander
gestapelten Projektoren warfen
3 sich überlagernde Lichtkreise an
die Wand und bildeten die *Projek-
tionsskulptur I*. Im Vordergrund sind
die Lichtquellen der *Projektions-
skulptur II* zu erkennen.

Projektionsskulptur I, 1993,
Konrad Fischer Galerie, Düsseldorf;
3 slide projectors, 3 slides,
pedestal 120 x 40 x 40 cm
(photograph: Dorothee Fischer,
Düsseldorf)

Projectors stacked on a pedestal
project three overlapping circles
of light onto the wall, forming the
Projektionsskulptur I. In the fore-
ground can be seen the light sources
for *Projektionsskulptur II*.

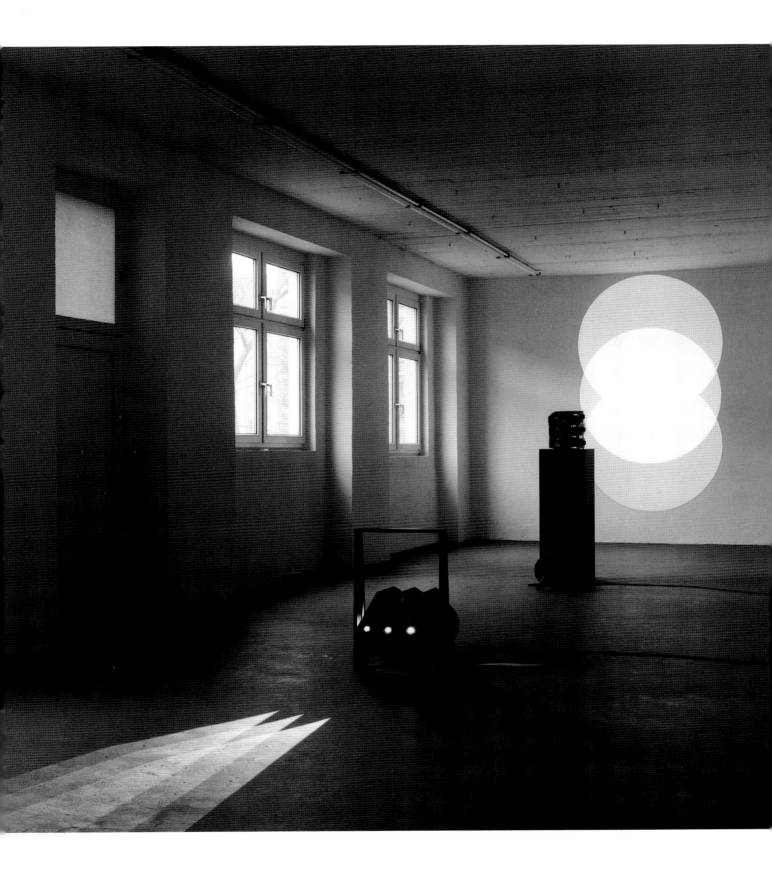

Mies-Mies I, 1993,
Konrad Fischer Galerie, Düsseldorf;
5 Stelen à 4 Leuchtkästen, Metall,
Maße 250 x 330 x 20 cm;
Sammlung Luxoom, Berlin
(Foto: Archiv Mischa Kuball, Düssel-
dorf)

Die Stelen setzen sich aus je 4
Leuchtkästen mit gleichen Motiven
zusammen. Die beiden äußeren
Stelen zeigen fotografische Details
von der Lichtwand im Mies van der
Rohe-Pavillon in Barcelona, die
beiden inneren Stelen das reine
Neonlicht und die mittlere den Pavil-
lon selbst, durch 4 verschiedene
Gläser fotografiert.

Mies-Mies I, 1993,
Konrad Fischer Galerie, Düsseldorf;
5 steles, each with 4 light boxes,
metal, dimensions 250 x 330 x 20 cm;
Luxoom Collection, Berlin
(photograph: Mischa Kuball Archive,
Düsseldorf)

The steles are each made of four
light boxes with the same motifs.
The two steles on the outside feature
details of photographs of the wall
of light in the Mies van der Rohe
Pavilion in Barcelona; the two inside
steles feature pure neon light, and
the center stele shows the pavilion
itself, photographed through four
different glasses.

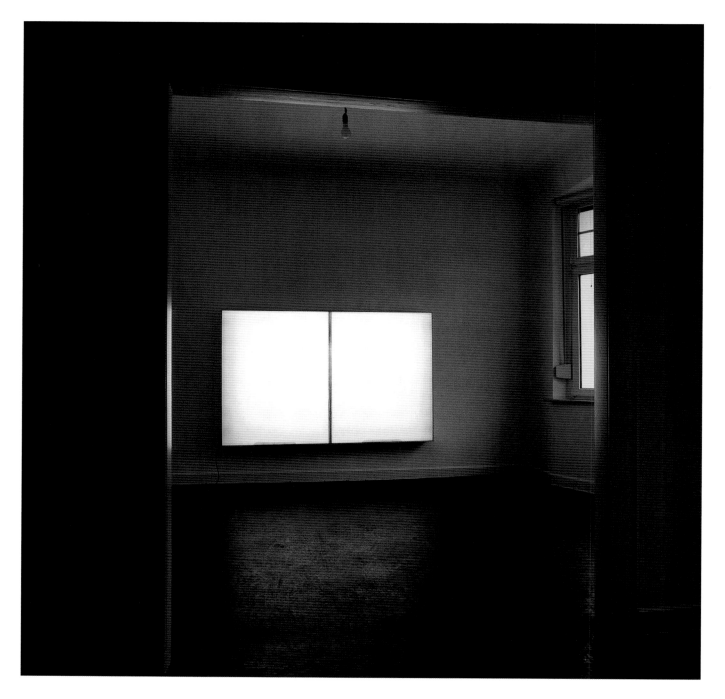

Mies-Mies II, 1994,
Konrad Fischer Galerie, Düsseldorf;
Leuchtkasten 142 x 220 x 20 cm,
Zentrum für Internationale Licht-
kunst, Unna
(Foto: Dorothee Fischer, Düsseldorf)

Der Leuchtkasten zeigt die auf den
Betrachter rückverweisende
»Lichtwand« im Mies van der Rohe-
Pavillon in Barcelona.

Mies-Mies II, 1994,
Konrad Fischer Galerie, Düsseldorf;
light box 142 x 220 x 20 cm, Zentrum
für Internationale Lichtkunst, Unna
(photograph: Dorothee Fischer,
Düsseldorf)

The light box shows the "light wall,"
which reflects its viewer, at the Mies
van der Rohe Pavilion in Barcelona.

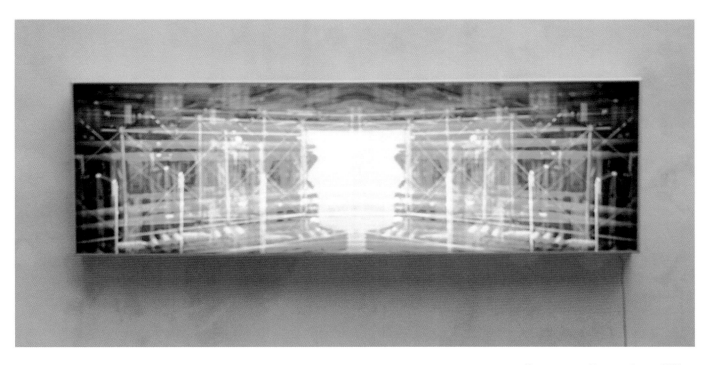

Kunstzentrum-Zentrumskunst, 1992,
Konrad Fischer Galerie, Düsseldorf;
Leuchtkasten 220 x 80 x 20 cm
(Foto: Archiv Mischa Kuball, Düssel-
dorf)

Der Leuchtkasten zeigt die stark
selbst reflektierende Architektur des
Centre Pompidou. Im Sinne des
Rorschachmodells entstand aus dem
gespiegelten Ausstellungshaus in
Paris eine eigene Figur.

Kunstzentrum-Zentrumskunst, 1992,
Konrad Fischer Galerie, Düsseldorf;
light boxes 220 x 80 x 20 cm
(photograph: Mischa Kuball Archive,
Düsseldorf)

The light box shows the self-reflect-
ing architecture of the Centre Pom-
pidou. The reflected exhibition space
in Paris created its own figure,
reminiscent of the Rorschach model.

Chicago, III, 1992/97,
Museum Folkwang, Essen;
Diaprojektor, 81 Dias, 100 Wasser-
gläser, Maße variabel
(Foto: Archiv Mischa Kuball, Düssel-
dorf)

Abbildungen von bekannten Gebäu-
den in Chicago werden entlang
von Gläserrändern auf die Wand pro-
jiziert. Die alten Aufnahmen waren
vom Wasser aus gemacht worden
und finden sich deshalb auch durch
die mit Wasser gefüllten Gläser
gespiegelt.

Chicago, III, 1992/97,
Museum Folkwang, Essen;
slide projector, 81 slides, 100 tum-
blers, dimensions variable
(photograph: Mischa Kuball Archives,
Düsseldorf)

Photographs of famous buildings in
Chicago were projected along the
edges of tumblers onto the wall. The
old photographs were shot from the
water and thus are also projected
through water-filled tumblers.

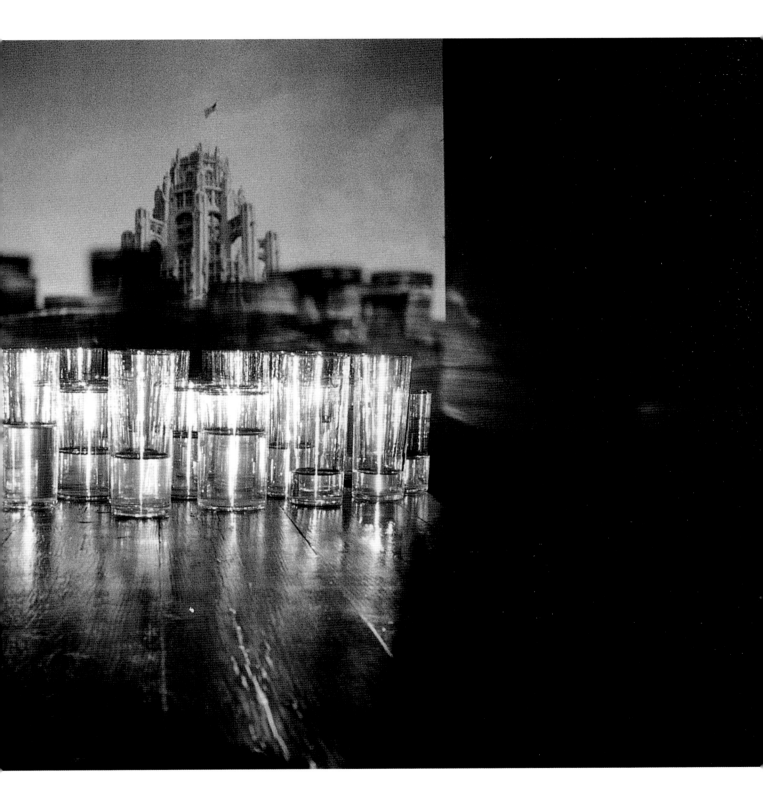

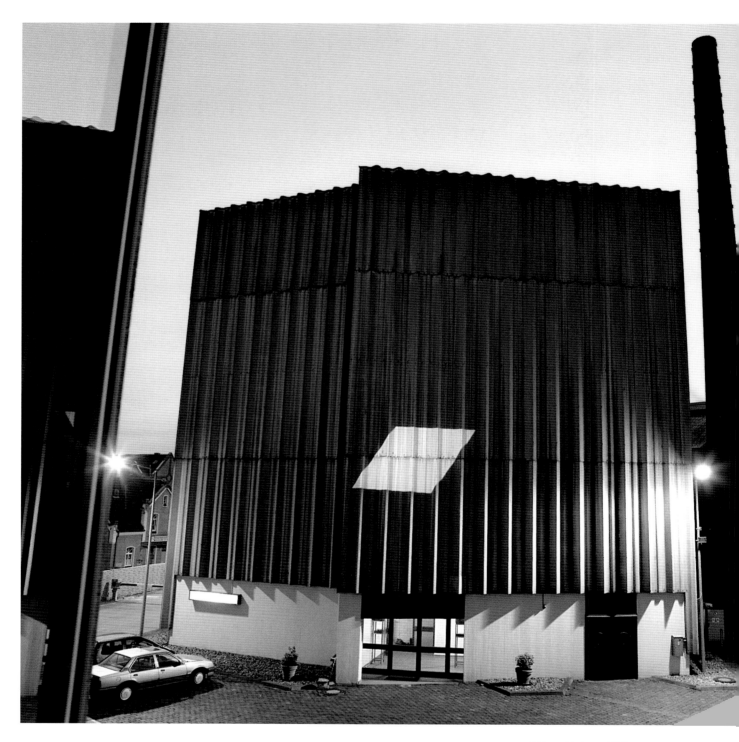

Lichtverbindung, 1998,
Herrenhäuser Turm, Hanover;
slide projector, 81 slides
(photograph: Kelly Kellerhoff, Berlin)

Geometric light shapes were pro-
jected onto the façade of the Herren-
häuser Turm. The installation was
part of a multiple-part, site-specific
exhibition, *Tower of Power*, which
took place in and around the Herren-
häuser Turm.

Lichtverbindung, 1998,
Herrenhäuser Turm, Hannover;
Diaprojektor, 81 Dias
(Foto: Kelly Kellerhoff, Berlin)

Geometrische Lichtformen wurden
auf die Fassade des Herrenhäuser
Turms projiziert. Die Installation war
ein Teil der mehrteiligen, ortspezi-
fischen Ausstellung *Tower of Power*
im und am Herrenhäuser Turm.

Chick Lights/Tri-star, 1999,
Museum of Installation, London;
Leuchtkasten 160 x 120 cm, Foto-
grafie auf Diasec 220 x 160 cm;
Sammlung Helge Achenbach,
Düsseldorf
(Foto: Edward Woodman und
Museum of Installation, London)

Der Leuchtkasten zeigt das Foto
eines brennenden Hauses, das
im rechten Winkel zum Foto einer
Deckenlampe positioniert ist.

Chick Lights/Tri-star, 1999,
Museum of Installation, London;
light box 160 x 120 cm, face-mounted
photograph 220 x 160 cm;
Helge Achenbach Collection,
Düsseldorf
(photograph: Edward Woodman
and Museum of Installation, London)

The light box features the photograph
of a burning house, which is posi-
tioned at a right angle to the photo-
graph of a ceiling lamp.

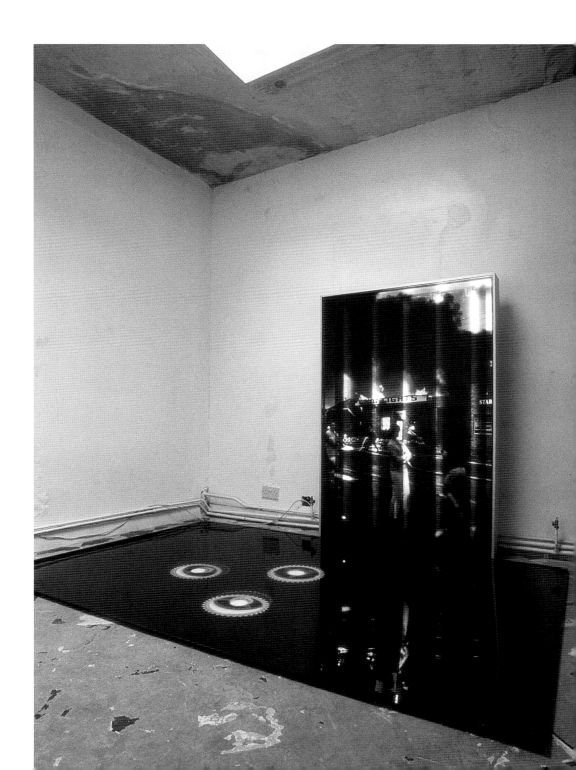

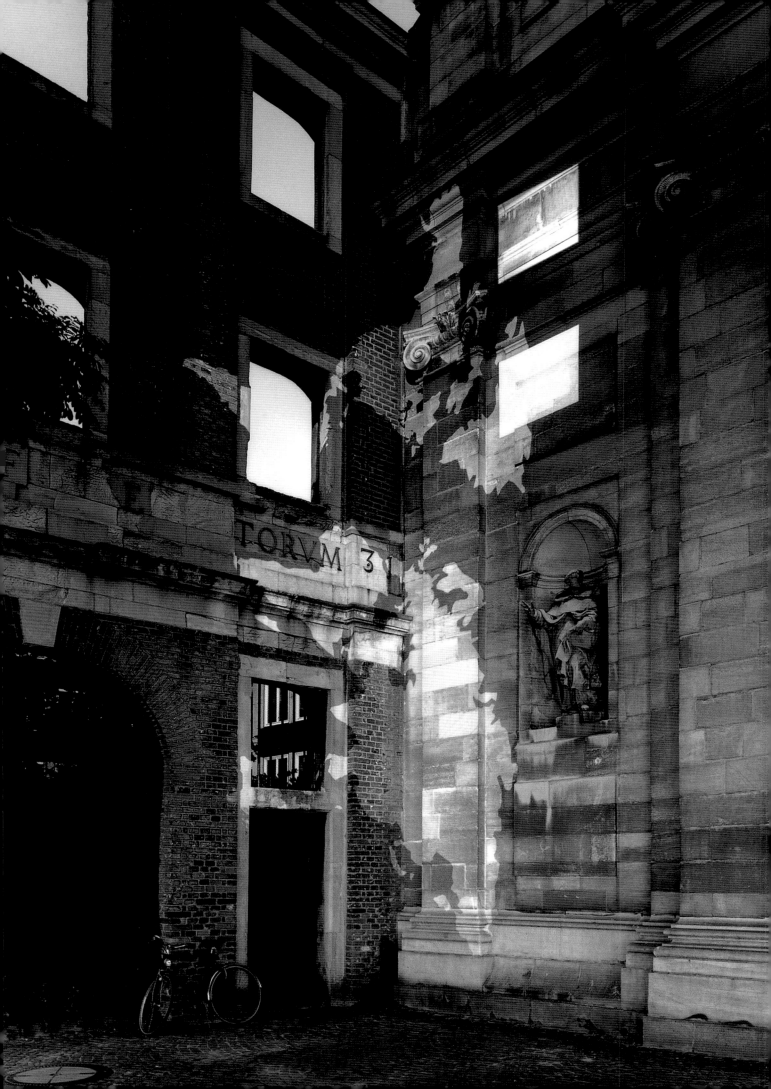

Gegenbilder, 1993,
Dominikaner Kirche, Münster;
2 Diaprojektoren, je 81 Dias
(Fotograf: Tomasz Samek, Münster)

Geometrische Lichtformen und die
Weltkarte wurden auf die barocke
Architektur der Dominikanerkirche
in Münster projiziert und belichteten
dynamisch Details der Fassade im
urbanen Raum.

Gegenbilder, 1993,
Dominikaner Kirche, Münster;
2 slide projectors, each containing
81 slides
(photographer: Tomasz Samek,
Münster)

Geometric light shapes and a map
of the world were projected onto the
Baroque architecture of the Domini-
can Church in Münster, illuminating
dynamic details of the façade in
urban space.

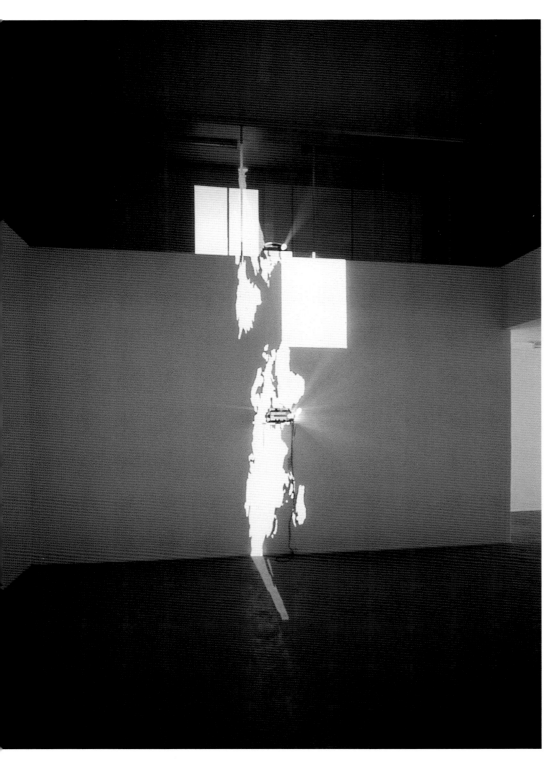

Double Standard, 1993,
Stichting de Appel, Amsterdam;
4 Diaprojektoren, je 81 Dias
(Foto: Hubertus Birkner, Köln)

Geometrische Lichtformen und die
Weltkarte wurden auf die Wände des
Ausstellungsraums projiziert. Der
stetige Wechsel der Motive ließ neue
Raumwahrnehmungen zu.

Double Standard, 1993,
Stichting de Appel, Amsterdam;
4 slide projectors, each containing
81 slides
(photograph: Hubertus Birkner,
Cologne)

Geometric light shapes and a map
of the world were projected onto the
walls of the gallery space. The con-
stant motion of the motifs allowed
new perceptions of the space.

World-Rorschach/Rorschach-World,
1995, Diözesanmuseum, Köln;
2 Diaprojektoren, 2 Deckenmotoren,
je 81 Dias, 2 Glasplatten je 50 x 50 cm,
2 Projektionsständer, 1 Parallel-
schalter; Diözesanmuseum, Köln
(Foto: Archiv Mischa Kuball, Düssel-
dorf)

Spiegelsymmetrisch angeordnete
Weltkarten wurden in den Raum pro-
jiziert. Durch die sich drehenden
Glasscheiben reflektiert, wanderten
die Projektionen über sämtliche
Wände, Gegenstände und Personen
im Raum, unter anderem über das
»Dreigesicht«, eine barocke Holz-
skulptur.

World-Rorschach/Rorschach-World,
1995, Diözesanmuseum, Cologne;
2 slide projectors, each containing
81 slides, 2 ceiling motors, 2 glass
plates, each 50 x 50 cm, 2 projection
stands, 1 parallel connection;
Diözesanmuseum, Cologne
(photograph: Mischa Kuball Archive,
Düsseldorf)

Inversely symmetrical maps of the
world were projected into the space.
Reflected through the revolving glass
plates, the projections moved over
all of the walls, objects, and people
in the space, including the *Dreigesicht*,
a Baroque wooden sculpture.

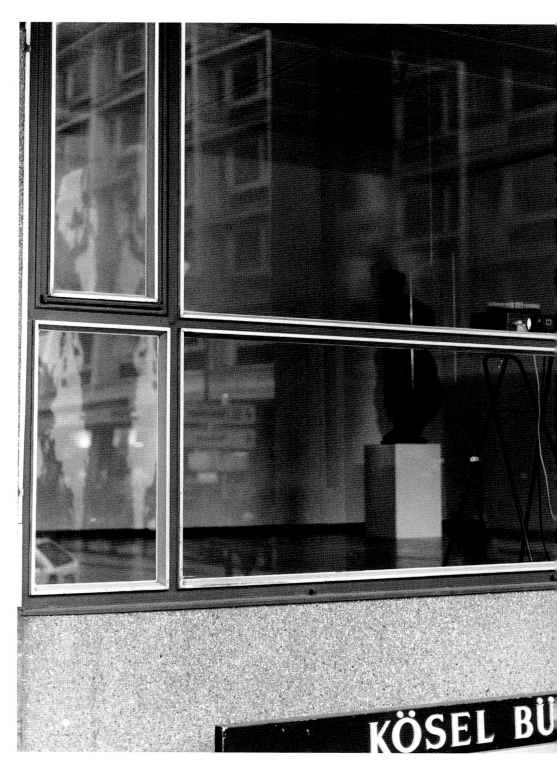

Viele Teile und kein Ganzes, 1987/1991,
Haus Wittgenstein, mit Vilém Flusser,
Wien; 18-teilig: 9 Teile 21 x 30 cm,
9 Holzplatten 50 x 90 cm
(Foto: Matthias Herrmann, Wien)

Die 2 x 9 Wand- und Bodenobjekte
waren Teil der Ausstellung *Welt/
Fall*, für die Kuball eigens Arbeiten
entworfen hatte, die wie visuelle,
abstrakte Zeichen dem Betrachter
eine Vielzahl von Interpretations-
möglichkeiten boten.

Viele Teile und kein Ganzes, 1987/1991,
Haus Wittgenstein, with Vilém Flusser,
Vienna; 18 parts: 9 sections
21 x 30 cm, 9 wooden boards
50 x 90 cm
(photograph: Matthias Herrmann,
Vienna)

The nine wall and nine floor objects
were part of a conceptual exhibition
entitled *Welt/Fall*, for which Kuball
designed a work, which—like visual,
abstract signs—offered the viewer
a number of different interpretations.

Links/Rechts I – IV, 1988,
Haus Wittgenstein, mit Vilém Flusser,
Wien; 4-teiliges Wandobjekt
(Foto: Matthias Herrmann, Wien)

In den Wandobjekten wurden Verbin-
dungen zwischen Wand/Raum sowie
Material und Sprache ausgelotet.

Links/Rechts I – IV, 1988,
Haus Wittgenstein, with Vilém
Flusser, Vienna; 4-part wall object
(photograph: Matthias Herrmann,
Vienna)

These wall objects explored connec-
tions between wall and space as
well as material and language.

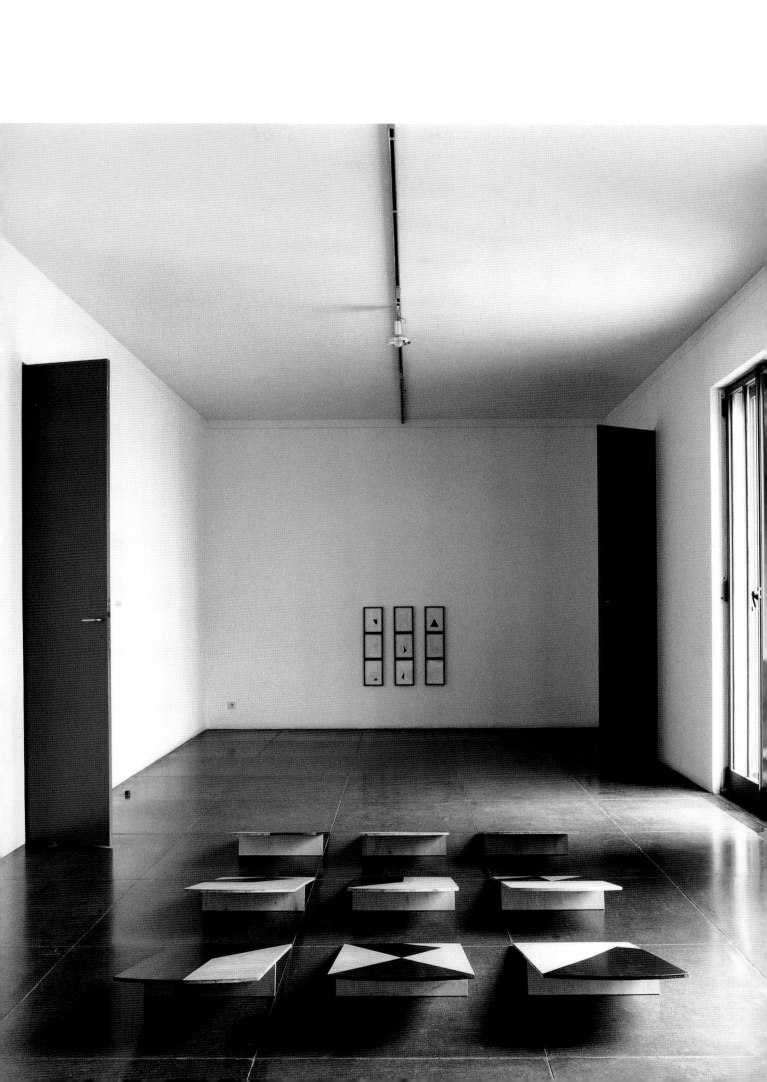

Bauhaus I/Lotterie, 1990/91,
Städtisches Museum Mülheim an
der Ruhr
(Foto: Olaf Bergmann, Witten)

Bauhaus I/Lotterie, 1990/91,
Städtisches Museum Mülheim an
der Ruhr
(photograph: Olaf Bergmann, Witten)

Bauhaus I/Lotterie, mit einer Klang-
installation von Heiner Goebbels,
1991, Neue Kunst im Hagenbucher,
Heilbronn; 4 Stelen MDF je
200 x 100 x 50 cm, 4 Diaprojektoren,
je 81 Dias, Audio-Tapes
(Foto: Klaus Schaeffer, Heilbronn)

Dias mit geometrischen Lichtformen
wurden auf die Stelen projiziert.
Die Installation untersuchte audio-
visuell das Verhältnis von »Real«-
und Museumsraum. Die Klänge des
Alltags wurden von Heiner Goebbels
für den Raum arrangiert.

Bauhaus I/Lotterie, with a sound
installation by Heiner Goebbels,
1991, Neue Kunst im Hagenbucher,
Heilbronn; 4 MDF steles, each
200 x 100 x 50 cm, 4 slide projectors,
each containing 81 slides, audiotapes
(photograph: Klaus Schaeffer,
Heilbronn)

Slides of geometric light shapes
were projected onto steles. The
installation was an audiovisual inves-
tigation of the relationship between
"real" and museum space. Heiner
Goebbels arranged everyday sounds
for the space.

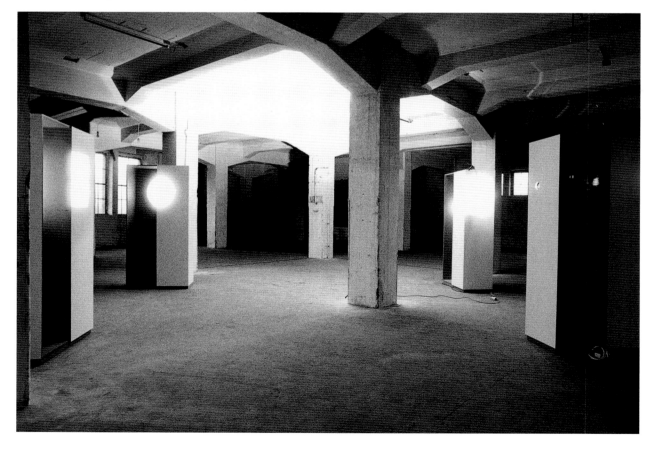

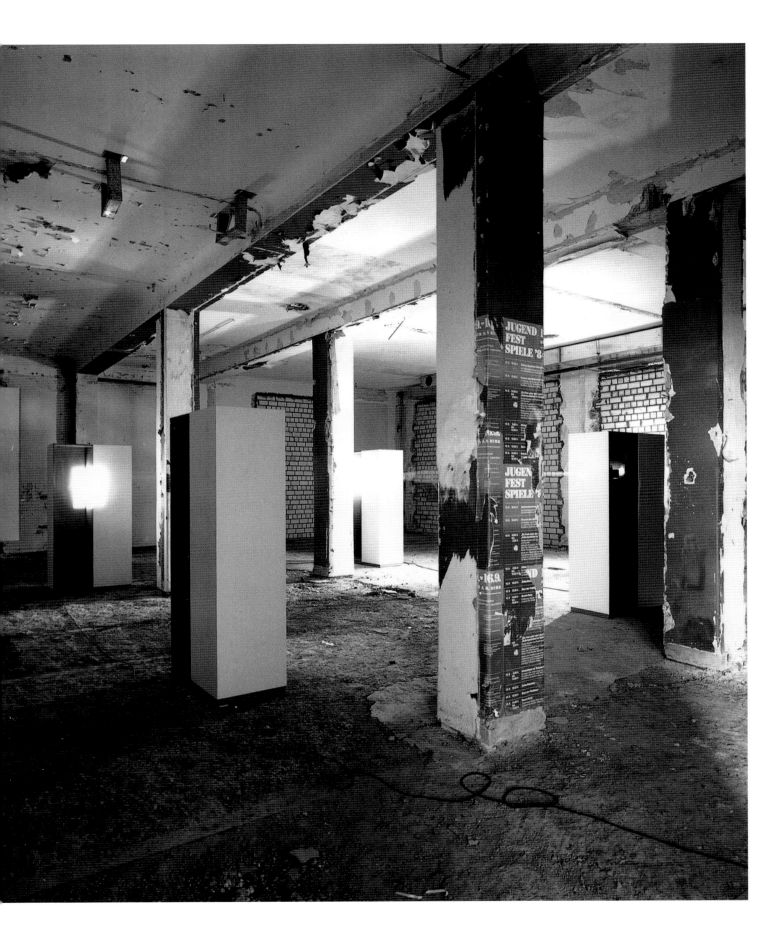

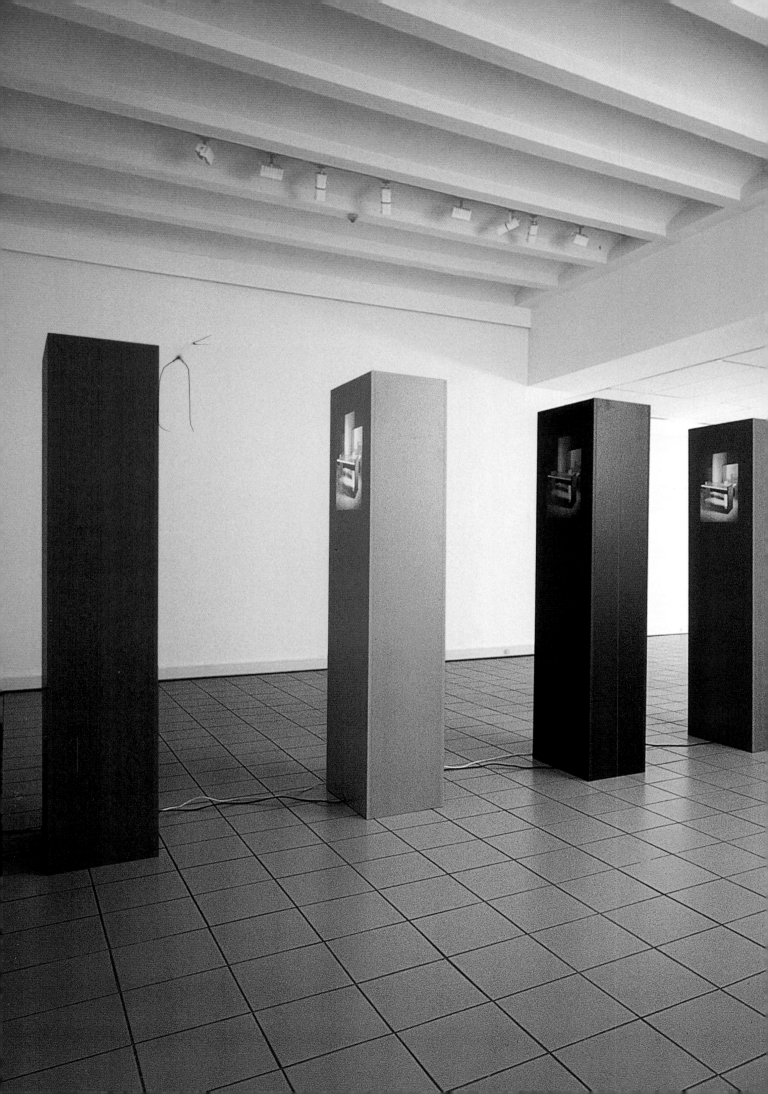

Deutsches Haus/Reihen und Stapeln I, 1990/91,
Städtisches Museum Mülheim an der Ruhr; 2 von 4 Unikatfotografien, 2-teilig, MDF 10 x 70 x 16 cm; Sammlung Heinen, Düsseldorf
(Foto: Olaf Bergmann, Witten)

Fotografische Arbeit aus der Installation *Deutsches Haus (sozialer Wohnungsbau)*

Deutsches Haus/Reihen und Stapeln I, 1990/91,
Städtisches Museum Mülheim an der Ruhr; 2 of 4 signature photographs, 2-part, MDF 10 x 70 x 16 cm; Heinen Collection, Düsseldorf
(photograph: Olaf Bergmann, Witten)

Photographic work from the *Deutsches Haus (sozialer Wohnungsbau)* installation.

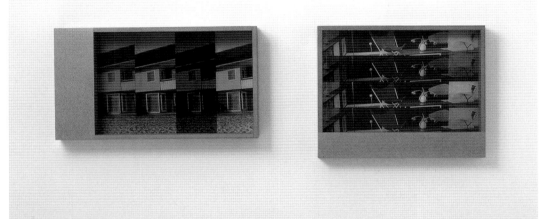

Deutsches Haus (sozialer Wohnungsbau), 1989/91,
Städtisches Museum Mülheim an der Ruhr; Stelen: Spanplatte, Resopal, je 225 x 40 x 60 cm, 4 Projektoren, je 81 Dias; Städtische Galerie im Museum Würzburg
(Foto: Olaf Bergmann, Witten)

Dias von 81 Architekturen, Wohn-Architekturen, Innen- wie Außenräume wurden an die Wände und auf die Stelen projiziert. Mischa Kuball inszenierte hier eine Typologie des Wohnens.

Deutsches Haus (sozialer Wohnungsbau), 1989/91,
Städtisches Museum Mülheim an der Ruhr; steles: chipboard, Formica, 225 x 40 x 60 cm each, 4 projectors, each containing 81 slides; Städtische Galerie im Museum Würzburg
(photograph: Olaf Bergmann, Witten)

Slides of 81 buildings, dwellings, and interior and exteriors spaces were projected onto the walls and steles. Here, Kuball staged a typology of living space.

Manifest, 1990/91,
Städtisches Museum Mülheim an
der Ruhr; 2 Holzcontainer, MDF,
2 Diaprojektoren, 2 Dias, insgesamt
275 x 100 x 80 cm
(Foto: Olaf Bergmann, Witten)

2 Diaprojektoren warfen das Lichtbild
aus einem Gehäuse auf jeweils eine
Seite einer rechteckigen Platte an
die Decke, sodass sich ein Sechseck
formte. Die Arbeit bezog sich auf
die in einem Holzschnitt von Lyonel
Feininger visionär heraufbeschwo-
rene »Kathedrale der Zukunft«
anlässlich des Bauhaus-Manifests
1919 in Weimar.

Manifest, 1990/91,
Städtisches Museum Mülheim an der
Ruhr; 2 wooden containers, MDF,
2 slide projectors, 2 slides, total
dimensions 275 x 100 x 80 cm
(photograph: Olaf Bergmann, Witten)

Two slide projectors projected an
image of light from a container onto
each side of a rectangular board on
the ceiling, forming a hexagon. The
work referred to a woodcut by Lyonel
Feininger, the visionary *Kathedrale
der Zukunft* done for the Bauhaus
manifesto in 1919 in Weimar.

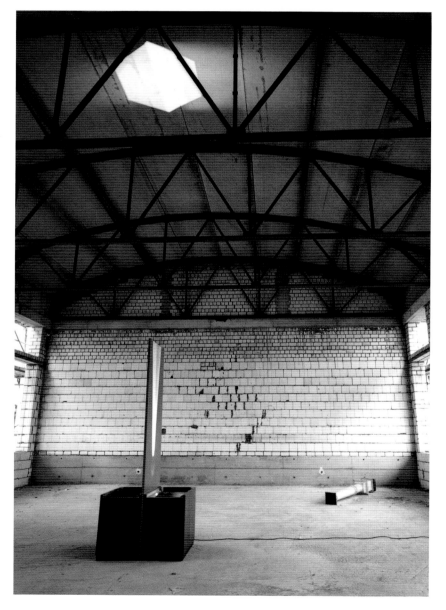

Denkprinzip II, 1991,
Städtisches Museum Mülheim a. d.
Ruhr; Diaprojektor, 81 Dias, Glas,
Stahl, MDF, ca. je 225 x 246 x 50 cm
(Foto: Olaf Bergmann, Witten)

Die 81 Dias bekannter historischer
Architekturen werden auf Gehäuse
aus Stahl und Glas projiziert. Die
Arbeit spiegelt die Selbstreferentia-
lität »Moderner Architektur« wider.

Denkprinzip II, 1991,
Städtisches Museum Mülheim an der
Ruhr; slide projector, 81 slides,
glass, steel, MDF, each approx.
225 x 246 x 50 cm
(photograph: Olaf Bergmann, Witten)

Eighty-one slides of well-known
historical buildings were projected
onto containers of steel and glass.
The work reflects the self-referen-
tiality of "modern architecture."

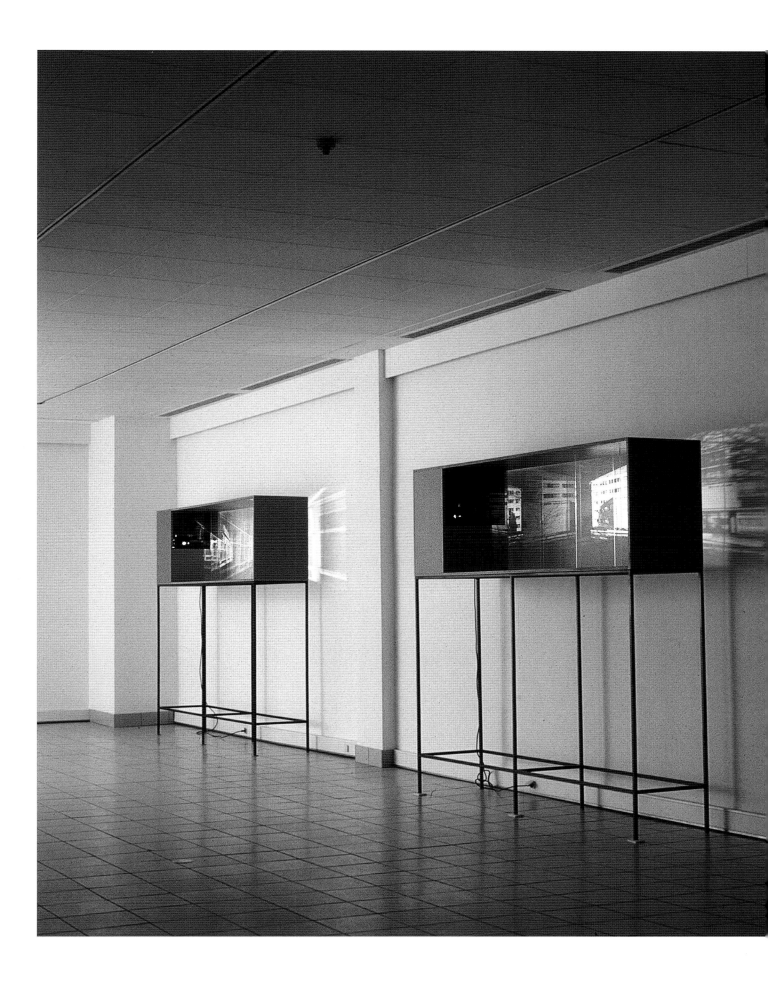

Erfurt 52, 1989/91,
Städtisches Museum Mülheim an
der Ruhr; 7 Tapeziertische je
296 x 50 x 73 cm, Raufaser »Erfurt
52«; 1 Tisch Sammlung Lutz Schöbe,
Dessau
(Foto: Olaf Bergmann, Witten)

7 Tapeziertische wurden mit der
Raufaser »Erfurt 52«bezogen und
vertikal an die Wände montiert.
Sie simulierten eine Wand in Form
einer Skulptur anlässlich der Aus-
stellung *B(l)aupause*, die während des
Umbaus der Mülheimer Post zum
heutigen Kunstmuseum stattfand.

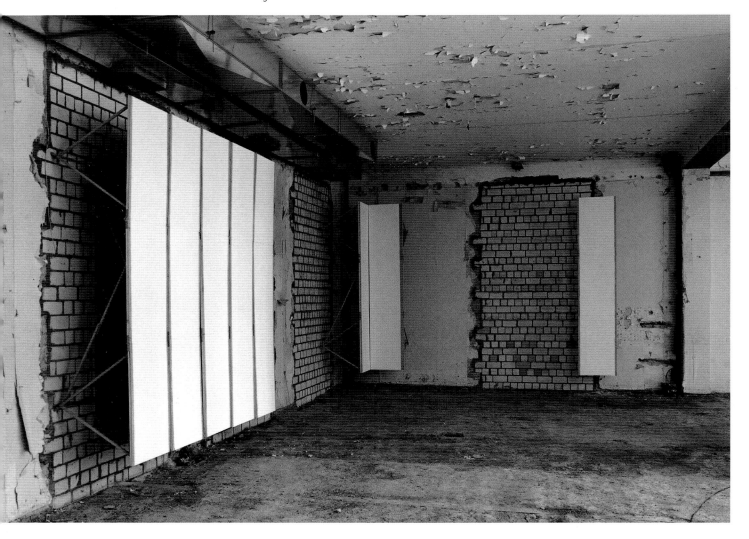

Erfurt 52, 1989/91,
Städtisches Museum Mülheim an der
Ruhr; 7 trestle tables, 296 x 50 x 73 cm
each, woodchip wallpaper "Erfurt
52"; 1 table Lutz Schöbe Collection,
Dessau
(photograph: Olaf Bergmann, Witten)

Seven trestle tables were covered in
"Erfurt 52" wallpaper and vertically
mounted on the walls. They simu-
lated a wall in the shape of a sculp-
ture for the exhibition *B(l)aupause*,
which took place while the Mülheim
Post Office was being remodeled
and turned into the city's new art
museum.

Kippfenster I–V, 1990,
Städtisches Museum Mülheim an
der Ruhr; 5-teilig, je 80 x 80 x 40 cm,
Holz, Rillenglas
(Foto: Olaf Bergmann, Witten)

Kippfenster wurden auf die Wände
der ehemaligen Hauptpost montiert,
die zum Kunstmuseum umgebaut
wurde.

Kippfenster I–V, 1990,
Städtisches Museum Mülheim an der
Ruhr; 5 sections, 80 x 80 x 40 cm
each, wood, ribbed glass
(photograph: Olaf Bergmann, Witten)

Tilt windows were mounted on the
walls of the former main post office,
which was being remodeled into an
art museum.

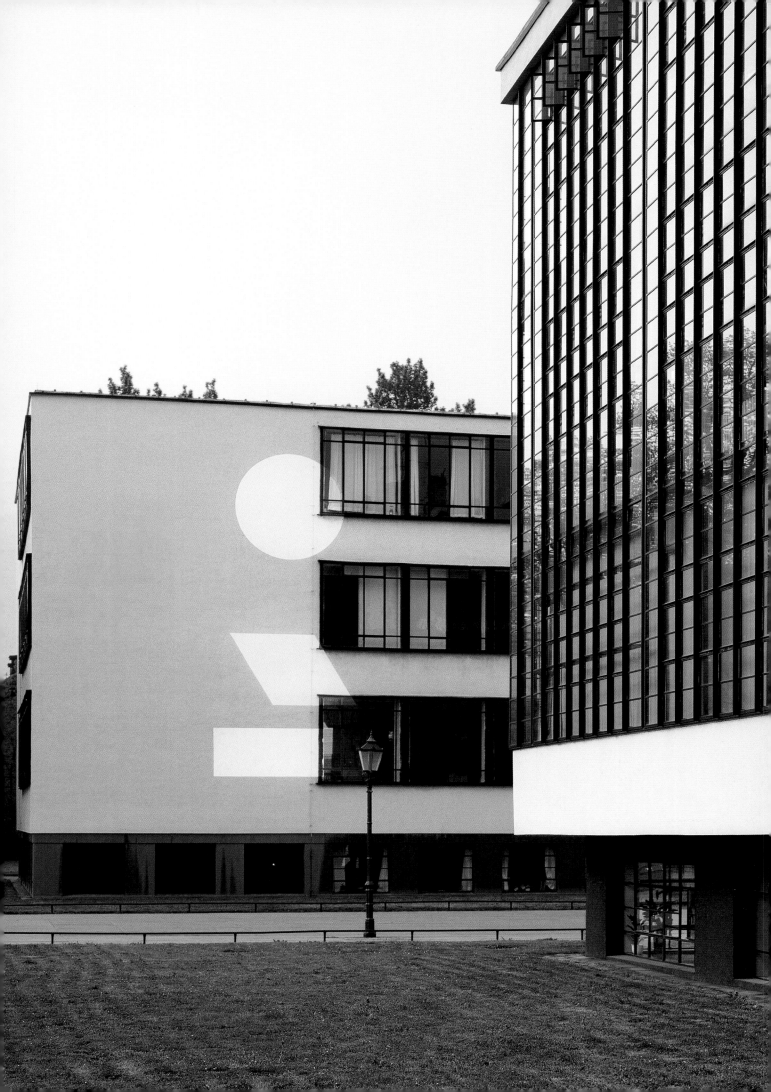

Lichtbrücke, 1992,
Bauhaus Dessau; 3 Diaprojektoren,
je 81 Dias
(Foto: Kelly Kellerhoff, Berlin)

Die über vierzig Meter hinausrei-
chende Projektion verband die
geometrischen Lichtelemente mit
den Fassadendetails und Fenster-
ausschnitten des Bauhauses und
setzte damit ein sichtbares, dynami-
sches Zeichen in den Stadtraum
von Dessau.

Lichtbrücke, 1992,
Bauhaus Dessau; 3 slide projectors,
each containing 81 slides
(photograph: Kelly Kellerhoff, Berlin)

The over forty-meter-long projection
linked geometric elements of light
to the details of the façade and win-
dow areas of the Bauhaus, creating
a visible, dynamic sign in Dessau's
urban space.

Bauhaus I/Lotterie, 1991,
Bauhaus Dessau
(Foto: Kelly Kellerhoff, Berlin)
S. S. 120

Bauhaus I/Lotterie, 1991,
Bauhaus Dessau
(photograph: Kelly Kellerhoff, Berlin)
See p. 120

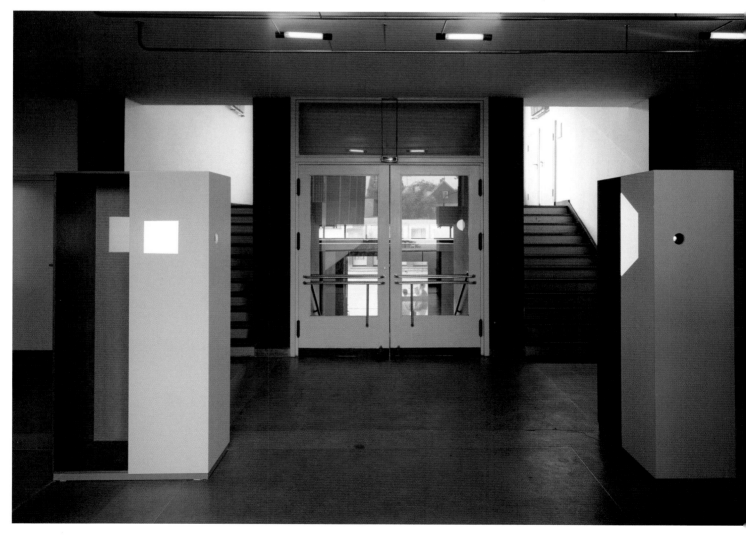

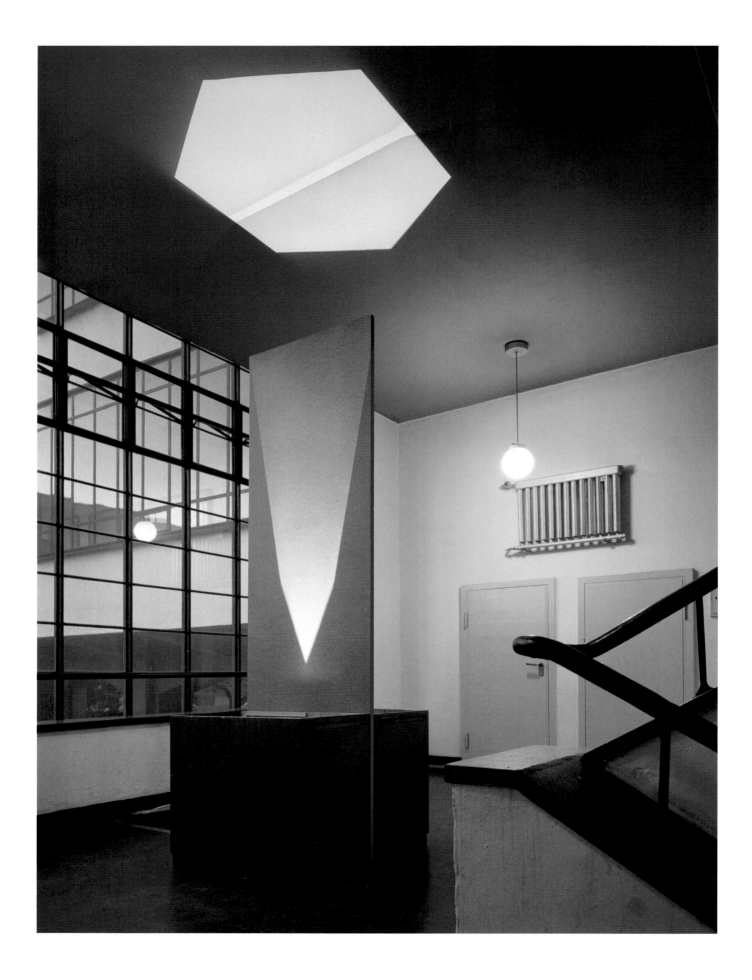

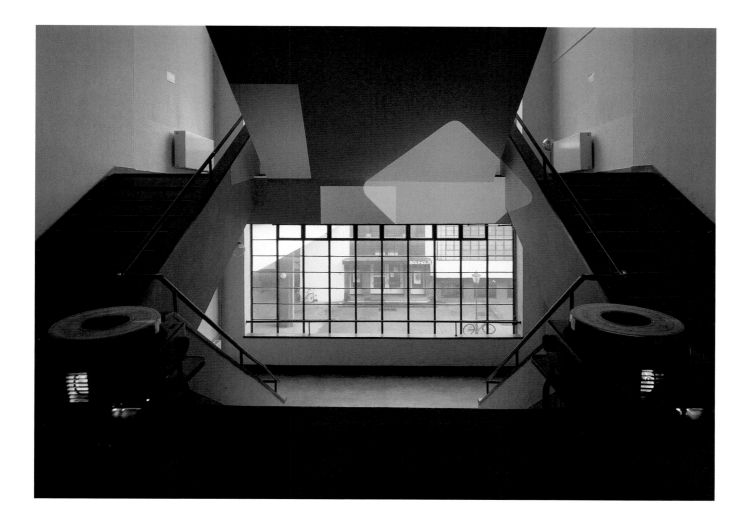

Manifest, 1991,
Bauhaus Dessau; 2 Holzcontainer,
MDF, 2 Diaprojektoren, 2 Dias,
insgesamt 275 x 100 x 80 cm
(Foto: Kelly Kellerhoff, Berlin)
S. S. 124

Manifest, 1991,
Bauhaus Dessau; 2 wooden MDF
containers, 2 slide projectors,
2 slides, total dimensions
275 x 100 x 80 cm
(Photograph: Kelly Kellerhoff, Berlin)
See p. 124

Projektionsraum 1:1:1, 1991/92,
Bauhaus Dessau; 2 Diaprojektoren,
je 81 Dias
(Foto: Kelly Kellerhoff, Berlin)

Die Arbeit wurde im berühmten Trep-
penhaus der Bauhaus-Werkstätten
installiert.

Projektionsraum 1:1:1, 1991/92,
Bauhaus Dessau; 2 slide projectors,
each containing 81 slides
(photograph: Kelly Kellerhoff, Berlin)

The work was installed in the famous
stairwell at the Bauhaus.

Erfurt 52, 1990,
Bauhaus Dessau; 7 Tapeziertische
je 296 x 50 x 73 cm, Raufaser
»Erfurt 52«
(Foto: Kelly Kellerhoff, Berlin)
S. S. 126

Erfurt 52, 1990,
Bauhaus Dessau; 7 trestle tables,
296 x 50 x 73 cm each, woodchip
wallpaper "Erfurt 52"
(photograph: Kelly Kellerhoff, Berlin)
See p. 126

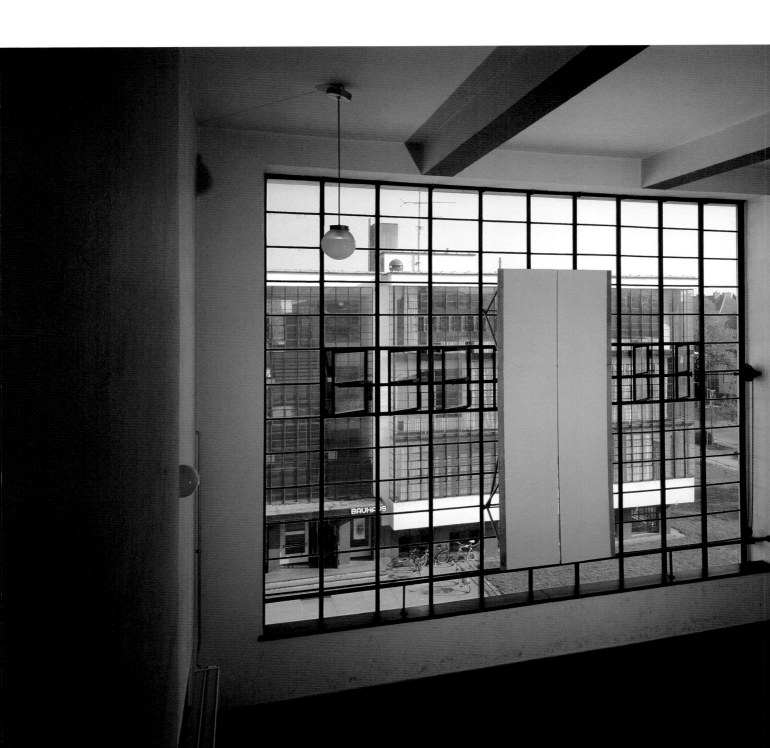

Bauhaus-Los, 1990–92,
Bauhaus Dessau; 20 Tafeln
je 220 x 140 x 5 cm; 1/20 Sammlung
Luxoom, Berlin; 2/20 Sammlung
SINO AG, Düsseldorf
(Foto: Kelly Kellerhoff, Berlin)

1000 handgemachte Lose positio-
nierte Mischa Kuball pro Tafel,
thematisiert wurde damit die gestal-
terische Kraft von Basis-Zeichen und
ihrer Kombinatorik.

Bauhaus-Los, 1990–92,
Bauhaus Dessau; 20 panels,
220 x 140 x 5 cm each; 1/20 Luxoom
Collection, Berlin; 2/20 SINO AG
Collection, Düsseldorf
(photograph: Kelly Kellerhoff, Berlin)

Kuball arranged one thousand hand-
made lottery tickets on each panel;
the theme was the creative power of
basic signs and their combinations.

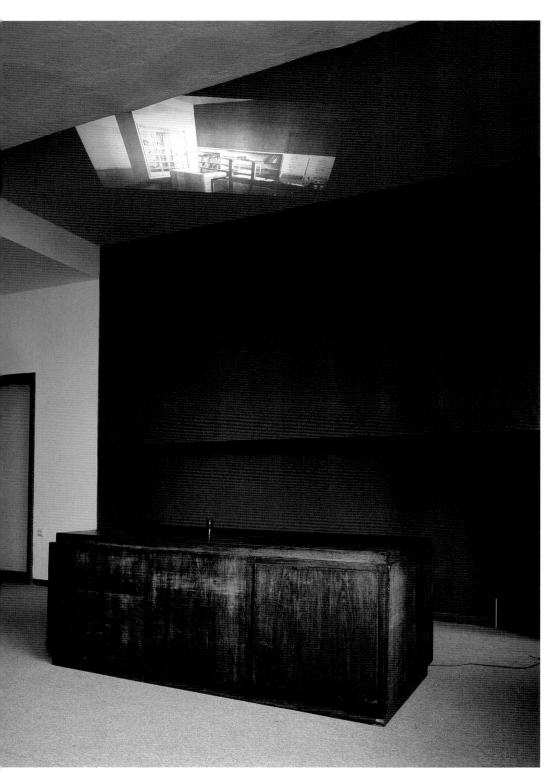

Re-projektion, 1992,
Bauhaus Dessau; Diaprojektor, 1 Dia
(Foto: Kelly Kellerhoff, Berlin)

Das einzige überlieferte Bildmaterial
von Walter Gropius' »Direktoren-
zimmer« wurde in den Ursprungs-
raum »zurück«-projiziert.

Re-projektion, 1992,
Bauhaus Dessau; slide projector,
1 slide
(photograph: Kelly Kellerhoff, Berlin)

The only surviving visual material
from Walter Gropius' "Direktoren-
zimmer" was projected "back" into
the original room.

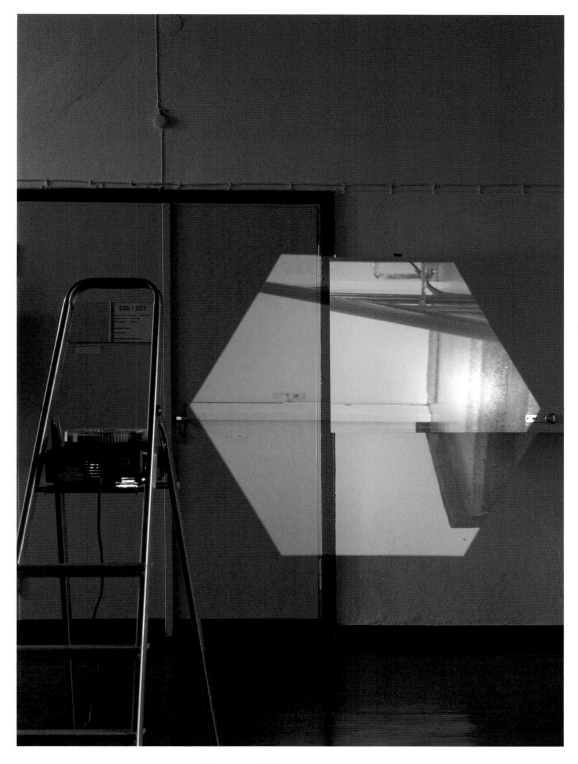

Apartment, 1992,
Bauhaus Dessau; 4 DIN-Türen,
je 200 x 90 x 20 cm, 4 Projektoren,
je 81 Dias
(Foto: Kelly Kellerhoff, Berlin)

Dias von privaten Räumen wurden
in dem öffentlichen architektoni-
schen Kontext auf Appartementtüren
projiziert.

Apartment, 1992,
Bauhaus Dessau; 4 standard doors,
200 x 90 x 20 cm each, 4 projectors,
each containing 81 slides
(photograph: Kelly Kellerhoff, Berlin)

Slides of private spaces were seen
projected onto apartment doors in
a public architectural context.

Tagebau/Raubbau, 1991/92,
Bauhaus Dessau; 2 Diaprojektoren,
je 81 Dias, 200 x 300 cm
(Foto: Kelly Kellerhoff, Berlin)

In einem Werkstattraum überlager-
ten sich Projektionen mit den Plänen
von Ferropolis von Martin Brück.
Ferropolis, auf dem Gelände des ehe-
maligen Braunkohletagebaureviers
Golpa-Nord entstanden, umfasst
heute sowohl eine Veranstaltungs-
arena als auch ein Industriemuseum
und wird von dem Initiator und Archi-
tekten Martin Brück betrieben.

Tagebau/Raubbau, 1991/92,
Bauhaus Dessau; 2 slide projectors,
each containing 81 slides,
200 x 300 cm
(photograph: Kelly Kellerhoff, Berlin)

In a studio space, projections of the
plans for Ferropolis by Martin Brück
overlapped each other. Ferropolis,
created on the property of what was
formerly a brown coal mining area,
Golpa-Nord, today comprises an
events arena as well as an industrial
museum, and is operated by its
founder and architect, Martin Brück.

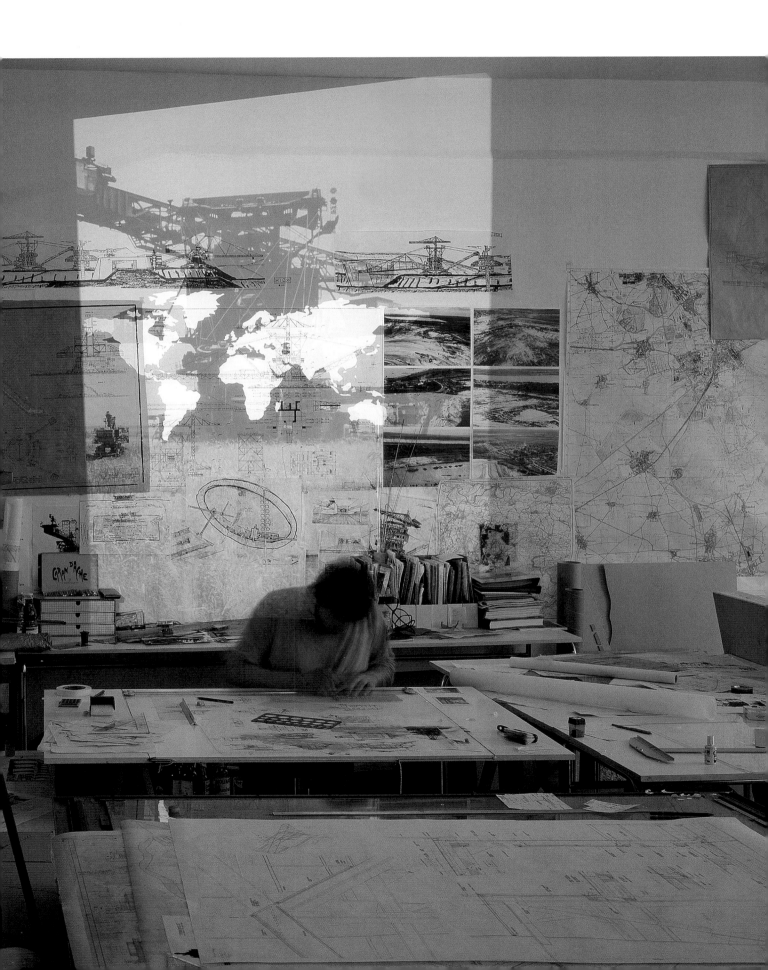

Vorkurs/Experiment V, 1991/92,
Bauhaus Dessau; Diaprojektor,
81 Dias, 2 Stühle, Karton,
70 x 250 x 70 cm
(Foto: Kelly Kellerhoff, Berlin)

Der auf einem Stuhl positionierte
Diaprojektor projizierte geometrische
Lichtformen auf die Sitzunterseite
eines in einem Pappkarton liegenden
Bürostuhls.

Vorkurs/Experiment V, 1991/92,
Bauhaus Dessau; slide projector,
81 slides, 2 chairs, cardboard box,
70 x 250 x 70 cm
(photograph: Kelly Kellerhoff, Berlin)

A slide projector placed on a chair
projected geometric shapes of light
onto the underside of the seat of
an office chair in a cardboard box.

Vorkurs/Resopal VI, 1992,
Bauhaus Dessau; 4 Projektoren,
je 81 Dias, 4 Resopal Muster,
je 200 x 100 x 16 cm
(Foto: Kelly Kellerhoff, Berlin)

Mit Resopal beschichtete Muster-
hölzer, wie sie sich noch 1945 in
deutschen Wohnzimmern befanden,
dienten als Projektionsfläche für
die rein geometrischen Lichtformen
aus dem Bauhaus-Vorkurs.

Vorkurs/Resopal VI, 1992,
Bauhaus Dessau; 4 slide projectors,
each containing 81 slides, 4 Formica
samples, 200 x 100 x 16 cm each
(photograph: Kelly Kellerhoff, Berlin)

Wood samples, laminated with
Formica of the type still found in
German living rooms in 1945, served
as a projection surface for the purely
geometrical light shapes from the
Bauhaus preliminary course.

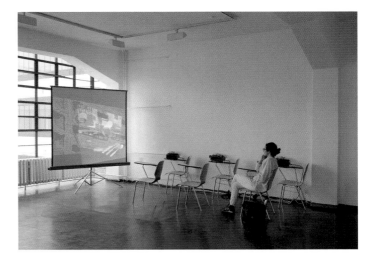

Repeat!, 1992,
Bauhaus Dessau; 6 Stühle, 3 Dia-
projektoren, Leinwand, je 81 Dias,
Maße raumabhängig
(Foto: Kelly Kellerhoff, Berlin)

Die Dias der 3 Projektoren bildeten
Motive aus den unterschiedlichsten
Bereichen des Bauhauses wie etwa
Architektur, Textilgestaltung, Metall-
werkstatt und Kunst ab. Die Instal-
lation fasste die gestalterischen
Aspekte am Bauhaus auf einer Lein-
wand zusammen.

Repeat!, 1992,
Bauhaus Dessau; 6 chairs, 3 slide
projectors each containing 81 slides,,
screen, dimensions dependent upon
space
(photograph: Kelly Kellerhoff, Berlin)

Slides from the three projectors
created motifs from the different
Bauhaus fields, such as architecture,
textile design, metalworking, and art.
The installation summarized the
creative aspects of the Bauhaus on
the screen.

Louder-Speaker I + II, 1988,
Bauhaus Dessau; Dispersion auf
Rupfen, Keilrahmen,
je 220 x 120 x 5 cm; Sammlung
Dr. Axel Feldkamp, Duisburg
(Foto: Kelly Kellerhoff, Berlin)

Louder-Speaker I + II, 1988,
Bauhaus Dessau; dispersion on
gunny, canvas stretcher,
220 x 120 x 5 cm each; Dr. Axel Feld-
kamp Collection, Duisburg
(photograph: Kelly Kellerhoff, Berlin)

Robbiehouse, 1991,
Bauhaus Dessau; Modellplan, Glas,
Farbe, 16-teilig je 40 x 30 cm;
Sammlung Dr. Axel Feldkamp,
Duisburg
(Foto: Kelly Kellerhoff, Berlin)

Die mehrteilige Installation geht von
einem Modellplan aus. Auf jeder
einzelnen Tafel ist eine sich wieder-
holende Handzeichnung abgebildet.
Die technische Konstruktionsan-
leitung wird damit in den künstleri-
schen Prozess zurückgeholt.

Klub, 1992,
Bauhaus Dessau; 4 Tische, 4 Stühle,
4 Diaprojektoren, je 81 s/w-Negativ-
Dias, Maße raumabhängig
(Foto: Kelly Kellerhoff, Berlin)

Die 4 auf Stühlen platzierten Projek-
toren projizierten auf die Rücken-
lehnen des jeweils gegenüberstehen-
den Stuhls Negative in Schwarz-
Weiß, die 1989 in der Stadt Leipzig,
also in der Zeit der Wende, aufge-
nommen worden waren.

Klub, 1992,
Bauhaus Dessau; 4 tables, 4 chairs,
4 slide projectors, each containing
81 b/w negative slides, dimensions
dependent upon space
(photograph: Kelly Kellerhoff, Berlin)

Four projectors placed on chairs
projected black-and-white negatives
onto the backs of the chairs opposite.
These images were taken in 1989 in
the city of Leipzig, at the time when
Germany was about to be reunited.

Robbiehouse, 1991,
Bauhaus Dessau; model plan, glass,
paint, 16 sections, each 40 x 30 cm;
Dr. Axel Feldkamp Collection, Duisburg
(photograph: Kelly Kellerhoff, Berlin)

The multiple-part installation began
with a model plan. The same draw-
ing, done by hand, is reproduced on
each individual panel. This brings the
technical instructions for construc-
tion back into the artistic process.

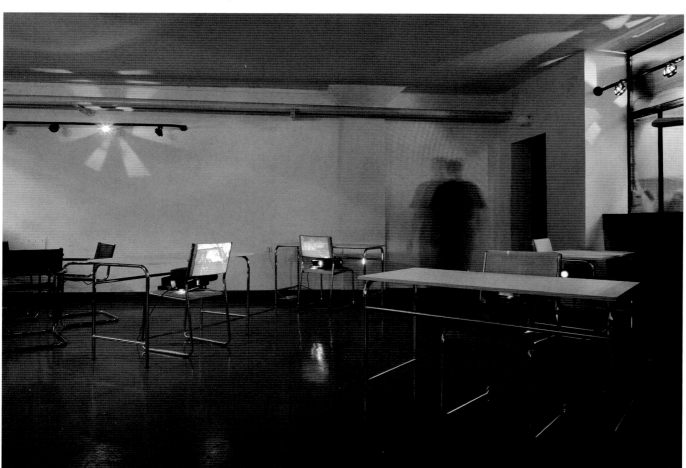

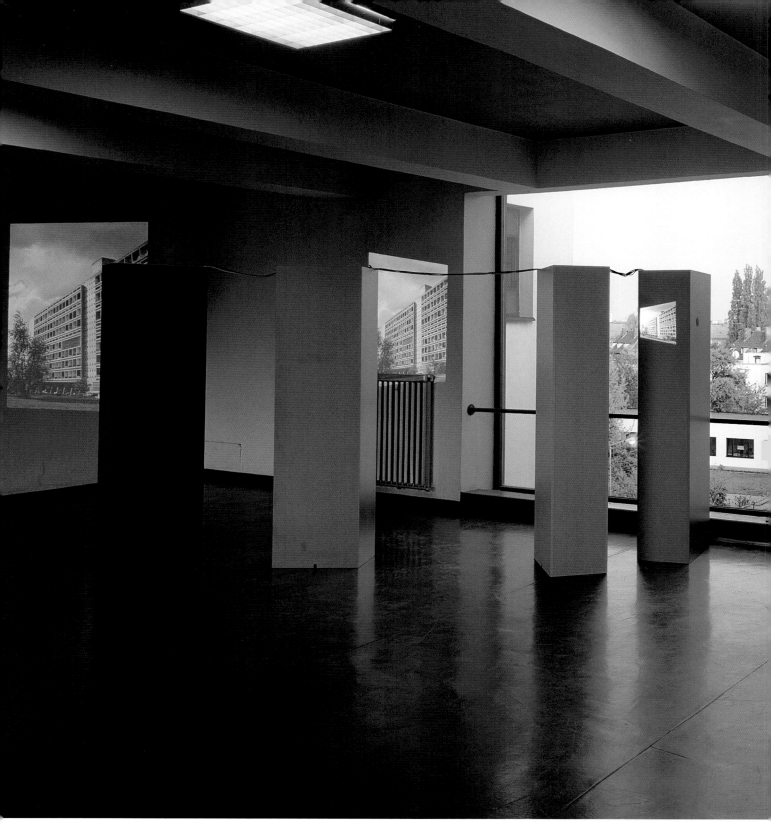

**Deutsches Haus (sozialer Wohnungs-
bau), 1989,**
Bauhaus Dessau; 4 Stelen: Span-
platte, Resopal, je 225 x 40 x 60 cm,
4 Projektoren, je 81 Dias; Städtische
Galerie im Museum Würzburg
(Foto: Kelly Kellerhoff, Berlin)
S. S. 122

Deutsches Haus (sozialer Wohnungs-
bau), 1989,
Bauhaus Dessau; 4 steles: chipboard,
Formica, 225 x 40 x 60 cm each,
4 projectors, each containing
81 slides; Städtische Galerie im
Museum Würzburg
(photograph: Kelly Kellerhoff, Berlin)
See p. 122

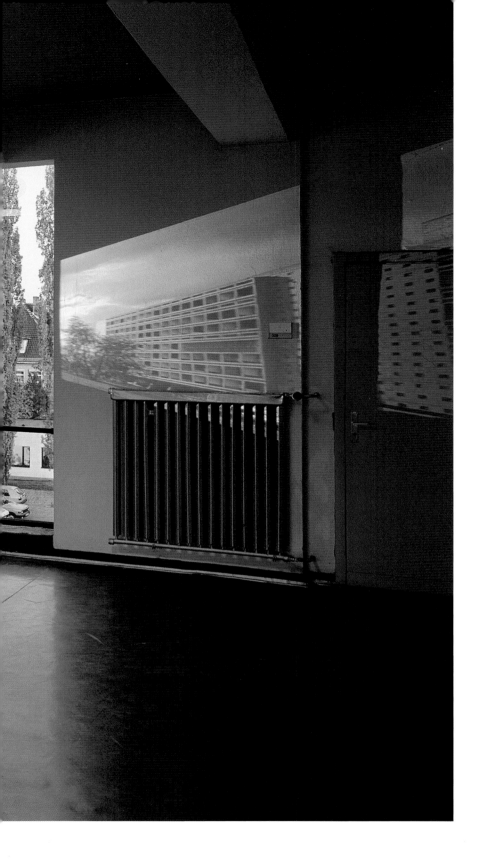

Bauhaus-Los, 1990–92/93,
Museum Folkwang, Essen;
insgesamt 20 Tafeln, je 220 x 140 x 5 cm
(Foto: Stefan Dolfen, Essen)
S. S. 133

Bauhaus-Los, 1990–92/93,
Museum Folkwang, Essen; a total of
20 panels, 220 x 140 x 5 cm each
(photograph: Stefan Dolfen, Essen)
See p. 133

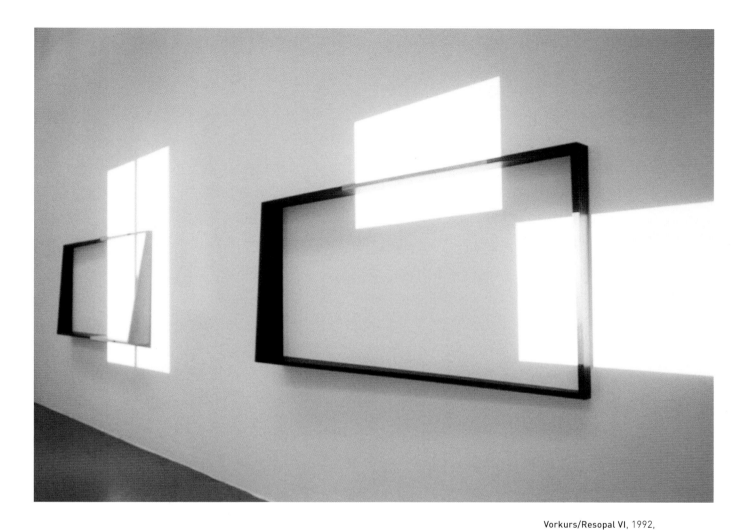

Vorkurs/Resopal **VI**, 1992,
Museum Folkwang, Essen;
4 Projektoren, je 81 Dias, 4 Resopal
Muster, je 200 x 100 x 16 cm
(Foto: Stefan Dolfen, Essen)
S. S. 139

Vorkurs/Resopal, 1992,
Museum Folkwang, Essen;
4 slide projectors, each containing
81 slides, 4 Formica samples,
200 x 100 x 16 cm each
(photograph: Stefan Dolfen, Essen)
See p. 139

Klub, 1992/1994,
Heidelberger Kunstverein; 4 Tische,
4 Stühle, 4 Diaprojektoren, je 81 Dias,
Maße raumabhängig
(Foto: Archiv Mischa Kuball, Düssel-
dorf)

Klub, 1992/1994,
Heidelberger Kunstverein; 4 tables,
4 chairs, 4 slide projectors, each
containing 81 slides, dimensions
dependent upon space (photograph:
Mischa Kuball Archives, Düsseldorf)

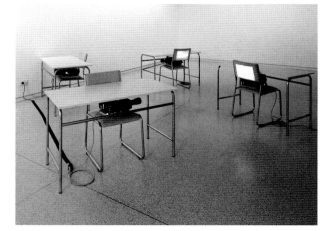

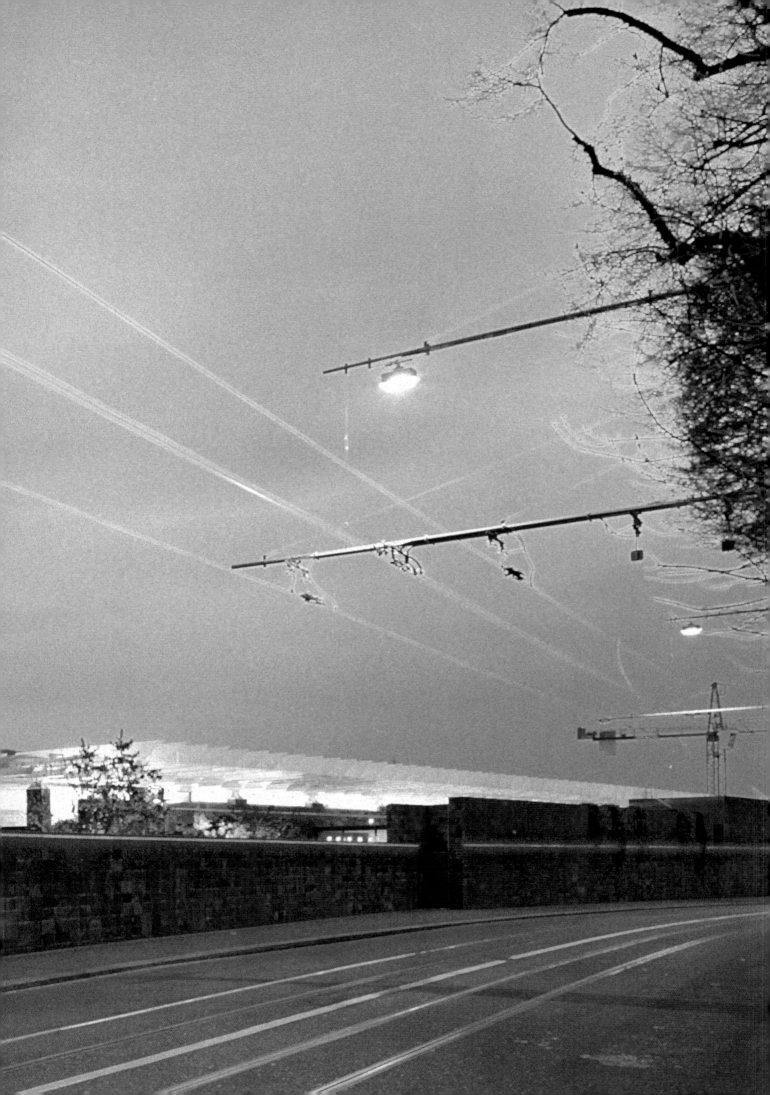

BORIS GROYS

DIE TOPOLOGIE DER ZEITGENÖSSISCHEN KUNST
THE TOPOLOGY OF CONTEMPORARY ART

Der Begriff »zeitgenössische Kunst« bezeichnet heute nicht einfach Kunst, die in unserer Zeit produziert wird. Vielmehr demonstriert die heutige zeitgenössische Kunst, auf welche Weise das Zeitgenössische an sich seinen Ausdruck findet: im Akt der Präsentation der Gegenwart. Hierin unterscheidet sich die zeitgenössische Kunst von der auf die Zukunft gerichteten Moderne ebenso wie von der postmodernen Kunst, die eine historische Reflexion des Projekts der Moderne war. Die heutige zeitgenössische Kunst privilegiert die Gegenwart gegenüber der Zukunft und Vergangenheit. Um das Wesen der zeitgenössischen Kunst richtig zu verstehen, erscheint es daher notwendig, sie in ihrer Beziehung zum Projekt der Moderne und dessen postmoderner Neubewertung zu verorten.

Die zentrale Idee der modernen Kunst war die Idee der Kreativität. Der genuin kreative Künstler sollte einen radikalen Bruch mit der Vergangenheit vollziehen, die Vergangenheit auslöschen, zerstören, um an einen Nullpunkt der Kunsttradition zu gelangen – und dadurch einen Neubeginn, eine neue Zukunft ermöglichen. Das traditionelle mimetische Kunstwerk wurde der ikonoklastischen, zerstörerischen Analyse und Reduktion unterworfen. So ist es auch kein Zufall, dass das von der historischen Avantgarde ständig benutzte Vokabular die Sprache des Ikonoklasmus war. Traditionen abschaffen, mit den Konventionen brechen, die alte Kunst zertrümmern, überholte Werte tilgen – so lauteten die Slogans der Zeit. Die Praxis der historischen Avantgarde basierte auf einer Gleichung, die schon

The term "contemporary art" does not simply designate art that is produced in our time. Rather, today's contemporary art demonstrates the way in which the contemporary as such shows itself—the act of presenting the present. In this respect, it is different from the modern art that was directed toward the future, and it is also different from the postmodern art that was a historical reflection on the modern project. Contemporary "contemporary art" privileges the present with respect to the future and to the past. So, in order to accurately characterize the nature of contemporary art it seems to be necessary to situate it in its relationship to the modern project and to its postmodern reevaluation.

The central notion of modern art was that of creativity. The genuinely creative artist was supposed to bring about a radical break with the past; to erase, destroy the past; to achieve a zero point of artistic tradition—and by doing so give a new start to a new future. The traditional mimetic artwork was subjected to iconoclastic, destructive analysis and reduction. It is also no accident that the vocabulary constantly used by the historical avant-garde has its origins in the language of iconoclasm. Abolishing traditions, breaking with conventions, destroying old art, and eradicating outdated values were the slogans of the day. The practice of the historical avant-garde was based on the equation that had already been formulated by Bakunin, Stirner, and Nietzsche: negation is creation. The

Horizontal Parallel Structure (Detail),
2000, Installation Fondation Beyeler,
Riehen/Basel
(Foto: Andreas F. Voegelin, Basel),
Vgl. Abb. S. 186–187 /
See fig. pp. 186–187

Bakunin, Stirner und Nietzsche formuliert hatten: Negation ist Schöpfung. Die ikonoklastischen Bilder der Zerstörung und Reduktion wurden zu den Ikonen der Zukunft bestimmt. Der Künstler sollte den »aktiven Nihilismus« verkörpern: das Nichts, in dem alles seinen Ursprung hat. Aber wie kann ein einzelner Künstler beweisen, dass er oder sie wahrhaft kreativ ist? Offenbar nur, indem aufgezeigt wird, wie weit er oder sie auf dem Weg der Reduktion und Zerstörung des traditionellen Bildes zu gehen bereit ist, wie radikal, wie ikonoklastisch seine oder ihre Arbeit ist. Um ein genuin ikonoklastisches Bild als ein solches zu erkennen, müssen wir es mit den traditionellen Bildern, den Ikonen der Vergangenheit vergleichen können. Wie sonst sollte das Werk symbolischer Zerstörung belegbar sein?

Das heißt: Das Erkennen des Ikonoklastischen, des Schöpferischen, des Neuen setzt den fortwährenden Vergleich mit dem Traditionellen, dem Alten voraus. Das Ikonoklastische und das Neue können nur vom kunsthistorisch gebildeten, museal geschulten Blick erkannt werden. Dies ist der Grund für das Paradox, dass man, je mehr man sich von der Kunsttradition zu befreien sucht, umso mehr in der Logik kunstgeschichtlicher Erzählung und musealer Sammlung befangen ist. Ein kreativer Akt, verstanden als ein ikonoklastischer Gestus, setzt die permanente Reproduktion des Kontextes voraus, unter dem der Akt zustande kommt. Und diese Art der Reproduktion beeinflusst den kreativen Akt von Anfang an. Ja, man kann sogar sagen, dass sich unter den Bedingungen des modernen Museums das Neue aktuell geschaffener Kunst nicht erst post factum als ein Ergebnis des Vergleichs mit alter Kunst etabliert. Vielmehr findet der Vergleich schon vor dem Auftauchen eines

iconoclastic images of destruction and reduction were destined to serve as the icons of the future. The artist was supposed to embody "active nihilism"—the nothingness from which everything originates. But how can an individual artist prove that he or she is really, genuinely creative? Obviously, artists can only substantiate their creativity by demonstrating how far they traveled along the path of reduction and destruction of the traditional image; how radical, how iconoclastic their work is. But to recognize a certain image as a truly iconoclastic one we have to be able to compare it with traditional images, with the icons of the past, otherwise the work of symbolic destruction would remain unaccounted for.

What this means is that recognition of the iconoclastic, of the creative, of the new requires a permanent comparison with the traditional, with the old. The iconoclastic and the new can only be discerned by a museum-trained gaze primed in art history. Paradoxically, this is why the more you want to free yourself from art tradition, the more you become subjected to the logic of the art historical narrative and to the museum collection. A creative act—if it is understood as an iconoclastic gesture—presupposes a permanent reproduction of the context within which the act occurs. And this kind of reproduction influences the creative act from the outset. We can even say that under the conditions of the modern museum, the newness of newly produced art is not established *post factum*— as a result of the comparison with old art. Rather, the comparison takes place before the

neuen, radikal ikonoklastischen Kunstwerks statt – und dieser lässt das neue Kunstwerk faktisch auch entstehen. So wird das moderne Kunstwerk schon vor seiner Produktion repräsentiert und erkannt. Und das bedeutet ferner: Die modernistische Produktion durch Negation ist von der Reproduktion der Vergleichsmittel gelenkt: von einer bestimmten historischen Erzählung, einem bestimmten Kunstmedium, einer bestimmten visuellen Sprache, einem bestimmten fixierten Vergleichskontext. Dieser paradoxe Charakter des Projekts der Moderne wurde von zahlreichen Theoretikern erkannt und beschrieben; viele Künstler der Sechziger- und Siebzigerjahre haben ihn weiter reflektiert. Die Erkenntnis des intrinsischen Wiederholungscharakters des Projekts der Moderne führte in den letzten Jahrzehnten zu seiner Neudefinition und zur postmodernen Thematisierung der Problematik von Repetition, Iteration und Reproduktion.

Es ist kein Zufall, dass Walter Benjamins berühmter Aufsatz *Das Kunstwerk im Zeitalter seiner technischen Reproduzierbarkeit* in der Postmoderne auf so große Resonanz stieß. Dies hängt damit zusammen, dass für Benjamin nicht etwa die Schaffung des Neuen, sondern die Massenproduktion die Moderne konstituiert. Bekanntlich führt Benjamin in seinem Aufsatz das Konzept der Aura ein, um den Unterschied zwischen Original und Kopie unter den Bedingungen der perfekten technischen Reproduzierbarkeit begrifflich zu fassen. Seither hat das Konzept der Aura eine erstaunliche philosophische Karriere durchlaufen, wenn auch überwiegend in der berühmten Formel des »Verlusts der Aura«, die das Schicksal des Originals im Zeitalter der Moderne kennzeichnet. Den »Verlust der Aura«

emergence of a new, radical, iconoclastic artwork—and virtually produces the new artwork. The modern work of art is represented and recognized before it has been produced. And furthermore, this means that modernist production by negation is governed by reproduction of the means of comparison—of a certain historical narrative, of a certain artistic medium, of a certain visual language, of a certain fixed context of comparison. This paradoxical character of the modern project was recognized and described by a number of the theorists and reflected on by many artists in the 1960s and 1970s. Identification of this inner repetitiveness of the modern project had led to its redefinition in recent decades and to a postmodern thematicization of the problems associated with repetition, iteration, and reproduction.

It is no accident that Walter Benjamin's famous essay "The Work of Art in the Age of Mechanical Reproduction" exerted tremendous influence during these postmodern years. This can be attributed to the fact that for Benjamin, mass reproduction and not the creation of the new constitutes modernity. As we all know, in his essay Benjamin introduces the concept of "aura" to describe the difference between original and copy under the conditions of flawless technical reproducibility. Since its introduction, the concept has had an astonishing philosophical career, largely as part of the famous formula of the "decay of the aura," which characterizes the fate of the original in the modern age. Benjamin describes the "decay of the aura" precisely as the loss of a fixed, repetitive context of a

beschreibt Benjamin präzise als den Verlust eines fixierten, sich wiederholenden Kontexts eines Kunstwerks. Benjamin zufolge verlässt das Kunstwerk in unserer Zeit seinen ursprünglichen Kontext, um anonym in den Netzwerken der Massenkommunikation, -reproduktion und -distribution zu zirkulieren. Mit anderen Worten: Benjamin beschreibt, dass die Produktion der Massenkultur auf der Umkehrung der Strategie der »hohen« Kunst der Moderne basiert. Die »hohe« Kunst verweigert sich zwar der Wiederholung der traditionellen Bilder, lässt aber den traditionellen kunstgeschichtlichen Kontext intakt, während die »niedere« Kunst die Bilder reproduziert, dafür aber ihren ursprünglichen Kontext negiert und zerstört. Im Zeitalter der Moderne negiert man entweder ein Kunstwerk oder seine Aura, seinen Kontext – aber nicht beides zugleich.

Dass der Hauptakzent zumeist auf den Verlust der Aura gelegt wird, ist einerseits völlig legitim und stimmt sicherlich mit der Gesamtintention von Benjamins Texts überein. Doch vielleicht ist es nicht der Verlust der Aura, sondern vielmehr ihre Entstehung, die es uns erlaubt, die Prozesse in der heute überwiegend mit den neuen Medien und Techniken der Reproduktion operierenden Kunst besser zu verstehen. Damit ist zu einem besseren Verständnis nicht nur das Schicksals des Originals, sondern auch das der Kopie in unserer Kultur gemeint. Denn die Aura, wie Benjamin sie versteht, kommt ja erst dank der modernen Reproduktionstechniken auf. Das heißt, sie kommt genau in dem Moment zum Vorschein, in dem sie verfällt. Und sie kommt aus demselben Grund zum Vorschein, aus dem sie verloren geht. Ja, Benjamin geht von der Möglichkeit einer vollendeten Reproduktion

work of art. He asserts that in our age, the work of art leaves its original context and begins to circulate anonymously in the networks of mass communication, reproduction, and distribution. In other words, Benjamin depicts the production of mass culture as operating by way of a reversal of the "high" modernist art strategy: "high" modernist art negates the repetition of traditional images but leaves the traditional art historical context intact, whereas "low" art reproduces these images but negates or destroys their original context. In the modern age, one negates either an artwork or its aura, its context— but not both of them simultaneously.

On the one hand, the general accent on the decay of the aura is entirely legitimate, and it is certainly in tune with the overall intention of Benjamin's text. But it may be that it is not the decay of the aura but rather its emergence that makes it possible to better understand the processes taking place in today's art, which operate predominantly with new media and methods of reproduction; that is to say, to better understand not only the destiny of the original but the destiny of the copy in our culture as well. In fact, the aura as described by Benjamin does not come into being until the emergence of modern techniques of reproduction—at the very same moment it is disappearing. Furthermore, it appears for precisely the same reason it disappears. Indeed, in his essay Benjamin starts from the possibility of a perfect reproduction that would no longer allow any "material," visually recognizable difference between original and copy. Thus the question he formu-

aus, die keinen »materiellen«, visuell erkennbaren Unterschied zwischen Original und Kopie mehr zulässt. Die Frage, die Benjamin hier stellt, lautet: Bedeutet die Auslöschung jedes visuell erkennbaren Unterschieds zwischen Original und Kopie auch, dass der Unterschied als solcher ausgelöscht ist? Natürlich verneint er dies. Die – zumindest potenzielle – Auslöschung aller visuell erkennbaren Unterschiede zwischen Original und Kopie eliminiert nicht einen anderen Unterschied, der, wenngleich nicht sichtbar, nichtsdestoweniger ausschlaggebend ist: Das Original hat eine Aura, die der Kopie fehlt. Und das Original verfügt deshalb über eine Aura, weil es einen fixierten Kontext hat, einen genau definierten Ort im Raum, und aufgrund dieses besonderen Orts ist es als ein singulärer, originärer Gegenstand auch in die Geschichte eingeschrieben. Die Kopie hingegen hat keinen Ort und ist daher geschichtslos – von Beginn an also eine potenzielle Multiplizität. Reproduktion bedeutet Dislozierung, Deterritorialisierung, durch sie finden Kunstwerke Eingang in Netzwerke, deren Zirkulation topologisch unbestimmbar ist. Benjamins diesbezügliche Ausführungen sind bekannt: »Noch bei der höchstvollendeten Reproduktion fällt eines aus: das Hier und Jetzt des Kunstwerks – sein einmaliges Dasein an dem Orte, an dem es sich befindet«. Und er fährt fort: »Das Hier und Jetzt des Originals macht den Begriff seiner Echtheit aus«. Wenn aber der Unterschied zwischen Original und Kopie nur ein topologischer ist – das heißt, lediglich der Unterschied zwischen einem geschlossenen, fixierten, markierten auratischen Kontext und einem offenen, nichtmarkierten, profanen Raum anonymer Massenzirkulation – dann wäre nicht nur eine Dislozierung und Deterritorialisierung des Origi-

lates is namely: Does the eradication of any visually recognizable difference between original and copy also mean the eradication of the difference between the two as such? Benjamin's answer to that question is, of course, "no." The—at least potential—removal of all visually recognizable differences between original and copy does not eliminate another distinction existing between them, which, albeit invisible, is decisive nonetheless: the original has an aura the copy lacks. The original has an aura because it has a fixed context, a well-defined place in space, and through that particular place it is also inscribed in history as a singular, original object. In contrast, because it has no place, the copy is ahistorical, a potential multiplicity from the outset. Reproduction means dislocation, deterritorialization; it transports works of art to networks of topologically indeterminable circulation. Benjamin's formulations in this respect are very well known: "Even the most perfect reproduction of a work of art is lacking in one element: its presence in time and space, its unique existence at the place where it happens to be." He continues: "The presence of the original is the prerequisite to the concept of authenticity." But if the difference between original and copy is only a topological one—that is to say, if it is only a difference between a closed, fixed, marked, auratic context and an open, unmarked, profane space of anonymous mass circulation—then not only the operation of dislocation and deterritorialization of the original is possible, but also the operation of relocation and reterritorialization of the copy. We are not only able to produce a copy of an original by

nals möglich, sondern umgekehrt auch eine Relozierung und Reterritorialisierung der Kopie. Wir sind nicht nur in der Lage, mittels einer Reproduktionstechnik die Kopie eines Originals herzustellen, wir sind ebenso in der Lage, mittels einer Technik topologischer Relozierung der Kopie aus einer Kopie ein Original zu erstellen – und zwar mittels der Installationstechnik.

Die Installation, die heute zur führenden Kunstform im System der zeitgenössischen Kunst geworden ist, funktioniert wie eine Umkehrung der Reproduktion. Sie nimmt eine Kopie aus einem angeblich nichtmarkierten, offenen Raum anonymer Zirkulation und stellt sie – wenn auch nur vorübergehend – in den fixierten, stabilen, geschlossenen Kontext eines topologisch genau definierten »Hier und Jetzt«. Und das heißt, alle in einer Installation verorteten Objekte sind Originale, auch wenn – oder gerade wenn – sie außerhalb der Installation als Kopien zirkulieren. Kunstwerke in einer Installation sind Originale aus einem einfachen topologischen Grund: Man muss die Installation aufsuchen, um sie zu sehen. Vor allem aber ist die Installation eine sozial kodifizierte Variation des individuellen Flanierens, wie es von Benjamin beschrieben wurde, und daher ein Ort der Aura, der »profanen Erleuchtung«. Unser zeitgenössischer Bezug zur Kunst kann somit nicht auf einen »Verlust der Aura« reduziert werden. Vielmehr veranstaltet das Zeitalter der Moderne ein komplexes Wechselspiel von Dislozierungen und Relozierungen, von Deterritorialisierungen und Reterritorialisierungen, von De-Auratisierungen und Re-Auratisierungen. Was die zeitgenössische Kunst von der Kunst früherer Zeiten unterscheidet, ist lediglich der

means of methods of reproduction, we also are able to produce an original from a copy through the topological relocation of the copy—the installation.

The installation, which within the framework of contemporary art has currently become the leading art form, operates as a reversal of reproduction. It takes a copy out of an allegedly unmarked, open space of anonymous circulation and places it—even if only temporarily—in a fixed, stable, closed context of topologically well-defined "presence." And that means that all of the objects included in an installation are originals, even when—or precisely when—they circulate outside of the installation as copies. Works of art in the form of installations are originals for a simple topological reason: it is necessary to physically visit the venue in order to see them. More than anything else, the installation is a socially codified variation of individual flâneurship as it was described by Benjamin and hence a place for the aura, for "profane illumination." Our current relationship with art can therefore not be reduced to a "decay of the aura." Rather, the modern age organizes a complex interplay of dislocation and relocation, of deterritorialization and reterritorialization, of deauratization and reauratization. The only thing that distinguishes contemporary art from previous periods is the fact that the originality of a work of art in our age is not established based on its own form, but through its inclusion in a certain context, in a certain installation: through its topological inscription.

Umstand, dass die Originalität eines Werks sich heute nicht mehr in Abhängigkeit von dessen Form begründet, sondern über das Einbezogensein in einen bestimmten Kontext, in eine bestimmte Installation durch seine topologische Einschreibung.

Benjamin übersah die Möglichkeit – und sogar Unausweichlichkeit – von Re-Auratisierungen, Relozierungen und neuen topologischen Einschreibungen einer Kopie, weil er mit der Hochkunst der Moderne den Glauben an einen einmaligen, normativen Kontext von Kunst teilte. Nur unter der Voraussetzung des Verlusts seines einmaligen, originären Kontexts würde das Kunstwerk für immer seine Aura verlieren – zu einer Kopie seiner selbst werden. Die Re-Auratisierung eines individuellen Kunstwerks würde die Sakralisierung des gesamten profanen Raums der topologisch unbestimmten Massenzirkulation einer Kopie erfordern – ein totalitäres, faschistisches Projekt. Und das ist das Hauptproblem im Denken Benjamins: Er nimmt den Raum der Massenzirkulation einer Kopie als einen universellen, neutralen und homogenen Raum wahr. Und er besteht auf der permanenten visuellen Erkennbarkeit, auf der eigenen Identität einer in unserer zeitgenössischen Kultur zirkulierenden Kopie. Doch beide Hauptvoraussetzungen in Benjamins Text sind fragwürdig. Im System der zeitgenössischen Kunst zirkuliert ein Bild konstant von einem Medium zum anderen, von einem geschlossenen Kontext zum nächsten. Filmmaterial kann in einem Kino gezeigt werden, dann digitalisiert und auf eine Website gestellt werden oder aber es wird zur Illustration auf einer Konferenz gezeigt, ist privat auf dem Fernsehschirm im Wohnzimmer zu sehen oder im Kontext einer Installation im Museum. Auf seinem Weg

Benjamin overlooked the possibility—and even unavoidability—of reauratization, relocation, and the new topological inscription of a copy because he shared with high modern art the belief in a unique, normative context of art. Under this presupposition, for an artwork to lose its unique, original context means losing its aura forever—and becoming a copy of itself. A reauratization of an individual work of art would require a sacralization of the whole profane space of the topologically undetermined mass circulation of a copy, which would be a totalitarian, fascist project. And this is the main problem in Benjamin's line of thought: he perceives the space of the mass circulation of a copy as a universal, neutral, and homogeneous space, and he insists on the permanent visual recognizability or self-identity of a copy as it circulates in our contemporary culture. Yet both of these main presuppositions in Benjamin's essay are questionable. Within the framework of present-day culture, an image permanently circulates from one medium to another, and from one closed context to another. Certain film footage can be shown in a movie theater, then digitalized and put on view on someone's Web site. It can be seen during a conference as part of a presentation, watched on a television screen in the privacy of one's own living room, or placed in the context of a museum installation. On its journey through different contexts and media, this film footage is transformed by means of different program languages, different software, different framings on the screen, different placement in an installation space, etc. Is what we have here the same film footage? Is it the same

durch verschiedene Kontexte und Medien wird das Filmmaterial beispielsweise durch unterschiedliche Programmiersprachen oder Software, verschiedene »Framings« auf dem Bildschirm oder Positionen in einem Installationsraum transformiert. Haben wir es die ganze Zeit mit ein und demselben Filmmaterial zu tun? Ist es dieselbe Kopie derselben Kopie desselben Originals? Die Topologie der heutigen Netzwerke der Kommunikation, Generierung, Umsetzung und Distribution von Bildern ist extrem heterogen. Auf ihrem Weg durch diese Netzwerke werden die Bilder laufend verwandelt, umgeschrieben, redigiert und reprogrammiert – und verändern sich bei jedem dieser Schritte auch visuell. Ihr Status als Kopien wird somit zur bloßen kulturellen Konvention – so wie früher der Status des Originals. Benjamin ging davon aus, dass die neue Technologie in der Lage sein würde, die Kopie dem Original immer mehr anzugleichen. Das Gegenteil ist der Fall. Die zeitgenössische Technologie denkt in Generationen. Und die Übertragung einer Information von einer Hardware- und Software-Generation zur nächsten bringt es mit sich, dass diese signifikant umgewandelt wird. Der metaphorische Gebrauch des Begriffs »Generation« im heutigen Kontext der Technologie ist sehr aufschlussreich. Wir wissen alle, was es bedeutet, einen Teil des kulturellen Erbes von einer Studentengeneration zur nächsten weiterzureichen. Die Bedingungen der »technischen Reproduktion« im Kontext des, sagen wir, zeitgenössischen Internets sind nicht weniger kompliziert – vielleicht sogar noch komplizierter.

Wir sind weder in der Lage, eine Kopie als Kopie, noch ein Original als Original zu stabilisieren. Es gibt keine ewigen Kopien, so wie es keine ewigen Originale gibt. Die Repro-

copy of the same copy of the same original? The topology of today's networks of communication, of the generation, translation, and distribution of images, is extremely heterogeneous. On their way through these networks, the images are constantly being transformed, rewritten, reedited, reprogrammed—and also becoming perceptibly different in the process. Their status as copies is therefore nothing more than a cultural convention—as was previously the case with the original. Benjamin suggests that the new technology is capable of making a copy more and more identical to the original. However, the contrary is the case. Contemporary technology thinks in terms of generations, and to transmit information from one generation of hardware and software to the next means transforming it in a significant way. The metaphorical use of the notion of "generation" as it is currently being practiced in a context of technology is very revealing. All of us know what it means to transmit a certain cultural heritage form one generation of students to another. The conditions of "mechanical reproduction" in the context of, let's say, the Internet are no less difficult—perhaps even more difficult.

We are as incapable of stabilizing a copy as a copy as we are of stabilizing an original as an original. Just as there are no everlasting originals, there are no everlasting copies. Reproduction is as much influenced by originality as originality is influenced by reproduction. In the course of its circulation through different contexts, a copy becomes a series of different originals. Every change of context, every change of medium can be interpreted

duktion ist ebenso von der Originalität beeinflusst wie die Originalität von der Reproduktion. Die Zirkulation durch verschiedene Kontexte macht aus einer Kopie eine Serie verschiedener Originale. Jede Änderung des Kontexts, jeder Wechsel des Mediums kann als eine Negation des Status einer Kopie als Kopie ausgelegt werden – als ein grundlegender Bruch, ein Neubeginn, der eine neue Zukunft eröffnet. In diesem Sinne ist eine Kopie niemals wirklich Kopie – sondern vielmehr stets ein neues Original in einem neuen Kontext. Jede Kopie ist per se ein Flaneur – und erfährt immer wieder ihre »profane Erleuchtung«, die sie in ein Original verwandelt. Sie verliert alte Auren und erhält neue. Sie bleibt vielleicht dieselbe Kopie, wird jedoch zu verschiedenen Originalen. Hier wird deutlich, warum das postmoderne Projekt und seine Reflexion des repetitiven, iterativen und reproduktiven Charakter eines Bildes ebenso paradox ist wie das moderne Projekt der Erkenntnis des Originals und des Neuen. Zugleich wird erkennbar, warum die postmoderne Kunst den Eindruck des Neuen zu wecken vermag, auch wenn – oder gerade weil – sie gegen die Idee des Neuen gerichtet ist. Unsere Entscheidung, ein bestimmtes Bild als Original oder als Kopie anzuerkennen, hängt vom Kontext ab: von dem Ort, an dem die Wahl getroffen wird. Und diese Entscheidung ist immer zeitgenössisch – sie betrifft nicht die Vergangenheit und Zukunft, sondern allein die Gegenwart.

Aus diesem Grund betrachte ich die Installation als die führende Kunstform der zeitgenössischen Kunst. In der Installation wird eine bestimmte Auswahl, eine Kette von Entscheidungen sichtbar, eine bestimmte Logik des Einschlusses und des Ausschlusses. Und

as a negation of the status of a copy as a copy—as an essential rupture, as a new start that opens up a new future. In this sense, a copy is never really a copy; rather, it is always a new original in a new context. Every copy is a flâneur in its own right and experiences time and again its own "profane illuminations," which turn it into an original. It sheds old auras and acquires new ones. It may remain the same copy but it becomes different originals. This shows that the postmodern project of reflecting on the repetitive, iterative, reproductive character of an image is as paradoxical as the modern project of discerning the original and the new. This is also why postmodern art is incapable of appearing to be very new, even if—or actually because—it is directed against the notion of the new. Our decision to identify a certain image as an original or as a copy is dependent on the context—on the actual scene where the decision is made. And it is always a contemporary decision—one that belongs not to the past or the future, but to the present.

This is why I would argue that the installation is the leading art form in contemporary art. The installation demonstrates a certain choice, a certain chain of decisions, a certain logic of inclusions and exclusions. And in doing so, certain conclusions as to what is old and what is new, what is an original and what is a copy, manifest themselves in the installation in the here and now. Every large-scale exhibition or installation is engineered with the intention of designing a new order of memories, of proposing new criteria for telling a story, of distinguishing between past and future. Modern art worked at the level of an

dadurch manifestieren sich in einer Installation im »Hier und Jetzt« Entscheidungen über das, was alt ist und was neu, was ein Original und was eine Kopie ist. Hinter jeder großen Ausstellung oder Installation steht die Absicht, eine neue Ordnung der Erinnerungen zu entwerfen, neue Kriterien für das Erzählen einer Geschichte vorzuschlagen, zwischen Vergangenheit und Zukunft zu unterscheiden. Die moderne Kunst arbeitete auf der Ebene der individuellen Form. Zeitgenössische Kunst nutzt die Ebene des Kontexts, des Systems, des Hintergrunds oder einer neuen theoretischen Interpretation. Deshalb ist unter zeitgenössischer Kunst weniger die Produktion individueller Kunstwerke zu verstehen als vielmehr die Manifestation einer individuellen Wahl, Dinge und Bilder, die anonym in unserer Welt zirkulieren, ein- oder auszuschließen: sie in einen neuen Kontext zu stellen oder dies zu verweigern. Es ist eine private Auswahl, die zugleich öffentlich zugänglich und dadurch manifest, präsent, explizit ist. Selbst wenn eine Installation aus nur einem einzelnen Gemälde besteht, handelt es sich dennoch um eine Installation, da der entscheidende Aspekt des Gemäldes als Kunstwerk nicht darin liegt, dass es von einem Künstler produziert, sondern dass es von einem Künstler ausgewählt wurde und auch als dessen Auswahl präsentiert wird.

Der Installationsraum kann natürlich alle möglichen Gegenstände und Bilder umfassen, die in unserer Zivilisation zirkulieren: Gemälde, Zeichnungen, Fotografien, Texte, Videos, Filme, Tonaufnahmen und so weiter. Daran liegt es, dass der Installation häufig der Status einer spezifischen Kunstform verweigert wird, denn es stellt sich die Frage nach

individual form. Contemporary art uses the level of context, framework, background, or of a new theoretical interpretation. It is for this reason that contemporary art is less the production of individual works of art than it is the manifestation of an individual decision to include or exclude things and images that circulate anonymously in our world, to give them a new context or to deny them one: a personal selection that is at the same time publicly accessible and thereby made manifest, present, explicit. Even if an installation consists of one individual painting, it is still an installation, since the crucial aspect of the painting as a work of art is not the fact that it was produced by an artist but that it was selected by an artist and presented as something he or she selected.

The installation space can, of course, incorporate all kinds of things and images circulating in our civilization: paintings, drawings, photographs, texts, videos, films, recordings, and so on. This is the reason why the installation is frequently denied the status of a specific art form: the question arises of what the medium of an installation is. Traditional art media are all defined by a specific carrier for the medium: canvas, stone, or film. The carrier of the medium in an installation, however, is the space itself. This artistic space may be a museum or an art gallery, but it may also be a private studio, a home, or a construction site. All of them can be turned into the venue for an installation by documenting the selection process, regardless of whether it was performed by an individual or an institution. Yet this does not mean that the installation is somehow "immaterial." On the con-

dem Medium der Installation. Die traditionellen Kunstmedien sind alle definiert durch einen spezifischen materiellen Träger: Leinwand, Stein oder Film. Der materielle Träger des Mediums einer Installation ist aber der Raum selbst. Dieser künstlerische Raum der Installation kann ein Museum oder eine Kunstgalerie sein, aber auch ein privates Atelier, ein Wohnhaus oder eine Baustelle. Sie alle können zum Schauplatz einer Installation werden, indem der Auswahlprozess dokumentiert wird, ob er nun auf privater oder auf institutioneller Ebene stattfindet. Daraus folgt allerdings nicht, dass die Installation in irgendeiner Weise »immateriell« wäre. Im Gegenteil: Die Installation ist materiell par excellence, da sie im Raum angesiedelt ist – und die Räumlichkeit spielt eine wesentliche Rolle in der Definition des Materiellen. So offenbart gerade die Installation die Materialität der Zivilisation, in der wir leben, denn sie installiert alles, was in unserer Zivilisation nur zirkuliert. Die Installation zeigt somit die materielle Hardware der Zivilisation, die andernfalls unter der Oberfläche der in den Massenmedien zirkulierenden Bildern verborgen bliebe. Zugleich aber darf die Installation nicht als eine Manifestation bereits vorhandener Beziehungen zwischen Gegenständen verstanden werden, sie eröffnet im Gegenteil die Möglichkeit, Gegenstände und Bilder unserer Zivilisation subjektiv und individuell in einen Zusammenhang zu stellen. In gewissem Sinne hat die Installation für unsere Zeit die gleiche Bedeutung wie der Roman für das 19. Jahrhundert. Der Roman war eine literarische Gattung, die alle anderen literarischen Gattungen jener Zeit in sich vereinte – die Installation ist eine Kunstform, die alle anderen zeitgenössischen Kunstformen integriert.

trary: because it is spatial, the installation is material par excellence, and being in the space is the most general definition of being material. It is precisely the materiality of the civilization in which we live that the installation reveals because it *installs* everything our civilization simply *circulates*. The installation thus demonstrates the material hardware of civilization that would otherwise go unnoticed behind the surface of image circulation in the mass media. At the same time, an installation is not a manifestation of preexisting relationships among things but, quite the opposite, an installation gives us the opportunity of using the things and images of our civilization in a very subjective, individual way. In a certain sense, in our day and age the installation is what the novel was for the nineteenth century. The novel was a literary form that included all other literary forms of that time—and the installation is an art form that includes all other contemporary art forms.

The inclusion of film footage in an artistic installation shows its transformative power in a particularly patent way. A video or film installation secularizes the conditions of film presentation. The viewer is no longer immobilized, bound to a seat and left in the darkness, compelled to watch a movie from beginning to end. At an installation in which a video is being shown in a continuous loop, the viewer may move about freely in the room and leave or return at any time. This movement of the viewer in the exhibition space cannot be arbitrarily stopped because it has an essential function in the perception of the

Die Einbeziehung von Filmmaterial in künstlerische Installationen macht ihre transformative Kraft besonders augenfällig. Eine Video- oder Filminstallation säkularisiert die Bedingungen der Filmvorführung. Der Zuschauer ist nicht länger bewegungslos an seinen Platz gefesselt und der Dunkelheit ausgeliefert. Im Kino wird erwartet, dass er sich den Film bis zum Ende ansieht. In der Videoinstallation, in der in Endlosschleife ein Video gezeigt wird, kann sich der Zuschauer frei im Raum bewegen und jederzeit entfernen oder auch wieder zurückkehren. Die Bewegung des Zuschauers im Ausstellungsraum kann nicht diktatorisch angehalten werden, da ihr eine wesentliche Rolle in der Wahrnehmung der Installation zukommt. Hier haben wir es mit einer Situation zu tun, in der die konträren Erwartungen an den Besuch eines Kinos und eines Ausstellungsraum den Betrachter vor einen Konflikt stellen: Soll er oder sie stehen bleiben und die Bilder vor sich ablaufen lassen wie in einem Kino oder weitergehen? Die aus diesem Konflikt resultierende Unsicherheit stellt den Betrachter vor die Wahl. Der Betrachter sieht sich mit der Aufgabe konfrontiert, eine individuelle Strategie zu entwickeln, wie er sich den Film ansehen, der individuellen Filmerzählung folgen soll. Die Zeit, die dem Ansehen des Films gewidmet ist, muss zwischen Künstler und Betrachter fortlaufend neu verhandelt werden. Dies zeigt sehr klar, dass sich ein Film unter den Bedingungen des Besuchs einer Installation radikal, wesentlich verändert – die Kopie des Films ist identisch, es entsteht jedoch ein neues Original.

Doch wenn eine Installation den Raum bietet, an dem die Unterscheidung zwischen Original und Kopie, Innovation und Wiederholung, Vergangenheit und Zukunft getroffen

installation. Clearly, a situation arises in which the expectations associated with a visit to a movie theater and a visit to an exhibition space collide and create a conflict for the visitor: should they stand before the screen and allow the images to move as in a movie theater or continue on? The feeling of insecurity resulting from this conflict places the viewer in a situation of having to make a choice. He or she is confronted with the necessity of having to develop an individual strategy of watching the film, the individual film narrative. The duration of contemplation has to be constantly renegotiated between the artist and the viewer. This clearly demonstrates that a film is radically, substantially altered by being subjected to the conditions of an installation visit—being a same copy, the film becomes a different original.

However, if an installation is a space where the distinction between original and copy, innovation and repetition, past and future occurs, can we speak of an individual installation itself as being original or new? Now, an installation cannot be a copy of another installation because an installation is by definition present, contemporary. An installation is a presentation of the present—of a decision that is made in the here and now. But at the same time, an installation cannot be truly new for the simple fact that it cannot be immediately compared to other, earlier, older installations. In order to be able to compare one installation to another, we would have to create a new installation that would provide the place for such a comparison. This means that we have no outside posi-

wird, können wir dann auch sagen, eine individuelle Installation selbst sei ein Original oder neu? Nun kann eine Installation ja nicht die Kopie einer anderen Installation sein, da eine Installation per definitionem gegenwärtig ist. Eine Installation ist die Präsentation der Gegenwart – einer Entscheidung, die im »Hier und Jetzt« stattfindet. Gleichzeitig kann eine Installation nicht wirklich neu sein – ganz einfach deswegen, weil sie nicht unmittelbar mit anderen, früheren, älteren Installationen verglichen werden kann. Um eine Installation mit einer anderen zu vergleichen, müssten wir eine neue Installation schaffen, die den Platz für einen solchen Vergleich schaffen würde. Und das heißt, dass wir nicht die Position eines Außenstehenden gegenüber der Installationspraxis einnehmen können. Genau deshalb ist die Installation als Kunstform so beherrschend und unausweichlich.

Hinzu kommt ihr dezidiert politischer Charakter. Die wachsende Bedeutung der Installation als Kunstform ist deutlich mit der Repolitisierung der Kunst verbunden, die wir in den letzten Jahren erlebt haben. Die Installation ist nicht nur politisch, weil sie die Möglichkeit eröffnet, politische Positionen, Projekte, Aktionen und Ereignisse zu dokumentieren – selbst wenn derartige Dokumentationen mittlerweile zur weit verbreiteten künstlerischen Praxis geworden sind. Wichtiger ist, dass die Installation selbst, wie oben formuliert, ein Raum der Entscheidungsfindung ist – und dies betrifft in erster Linie die Unterscheidung zwischen Alt und Neu, Tradition und Innovation. Im 19. Jahrhundert diskutierte Søren Kierkegaard den Unterschied zwischen Alt und Neu anhand der Gestalt Jesu Christi. Kierkegaard stellt fest, dass es für einen Zeitgenossen von Jesus Christus unmöglich gewesen

tion in relation to the installation practice. This is the reason why the installation is such a pervasive and unavoidable art form.

This is also why it is truly political. The growing importance of the installation as an art form is very clearly connected to the repoliticization of art we have experienced in recent years. The installation is political not only because it provides a forum for documenting political positions, projects, actions, and events—even though this type of documentation has in the meantime became a widespread artistic practice. More importantly, as has already been mentioned, the installation is in itself a space in which decisions are made—primarily decisions concerning the distinction between old and new, traditional and innovative. In the nineteenth century, Søren Kierkegaard discussed the difference between old and new by example of Jesus Christ. Indeed, Kierkegaard states that for Jesus Christ's contemporaries, it was impossible to recognize him as a new God precisely because he did not look new—Christ initially looked like every other ordinary human being at that time in history. In other words, confronted with the person of Christ, an objective viewer at the time was incapable of discerning any concrete difference between Jesus Christ and an ordinary human being—a perceptible distinction that would suggest that Christ was not simply a man, but also a God. So for Kierkegaard, Christianity is based on the impossibility of recognizing Christ as God—the impossibility of recognizing Christ as perceptibly different: by merely looking at Christ we cannot decide whether he is a copy

sei, in Christus einen neuen Gott zu erkennen, weil sein Aussehen nicht »neu« gewesen sei, das heißt sich nicht von dem eines anderen, durchschnittlichen Menschen jener Zeit unterschieden habe. Mit anderen Worten: Ein mit der Gestalt Christi konfrontierter Beobachter konnte keinen sichtbaren, konkret fassbaren Unterschied zwischen Christus und einem gewöhnlichen Menschen feststellen – einen sichtbaren Unterschied, an dem zu erkennen gewesen wäre, dass Christus nicht nur ein Mensch, sondern auch ein Gott ist. Daher ist das Christentum für Kierkegaard auf der Unmöglichkeit begründet, Christus als Gott zu erkennen, das heißt Christus als visuell verschieden zu erkennen: Das bloße Anschauen Christi versetzt uns nicht in die Lage zu entscheiden, ob er Kopie oder Original ist, ein gewöhnlicher Mensch oder Gott. Für Kierkegaard impliziert dies, dass Christus tatsächlich neu und nicht bloß erkennbar anders gewesen ist und das Christentum deswegen eine Manifestation des Unterschieds jenseits der Unterscheidbarkeit ist. Man kann sagen, dass Christus nach Kierkegaard ein Readymade unter den Göttern ist – so wie Duchamps Urinoir ein Readymade unter den Kunstwerken ist. In beiden Fällen entscheidet der Kontext über das Neue – und in beiden Fällen können wir uns nicht auf einen etablierten, institutionellen Kontext verlassen, sondern wir müssen eine theologische oder künstlerische Installation schaffen, die es uns erlaubt, eine Entscheidung zu fällen und zu artikulieren.

Insofern ist die Unterscheidung zwischen Alt und Neu, Wiederholung und Original, konservativ und progressiv, traditionell und liberal nicht nur eine Unterscheidung unter vielen. Es ist vielmehr eine zentrale Unterscheidung, die alle anderen religiösen und politi-

or an original, an ordinary human being or God. Furthermore, for Kierkegaard this implies that Christ is *really* new and not merely recognizably different—and that Christianity is a manifestation of difference beyond difference. We can say that Christ according to Kierkegaard is a readymade among Gods—like Duchamp's toilet bowl was a readymade among works of art. In both cases the context decides the newness—and in both cases we cannot rely on an established, institutional context but have to create something like a theological or artistic installation that would allow us to make a decision and to articulate it.

Thus, the distinction between old and new, repetitive and original, conservative and progressive, traditional and liberal is not just one distinction among many others. Rather, it is a central distinction that permeates all of the other religious and political options in modernity, which the vocabulary of modern politics clearly demonstrates. The aim of the contemporary artistic installation is to present the scene, the context, the strategy of this distinction as it takes place in the present, and this is the reason why it can indeed be referred to as genuinely contemporary.

schen Alternativen im modernen Zeitalter durchdringt – das Vokabular der modernen Politik zeigt dies sehr deutlich. Die zeitgenössische künstlerische Installation verfolgt das Ziel, den Schauplatz, den Kontext, die Strategie dieser Entscheidung, die im »Hier und Jetzt« getroffen wird, zu präsentieren – und eben deshalb können wir sie als genuin zeitgenössisch bezeichnen.

URBAN | ARCHITEKTUR TEMPORÄR

URBAN | ARCHITECTURE TEMPORARY

<<
Greenlight (Detail), 1999,
Montevideo
(Foto: Oskar Bonilla, Montevideo),
Vgl. Abb. S. 180–181 /
See figs. pp. 180–181

Mannesmann-Hochhaus, 1988
(Recherchefoto: Archiv Mischa Kuball,
Düsseldorf)

(Research photograph: Mischa Kuball
Archive, Düsseldorf)

Diese und folgende Seiten
Megazeichen I – VI, 1990,
Mannesmann-Hochhaus, Düsseldorf
(Foto: Ulrich Schiller, Düsseldorf)

Über einen Zeitraum von insgesamt
sechs Wochen blieb nachts in
bestimmten Büros und Fluren des
Mannesmann-Hochhauses das Licht
an, sodass die beleuchteten Fenster
in der Konstellation ein weithin sicht-
bares Zeichen ergaben. Die Lichter-
scheinungen wechselten wöchentlich
an der 23-stöckigen Fassade des
Gebäudes, erst im Ablauf der Aktion
ergab sich das systematische
Gesamtprogramm zu erkennen.
S. S. 362–363

These and the following pages
Megazeichen I – VI, 1990,
Mannesmann High-rise, Düsseldorf
(photograph: Ulrich Schiller,
Düsseldorf)

Over the course of six weeks, the
lights were kept on in certain offices
and hallways of the Mannesmann
building; the illuminated windows
produced a sign that could be seen
from a distance. The lighted manifes-
tations on the façade of the twenty-
three-storied building changed every
week, but as time wore on, it was
possible to recognize the overall sys-
tematic program.
See pp. 362–363

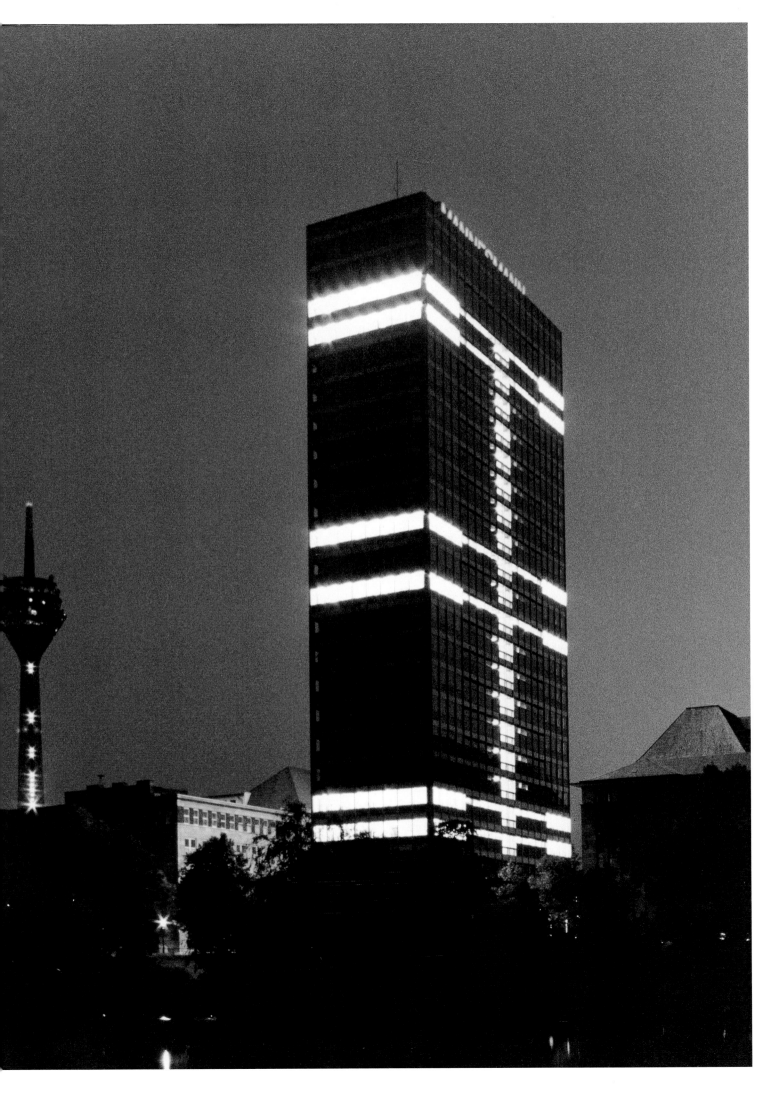

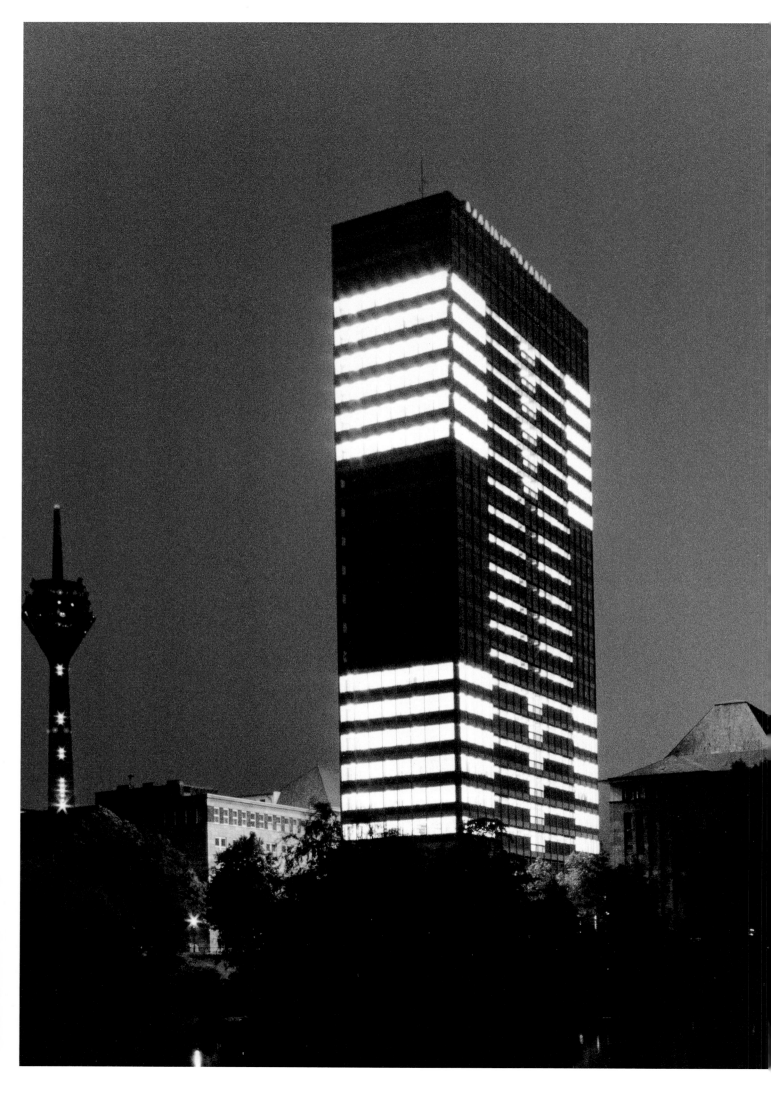

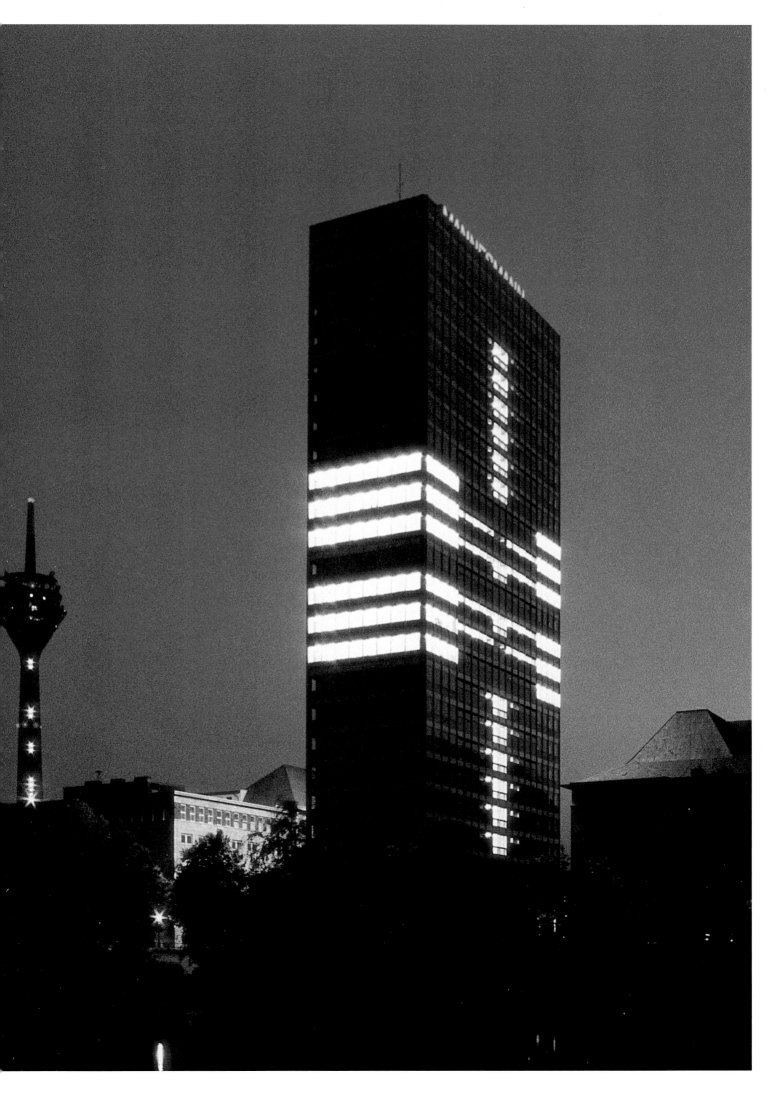

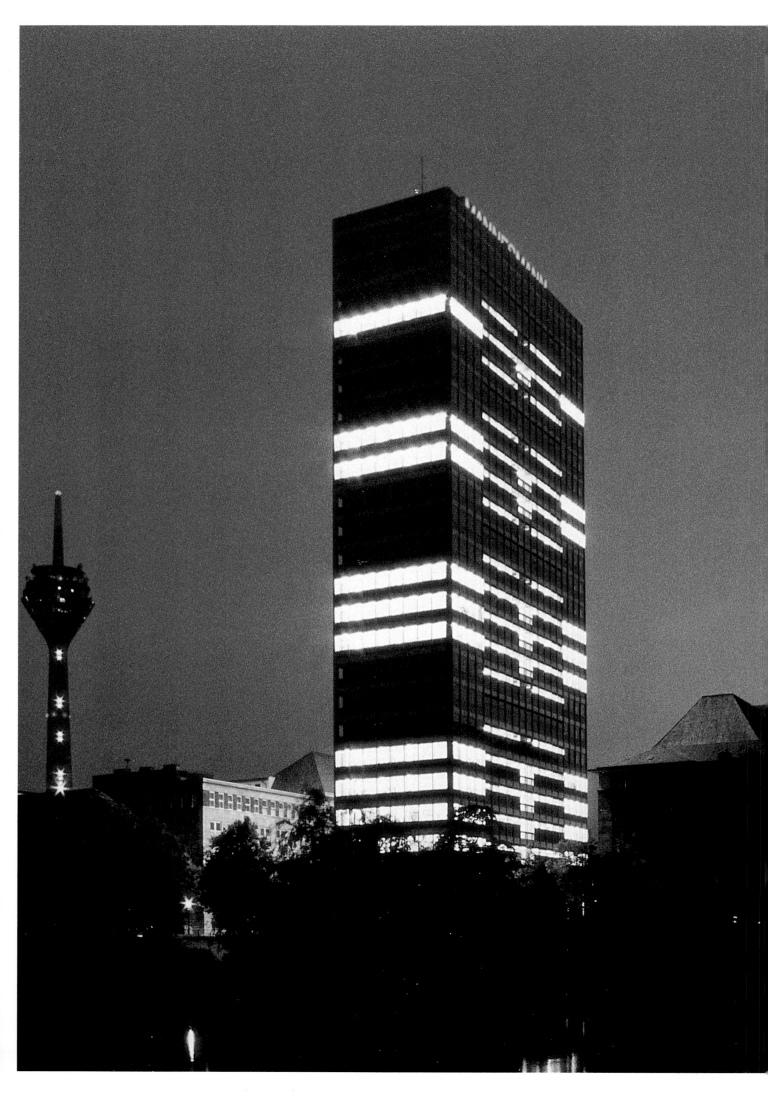

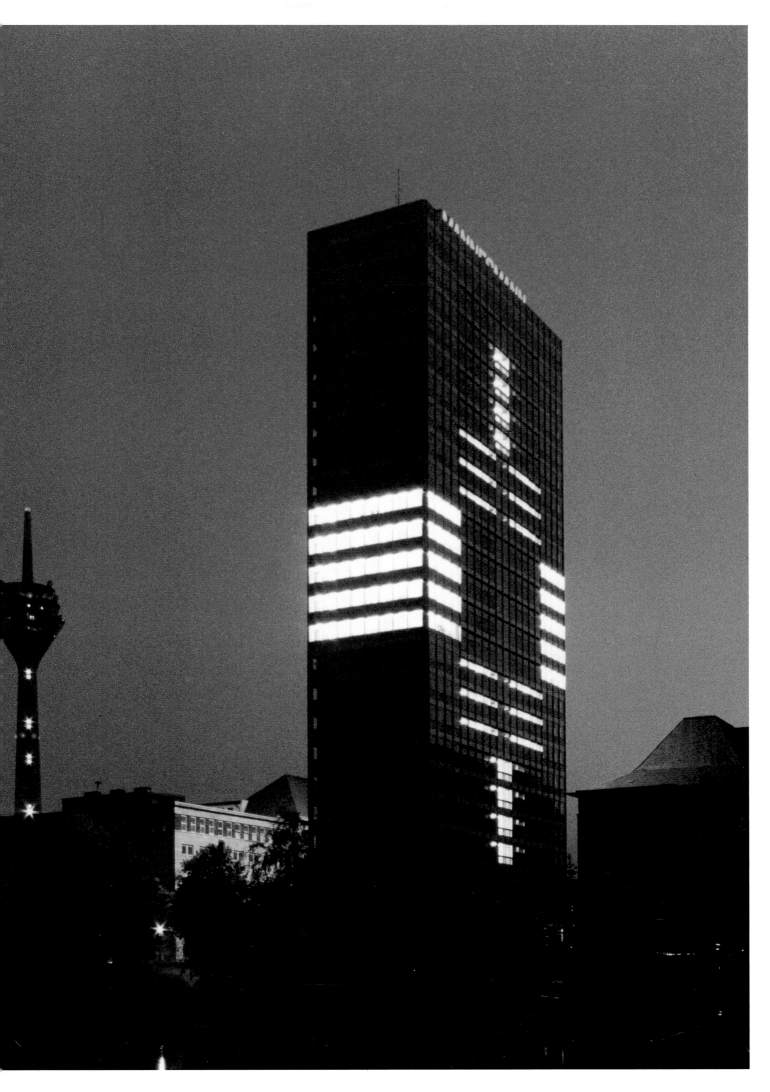

Luxpowertable, 1992,
Lux Europae, Edinburgh; 2 Leucht-
kastentische, je 75 x 75 x 75 cm;
Sammlung Meikel Vogt, London
(Foto: Michael Schindel, Lüneburg)

Die Leuchtkastentische wurden im
Restaurant Cafe Royal von den
Gästen tatsächlich auch genutzt.
Die beiden Leuchtkästen zeigen das
Kernkraftwerk Torness an der Küste
Schottlands, das für den kontami-
nierten Fisch in dieser Region mit-
verantwortlich ist.

Luxpowertable, 1992,
Lux Europae, Edinburgh; 2 light
boxes, 75 x 75 x 75 cm each;
Meikel Vogt Collection, London
(photograph: Michael Schindel,
Lüneburg)

Guests at the Cafe Royal restaurant
actually used the light-box tables.
The two light boxes featured an
image of the Torness nuclear power
plant on the coast of Scotland, which
is partially responsible for the con-
taminated fish in this region.

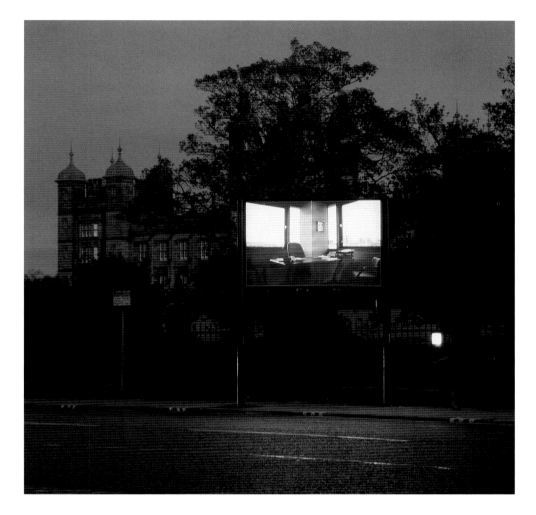

Public Office, 1992,
Lux Europae, Edinburgh; Leucht-
kasten auf Gerüst, 3 x 5 x 0,3 m
(Foto: Michael Schindel, Lüneburg)

Auf der Straße von Edinburgh nach
Glasgow wurde ein Leuchtkasten
positioniert, auf dem eine Innenauf-
nahme mit Blick aus dem LEEL-
Building, dem Gebäude einer schot-
tischen Kulturorganisation, zu erken-
nen war. Da die verspiegelte Fassade
keinen Blick ins Innere des Gebäudes
zulässt, öffnete Mischa Kuball ein
»Fenster« in das Büro des Vorstandes.

Public Office, 1992,
Lux Europae, Edinburgh; light box
on scaffolding, 3 x 5 x 0.3 m
(photograph: Michael Schindel,
Lüneburg)

A light box was placed on the street
leading from Edinburgh to Glasgow.
On it could be seen a photograph
of the view from inside the LEEL
building, which houses a Scottish
cultural organization. Since the mir-
rored façade does not permit a view
inside the building, Kuball opened
up a "window" into the boardroom.

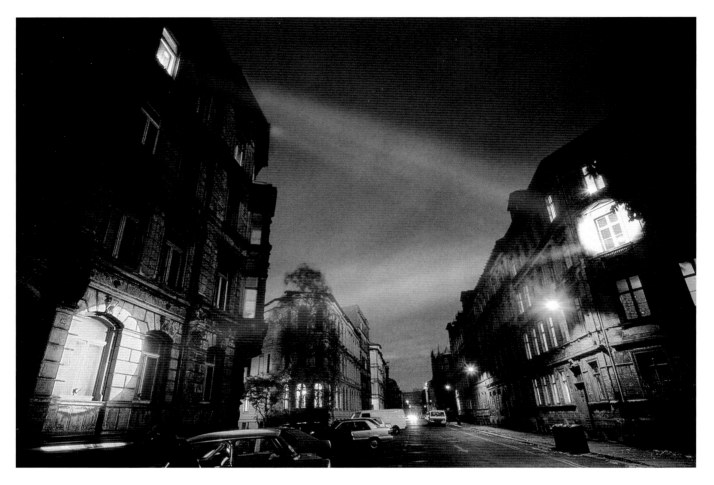

Leerstand/Peepout, 1994,
Leipziger Galerie für Zeitgenössische
Kunst; 2 Suchscheinwerfer
(Foto: Punctum/Hans Christian
Schink, Leipzig)

Die beiden Scheinwerfer wurden in
einer bewohnten Wohnung aufge-
stellt und markierten mit ihrem
Lichtfokus die Fassade der gegen-
überliegenden Seite. Das Licht
trat durch die Fenster in eine leer
stehende Wohnung.

Leerstand/Peepout, 1994,
Leipziger Galerie für Zeitgenössische
Kunst; 2 searchlights
(photograph: Punctum/Hans Christian
Schink, Leipzig)

Two searchlights were set up in an
inhabited apartment; their light
focused on the façade of the opposite
building. Light shone through the
windows into a vacant apartment.

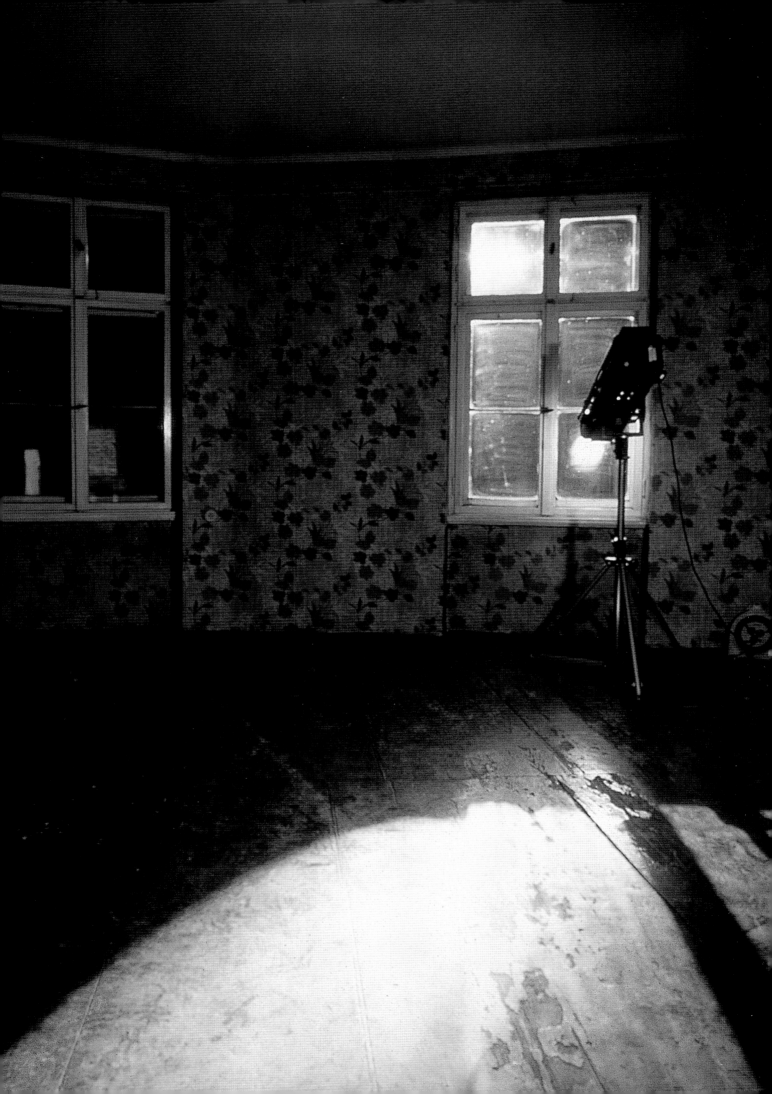

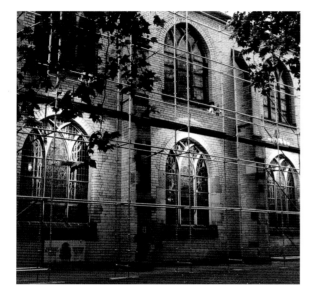

Projektion/Reflektion, 1995,
Kunststation St. Peter, Köln;
11 x 2 kW Scheinwerfer, Stahlgerüst
ca. 60 x 25 m, 11 Spiegel je
ca. 250 x 80 cm
(Foto: Kurt Danch, Bensberg)

Die Kirche von St. Peter wurde kom-
plett eingerüstet. An dem Gerüst
vor den Fenstern strahlten Schein-
werfer durch die Kirchenfenster nach
innen, sodass die Fensterbilder in
den Innenraum projiziert wurden.
Im Innenraum waren unter den
Fenstern Spiegel angebracht, die
wiederum das künstliche Licht und
die Besucher in dem Licht reflektier-
ten. Die sakrale Definition von Licht
im Kirchenraum als »das göttliche
Licht« erfuhr dadurch eine techni-
sche Komponente. Innen und Außen
überlagerten sich.

Projektion/Reflektion, 1995,
Kunststation St. Peter, Cologne;
11 2-kW spotlights, steel scaffolding
approx. 60 x 25 m, 11 mirrors,
each approx. 250 x 80 cm
(photograph: Kurt Danch, Bensberg)

Scaffolding completely covered the
Church of St. Peter. Spotlights were
attached to the scaffolding in front
of the windows, where they shone
into the church through its windows
so that the images on the windows
were projected inside the church.
Inside, mirrors were attached under-
neath the windows, so that the
artificial light and the visitors were
reflected in the light. This gave a
technical component to the sacred
definition of light inside a church
space, "the divine light." Interior and
exterior overlapped each other.

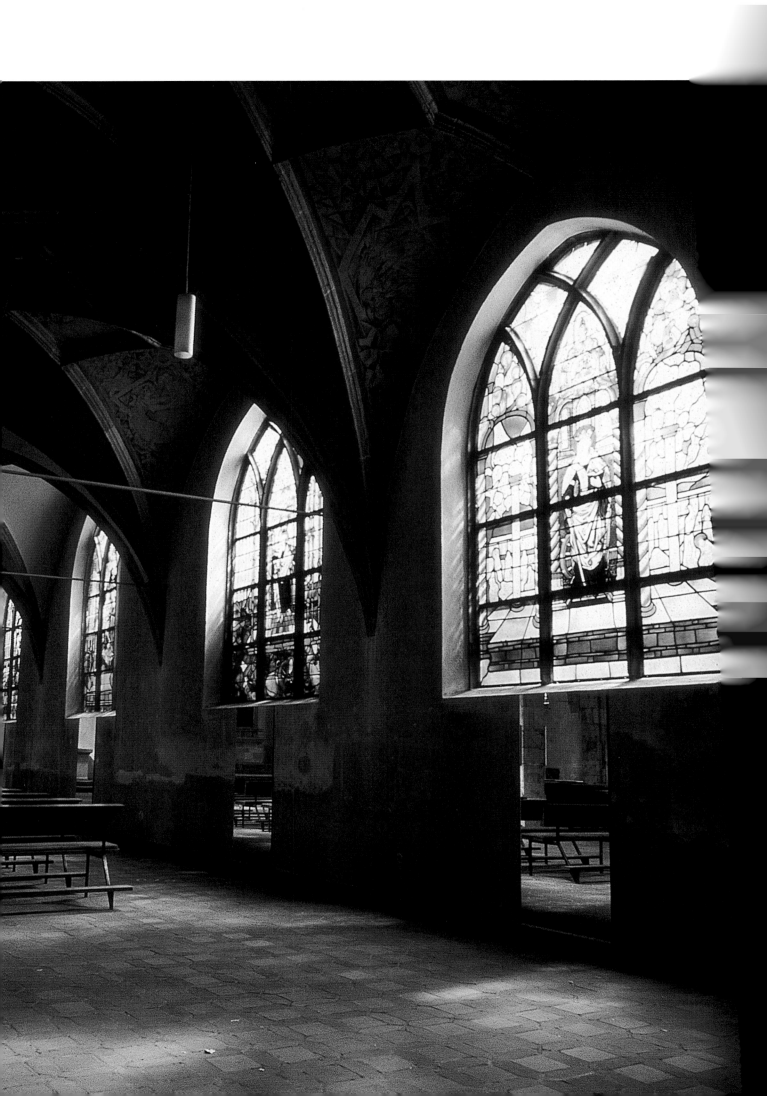

Rotierenderlichtraumhorizont, 1995,
Wandelhalle, Deutzer Brücke, Köln;
12 Diaprojektoren, je 81 Dias,
12 Drehbühnen
(Foto: Thomas Eigel, Köln)

Im 430 Meter langen Hohlraum der
Deutzer Brücke rotierten die Diapro-
jektoren und warfen geometrische
Lichtformen und Architekturfotogra-
fien von öffentlichen Gebäuden an die
Wände. Der dunkle Innenraum ver-
wandelte sich zu einer dynamisierten
Projektionsfläche.

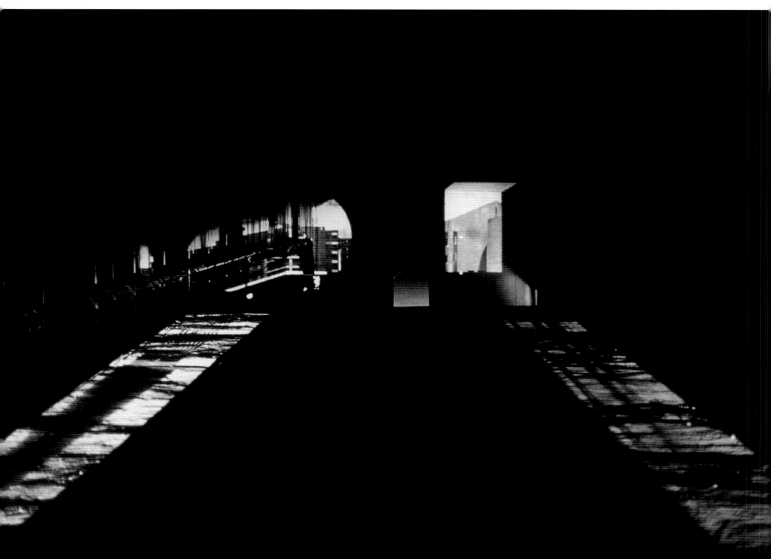

Rotierenderlichtraumhorizont, 1995,
Wandelhalle, Deutzer Bridge,
Cologne; 12 slide projectors, each
containing 81 slides, 12 revolving
stages
(photograph: Thomas Eigel, Cologne)

The slide projectors revolved in the
430-meter-long hollow space of the
Deutzer Bridge, projecting geometric
shapes of light and photographs of
public buildings onto the walls. The
dark interior was transformed into
a dynamic projection surface.

Greenlight, 1999,
Montevideo; ca. 30 Standard-Bau-
lampen mit grünen Glühlampen
(Foto: Oskar Bonilla, Montevideo)

Kuball installierte grüne Baulampen
über Türrahmen an der Calle Demo-
cracia im Barrio Reus in Montevideo.
Der Stadtteil Barrio Reus galt als das
Zentrum jüdischer Emigranten, die
auch als »grihne Leit« bezeichnet
wurden. Die ausgewählten Türrah-
men gehörten zu unbewohnten oder
verlassenen Häusern, deren Ein-
gänge manchmal zugemauert waren.
Der minimale Einsatz des Lichts
markiert die Überlagerung von
Privatem und Öffentlichem, von Vor-
handenem und Abwesendem.

Greenlight, 1999,
Montevideo; approximately 30 stan-
dard building lights with green bulbs
(photograph: Oskar Bonilla,
Montevideo)

Kuball installed standard building
lights with green bulbs above door-
frames along the Calle Democracia
in the Barrio Reus of Montevideo.
Barrio Reus is known as the neigh-
borhood for Jewish immigrants, who
were also described as "grihne Leit."
The doorframes selected belonged
to uninhabited or abandoned houses,
some of whose entrances had already
been blocked up. The minimal use of
light was a reserved yet penetrating
mark of the overlapping of public and
private, of presence and absence.

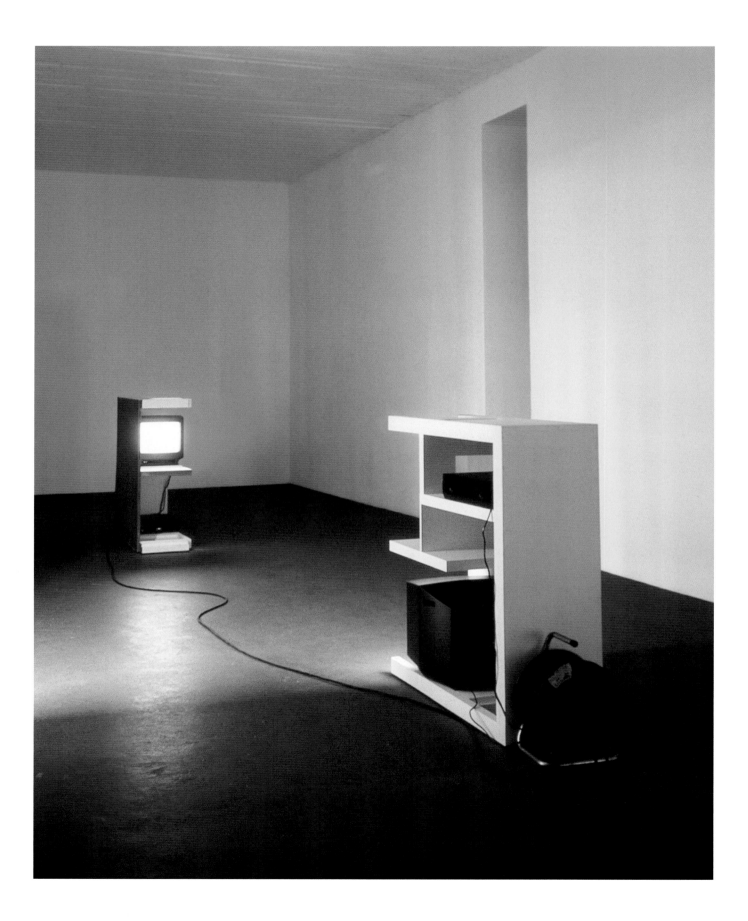

Fischer's Loop, 1999,
Konrad Fischer Galerie, Düsseldorf;
2-teiliges Modell der Galerie,
je 35 x 95 x 105 cm, 2 TV-Monitore,
2 VHS-Player, 2 Tapes, je 30' mit Ton
(Foto: Dorothee Fischer, Düsseldorf)

Monitorarbeit im Modell der Galerie,
die einen Parcours der geschleuder-
ten Kamera durch die leere Galerie
Fischer zeigt. Der entleerte Präsen-
tationsraum repräsentiert sich
selbst.

Fischer's Loop, 1999,
Konrad Fischer Galerie, Düsseldorf;
2-part model of the gallery,
35 x 95 x 105 cm each, 2 TV monitors,
2 VHS players, 2 tapes 30' each,
with sound
(photograph: Dorothee Fischer,
Düsseldorf)

A work for TV monitor; based on a
model of the gallery, it features a
course for the camera as it glided
around inside the empty gallery.
The empty presentational space was
itself represented.

SIX-PACK-SIX, 2000,
RWE-Turm, Museum Folkwang,
Essen, 6 einzelne Aluminium-
Abgüsse mit 6 Spiegelflächen je
40 x 200 cm, 13 s/w, transparente
Fotofolien auf Plexiglas in Alu-
rahmen-Konstruktion 180 x 240 cm
(Foto: Nic Tenwiggenhorn, Düssel-
dorf)

Das runde Foyer des RWE-Turms
verwandelte Mischa Kuball in einen
offenen Projektionskörper. Die unter-
schiedlich gestapelten Diaprojek-
toren strahlten ausgehend von Foto-
folien zum Zentrum des Foyers.
Aluminiumabgüsse von Original-Dia-
geräten standen auf Spiegelflächen
im Inneren des Turms.
Die Diaprojektoren suggerierten so
ein magisches Licht im Inneren des
Turms, das allerdings durch das
natürliche, durch die Folien schei-
nendes Licht intensiviert worden war.

SIX-PACK-SIX, 2000,
RWE Tower, Museum Folkwang,
Essen, 6 individual aluminum casts,
each with 6 mirrored surfaces
measuring 40 x 200 cm, 13 b/w,
transparent photographs on Plexi-
glas in aluminum frame construction
180 x 240 cm
(photograph: Nic Tenwiggenhorn,
Düsseldorf)

Kuball transformed the round lobby
of the RWE Tower into an open struc-
ture for projections. The slide projec-
tors, in stacks of different heights,
projected from behind the transpar-
ent film on Plexiglas plates into the
center of the lobby. Aluminum casts
of original slide projectors stood on
mirrored surfaces inside the tower.
The slide projectors thus suggested
a magical kind of light inside the
tower, which, however, was intensi-
fied by the natural light shining
through the transparent film on Plexi-
glas.

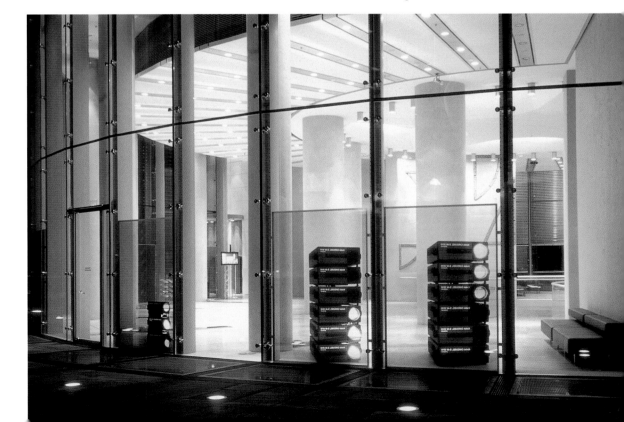

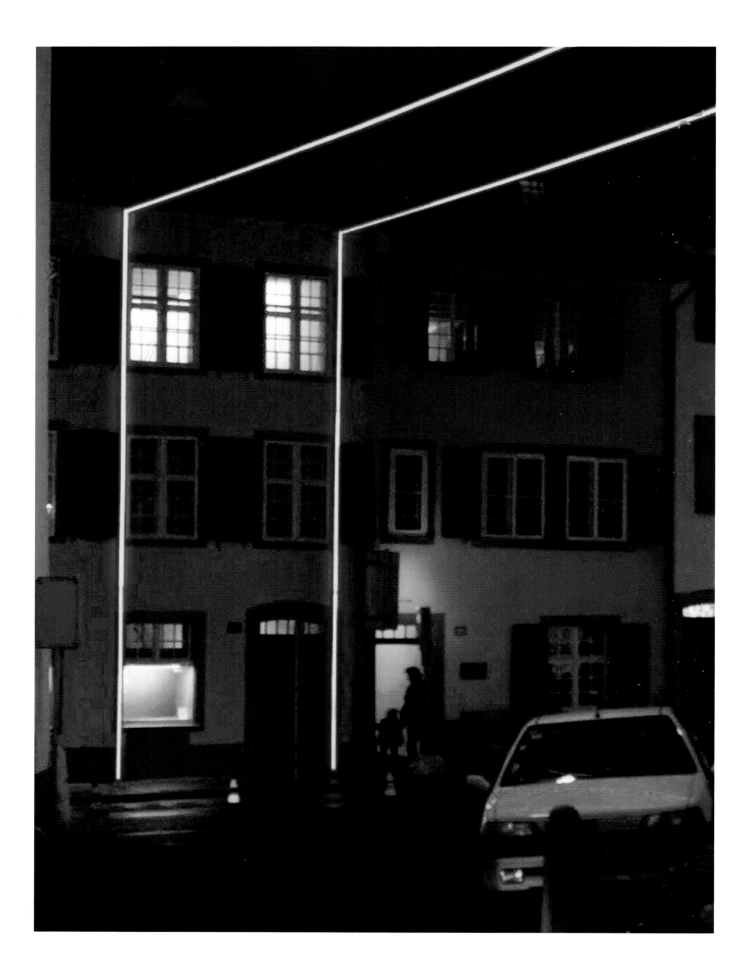

Red Gate, 2000,
ARTlight, Galerie Beyeler, Basel;
2 LED-Leuchtstoffröhren, je ca. 120 m
(Foto: start.design, Ralph Kensmann,
Essen)

Der Eingangsbereich der Galerie
Beyeler wurde im Rahmen der Aus-
stellung *ArtLight* von zwei roten LED-
Linien eingerahmt, die am Dach der
Galerie in einem rechten Winkel die
Straße überbrückten und am Dach
des gegenüberliegenden Gebäudes
endeten. *Red Gate* spielte somit auf
die Eingangssituation der Galerie und
auch auf ein Tor im urbanen Raum
von Basel an.

Red Gate, 2000,
ARTlight, Galerie Beyeler, Basel;
2 LED tubes, each approx. 120 m
(photograph: start.design,
Ralph Kensmann, Essen)

As part of the *ARTlight* exhibition, the
entrance to the Galerie Beyeler was
framed by two red LED lamps, which
ran along the roof of the gallery and
crossed the street at a right angle,
ending at the roof of the building
opposite. *Red Gate* thus alluded to the
situation at the gallery entrance and
to a gate in urban Basel.

Transformation No.1, 2000,
Kunstraum, Innsbruck; 3 Diapro-
jektoren je 81 Dias
(Foto: Courtesy Kunstraum Inns-
bruck)

Die Projektionen warfen geometri-
sche Lichtformen und Abbildungen
von Modellen internationaler Archi-
tektur auf den Kühlturm der ehema-
ligen Adambräu und zugleich auf
die neuen Gebäude auf dem Gelände,
sodass eine immaterielle Verbindung
entstand.

Transformation No. 1, 2000,
Kunstraum, Innsbruck; 3 slide pro-
jectors, each containing 81 slides
(photograph: Courtesy of Kunstraum
Innsbruck)

Projections of geometric light shapes
and images of models of interna-
tional architecture were seen on both
the cooling tower of the former Adam
Brewery as well as on the new build-
ings on the property, creating a non-
material connection.

Tangential Orange, 1999/2000,
Kunstlicht, München; LED-Leucht-
stoffröhre, 290 m
(Foto: Alexander Timtschenko,
München)

Die orangefarbene Lichtlinie ver-
band den Marienplatz und den Max-
Joseph-Platz miteinander. In circa
8 Meter Höhe markierte sie die hori-
zontale Bewegung der Passanten und
des Autoverkehrs. Zusätzlich machte
die Tangente auf eine leichte histo-
rische Krümmung der Diener Strasse
aufmerksam und kontrastierte in
ihrer formalen Erscheinung die sie
umgebende historische Architektur.

Tangential Orange, 1999/2000,
Kunstlicht, Munich; LED tube, 290 m
(photograph: Alexander Timtschenko,
Munich)

An orange-colored line of light con-
nected the Marienplatz with the Max
Joseph Platz in Munich. At a height
of about eight meters, it marked the
horizontal motion of passers-by and
automobile traffic. In addition, it drew
attention to a slight historical curve
in Diener Strasse, while its formal
appearance contrasted with the his-
torical architecture surrounding it.

Horizontal Parallel Structure, 2000,
Installation an der Fondation Beyeler,
Riehen/Basel; 2 LED-Leuchtstoff-
röhren/Orange 150 m, 60 m
(Foto: Andreas F. Voegelin, Basel)

Im Rahmen der Ausstellung *Farbe
zu Licht* installierte Mischa Kuball
eine 150 m lange LED-Leuchtstoff-
röhre an der Außenmauer und eine
60 m lange Röhre an der Dachkon-
struktion der Fondation Beyeler.
So fungierte die *Horizontal Parallel
Structure* als Wahrnehmungswerk-
zeug im öffentlichen Raum – um so
Gelände und Architektur in eine
Relation zu setzen.

Horizontal Parallel Structure, 2000,
Installation at Fondation Beyeler,
Riehen/Basel; 2 orange LED tubes
150 m, 60 m
(photograph: Andreas F. Voegelin,
Basel)

As part of the *Farbe zu Licht* exhibi-
tion Kuball installed a 150-meter-
long LED tube on the exterior wall
and a 60-meter-long tube on the roof
on the Fondation Beyeler. Hence,
the *Horizontal Parallel Structure* func-
tioned as a perceptual tool in public
space, placing the grounds and the
architecture in a relationship to each
other.

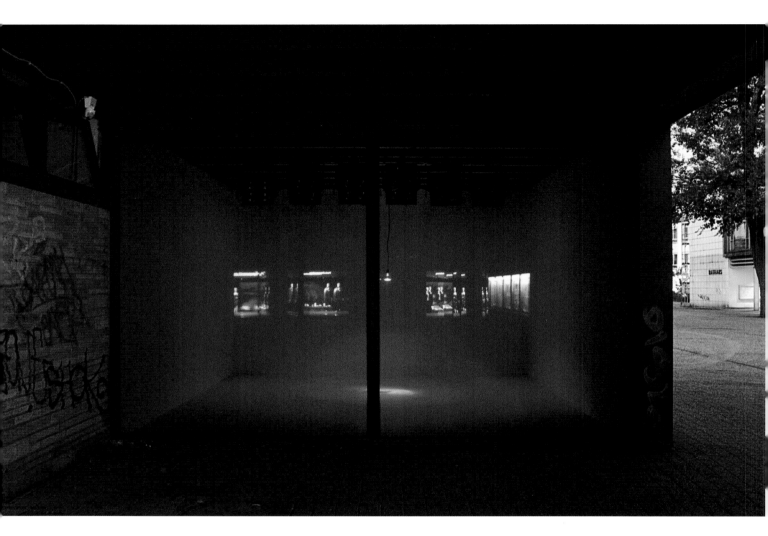

Darkroom, 2003,
Lichtrouten Lüdenscheid; 6 Theater-
Scheinwerfer, 1 rote Lichtquelle,
Bewegungssensor
(Foto: Claus Langer, Düsseldorf)

Im städtebaulich verwaisten Pavillon
am Rathausplatz inszenierte Mischa
Kuball 2 Lichträume. Weithin sicht-
bar leuchtete der Raum in rotem
Licht, bei Annäherung ließen die

6 Scheinwerfer den Raum in gleißend
weißem Licht erstrahlen und blen-
deten den neugierigen Besucher.

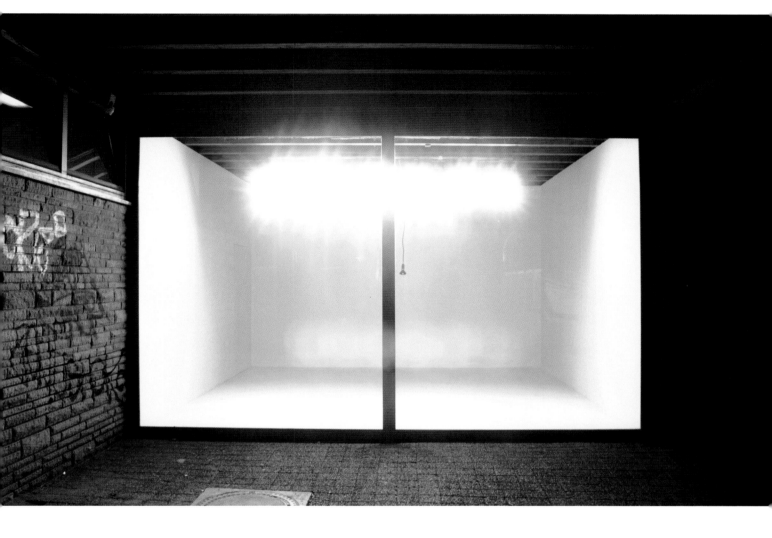

Darkroom, 2003,
Lichtrouten Lüdenscheid; 6 theater
spotlights, 1 source of red light,
motion sensor
(photograph: Claus Langer,
Düsseldorf)

Kuball set up two light spaces at the
neglected pavilion on the Rathaus-
platz. The space bathed in red light
could be seen from quite a distance.
On approaching the installation, curi-
ous visitors were blinded by six spot-
lights, which covered the space in
glowing white light.

Reflektor, 2004,
Privatgrün, Dachterrasse H. W. Pausch;
Verkehrsspiegel
(Foto: Jochen Heufelder, Köln)

Auf der südlich ausgerichteten Dach-
terrasse installierte Mischa Kuball
einen Verkehrsspiegel, der so weit
über das Hausdach reichte, dass
er den Blick auf das Stadtzentrum
und den Kölner Dom freigab.

Reflektor, 2004,
Privatgrün, H. W. Pausch roof garden;
traffic mirror
(photograph: Jochen Heufelder,
Cologne)

Mischa Kuball installed a traffic mir-
ror on the south-facing roof garden
that extended so far beyond the roof
of the building that it provided a view
of the city center and the Cologne
Cathedral.

Zwei Abendräume für Köln, 2006,
Kunststation St. Peter/Schnütgen-
museum St. Cäcilien, Köln; 6 Dia-
projektoren, je 1 Paper-Cut-Dia,
6 Drehbühnen, 2 Stroboskop-Lichter
zwischen den beiden Kirchen
(Foto: Egbert Trogemann, Düsseldorf)

Die Installation in St. Peter bestand
aus 4 Diaprojektoren, die im Erdge-
schoss und auf der Empore positio-
niert wurden. Die mit- und gegen-
einander rotierenden Projektoren
transportierten horizontale und verti-
kale Lichtschlitze, die den liturgi-
schen Raum mit Licht »abgriffen«,
sodass für kurze Momente kreuzför-
mige Schnittpunkte entstanden.
Im musealen Raum von St. Cäcilien,
dem Schnütgenmuseum, positio-
nierte Mischa Kuball 2 rotierende
Diaprojektoren, die formal wie in der
Nachbarkirche den Raum mit Licht
abtasteten und dabei den aktuellen
Ausstellungsbereich mit einbezogen.
Die visuelle Verbindung der neben-
einander stehenden Kirchen funktio-
nierte durch 2 gegenüberliegende
Türen in den jeweiligen Gebäuden,
die Mischa Kuball mit 2 blitzenden
Stroboskop-Lichtern markiert hatte.

Zwei Abendräume für Köln, 2006, Kunststation St. Peter/Schnütgenmuseum St. Cäcilien, Cologne; 6 slide projectors, each with 1 papercut slide, 6 revolving stages, 2 strobe lights between the two churches (photograph: Egbert Trogemann, Düsseldorf)

The installation in St. Peter's consisted of four slide projectors positioned in the ground floor and on the gallery. The projectors revolved with and counter to each other, transporting horizontal and vertical slits of light that "felt" the liturgical space with light, briefly creating cross-shaped intersections.

In the museum space of St. Cecilia, the Schnütgenmuseum, Kuball posi-tioned two rotating slide projectors that also felt out the space with light, as in the neighboring church, and thereby included the exhibition space. The visual connection of the two neighboring churches functioned with the help of two doors, one in each building, which faced each other, and which Kuball marked with two flashing strobe lights.

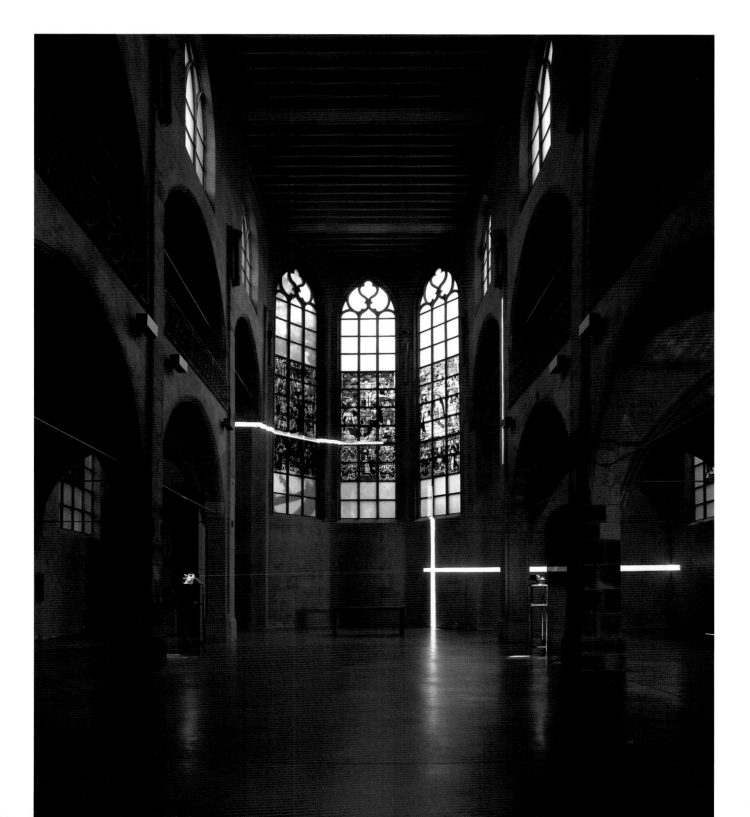

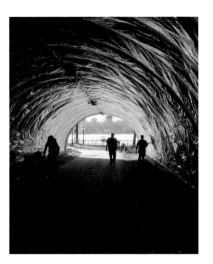

Silver Tunnel, 2006,
Studio in the Park project by Bravin-
LeeProjects, New York, Riverside
Park, Manhattan/New York;
1200 m² reflektierende Aluminium-
folie, 4 x 500 Watt Leuchten
(Foto: Archiv Mischa Kuball, Düssel-
dorf)

Im Riverside Park entlang des Hud-
son Rivers inszenierte Mischa Kuball
eine tunnelförmige Unterführung
neu: Die Wände des halbrunden
Raums waren mit glänzender Folie
ausstaffiert. An der Decke wurden
starke Leuchten installiert, die neues
Licht in den dunklen Tunnel warfen.
Die fragile Installation wurde bereits
drei Tage nach der Eröffnung durch
Vandalismus zerstört.

Silver Tunnel, 2006,
Studio in the Park project by Bravin-
LeeProjects, New York, Riverside
Park, Manhattan/New York;
1200 m² reflecting aluminum foil,
4 500-watt lights
(photograph: Mischa Kuball Archives,
Düsseldorf)

In Riverside Park along the Hudson
River, Kuball changed the situation
in a pedestrian tunnel: the walls of
the semi-circular space were covered
in gleaming aluminum foil. Strong
lights were installed on the ceiling,
which provided the dark tunnel with
new light. Vandals destroyed the
fragile installation just three days
after it was opened.

194

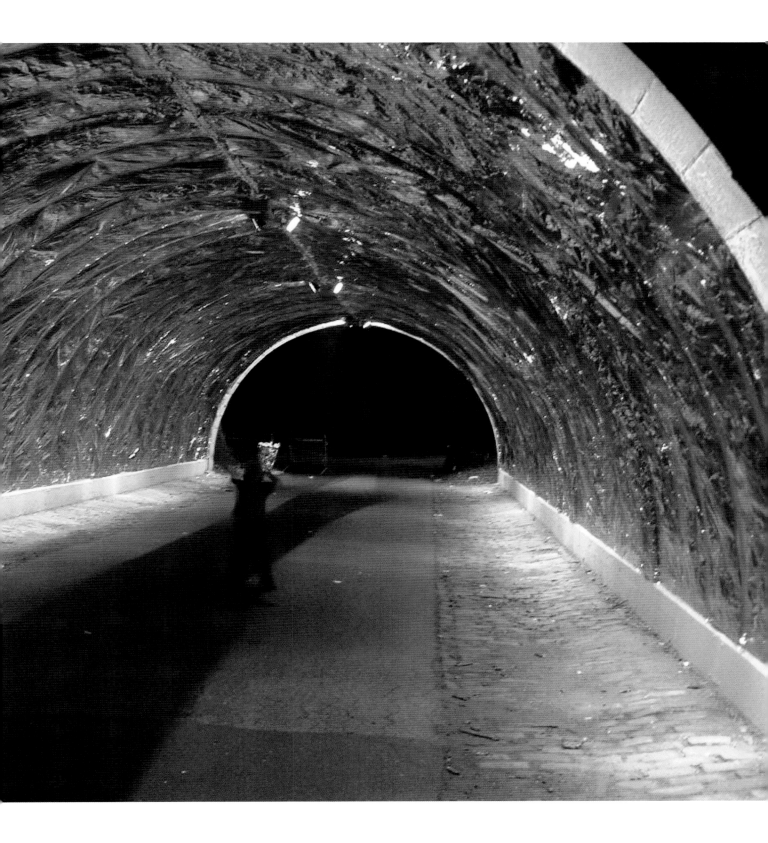

Bridge over Manhattan; Lattice on
structure; Construction; Park Ave.
Meets Broadway; City Sculpture –
to R. Serra, 1984,
(Keller)Galerie, Düsseldorf;
5 Collagen 68 x 100 x 8 cm; Samm-
lung Alfons Mencke, Valdemossa,
5 Unikat-Fotografien, 68 x 100 cm;
Sammlung Hanno Haniel, Köln
(Foto: Norbert Faehling, Düsseldorf)

In 5 seiner frühesten Arbeiten suchte
Mischa Kuball in konstruktivistischer
Manier Manhattan neu zu vermessen.
Auf den schwarz-weißen Stadtplänen
verspannte er Wollfäden, griff in die
Topografie ein und hob buchstäblich
bestimmte Abschnitte hervor: in *City
Sculpture – to R. Serra* etwa hoben
Stahlplatten bestimmte Stadtbezirke
an. Diese »einschneidende« Form
der Auseinandersetzung mit urbanen
Strukturen sind optische Ansatz-
punkte für spätere installative Ein-
griffe in den Stadtraum.

Bridge over Manhattan; Lattice on
Structure; Construction; Park Ave.
Meets Broadway; City Sculpture –
to R. Serra, 1984,
(Keller) Galerie, Düsseldorf;
5 collages 68 x 100 x 8 cm;
Alfons Mencke Collection,
Valdemossa, 5 signature photo-
graphs, 68 x 100 cm; Hanno Haniel
Collection, Cologne
(photograph: Norbert Faehling,
Düsseldorf)

In five of his earliest works, Kuball
attempted to resurvey Manhattan in a
Constructivist manner. He stretched
woolen threads over the black-and-
white maps of the city, intervening
in the topography and literally point-
ing up particular sections: in *City
Sculpture – to R. Serra*, for instance,
steel plates elevated particular dis-
tricts of the city. This "incisive" form
of exploring urban structures became
the visual starting point for later
installative interventions in urban
space.

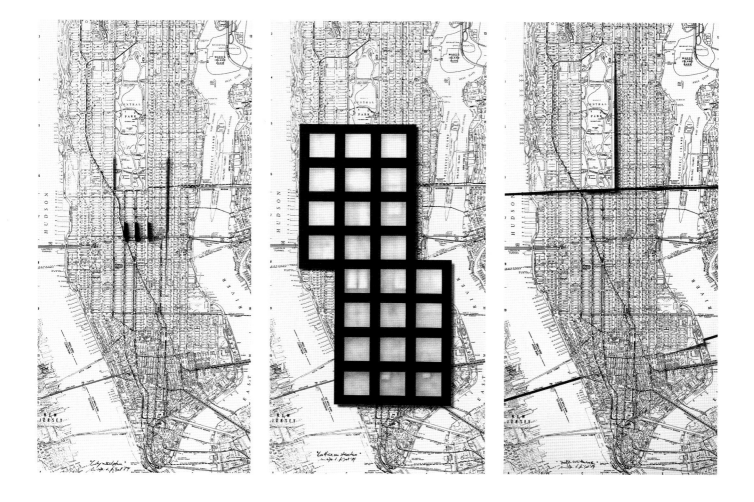

Lichtbrücke, in Kooperation mit Riken Yamamoto und Beda Faessler, 2004, con-con, stadtkunstprojekte e.V., Friedrichsbrücke, Museumsinsel Berlin; Xenonprojektion (Foto: Uwe Walter, Berlin)

Bei Anbruch der Dunkelheit wurde eine künstlich generierte Wasserstruktur auf die Brückenoberfläche projiziert, die die Fließbewegung realen Wassers simulierte.

Lichtbrücke, in cooperation with Riken Yamamoto and Beda Faessler, 2004, con-con, stadtkunstprojekte e.V., Friedrichsbrücke, Museumsinsel Berlin; Xenon projection (photograph: Uwe Walter, Berlin)

At twilight, an artificially generated water structure was projected onto the surface of the bridge, simulating the flowing motion of real water.

Pont lumière, in Kooperation mit
Riken Yamamoto und Beda Faessler,
2005, Passerelle du barrage, Genf;
Beamer, DVD, Programm
(Foto: start.design, Ralph Kensmann,
Essen)

Bei Anbruch der Dunkelheit wurde
eine künstlich generierte Wasser-
struktur auf die Brückenoberfläche
der Passerelle du barrage du Seujet
projiziert, die die Fließbewegung
realen Wassers simulierte.

Pont lumière, in cooperation with
Riken Yamamoto and Beda Faessler,
2005, Passerelle du barrage, Geneva;
projector, DVD, program
(photograph: start.design,
Ralph Kensmann, Essen)

At twilight, an artificially generated
water structure was projected onto
the surface of the Passerelle du
barrage du Seujet, simulating the
flowing motion of real water.

Flash-Bridge-Flash, 2006,
Casino Luxembourg, Luxemburg,
ca. 250 Glühlampen
(Foto: Rémi Villaggi, Metz)

An den seitlichen Rändern des Via-
dukts positionierte Mischa Kuball
über die gesamte Länge eine blin-
kende Lichterkette. Die formale Hän-
gung der blinkenden Lichterkette
imitierte die Bogenproportionen
des Viadukts. Nachts zeichneten sich
die umgekehrten Umrisse einer
Brückenform ab.

Flash-Bridge-Flash, 2006,
Casino Luxembourg, Luxembourg,
approx. 250 light bulbs
(photograph: Rémi Villaggi, Metz)

Kuball positioned a chain of blinking
lights along the lateral edges of
the entire length of a viaduct. The
lights were hung to correspond to the
proportions of the arches on the
viaduct. At night, the inverse outline
of the shape of a bridge can be seen.

NINA HÜLSMEIER

HAUSBESETZUNG
SQUATTING ACTION

»Ich betrete die Baustelle auf eigene Gefahr, das was mich sonst hindert, ist jetzt Einladung.«[1]

Abb. S. 126–127

1991 initiierte Mischa Kuball auf der Baustelle der ehemaligen Mülheimer Post, die zum Kunstmuseum umgebaut wurde, 12 ortsspezifische Interventionen, die sich mit den transhistorischen Qualitäten der zeitlichen und räumlichen Zwischensituation auseinandersetzten. Er untersuchte die Verhältnismäßigkeit der gegebenen Architektur mit dem Medium der Projektion – eine Methode, die behutsam den Wandel des Ortes thematisierte. Wirklichkeit und Projektion bestritten ein reflexives Wechselspiel und so wurde Imaginäres und real Mögliches in der Architektur inszeniert. In dem Projekt mischten sich Situation und Setzung, und die Grenzen zwischen Werk und Wirkung waren fließend. Erst die Störung einer Ordnung, die Reflexion von Lichtstrahlen an Körpern im sonst »leeren« Raum, macht Kräfte und Energien sichtbar.

Im Zentrum der Arbeiten Kuballs steht immer wieder das Urbane. Architektur dient dabei als Vermittler zwischen den Grenzen von Öffentlichem und Privatem. Seit er von 1988–1990 die Arbeit *Megazeichen* am Mannesmann-Hochhaus mithilfe der Mitarbeiter des Konzerns realisierte, greift er mit seinen temporären Lichtarbeiten verändernd in den

Abb. S. 166–171

öffentlichen Raum ein. Kuball negierte in seiner Arbeit *Megazeichen* die traditionellen Vermittlungswege für Kunst und stieß in den Bereich der Öffentlichkeit vor. Das Hochhaus der

"I enter the construction site at my own risk. What otherwise prohibits me from doing so is now an invitation."[1]

Figs. pp. 126–127

In 1991, at the construction site of the former Mülheim post office, which was being converted into an art museum, Mischa Kuball initiated twelve site-specific interventions that dealt with the transhistorical qualities of the interim temporal and spatial situation. He examined the proportionality of the given architecture using the medium of projection—a method which carefully thematicized the changes the location was undergoing. Reality and projection played a reciprocal game, staging in this way both the imaginary and the materially possible in the architecture. It was a project which blended situation and positioning; the boundary between the work and its effect was fluid. Forces and energies only became visible when the order was disturbed, when the rays of light were reflected on bodies in an otherwise 'empty' space.

Urbanity has always been accorded a central role in Kuball's works. Architecture serves here as an intermediary between the boundaries of the public and private spheres. Since realizing *Megazeichen* between 1988 and 1990 at the Mannesmann high-rise building in Düsseldorf, with the help of the company's employees, he has encroached on—and changed—public spaces with his temporary light installations. With *Megazeichen*, Kuball

Leerstand/Peepout (Detail), 1994,
Leipziger Galerie für Zeitgenössische
Kunst
(Foto: Punctum/Hans Christian
Schink, Leipzig), Vgl. Abb. S. 174–175 /
See figs. pp. 174–175

Mannesmann AG am Düsseldorfer Rheinufer geriet über einen Zeitraum von sechs Wochen zum Träger für 6 verschiedene Lichtzeichen. Das Bürogebäude erfuhr nachts eine inhaltliche Umdeutung zu einer monolithischen Lichtskulptur. Nicht Kuball projizierte, vielmehr projizierte das Gebäude sich selbst nach außen, und zwar durch das alltägliche Funktionslicht der Büros.

Künstliches Licht wird seit der Moderne als aktives Gestaltungsmittel in die Architektur integriert und erweitert so die traditionellen architektonischen Ausdrucksmittel. Die Architekturgeschichte des 20. Jahrhunderts zeigt, dass Licht sich als rhetorische Komponente der Architektur emanzipiert hat. Mies van der Rohe beispielsweise setzte sich mit der autonomen Lichtarchitektur fern mystischer Aufladungen, aber auch fern der von Lichtreklame entlehnten Formen intensiv auseinander und untersuchte in seinen Bauten die Wirkungsweise des »immateriellen Baustoffs«. Im 1929 gebauten Barcelona-Pavillon wird eine beleuchtete Wand multifunktional, indem sie tagsüber als lichtdurchlässiges Fenster, nachts als Lichtquelle und als undurchdringlicher Raumabschluss dient.

Mischa Kuballs Auseinandersetzung mit dieser Architektur ist evident: Die Leuchtkastenarbeiten *Mies-Mies I* aus dem Jahre 1993 und *Mies-Mies II* aus dem Jahre 1994 spiegeln die visuellen Beobachtungen, die er während eines mehrere Tage und Nächte währenden Aufenthalts im Pavillon gemacht hat. *Mies-Mies I* setzt sich aus Stelen mit jeweils 4 in den Motiven identischen Leuchtkästen zusammen. Die beiden äußeren Stelen zeigen fotografische Details von der Lichtwand im Mies-van-der-Rohe-Pavillon in Barcelona, die beiden

Abb. S. 106–108

negated the traditional channels of communication for art and forged ahead into the public domain. The Mannesmann AG high-rise on the banks of the Rhine displayed six different arrangements of light for a period of six weeks, transforming the office building by night into a monolithic light sculpture. Kuball was not the projectionist; rather, the building projected itself outward through everyday functional office lighting.

Figs. pp. 166–171

Artificial light has been integrated into architecture as an active design technique since the advent of modernism, enhancing the traditional architectural means of expression. Twentieth-century architectural history has shown that light has emancipated itself as a rhetorical component of architecture. Ludwig Mies van der Rohe, for example, was concerned with autonomous architectural lighting design far removed from any mystical connotations or from those forms which had borrowed from neon advertising. In his buildings, he examined the effectiveness of this "immaterial building material." In the Barcelona Pavilion, built in 1929, a lit wall becomes multifunctional: during the day it serves as a translucent window, transforming at night into a source of light and an impenetrable partition wall.

Mischa Kuball's examination of this architecture is evident: the light-box pieces *Mies-Mies I* from 1993 and *Mies-Mies II* from 1994 reflect the visual observations he made while staying in the Pavilion over a period of several days and nights. *Mies-Mies I* is composed of columns, each containing four light boxes with identical motifs. The two outside

Figs. pp. 106–108

inneren Stelen das reine Neonlicht und die mittlere zeigt den Pavillon selbst durch 4 diverse Gläser fotografiert. Der Leuchtkasten *Mies-Mies II* wiederum zeigt die auf den Betrachter rückverweisende »Lichtwand« im Mies-Pavillon in Barcelona.

Der Fokus Kuballs richtet sich jedoch nicht hauptsächlich auf die rein formale Aussage des lichtarchitektonischen Eingriffs Mies van der Rohes. Vielmehr reflektieren die Leuchtkästen den konzeptionellen Schwerpunkt der architektonischen Immaterialität. Licht wird zum architektonischen Element, mehr noch: Licht wird zu multifunktionaler Architektur, zum Zeichen. Das gestalterische Element, das die Lichtwand definiert, wird zu einem abstrakten Bild, dessen örtliche Bezogenheit nicht entziffert werden kann. Das Projektive der architektonischen Begrenzung wird selbst Gegenstand der Projektion. Ein Raum der Kunst wird zum Objekt der Kunst.

Die Beschäftigung mit den Traditionen der Avantgarde ist signifikant für Mischa Kuball. Dabei kommt dem Bauhaus, gegründet 1919 in Weimar und fortgesetzt 1925 in Dessau, eine zentrale Rolle zu. Das Bauhaus als wichtigste Kunstschule der Moderne sorgte nicht nur für eine formale Neuorientierung der Kunst, seine Wirkungsgeschichte zog ebenso eine neue Funktionszuweisung von Kunst nach sich. Der subversive und zugleich provokative Bauhaus-Gedanke einer sozial relevanten Kunst, die wichtige formale Innovationen hervorbrachte, fasziniert bis heute.

Dieser utopische Mythos wird von Mischa Kuball in dem ortsspezifischen Ausstellungsprojekt *Bauhaus-Block* 1992 in Dessau neu befragt, wenn er in 20 Interventionen for-

columns show photographic details of the wall of light in the Barcelona Pavilion, the two inside columns show pure neon light, and the center column shows the Pavilion itself photographed through four different glasses. The light-box *Mies-Mies II*, in contrast, shows the wall of light in the Pavilion reflecting back onto the observer.

Kuball does not, however, primarily focus on Mies van der Rohe's purely formal statement of architectural light intervention. Instead, light boxes reflect the conceptual emphasis on architectural immateriality. Not only does light become an architectural element, it becomes multifunctional architecture, a symbol. The design element which defines the wall of light becomes an abstract image, and it is not possible to decipher its spatial relation. The projective quality of the architectural boundary itself becomes the object of the projection. A space of art becomes the object of art.

This occupation with the traditions of the avant-garde is significant for Mischa Kuball. The Bauhaus (founded in Weimar in 1919, continued in Dessau in 1925) plays a central role in this. As the most important school of modern art, not only was it responsible for a formal reorientation of art, its legacy resulted in a reassignment of art's function. The subversive and yet provocative Bauhaus idea of a socially relevant form of art, which produced important formal innovations, has proved fascinating right through to the modern day.

male und inhaltliche Ideen der Bauhaus-Programmatik inszeniert. Die konzeptuellen Ein- Abb. S. 130
griffe reflektieren thematische Bezüge, wie es zum Beispiel die Arbeiten *Manifest* oder
Vorkurs/Experiment aufzeigen. Der Einsatz von Licht kommentiert die materialästhetischen Abb. S. 138
Innovationen am Bauhaus. Das Bauhaus als künstlerische Schule entwickelte zwei Archi-
tekturelemente, die in den architektonischen Kanon eingingen: die sogenannte »Eck-
lösung« und den entmaterialisierenden Umgang mit Licht. Die *Lichtbrücke* skizziert mit- Abb. S. 129
hilfe des Projektors diese beiden Elemente, indem Kuball von einer verglasten Ecke des von
Walter Gropius entworfenen Bauhausgebäudes auf die gegenüberliegende Außenwand das
geometrische Formenvokabular der Kunstschule projiziert. Zusätzlich markiert die *Licht-
brücke* die unsichtbare Grenze zwischen öffentlichem und weniger öffentlichem Raum.
Mischa Kuball analysiert und kommentiert somit die Verhältnismäßigkeit von Architektur.

Im Treppenhaus des Bauhauses wiederum simuliert der *Projektionsraum 1:1:1* eine
Farbigkeit der Wände, die bereits historisch vorgegeben war. Die 1991/92 zum ersten Mal in
der Galerie Konrad Fischer gezeigte Installation projiziert geometrische Lichtformen an die Abb. S. 96–97
Wände eines Raumes, nimmt das fiktive Potential von Raumstrukturen auf und fügt ihm
eine okkupierende Komponente hinzu. Diese Arbeit erweiterte Mischa Kuball 1995 im
Rahmen einer Bielefelder Ausstellung zu László Moholy-Nagys 100. Geburtstag in den *Pro-
jektionsraum 1:1:1/Spinning Version*. Die Lichtformen werden durch rotierende Glasplatten, Abb. S. 101
die vor den Diaobjektiven angebracht sind, in den Raum reflektiert. Durch das Moment des
Rotierens der Glasscheiben wird der gesamte Raum von diversen Kombinationen aus Licht-

Mischa Kuball questioned this utopian myth anew in 1992 in the site-specific exhibition
project *Bauhaus-Block* in Dessau. Twenty interventions produced ideas relating to the
form and content of the Bauhaus program. These conceptual interventions reflected
direct thematic references, as exemplified by the works *Manifest* or *Vorkurs/Experiment*. Figs. p. 130 and p. 138
The use of light was a comment on the material aesthetic innovations at the Bauhaus. As
an art school, it developed two architectural elements which became part of the architec-
tural canon: the *Ecklösung* (corner solution) and the dematerializing treatment of light.
The *Lichtbrücke* outlines both of these elements with the help of a projector, with which Fig. p. 129
Kuball projected Bauhaus's geometric formal vocabulary from a glass corner of a
Bauhaus building designed by Walter Gropius onto the opposing exterior wall. In addition,
Lichtbrücke marked the invisible boundary between public and less public space, thus
analyzing and commenting on the proportionality of architecture.

Projektionsraum 1:1:1 in the Bauhaus stairwell, on the other hand, simulates a his-
torically predetermined wall coloration. The installation, shown for the first time in
1991–92 at the Galerie Konrad Fischer, projects geometric light forms onto the walls of a Figs. pp. 96–97
space, absorbs the fictitious potential of spatial structures, and adds to it an occupying
component. Kuball expanded this work in 1995 as *Projektionsraum 1:1:1/Spinning Version,* Fig. p. 101
as part of a Bielefeld exhibition marking László Moholy-Nagy's 100th birthday. The light
forms are reflected into the space by rotating plates of glass attached to the front of slide

überschneidungen und –formen erfasst. Die unterschiedlichen Distanzen des ausgestrahlten Lichts zu den Raumbegrenzungen hin verstärken die komplexe Choreografie von Licht, Form, Bewegung und Geschwindigkeit. Die Reminiszenz an Moholy-Nagys berühmten *Licht-Raum-Modulator* – zugleich unter dem Namen *Lichtrequisit* bekannt – ist durchaus beabsichtigt. Auch da bestand die kompositorische Kraft in der Erzeugung dynamischer Licht- und Raumwirkungen.

Das Aufbrechen konstruktiver Strukturen mittels Licht geht auf eine kunsthistorische Tradition zurück, deren theoretische Konzepte das künstlerische Programm unseres Jahrhunderts revolutionierten. Mischa Kuball bezieht sich mit seinen künstlerischen Eingriffen auf die Traditionen der Avantgarde. Dieser Bezug auf die Moderne zeigt eine Signifikanz für die Gegenwartskunst in der heutigen Zeit auf. Die formalen Beziehungen zu den Künstler-Ingenieuren der 1920er-Jahre wie Moholy-Nagy, die das Licht als produktives Gestaltungsmittel einsetzten, um raumgreifende, raumkonstituierende und raumtranszendierende Wirkungen zu erzielen, sind offensichtlich. Die formelle und inhaltliche Ausdehnung steigert sich bei Moholy-Nagy vom Bühnenraum über einen »virtuellen Raum« bis zu einem »Raum der Gegenwart«,[2] der als Laboratorium zur Sensibilisierung der Wahrnehmung gedacht ist. In Mischa Kuballs Arbeit *Projektionsraum 1:1:1/Spinning Version* dynamisiert der Akt der Rotation der Glasplatten die Installationen und evoziert dadurch noch augenscheinlichere Parallelen zum *Licht-Raum-Modulator* Moholy-Nagys. Mischa Kuball integriert über die sich bewegenden Lichtquellen die Umgebung und auch die Betrachtenden in

projector lenses. The momentum of the rotating plates of glass allows the entire space to be captured by diverse combinations of light intersections and forms. The varying distances of the projected light to the edges of the space strengthen the complex choreography of light, form, movement, and speed. Any resemblance to Moholy-Nagy's famous *Licht-Raum-Modulator* (also known as *Lichtrequisit*) is entirely intentional. The compositional force in that work also lay in the creation of dynamic light and spatial effects.

That light can be used to break open constructive structures can be traced back to a tradition of art history, the theoretical concepts of which have revolutionized the artistic agenda since the twentieth century. Mischa Kuball's artistic interventions allude to the traditions of the avant-garde, a reference to modernism which is significant for present-day contemporary art. There are obvious formal relationships to the artist-cum-engineers of the 1920s such as Moholy-Nagy, who utilized light as a productive means of design in order to achieve effects which consumed, constituted, and transcended space. His expansion, in terms of form and content, progresses from stage area to "virtual space" to a "space of the present,"[2] which is conceived of as a laboratory for perceptual sensitization. The rotation of the glass plates lends the installation *Projektionsraum 1:1:1/Spinning Version* a dynamic character, evoking even more apparent parallels to Moholy-Nagy's *Licht-Raum-Modulator.* Mischa Kuball uses the moving light sources to integrate both the surrounding area and the observer into a situation resembling a stage.

eine bühnenähnliche Situation. Die museale Präsentationsform zu verlassen, sich in Opposition zu bestehenden Kunstverhältnissen zu begeben und sich damit realen Kunstverwertungsmechanismen zu verweigern, das hat Kuball kategorial mit der Moderne gemein. Arbeiten wie der *Bauhaus-Block* zeugen von der abstrakten Auseinandersetzung mit dem Raum. In Arbeiten wie *Moderne, rundum* tritt die modernistische Syntax der Lichtformen in Kontrast zu Abbildungen kunsthistorischer Monumente der Moderne. Die rotierenden Bilder sind nur für wenige Augenblicke identifizierbar, um dann verfremdet im Raum zu verschwinden.

Abb. S. 90–95

Mischa Kuballs Raumbesetzungen oszillieren zwischen Abstraktem und Konkretem, wie etwa in der 2006 gezeigten Installation *Zwei Abendräume für Köln*. In den benachbarten Kirchen St. Peter und St. Cäcilien[3] transportieren mit- und gegeneinander rotierende Projektoren horizontale und vertikale Lichtschlitze, die den liturgischen Raum mit Licht »abgreifen«, sodass für kurze Momente kreuzförmige Schnittpunkte entstehen. Die rotierenden Lichtstreifen tasten in unterschiedlicher Höhe die Innenwände der Räume ab und scheinen die Raumoberfläche ebenso wie Personen und Gegenstände im Lichtfokus zu scannen. Eine nur kurzfristig auftauchende Kreuzform bildet das einzige wiedererkennbare Zeichen. Die fraktale und sinnliche Qualität von Licht erscheint wie eine Metapher des visuellen »Begreifens«. Spiegeln sich darin nicht die limitierten menschlichen Fähigkeiten, komplexe Dinge gleichzeitig zu erkennen und in Beziehung zueinander zu setzen?

Abb. S. 192–193

Kuball undoubtedly shares some similarities with modernism: abandoning a museal form of presentation, positioning himself in opposition to the prevailing conditions in the art scene, and thus rejecting the existing mechanisms of the exploitation of art.

Works such as *Bauhaus-Block* from 1992 are evidence of the abstract examination of space. The modernistic syntax of light forms in *Moderne, rundum,* for example, contrasts with illustrations of historical monuments of modern art. The rotating pictures can only be identified briefly before disappearing, distorted, into the space.

Figs. pp. 90–95

Mischa Kuball's appropriations of space oscillate between the abstract and the concrete. One example of this is the installation *Zwei Abendräume für Köln,* shown in 2006. Projectors rotate both parallel and counter to each other in two neighboring churches, St. Peter and St. Cäcilien.[3] They carry horizontal and vertical strips of light which "grip" the liturgical space, creating cruciform intersections for a fleeting second. The rotating strips of light sweep the interior walls at various heights, seeming to scan the surface of the room, people, and objects with their focus. The shape of a cross briefly appears, constituting the only recognizable symbol. The fractal and sensual quality of light seems to be a metaphor for visual "grasping," or comprehending. Is this not a reflection of the limited human ability to recognize complex things simultaneously and place them in relation to one another?

Figs. pp. 192–193

Mischa Kuball entwickelt neue Zugänge der Wahrnehmung, er differenziert Bekanntes, inszeniert seine ästhetische Analyse an und in Räumen, durchleuchtet Übergänge. Innen und Außen stehen dabei immer in Verbindung und gleichzeitig zur Diskussion. Bei der Kölner Installation geschieht die visuelle Verbindung der Kirchen über die beiden einander gegenüberliegende Türen in den Gebäuden, die Mischa Kuball mit 2 blitzenden Stroboskop-Lichtern markiert. Unbehagliches Blitzlicht im Außenbreich kontrastiert das ruhige Gleiten des Lichts im Inneren.

Abb. S. 348–349 Diese Aufmerksamkeit erregende Methodik hat Mischa Kuball unter anderen Vorzeichen bereits 2005 bei seinem Projekt *FlashBoxOldenburg* angewendet. Anlässlich des 100-jährigen Jubiläums einer 1905 von Peter Behrens in Oldenburg kuratierten Landesausstellung, entwickelte Mischa Kuball eine zweiteilige Installation für die Stadt. Die Ausstellungsräume der beteiligten Institutionen, das Edith-Ruß-Haus für Medienkunst und der Oldenburger Kunstverein, wurden ihrer repräsentativen Funktion enthoben, indem sie entleert, mit Aluminiumfolie ausgekleidet und mit 36 000 Watt starken Stroboskopblitzen ausgestattet wurden. Parallel dazu wurden die Oldenburger Bürger über die Zeitung gebeten ihre Hauswände für die Installation einer 17 Watt starken blitzenden Stroboskoplampe zur Verfügung zu stellen. Insgesamt wurden über 60 Lichter an den Hauswänden montiert, involviert waren jedoch sehr viel mehr Personen, denn die optische Wirkung der Blitze erreichte vor allem auch die Nachbarn und löste kontroverse Diskussionen und Besorgnis aus. Mit dieser kalkulierten Störung filterte Mischa Kuball die lokalen Bedingungen der

Mischa Kuball develops new avenues of perception, identifies differences in the familiar, enacts his aesthetic analysis of and in spaces, and illuminates transitions. While the internal and external are connected, they are also the subject of discussion. In the Cologne installation the churches are visually connected by the opposing doors of the structures. Mischa Kuball has marked them with two flashing stroboscopic lights. The discomfort of the flashing light outside forms a contrast to the calm light inside.

Figs. pp. 348–349 Mischa Kuball had already used this attention-raising technique, albeit under different circumstances, for his *FlashBoxOldenburg* project in 2005. He developed a two-part installation for the German town of Oldenburg to mark the one hundredth anniversary of a regional exhibition curated by Peter Behrens in 1905. The exhibition spaces of the participating institutes—the Edith-Russ-Haus für Medienkunst and the Oldenburger Kunstverein—were relieved of their more conventional function and emptied, lined with aluminum foil, and equipped with 36,000-watt stroboscopic lights. Parallel to this, the local newspaper ran an article asking citizens of Oldenburg if they would permit a seventeen-watt flashing stroboscopic light to be installed on their house fronts. Over sixty lights in total were attached to the façades of private homes, yet far more people than that were involved: the optical effect of the flashing lights was experienced primarily by the neighbors, setting off controversial discussions and causing concern. Mischa Kuball used this calculated disturbance to filter the local conditions of the town by using its resources. By

Stadt, nutzte ihre Ressourcen. Durch die Integration der Oldenburger Bürger in sein urbanes Experiment schuf er ein temporäres Kollektiv, dessen heterogene Struktur kommunikative Prozesse initiierte. Kuballs Definition der »Öffentlichkeit als Labor«[4] sieht den Künstler in der Rolle eines Forschers, der um noch unentdeckte Potenziale innerhalb eines sozialen Gefüges in der Stadt ringt. Diese Stimulation von Kommunikationsprozessen in der Tradition Marshall McLuhans, der das »Licht als Botschaft« propagierte, geschieht fern eines materialistischen Kunstwerkes oder –wertes, sondern als aktivierender Impuls. In unserem heutigen Medienzeitalter besitzen McLuhan zufolge derartige ästhetische »Wahrnehmungsexperimente eine hohe Attraktivität«, da sie »das Physische in seinen imaginären Dimensionen befragen«.[5]

Mischa Kuball erreicht via Lichtinterventionen das Publikum einer belebten Stadt, berührt eine Sphäre zwischen dem Innen und Außen der Architektur und dem gebauten Gefüge einer Stadt. Architektur oder Raum wird neu besetzt.

Die Futuristen zielten in ihren Manifesten sowie Performances darauf ab, die Distanz von Kunst und Alltag zu reduzieren und antizipierten so aktionistische Handlungen der performativen Kunstrichtungen der 1960er-Jahre, wodurch sich bereits der traditionelle Kunstbegriff öffnete. Zwei Aspekte dieser Entwicklung sind wiederum in der Konstruktion der Kunst Mischa Kuballs entscheidend: Die Kunst als Aktion schließt Partizipation mit ein, und die Disposition des Wahrnehmens und optimalerweise des Handelns im Alltag soll modifiziert werden.

integrating the people of Oldenburg into his urban experiment, he created a temporary collective, the heterogenic structure of which initiated communicative processes. According to Kuball's definition of "the public laboratory,"[4] the artist is a researcher struggling with the undiscovered potential within a social structure in the town. This stimulation of communicative processes following the tradition of Marshall McLuhan, who propagated "light as message," occurs as an activating impulse, far from a materialistic work of art (or art value). McLuhan believes that in our media age, aesthetic "perceptual experiments are highly attractive" because they "question the physical in its imaginary dimensions."[5]

Mischa Kuball reaches the public of a busy town with his light interventions, touches a sphere between interior and exterior architecture and the structure of buildings within a town. Architecture or space is reoccupied and redefined.

Futurist manifestos and performances aimed to reduce the distance between art and everyday life; in so doing they anticipated the actionism of Performance Art in the 1960s and consequently widened the traditional concept of art. Two aspects of this development are in turn crucial to the construction of Mischa Kuball's art: firstly, that art as action relies on participation; and secondly, that the nature of perception and of (ideally) everyday activity should be transformed.

Gerade die Entgrenzungsstrategien der 1960er-Jahre hinterließen nachhaltige Spuren, indem sie nahezu jedes beliebige Material als »kunstwertig« nobilitierten und den traditionellen Kunstraum aus seiner eindeutigen Bestimmung befreiten. Kunst begann, das institutionelle Umfeld des White Cube zu negieren und künstlerische Verfahren abseits tradierter Methoden zu erforschen.

Die eingelöste Vision der Verschmelzung von Kunst und Leben der 1960er- und 1970er-Jahre bewirkte eine neue Stufe der Interaktion zwischen Kunst und Öffentlichkeit. Als legitimierte künstlerische Praxis setzte sich das Konzept der Ortsspezifik durch, das die Gewichtung vom autonomen Werk zum ortsspezifischen Konzept vornimmt. Anfang der 1990-er Jahre fokussieren sich die zu verhandelnden Themen auf spezifisch gesellschaftliche Phänomene, und die Künstler suggerieren durch Integration der Betrachter eine konkrete soziale Relevanz.

Angesichts der heute ungewissen Bedeutung des öffentlichen Raumes und seines ungenutzten Potenzials drücken die Interventionen Kuballs den Versuch aus, neue Formen raumspezifischer »Be-Setzungen« zu erproben. Kuballs konzeptuelle Behutsamkeit nutzt dabei das Vorhandene der jeweiligen Orte. Seine ortsspezifischen Eingriffe zielen darauf, gegebene Raum-Situationen in ihrer Struktur und Funktion sichtbar zu machen. In der 1994 entstandenen Leipziger Arbeit *Leerstand/Peepout* bricht er die Raumkonstellationen auf und disponiert sie neu. Kuball stellt 2 Scheinwerfer in einer bewohnten Wohnung auf, die mit ihrem Lichtfokus die Fassade des gegenüberliegenden Hauses markieren. Das

Abb. S. 174–175

Precisely these strategies aimed at dissolving boundaries in the 1960s left long-lasting traces, crowning virtually any old material as "artistically valuable" and freeing the traditional artistic space from its narrow confines. Art began to negate the traditional environment of the white cube and venture out beyond orthodox artistic methods.

The redeemed vision of the fusion of art and life from the 1960s and 1970s effected a new level of interaction between art and the public sphere. The concept of site-specificity became accepted as a legitimate artistic practice, emphasis shifting from the autonomous work to the site-specific one. The focus was on specific social phenomena at the beginning of the 1990s, and the artists imply a concrete social relevance by integrating the observer.

Faced with the currently ambivalent significance of public space and its unused potential, Kuball's interventions express the attempt to try out new forms of space-specific "appropriations." His conceptual caution uses what is already available at each site. His site-specific interventions aim to make the given spatial situations visible in their

Figs. pp. 174–175

structure and function. In his 1994 Leipzig work *Leerstand/Peepout,* he takes apart the combinations of rooms and rearranges them. He places two spotlights in an inhabited apartment which highlight the front of the opposing house with their rays. The light enters an uninhabited apartment through the window. Highlighting these empty apartments helped uncover further unoccupied apartments during the course of the project.

Licht tritt durch die Fenster in eine unbelebte Wohnung. Diese Markierung des Leerstands von Wohnungen deckte im Verlauf des Projekts weiteren Leerstand auf.

Die vorhandene Architektur wird durch den punktuellen Scheinwerfer zu einem symbolischen Display. Die Bedeutungen schwingen zwischen der störenden Markierung und ihren politischen Implikationen hin und her. Indem der Lichtkegel die Aufmerksamkeit auf ein städtisches Problem richtet, thematisiert er die Leere und reißt sie für einen Moment aus ihrer »Nicht-Existenz«. Kunst agiert als eine »notwendige Belästigung«,[6] indem sie die Betrachter für bestimmte urbane Räume, deren soziale Qualitäten verloren gegangen sind, zu sensibilisieren versucht. Gerade die der Immaterialität inhärente Reinheit von Licht hat die ästhetische Kompetenz, den ortsspezifischen Dialog zwischen Betrachter und Werk anzustoßen, die historische, soziale oder politische Relevanz eines Ortes ins Bewusstsein zu heben und in den Fokus einer gesteigerten Wahrnehmung zu rücken.

Kuballs Interventionen zielen auf eine visuelle Sensibilisierung für noch unentdeckte und doch sichtbare Dialoge im urbanen Umfeld. Seine Formen der Hausbesetzung implizieren zwei zentrale Assoziationen: Raum und Handlung. Innerhalb dieser konzeptuellen Dualität werden grundlegende Aspekte der künstlerischen Methodik Mischa Kuballs verhandelt. Seine »politische Grundlagenforschung« befragt die soziale Realität urbaner Räume, durchleuchtet anarchistisch die Stadt. Die urbane Lebenswelt ist durch die Erfahrung alltäglicher Kommunikation und Kooperation geprägt. Mischa Kuballs Interventionen agieren an den Grenzen dieser Lebenswelt. Sie überhöhen, irritieren, konfrontieren, ver-

The existing architecture is transformed into a symbolic display by the selectiveness of the spotlight. The significance of this oscillates back and forth between the disrupting marking of the spotlight and its political implications. By using a sphere of light to direct attention to an urban problem, he highlights emptiness, tearing it momentarily from its state of "non-existence." Art acts as a "necessary intrusion"[6] by trying to sensitize the observer to certain urban spaces that have lost their social qualities. It is light, with its purity inherent to immateriality, which has the aesthetic power to activate the site-specific dialogue between the observer and the work of art, to raise awareness of the social or political relevance of a location, to place it in the focus of heightened perception.

The goal of Kuball's interventions is the visual sensitization to those dialogues within urban surroundings which are visible yet remain undiscovered. His form of appropriation—squatting—implies two central associations: space and action. Essential basic aspects of Mischa Kuball's methodology are addressed within this conceptual duality. His "fundamental political research" questions the social reality of urban space and provides an anarchistic x-ray of the town. Urban life is characterized by the experience of everyday communication and cooperation. Mischa Kuball's interventions operate at the boundaries of this urbanity. They exaggerate, confuse, confront, and mediate. His "squatting actions" defend themselves against the mechanisms in society that control the "allocation of space." These self-determined components of Kuball's working methods create their own

ANMERKUNGEN

1 »Marc Mer in einem mit Interview Mischa Kuball«, in: *Translokation. Der ver-rückte Ort. Kunst zwischen Architektur*, hrsg. von Marc Mer u. a., Ausst.-Kat. Haus der Kunst, Graz, Wien 1994, S. 77.

2 Der »Raum der Gegenwart« stellt ein utopisches Raummodell Moholy-Nagys dar, der synthetisierend »Licht« ausstellen und zugleich theoretisch thematisieren sollte. Vgl. Anne Hoormann, *Lichtspiele. Zur Medienreflexion der Avantgarde in der Weimarer Republik*, München 2003, S. 238–247.

3 St. Peter fungiert als Kirche und temporärer Ausstellungsraum Kunststation St. Peter. Die ehemalige Kirche St. Cäcilien ist heute ein Teil des Museums Schnütgen in Köln.

4 Mischa Kuball: »›And it's a pleasure . . . ‹. Öffentlichkeit als Labor«, in: *Public Art. Kunst im öffentlichen Raum*, hrsg. von Florian Matzner, Ostfildern 2001, S. 307.

5 Monika Wagner, *Das Material in der Kunst. Eine Geschichte der Moderne*, München 2001, S. 297.

6 *Leerstand. Comfortable Conceptions*, Ausst.-Kat. Förderkreis der Galerie für Zeitgenössische Kunst, Leipzig 1994, S. 46.

7 Mischa Kuball, in: Matzner 2001, S. 307

NOTES

1 Mischa Kuball, interview by Marc Mer, in *Translokation: Der ver-rückte Ort: Kunst zwischen Architektur,* ed. Marc Mer et al., exh. cat. Haus der Kunst, Graz (Vienna, 1994), p. 77.

2 The "space of the present" represents a utopian spatial model of Moholy-Nagy, which is simultaneously a synthetic exhibit and a theoretical examination of "light." See Anne Hoormann, *Lichtspiele: Zur Medienreflexion der Avantgarde in der Weimarer Republik* (Munich, 2003), pp. 238–247.

3 St. Peter is both a church and a temporary exhibition space, known as Kunststation St. Peter. The former church of St. Cäcilien is now part of the Schnütgen Museum in Cologne.

4 Mischa Kuball, "'And it's a pleasure . . .' /The Laboratory of Public Space," in *Public Art: A Reader,* 2nd, revised edition, ed. Florian Matzner (Ostfildern, 2004), p. 291.

5 Monika Wagner, *Das Material in der Kunst: Eine Geschichte der Moderne* (Munich, 2001), p. 297.

6 *Leerstand: Comfortable Conceptions*, exh. cat. Förderkreis der Galerie für Zeitgenössische Kunst (Leipzig, 1994), p. 46.

7 Mischa Kuball, in Matzner 2004 (see note 4).

mitteln. Seine »Hausbesetzungen« wehren sich gegen die gesellschaftlichen Mechanismen der »Raumzuweisung«. Diese selbstbestimmte Komponente der Arbeitsweise Kuballs schafft sich einen eigenen Freiraum jenseits der durch Konventionen definierten Orte. Darin drückt sich ein Bedürfnis aus, das sich als kritischer Kommentar zur Teilnahmslosigkeit gegenüber dem öffentlichen Raum lesen lässt, in dem sich heute durch die mannigfaltigen Verfahren der Überwachung sogar der Argwohn gegenüber jeder Äußerung des Individuellen andeutet.

Hausbesetzung als aufklärerisches Wagnis! Die Tatsache, dass Mischa Kuballs erste Ausstellung 1980 in einem besetzten Haus in Düsseldorf stattfand, erscheint wie eine ironische »Prä-Position«, wie ein potentieller Vorgriff für seine zukünftige Wirkungskraft. Kuball selbst klärt kämpferisch auf: »Jede Geste in der Stadt ist politisch.«[7]

free space beyond those places defined by convention. A need is expressed through this which can be read as a critical commentary on the indifference to public space, in which the manifold opportunities for surveillance indicate suspicion of any comment made by an individual.

So squatting becomes an educational adventure or dare! The fact that Mischa Kuball's first exhibition was held in a squatted building in Düsseldorf seems to be an ironic "pre-position," like a potential anticipation of his future impact. Kuball's own comment is pugnacious: "Every gesture in the city is political."[7]

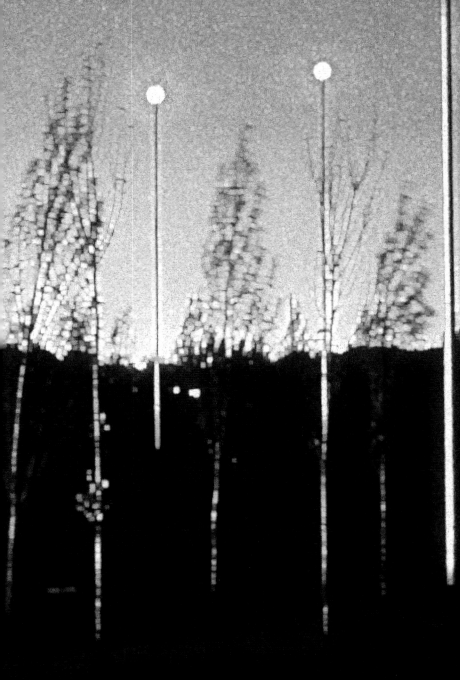

ARCHITECTURE | PERMANENT

ARCHITEKTUR | PERMANENT

<<
Oval Light (Detail), 1999,
Fortbildungsakademie Mont-Cenis,
Herne
(Foto: Werner Hannappel, Essen),
Vgl. Abb. unten / See fig. below

Oval Light, 1999,
Fortbildungsakademie Mont-Cenis,
Herne; 41 Lichtmasten von je 2,20
bis 17,50 m Höhe
(Foto: Werner Hannappel, Essen)

Die Lichtinstallation kommuniziert
mit dem kubischen, durch die Glas-
flächen transparenten Baukörper
der französischen Architektin Fran-
çoise Hélène Jourda. Die elliptische
Landschaftsform der Umgebung wird
als raumschaffende Lichtprojektion
zum Gebäude der Akademie in Bezie-
hung gesetzt. Insgesamt 41 Licht-

punkte markieren den Verlauf des
Ovals in der Lichtfarbe Blau. Auf
Lichtmasten von 2,20 bis zu 17,50
Metern steigen sie in progressiven
Schritten aus dem Boden heraus, bis
sie eine Höhe mit der Gebäudeober-
kante einnehmen und so die Orientie-
rung an der vorhandenen architek-
tonischen Struktur deutlich wird.

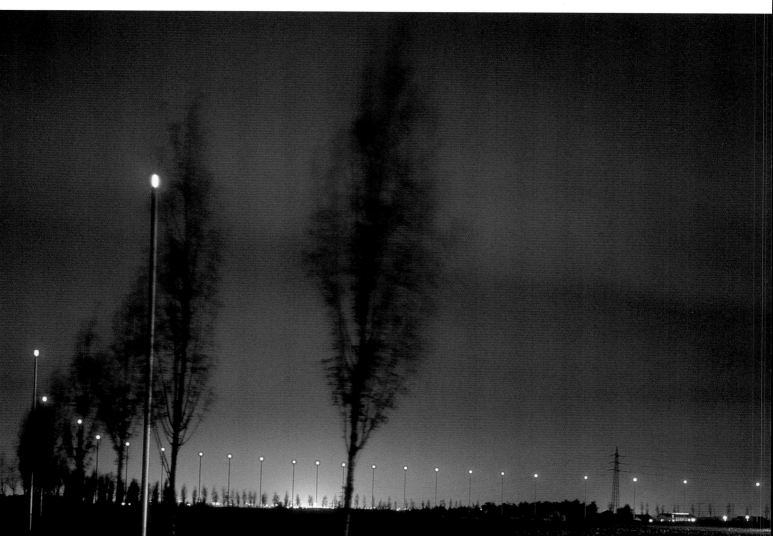

Oval Light, 1999,
Fortbildungsakademie Mont-Cenis,
Herne; 41 light masts, each ranging
from 2.20 to 17.50 m in height
(photograph: Werner Hannappel,
Essen)

The light installation communicates
with the cubic, transparent glass
structure by French architect
Françoise Hélène Jourda. As a space-
creating light projection, the ellipti-
cal landscape shape of the surround-
ing environment takes on a relation-
ship to the academy building. A total
of 41 points of blue light mark the
outline of the oval. On light masts
ranging in height from 2.20 to 17.50
meters, they project out of the
ground, moving to progressively
higher stages, until they reach the
height of the top edge of the building,
which makes it clear that the instal-
lation is oriented toward the existing
architectural structure.

Metasigns, 2000/01,
Holzmarkt, Jena; je 11 Hindernis-
feuer-Leuchten, Ø Bodenkreis:
18 m, Ø Dachkreis: 90 m
(Foto: Archiv Mischa Kuball, Düssel-
dorf)

Am zentralen Holzmarkt in Jena wur-
den 11 orangefarbene Hindernis-
feuer-Leuchten kreisförmig in den
Boden versenkt. 5-fach vergrößert
wurde ein weiterer Leuchtkreis
schließlich an den Dächern der
umliegenden Häuser installiert. Die-
ser nur aus der Höhe wahrnehm-
bare Kreis ist für Passanten auf der
Ebene der Kreisform auf dem Markt
jedoch ideell nachvollziehbar. *Meta-
signs* ist ein Beispiel für eine konzep-
tuelle urbane Intervention, da sie
sich einer direkten Einsichtnahme
entzieht.

Metasigns, 2000/01,
Holzmarkt, Jena; 11 obstacle lights,
Ø ground: 18 m, Ø roof: 90 m
(photograph: Mischa Kuball Archive,
Düsseldorf)

At the central Holzmarkt in Jena,
eleven orange obstacle lights were
sunk into the ground in a circle.
Another circle of lights five times as
large was then installed on the roofs
of the surrounding houses. However,
passers-by can imagine this circle,
which could only be seen from above,
at the level of the circle at the mar-
ketplace. *Metasigns* is an example
of a conceptual urban intervention,
since it prohibits direct perusal.

217

Yellow Marker (Ostpol und Westpol),
2001, Kamp-Lintfort und Bönen;
2 je 87 m lange LEDs, 2 je 124 m
lange LEDs
(Foto: Werner Hannappel, Essen)

Im Rahmen der IBA Emscher-Park
inszeniert Mischa Kuball eine ima-
ginäre Verbindung zwischen Osten
und Westen des Emscher Parks.
An den Fördertürmen der Zeche Ros-
senray (in Betrieb) in Kamp-Lintfort
im Westen und der Zeche Königsborn
in Bönen (1988 stillgelegt) im Osten
installierte er jeweils 2 gelbe Licht-
linien aus LEDs. Die auf gleicher
Höhe endenden vertikalen Lichtlinien
bilden so über die Distanz von 80 km
eine ideelle horizontale Verbindung.

Yellow Marker (Ostpol and Westpol),
2001, Kamp-Lintfort and Bönen;
2 87-meter-long LED tubes,
2 124-meter-long LED tubes
(photograph: Werner Hannappel,
Essen)

For the IBA Emscher Park Kuball
sets up an imaginary connection
between the east and west sides of
the Emscher Park. On the shaft
towers of the Rossenray mine (still
in operation) in Kamp-Lintfort in the
west and the Königsborn mine in
Bönen (closed in 1988) in the east,
he installed two yellow lines of LED
light. The vertical lines, which end
at the same height, form an ideal
horizontal connection even at a dis-
tance of eighty kilometers.

NetLight, 2002/3,
Erfurt; 4 Stahlmasten 10 m Höhe,
10 cm Durchmesser, 4 LED Licht-
linien je 3 m
(Foto: start.design, Ralph Kensmann,
Essen, Thomas-Michael Franke,
Erfurt)

Einer von 4 Stahlmasten, die alle mit
einer roten LED-Lichtlinie versehen
sind, ist vor dem Neubau des Stadt-
theaters positioniert. Die 3 weiteren
Masten befinden sich an städtebau-
lich zentralen Positionen in Erfurt.
Diese Form der urbanen Vernetzung
von Theaterneubau und Stadtraum
von Erfurt findet seine Fortsetzung
im Foyer des Theaters, wo die Licht-
linien im Dialog mit der Architektur
eingelassen sind.

NetLight, 2002/3,
Erfurt; 4 steel masts 10 m high,
10 cm circumference, 4 lines of
LED light, each 3 m
(photograph: start.design,
Ralph Kensmann, Essen, Thomas-
Michael Franke, Erfurt)

One of four steel masts, all of them
with a line of red LED lights, is posi-
tioned in front of the new Stadtthe-
ater. Three other masts are located
in central positions in the city of
Erfurt. This form of urban network,
connecting the theater and the urban
space of Erfurt, was continued in
the theater lobby, where the lines
of light were involved in a dialogue
with the architecture.

Public Eye I + II, 2002,
Kunstmuseum Bonn; 2 Videostills,
Digitaldruck auf Plane,
je 5 x 5 x 1 m, 2 Dia-Leuchtkästen
(Foto: Achim Kukulies, Düsseldorf)

Die Lichtinstallation ist als Leucht-
kasten in die Fassade des Museum
integriert und besteht aus zwei
hinterleuchteten Stills aus dem Video
City thru Glas/New York night version.
Dies ergänzte eine Videoinstallation
im Innenraum des Museums, die
City thru Glas/Night Version NY zeigte.

Public Eye I + II, 2002,
Kunstmuseum Bonn; 2 video stills,
digital print on tarpulin, 5 x 5 x 1 m
each, 2 slide light boxes
(photograph: Achim Kukulies,
Düsseldorf)

The light installation is integrated
into the façade of the museum and
consists of two backlit stills from
the video *City thru Glass/New York
Night Version*. This accompanied
a video installation inside the
museum showing *City thru Glass/
Night Version NY*.

Crosses, 2005,
Johanneskirche, Diözesanmuseum
Freising; LED-Blitzprojektion
250 x 250 cm
(Foto: Hermann Reichenwallner,
Freising)

Das aus LED-Blitzen konstruierte
Kreuz in der Freisinger Johannes-
kirche setzt sich mit dem symbo-
lischen Gehalt dieser Form ausein-
ander, indem verschiedene Blitzfor-
mationen unterschiedliche Kreuz-
arten erscheinen lassen. Nach länge-
rer Betrachtung offenbaren sich den
geblendeten Augen 3 verschiedene
Kreuzformen: das T-Kreuz, das latei-
nische und das griechische Kreuz.

Crosses, 2005,
Johanneskirche, Diözesanmuseum
Freising; LED flash projection,
250 x 250 cm
(photograph: Hermann Reichen-
wallner, Freising)

The cross of flashing LED lights in
the Johanneskirche in Freising
explores the symbolic content of this
form, since various flashing forma-
tions make different kinds of crosses
appear. After longer observation,
the dazzled eye finally perceives
three different kinds of crosses: the
Tau, the Roman, and the Greek cross.

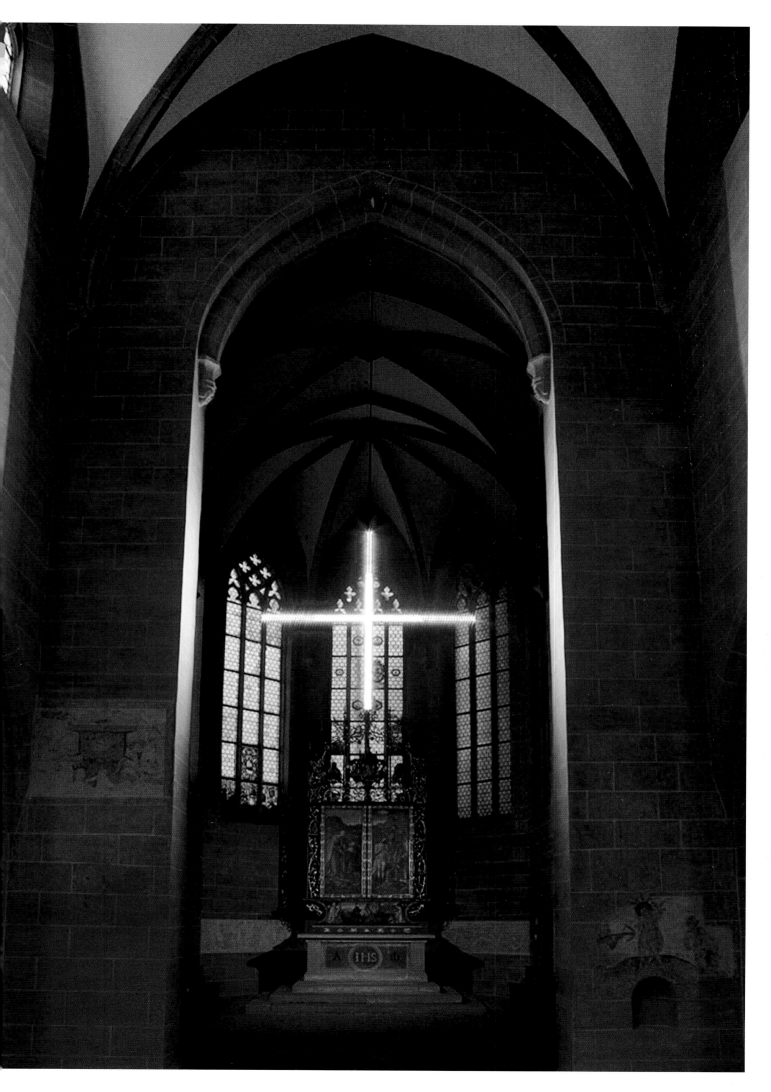

KUNSTSAMMLUNGENDERRUHR-
UNIVERSITÄTBOCHUM, 2003,
Kunstsammlungen der Ruhr-Univer-
sität Bochum; 37 weiße Neonbuch-
staben, Versalhöhe 1000 mm,
auf 65 m Breite installiert, Zufalls-
steuerung DMX-Programmierung
(Foto: Thorsten Koch, Bochum)

Die Großbuchstaben des Schrifttyps
Futura Light verblenden das nach
oben abschließende Betonband des
Gebäudes, in dem sich die Kunst-
sammlung befindet. Ein Zufallsge-
nerator lässt punktuell einzelne
Buchstaben aufleuchten, alle 5–10
Minuten wird das gesamte Schrift-
bild aktiviert.

KUNSTSAMMLUNGENDERRUHR-
UNIVERSITÄTBOCHUM, 2003,
Kunstsammlungen der Ruhr Univer-
sität Bochum; 37 white neon capital
letters, 1000 mm high, installed
over a width of 65 m, random control
DMX programming
(photograph: Thorsten Koch, Bochum)

The large Futura light letters face
the upper concrete beam of the
building housing the art collection.
A random generator illuminates
individual letters, while the entire
written image is activated every five
to ten minutes.

UNIVERSITÄTSBIBLIOTHEKBOCHUM,
2005, Ruhr-Universität, Bochum;
28 weiße Neonbuchstaben, Versal-
höhe 1000 mm, auf 65 m Breite
installiert, Zufallssteuerung DMX-
Programmierung
(Foto: Thorsten Koch, Bochum)

Diese Arbeit steht in formaler und
gedanklicher Korrespondenz zu
Kuballs Neoninstallation der Univer-
sitätskunstsammlung, die sich am
gleichen Gebäude auf der »Rück-
seite« befindet. Am oberen Beton-
fries der Front der Bochumer Uni-
versitätsbibliothek erstreckt sich
spiegelverkehrt in weißen Neon-
buchstaben die Bezeichnung des
Gebäudes. Ein Zufallsgenerator lässt
punktuell einzelne Buchstaben auf-
leuchten, alle 5–10 Minuten wird das
gesamte Schriftbild aktiviert.

UNIVERSITÄTSBIBLIOTHEKBOCHUM,
2005, Ruhr University, Bochum;
28 white neon capital letters, 1000
mm high, installed over a width of
65 m, random control DMX program-
ming
(photograph: Thorsten Koch, Bochum)

This work stands in a formal and
conceptual correspondence to
Kuball's neon installation at the Uni-
versity art collection, which is on
the "reverse side" of the same build-
ing. The description of the building
in backward white neon letters
stretches along the upper concrete
frieze on the front of the Bochum
University library. A random genera-
tor illuminates individual letters,
while the entire written image is acti-
vated every five to ten minutes.

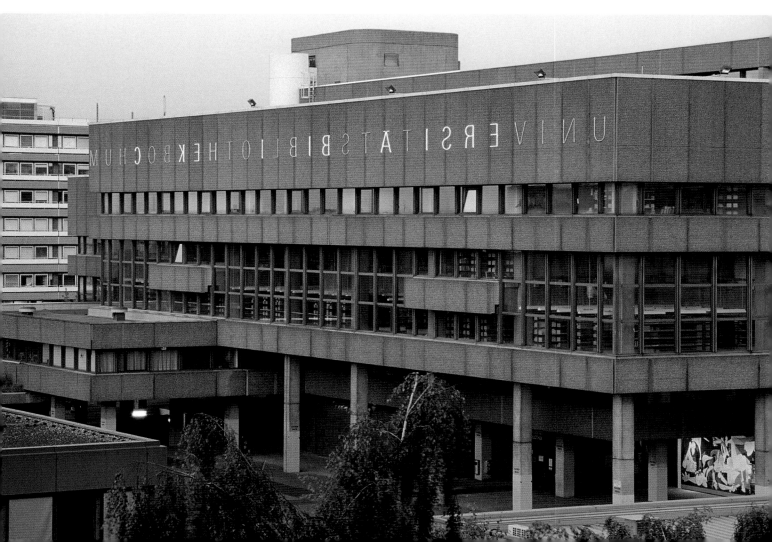

Lichtprojekt am/im Hochhaus der Schweizer National, 2006, Frankfurt am Main, 5 umlaufende LED-Lichtlinien je 160 m sowie 5 LED-Linien im Innenraum, Gesamtlänge ca. 120 m (Foto: Jürgen Hartmann, Frankfurt am Main)

Im Rahmen der Revitalisierung des ältesten Hochhauses in Frankfurt am Main akzentuiert Kuballs Lichtprojekt die klaren Architekturlinien im Außen- und Innenbereich. LED-Lichtlinien wurden an den 5 bügelförmigen Rahmenkonstruktionen angebracht und betonen so minimalistisch das architektonische Alleinstellungsmerkmal in der Frankfurter Skyline.

Lichtprojekt am/im Hochhaus der Schweizer National, 2006, Frankfurt am Main, 5 running lines of LED lights, 160 m each, and 5 lines of LED lights inside, total length approx. 120 m
(photograph: Jürgen Hartmann, Frankfurt am Main)

As part of the revitalization of Frankfurt's oldest high-rise, Kuball's light project accentuates the clear architectural lines of the building's exterior and interior. Lines of LED lights are attached to the five bow-shaped frame-like structures, giving a minimalist emphasis to this unique architectural hallmark of Frankfurt's skyline.

Folgende Doppelseite
Pacemaker, 2006 ff., Stadtwerke Düsseldorf; Lichtstele 12 m, 17 Scheinwerfer, Timer/ Programmierung, 8 Bodenschein-werfer
(Foto: Egbert Trogemann, Düsseldorf)

3 pulsierende Lichtpositionen besetzt Mischa Kuball auf dem Großareal der Düsseldorfer Stadtwerke. 8 oktogonal angeordnete Scheinwerfer verweisen auf einen nicht mehr vorhandenen Kühlturm. Der Turm des Gasturbinenkraftwerks wird durch 9 Scheinwerfer von 3 Seiten komplett dynamisch illuminiert. Die pulsierende Lichtstele am Eingang des Stadtwerkeparks verbindet die Arbeit mit dem Gelände und dem vitalen Stadtraum. Alle drei Lichtarbeiten pulsieren im gleichen Rhythmus, verweisen auch nachts visuell auf das ständige Fließen und erzeugen Energie an diesem Standort.

Following double-page spread
Pacemaker, 2006ff., Stadtwerke Düsseldorf; light stele 12 m, 17 spotlights, timers/programming, 8 ground spotlights
(photograph: Egbert Trogemann, Düsseldorf)

Kuball occupies three pulsating positions of light on the large area occupied by the Düsseldorf Stadtwerke. Eight octagonally arranged spotlights refer to a cooling tower that no longer exists. Nine spotlights completely and dynamically illuminate three sides of the tower of the gas turbine power plant. The pulsating light stele at the entrance to the Stadtwerke Park connects the work to the grounds and the vital urban space. All three light works pulse in the same rhythm. At night, they are visual references to the constant flow and creation of energy at this site.

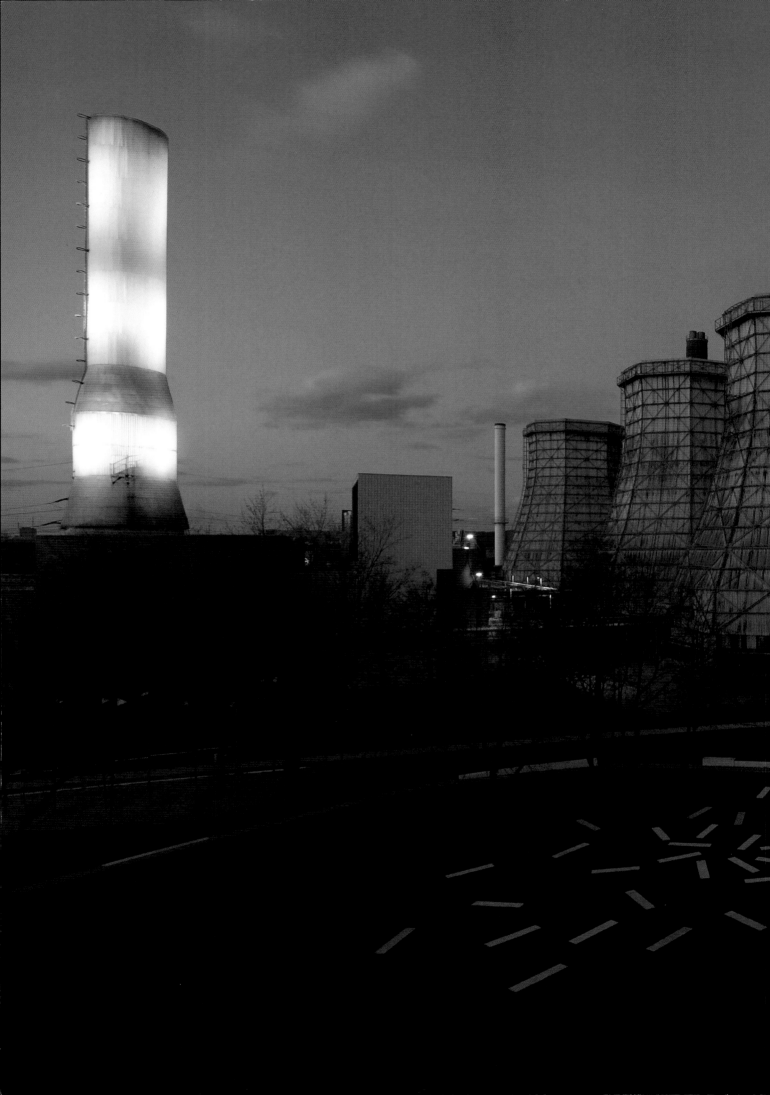

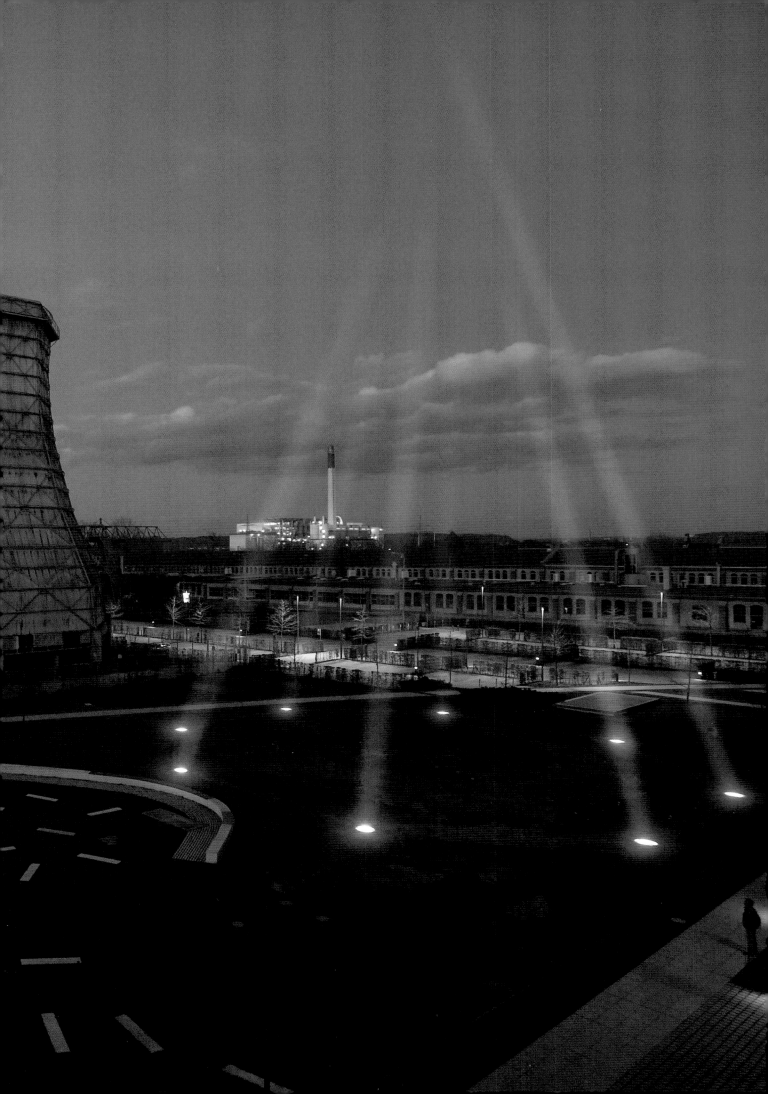

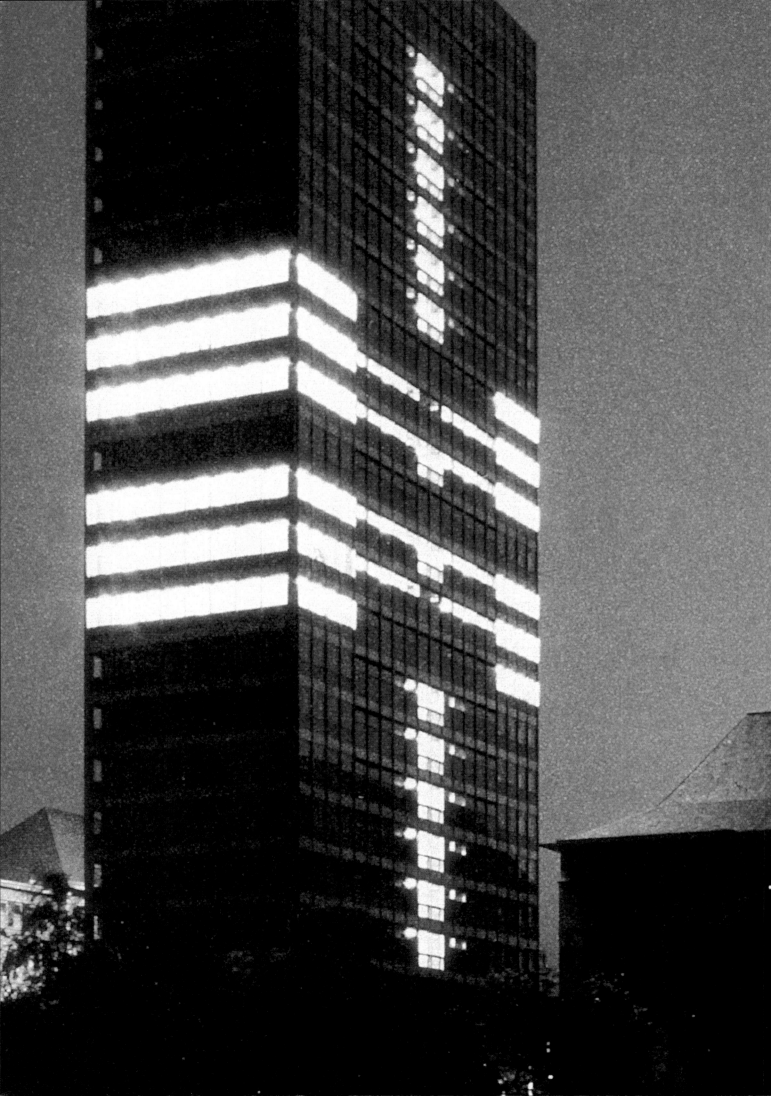

WALTER GRASSKAMP

NACHT IM ÖFFENTLICHEN RAUM
NIGHTTIME IN PUBLIC SPACE

Nur künstliches Licht kann während der Nacht sicher stellen, was tagsüber ganz selbstverständlich öffentlicher Raum ist – ohne dieses Licht wäre er pure Dunkelheit, nicht mal Raum und schon gar kein öffentlicher. Wir haben das Gespür dafür verloren, wie vollkommen dunkel es nachts mitten in einer Stadt sein kann, eine Erfahrung, die dem 18. Jahrhundert noch sehr vertraut war, wie es in Wolfgang Schivelbuschs Buch *Lichtblicke. Zur Geschichte der künstlichen Helligkeit im 19. Jahrhundert* von 1983 nachzulesen ist. Es handelt sich um ein Standardwerk zur Energiegeschichte der Moderne.

Künstliches Licht ist nachts das beste Mittel (tagsüber ist es der Lärm), um Aufmerksamkeit zu erregen und zu steuern; das gilt auch für Innenräume, aber erst recht für die öffentliche Nacht. Anders als der Lärm ist das künstliche Licht allerdings attraktiv, angenehm und willkommen, jedenfalls solange die Luxzahl stimmt. Ja, es hat eine magische Wirkung, die sich aus einer räumlichen Konzentration und der Selbstverortung des Nutznießers ergibt, sich aus dessen Orientierungsgewinn und einem Gefühl der Sicherheit zusammensetzt – sofern man nicht aus dem Dunkeln heraus mit Scheinwerfern angestrahlt und auf diese Weise exponiert wird.

Künstliches Licht gestaltet sich seinen eigenen hellen Raum in der diffusen Gegenwart des Dunkels; es schneidet mehr oder weniger trennscharf dreidimensionale Räume aus der spürbaren, aber nicht sichtbaren Masse der Dunkelheit – Räume, die ihr Umfeld

Only artificial light can reveal at night what is obviously public space during the day. Without this light, it would be pure darkness, not space at all and certainly not public space. We no longer realize how utterly dark it can be in the midst of a city at night, an experience that was quite familiar to people of the eighteenth century, as we learn from Wolfgang Schivelbusch's *Disenchanted Night: The Industrialization of Light in the Nineteenth Century* from 1983, which is now regarded as a standard work on the history of energy in the modern era.

Artificial light is the next best means of attracting and focusing attention (during the day it is noise). This applies to interior spaces as well, but especially to public night. Unlike noise, artificial light is attractive, pleasant, and welcoming, provided the intensity is right. Indeed, it has a magical effect that emerges from a sense of spatial concentration and the ability of those who benefit from it to localize themselves, an effect that combines improved orientation and a feeling of security, provided one is not illuminated and exposed by spotlights from out of the darkness.

Artificial light creates its own bright space in the diffuse presence of darkness. It cuts more or less sharply defined three-dimensional spaces from the evident, yet invisible mass of darkness—spaces that leave their surroundings in soft focus and

Megazeichen IV (Detail), 1990,
Mannesmann-Hochhaus, Düsseldorf
(Foto: Ulrich Schiller, Düsseldorf),
Vgl. Abb. S. 166–171 /
See figs. pp. 166–171

231

luminös im Unscharfen lassen und die Masse der Dunkelheit ex negativo anschaulich wer-
den lassen, denn für sich betrachtet ist jede Dunkelheit unräumlich.

Ein solcher Lichtraum kann auch dann ein öffentlicher Raum sein, wenn er nicht
betretbar ist, denn er bündelt öffentliche Aufmerksamkeit. Neonwerbung und ausgeleuch-
tete Billboards nutzen diese Eigenschaft des künstlichen Lichts, wenn auch meist eher in
der Fläche. Seit wann nutzt sie aber die Kunst im öffentlichen Raum?

Folgt man Schivelbusch, dann ist die Nacht maßgeblich durch Arbeit und Handel
erobert worden. Als Nebenprodukt der industriellen Produktion und urbanen Sicherheits-
politik hatte das künstliche Licht auch kulturelle Folgen, etwa in der Inszenierung des städ-
tischen Massenkonsums in den nun künstlich erleuchteten Schaufenstern, vor denen die
abendlichen Passanten flanieren und auf ihre Weise die Nacht erobern konnten.

Erst recht erlaubte das moderne Licht eine Vernächtlichung des Kulturkonsums, nicht
nur im häuslichen Leseverhalten, sondern vor allem in den klassischen Institutionen –
deren Veranstaltungen ließen sich nun sicherer als zuvor in die Nacht verlegen. Oper,
Schauspiel und Konzert konnten nun auch für große Besuchermassen abends organisiert
werden. Das Kerzenlicht des höfischen Kulturbetriebs hatte ausgedient und aus dem Thea-
ter wurde schließlich das Kino, in dem das künstliche Licht sogar Geschichten erzählt.

Die Kunst spielte dabei eher eine Nebenrolle, auch wenn im höfischen Fest natürlich
das Feuerwerk noch eine selbstverständliche Gattung der Kunst war. Wann zum ersten Mal
künstliches Licht als integraler Bestandteil eines Innenraum-Kunstwerks eingesetzt wor-

make the mass of darkness perceptible as a negative form, for darkness itself is non-
spatial.

Such a light space can be a public space even if it is inaccessible, as it focuses public
attention. Neon lights and illuminated billboards take advantage of this property of artifi-
cial light, although ordinarily in two dimensions. But since when has art used it in public
space?

According to Schivelbusch, night has been substantially conquered by labor and
commerce. As a byproduct of industrial production and urban safety policy, artificial light
had a cultural impact as well—in the enactment of urban mass consumption in the now
artificially illuminated display windows that attract the gazes of passers-by, who then
conquered the night in their own way.

Most importantly, modern forms of lighting have led to the nocturnalization of cul-
tural consumption, not only in people's domestic reading habits but above all in tradi-
tional institutions, which were now able to schedule their events at night much more
safely than ever before. Opera, theater, and concert performances could now be organ-
ized for large numbers of visitors during the evening hours. The era of courtly cultural
events illuminated by candlelight had passed, and the theater evolved into the cinema,
where artificial light can even tell stories.

den ist, für diese Frage bieten experimentelle Arbeiten von Künstlern des Bauhauses, vor allem von László Moholy-Nagy, erste Anhaltspunkte.

Anders steht es mit der Frage nach dem ersten Kunstwerk im öffentlichen Raum, das sein eigenes Licht mitbrachte. Auch hier dürfte das Gesetz der Verzögerung gelten, nach dem die moderne Kunst zunächst eine Innenraumkunst gewesen ist, eine Kunst aus dem Atelier für das Museum, bevor sie die im Innenraum entwickelten Formen auch im Außen-raum zur Geltung brachte.

Kunst im öffentlichen Raum hat sich um das Thema des Lichts und um ihre Sichtbar-keit bei Nacht ohnehin lange nicht scheren müssen, denn sie profitierte, sofern sie sich im urbanen Raum befand, von dessen profaner Ausleuchtung. Angesichts dieses parasitären Status wäre es nicht erstaunlich, wenn die Kunst die Nacht erst spät auf eigene Faust erobert hätte, um mit eigenem Licht am künstlich beleuchteten, öffentlichen Raum nicht nur zu partizipieren, sondern ihm auch eigene Schwerpunkte zu liefern oder ihn gar erst zu konstituieren.

Man könnte darüber streiten, ob der berühmte *Lichtdom*, den Albert Speer 1936 auf dem Nürnberger Reichsparteitagsgelände mit rund 150 senkrecht in den Himmel strahlen-den Scheinwerfern inszenierte, in diese Geschichte gehört: »Es handelte sich um soge-nannte Flak-Scheinwerfer, wie sie bereits im Ersten Weltkrieg zum Auffinden von feindli-chen Flugzeugen Verwendung fanden. In den Dreißigerjahren konnten sie so stark verbessert werden, dass ihre Reichweite je nach Durchmesser und Typ zwölf bis fünfzehn

Art played a secondary role in this context, although fireworks were taken for granted as an art form at courtly festivities. For an answer to the question of when artificial light was first used as an integral component of an indoor work of art, we look first of all to experimental works by Bauhaus artists, most notably László Moholy-Nagy.

The search for the first work of art in public space that brought along its own light takes us elsewhere. The principle of delayed reaction applies here as well. Modern art was originally indoor art, art meant for the studio or the museum, before it began to transpose forms developed for indoor space into outdoor settings.

Art in public space did not have to worry long about its visibility at night, for it bene-fited wherever it appeared in public space from ordinary public lighting. Given this para-sitic relationship, it would have come as no surprise if art had not conquered the night on its own until much later, not only as a means of participating in artificially illuminated public space with its own light but also to set accents of its own or to constitute it in the first place.

One might wonder whether the famous *Dome of Light* composed of 150 spotlights shining vertically into the heavens on the Reichsparteigelände (Reich Party Rally Grounds) presented by Albert Speer in 1936 belongs to this story. "They were so-called flak spotlights of the kind used as early as World War One to locate enemy aircraft. They were so greatly improved during the 1930s that they achieved a range of twelve to fifteen

Kilometer betrug. Mit dem *Lichtdom* setzten die Nationalsozialisten elektrisches Licht nicht nur zu Beleuchtungszwecken, sondern als eigenständiges, raumschaffendes Gestaltungsmittel ein«, schreibt Anne Krauter in ihrer Heidelberger Dissertation *Die Schriften Paul Scheerbarts und der Lichtdom von Albert Speer. Das große Licht* und legt schon mit dieser Genealogie nahe, Speers Lichtinszenierung eher dem Bereich der Licht-Architektur als dem einer Kunst im öffentlichen Raum zuzurechnen.

Da die Scheinwerfer erst beim Eintreffen Hitlers spektakulär eingeschaltet wurden, kann man sogar darüber streiten, ob es sich bei dem von ihnen ausgegrenzten Feld überhaupt um einen öffentlichen oder nicht eher um einen repräsentativen Raum gehandelt hat, um ein monumentales Forum für ein byzantinisches Hofritual auf der Höhe der modernen Technik. Hannah Arendt hätte ihm, trotz der vorgesehenen 200.000 Zuschauer, schwerlich die Eigenschaft der Öffentlichkeit zugesprochen, weil hier das Prinzip der Gleichschaltung nicht nur für die Scheinwerfer galt.

Ab wann kann man also von einer Kunst im öffentlichen Raum sprechen, die ihr eigenes Licht mitbringt oder gar nur aus Licht besteht? Versteht man ein Kunstwerk im öffentlichen Raum im konventionellen Sinne als frei stehendes, sich selbst begrenzendes und aus der Umgebung hervorgehobenes Exponat außerhalb geschlossener Bauten sowie in sozial gemischt genutzten Zonen, dann kommt als eines der ersten Beispiele Eduardo Paolozzis Brunnen auf der Bundesgartenschau *Planten un Blomen* in Frage, die 1953 in Hamburg mit einem Aufsehen erregenden Skulpturenprogramm stattfand: Paolozzi hatte in

kilometers, depending upon their diameter and type. In the *Dome of Light,* the National Socialists used electric light not only as lighting per se but as a space-creating artistic resource in its own right," wrote Anne Krauter in her Heidelberg dissertation entitled *Die Schriften Paul Scheerbarts und der Lichtdom von Albert Speer. Das große Licht* (Paul Scheerbart's Writings and Albert Speer's Dome of Light: The Great Light). In establishing this genealogy, she lends support to those who regard Speer's light show more as light architecture than as art in public space.

Since the spotlights were not turned on to begin the spectacular display until Hitler's arrival, one might also argue whether the field they isolated was a public space at all or, as some have suggested, representational space, a monumental forum for a Byzantine-style court ritual staged with state-of-the-art technology. Despite the anticipated 200,000 spectators, Hannah Arendt would hardly have affirmed its public character, as the principle of "synchronization" applied to more than the spotlights alone.

So at what point can one begin to speak of art in public space, art that brings along its own light or actually consists of light? Is a work of art in public space to be understood in the conventional sense as a free-standing, self-enclosed object that stands out from its surroundings, apart from solid structures and in socially heterogeneous zones? If so, then one of the first examples was Eduardo Paolozzi's fountain at the National Garden Show, *Planten un Blomen,* which took place in Hamburg in 1953 and featured a sculpture

einer »käfigartigen Raumkonstruktion« (Winfried Konnertz), einem offenen Gerüst aus Metallstangen und kantigen Elementen, Scheinwerfer so integriert, dass sein Ausstellungsbeitrag auch nachts zu sehen war – oder vielmehr nachts eine völlig andere Gestalt annahm als tagsüber, aber eine weithin sichtbare.

Die Außenskulpturen, die auf der *Documenta* in Kassel erst von 1959 an gezeigt wurden, waren dagegen noch lange auf jene Scheinwerfer angewiesen, die Arnold Bode vor der Orangerie auf dem Boden hatte aufstellen lassen. Sie leuchteten die Open-Air-Ausstellungen der *Documenta* 2 und 3 abends und nachts so geisterhaft aus, dass der gelernte Maler Bode sich für diese Schattenbühne den gleichen Vorwurf anhören musste wie für seine Arrangements von Skulpturen vor den transparenten Fenstervorhängen des Fridericianums: nämlich das plastische Volumen auf grafische Silhouetten reduzieren zu wollen.

Obwohl 1964 mit George Rickey bereits das Thema der eigenbewegten Skulptur in die Karlsaue einzog, sollte es bis 1968, bis zur 4. *Documenta* dauern, dass mit Klaus Geldmachers enormem Lichtwürfel ein aus sich selbst herausleuchtendes Exponat vor der Orangerie die Aufmerksamkeit bei Tag und bei Nacht auf sich zog – was im ungeschützten öffentlichen Raum vermutlich nicht lange geschehen wäre, weil der Lichtwürfel ein zwar markantes, letztlich aber empfindliches Gebilde war. Vermutlich ist gerade die Anfälligkeit für Vandalismus ein Grund dafür, dass Licht in der Geschichte von Kunst im öffentlichen Raum noch nicht lange eine Rolle spielt und zudem eine eher sporadische.

program that attracted considerable attention. Paolozzi incorporated spotlights into an open framework of metal rods and angular elements, a "cage-like spatial structure" (W. Konnertz), in such a way that his piece was also visible at night—or rather assumed a completely different form at night than during the day.

The outdoor sculptures first shown at the documenta in Kassel beginning in 1959 depended for quite some time on the spotlights erected by Arnold Bode on the ground outside the Orangerie. They cast such ghostly light at the open-air exhibitions of documenta 2 and 3 in the evening and at night that Bode, a painter by trade, was criticized with regard to this shadow stage for having sought to reduce three-dimensional volumes to graphic silhouettes, as he had allegedly done with his arrangements of sculptures in front of the transparent curtains of the Fridericianum.

Although the theme of the kinetic sculpture was presented by George Rickey in the Karlsaue as early as 1964, it was not until 1968, at documenta 4, that an object that emitted its own light, Klaus Geldmacher's enormous light cube, attracted attention both night and day outside the Orangerie—something that presumably would not have been possible in public space for very long, as the light cube was ultimately an extremely delicate structure, despite its striking appearance. It is likely that the susceptibility to vandalism was one of the reasons why light played a very minor and rather sporadic role in the history of art in public space for many years.

235

Man kann sich fragen, ob Imi Knoebels bemerkenswerte weiße Lichtprojektionen aus einem statischen oder mit dem Auto herumgefahrenen Dia-Apparat aus den frühen 1970er-Jahren in diese Genealogie gehören – ob diese einen öffentlichen Raum in der Nacht konstituierten oder nur die künstlerischen Mittel eines konstruktivistischen Programms in einem ungewohnten Medium und an einem ungewohnten Schauplatz zur Geltung brachten. Sie bestechen jedenfalls bis heute in der Durchdringung einer weißen Lichtfläche durch eine aus dem Dunkel geholte kubische Konkurrenz urbaner Dach- und Fassadenlandschaften und deren Verfremdung mittels eines standardisierten Lichtausschnitts.

Dagegen erreichte Thomas Struth 1987 bei den *SkulpturProjekten* in Münster mit seiner Dia-Projektion von Münsteraner Straßenzügen und Fassaden auf eine Hauswand des Domplatzes sogar die Verschränkung zweier öffentlicher Räume, nämlich der tagsüber fotografierten Straßen mit dem nächtlichen Domplatz. Die Beleuchtung von Berliner Baukränen am Potsdamer Platz, die 1996 mit 2200 Neonröhren für eine Aktion von Gerhard Merz eingerichtet wurde, schuf mit ihren 11 Lichtsäulen einen öffentlichen Wahrnehmungsraum sogar auf einer normalerweise unbetretbaren Baustelle.

Es gibt inzwischen viele Künstler, die sich nicht nur im Innen-, sondern auch im Außenraum mit Licht beschäftigen, wie etwa 1992 die Ausstellung *Lux Europae* in Edinburgh belegte, aber kaum einer hat das Spannungsfeld von Licht und öffentlichem Raum, von privatem und öffentlichem Kunstlicht so unter Strom gesetzt und systematisch ausge-

One may wonder whether Imi Knoebel's remarkable white light projections from a stationary or mobile slide projector from the early 1970s belongs to this genealogy, whether it constituted nocturnal public space or merely employed the artistic resources of a Constructivist program in an unusual medium and at an unusual location. In any event, they continue to attract attention today as a white surface of light penetrated by a competing Cubist landscape of roof and façade landscapes and alienated through the use of a standardized frame of light.

In contrast, Thomas Struth actually achieved a merger of two public spaces, namely the streets photographed during the day and the Domplatz at night, with his slide projections of streets in Münster and façades onto a building wall at Münster *SkulpturProjekte* in 1987. With its eleven columns of light, the illumination of construction cranes at Berlin's Potsdamer Platz with 2200 neon tubes, which were set up for an action by Gerhard Merz in 1996. created a public zone of perception at a normally inaccessible construction site.

Today, many artists work with light not only indoors but in outdoor space as well, as was the case at the "Lux Europae" exhibition in Edinburgh in 1992. Yet hardly an artist has electrified and systematically explored the field of tension between light and public space, between private and public artistic light as has Mischa Kuball. From the equally lucid and monumental *Megazeichen* on the nighttime façade of the Mannesmann building in Düs- Figs. pp. 166–171

Abb. S. 166–171
Abb. S. 128–129

Abb. S. 38–39, 338–339

lotet wie Mischa Kuball: Von den ebenso luziden wie monumentalen *Megazeichen* auf der nächtlichen Fassade des Düsseldorfer Mannesmann-Hochhauses (1990) über die *Lichtbrücke* am Bauhaus (Dessau, 1992) führte ihn sein zunächst eher formalistisch anmutendes Werkthema direkt zu der kapitalen Arbeit *Refraction House* in der Synagoge Stommeln (1994). Sie ist zu den besten künstlerischen Lösungen jener schwierigen ortsspezifischen Aufgabe in Stommeln zu zählen, der sich im Laufe der Jahrzehnte nacheinander eine Reihe angesehener Künstler gestellt haben, zuletzt Santiago Sierra.

Kuballs *Refraction House* wirkt wie ein kleines, aber gewaltiges Gegenstück zu Speers unseligem Kristallnachtsdom – auch, weil es gewalttätig war, mit seiner grotesk überhöhten Luxzahl, die den Anwohnern keinen ungeschützten Nachtschlaf und dem Besucher keine rechte Anschauung gewährte, sondern Licht in der aggressivsten Form der Aufklärung war. Im öffentlichen Umraum der einstigen Synagoge beschwor es eine Präsenz der Toten ohne die übliche Kranzschleife und Blasmusik.

Danach folgten mit *Peep-Out/Leerstand* (Leipzig, 1994) und *Rotierenderlichtraumhorizont* in der Kölner Wandelhalle (1995) zwei Arbeiten, die sonst unzugängliche Innenräume über das Ausleuchten in öffentliche Räume verwandelten – im Fall der Wandelhalle einen lang gestreckten Hohlraum der Deutzer Brücke in Köln; bei *Peep-Out/Leerstand* Leerräume im städtischen Wohnungsbau, die dadurch wie ausgeforscht und bloßgestellt erschienen. Weil sie nur das Licht und – mit ihm – den Blick einließen, wirkten sie weiterhin intim und wiesen dem Betrachter die Rolle eines Voyeurs zu, verloren aber zugleich ihre Unschuld,

Figs. pp. 128–129
Figs. pp. 38–39, 338–339

seldorf (1990) and the *Lichtbrücke* at the Bauhaus (Dessau, 1992), this initially seemingly formalistic theme led him directly to the capital work *Refraction House* in the synagogue in Stommeln (1994). This is surely one of the best artistic solutions for that difficult site-specific problem in Stommeln, which has been addressed over decades by a succession of well-known artists, including most recently Santiago Sierra.

Kuball's *Refraction House* appeared to be a small yet powerful answer to Speer's unholy *Dome of Light,* in part because it was violent, with its grotesquely excessive luminosity, which robbed local residents of peaceful sleep. It provided visitors no real view of anything but was merely light In the most aggressive form of enlightenment. In the public surroundings of the former synagogue, it suggested the presence of the dead without the customary wreaths and funeral processions.

Two later works, *Peep-Out/Leerstand* (Leipzig, 1994) and *Rotierenderlichtraumhorizont* at the Wandelhalle in Cologne (1995), transformed otherwise inaccessible interior rooms into public spaces—in the case of the Wandelhalle it was an elongated hollow space in the Deutzer Bridge in Cologne, and in *Peep-Out/Leerstand,* vacant rooms in urban housing units, which consequently looked exposed and explored to death. Because they admitted only the light and—along with it—the viewers' gazes, they seemed somehow still intimate and assigned the viewer the role of a voyeur. Yet they lost their innocence, as total exposure to the strong light suggested a meaningful reason and made the rooms

weil die Ausforschung durch das starke Licht einen sinnvollen Grund suggerierte und die Räume so ausgeliefert erscheinen ließ wie den Schauspieler Yves Montand in dem Costa-Gavras-Film *Das Geständnis* (1969) vor der starken Schreibtischlampe des ihn verhörenden Politkommissars.

Mit *Private Light/Public Light* (Biennale São Paolo, 1998) beginnt dann die systematische Umsiedlung von privaten Lichtquellen in Ausstellungsräume, ihre Dekontextualisierung, wie man heute sagt, ihre Herauslösung aus einem gewohnten Ambiente mit seinen privaten Bezügen für eine zeitweilige Versetzung in einen öffentlichen Raum – sei es, wie bei der Biennale in São Paolo, ein Ausstellungsraum oder, wie in München 2004 bei *Public Blend II*, der öffentliche Raum einer Stadtstraße.

Abb. S. 340–343

Mit *Urban Context* hat Kuball dann 2000 in Lüneburg das Raumvolumen eines beinahe vergessenen, aber wieder zugänglich gemachten Bunkers als Lichtraum auf eine Stadtstrasse versetzt. So verwandelte er einen unterirdischen Angstraum, der einst öffentlich genutzt wurde, in eine oberirdische Passage. 2003 hat er in Berlin seine *Lichtbrücke* unter starkes Videolicht und für die Benutzer optisch unter Wasser gesetzt, 2005 bei *FlashBoxOldenburg* hundert stroboskopisch aufblitzende Flashlights über die Oldenburger Hauseingänge freiwilliger Teilnehmer verteilt und dabei die Nacht zum Spielraum zeitlich unvorhersehbarer, heller Überraschungen gemacht.

Abb. S. 40–41

Abb. S. 198–199

Abb. S. 348–349

In der Summe lassen diese Arbeiten das durchgängige Interesse erkennen, anhand des Lichts die Grenze von privat und öffentlich neu zu vermessen und den Unterschied von

look as vulnerable as actor Yves Montand in the Costa-Gavras film *Z* (1969) in front of the bright lamp on the desk of his interrogator, the political commissar.

Private Light/Public Light (São Paolo Biennale, 1998) marked the beginning of a systematic relocation of private light sources to exhibition spaces, where they were decontextualized, to use the now popular term, removed from a familiar setting and its personal connotations, and transposed temporarily into public space—an exhibition hall in the case of the Biennale in São Paolo or to the public space of a city street, as in *Public Blend II* in Munich (2004).

Figs. pp. 340–343

With *Urban Context* in Lüneburg (2000), Kuball shifted the spatial volume of a nearly forgotten but later reopened bunker to a city street as a light space. Here, he transformed a subterranean space of fear once used for official purposes into an above-ground passage. In 2003 in Berlin, he exposed his *Lichtbrücke* to strong video lighting and immersed it visually for users under water. In *FlashBoxOldenburg* (2005), he placed one hundred flashing stroboscopic lights over the doorways of the homes of voluntary participants, turning the night into a playground of unpredictable, bright surprises.

Figs. pp. 40–41

Figs. pp. 198–199

Figs. pp. 348–349

Viewed as a whole, these works reveal a consistent interest in remapping the boundary between private and public with the aid of light and using the difference between day and night for the purposes of art in public space. Several of these—*Private Light/Public Light* (São Paolo), *Public Blend II* (Munich), and *FlashBoxOldenburg*—generate not only a

Figs. pp. 346–347

Abb. S. 346–347

Tag und Nacht für die Kunst im öffentlichen Raum zu nutzen. Einige von ihnen – *Private Light/Public Light* (São Paolo), *Public Blend II* (München) oder *FlashBoxOldenburg* – stiften nicht nur einen öffentlichen Raum des Lichts, sondern setzen zugleich eine komplexe soziale Verständigung voraus. Denn für die Verpflanzungsaktionen privater Beleuchtungskörper in öffentliche Räume oder für die Anbringung von Flashlights über privaten Hauseingängen war natürlich zuerst die Zustimmung der gewünschten Mitspieler einzuholen, damit die Projekte am Ende überhaupt sichtbar werden konnten.

So liegt es also nicht nur am künstlichen Licht, dass diese 3 Projekte sichtbar wurden, sondern auch an Tauschprozessen innerhalb einer Teilöffentlichkeit, die schließlich im öffentlichen Raum als Oberfläche eines sozialen Netzes von Mitwirkenden aufleuchtet. Es wirkt wie eine ephemere, lokalbezogene Sektengründung, was Mischa Kuball mit diesen 3 Projekten jeweils zu Wege gebracht hat – zumal das Licht ja auch ein zentraler Bezugspunkt vieler Kulte und Religionen ist. Wie in der von Jorge Louis Borges beschriebenen Phönix-Sekte kann dabei keiner so genau begründen, worum es bei dem Ritual letztlich eigentlich geht, und doch wissen alle sicher, dass sie dazu gehören, denn jeder hatte die Wahl, aber die meisten konnten dem charmanten Ideenstifter einfach nicht widerstehen, der ihnen sein Licht brachte, damit sie ihres dafür hergeben – eine wirklich bemerkenswerte soziale Energietechnik, bei Tage besehen!

»I can' t help that. These invoices have to be in the mail tonight.«
Comic aus dem Magazin *New Yorker* in den 1950er-Jahren
Cartoon from the magazine *The New Yorker*, 1950s

public space of light but also presuppose a complex social dialogue; for in order to carry out the transplantation of private lighting fixtures to public space or fix flashing lights above the doorways of private homes, the artist had to obtain the consent of the selected participants so that the project would be visible at all when it was completed.

Thus it was not artificial light alone that made these three projects visible but also a series of interactive processes within a segment of the public, which ultimately shine forth as the surface of a public network of participants in public space. At work here is an ephemeral process of creating local sects that Mischa Kuball pursued in these three projects—after all, light is a central point of reference in many cults and religions. As in the Phoenix sect described by Jorge Louis Borges, no one can really explain the actual purpose of the ritual, yet everyone knows that or she is a part of it, for everyone had the choice, although most were simply unable to resist the advances of the charming provider of ideas who brought them light so that they would contribute theirs in return—viewed in the clear light of day, a truly remarkable example of social energy technology!

MEDIENDRAMA | BEWEGTE BILDER

MEDIA DRAMA
MOVING IMAGES

Abb. S. 346–347

Tag und Nacht für die Kunst im öffentlichen Raum zu nutzen. Einige von ihnen – *Private Light/Public Light* (São Paolo), *Public Blend II* (München) oder *FlashBoxOldenburg* – stiften nicht nur einen öffentlichen Raum des Lichts, sondern setzen zugleich eine komplexe soziale Verständigung voraus. Denn für die Verpflanzungsaktionen privater Beleuchtungskörper in öffentliche Räume oder für die Anbringung von Flashlights über privaten Hauseingängen war natürlich zuerst die Zustimmung der gewünschten Mitspieler einzuholen, damit die Projekte am Ende überhaupt sichtbar werden konnten.

So liegt es also nicht nur am künstlichen Licht, dass diese 3 Projekte sichtbar wurden, sondern auch an Tauschprozessen innerhalb einer Teilöffentlichkeit, die schließlich im öffentlichen Raum als Oberfläche eines sozialen Netzes von Mitwirkenden aufleuchtet. Es wirkt wie eine ephemere, lokalbezogene Sektengründung, was Mischa Kuball mit diesen 3 Projekten jeweils zu Wege gebracht hat – zumal das Licht ja auch ein zentraler Bezugspunkt vieler Kulte und Religionen ist. Wie in der von Jorge Louis Borges beschriebenen Phönix-Sekte kann dabei keiner so genau begründen, worum es bei dem Ritual letztlich eigentlich geht, und doch wissen alle sicher, dass sie dazu gehören, denn jeder hatte die Wahl, aber die meisten konnten dem charmanten Ideenstifter einfach nicht widerstehen, der ihnen sein Licht brachte, damit sie ihres dafür hergeben – eine wirklich bemerkenswerte soziale Energietechnik, bei Tage besehen!

public space of light but also presuppose a complex social dialogue; for in order to carry out the transplantation of private lighting fixtures to public space or fix flashing lights above the doorways of private homes, the artist had to obtain the consent of the selected participants so that the project would be visible at all when it was completed.

Thus it was not artificial light alone that made these three projects visible but also a series of interactive processes within a segment of the public, which ultimately shine forth as the surface of a public network of participants in public space. At work here is an ephemeral process of creating local sects that Mischa Kuball pursued in these three projects—after all, light is a central point of reference in many cults and religions. As in the Phoenix sect described by Jorge Louis Borges, no one can really explain the actual purpose of the ritual, yet everyone knows that or she is a part of it, for everyone had the choice, although most were simply unable to resist the advances of the charming provider of ideas who brought them light so that they would contribute theirs in return—viewed in the clear light of day, a truly remarkable example of social energy technology!

»I can' t help that. These invoices have to be in the mail tonight.«
Comic aus dem Magazin *New Yorker* in den 1950er-Jahren
Cartoon from the magazine *The New Yorker*, 1950s

MEDIENDRAMA | BEWEGTE BILDER

MEDIA DRAMA
MOVING IMAGES

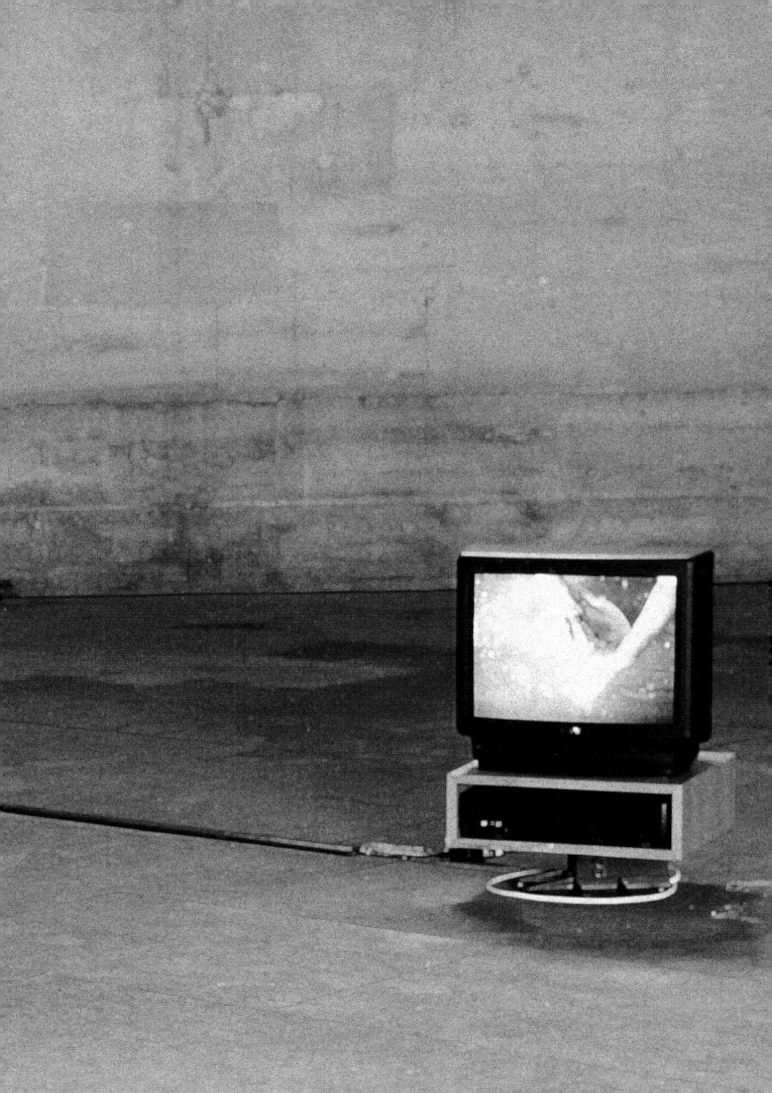

Mediendrama, 1987,
Museum Folkwang, Essen; Diapro-
jektor, Fernseher, Zimmerantenne,
81 Dias; ZKM | Zentrum für Kunst
und Medientechnologie Karlsruhe
(Foto: Helmut Steinhauser, Kyoto)

Ein gezeichnetes Lichtraster wird
mit einem Diaprojektor auf die Bild-
schirmoberfläche eines Fernsehers
geworfen, auf dem das jeweilige
lokale Fernsehprogramm über eine
Zimmerantenne eingespielt wird.

<<
... kneten (Félix Guattari und Gilles
Deleuze gewidmet) (Detail), 1996,
Chapelle de Salpetrière, Paris
(Foto: Dennis Bouchard, Paris),
Vgl. Abb. S. 259 / See fig. p. 259

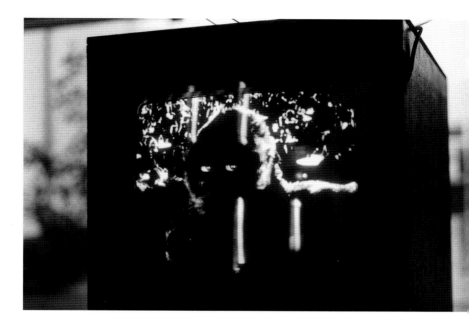

Mediendrama, 1987,
Museum Folkwang, Essen
(Foto: Helmut Steinhauser, Kyoto)

Detail eines zufälligen Fernsehbilds
aus dem Film *King Kong*.

Mediendrama, 1987,
Museum Folkwang, Essen
(photograph: Helmut Steinhauser,
Kyoto)

Detail of a random television image
from the film *King Kong*.

Mediendrama, 1987,
Museum Folkwang, Essen; slide
projector, television, indoor aerial,
81 slides; ZKM | Zentrum für Kunst
und Medientechnologie Karlsruhe
(photograph: Helmut Steinhauser,
Kyoto)

A grid of light is projected by a slide
projector onto the screen of a tele-
vision; a room antenna transmits the
local television broadcast to the TV.

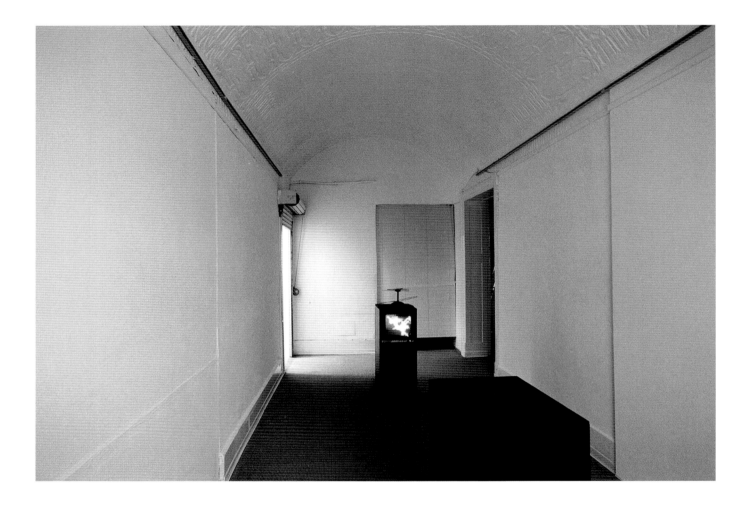

Mediendrama, 1988,
Neuer Berliner Kunstverein, Berlin;
Diaprojektor, Fernseher, Zimmer-
antenne, 81 Dias
(Foto: Ulrich Sauerwein, Berlin)

Mediendrama, 1988,
Neuer Berliner Kunstverein, Berlin;
slide projector, television, indoor
aerial, 81 slides
(photograph: Ulrich Sauerwein, Berlin)

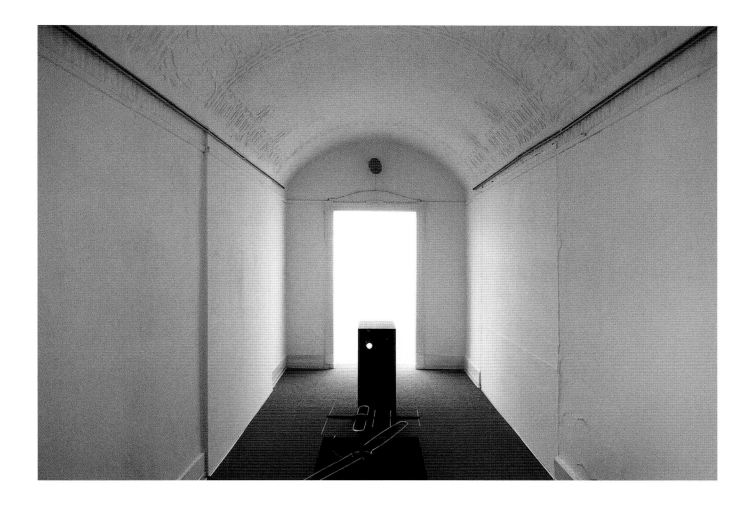

Mediendrama, 1988,
Neuer Berliner Kunstverein, Berlin
(Foto: Ulrich Sauerwein, Berlin)

Mediendrama, 1988,
Neuer Berliner Kunstverein, Berlin
(photograph: Ulrich Sauerwein, Berlin)

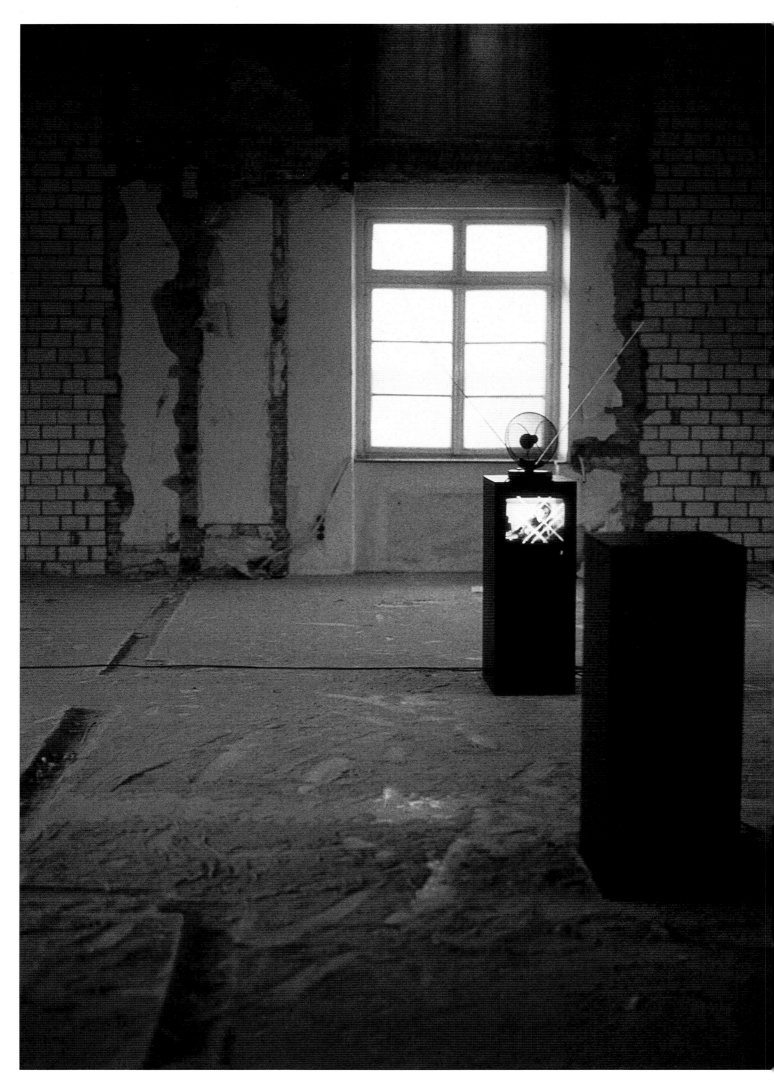

Mediendrama, 1986/91,
Städtisches Museum Mülheim an
der Ruhr; Diaprojektor, Fernseher,
Zimmerantenne, 81 Dias
(Foto: Olaf Bergmann, Witten)

Mediendrama, 1986/91,
Städtisches Museum Mülheim an der
Ruhr; slide projector, television,
indoor aerial, 81 slides
(photograph: Olaf Bergmann, Witten)

Stadt durch Glas, 1995/96,
Konrad Fischer Galerie, Düsseldorf;
2 Monitore, 2 Videos, 60' Loop,
ohne Audio; Sammlung Heinen,
Düsseldorf
(Foto: Dorothee Fischer, Düsseldorf)

Die Monitore zeigen synchron das
Video *Stadt durch Glas*, eine Kamera-
fahrt in Düsseldorf vom Atelier (auf
Umwegen) zu Konrad Fischer. Vor
das Objektiv der Kamera war wäh-
rend der Aufnahmen ein Trinkglas
montiert.

Stadt durch Glas, 1995/96,
Konrad Fischer Galerie, Düsseldorf;
2 monitors, 2 videos, 60' loop, silent;
Heinen Collection, Düsseldorf
(photograph: Dorothee Fischer,
Düsseldorf)

In synch, the two monitors show a
video, *Stadt durch Glas*, a camera trip
in Düsseldorf shot on the way from
the studio (via detours) to Konrad
Fischer Galerie. During shooting, a
drinking glass was mounted in front
of the camera lens.

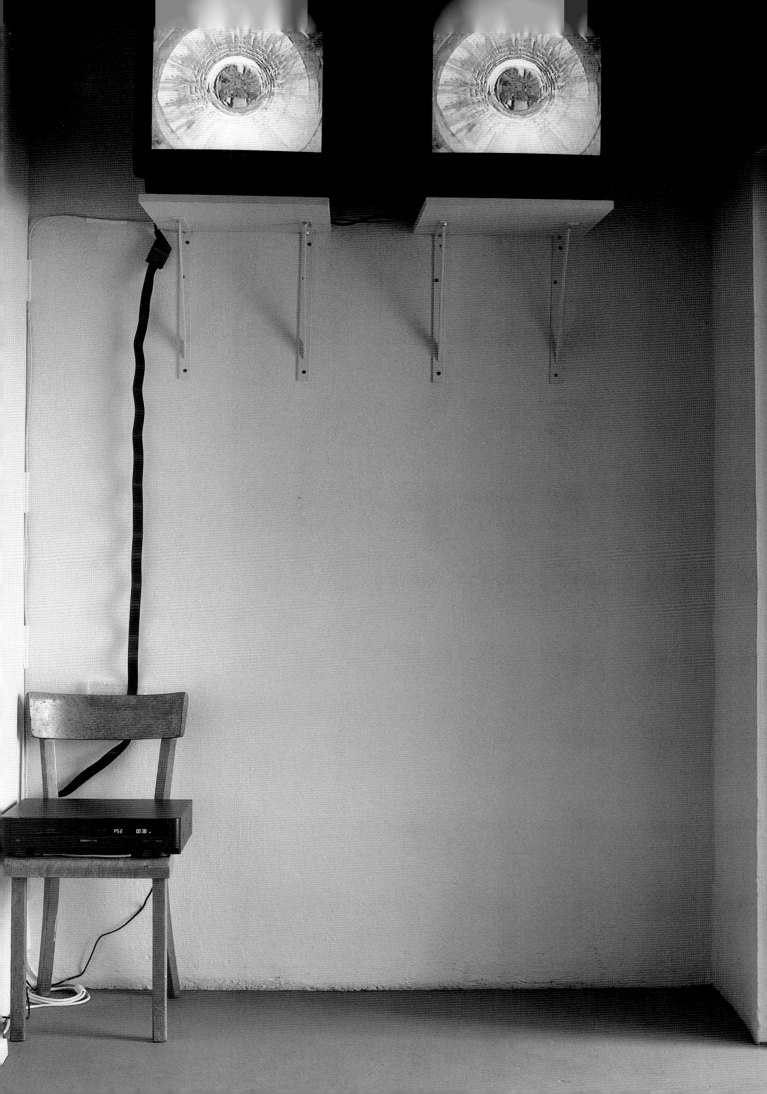

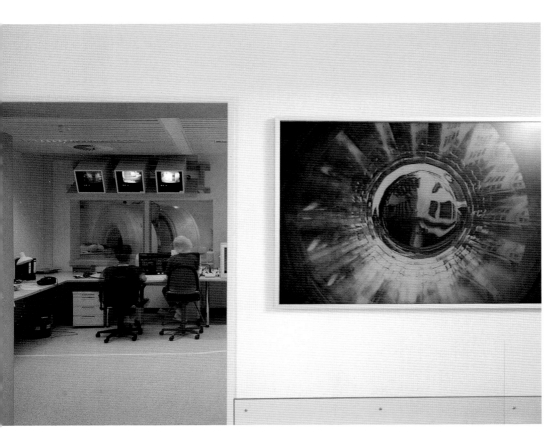

Durch das große Glas, 1999,
Konrad Fischer Galerie, Düsseldorf;
Spiegelschrank, 220 x 160 cm,
Monitor, 25' Loop
(Foto: Daniela Steinfeld, Düsseldorf)

Mischa Kuball filmte durch ein Glas
den Alltag auf der Corneliusstraße
in der Nähe seines Ateliers. Dieser
Film läuft auf in einem Spiegel-
schrank installierten Monitor und ist
lediglich durch Türspione zu sehen.
Da man keinen Monitor erkennt,
nimmt man nur die Kamerafahrt
wahr. Die Arbeit orientiert sich an
Marcel Duchamps *Großem Glas*
(1915–1923).

Stadt durch Glas, Fotoversion, 1999,
Sammlung Neurochirurgische Klinik,
Krefeld; 6 Unikatfotos mit 6 Kristall-
spiegeln, 150 x 100 x 5 cm
(Foto: Elger Esser, Düsseldorf)

Videostills aus dem Film *Stadt durch
Glas* von 1995/96 wurden auf Diasec
produziert. Neben das Motiv mon-
tierte Mischa Kuball einen vertikalen
Spiegel. Die Wandtableaus wurden
in den Gängen und einem Unter-
suchungszimmer der Klinik aufge-
hängt und sind dort permanent
installiert. Die Thematisierung des
Sehens wird in dieser Arbeit auf
mehreren Ebenen reflektiert – ein
direkter Bezug zu den bildgebenden
Verfahren der Klinik ist beabsichtigt.

Stadt durch Glas, photograph version,
1999, Collection Neurosurgical Clinic,
Krefeld; 6 signature photographs with
6 crystal mirrors, 150 x 100 x 5 cm
(photograph: Elger Esser, Düsseldorf)

Video stills from the film *Stadt durch
Glas* from 1995/96 (face-mounted).
Kuball mounted a vertical mirror next
to the motif. The tableaux were hung
on the walls of hallways and an
examination room in the clinic and
are permanently installed there.
In this work, the theme of vision is
reflected on several levels—there is
a deliberate direct reference to the
imagery procedure at the clinic.

Durch das große Glas, 1999,
Konrad Fischer Galerie, Düsseldorf;
mirror-door wardrobe, 220 x 160 cm,
monitor, 25' loop
(photograph: Daniela Steinfeld,
Düsseldorf)

Kuball filmed daily life on Cornelius-
strasse, close to his studio, through
a glass. This film plays on a monitor
installed in a mirror-door wardrobe
and can only be viewed through peep-
holes. Since the monitor cannot be
recognized, the viewer only perceives
the motion of the camera. The work
is based on Marcel Duchamp's *Large
Glass* (1915–1923).

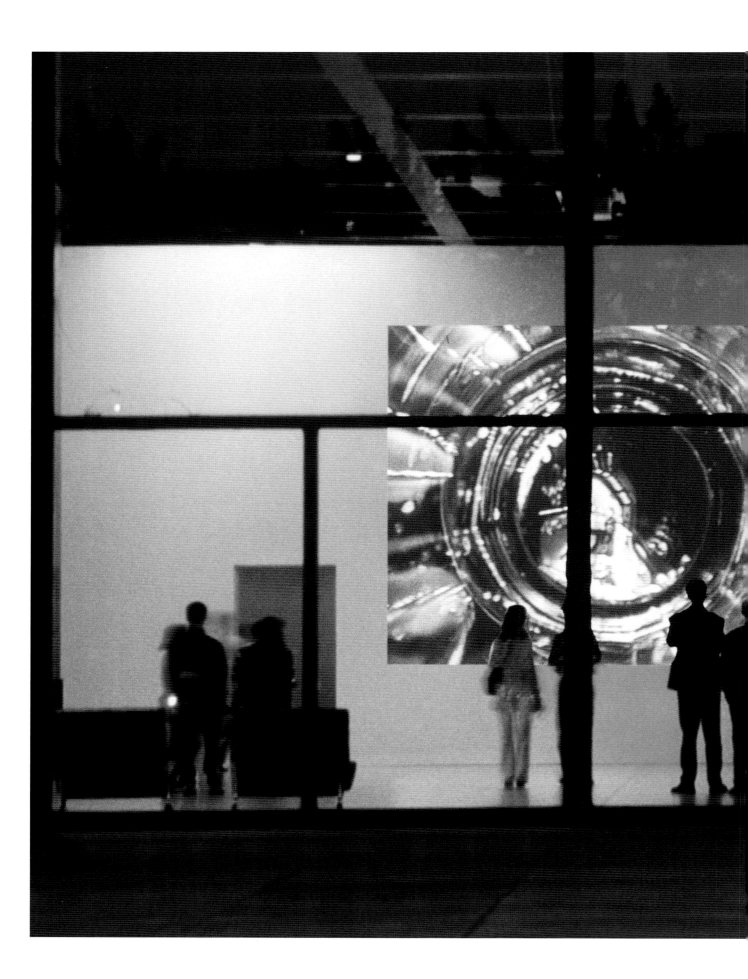

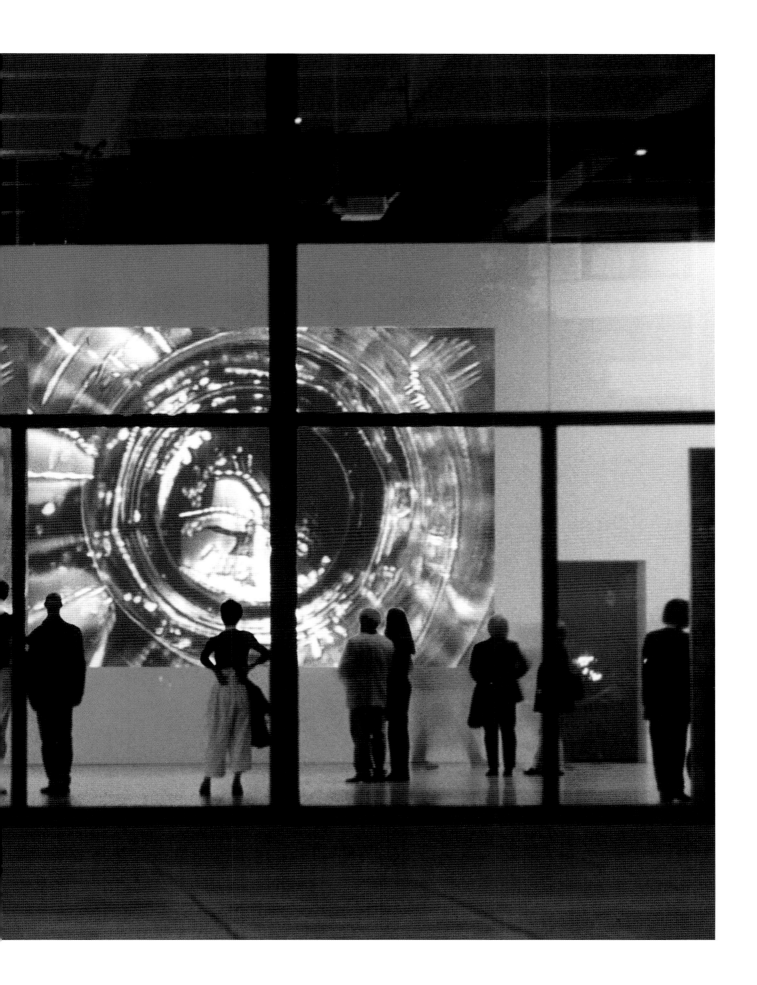

Vorhergehende Doppelseite
Stadt durch Glas/Night Version NY,
1999, *Das XX. Jahrhundert*, Neue
Nationalgalerie, Berlin; 2 Video-
Beamer auf Ausstellungswände,
Projektionsgröße ca. 6 x 18 m, Video-
player, Parallelschaltung, Video
60' Loop, ohne Audio; Ed. 1/3 Kunst-
museum Bonn
(Foto: Arwed Messmer, Berlin)

Am binocularen System unseres
Sehens orientiert, zeigte Mischa
Kuball in der Neuen Nationalgalerie
auf zwei Leinwänden eine synchrone
Kamerafahrt. Die 1997 durch ein
Glas gefilmte Fahrt durch das nächt-
lich New York geht von South Bronx
nach Downtown Manhattan.

Previous double-page spread
Stadt durch Glas/Night Version NY,
1999, *Das XX. Jahrhundert*, Neue
Nationalgalerie, Berlin; 2 video
projectors on the exhibition space
walls, size of the projection approx.
6 x 18 m, VCR, parallel connection,
video 60' loop, silent; edition 1/3
Kunstmuseum Bonn
(photograph: Arwed Messmer, Berlin)

Oriented toward the binocular system
of our vision, Kuball shows a camera
trip synchronized on two screens.
The journey through New York at
night in 1997, filmed through a glass,
goes from the South Bronx to down-
town Manhattan.

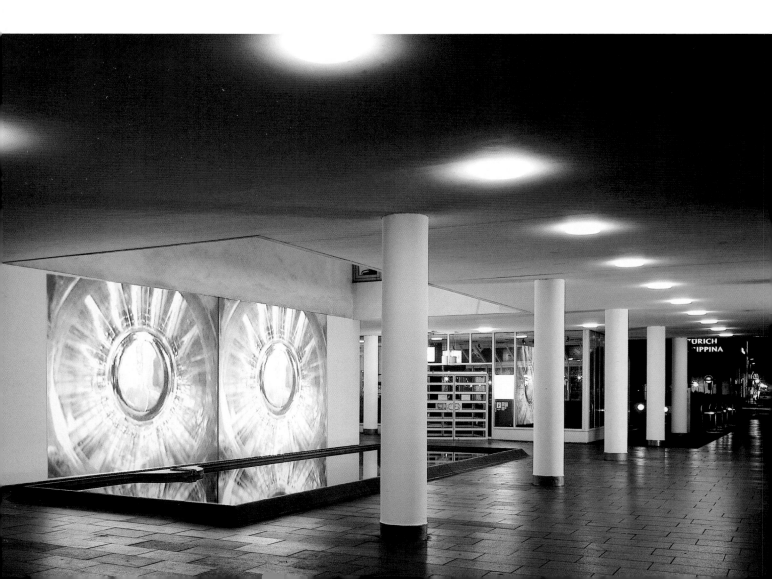

Stadt durch Glas/
Moskau – Düsseldorf – Moskau, 2003,
K20/Kunstsammlung NRW, Düssel-
dorf; 2 Beamer, DVD-Player, DVDs,
60' Loop, ohne Audio; Ed. 1/3 Kunst-
sammlung NRW, Düsseldorf
(Foto: Christoph Schuhknecht,
Düsseldorf)

Mischa Kuball zeigte in der Passage
der Düsseldorfer Kunstsammlung,
also zwischen Kunstsammlung und
Stadtraum, eine Doppelprojektion der
Stadt durch Glas-Arbeiten. Die Düs-
seldorfer Filmaufnahmen (s. S. 248)
kombinierte Mischa Kuball mit einer
jeweils 20-minütigen gefilmten Tag-
und Nachtfahrt aus Moskau – eben-
falls mit einem Trinkglas vor dem
Objektiv aufgenommen. Diese Prä-
sentationsform der verfremdeten
Stadtbilder im öffentlichen Raum,
die hier erstmalig eingesetzt wurde,
nennt Mischa Kuball »Urban Screen-
ings«.

Stadt durch Glas/
Moskau – Düsseldorf – Moskau, 2003,
K20/Kunstsammlung NRW, Düssel-
dorf; 2 projectors, DVD player, DVDs,
60' loop, silent; edition 1/3 Kunst-
sammlung NRW, Düsseldorf
(photograph: Christoph Schuhknecht,
Düsseldorf)

In the transition of the building hous-
ing the Düsseldorf art collection
between the art collection and the
surrounding city, Kuball showed a
double projection of *Stadt durch Glas*
works. Kuball combined the footage
of Düsseldorf (p. 248). with two
twenty-minute trips through Moscow,
one by day, the other at night, which
were also shot through a drinking
glass in front of the camera lens.
Kuball calls this form of presenting
distorted images of the city in public
space, which he employed here for
the first time, "urban screenings."

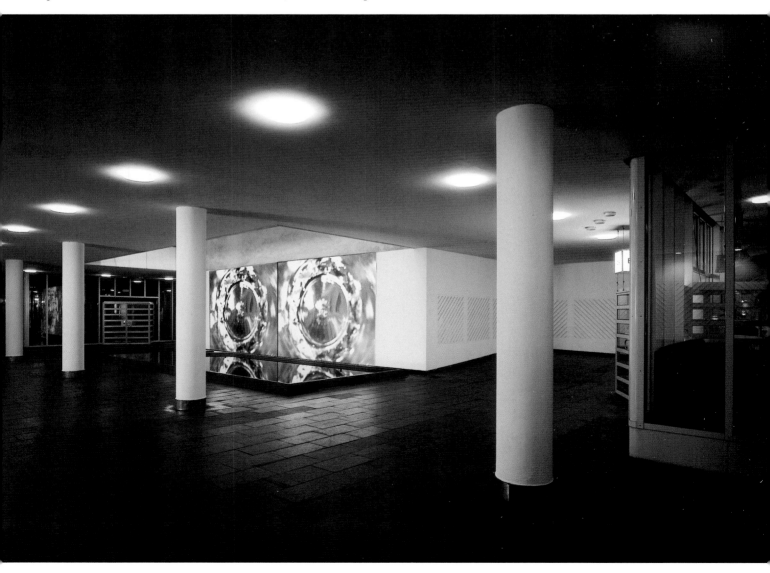

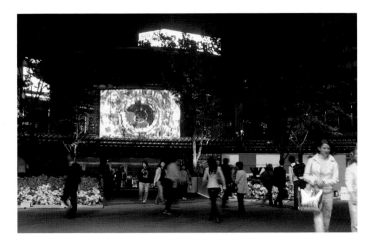

City thru Glass/Tokyo Day & Night, 2005,
»Deutsche Woche in Roppongi Hills«,
im Rahmen von Deutschland in Japan
2005/2006, Tokio; 7 Beamer, 7 DVD-
Player, 7 DVDs, 60' Loop, ohne Audio
(Foto: Mihoko Tanno, Tokio)

Mischa Kuball präsentierte den 2004
entstandenen Film einer Tag- und
Nacht-Kamerafahrt durch Tokio. An
verschiedenen Orten im öffentlichen
Raum fanden die »Urban Scree-
nings« der Doppelprojektionen statt,
wie etwa auf 2 Großmonitoren in
der Metrostation Hat, auf dem West-
walk Plasma Display, in der Nähe
des Ticket-Schalter des Mori Art
Museums, im Foyer der Virgin Cine-
mas, auf einem Aufzugmonitor und
auf dem TV-Asahi-Großbildschirm.

City thru Glass/Tokyo Day & Night, 2005,
"German Week in Roppongi Hills,"
in connection with German in Japan
2005/2006, Tokyo; 7 projectors,
7 DVD players, 7 DVDs, 60' loop, silent
(photograph: Mihoko Tanno, Tokyo)

Kuball presented a 2004 film of a day
and night camera trip through Tokyo.
The urban screenings took place at
various public sites, such as on two
large monitors in the Hat metro sta-
tion, on the Westwalk Plasma Dis-
play, near the ticket counter of the
Mori Art Museum, in the lobby of the
Virgin Cinema, on an elevator moni-
tor, and on the large-screen Asahi
TV.

**City thru Glass/
Moscow – Düsseldorf – Moscow**, 2004,
VC6xMAM – Virgin Cinemas Roppongi
Hills/Mori Art Museum Collaboration,
Tokio; 2 Beamer, DVD-player, DVDs,
60' Loop, ohne Audio
(Foto: Keizo Kioku, Tokio/Courtesy
Mori Art Museum, Tokio)

Ein weiterer Ort der »Urban Scree-
nings« war das Foyer des Virgin
Cinemas Roppongi Hills in Tokio.
Die Doppelprojektion der Filmcollage
der durch ein Wasserglas aufge-
nommenen Kamerafahrten durch
Düsseldorf und Moskau wurde an
2 Orten im Foyer präsentiert.

City thru Glass/
Moscow – Düsseldorf – Moscow, 2004,
VC6xMAM – Virgin Cinemas Roppongi
Hills/Mori Art Museum Collaboration,
Tokyo; 2 projectors, DVD player,
DVDs, 60' loop, silent
(photograph: Keizo Kioku, Tokyo/
Courtesy Mori Art Museum, Tokyo)

Another site of the urban screenings
was the lobby of the Virgin Cinema
in Roppongi Hills in Tokyo. The dou-
ble projection of the film collage of
the camera trips through Düsseldorf
and Moscow, filmed through a water
glass, was presented at two locations
in the lobby.

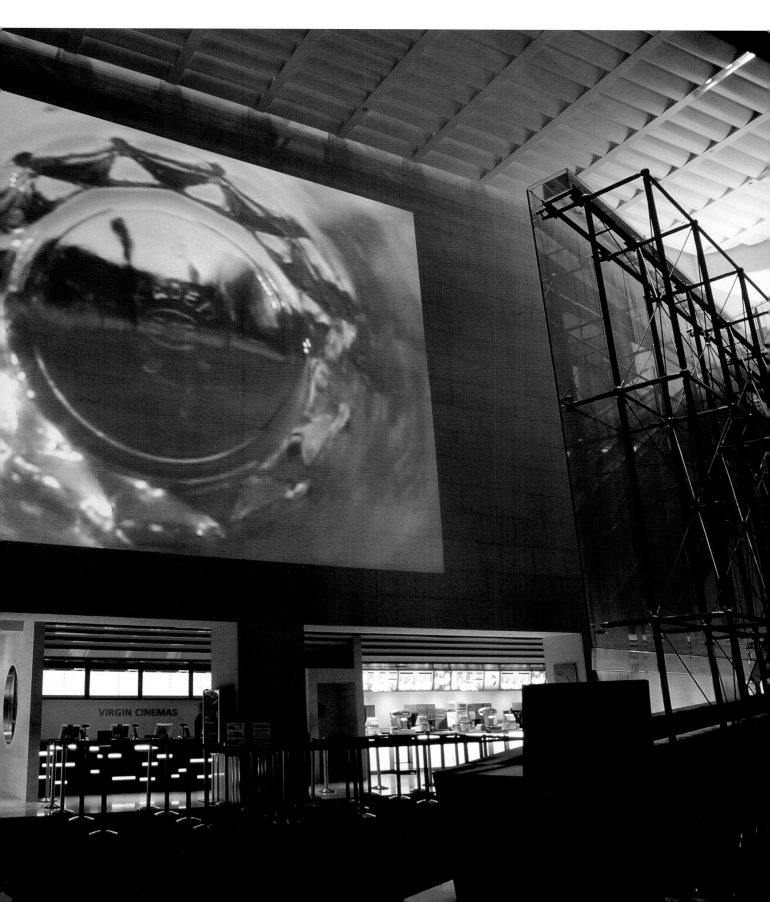

... kneten (Félix Guttari und Gilles
Deleuze gewidmet), 1996,
Kulturhuset, Stockholm; Video,
60' Loop, mit Audio
(Foto: Archiv Mischa Kuball, Düssel-
dorf)

Zwei kraftvolle Hände kneten Teig,
begleitet wird die Aktion von 2 Ton-
spuren: Eine flüsternde und eine
verlangsamte Stimme sprechen den
Text »Le pli. Leibniz et le baroque«
von Félix Guattari und Gilles Deleuze
zur Frage der Monade.

... kneten (Félix Guattari und Gilles
Deleuze gewidmet), 1996,
Kulturhuset, Stockholm; video,
60' loop, sound
(photograph: Mischa Kuball Archive,
Düsseldorf)

Two strong hands knead dough;
the performance is accompanied by
two soundtracks: one whispering
voice-over and another that has been
slowed down speak the text "Le pli.
Leibniz et le baroque" by Félix Guat-
tari and Gilles Deleuze on the monad.

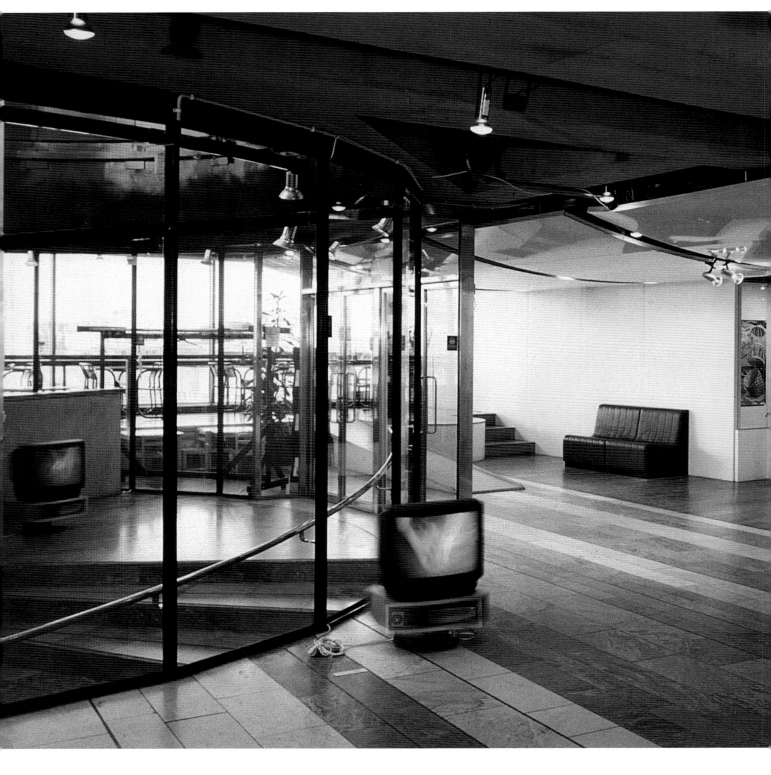

... kneten (Félix Guttari und Gilles
Deleuze gewidmet), 1996,
Chapelle de Salpetrière, Paris
(Foto: Dennis Bouchard, Paris)

... kneten (Félix Guttari und Gilles
Deleuze gewidmet), 1996,
Chapelle de Salpetrière, Paris
(photograph: Dennis Bouchard, Paris)

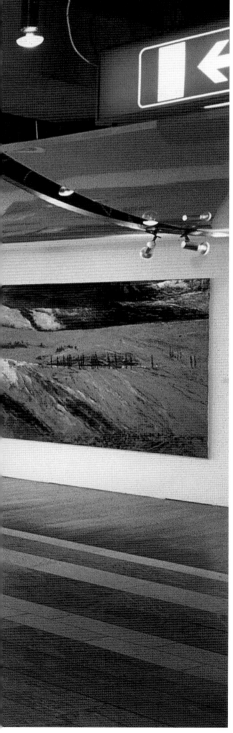

... kneten (Félix Guttari und Gilles
Deleuze gewidmet), 1995/96

Videostill

... kneten (Félix Guttari und Gilles
Deleuze gewidmet), 1995/96

Video still

Schleudertrauma, 2000,
Kunstverein Ruhr, Essen;
Video, 25' Loop, mit Audio

Videostill
S. S. 44–45

Schleudertrauma, 2000,
Kunstverein Ruhr, Essen;
video, 25' loop, sound

Video still
See pp. 44–45

Red Line und **Gegenlicht**, 1999,
Konrad Fischer Galerie, Düsseldorf;
Red Line: Videosequenz ca. 30',
mit Audio; *Gegenlicht*: Video 8' Loop,
mit Audio
(Foto: Dorothee Fischer, Düsseldorf)

Die Arbeit *Red Line* existiert nicht
mehr, aus der Arbeit wurde *Black
Square/Speed Suprematism* entwickelt
(S. 264). Eine am Gürtel Mischa
Kuballs befestigte Kamera filmte ihn
selbst beim Squash-Spiel mit Axel
Feldkamp und Reinhard Spieler.
In *Gegenlicht* nahm Mischa Kuball
das Licht direkt aus der Linse eines
Super-8-Projektors auf, weshalb
auch die typischen Projektorgeräu-
sche zu hören sind. Diese Arbeit wird
seit 2000 unter dem Titel *AntiKino*
gezeigt.

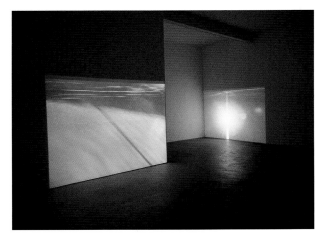

Red Line and Gegenlicht, 1999,
Konrad Fischer Galerie, Düsseldorf;
Red Line: video sequence approx. 30',
sound; *Gegenlicht*: video 8' loop,
sound
(photograph: Dorothee Fischer, Düs-
seldorf)

Red Line no longer exists; the work
was turned into *Black Square/
Speed Suprematism* (p. 264). A cam-
era attached to Kuball's belt filmed
him while he was playing squash with
Axel Feldkamp and Reinhard Spieler.
In *Gegenlicht*, Kuball filmed the light
directly from the lens of a Super-8
projector, which is why typical
projector noises can be heard. This
work has been shown since 2000
as *AntiKino*.

Gegenlicht I – III, 1999,
3 Unikat-Fotografien, 3 Diasec,
je 75 x 75 cm; Sammlung Ursula &
Alwin Lahl, Wiesbaden
(Foto: Archiv Mischa Kuball, Düssel-
dorf)

Gegenlicht I – III, 1999,
3 face-mounted signature photo-
graphs, 75 x 75 cm each; Ursula &
Alwin Lahl Collection, Wiesbaden
(photograph: Mischa Kuball Archive,
Düsseldorf)

Black Square/Speed Suprematism,
2003, Kunstsammlungen der
Ruhr-Universität Bochum, Video,
ca. 30′ Loop, ohne Audio
(Foto: Thorsten Koch, Bochum)

Über ein Foto des *Schwarzen Qua-
drats* von Malewitsch lief in der von
Kuball überarbeiteten Version mit
der eingeblendeten Hand des Künst-
lers jener Film, der den Künstler aus
der »Gürtelperspektive« beim Squash
spielen zeigt. Diese beiden Ebenen
werden durch eine dritte Ebene ver-
knüpft, indem die bereits bestehende
mediale Überlagerung wiederum
gefilmt worden ist. Präsentiert war
die Arbeit in der Ausstellung *Utopie/
Black Square 2001 ff.* (S. 56–57), in
der das Video über 3 Ausstellungsex-
ponate von Mischa Kuball projiziert
wurde.

Black Square/Speed Suprematism,
2003, Kunstsammlungen der Ruhr
Universität Bochum, video,
approx. 30′ loop, silent
(photograph: Thorsten Koch, Bochum)

Kuball's revised version of the film
showing the "belt perspective" of the
artist playing squash; this version
features the artist's hand blended
into the film, and it is played on top
of a photograph of Malevich's *Black
Squares*. The two levels are con-
nected by a third, as the existing
overlaps of media were filmed once
again. The work was presented as
part of the exhibition *Utopie/Black
Square 2001 ff.* (pp. 56–57), where the
video was projected onto three of
Kuball's works.

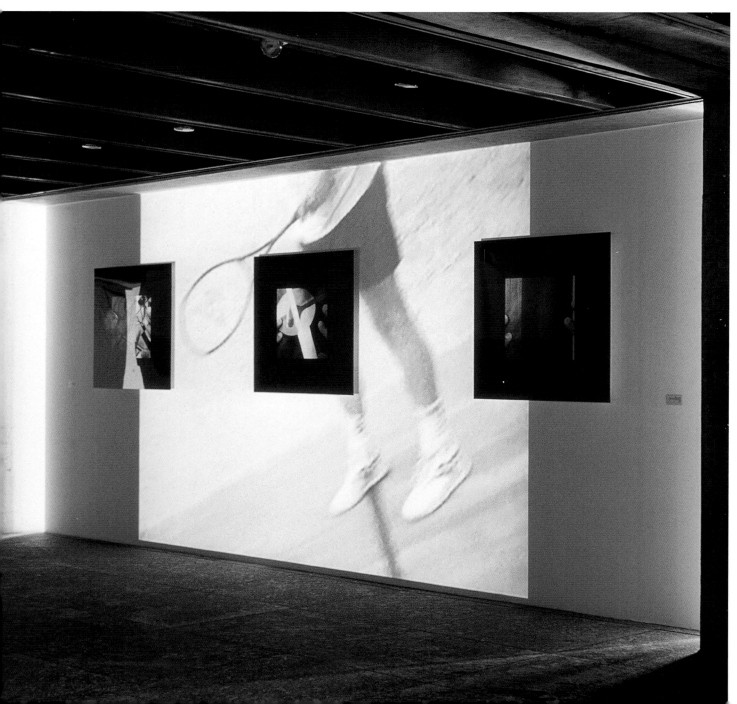

Stage II, 2005,
Videonale Bonn; Video, 18' Loop,
ohne Audio, schwarze Plexiglas-
Maske für den Monitor 40 x 30 x 80 cm
(Foto: Archiv Mischa Kuball, Düssel-
dorf)

Der horizontale Bildausschnitt prä-
sentiert nur die Deckenbeleuchtung
einer Bühnensituation. Reduziert auf
die reinen Bildinformationen – es
existiert kein Ton – konzentriert sich
die Arbeit auf die vielfältigen Licht-
signale. Die Präsentationsform der
Arbeit (eine Sichtblende/schwarze
Maske) unterstützt die horizontale
Begrenzung, intensiviert dadurch die
räumliche Distanz.

Stage II, 2005,
Videonale Bonn; video, 18' loop,
silent, black Plexiglas mask for the
monitor 40 x 30 x 80 cm
(photograph: Mischa Kuball Archive,
Düsseldorf)

This horizontal section of an image
showed only the overhead lights
above a stage. Reduced to pure visual
information—there is no sound—the
work concentrated on the variety
of light signals. The way the work
was presented (a sight screen/
black mask) supports the horizontal
limits, intensified through the spatial
distance.

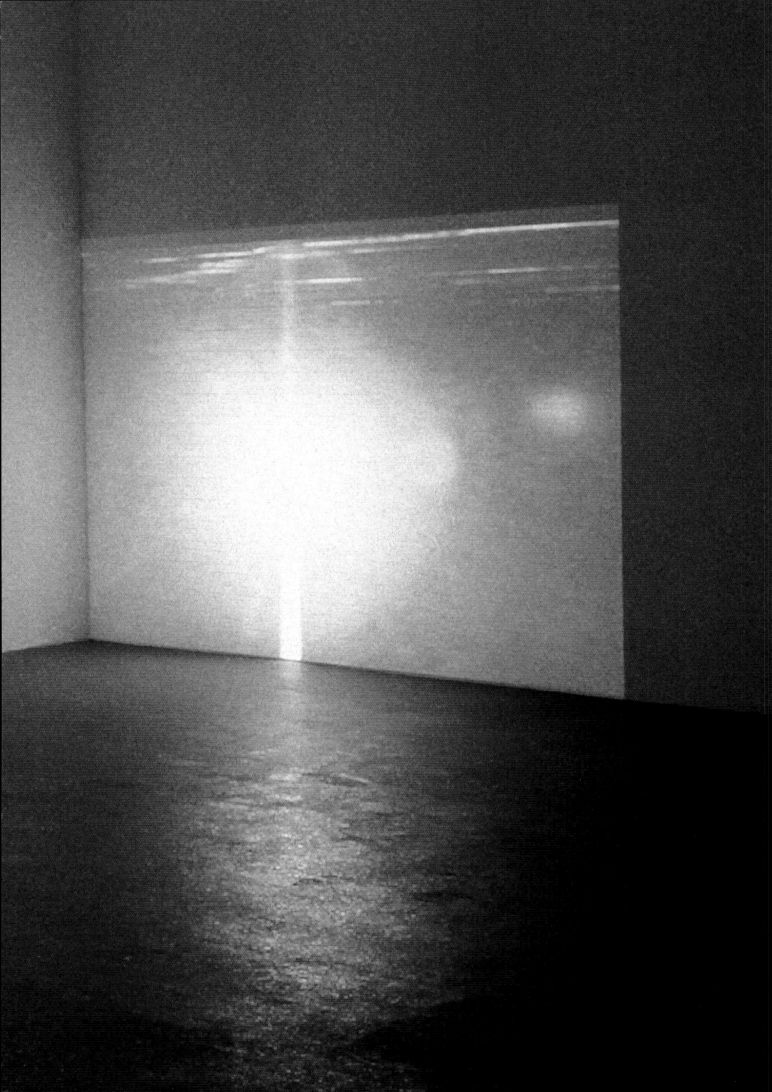

PETER WEIBEL

LICHTPOLITIK
THE POLITICS OF LIGHT

DIE KUNST DES LICHTS IN SEINER ETHISCHEN, SOZIALEN UND POLITISCHEN DIMENSION

Abb. S. 166–171

Abb. S. 128–129

Abb. S. 38–39, 338–339

Abb. S. 346–347

Abb. S. 180–181

Abb. S. 356

Abb. S. 364–365

In den 1990er-Jahren ist Mischa Kuball durch Lichtinstallationen von architektonischer Dimension aufgefallen. 1990 wandelte er das Mannesmann-Hochhaus in Düsseldorf sechs Wochen lang in eine Lichtskulptur um. Fassadengestaltung durch Licht ist heute eine alltägliche Routine, damals war es noch ein *Megazeichen*, so der Titel der Arbeit. 1992 versetzten geometrische Lichtzeichen das Dessauer Bauhaus in den Status einer Skulptur (*Lichtbrücke*). 1994 ist die innen grell beleuchtete Synagoge in Stommeln als *Refraction House* ins Bewusstsein der Öffentlichkeit gedrungen. 1998 tauschte er für die *Biennale von São Paulo* standardisierte Lampen gegen Leuchtkörper aus privaten Haushalten aus (*Private Light/Public Light*). 1999 markierte er verlassene Häuser des jüdischen Viertels in Montevideo mit grünen 100-Watt-Baulampen (*Greenlight*). 1999 wollte er den Lichtstrahl eines Scheinwerfers, gesteuert durch ein Zufallsprogramm, vom Turm des ehemaligen Weimarer Gauforums über den Platz bewegen (*Sprach Platz Sprache*, nicht realisiert). 2000 konnten die Bewohner von Moritzburg eine von Kuball konstruierte öffentliche Bühne für ihre Auftritte verwenden (*Public Stage*).

Die sorgfältig gewählten Titel geben bereits Auskunft über die künstlerischen Intentionen von Kuballs Licht- und Projektionskunst. Das Wort Bühne deutet darauf hin, dass

THE ART OF LIGHT IN ITS ETHICAL, SOCIAL, AND POLITICAL DIMENSION

Figs. pp. 166–171

Figs. pp. 128–129

Figs. pp. 38–39, 338–339

Figs. pp. 346–347

Figs. pp. 180–181

Figs. p. 356 and pp. 364–365

During the 1990s, Mischa Kuball excited attention with his light installations of architectonic dimensions. He transformed the Mannesmann building in Düsseldorf into a light sculpture for six weeks in 1990. Nowadays it is common routine to alter building façades with the aid of light, but in those days it was still a mega-symbol, as the title of the work, *Megazeichen*, indicates. In 1992, his illuminated geometrical signs (*Lichtbrücke*, or Light Bridges) gave the Bauhaus in Dessau sculptural status. Two years later, the synagogue in Stommeln, lit brightly from the inside, penetrated public consciousness under the title *Refraction House*. For the 1998 Biennale do São Paulo, Kuball exchanged standard lights for ones from private households (*Private Light/Public Light*). In 1999, he marked abandoned houses in the Jewish quarter of Montevideo with green, hundred-watt construction lights (*greenlight*). That same year, randomly controlled rays produced by a spotlight stationed on the tower of the old Gauforum in Weimar were to move across the square (*Sprach Platz Sprache*, or Speak Square Language). In 2000, he supplied the residents of Moritzburg with a public stage to use for their own performances (*public stage*).

Carefully selected titles provide information as to the intentions behind Kuball's light and projection art. The word "stage" alludes to the fact that Kuball understands that light

Gegenlicht/AntiKino (Detail), 1999, Konrad Fischer Galerie, Düsseldorf (Foto: Dorothee Fischer, Düsseldorf), Vgl. Abb. S. 262 / See fig. p. 262

Kuball verstanden hat, dass Licht immer eine Inszenierung und Dramatisierung bedeutet und dass dort, wo inszeniert und konstruiert wird, das Leben zur Bühne wird. Im Raum des Lichts wird das gesamte Leben zu einer öffentlichen Bühne, im Zeitalter der Medien mehr denn je. Das Scheinwerferlicht ist der Beginn jenes Zeitalters, wo jeder im Brennpunkt, im Spot steht, wo jeder der Regie einer Kontrollgesellschaft unterworfen ist. Ob via Schein- werfer oder Kamera, via Zeitung oder Handy, jeder kann zufällig Teil des öffentlichen Rau- mes werden, Teil der öffentlichen Aufmerksamkeit. Jeder ist immer potenziell Akteur in einem Projekt. Die Zusammenarbeit mit Vilém Flusser 1991 im Haus Wittgenstein in Wien (*Welt/Fall*) deutet darauf hin, dass Kuball sich der Assoziationskette Projekt – Projektion – Projektil wohl bewusst ist, dass also Scheinwerfer und Lichtbatterien zum militaristischen Inventarium gehören, dass also die Lichttechnik insgesamt ein Produkt der Kriegstechno- logie ist, wie es uns Paul Virilio und Friedrich Kittler immer wieder nahe legen. Deswegen hat Kuball bei dem Projekt *Urban Context* im Bunker Lüneburg (2000) auch im Katalog auf die »Bunker Archäologie« von Paul Virilio hingewiesen und deswegen hat er im Katalog für das Projekt *Ein Fenster* für die Johanneskirche in Düsseldorf 2001 einen Text von Friedrich Kittler (»Eine Kurzgeschichte des Fensters«) ausgewählt, der bekanntlich auch eine »Kurze Geschichte des Scheinwerfers« verfasst hat.

Abb. S. 118–119

Abb. S. 40–41

Abb. S. 368–369

In diesem Beispiel des Verweises auf die Zusammenhänge von Licht und Krieg, den auch die Arbeit für das ehemalige Weimarer Gauforum transportiert, ist klar erkennbar, dass Kuball nicht wie andere Künstler das Licht nur als Medium ästhetischer Reize, als

always implies staging, dramatization; and that wherever things are staged and con- structed, life itself becomes a stage. When illuminated, all of life becomes a public stage, more so than ever in the media age, that age began with the spotlight. It is the age in which everyone is in the hot spot, where everyone is subjected to the direction of a con- trolling society. Whether through the spotlight or camera, newspaper or cell phone, any- one can randomly become part of public space, an object of public attention. Everyone is always a potential actor in a project. It seems reasonable to suppose that in Kuball's 1991 work with Vilém Flusser, *Welt/Fall* at the Wittgenstein House in Vienna, the artist was probably aware of the chain of associations involving project-projection-projectile. Very likely, he knew that spotlight and light batteries are part of the military inventory, and that light technology as a whole is a product of military technology, as Paul Virilio and Friedrich Kittler have always suggested. That is the reason why Kuball also referred to Virilo's *Bunker Archaeology* in the catalogue for the project *urban context*, which was part of the Projekt.Bunker Lüneburg (1995–2000), and it is also why, for the catalogue for 2001's *ein fenster* (a window) done for the Johanneskirche in Düsseldorf, he selected a text by Kittler ("A Short History of the Window")—who, it is known, also wrote a "Short History of the Spotlight."

Figs. pp. 118–119

Figs. pp. 40–41

Figs. pp. 368–369

In this reference to the connections between light and war—also conveyed in the work set up in the former Gauforum in Weimar—it is easy to see that Kuball does not, as

Medium von Farblichtspielen, als Glanz und Elend der Spektralfarben, als Erweiterung der Farbe in den Raum verwendet, wie es die etwas blasse Mission der Neo-Avantgarde der 1950er- und 1960er-Jahre war, sondern dass er unverkennbar den sozialen und politischen Kontext des Mediums Licht sichtbar macht. Schon seine Schauplätze – von der Synagoge in Stommeln bis zu den Häusern des jüdischen Viertels in Montevideo – zeigen, dass er nicht auf neutrale Weise mit seinen Lichtinstallationen im öffentlichen Raum interveniert, sondern dass er den öffentlichen Raum als politischen und sozialen Raum mit seinen Lichtinstallationen akzentuiert. Das ist in der Geschichte der Lichtkunst eine einzigartige Leistung. Wenn bisher von den Künstlern und ihren Kommentatoren gesagt wurde: »Licht ist Farbe, Licht ist Musik«, so fügt Kuball hinzu: »Licht ist Soziologie, Licht ist Politik«. Die politische und soziale Position des Lichts hat niemand besser ausgeleuchtet als Kuball. Die Immaterialität des Lichts, wie sie von Yves Klein und Jesús Raphael Soto benutzt wurde, um Ort und Raum zu überwinden, um in die Leere zu springen, hat Kuball umgedreht. Kuball verwendet seine Video- und Diaprojektionen, seine Lichtinstallationen dazu, über die Immaterialität des Lichts die Schwerkraft des historischen Materials – die Gravitation der Geschichte – in den leeren Raum der Kunst miteinzuführen. Er reist mit dem Lichtstrahl nicht nach vorne in eine scheinbar helle Zukunft, sondern er macht eine Zeitreise in umgekehrter Art, er reist mit dem Lichtstrahl zurück in das Dunkel der Geschichte. Dort erhellt er die vergessenen und vergrabenen Räume, die verdunkelten und verdrängten Räume. Er bringt ans Licht, was keiner mehr sehen wollte und will. Die Geschichte wird zu

other artists do, employ light only as an aesthetically alluring medium, one of interacting color and light, or as the radiance and misery of the colors of the spectrum, as the expansion of color in space, which was the somewhat bland mission of the neo-avant-garde in the 1950s and 1960s. Instead, he obviously makes it possible to see the social and political context of the medium of light. Starting with his locations, from the synagogue in Stommeln to the buildings in the Jewish quarter in Montevideo, it can be seen that his light installations do not intervene in a neutral way in public space. Instead, they accentuate public space as a political and social space. This is a unique achievement in the history of light art. Until now, artists and their commentators have said, "Light is color, light is music," but Kuball adds, "light is sociology, light is politics." No one has done better at illuminating the political and social position of light than Kuball. He has reversed the immateriality of light, as it was used by Yves Klein and Jésus Rafael Soto to overcome place and space in order to make the leap into the void. Assisted by the immateriality of light, Kuball uses his projections of videos and slides, and his light installations to introduce the gravity of the historical material, the gravitational pull of history, into the empty space of art. He does not travel forward with the ray of light into an apparently bright future, but rather journeys through time in the opposite way: he accompanies the ray of light back into the darkness of history. There he illuminates the forgotten and buried spaces, the darkened and repressed spaces. He brings to light things that no one

einer öffentlichen Bühne und steht im Scheinwerferlicht. Seine Lichtinstallationen re-
inthronisieren im Alltag die historischen Erfahrungen. Das Leben des sozialen Handelns
wird durch die Beleuchtung zum Theater, der Ort der Geschichte zur Bühne des ethischen
Urteils. Das ästhetische Urteil wird durch Kuballs Lichtinstallationen, durch seine Interven-
tionen im historischen und öffentlichen Dunkel, zu einem ethischen Urteil. Was in Kants
berühmtem Wahlspruch »der gestirnte Himmel über mir und das moralische Gesetz in
mir« anklingt, der Zusammenhang von Licht und Moral, von Ästhetik und Ethik, kommt in
Kuballs Licht-Interventionen wunderbar zum Ausdruck. Kant mit Kuball heißt: Das Licht
kann im öffentlichen Raum als moralische und ethische Instanz eingesetzt werden, welche
einen Rahmen und ein Gedächtnis für das soziale Handeln liefert. Ein Scheinwerfer ist nicht
einfach ein Scheinwerfer, sondern er verwandelt die Welt in eine Bühne. Die Akteure han-
deln auf dieser Bühne nach bestimmten Regeln, in dieser unserer Welt gibt es keine bloßen
Zuschauer des Weltgeschehens, sondern jeder Mensch partizipiert durch sein Handeln am
Weltgeschehen. Jeder Mensch ist ein Akteur der Geschichte, tritt auf auf der Bühne der
Geschichte, sodass die Unterscheidung zwischen privat und öffentlich fällt. Dies machen
die Licht-Interventionen von Mischa Kuball im öffentlichen Raum, auf der Bühne des sozia-
len Handelns, im Raum der Geschichte bewusst. Das Licht wird bei ihm zu einem Medium
des Bewusstseins, zu einem Medium politischen Bewusstseins der Mündigkeit und Auf-
klärung. Das Licht ist für ihn nicht nur ein perzeptives Phänomen, ein Phänomen der Wahr-
nehmung, des Auges, ein Ereignis im Labor der Sinnesorgane, sondern das Licht dringt bei

wanted—and still does not want—to see. History becomes a public stage; it is in the spot-
light. His light installations reintroduce historical experiences into the everyday. Illumina-
tion turns the life of social activity into theater; the historical site becomes the setting for
the ethical judgment. Through Kuball's light installations, through his interventions in
historical and public darkness, the aesthetic judgment becomes an ethical judgment.
What resonates in Kant's famous phrase, "the starry heavens above me and the moral law
within"—the association of light with morality, of aesthetics with ethics—is beautifully
articulated in Kuball's light interventions. Kant and Kuball mean this: light can be used in
the public space as a moral and ethical authority that provides a framework for social
action as well as a recollection of it. A spotlight is not merely a spotlight; instead, it trans-
forms the world into a stage. Those on this stage act according to certain rules. In this,
our world, nobody is simply a witness to world events, but through his own activity, each
person participates in the events of the world. Everyone is an actor in history, appears on
the stage of history, so that the difference between private and public falls away. Kuball's
light interventions do this consciously in public space, on the stage of social activity, in the
space of history. For him, light becomes a medium of consciousness—the political con-
sciousness of maturity, responsibility, and enlightenment. For him, light is not simply a
perceptual phenomenon, a phenomenon of perception, the eye, something experienced in
the laboratory of the sensory organs. Rather, in his work, light penetrates the conscious-

ihm durch das Auge zum Bewusstsein. Es wird zu einem kognitiven Phänomen, zu einem Phänomen des Bewusstseins, ein Ereignis im Labor des Gehirns. Kuball ist kein Maler des Lichts, Kuball ist ein Konzeptkünstler des Lichts, ein politischer Künstler des Lichts – eine einzigartige Position von Rang.

ness through the eye; it becomes a cognitive phenomenon, a phenomenon of consciousness, something experienced in the laboratory of the mind. Kuball is not a painter of light; Kuball is a conceptual artist of light, a political artist of light—a unique and important stance.

DORIS KRYSTOF

»SIEH' DURCH MEINE AUGEN«
MISCHA KUBALLS VIDEOARBEITEN "LOOK THRU' MY EYES"
MISCHA KUBALL'S VIDEO INSTALLATIONS

»Video ist die Poetik des elektronischen Bildes. Video ist virtuelle
Basisdemokratie oder Anarchie. Die Camera obscura wird im TV
zum schwarzen Koffer. Video hingegen ist das Fundbüro des Lichts.«[1]

1

Mischa Kuballs Arbeit mit der Videokamera setzte Mitte der 1990er-Jahre ein und begleitet
seitdem seine künstlerische Praxis, die konsequent die immaterielle Wirkung von Licht und
Schatten nutzt und vorwiegend aus Interventionen im öffentlichen Raum besteht. Jenseits
der mit dem Medium Video genuin verknüpften Dokumentationsmöglichkeiten schließt sich
Kuballs Videopraxis an die künstlerische Auseinandersetzung mit Licht an. Bei Kuballs
Videos handelt es sich um meist abstrakte Bewegungsbilder, die zu Endlosschleifen arran-
giert sind und sämtliche narrative Spezifika von Film und Video – lineare Erzählweisen,
figurativ szenische Darstellungen oder dokumentarische Aspekte – in den Hintergrund
drängen. Obwohl Kuball Realität nicht abfilmt, stellt die sichtbare Welt den Ausgangspunkt
seiner Arbeiten dar. So wird in den Videos Realität manipuliert, neu konstruiert und zu
emblematischen Filmbildern verdichtet. Indem Licht und Schatten, Form und Farbe eine
tragende Rolle spielen, indem die Akzentuierung des Lichts thematisch und produktions-
technisch als unverzichtbarer Bestandteil von Film- und Videokunst hervorgehoben wird,

"Video is the poetry of the electronic image. Video is virtual grass-roots
democracy or anarchy. The camera obscura becomes TV's black box.
Video, by contrast, is the lost and found of light."[1]

1

Mischa Kuball first started working with a video camera in the mid-1990s, and it has been
part of his artistic practice since. His work consistently uses the immaterial effect of light
and shade and consists predominately of interventions in public space. Kuball's video
technique is connected to the artistic examination of light, beyond the options for docu-
mentation genuinely connected to video as a medium. Kuball's videos are mostly abstract
images in motion that have been arranged in an endless loop. They force all the narrative
specifications of film and video into the background—linear narrative techniques, figura-
tive scenic representation or documentary aspects. Although Kuball does not film reality,
he does take the visible world as a starting point for his work. Reality is consequently
manipulated, reconstructed, and summarized as emblematic film images in the videos.
Light and shade, form and color play a decisive role, just as the accentuation of light is
highlighted, both thematically and in terms of production, as an indispensable component

**Stadt durch Glas/
Moskau – Düsseldorf – Moskau**
(Detail), 2003, K20/Kunstsammlung
NRW, Düsseldorf
(Foto: Christoph Schuhknecht,
Düsseldorf), Vgl. Abb. S. 252–255 /
See figs. pp. 252–255

273

sind Kuballs Videoarbeiten als eine besondere Form von Lichtkunst zu betrachten, in der Vorgänge des Sehens, Wahrnehmens und Erkennens selbst zum Thema werden.

Im Zusammenhang des Gesamtwerks bilden die Videoarbeiten eine relativ kleine Gruppe von weniger als zehn Titeln, dennoch nimmt das Medium Video in Kuballs Schaffen eine wichtige Position ein. Der vermeintlich geringen Anzahl an Bändern steht eine Fülle von Aufführungen beziehungsweise Screenings entgegen, was in seinem besonderen Umgang mit Videoarbeiten begründet liegt. Kuball handhabt die einzelnen Titel wie konzeptionelle Module, die in unterschiedlichsten Varianten und Modifikationen realisiert und präsentiert werden. Die Videoarbeiten ähneln insofern temporären Installationen, und tatsächlich beziehen sich Monitorpräsentation oder Projektion vielfach direkt auf den Ort der Ausstellung. Video artikuliert sich damit als »Aufführungskunst«,[2] als Kunst, die einen anderen, dynamischen Werkbegriff, eine erweiterte Definition von Original und Kopie, eine neue Form der Werk-Chronologie impliziert. Am deutlichsten demonstriert das Kuballs wohl prominenteste Videoarbeit *Stadt durch Glas/Sieh' durch meine Augen*, deren Grundidee nach einer ersten Realisation im Jahr 1995 zahlreiche Wiederaufnahmen und Modifikationen erfahren hat. Hinter ein und demselben Titel verbergen sich insofern inhaltlich verwandte, aber formal durchaus unterschiedliche Arbeiten aus den Jahren 1995 bis 2006 (wobei es sich in einem Fall nicht einmal um ein Video, sondern um Fotoarbeiten handelt). *Stadt durch Glas/Sieh'durch meine Augen* stellt sich exemplarisch für Kuballs Umgang mit dem Medium Video als komplexes thematisches Konzept und

Abb. S. 248–257

of film and video art. For the above reasons, Kuball's work can be regarded as a special form of light art which addresses the processes of sight, perception, and recognition.

Within the context of his oeuvre, video installations form a relatively small group of fewer than ten works. Nevertheless, video as a medium assumes an important position within his creative works. The apparently low number of videotapes is compensated for by a plethora of performances and screenings. This is thanks to his particular treatment of video installations. He treats the individual titles as conceptual modules, which are realized and presented in a widely-differing variants and modifications. The video works resemble temporary installations in this respect, and indeed the monitor presentation or projection frequently refers directly to the exhibition venue. Video thus articulates itself as "performance art,"[2] a form of art which implies a different, more dynamic concept, a broader definition of original and copy or a new chronological form of the artist's works. This is most clearly demonstrated in what is probably Kuball's most prominent video installation, *Stadt durch Glas/Sieh' durch meine Augen* (City thru' Glass/Look thru' My Eyes). First realized in 1995, its basic concept was subsequently subjected to numerous rerecordings and modifications. The same title is used to describe works between 1995 and 2006 (although in one case it does not even refer to a video but to photographic works), which are similar in content, yet display significant formal differences. *Stadt durch Glas/Sieh' durch meine Augen* is representative of Kuball's treatment of the medium video

Figs. pp. 248–257

unabgeschlossener Prozess dar, als »work in progress«, virtuell erweiterbar und poten-
ziell unendlich.

2

Von den Bauhauskünstlern über Dan Flavin bis hin zu Olafur Eliasson ist zu beobachten,
dass die künstlerische Verwendung von Licht eine nahezu programmatische Ausblendung
von Stil, Subjektivität, persönlichem Ausdruck und Autorschaft beinhaltet. Mit einer Aus-
sage wie, »alles, was ich mache, ist transparent und es ist vergänglich [...]«,[3] deklariert
Kuball seinen künstlerischen Anspruch auf Intersubjektivität, Klarheit, Prozessualität und
Offenheit. Zur produktiven Bezugnahme auf die Tradition von Minimal Art und Concept-Art
tritt bei ihm eine intensive Auseinandersetzung mit aktuellen naturwissenschaftlichen
Ansätzen (Physik, Optik, Neurologie), insbesondere mit den spezifischen bildgebenden Ver-
fahren. Fernab jeglicher »High-End-Ästhetik« enthalten Kuballs Arbeiten jedoch immer
auch eine subtile Kritik an Technik und Innovation. Das zeigt sich in der Hinwendung zum
Selbstgemachten, zum kleinen gebastelten Artefakt – zum Beispiel an der Verwendung
einfacher schwarzer Pappen bei den unterschiedlichsten Lichtprojektionen. Dieser Hang zu
einer »Do-it-yourself-Ästhetik«, zum durchschaubaren, offen gelegten Kunstgriff lässt sich
auch an Kuballs Videoarbeiten beobachten. Vor dem Hintergrund der raumgreifenden
Monumentalisierung von Film und Video, die in der Kunst der 1990er-Jahre Einzug hielt, ist
dies als deutliches Statement für die Ursprünge der Videokunst zu verstehen, als noch ein-

as a complex thematic concept and uncompleted process; a "work in progress," virtually
expandable and potentially infinite.

2

From the artists of the Bauhaus and Dan Flavin to Olafur Eliasson it can be observed that
the artistic use of light involves a virtually programmatic blocking-out of style, subjectiv-
ity, personal expression, and authorship. When Kuball comments "everything I do is
transparent and transitory,"[3] he is declaring his artistic claim to intersubjectivity, clarity,
processualization, and openness. Standing in productive relationship to the tradition of
Minimal and Conceptual Art, he conducts an intensive analysis of current approaches in
the natural sciences (physics, optics, neurology), in particular with the specific imaging
procedures. Far removed from any manner of "high-end aesthetics," Kuball's works nev-
ertheless always contain a subtle criticism of technology and innovation. This becomes
apparent in the tendency toward the home-made, the small self-made artifacts, such as
the simple black cardboards used in various light projections. This leaning to the "do-it-
yourself aesthetic," the transparent artistic maneuver revealed to all, can also be seen in
Kuball's video installations. Within the context of the space-consuming monumentaliza-
tion of film and video which emerged in the art world during the 1990s, this can be under-
stood as a clear statement on the origins of video art, when its simplicity of use, instant

fache Bedienbarkeit, Instantwirkung und leichte Überprüfbarkeit der visuellen Resultate unschlagbare Vorteile für den künstlerischen Umgang mit der Videokamera darstellten.

Auf die Vorzüge des spontanen und direkten Arbeitens spielte etwa der amerikanische Künstler John Baldessari an, wenn er in den 1970er-Jahren den Künstlern empfahl, die Videokamera als Bleistift zu verwenden. Aber auch in den folgenden Jahrzehnten haben einige Künstler – Tony Oursler (vor allem in seinen frühen Arbeiten), Rosemarie Trockel oder Heimo Zobernig – zu einer einfachen, gewissermaßen handgemachten Videoästhetik beigetragen. Auch Kuball benötigt für die Produktion seiner Videoarbeiten weder komplizierte Sets noch raffinierte Castings oder ausgefeilte Filmtechniken. Es zeigt sich bei ihm vielmehr eine Bevorzugung des kleinen Formats, der konzisen Miniatur, die es erlaubt, einen Gedanken schlüssig in ein bewegtes Bild in der Art von *Kneten* (1995/96) oder *Public Alphabet* (2003) umzusetzen. Gleichermaßen kommt bei Kuball ein subjektivistischer und experimenteller Ansatz in puncto Videopraxis zum Tragen, der sich in einem dynamisch-performativen Umgang mit der Kamera zeigt, die geschleudert, geworfen oder apparativ manipuliert wird. Videoarbeiten wie *Stadt durch Glas* (von 1995 an) oder *Schleudertrauma* (2000) nutzen gezielt den Faktor Zufall und bleiben doch auf das ausübende, künstlerische Subjekt bezogen.

Abb. S. 258–259

Abb. S. 304

Abb. S. 248–249 und S. 260

effects, and easy checking of the visual results represented unbeatable advantages for artists working with the video camera.

The American artist John Baldessari referred to the advantages of working spontaneously and directly, for example, when he enjoined artists in the 1970s to use a video camera as if it were a pencil. Several artists in the following decades—Tony Oursler (especially in his early works), Rosemarie Trockel, or Heimo Zobernig—have also contributed to a simple, in part hand-crafted video aesthetic. Kuball himself does not require complicated sets, sophisticated casting, or polished film techniques in order to produce his video works. He prefers instead a small format, a concise miniature, which permits a thought to be transformed into a moving picture, as in *Kneten* (Kneading) (1995–96) or *Public Alphabet* (2003). He likewise applies a subjective and experimental approach to video techniques, which is demonstrated in his dynamic, performative camera style—catapulting, throwing, and apparatively manipulating it. Video works such as *Stadt durch Glas* (from 1995 onwards) or *Schleudertrauma* (Whiplash) (2000) deliberately use the concept of coincidence, and yet they continue to refer to the practicing, artistic subject.

Figs. pp. 258–259

Fig. p. 304

Figs. pp. 248–249 and p. 260

3

Abb. S. 242–247

Als Vorläufer der Arbeit mit der Videokamera und als ein erster Beitrag zum Thema Video-kunst zugleich ist die Arbeit *Mediendrama* zu betrachten, die 1986 im Atelier entstand und erstmals 1987 im Rahmen der ersten Museumsausstellung des Künstlers im Museum Folk-wang in Essen gezeigt wurde. *Mediendrama* bezieht sich auf das Fernsehen als Massenme-dium und nimmt eine künstlerische Aneignung der Fläche des Fernsehbildschirms vor. Damit schließt sich die Arbeit an den in den Achtzigerjahren von Medientheoretikern wie Vilém Flusser beschriebenen Konkurrenzkampf zwischen »elektronischen« und »her-kömmlichen« Bildern an. Kuballs Beitrag zu diesem »Wettstreit« besteht aus einer handge-zeichneten Schraffur, die per Diaprojektor auf ein laufendes Fernsehbild projiziert wird: Die abstrakte Handzeichnung – subjektivistische Künstlergeste par excellence – wird gegen das konfektionierte massenmediale Bild ausgespielt.[4] Die Art der Störung des Fernsehbildes erinnert entfernt an Nam June Paiks Manipulationen des laufenden Fernsehprogramms, wobei dieser in den frühen 1960er-Jahren Magnetsteine und ab circa 1970 einen eigens ent-wickelten Synthesizer eingesetzt hat, um das TV-Bild mit malerischen Schlieren und psy-chedelisch wirkenden Formen zu überziehen. Stand bei Paik das Interesse an einer Syn-these von gemaltem und elektronischem Bild im Vordergrund, so stellt Kuballs Eingriff im Gegensatz dazu die Differenz der Medien deutlich heraus. Als konzeptionelle Arbeit ist *Mediendrama* unter Verwendung derselben Geräte mehrfach gezeigt worden, wobei die pro-jizierte Zeichnung auf das jeweils laufende Fernsehbild des örtlichen Regionalsenders traf.

3

Figs. pp. 242–247

Mediendrama (Media Drama) can be regarded as a precursor to the work with the video camera as well as an initial contribution to the subject of video art. It was created in the studio in 1986 and initially shown in 1987 as part of the artist's first museum exhibition at the Museum Folkwang in Essen. *Mediendrama* deals with television as a mass medium, looking at the surface of a television screen from an artistic perspective. This relates to the work of media theorists in the 1980s, such as Vilém Flusser, who described the com-petitive struggle between "electronic" and "conventional" images. Kuball's contribution to this "competition" consists of hand-drawn hatching, which is projected onto a moving television image by a slide projector. The abstract drawing—a subjectivist artistic gesture par excellence—is pitted against the converted mass-media image.[4] The manner in which the television image is disrupted bears a slight resemblance to Nam June Paik's manipu-lation of a program being broadcast on television, for which he initially utilized magnetic stones—and from approximately 1970 onwards a self-developed synthesizer—to cover the TV image with "painterly" streaks and what appeared to be psychedelic forms. Whereas Paik focused on the synthesis of painted and electronic images and of colored and acoustic tones (an interest derived from Fluxus), Kuball is concerned with clearly highlighting the differences between the media. As a conceptional piece of art, *Medien-drama* has been shown on a number of occasions using the same apparatus, although the

4

Marshall McLuhan, »Nestor der modernen Medienwissenschaften«, argumentierte, dass die Geschichte der Medien mit der Geschichte des Sehens und der Wahrnehmung gleichzu-setzen sei.[5] Einschlägig belegen das Motive des Auges beziehungsweise des Blicks, die sich wie ein roter Faden durch die Film- und Videokunstgeschichte ziehen. Um 1900 ging von den ersten Filmvorführungen eine geradezu hypnotische Wirkung aus, und die Bilder rasender Züge haben bekanntlich bei den Zuschauern Angst und Schrecken erzeugt. Gezielt setzten die ersten bewegten Bilder beim Sehen als leiblich-körperlicher Sinnes-erfahrung an. Eine Weiterentwicklung stellen in dieser Hinsicht filmische Bilder dar, die von einer schnell bis unkontrolliert bewegten Kamera aufgenommen werden. Wenn dem Auge jeglicher räumliche Fixpunkt fehlt, an dem es sich festhalten könnte, löst das unwei-gerlich heftige physische Reaktionen aus. Im europäischen Avantgardefilm der 1910er- und 1920er-Jahre finden sich – etwa im Kreis um Sergej M. Eisenstein – eine Reihe von Experi-menten des entsubjektivierten Kameragebrauchs im Sinne eines kinematografischen Bei-trags zur revolutionären Neubestimmung von Standort, Perspektive und menschlichem Individuum. Mit *Stadt durch Glas/Sieh' durch meine Augen* knüpfte Kuball zum einen an die modernistische Tradition der Kamera als apparative Verlängerung des menschlichen Seh-sinns an.[6] Zum anderen entwickelte sich parallel zu der anhaltenden Beschäftigung mit *Stadt durch Glas* das künstlerische Interesse an den physikalisch-biologischen Konditionen von Wahrnehmung und Bewusstsein, sodass in der Verschmelzung beider Stränge die zen-

Abb. S. 248–257

drawing projected onto the television screen confronted whatever was being shown on the local TV station.

4

Marshall McLuhan, the "Nestor of the modern media sciences," argued that the history of the media can be equated with the history of sight and perception.[5] The themes of the eye and the gaze, which have been used throughout the history of film and video art, provide relevant proof for this. The first film screenings around 1900 had a virtually hypnotic effect on audiences, and the images of racing trains notoriously caused fear and terror. When the first moving pictures were seen, they were specifically intended as a physical, sensual experience. A further development in this respect was provided by filmic images shot with a fast-moving, possibly even uncontrolled camera. When the eye has no spatial point to fix onto, it inevitably leads to severe physical reactions. European avant-garde film of the 1910s and 1920s—an example being the circle surrounding Sergei M. Eisen-stein—carried out a series of experiments on the desubjectivized camera in terms of a cinematographic contribution to the new revolutionary concepts of location, perspective, and the human individual. With *Stadt durch Glas/Sieh durch meine Augen,* Kuball firstly continued the modernist tradition of regarding the camera as an apparative extension of people's sense of sight.[6] Secondly, an artistic interest in the biological state of perception

Figs. pp. 248–257

trale Bedeutung von *Stadt durch Glas* für Kuballs künstlerischen Ansatz zu sehen ist. Das Filmmaterial entstand 1995 sowohl bei nächtlichen Autofahrten als auch tagsüber bei Gängen durch Düsseldorf, wobei der Weg jeweils vom Atelier des Künstlers in Friedrichstadt zur Galerie von Konrad Fischer in der Platanenstraße im Stadtteil Flingern führte. Vor die Linse der Videokamera hatte Kuball ein einfaches, vieleckiges Wasserglas gesetzt und damit eine ähnlich kaleidoskopische Verfremdung der gefilmten Bilder bewirkt wie der amerikanische Experimentalfilmer Stan Brakhage, der einen Kristall-Aschenbecher zur Manipulation der Kamera-Optik verwendete.[7] Bei *Stadt durch Glas* ergibt sich der visuelle Effekt einer konzentrisch um einen Kreis angeordneten Komposition: ein schillerndes Gebilde aus bald rötlichen, bald bläulichen, bald weißen Facetten und Flecken, in dem ab und zu Details der Stadtansichten erscheinen. Erinnert die radiale Struktur bereits an eine Iris, so unterstützt der dunkle, pupillenförmige Kreis in der Mitte des Videobildes erst recht die Assoziation an ein Auge. Vor allem aber ruft die parallele Anbringung von zwei Monitoren beziehungsweise Projektionen, die nebeneinander jeweils synchron dasselbe *Stadt durch Glas*-Filmmaterial zeigen, die Vorstellung von Augen hervor. Suggeriert wird ein in der Dunkelheit leuchtender Blick, der in den Raum gerichtet ist und auf die Blicke der Betrachtenden trifft. Nachdem die Arbeit im Jahr 1996 erstmals auf 2 erhöht im Raum angebrachten Monitoren in einer Ausstellung der Konrad Fischer Galerie gezeigt wurde, hat Kuball in New York (1997), Moskau (2003), Tokyo (2004) und im australischen Brisbane (2006) weitere Kamerafahrten mit vor die Linse montiertem Glas unternommen. Wiederum

and consciousness developed parallel to the ongoing preoccupation with *Stadt durch Glas*. Consequently, the amalgamation of these two strands allows the central significance of this piece for Kuball's artistic approach to be revealed. The film footage was shot in 1995 during automobile rides through Düsseldorf at night, as well as during daytime walks through the city; the route in both cases led from the artist's studio in Friedrichstadt to Konrad Fischer's gallery in Platanenstrasse in the Flingern district. Kuball placed a simple, polygonal glass tumbler in front of the video camera's lens, creating a similarly kaleidoscopic alienation from the filmed images as the American experimental filmmaker Stan Brakhage when he used a crystal ashtray to manipulate the camera lenses.[7] The visual effect in *Stadt durch Glas* is of a composition arranged around a circle; a dazzling formation of first reddish, then bluish, then white facets and marks in which details of city views can occasionally be glimpsed. If the radial structure is reminiscent of an iris, the dark, pupil-like circle in the center of the video image only confirms the eye-like connotations. Above all, it is the parallel monitors or projectors placed next to one another, showing the same synchronized *Stadt durch Glas* footage, which evoke the impression of eyes. It suggests a gaze shining in the darkness, directed through the room until it meets the gaze of the observer. The work was first shown on two raised monitors in an exhibition at the Konrad Fischer Galerie in 1996; Kuball subsequently carried out further camera journeys with glass fixed in front of the lens in New York (1997), Moscow (2003), Tokyo (2004),

wurde das Filmmaterial jeweils als Bilderpaar präsentiert, wobei es sich nun meist um wandfüllende, häufig im öffentlichen Raum platzierte Beamerprojektionen und damit um eine Monumentalisierung des funkelnden Augenpaares handelte.[8]

5

Geschwindigkeit und Dynamik der Großstadt, Aufsplitterung der sichtbaren Welt, Fragmentierung von Perspektiven gehören zu den Topoi der Moderne, die bis in die heutige Zeit nachwirken.[9] Ein Filmklassiker wie Dziga Vertovs *Der Mann mit der Kamera* (1929) lebt etwa in der Video-Installation *Drumroll* (1998) des britischen Künstlers Steve McQueen, in der sich kreiselnde Bilder als Schwindel erregendes Großstadtpanoptikum präsentieren.[10] Bei Kuballs Filmdreh in der Stadt liegt der Akzent indessen nur vordergründig auf der Evokation urbaner Turbulenz, denn seine Rundbilder wurden einer zusätzlichen, geradezu gegenläufig anmutenden Manipulation unterzogen. Mit der Halbierung der Abspielgeschwindigkeit (gezeigt werden statt 24 nur 12 Bilder pro Sekunde) ergibt sich ein stakkatoartiger Zeitlupeneffekt, eine Verzögerung des Strudels der Bilder.[11] Weder Großstadttempo noch Hektik oder Zerstreuung kommen damit zum Ausdruck, sondern nach innen gerichtete Fokussierung, Trance, Traum, Hypnose. Die zersplitterten Bilder- und Seherfahrungen, die seit der Moderne für ein Auseinanderklaffen von Innen und Außen stehen, bilden bei Kuball einen wichtigen Ausgangspunkt. Darüber hinaus berühren Kuballs Großstadtveduten mit ihren atmosphärischen und informellen Strukturen gezielt die Grenzen von

and Brisbane (2006). The footage was again always presented as a pair of images; however, the video projections mostly took up an entire wall and in public spaces, constituting a monumentalization of the glittering eyes.[8]

5

The speed and dynamism of the city—the splintering of the visible world—the fragmentation of perspectives—they all belong to the topoi of the modern which resonate through to the present.[9] A film classic such as Dziga Vertov's *The Man with a Movie Camera* (1929) lives on in the video installation *Drumroll* (1998) by the British artist Steve McQueen, in which rotating images are presented as a dizzying panopticon of the city.[10] The evocation of urban turbulence is only superficially emphasized during Kuball's filming in the city, for his circular images were then subjected to an additional, apparently contradictory manipulation. The film speed is halved (only twelve images per second are shown instead of twenty-four), resulting in a jerky, slow-motion effect delaying the whirlwind of images.[11] There is no big-city speed, frantic activity or distraction. There is just an inward-looking focus—a trance, a dream, a hypnotic state. The fragmented pictorial and visual experiences (which since the age of modernism have represented the divergence of the internal and external) form an important starting point for Kuball. Furthermore, the atmospheric and informal structures of Kuball's cityscapes consciously reach the boundaries of visibil-

Abb. S. 308–309

Sichtbarkeit. Damit leiten sie zum Komplex »Wahrnehmung und Bewusstsein« über, der in Kuballs anschließenden Arbeiten etwa zum Broca-Areal des Gehirns eine zentrale Rolle spielen wird. In *Stadt durch Glas* markieren tradierte darstellerische Mittel wie Unschärfe oder die Verwischung und Auflösung von Konturen die Relation von Sehen und Bewegen. Ins Spiel gebracht wird die Frage, wer oder was sich hinter den regsamen, kosmisch leuchtenden Bilder verbergen könnte. Das zielt auch auf die Frage nach einem Subjekt, das sich womöglich gekonnt hinter den filmisch apparativen Verfremdungseffekten zu verbergen sucht, um sich – mit einer rätselhaften Formulierung im Titel der Arbeit – dennoch zu erkennen zu geben: *Sieh' durch meine Augen*.

Video war seit jeher das künstlerische Medium zur Erkundung des Selbst innerhalb der geltenden gesellschaftlichen Konditionen. Auch Kuball nimmt die Kamera als Spiegel, bezieht aber von der neueren Naturwissenschaft entwickelte Parameter wie Willensfreiheit, Aufmerksamkeit, Bewusstsein et cetera in seine Überlegungen mit ein. Die technisch bedingte Auflösung tradierter Vorstellungen von Imagination, Raum und Zeit, die aktuell in den naturwissenschaftlichen Disziplinen verhandelt werden, führen zu einem Kameragebrauch, der handelnd und denkend die Außenwelt erfasst, der Sehen und Bewegen mit unterschiedlichen filmischen Mitteln kurzschließt. So gesehen ist jede Wiederholung der Kamerafahrt mit vorgesetztem Wasserglas als weiteres Element einer Versuchsreihe namens *Stadt durch Glas* zu betrachten. Deswegen kommen trotz der Vielzahl der aus einer praktischen Erfahrung heraus entwickelten *Stadt durch Glas*-Arbeiten weniger formale

Abb. S. 248–249

Figs. pp. 308–309

ity. This leads to the "perception and consciousness" complex, which plays such a central role in subsequent works, for instance the *Broca'sche Areal*. In *Stadt durch Glas*, the relationship between sight and motion is marked by conventional means of representation such as blurring of focus or the obliteration and disintegration of contours. The question is posed of who or what could be concealed behind the busy, cosmically-lit pictures. It also leads to the question of the subject, who attempts to hide behind the filmic apparative alienation effects as skillfully as possible, only to then be revealed by the puzzling title of the work: *Sieh' durch meine Augen*.

Since its inception, video has been the artistic medium for self-discovery within existing social conditions. Kuball also uses the camera as a mirror but incorporates more recently developed parameters from the natural sciences such as freedom of the will, attention, consciousness, and so on, into his deliberations. The breaking down of the conventional division between imagination, space, and time (caused by technological developments), which is currently being debated in science, results in a camera technique which records the external world in action and intention, and which bypasses sight and movement with various filmic means. In this respect, every repetition of the camera journey with a glass tumbler fixed to the front can be regarded as a further element in a series of experiments entitled *Stadt durch Glas*. Therefore, despite the large number of *Stadt-durch-Glas* works which developed from practical experience, few formal artistic

Figs. pp. 248–249

künstlerische Mittel wie Wiederholung, Serie, Kopie zum Tragen, sondern es geht darum, die Gleichzeitigkeit von Sehen und Bewegung unter immer wieder anderen Bedingungen zu vollziehen und zu registrieren. Als Vorgehensweise erinnert das in gewisser Hinicht an manche in den 1970er-Jahren als »Task Performances« entwickelte Strategien zur Erforschung von »Welt und Selbst«. Doch auch wenn Kuball auf solche historischen Vorgaben – etwa durch die Einbeziehung der eigenen Person als ausführenden Agenten – in Videoarbeiten wie *Speed Suprematism* (2004) oder *Public Alphabet* zurückgegriffen hat, steht dabei weder seine Person noch die exemplarische Rolle des Künstlers im Vordergrund. Es geht vielmehr um die funktionale Ausführung von selbst gestellten Aufgaben, was die Videoarbeit *Kneten* auf pointierte Weise vorführt: Die aus der Vogelperspektive gefilmte Aufnahme rückt Kopf und Hand als steuernde und ausführende Organe bei einer vermeintlich banalen Tätigkeit wie Teig kneten in den Mittelpunkt, wobei die traumwandlerische Ausführung der Handlung darüber hinwegzutäuschen vermag, dass gerade die einfach scheinenden, halbautomatischen Verrichtungen von höchster neurophysiologischer Komplexität sind.[12]

Abb. S. 264 und S. 304

6

Zahlreiche Videos von Kuball beziehen sich auf das Gehirn, das »als Mind Machine« und »Versteck des Geistes« einen großen Vorrat an Metaphern für grundlegende Fragen der Existenz ausgebildet hat.[13] Im Jahre 1999 wurde die Arbeit *Stadt durch Glas/Sieh' durch*

means such as repeats, series, or copies were brought to bear. The focus was rather on completing and registering the simultaneity of sight and motion under constantly changing conditions. As a modus operandi it is somewhat reminiscent of strategies developed as "task performances" in the 1970s to explore "the world and oneself." Yet even if Kuball has resorted to these historic parameters (for example, by involving himself as the executive agent) in video works such as *Speed Suprematism* (2004) or *Public Alphabet*, he foregrounds neither himself nor the exemplary role of the artist. It has more to do with the functional execution of tasks he has set himself, as he pointedly demonstrates in the video installation *Kneten*. The shot, filmed from a bird's-eye perspective, focuses on the head and hand as the controlling and executive organs in a seemingly commonplace activity such as kneading dough. Yet the dreamlike atmosphere may be deceptive, as it is precisely these apparently simple semiautomatic performances which are, neurophysiologically speaking, so highly complex.[12]

Figs. p. 264 and p. 304

6

Countless videos by Kuball refer to the brain, which as "mind machine" and "hiding place of the spirit" has developed a large collection of metaphors for the fundamental questions of existence.[13] In 1999, *Stadt durch Glas/Sieh' durch meine Augen* was associated with a location which specializes in delving deeply into people: the neurological teaching hospi-

Abb. S. 250

meine Augen mit einem Ort in Verbindung gebracht, der auf Blicke in das tiefste Innere des Menschen spezialisiert ist: mit dem 1995 in Krefeld eröffneten neurologischen Lehrkrankenhaus der Düsseldorfer Universitätsklinik. Aus Videostills des Filmmaterials entwickelte Kuball Wandobjekte, die aus der Nachbarschaft zu einem ultramodernen Magnetresonanztomographen und anderen Geräten zur Durchleuchtung des menschlichen Körpers eine besondere Wirkung bezogen. Die im Diasec-Verfahren hergestellten Fotoscheiben, die jeweils mit Kristallspiegeln kombiniert waren, fokussierten in den Gängen und Wartezonen vor den Behandlungsräumen eine Vielzahl von divergenten Blicken und Sichtbarkeiten.[14]

Abb. S. 260

Das damit erzeugte Wechselspiel von Bildgebung und polyvalenten Wirklichkeitsbezügen lässt sich auch an anderen Videoarbeiten Kuballs beobachten. *Schleudertrauma* – der Titel verweist erneut auf den Bereich der Neurologie – beruht auf der Verwendung einer bewegten Kamera, die am lang ausgestreckten Arm in weit ausholenden, schwungvollen Kreisen geführt wurde. Ort der Aktion und der Ausstellung war der Kunstverein Ruhr, der im Unter-

Abb. S. 45

geschoss der Alten Essener Synagoge untergebracht war. Die »geschleuderten« Bilder wurden als wandfüllende Doppelprojektion gezeigt und bildeten eine verschwommene »Allover«-Komposition aus rotierenden Flächen und Schlieren, die »die erstarrten Erzählungen von der leidvollen Geschichte der Juden in der NS-Zeit buchstäblich in Bewegung [bringt], ohne sie in eine neue Narration zu überführen.«[15] Wurde Sehen hier in einer erweiterten Bedeutung von Erkennen, Erinnern, Einsehen vorgeführt, so stand dem die Indiffe-

Abb. S. 264–265

renz des bloß registrierenden Sehens des Kameraapparates gegenüber. Eine Variante der

Fig. p. 250

tal of the Düsseldorf University Clinic, which opened in 1995. Kuball developed wall-hanging objects from video stills of footage; these were particularly effective when situated near an ultramodern magnetic resonance scanner and other instruments for x-raying the human body. The photographic plates, produced using the diasec process and each combined with crystal mirrors, focused on a multiplicity of divergent gazes and visibilities in the corridors and waiting areas in front of the treatment rooms.[14] The interplay of visualization and polyvalent references to reality that this created can also be seen in

Fig. p. 260

Kuball's other video works. *Schleudertrauma*—the title, Whiplash, referring once more to the field of neurology—is based on the use of a handheld camera, which makes wide sweeping movements when held at arm's length. The action and exhibition was located in

Fig. p. 45

the Kunstverein Ruhr, situated in the basement of the old synagogue in Essen. The pictures were shown "spinning through the air" as a double projection covering the entire wall, and formed a blurry "allover" composition of rotating surfaces and streaks, which "literally bring movement to the sclerotic tales of the sorrowful fate of the Jews during the Nazi era, without leading to a new narration."[15] Seeing is applied here in its extended meaning of recognize, remember, realize, standing in marked opposition to the indifference of the eye of the camera mechanism, which merely registers. A variant on observa-

Figs. pp. 264–265

tional perception is revealed in the video installation *Black Square/Speed Suprematism*, which imitates a kind of laboratory setup. A squash player (the artist himself) carried a

beobachtenden Wahrnehmung offenbart sich in der Videoarbeit *Black Square/ Speed Suprematism*, die eine Art Laboranordnung imitiert. Ein Squashspieler – es ist der Künstler selbst – trug während des Spiels eine Kamera wie ein Messgerät am Gürtel. Indem sich filmische Mittel wie subjektive Kameraführung und die Praxis wissenschaftlicher Aufzeichnungsverfahren überlagern, werden die dynamischen Bewegungsabläufe innerhalb des begrenzten Spielfeldes als Ergebnisse komplexer zerebraler Steuerungsvorgänge erfahrbar.[16] Bewegungssteuerung, nun allerdings in einem digitalen und mechanischen Sinn, demonstriert schließlich die Monitorarbeit *Stage II* (2004). Von den Filmaufnahmen eines Pop-Konzerts sind durch Abkaschierung der unteren Hälfte des Bildschirms nur der Bühnenhimmel mit zahlreichen wie von Geisterhand gelenkten Deckenscheinwerfern zu sehen. Lautlos bewegen sie sich im Rhythmus einer (nicht zu hörenden) Musik über einer (nicht zu sehenden) Aktion. Die Ansicht der wie beseelt tanzenden Lichtkegel ergibt ein emblematisch anmutendes Bild des vom Gehirn gelenkten Sehsinns. Ein Bild, das stellvertretend für Kuballs Arbeit mit der Videokamera stehen kann. Das Zucken und Aufblitzen der bunten Lichter im Dunkeln erinnert an das flackernden Augenpaar aus *Stadt durch Glas*. Es ist, als sähe man einem Gehirn beim Sehen zu, als betrachte man den mitunter verzögerten Rhythmus der Synapsenschaltung, als verfolge man staunend den unendlichen Strom der neuronalen Botschaften und Signale.

camera like a measuring device on his belt during the game. Filmic means such as a subjective camera and the practice of scientific recording procedures are superimposed on one another, and through this the dynamic sequence of movements within the limited field of play can be experienced as the results of complex cerebral controlling operations.[16] The control of movements, although in a digital and mechanical sense, is demonstrated by the monitor installation *Stage II* (2004). Taking the footage of a pop concert, the bottom half of the screen has been masked so that only the roof of the stage can be seen, complete with countless spotlights moving in a seemingly uncontrolled fashion. They move silently to the rhythm of an (unheard) music, above (unseen) action. The sight of the cones of light, dancing like crazy, results in an apparently emblematic image of the sense of sight controlled by the brain. It is a picture which could be representative of Kuball's work with a video camera. The quivering and twinkling of the colored lights in the darkness is reminiscent of the flickering pair of eyes in *Stadt durch Glas*. It is as if one could watch a brain while it is seeing; as if one could observe the occasionally delayed rhythm of the synapses signaling; as if one were to follow with astonishment the endless stream of neural messages and signals.

ANMERKUNGEN

1 Peter Weibel (1986), zit. n. *Medien Kunst Interaktion*, hrsg. von Dieter Daniels und Rudolf Frieling, Wien und New York 2000, S. 86.
2 Vgl. Hans Dieter Huber, »Die Verkörperung von Code«, *40jahrevideokunst.de. Digitales Erbe: Videokunst in Deutschland von 1963 bis heute*, hrsg. von Rudolf Frieling und Wulf Herzogenrath, Ostfildern 2006, S. 58–63.
3 Mischa Kuball, »Moderne, rundum. Ein illustrierter Vortrag«, in: *Licht, Farbe, Raum. Künstlerisch-wissenschaftliches Symposium*, Hochschule für Bildende Künste, Braunschweig, hrsg. von Michael Schwarz, Braunschweig 1996, S. 10.
4 Das im Mediendiskurs der 1980er-Jahre verankerte Konkurrieren der Bilder hat Ulrich Krempel, Kurator von Kuballs Essener Ausstellung, hervorgehoben: »Die Mattscheibe wird zur ästhetischen Grenze von Innen- und Außenwelt. Noch erscheint auf ihr, elektronisch zerlegt, die schnelle Bildfolge des Alltäglichen, da wird sie in eine neue Funktion gezwungen: die nämlich, nur noch als Projektionsfläche dienstbar zu sein. Wo sich die immateriellen Bilder so treffen, kann sich das Sehen der Betrachter auf die eine wie die andere Seite schlagen; bald aber wird das Drama seinen Lauf nehmen und das eine Bild das andere überlagern und attackieren.«, zit. n. *Mischa Kuball. Installationen*, Ausst.-Kat. Museum Folkwang, Essen 1988, o. S.
5 Dazu: Lydia Haustein, *Videokunst*, München 2003, S. 22.
6 Vgl. Pia Müller-Tamm, »Die Stadt als Projektion«, in: *Mischa Kuball. Stadt durch Glas/Moskau – Düsseldorf – Moskau*, Ausst.-Kat. K20/Kunstsammlung NRW, Düsseldorf, Düsseldorf 2003, o. S.
7 Brakhages Film *Text of Light* entstand im Jahr 1974.
8 Vergleichbar damit ist die Videoarbeit *Gegenlicht* (2000): Die frontale Ansicht des von einem Super-8-Filmprojektor ausgehenden Lichtstrahls, der wie ein starres lichtvolles Auge auf den Rezipienten der Arbeit gerichtet ist.
9 Vgl. etwa Richard Sennett, *Civitas*, Frankfurt am Main 1994; *Die Großstadt als Text*, hrsg. von Manfred Smuda, München 1992.
10 Die Bilder wurden von 3 in einem Fass installierten Kameras aufgenommen, das der Künstler durch Uptown Manhattan rollte, vgl. Doris Krystof, »Das Lied der Straße. ›Drumroll‹ als künstlerisches Manifest«, in: *Steve McQueen*, Ausst.-Kat. Kunsthalle Wien, 2001, S. 20–36.

11 Dazu: Müller-Tamm (wie Anm. 6): »Die durch den Fluß bzw. das Stocken des Straßenverkehrs rhythmisierte Kamerafahrt wird durch das ruckartige Gleichmaß einer technisch reduzierten Bildfolge überlagert und gebrochen. Diese Manipulation verhindert die Entstehung in sich verschmolzener Nachbilder auf der Netzhaut des Betrachters.«

12 Die Verlangsamung der Tonspur einhergehend mit der Lektüre aus Gilles Deleuzes Buch *Mille Plateaux* stellt eine weitere Ebene des komplexen Zusammenspiels von Motorik, Kognition und Bewusstsein dar.

13 Günter Schulte, *Neuromythen. Das Gehirn als Mind Machine und Versteck des Geistes*, Frankfurt 2000.

14 Vgl. Julian Heynen, »Sich kreuzende Blicke«, in: *Mischa Kuball, Sieh' durch meine Augen/Stadt durch Glas*, hrsg. von Frank Ulrich, Ausst.-Kat. Neurochirurgische Klinik, Krefeld, Düsseldorf 1999, S. 5–7.

15 Friederike Wappler, »Drehung von Erinnerung«, in: *Schleudertrauma. Mischa Kuball*, hrsg. von Friederike Wappler, Ausst.-Kat. Kunstverein Ruhr, Essen, Düsseldorf 2000, S. 11. Zu Form und Aufbau der Arbeit vgl. ebd. Peter Friese, »Von der Nachhaltigkeit ephemerer Bilder«, S. 43–50: »Abwechselnd in vertikaler und horizontaler Bewegungsfolge sieht man eine jeweils etwa dreiminütige Sequenz schneller Kamerafahrten, welche offensichtlich im Innenraum der Alten Synagoge aber auch außen, direkt vor ihrem Hauptportal, entstanden sind. In ihrem Aufbau und inneren Rhythmus gleichen sich die linke und die rechte Bildprojektion, doch laufen sie ständig gegen- und nebeneinander und zudem zeitversetzt, so daß es keinen Parallel- oder Synchronlauf wirklich identischer Aufnahmen gibt. [...] Statt eindeutiger visueller Orientierung im Hier und Jetzt erleben wir eine vom Künstler bewußt inszenierte Desorientierung, ein Anschleudern gegen die gewohnte Verortung und Bestätigung.«

16 Die Arbeit wurde im Zusammenhang der Ausstellung *Utopie/Black Square 2001 ff.* als Beamerprojektion gezeigt, die die an der Wand installierten Fotoarbeiten partiell überstrahlte, vgl. Abb. 78 und 79 in: *Mischa Kuball. Utopie/Black Square 2001 ff.*, hrsg. von Kai-Uwe Hemken und Monika Steinhauser, Ausst.-Kat. für das Kunstgeschichtliche Institut der Ruhr-Universität, Frankfurt am Main 2004.

NOTES

1 Peter Weibel (1986), cited in *Medien Kunst Interaktion,* ed. Dieter Daniels and Rudolf Frieling (Vienna and New York, 2000), p. 86.

2 See Hans Dieter Huber, "The Embodiment of Code," in *40yearsvideoart.de: Digital Heritage: Video Art in Germany from 1963 to the Present*, ed. Rudolf Frieling and Wulf Herzogenrath (Ostfildern, 2006), pp. 58–63.

3 Mischa Kuball, "Moderne, rundum: Ein illustrierter Vortrag," in *Licht, Farbe, Raum: Künstlerisch-wissenschaftliches Symposium,* Hochschule für Bildende Künste, Braunschweig, ed. Michael Schwarz (Braunschweig, 1996), p. 10.

4 Ulrich Krempel, curator of Kuball's exhibition in Essen, pointed out the competition among images, anchored in the media discourse of the 1980s: "The television screen becomes the aesthetic boundary between inside and outside. It still presents, in an electronically dissected form, the rapid series of everyday images; here, it is forced into a new function, namely, one in which it merely serves as a projection surface. Wherever intangible images meet like this, the viewer's point of view can come down on one side or the other, but soon, however, the drama will take its course and one image will eclipse the other and attack." Cited from *Mischa Kuball: Installationen,* exh. cat. Folkwang Museum (Essen, 1988), unpaginated.

5 See Lydia Haustein, *Videokunst* (Munich, 2003), p. 22.

6 See Pia Müller-Tamm, "Die Stadt als Projektion," in *Mischa Kuball: Stadt durch Glas/Moskau—Düsseldorf—Moskau,* exh. cat. K20/Kunstsammlung NRW (Düsseldorf, 2003).

7 Brakhage's film *Text of Light* was produced in 1974.

8 The video piece *Gegenlicht* (2000) is comparable: this piece features the frontal view of the light emitted by a Super-8 projector, which is aimed at the viewer like a staring light-emitting eye.

9 See Richard Sennett, *The Conscience of the Eye: The Design and Social Life of Cities* (New York, 1990).

10 The images were take from three cameras installed in an oil rum which the artist rolled through uptown Manhattan; see Doris Krystof, "Das Lied der Strasse: 'Drumroll' als künstlerisches Manifest," in *Steve McQueen,* exh. cat. Kunsthalle Wien (Vienna, 2001), pp. 20–36.

11 See Müller-Tamm 2003 (see note 6): "The rhythmic motion of the camera, determined by either the flow or stoppage of traffic on the street, is eclipsed and interrupted by the jerky, uniform mass of a technologically reduced series of images. This manipulation hinders the creation of after-images that melt together on the viewer's retina."

12 The slowing down of the sound, following the reading of Gilles Deleuze's book *Thousand Plateaus*, represents a further level of the complex interaction of motor functions, cognition, and consciousness.

13 Günter Schulte, *Neuromythen: Das Gehirn als Mind Machine und Versteck des Geistes* (Frankfurt am Main, 2000).

14 See Julian Heynen, "Sich kreuzende Blicke," in *Mischa Kuball: Sieh' durch meine Augen/Stadt durch Glas*, ed. Frank Ulrich, exh. cat. Neurochirurgische Klinik, Krefeld (Düsseldorf, 1999), pp. 5–7.

15 Friederike Wappler, "Drehung von Erinnerung," in *Schleudertrauma: Mischa Kuball*, ed. Friederike Wappler, exh. cat. Kunstverein Ruhr, Essen (Düsseldorf, 2000), p. 11. On the form and installation of the piece, see Peter Friese, "Von der Nachhaltigkeit ephemerer Bilder," in the same catalogue, pp. 43–50: "One sees approximately three-minute-long sequences of rapid camera motions, a series of alternating vertical and horizontal movements, which were obviously shot inside the old synagogue as well as outside it, directly in front of its main entry. In their structure and internal rhythm, they resemble the left and right-hand visual projections; they are constantly running in opposition to and beside each other, and at the same time, they are unsynchronized, so that there is no parallel display of really identical takes ... Instead of a clear visual orientation in the here and now, we experience a kind of disorientation, consciously set up by the artist, an attack against the usual kind of orientation and confirmation."

16 The piece was shown on the occasion of the exhibition *Utopie/Black Square 2001 ff* as a beamer projected onto a wall partially covered with photographs; see ills. 78 and 79 in *Mischa Kuball: Utopie/Black Square 2001 ff.*, ed. Kai-Uwe Hemken and Monika Steinhauser, exh. cat. Kunstgeschichtliche Institut der Ruhr-Universität (Frankfurt am Main, 2004).

LANGUAGE SPACE

SPRACHRAUM

<<

Sprachraum/fragen (Detail), 1996,
Konrad Fischer Galerie, Düsseldorf
(Foto: Dorothee Fischer, Düsseldorf),
Vgl. Abb. unten / See fig. below

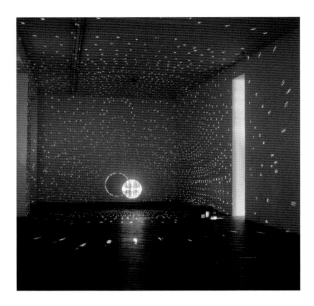

Sprachraum/fragen, 1996,
Konrad Fischer Galerie, Düsseldorf;
1 Spiegelkugel, 1 Deckenmotor,
1 Diaprojektor, 1 Rundschablone,
1 Dia; Sammlung Dr. Axel Feldkamp,
Duisburg
(Foto: Dorothee Fischer, Düsseldorf)

Die sich an der Decke drehende
Spiegelkugel wurde durch den fokus-
sierten Lichtstrahl des Projektors
angestrahlt. Sowohl weißes Licht
als auch die Buchstaben des Wortes
»fragen« wurden in dynamischen
Lichtrhythmen von der Spiegel-
kugel reflektiert und in den Raum
projiziert.

Sprachraum/fragen, 1996,
Konrad Fischer Galerie, Düsseldorf;
1 mirrored ball, 1 ceiling motor,
1 slide projector, 1 round template,
1 slide; Dr. Axel Feldkamp Collection,
Duisburg
(photograph: Dorothee Fischer,
Düsseldorf)

A focused ray of light from the pro-
jector illuminated a revolving mir-
rored ball hanging from the ceiling.
Both white light and the letters of
the word *fragen* (to question) were
reflected in a dynamic rhythm by the
mirrored ball and projected into the
space.

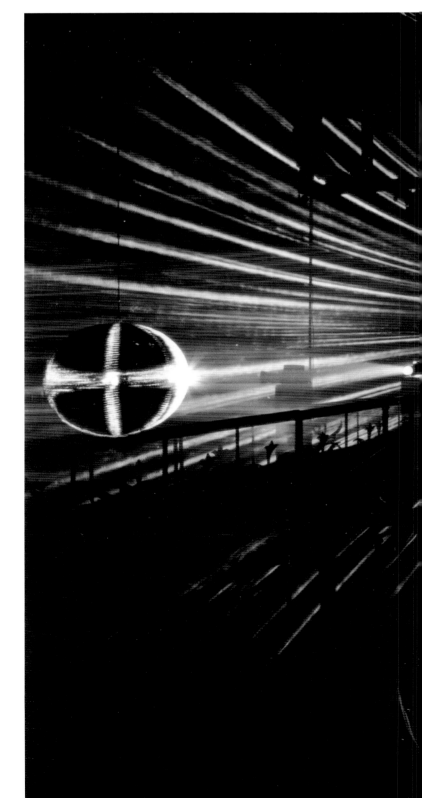

Sprachraum/twin version, 1996,
Kunstraum Wuppertal; 2 Spiegel-
kugeln, 2 Deckenmotoren, 2 Diapro-
jektoren, 2 Rundschablonen, 2 Dias
(Foto: Marion Mennicken, Köln)

Die sich an der Decke drehenden
Spiegelkugeln wurden durch den
fokussierten Lichtstreif der Projek-
toren angestrahlt. Sowohl weißes
Licht als auch die Buchstaben des
Begriffs »material/immaterial«
wurden in dynamischen Lichtrhyth-
men von den Spiegelkugeln reflek-
tiert und in den Raum projiziert.

Sprachraum/twin version, 1996,
Kunstraum Wuppertal; 2 mirrored
balls, 2 ceiling motors, 2 slide projec-
tors, 2 round templates, 2 slides
(photograph: Marion Mennicken,
Cologne)

Focused rays of light from the projec-
tors illuminated revolving mirrored
balls hanging from the ceiling. Both
white light and the letters of the words
material/immaterial were reflected
in a dynamic rhythm by the mirrored
balls and projected into the space.

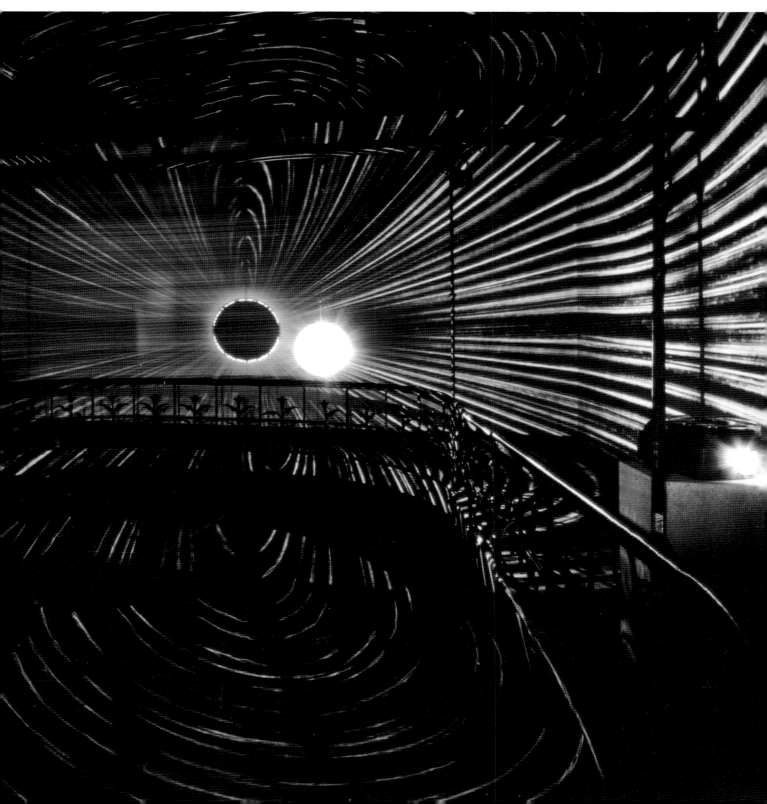

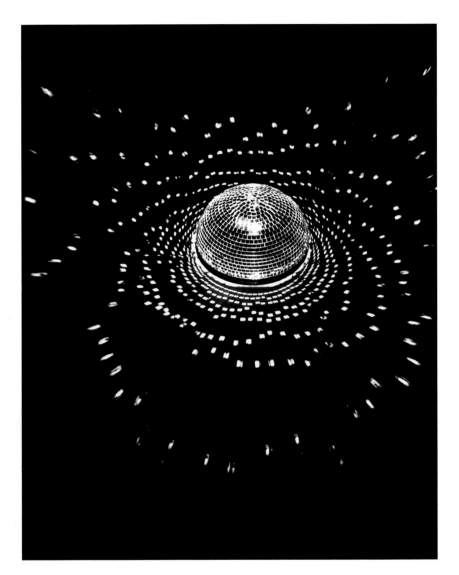

Tornado, 1990,
Foto, 50 x 70 cm
(Foto: Archiv Mischa Kuball, Düssel-
dorf)

Tornado, 1990,
photograph, 50 x 70 cm
(photograph: Mischa Kuball Archive,
Düsseldorf)

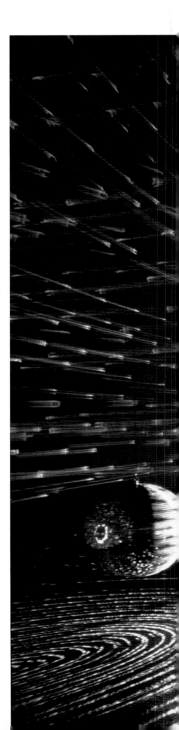

speed – space – speech, 1998,
The Power Plant, Toronto; 3 Spiegel-
kugeln, 3 Projektoren, 2 Decken-
rotoren, 3 Dias
(Foto: Cheryl O'Brien, Toronto)

Anlässlich der Ausstellung *Threshold*
reflektierten eine statische und zwei
sich drehende Spiegelkugeln die
Begriffe »space, speech, speed« in
die Räume von The Power Plant.

speed – space – speech, 1998,
The Power Plant, Toronto; 3 mirrored
balls, 3 projectors, 2 ceiling motors,
3 slides
(photograph: Cheryl O'Brien, Toronto)

For the *Threshold* exhibition, one still
and two revolving mirrored balls
projected the words "space, speech,
speed" into The Power Plant space.

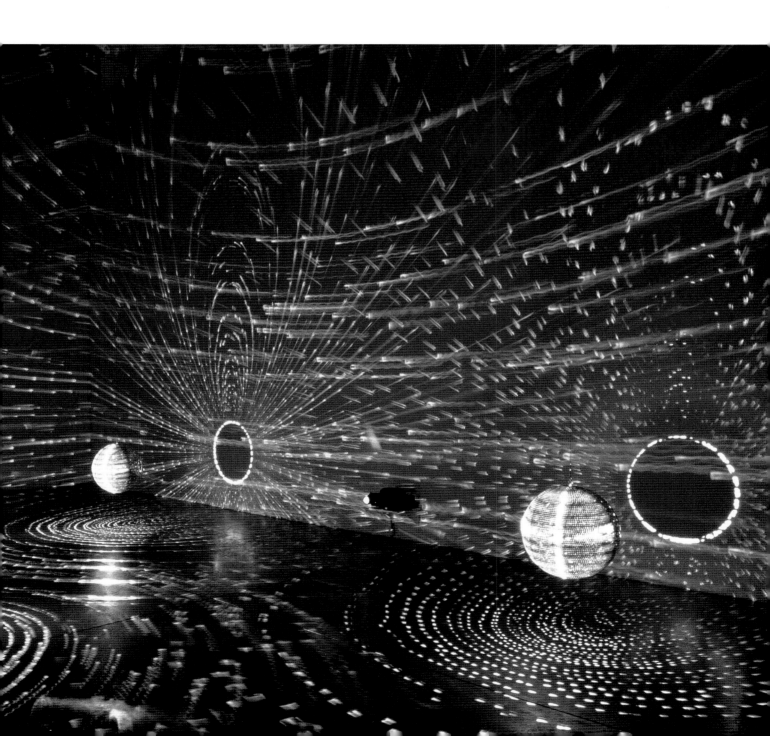

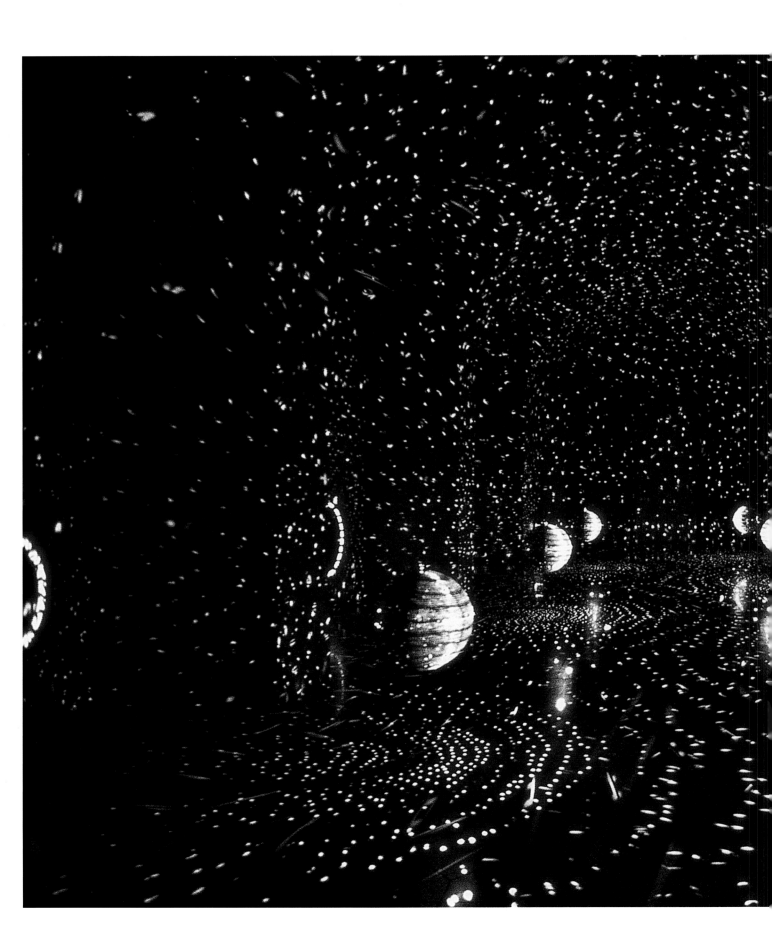

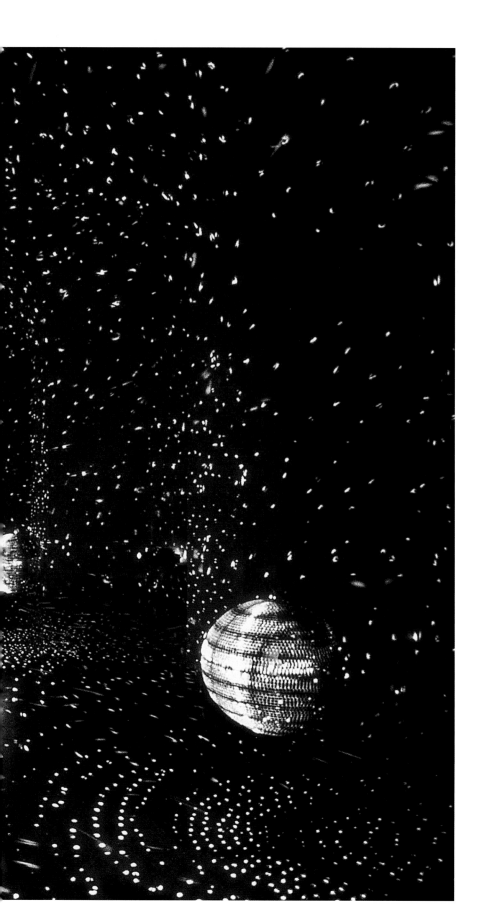

Seven Virtues, 1999,
Diözesanmuseum Freising;
7 Spiegelkugeln, 7 Dias, 7 Projek-
toren, 7 Deckenmotoren, 7 Vario-
Objektive; Sammlung des Diözesan-
museums Freising
(Foto: Archiv Mischa Kuball, Düssel-
dorf)

Die sich an der Decke drehenden
Spiegelkugeln reflektieren das Licht
der 7 Projektoren und die Begriffe
der 7 Tugenden »Glaube«, »Liebe«,
»Hoffnung«, »Laster«, »Demut«,
»Trieb«, »Gier« in den Raum des
Diözesanmuseums.

Seven Virtues, 1999,
Diözesanmuseum Freising;
7 mirrored balls, 7 slides, 7 projec-
tors, 7 ceiling motors, 7 Vario lenses;
Diözesanmuseum Freising Collection
(photograph: Mischa Kuball Archive,
Düsseldorf)

The revolving mirrored balls hanging
from the ceiling reflect the light
from seven projectors and words
describing seven vices and virtues
"Glaube," "Liebe," "Hoffnung,"
"Laster," "Demut," "Trieb," and
"Gier" (faith, love, hope, idleness,
humility, desire, greed) into the space
of the Diözesanmuseum.

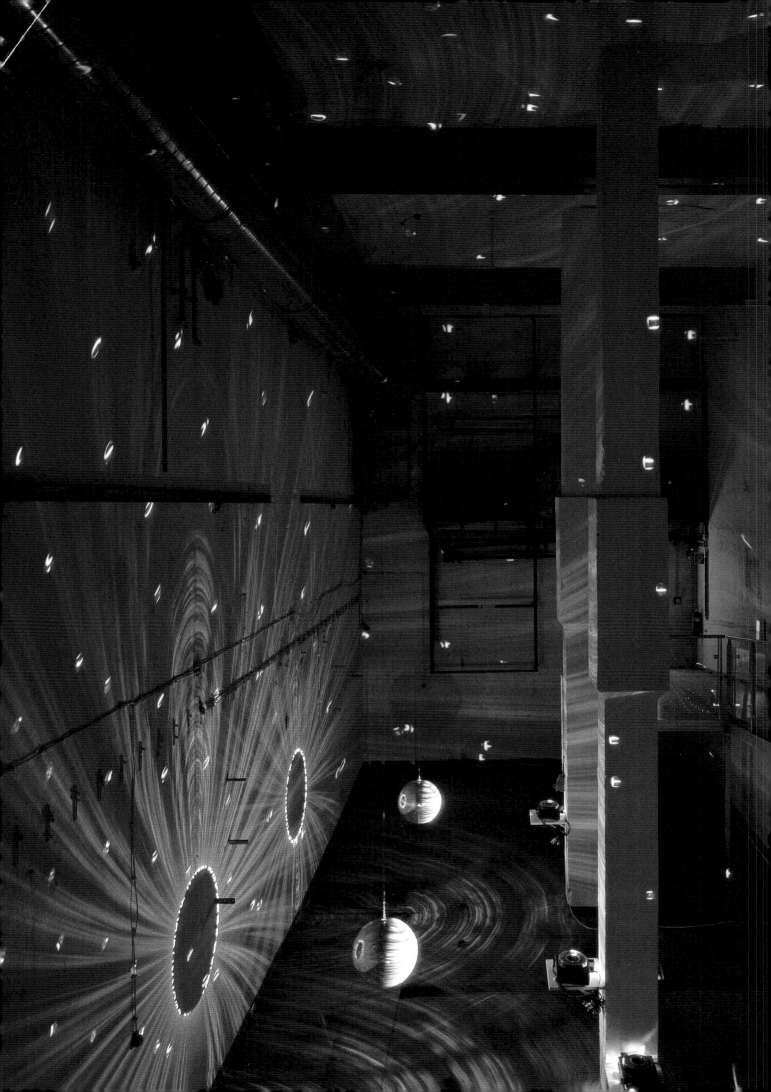

space – speech – speed, 1998/2001,
Zentrum für Internationale Licht-
kunst, Unna; 3 Spiegelkugeln,
3 Projektoren, 2 Deckenrotoren,
3 Dias, Maße raumabhängig;
Sammlung des Zentrums für Inter-
nationale Lichtkunst, Unna
(Foto: Werner Hannappel, Essen,
© Zentrum für Internationale Licht-
kunst, Unna)

Eine statische und zwei sich dre-
hende Spiegelkugeln reflektieren die
Begriffe »space, speech, speed« in
den Kellerraum einer ehemaligen
Brauerei, dem heutigen Zentrum für
Internationale Lichtkunst in Unna.

space – speech – speed, 1998/2001,
Zentrum für Internationale Licht-
kunst, Unna; 3 mirrored balls,
3 projectors, 2 ceiling motors,
3 slides, dimensions dependent upon
space; Zentrum für Internationale
Lichtkunst, Unna
(photograph: Werner Hannappel,
Essen, © Zentrum für Internationale
Lichtkunst, Unna)

One still and two revolving mirrored
balls project the words "space,
speech, speed" into the cellar of an
old brewery, which is today the
Zentrum für Internationale Licht-
kunst in Unna.

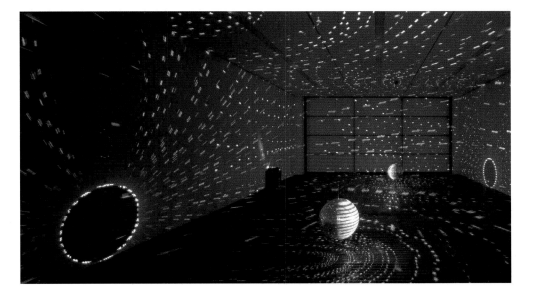

material/immaterial, 1999,
Galerie für Zeitgenössische Kunst,
Leipzig; 2 Spiegelkugeln, 2 Decken-
motoren, 2 Diaprojektoren, 2 Rund-
schablonen, 2 Dias
(Foto: Punctum/Hans Christian
Schink, Leipzig)

Die sich an der Decke drehenden
Spiegelkugeln wurden durch den
fokussierten Lichtstreif der Projek-
toren angestrahlt. Sowohl weißes
Licht als auch die Buchstaben des
Wortes »immaterial« wurden in
dynamischen Lichtrhythmen von den
Spiegelkugeln reflektiert und in den
Raum geworfen. An die Wand wie-
derum wurde das Wort »material«
projiziert.

material/immaterial, 1999,
Galerie für Zeitgenössische Kunst,
Leipzig; 2 mirrored balls,
2 ceiling motors, 2 slide projectors,
2 round templates, 2 slides
(photograph: Punctum/Hans Christian
Schink, Leipzig)

Focused rays of light from the projec-
tors illuminated two revolving mir-
rored balls hanging from the ceiling.
Both white light and the letters of the
word "immaterial" were reflected in
a dynamic rhythm by the mirrored
balls and projected into the space.
In turn, the word "material" was pro-
jected onto the wall.

FlashPlanet, 2005,
Institute of Modern Art, Brisbane;
4 runde Papierlampen, 4 Stroboskop-
Lampen, 4 Diaprojektoren, je 81 Dias
(Foto: Ihor Holubizky, Toronto)

In den in Kniehöhe aufgehängten
Papierlampen blitzte jeweils ein
Stroboskop-Licht auf. Auf die runden
Lampenkörper projizierte Mischa
Kuball Dias der Städte Düsseldorf,
Köln, Sydney und Brisbane, die er
während Spaziergängen aufgenom-
men hatte. Den scheinbar so unter-
schiedlichen Städten ist ihre Ver-
bindung zum Wasser gemein. Die
Lesbarkeit der Stadtansichten wurde
jeweils durch das Aufblitzen der
Lampen unterbrochen.

FlashPlanet, 2005,
Institute of Modern Art, Brisbane;
4 round paper lampshades,
4 stroboscopes, 4 slide projectors,
each containing 81 slides
(photograph: Ihor Holubizky, Toronto)

A stroboscope flashed inside each
of the paper lamps, which were hung
knee-high. Kuball projected slides
from the cities of Düsseldorf, Cologne,
Sydney, and Brisbane onto the round
lamps, which he had taken on walks
through these cities. These appar-
ently very different cities share a
connection to water. As the lights
flashed, the readability of the city
sights was interrupted.

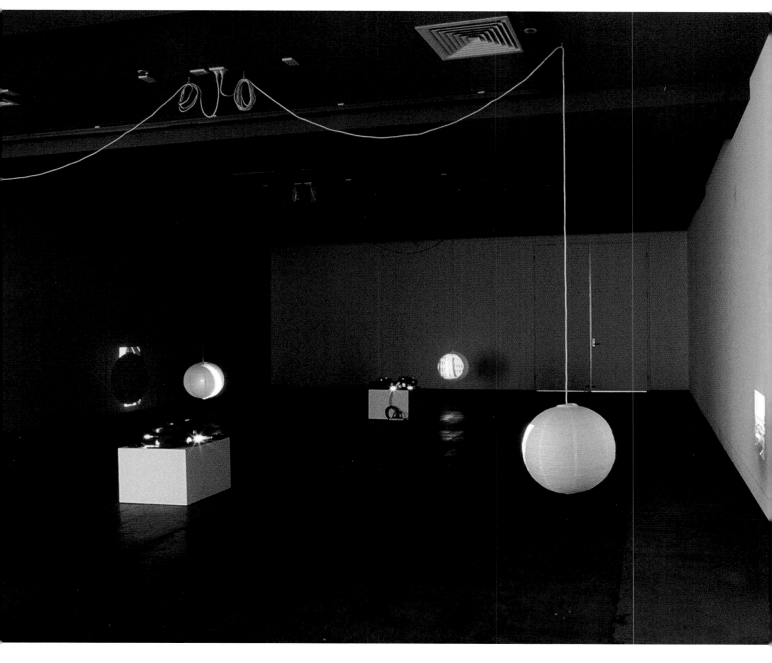

Sprachraum/Prisma, 1997,
Casa das Rosas, São Paulo;
2 von 10 s/w Unikat-Fotografien
(Foto: Archiv Mischa Kuball, Düssel-
dorf)

Buchstaben-Nudeln waren auf einer
Spiegelfläche in unterschiedlicher
Menge verstreut. Die einzelnen
Stufen der Verdichtung von Codes
wurden in 10 Fotoschritten, vom
Begriff »fragen« bis zum Chaos hin,
festgehalten.

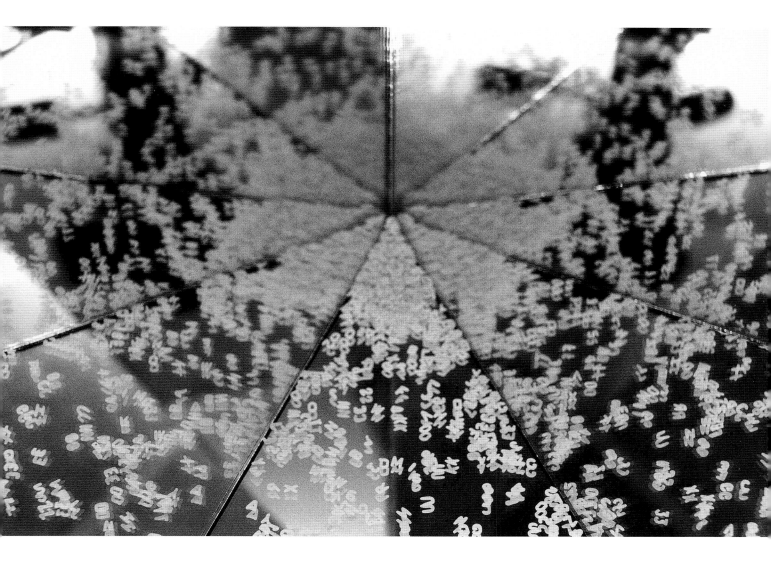

Sprachraum/Prisma, 1997,
Casa das Rosas, São Paulo;
2 of 10 b/w signature photographs
(photograph: Mischa Kuball Archive,
Düsseldorf)

Varying amounts of alphabet noodles
were scattered on a mirrored sur-
face. The individual phases of a code
were captured in ten photographs,
from "question" to chaos.

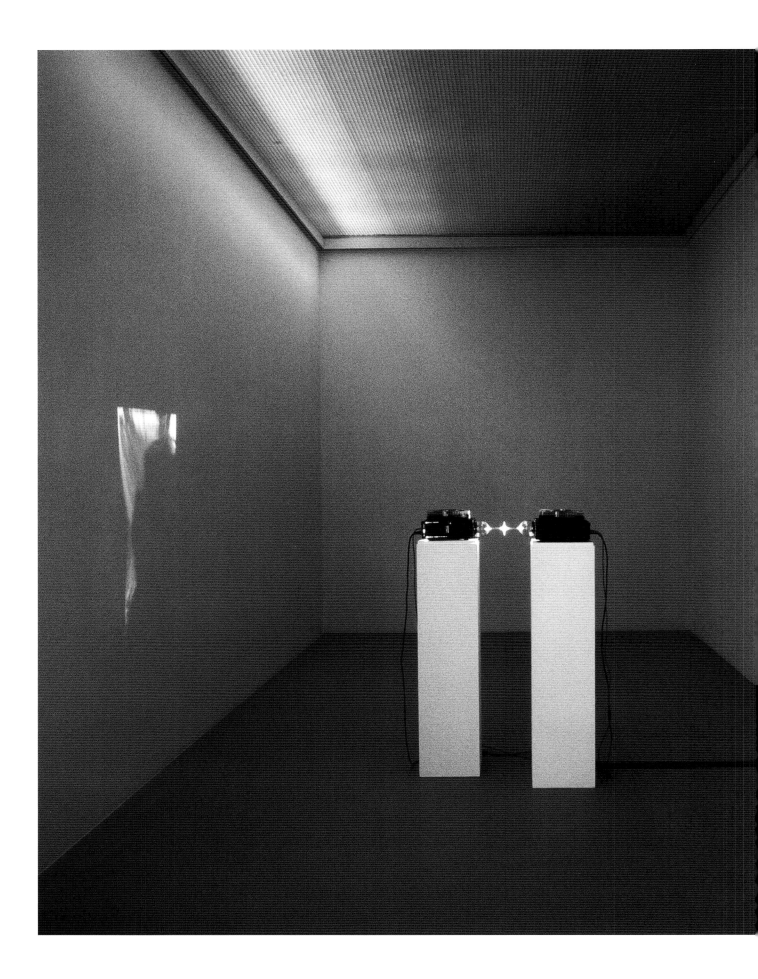

Mneme/Mneme, 1994,
Sprengel Museum Hannover;
2 Diaprojektoren, 2 Weingläser,
2 x 81 Dias; Sprengel Museum
Hannover
(Foto: Michael Herling, Hannover)

Dias mit Exponaten der ständigen
Sammlung des Sprengel Museums
in Hannover wurden an die Wand
projiziert. Vor die Linsen der beiden
Diaprojektoren war je ein Weinglas
montiert.

Mneme/Mneme, 1994,
Sprengel Museum Hannover;
2 slide projectors, 2 wine glasses,
2 x 81 slides; Sprengel Museum
Hannover
(photograph: Michael Herling,
Hanover)

Slides of objects from the permanent
collection at the Sprengel Museum
in Hanover were projected on the
wall. A wine glass was mounted
in front of the lens of each slide pro-
jector.

In Alphabetical Order, 1997,
Museum Boijmans van Beuningen,
Rotterdam, in Zusammenarbeit mit
der Ausstellung In Alphabetical Order,
1997, Galerie Fotomania, Rotterdam;
Buchstaben an Hausfassade,
2 Videomonitore im Schaufenster
(Foto: Archiv Mischa Kuball, Düssel-
dorf)

Alle Buchstaben der Begriffe
»Museum Boijmans van Beuningen
Rotterdam« wurden in alphabeti-
scher Reihenfolge an die Wand des
Eingangbereichs montiert. Auf den
Videomonitoren lief Kaleidoscope.

In Alphabetical Order, 1997,
Museum Boijmans van Beuningen,
Rotterdam, in cooperation with
1997's In Alphabetical order exhibition
at the Galerie Fotomania, Rotterdam;
writing on the façade of a house,
2 video monitors in a shop window
(photograph: Mischa Kuball Archive,
Düsseldorf)

All of the letters from the words
"Museum Boijmans van Beuningen
Rotterdam" were mounted in alpha-
betical order on the wall of the
entrance, while Kaleidoscope was
played on the video monitors.

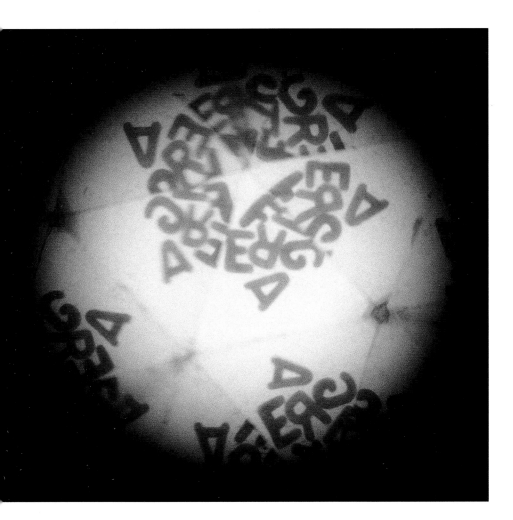

Kaleidoscope, 1996,
Videostill
(Foto: Archiv Mischa Kuball, Düssel-
dorf)

Kaleidoscope, 1996,
video still
(photograph: Mischa Kuball Archive,
Düsseldorf)

Buchstaben-Nudeln (fragen) wurden
in einem Kaleidoskop gefilmt.

Alphabet noodles (fragen) were
filmed in a kaleidoscope.

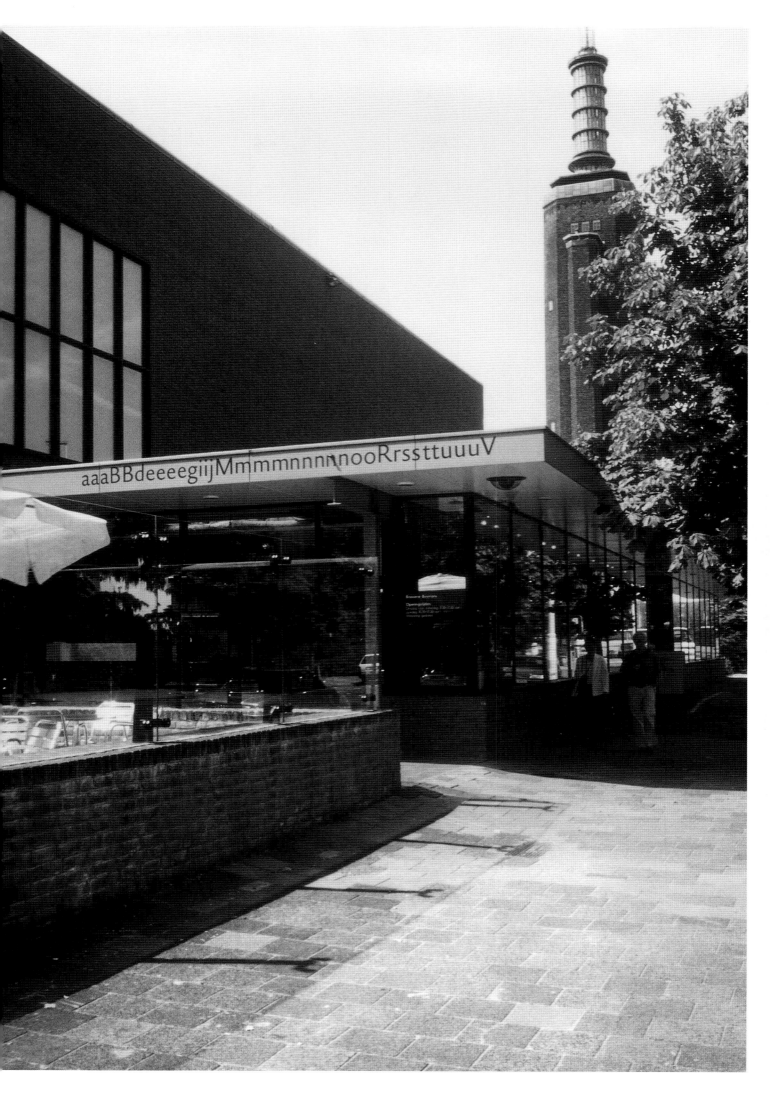

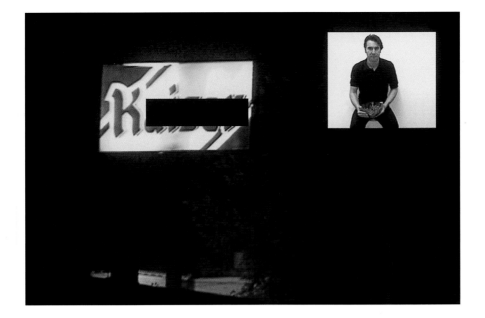

Public Alphabet, 1998,
Beitrag zur *24. Biennale São Paulo*,
Video; ca. 12' Loop, mit Audio
(Foto: Archiv Mischa Kuball, Düsseldorf)

2/26 Videosequenzen aus dem nächtlichen São Paulo, bei der die Neonreklame von verschiedenen Geschäften gezeigt wurde: Nur der erste Buchstabe des Neonschriftzugs war sichtbar, der hintere Teil geschwärzt. Die Sequenzen wurden in alphabetischer Reihenfolge präsentiert. In der rechten oberen Ecke der Projektion lief das Schwarz-Weiß-Video *Buchstabenfresser*, wo man Mischa Kuball aus einer Schüssel Buchstabenkekse essen sieht.

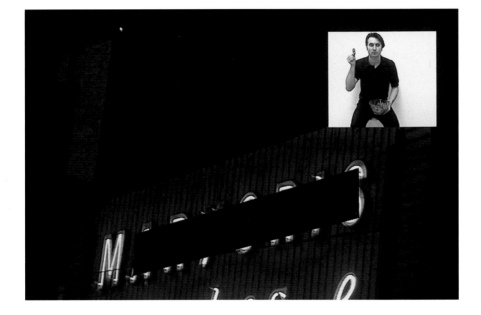

Public Alphabet, 1998,
contribution to the 24th São Paulo Biennial, video; approx. 12' loop, sound
(photograph: Mischa Kuball Archive, Düsseldorf)

2/26 video sequences taken in São Paulo at night, featuring neon signs from different businesses. Only the first of the neon letters was visible, the rest were blacked out. The sequences were shown in alphabetical order. A black-and-white video titled *Buchstabenfresser* (Letter Eater) was projected in the left corner of the projection. In it Kuball can be seen eating a bowl of alphabet cookies.

Buchstabenfresser und **Kaleidoscope**,
1998, Kölnischer Kunstverein, Köln;
Buchstabenfresser: Video, 12 min'
Loop, mit Audio; *Kaleidoscope*: Video,
12' Loop, mit Audio
(Foto: Boris Becker, Köln)

Im Kölner Kunstverein zeigte Mischa
Kuball im Rahmen der Ausstellungs-
reihe *Project Rooms* das Schwarz-
Weiß-Video *Buchstabenfresser*, wo
man Mischa Kuball aus einer Schüs-
sel die Kekse »Russisch Brot« essen
sieht. *Kaleidoscope*, die zweite Arbeit,
präsentierte durch ein Kaleidoskop
gefilmte Buchstaben-Nudeln.

Buchstabenfresser and Kaleidoscope,
1998, Kölnischer Kunstverein,
Cologne; *Buchstabenfresser*:
video, 12' loop, sound; *Kaleidoscope*:
video, 12' loop, sound
(photograph: Boris Becker, Cologne)

As part of an exhibition series titled
Project Rooms at the Kölner Kunst-
verein, Kuball showed the black-
and-white video *Buchstabenfresser*
(Letter Eater), which features Kuball
eating a bowl of alphabet cookies.
Kaleidoscope, the second work,
showed alphabet noodles filmed
through a kaleidoscope.

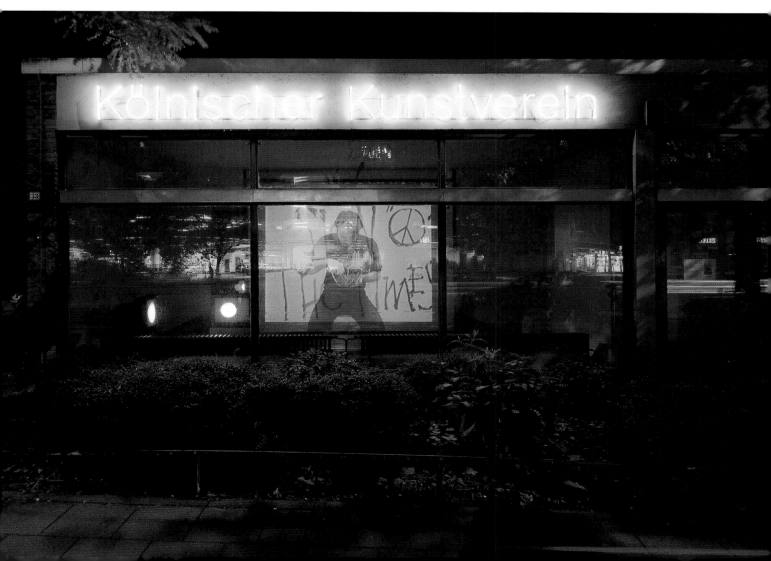

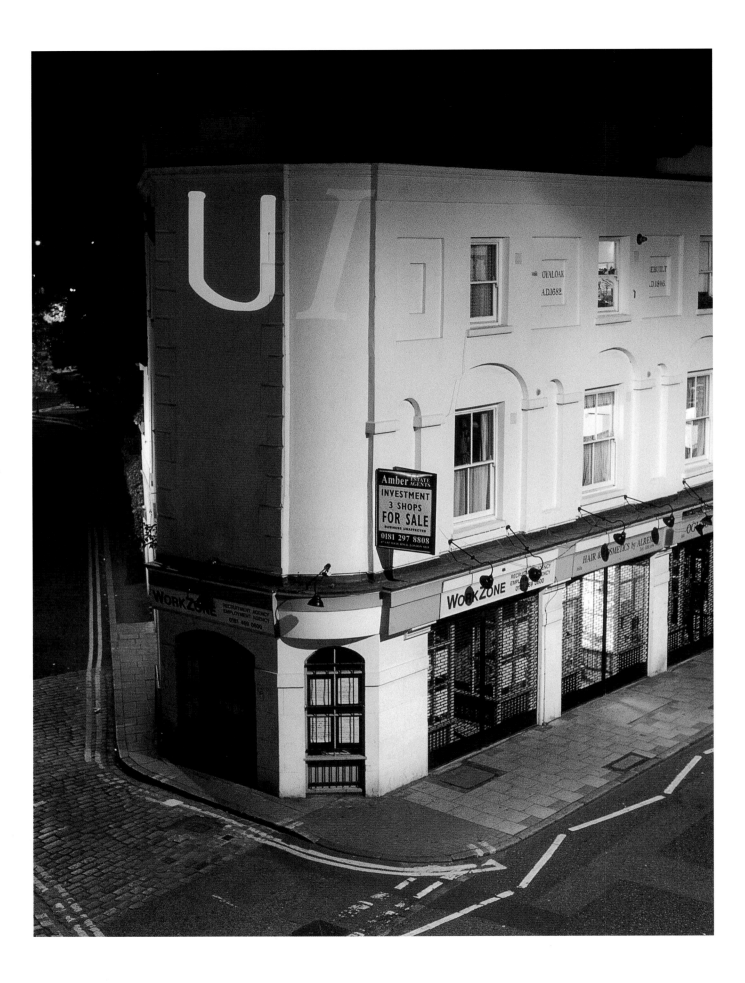

Codes (outdoor), 1999,
Museum of Installation, London;
2 Diaprojektoren, je 81 Dias mit
Buchstaben
(Foto: Edward Woodman und
Museum of Installation, London)

2 Diaprojektoren warfen einzelne
Buchstaben sowie Buchstaben-
Kombinationen an die Fassaden der
dem Museum of Installation benach-
barten Häuser.

Codes (outdoor), 1999,
Museum of Installation, London;
2 slide projectors, each containing
81 slides with letters
(photograph: Edward Woodman and
Museum of Installation, London)

Two slide projectors projected indivi-
dual letters and combinations of
letters onto the fronts of the neigh-
boring buildings of the Museum
of Installation.

Power of Codes, 1999,
Tokyo Nationalmuseum, Tokio,
6 Diaprojektoren, 6 Drehbühnen,
je 81 Dias
(Foto: Archiv Mischa Kuball, Düssel-
dorf)

6 Diaprojektoren warfen Buchstaben-
kombinationen über die Virtrinen
der historischen Schausammlung
des Nationalmuseums hinweg an die
Wände.

Power of Codes, 1999,
Tokyo National Museum, Tokyo,
6 slide projectors, each containing
81 slides 6 revolving stages
(photograph: Mischa Kuball Archive,
Düsseldorf)

Six slide projectors projected combi-
nations of letters through the display
cases of the historical collection onto
the walls of the National Museum.

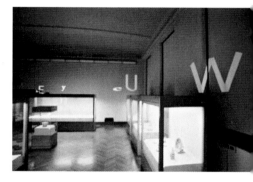

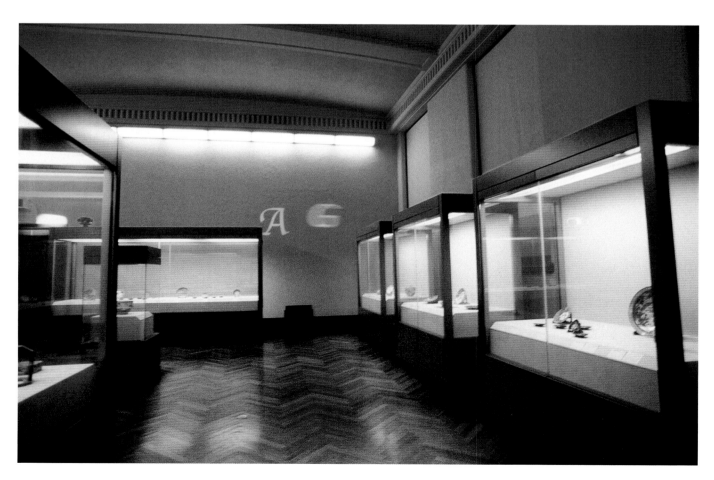

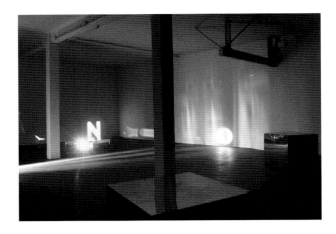

Broca'sches Areal, 2002,
Konrad Fischer Galerie, Düsseldorf;
3 Diaprojektoren, 3 Timer, 3 Dreh-
bühnen, 3 x 81 Dias, 2 verspiegelte
Kuben 70 x 70 x 70 cm, verspiegeltes
Pentagon 120 x 120 x 40 cm; ZKM |
Zentrum für Kunst und Medientech-
nologie Karlsruhe
(Foto: Dorothee Fischer, Düsseldorf)

Die sich drehenden Diageräte proji-
zierten die Buchstaben des Alphabets
an die Innenwand der Konrad Fischer
Galerie. Die verspiegelten Kuben
und das verspiegelte Pentagon
reflektierten die Buchstaben zusätz-
lich in den Raum.

Broca'sches Areal, 2002,
Konrad Fischer Galerie, Düsseldorf;
3 slide projectors, 3 timers, 3 revolv-
ing stages, 3 x 81 slides, 2 mirrored
cubes 70 x 70 x 70 cm, mirrored
pentagon 120 x 120 x 40 cm;
ZKM | Zentrum für Kunst und Medien-
technologie Karlsruhe
(photograph: Dorothee Fischer,
Düsseldorf)

Revolving slide projectors projected
letters of the alphabets on the
interior wall of the Konrad Fischer
gallery. The mirrored cubes and
pentagon also reflected the letters
in the room.

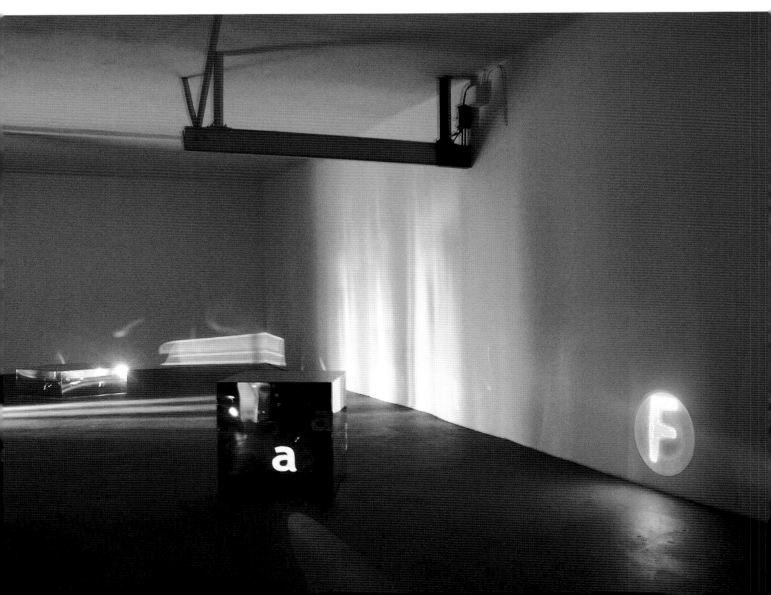

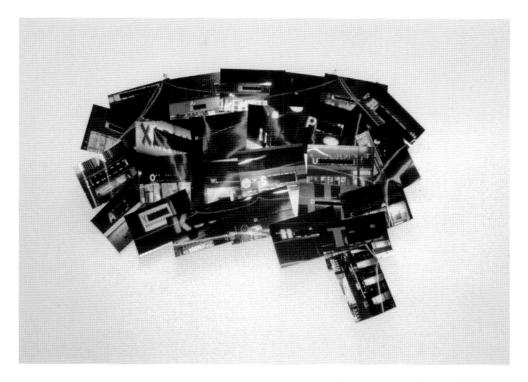

Broca'sches Areal/Collage, 2002,
Konrad Fischer Galerie, Düsseldorf;
Collage aus 26 DIN A5 Fotos,
90 x 110 cm; Sammlung Simone
Backhauß und Dr. Axel Feldkamp,
Duisburg
(Foto: Dorothee Fischer, Düsseldorf)

Collage aus 26 Fotos aller Buchstaben
des Alphabets.

Broca'sches Areal/Collage, 2002,
Konrad Fischer Galerie, Düsseldorf;
collage of 26 DIN A5 photographs,
90 x 110 cm; Simone Backhauss
and Dr. Axel Feldkamp Collection,
Duisburg
(photograph: Dorothee Fischer,
Düsseldorf)

Collage of 26 photographs of all the
letters of the alphabet.

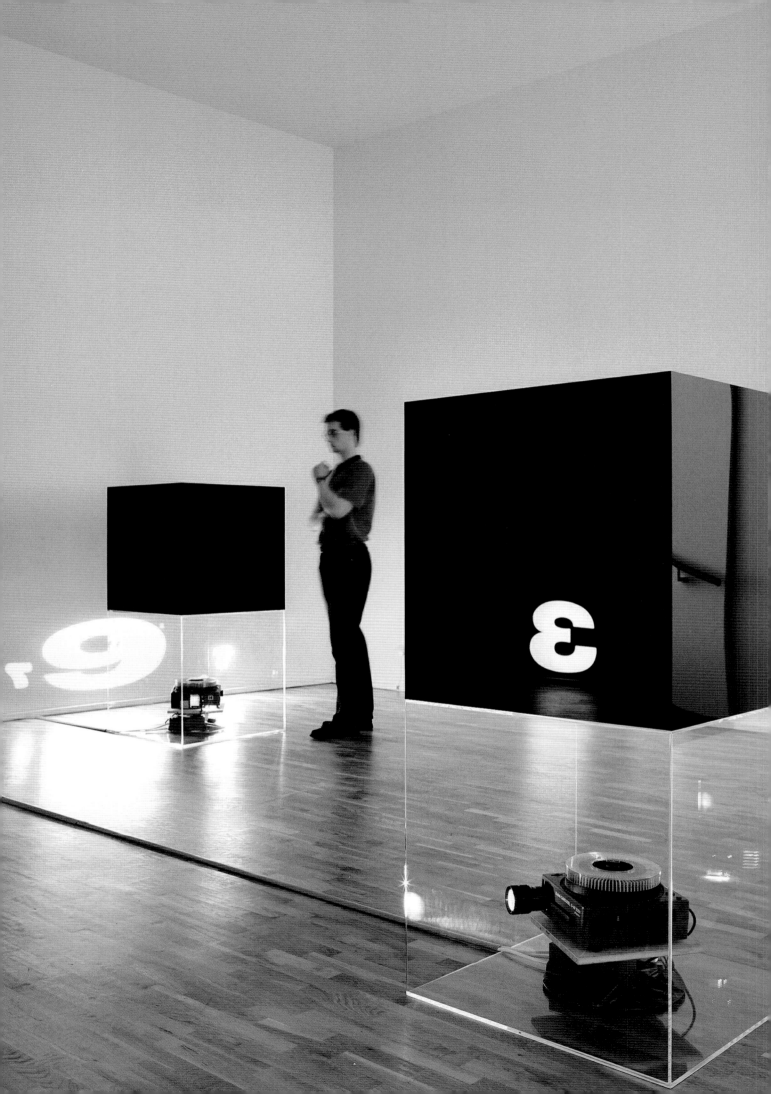

Lucky Numbers, 2003/2004,
Museum für Gegenwartskunst Siegen;
3 Projektoren, 3 x 81 Dias, 3 Dreh-
bühnen, 3 schwarze Plexiglaskuben
70 x 70 x 70 cm, 3 transparente
Plexiglaskuben 70 x 70 x 70 cm
(Foto: Roman Mensing/artdoc.de)

Die sich drehenden Diaprojektoren
projizierten in zufälliger Reihenfolge
die Zahlen von 0 bis 9 an die Innen-
wand des Museums. Durch die Plexi-
glaskuben wurden die Zahlen noch
zusätzlich in den Raum reflektiert.

Lucky Numbers, 2003/2004,
Museum für Gegenwartskunst Siegen;
3 projectors, 3 sets of 81 slides,
3 revolving stages, 3 black Plexiglas
cubes 70 x 70 x 70 cm, 3 transparent
Plexiglas cubes 70 x 70 x 70 cm
(photograph: Roman Mensing/
artdoc.de)

Revolving slide projectors projected
the numbers 0 to 9 in random order
on the interior wall of the museum.
The Plexiglas cubes also reflected
the numbers into the space.

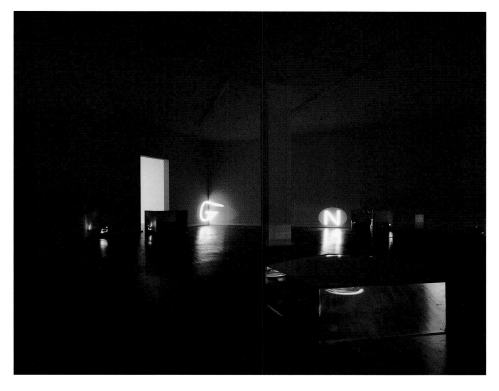

Broca'sches Areal, 2002,
Museum für Gegenwartskunst Siegen,
3 Projektoren, 3 x 81 Dias, 3 Dreh-
bühnen, 2 verspiegelte Kuben
70 x 70 x 70 cm, verspiegeltes Penta-
gon 120 x 120 x 40 cm
(Foto: Roman Mensing/artdoc.de)

Broca'sches Areal, 2002,
Museum für Gegenwartskunst Siegen,
3 projectors, 3 sets of 81 slides,
3 revolving stages, 2 mirrored cubes
70 x 70 x 70 cm, mirrored pentagon
120 x 120 x 40 cm
(photograph: Roman Mensing/
artdoc.de)

Numbers, 2006,
SINO AG, Düsseldorf; DVD, 8' Loop,
mit Audio
(Foto: Egbert Trogemann, Düsseldorf)

Eine Hand schreibt mit dem Zeige-
finger flüchtig Zahlen ins Licht.

Numbers, 2006,
SINO AG, Düsseldorf; DVD, 8' loop,
sound
(photograph: Egbert Trogemann,
Düsseldorf)

This work features a hand whose
index finger writes fleeting letters
in light.

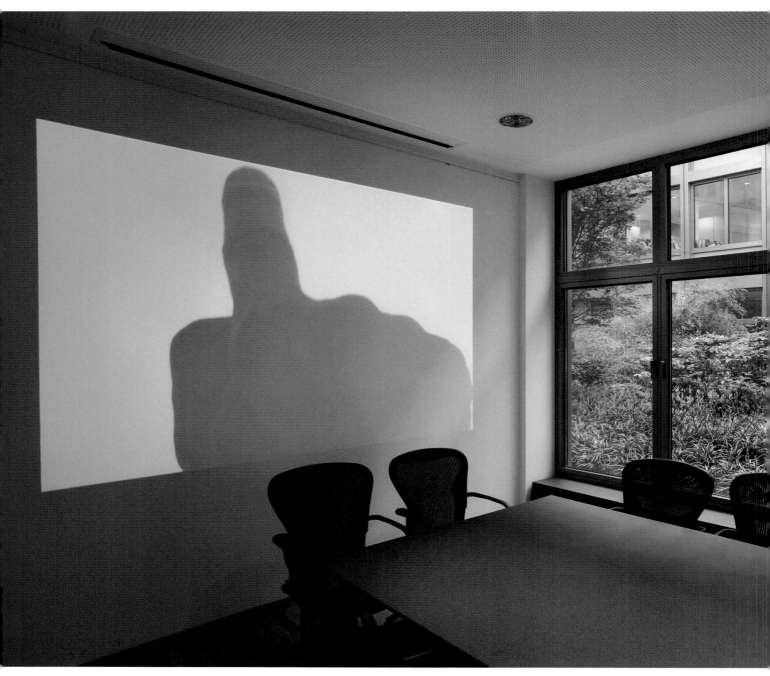

Kaleidoscope, 1997,
numbers/digits, 2006, Detail: *Lucky
Numbers*, 2003–2006, SINO AG,
Düsseldorf; DVD, 12' Loop, mit Audio;
1/12 Unikat-Fotografien, Diasec,
180 x 60 cm
(Foto: Egbert Trogemann, Düsseldorf)

Kaleidoscope, 1997,
numbers/digits, 2006, detail: *Lucky
Numbers*, 2003–2006, SINO AG,
Düsseldorf; DVD, 12' loop, sound;
1/12 face-mounted signature photo-
graph, 180 x 60 cm
(photograph: Egbert Trogemann,
Düsseldorf)

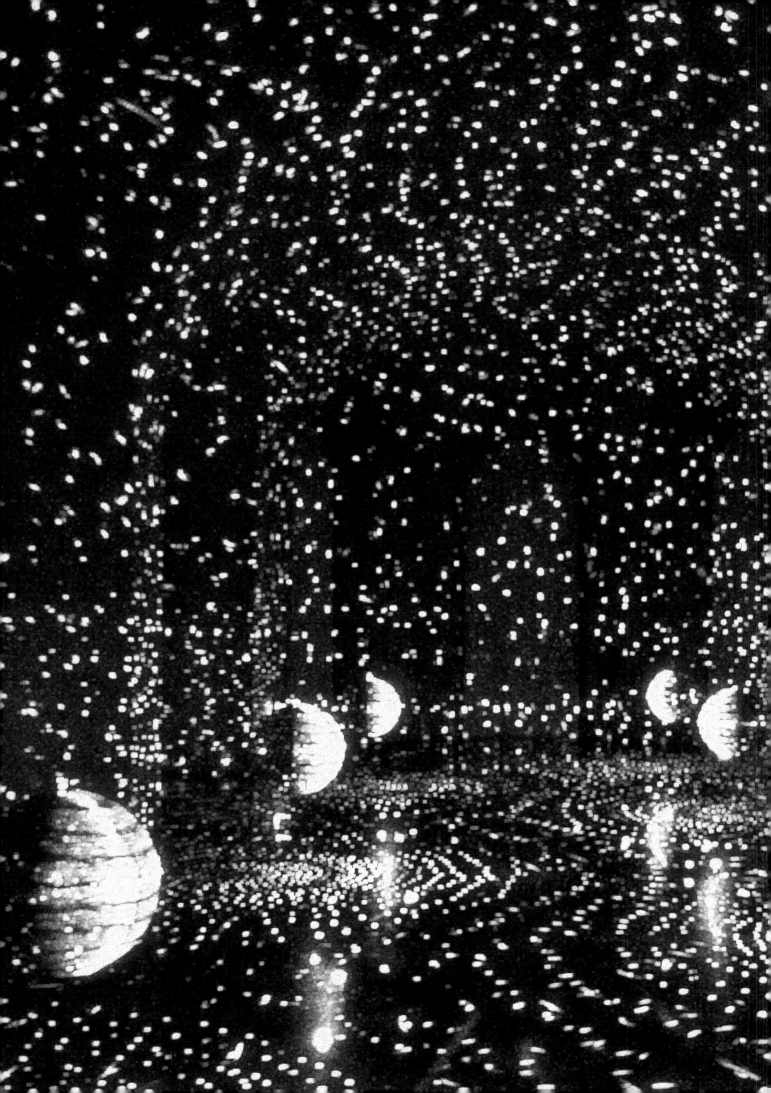

FLORIAN MATZNER

FRAGEN ÜBER FRAGEN, ABER KEINE ANTWORTEN!
QUESTION UPON QUESTION, BUT NO ANSWERS!

ANMERKUNGEN ZUR BILDSPRACHE VON MISCHA KUBALL

»Die Sprache interessiert mich in der Funktion des Codes – also im Sinne des Verschlüs-selns und Entschlüsselns. Es geht nicht um die Bedeutung des einen Begriffs, sondern konstitutiv um Sprache – im Zerlegen entfaltet sie diese Kraft! Hier muss man sich den Ver-sprachlichungsprozess im menschlichen Hirn vor Augen führen, denn die Evolutionsge-schichte der Menschheit ist eben auch in der Entwicklung der Sprachzusammenhänge ablesbar.« Mischa Kuball, 2006[1]

Abb. S. 286–288

Eine merkwürdige Situation: In einem abgedunkelten Raum wird eine Spiegelkugel von einem Projektor angestrahlt. Die Disco-Kugel reflektiert das Licht und projiziert ein Wort in rhythmischen Folgen in den Raum und an die Wände: »fragen« oder »Fragen«, als Verb oder als Substantiv, versehen mit einem Ausrufezeichen oder einem Fragezeichen. Was aber steht hier zur Disposition? Eventkultur oder Kunstraum? Diskothek oder Pinako-thek? Videothek der »Low Art« oder Cinemathek der »High Art«?[2] Mischa Kuball stellt mit seinen Kunstwerken im doppelten Wortsinn Fragen über Fragen, verweigert aber ebenso konsequent die Antworten. Der Betrachter der Lichtinstallation wird unversehens zum Leser einer Botschaft, die in ihrer scheinbar banalen Offensichtlichkeit doch eigenartig ver-schlüsselt bleibt.

NOTES ON MISCHA KUBALL'S VISUAL LANGUAGE

"Language interests me in its function as a code—in the sense of encoding and decoding. I'm not talking about the meaning of the one concept; it's about language itself—it mani-fests this power when deconstructed! You have to look at the process of language acquisi-tion in the human brain, because it is possible to read the history of human evolution from the development of linguistic relationships." Mischa Kuball, 2006[1]

Figs. pp. 286–288

A strange situation: A projector is illuminating a mirror ball in a darkened room. The disco ball reflects the light and projects a word in rhythmic sequence through the room and onto the walls: *fragen* or *Fragen* ("asking" as a verb or a noun), complete with an exclamation mark or a question mark. But just what is going on here? Is this event culture or art space? Disco or art show? Video store for "low art" or movie theater for "high cul-ture"?[2] Mischa Kuball's artworks pose question upon question, both literally and metaphorically; however, he is just as consistent in refusing to supply an answer. Who-ever looks at the light installation unintentionally becomes the reader of a message, which remains strangely encoded despite its apparently banal obviousness.

The scene changes: Mischa Kuball has used the same formal principle, but with a number of illuminated disco balls, which reflect the projected light multiplied kaleido-

Seven Virtues (Detail), 1999,
Diözesanmuseum Freising
(Foto: Archiv Mischa Kuball, Düssel-
dorf), Vgl. Abb. S. 292–293 /
See fig. pp. 292–293

Szenenwechsel: Das gleiche formale Prinzip der angestrahlten Disco-Kugel, die wiederum die Projektion kaleidoskopisch vervielfacht in den Ausstellungsraum zurückgibt, hat Mischa Kuball mit mehreren Spiegelkugeln realisiert. Sie können statisch sein oder sich in Bewegung befinden. Die projizierten Begriffe und Worte bilden jetzt Satz- und Sinnfragmente wie »speed – space – speech« oder »material – immaterial«, die ästhetische und konzeptuelle Abb. S. 291 und S. 289 Grenze zwischen dem einzelnen Raumbild und einem umfassenden Bildraum wird damit endgültig aufgelöst.[3] Der Betrachter ist gleichzeitig passiver Leser wie aktiver Besucher, denn seine Bewegung in Raum und Zeit wird ursächlicher Bestandteil der Rezeption.

Die Kooperation von Kunst und Sprache, von Bild und Wort ist bereits seit dem späten Mittelalter ein gängiger Topos zur erweiterten Kommunikation zwischen Kunstwerk und Betrachter.[4] Darüber hinaus aktiviert der Dialog dieser beiden Medien die 3 wichtigsten Sinne des Menschen: Das Sehen, das Hören und das Sprechen als intellektuelle Entität einer kulturellen Produktion. In der zeitgenössischen Kunst haben sich zahlreiche Künstler mit diesem Thema beschäftigt, wobei allerdings Mischa Kuball eine Sonderposition einnimmt: Für den Bereich Video und Licht stehen Namen wie Bruce Nauman, Jenny Holzer oder Mario Merz, im Bereich der Malerei und Fotografie dagegen Namen wie Ben Vautier, Joseph Kosuth, Barbara Kruger oder Lawrence Weiner.[5] Bei Mischa Kuball allerdings kommt noch das Motiv der Bewegung hinzu, also der Faktor Zeit. Seine Sprachräume werden zu Erzählräumen, in denen ein einziges, isoliertes Wort eine lange, ja endlose

scopically throughout the exhibition space. They can be static or in motion. The projected concepts and words now form fragments of phrases and sentences, such as "speed—space—speech" or "material—immaterial." The aesthetic and conceptual line between Figs. p. 291 and p. 289 the individual spatial vision and a comprehensive visual space is thus definitively dissolved.[3] As the viewer's movements in space and time become a causal component of the reception, he or she is both passive reader and active visitor.

The cooperation between art and language, between image and word, has been an established ground for enhanced communication between a work of art and its viewer since the late Middle Ages.[4] In addition, the dialogue between these two media activates the three most important human senses: seeing, hearing, and speaking as the intellectual entity of cultural production. Countless artists have concerned themselves with this theme in contemporary art, but Mischa Kuball is in a league of his own. Names such as Bruce Nauman, Jenny Holzer or Mario Merz represent the areas of video and light; for painting and photography there are Ben Vautier, Joseph Kosuth, Barbara Krüger or Lawrence Weiner.[5] Mischa Kuball, however, brings an extra element to his work, namely motion as a motif—the factor of time. His rooms of language become rooms of narrative, where a single, isolated word can tell a long, indeed endless story—a short moment of perception which is stretched out into eternity.

Geschichte erzählen kann – ein kurzer Moment der Wahrnehmung, der in die Ewigkeit gedehnt wird.

Abb. S. 302

Dieses Motiv der Endlosigkeit, das in die Absurdität zu gleiten scheint, hat Mischa Kuball auch in seiner Rotterdam-Ausstellung *In Alphabetical Order* 1997 verwendet. Der Schriftzug » Museum Boijmans Van Beuningen Rotterdam« ist in seine buchstäblichen Bestandteile zerlegt worden, die wiederum in alphabetisch korrekter Ordnung auf dem Dachvorsprung des Museumseingangs angebracht wurden: Die Worte und ihre Einzelteile sind zu einem Bild geworden, das sich dem Besucher des Boijmans van Beuningen als sinnloses Rätsel präsentierte, denn den Worten war ihre signifikante Bedeutung entzogen.[6] Dieses Zerlegen oder Sezieren von Worten und Begriffen in ihre linguistische Grundsubstanz – die einzelnen Buchstaben – hat Kuball auch im 2. Teil der Ausstellung in einer Videoarbeit zum Thema gemacht: Sie zeigte auf Monitoren die Bewegungsabläufe eines Kaleidoskops, das mit Buchstaben-Nudeln aufgefüllt worden war und so immer neue Wortfetzen und Bildfragmente bildete.[7] Das kindliche Spiel des assoziativen Bildens von Buchstabenfolgen, Silben und Worten wird hier zu einer fast zwanghaft erscheinenden Mischung aus Kreieren und gleichzeitigem Zerstören, wie dies auch in Kuballs Beitrag für die *24. Biennale São Paulo*[8] das zentrale Thema war. Eine nächtliche Autofahrt durch die südamerikanische Metropole registrierte wie zufällig Neonschriftzüge aus der Werbung, von Geschäften und so weiter. In der nachträglichen Bearbeitung hat der Künstler lediglich den ersten Buchstaben des jeweiligen Begriffs stehen lassen, während das eigentliche Wort wie

Fig. p. 302

Mischa Kuball also used this motif of endlessness, which appears to slide off into absurdity, in his 1997 Rotterdam exhibition "In Alphabetical Order." The text "Museum Boijmans Van Beuningen Rotterdam" was split into its component letters and then fixed in alphabetical order onto the overhanging roof of the entrance to the museum. The words and their individual parts consequently formed a picture which presented itself to the museum visitor as a meaningless puzzle, because the words were deprived of their significance.[6] Kuball also turned this dismantling or dissecting of words and concepts into their basic linguistic structure—the individual letters—into a video installation in the second part of the exhibition. Monitors showed the sequence of movements of a kaleidoscope filled with alphabet pasta, which thus continually formed new scraps of words and pictorial fragments.[7] The childish game where associative sequences of letters, syllables, and words are formed has developed into what appears to be a virtually compulsive mixture of simultaneous creation and destruction. This was also the central theme in Kuball's contribution for the 24th Bienal de São Paulo.[8] An automobile ride through the South American metropolis by night recorded the neon signs from advertising, businesses, and so on, as if by chance. In the subsequent editing, the artist retained only the first letter of each word, while the word itself was masked, as if by a censor bar. Left to their own imagination and quick wits, observers can partially decode these hidden words, whereas it is not possible to decipher others. Therefore, when referring to the applied text as an indis-

durch einen Zensurbalken verdeckt ist. Der eigenen Phantasie und schnellen Auffassungs-
gabe überlassen, kann der Betrachter diese Wortbalken zum Teil dechiffrieren, andere
Schriftzüge wiederum können nicht entziffert werden. So unterscheidet sich die ange-
wandte Schrift als unabdingbarer Bestandteil der urbanen Struktur einer Großstadt in die
von allen verstehbare und damit globalisierte Sprache und im Gegenzug in eine nur von
wenigen identifizierbare und damit nationale oder sogar lokal verständliche Sprache.[9]

Diese Unterscheidung von Sprache in das physikalisch anwesende, also materielle
Wort und seine erfundene, also immaterielle Bedeutung als Symbol, Begriff oder Zeichen
löst Mischa Kuball auf beinahe zynischer Weise im 2. Teil der Videoarbeit mit dem Titel
Public Alphabet auf, wenn er in der linken oberen Ecke des filmischen Bildes auf einem Abb. S. 304–305
Hocker sitzt, den Betrachter im einen Augenblick heiter, im anderen Moment provokativ
und dann wieder teilnahmslos anschaut und dabei die Buchstabenkekse »Russisch Brot«
vertilgt. Der Künstler als »Buchstabenfresser«? Der Künstler, der das Bild gegen das Wort
verteidigt? Der Künstler, der gegen die unerträgliche Lautstärke des Alltags die Stille for-
dert und demonstrativ die Sprache verspeist? Der Künstler, der das gesprochene oder
geschriebene Wort und seine Verwendung als Chiffren thematisiert, um der alltäglichen
Kommunikationslosigkeit die Sprache, die Schrift als Schnittstelle des zwischenmenschli-
chen Dialogs entgegenzusetzen? Fragen über Fragen, aber keine Antworten! Mischa Kuball
hat selbst dazu gesagt: »Das Verdauen ist ein Prozess: Das Licht und das Wort stehen für
das Projekt der Beschreibbarkeit von Welt. Wenn Sprache und Licht zusammenkommen,

pensable part of urban structure, it is possible to distinguish between a globalized lan-
guage, understood by all, and in a countermove a national or even local language, only
understood by the few.[9]

The differentiation of language into the physically present (i.e., material) word and its
invented (i.e., immaterial) meaning as symbol, concept or sign is resolved by Mischa
Kuball in an almost cynical manner in the second part of the video installation entitled
"Public Alphabet." He sits in the top left-hand corner of the screen on a stool, looking at Figs. pp. 304–305
the observer first cheerfully, then provocatively, then disinterested, all the time devouring
alphabet cookies. The artist as a "letter gobbler"? The artist who defends the image
against the word? The artist who demands silence in place of the unbearable level of
everyday noise and demonstratively eats language? The artist who takes the spoken or
written word and its application as a code as his theme in order to deal the general lack of
communication by propounding language and writing as an interface in interpersonal dia-
logue? Question upon question, but no answers! Mischa Kuball himself commented,
"There is a process of digestion: the light and the word stand for the project of being able
to describe the world. When language and light merge, they provide the basic ingredients
for insight—of course via the agreed codes!"[10]

sind die Grundelemente zur Erkenntnis gegeben – natürlich unter den vereinbarten Codes!«[10]

Abb. S. 306–307

Abb. S. 308–309

Und trotzdem: Mischa Kuball hebt selbstbewusst die Codierung von Sprache und Schrift auf, denn Buchstaben und Worte werden auch in seiner »Bildsprache« zu logoähnlichen Bedeutungen und Inhalten, wie wir dies aus der täglich wechselnden Werbung ebenso kennen wie von jahrzehntelang gültigen Verkehrszeichen. Allerdings hebt Kuball die Allgemeingültigkeit, die Universalität von Sprache bewusst auf zugunsten einer individuellen, assoziativen Rezeption des einzelnen Betrachters: In London hat Mischa Kuball 1999 einzelne Buchstaben und deren Kombinationen vom Museum of Installation aus auf benachbarte Hausfassaden projiziert – auf Fassaden und Wände, an denen gewöhnlich Werbung und andere Schriftzüge angebracht sind. Auch hier erhob Kuball den isolierten Buchstaben zu einem monumentalisierten Zeichen, dessen Bedeutungsschwere oder aber mögliche Bedeutungslosigkeit der Künstler bewusst dem individuellen Betrachter überließ. Die Londoner Außenarbeit, die wie selbstverständlich dem öffentlichen Raum seine Selbst-Verständlichkeit entzog und die Öffentlichkeit in ein Bilderrätsel verstrickte, hat Kuball drei Jahre später im White Cube eines Innenraumes transformiert: Das *Broca'sche Areal* projiziert über sich drehende Diaprojektoren alle Buchstaben des Alphabets auf die Galeriewände. In Anlehnung an die Entdeckung des französischen Arzts Paul Broca, der eine bestimmte Region des menschlichen Gehirns als Sprachzentrum hat identifizieren

Figs. pp. 306–307

Figs. pp. 308–309

And yet Mischa Kuball self-confidently suspends the encoding of language and text—even in his "visual language," letters and words resemble logos in meaning and content, something we know both from advertising (which changes on a daily basis) and traffic signs (which retain their validity for decades). However, the artist consciously suspends the universal nature of language in favor of an individual, associative reception by each observer: In London in 1999, Mischa Kuball projected letters, both singly and in combination, from the Museum of Installation onto neighboring building fronts—façades and walls which generally displayed advertising and other texts.

Kuball also raised the isolated letters to the status of monumental signs, consciously leaving the individual observer to decide on their level of significance, or possibly insignificance. This outdoor piece in London implicitly removed the implicitness from the public space and ensnared the public in a visual puzzle. Kuball transformed it three years later into the white cube of an interior space: *Broca'sche Areal* uses rotating slide projectors to display all the letters of the alphabet on the gallery walls. Taking its inspiration from a discovery made by the French physician Paul Broca, who succeeded in identifying the part of the human brain responsible for speech, the projectors spit out the ingredients of this brain matter: letters which become words; words which become sentences; sentences which become thoughts; thoughts which become stories; stories which become history. As if ensnared in a network, the viewer moves within a linguistic space where the

können, spucken die Projektoren die Ingredienzen dieser Hirnmasse aus: Buchstaben, die Worte werden; Worte, die Sätze werden; Sätze, die Gedanken werden; Gedanken, die Geschichten werden; Geschichten, die Geschichte werden. Als sei er in einem Netzwerk verstrickt, bewegt sich der Betrachter in einem Sprachraum, in dem das Innere des menschlichen Gehirns wie nach Außen gestülpt erscheint. In diesem Vorgang ist der Künstler ebenso selbstverständlich wie außergewöhnlich sowohl Handlanger als auch Drahtzieher einer Wirklichkeit, in der die Grenzen zwischen Realität und Virtualität fließend werden. Einer Wirklichkeit, in der der Künstler auf der Suche nach der Unalltäglichkeit des Alltags ist, auf der Suche nach dem Subtilen im Banalen.

contents of the human brain seem to have turned inside out. In this process, the artist is implicitly and exceptionally both sidekick and mastermind of a reality where the line between the real and the virtual is blurred. It is a reality where the artist is on a quest for the exceptional in the everyday and for the subtle in the banal.

ANMERKUNGEN

1 Mischa Kuball, E-Mail an den Verfasser, 28.12.2006.
2 Zur Installation *fragen* vgl. Georg Elben, »Medienkunst«, in: *Der Fuchs und die Trauben. Dokumentation 1991–1996*, Kunstraum Wuppertal, Ostfildern 1998 S. 132–33 sowie: *fragen/perguntar/asking.* Material/Immaterial, hrsg. v. Mischa Kuball und Karin Stempel, Ausst.-Kat. Casa das Rosas, São Paulo, Düsseldorf 1997.
3 Vgl. Uwe Rüth: »Mischa Kuball«, in: *Die Sammlung*, Zentrum für Internationale Lichtkunst, Unna, Köln 2004, S. 58–67.
4 Vgl. Peter Steiner, »Licht Raum Sprache«, in: *Unaussprechlich schön*, hrsg. von Kai-Uwe Schierz und Silke Opitz, Ausst.-Kat. Kunsthalle Erfurt, Köln 2003, S. 268–271. Bereits in der Bibel wird die Parallelität von Sprache und Licht hervorgehoben: »Im Anfang war das Wort … und Gott war das Wort … In ihm war das Leben und das Leben war das Licht der Menschen.« (Joh. 1, 1–4).
5 Zum Einsatz des Wortes in der bildenden Kunst vgl. *Buchstäblich, Bild und Wort in der Kunst heute*, Ausst.-Kat. Von der Heydt-Museum, Wuppertal, Wuppertal 1991; Andrea Domesle, *Leucht-Schrift-Kunst. Holzer, Kosuth, Merz, Nannucci, Nauman*, Berlin 1998; *Im Anfang war das Wort. Über die Sprache in der zeitgenössischen Kunst*, Ausst.-Kat. Haus der Kunst, München, Berlin 2006.
6 Konzeptuell gegensätzlich, aber im Ergebnis vergleichbar ist der Schriftzug an der Außenfassade der *KUNSTSAMMLUNGEN-DERRUHRUNIVERSITÄTBOCHUM*, in dem Mischa Kuball auf die Groß- und Kleinschreibung sowie die Leerräume zwischen den einzelnen Worten verzichtet hat, sodass ein im doppelten Wortsinn eigentümliches Schriftbild entsteht. Vgl: *Utopie/Black Square 2001ff.*, hrsg. von Monika Steinhauser und Kai-Uwe Hemken, Ausst.-Kat. für das Kunstgeschichtliche Institut der Ruhr-Universität Bochum, Frankfurt 2004, S. 9–10.
7 S. a. Nicolas de Oliveira, »The Temporary Event. The Project-Rooms of Mischa Kuball« in: *Mischa Kuball. Project Rooms*, Ausst.-Kat. Museum of Installation, London, London 1999, o. S.
8 *Private Light/Public Light. Mischa Kuball*, hrsg. von Karin Stempel, Ausst.-Kat. Deutscher Beitrag zur *24. Biennale São Paulo*, Ostfildern 1998.
9 Mischa Kuball, E-Mail an den Verfasser, 28.12.2006: »In vielen meiner Arbeiten spielt die ›Oral History‹ eine zentrale Rolle: Mit dem Verschwinden der Interventionen – also nach Ablauf des Projektes – tritt in diese Lücke substitutiv das Wort – gesprochen auf der Ebene der lokalen Netze und regionalen Kommunikation, geschrieben auf der Ebene der übergreifenden Diskurse.«
10 Ebd.: »Das Verdauen, also Essen und Kontextualisieren von Sprachraum und urbanem Raum – wie auf der Biennale von São Paulo – war in dieser Zeit gekoppelt an den Diskurs von Oswald de Andrade, der mit seinem *Anthropologischen Manifest* von 1928 eine provokative Antwort auf den europäischen Vorwurf des brasilianischen Plagiats formulierte. Die Suche nach einer festen Anbindung in der brasilianischen Kunst wird spätestens im Werk von Lygia Clark deutlich, die in den Sechzigerjahren Wollfäden verspeiste, die sie sich nach gewisser Zeit wieder aus dem Magen durch den Mund zog, um sie dann später im Ausstellungsraum zu verspannen.«

NOTES

1 Mischa Kuball, e-mail to the author, December 28, 2006.
2 On the "fragen" installation see Georg Elben, "Medienkunst," *Der Fuchs und die Trauben: Dokumentation 1991–1996*, Kunstraum Wuppertal (Ostfildern, 1998), pp. 132–133; *fragen/perguntar/asking,* ed. Mischa Kuball and Karin Stempel, exh. cat. Casa das Rosas, São Paolo (Düsseldorf, 1997).
3 Uwe Rüth, "Mischa Kuball," *Die Sammlung*, exh. cat. Zentrum für Internationale Lichtkunst, Unna (Cologne, 2004), pp. 58–67.
4 Peter Steiner, "Licht Raum Sprache," *Unaussprechlich schön*, ed. Kai-Uwe Schierz and Silke Opitz, exh. cat. Kunsthalle Erfurt (Cologne, 2003), pp. 268–271. The parallel nature of language and light is already emphasized in the Bible "In the beginning was the Word … and the Word was God. … In him was life, and the life was the light of men." (John 1:1–4).
5 On the application of the word in the visual arts, see *Buchstäblich: Bild und Wort in der Kunst heute,* ed. Von der Heydt Museum and Kunst- und Museumsverein Wuppertal, exh. cat. Von der Heydt Museum, Wuppertal, et al. (Wuppertal, 1991); Andrea Domesle, *Leucht-Schrift-Kunst: Holzer, Kosuth, Merz, Nannucci, Nauman* (Berlin, 1998); *Im Anfang war das Wort: Über die Sprache in der zeitgenössischen Kunst,* exh. cat. Haus der Kunst, Munich (Berlin, 2006).
6 The text on the façade of the KUNST-SAMMLUNGENDERRUHRUNIVERSITÄT-BOCHUM is similar in result, although conceptually antithetical. Mischa Kuball here rejected the distinction between upper and lower case as well as the spacing between the individual words, thus creating a text which is idiosyncratic and individual in its appearance. See *Utopie/Black Square 2001ff.*, ed. Monika Steinhauser and Kai-Uwe Hemken, exh. cat. Kunstgeschichtliches Institut der Ruhr Universität Bochum (Frankfurt, 2004), pp. 9–10.
7 Nicolas de Oliveira, "The Temporary Event: The Project-Rooms of Mischa Kuball," *Mischa Kuball: Project Rooms*, exh. cat. Museum of Installation, London (London, 1999), n. p.
8 *Private Light/Public Light: Mischa Kuball,* ed. Karin Stempel, exh. cat. German exhibit at the 24th São Paolo Biennale (Ostfildern, 1998).
9 Mischa Kuball, e-mail to the author, December 28, 2006: "'oral history' plays a central role in many of my works: once the interventions disappear—i.e., when the project has been completed—this gap is filled by substituting the word (spoken at the level of the local networks) and regional communication (written at the level of the overall discourse)."
10 Ibid. "Digestion, that is to say the ingestion and contextualization of linguistic and urban space—as in the São Paolo Biennale— was linked at the time to Oswald de Andrade's 1928 discourse, *Manifesto Antropófago (Cannibal Manifesto),* in which he formulated a provocative answer to the European accusation of Portuguese plagiarism, or 'cannibalism.' By the time Lygia Clark ate strands of wool in the 1960s, only to later pull them out of her stomach though her mouth and then span them across the exhibition room, it was clear that a connection was being sought within Brazilian art."

YUKIKO SHIKATA

MACHT DER CODES – RAUM FÜR REDE
POWER OF CODES—SPACE FOR SPEECH

I.

Ein modernes Hochhauses in Düsseldorf, das zu einem Lichtobjekt verwandelt wird. Experimente, die im Zuge von Lichtprojektionen inner- und außerhalb des Bauhaus-Gebäudes in Dessau durchgeführt werden. Die Synagoge von Stommeln, die mit Flutlicht eingeleuchtet wird. All diese ortsspezifischen Projekte von Mischa Kuball haben unsichtbare Erinnerungen und Wahrnehmungsformen der Menschen evident gemacht, indem sie den spezifischen gesellschaftlichen, geschichtlichen und architektonischen Kontext des Schauplatzes deuteten und verdeutlichten. Kuball verwendet Medien wie Projektoren, Monitore und Scheinwerfer, um so die nicht sichtbaren Aspekte einer bestimmten Örtlichkeit oder Gesellschaft zu erhellen, auf dass die Menschen sie zu erkunden anfangen. Alle Projekte beginnen mit der Identifizierung des Vorhandenen, erst daraufhin versetzt Kuball das entsprechende Objekt in verschiedene Kontexte. Die phänomenologischen Effekte von Lichtern – ausstrahlen, sichtbar machen, Aufmerksamkeit auf etwas lenken – werden so eingesetzt, dass das dadurch aktivierte Bewusstsein des Betrachters über die symbolischen Konnotationen des Lichts selbst hinausgelangt.

Kuball erforscht verschiedene Praktiken mit dem Begriff der »Projektion« und untersucht die kritische Verwendung des Projektors als Medium. Er realisiert seine Projekte häufig in öffentlichen Räumen und, indem er die örtlichen Gegebenheiten akzeptiert, prä-

I.

The transformation of a modern high-rise building in Düsseldorf into a light object, the experiments performed throughout the course of the light projections in- and outside the Bauhaus building in Dessau, the placement of bright light into the synagogue in Stommeln—these site-specific projects by Mischa Kuball made people's invisible memories and perception visible by reading the social, historical, and architectural/special contexts of each location.

Kuball uses media such as projectors, monitors, and lights to direct the spotlight toward the invisible aspects of a particular site or society as people begin to examine them. His projects commence with the identification of the existing object, after which he places it into different contexts. The phenomenological effects of lights—to emit, make visible, turn attention toward—are utilized to activate the viewer's consciousness in a manner that goes beyond the symbolic connotation of the light itself.

Kuball investigates the ways of dealing with the notion of "projection" and examines the critical use of the projector as a medium. His projects are frequently executed in public spaces; in his acceptance of the phenomena in place, he does not present a complete work but formulates questions to society by conceiving his role to be that of the "projec-

Broca'sches Areal (Detail), 2002, Konrad Fischer Galerie, Düsseldorf (Foto: Dorothee Fischer, Düsseldorf), Vgl. Abb. S. 308 / See fig. p. 308

sentiert er kein komplettes Werk, sondern formuliert Fragen an die Gesellschaft, der er wiederum konzeptuell die Rolle des »Projektors« zuspricht. Dabei ist Kuball neben der Bedeutung des Lichtphänomens der Gedanke der »Reflexion« wichtig, die der Betrachter zu leisten hat. Seine Projekte könnten als aktivierende Schnittstellen zum Reflexionsprozess gesehen werden, in denen die formulierten Fragen an viele andere Menschen weitergeleitet, »verlinkt« und neu verknüpft werden können, sodass sich weiter zu formulierende Fragen ergeben.

Wie bereits erwähnt, hat Kuball vor allem in der ersten Hälfte der Neunzigerjahre eine Vielzahl an Interventionen in modernen Gebäuden durchgeführt, bei denen er mit den Konzepten »Projektion« und »Reflexion« arbeitete. Diese Projekte beruhten auf seinem kritischen Ansatz, die »Modernität« als weltweit vorherrschende Struktur unseres neuzeitlichen Systems im 20. Jahrhundert zu überdenken und neu auszuleuchten. Aufgrund dieser Voraussetzung ist es für ihn auch von wesentlicher Bedeutung, künstliche Beleuchtungen wie Projektoren, Monitore und Lampen zu verwenden – allesamt Produkte des 20. Jahrhunderts. Moderne Gebäude ins Licht zu setzen, gründet im radikalen Ansatz des Künstlers. Seine minimalen Lichtinstallationen öffnen den Raum für eine Unterbrechung der selbstreferentiellen Spirale – mit anderen Worten, seine Projekte machen Platz für eine Umadressierung der Kommunikation, indem sie die Betrachter selber als Projektionen einbeziehen.

tor." In addition to its meaning as a phenomenon of light, Kuball attaches importance to the notion of "reflection (reflexion)" as something performed by the viewer. His projects could be regarded as the activating interface to the reflection process, where the questions that are formulated may be transferred, linked to various other people, and reconnected in order to formulate further questions.

As already mentioned, it was in particular in the first half of the 1990s that Kuball realized a large number of public interventions to modern buildings using the concepts of "projection" and "reflection." These projects were based on his critical approach to rethinking and projecting "modernity" as the globally predominant fundamental structure of our modern system in the twentieth century. In line with this premise, for him the use of artificial lighting such as projectors, monitors, lamps—all products of the twentieth century—is important. Setting modern architecture to light is founded in the artist's radical approach. His minimal light installations open up the space for interruption of the self-referential loop—in other words, his projects open up the space for redirecting communication by involving viewers themselves as projections.

II.

The first question that occurred to me while I was conceiving Kuball's first project in Japan was how the context of Japan would inspire him and how he would inspire Japan.

II.

Abb. S. 307 Die spontane Frage, die mir in den Sinn kam, als ich Kuballs erstes Projekt in Japan plante, war, wie ihn wohl der Kontext Japans inspirieren und wie er selbst Japan inspirieren würde. Von Anfang an war vorgesehen, sein Projekt im Tokyo National Museum im Ueno Onshi Park zu zeigen, das angesichts der Akzeptanz der europäischen Moderne in Japan als der geeignete Ort dafür schien. Nach über 250 Jahren der nationalen Isolation öffnete sich Japan in der Meiji-Ära (von 1867 an) und begann das moderne System der Zivilisation zu akzeptieren. Im Zuge dessen importierte Japan das westliche Museumssystem, und um diese Zeit wurde auch der Ausdruck »bijutsu« als Übersetzung von »Kunst« geprägt. Es setzte der Prozess ein, die typisch japanischen Eigenschaften der Kunst anhand der Spiegelung über den Blick anderer zu benennen. Zum Beispiel wurde das Wort »nihonga« – wörtlich übersetzt »japanische Malerei« – erfunden, um die traditionelle japanische Malerei von der europäischen Kunst zu unterscheiden. Das anlässlich der ersten Weltausstellung 1872 gegründete Tokyo National Museum ist das älteste Museum in Japan und symbolisiert die Akzeptanz europäischer Kultur und Kunst.

1876 eröffnete der Ueno Onshi Park – ebenfalls ein Produkt der Modernisierung –, 1882 wurden eben dort der Ueno Zoo und das National Museum eingeweiht. Mit seinen über sieben Museen, mit seinen Konzertsälen und Institutionen wie der Tokyo University of Fine Arts and Music (der ersten Kunstschule Japans, gegründet 1885) ist der Park das derzeit dichteste Kulturareal in der Stadt. Gleichzeitig beherbergt er auch die zahllosen blauen

Fig. p. 307 From the outset, the plan was to present his project at the Tokyo National Museum in Ueno Onshi Park, which, considering the acceptance of the European Modern in Japan, seemed to be the most appropriate venue. After more than 250 years of national isolation, Japan opened up in the Meiji era, which began in 1867, and started to accept the modern system of "civilization." It also imported the museum system, and the term "bijutsu" was coined as the translation of "art" at around the same time. A process was initiated of identifying typically Japanese features of art by means of reflection through the eyes of others—the word "nihonga," for example, which literally translated as "Japanese painting," was invented to distinguish traditional Japanese from European painting.

Founded on the occasion of the first International Exposition in Japan in 1872, the Tokyo National Museum is the oldest museum in Japan and symbolizes its acceptance of the European culture and European art. Ueno Onshi Park—the park also the product of modernization—opened in 1876, followed by the Ueno Zoo in 1882. With over seven museums and other institutions such as the Tokyo University of Fine Arts and Music (the first art school in Japan, established in 1885), concert halls, etc., the park is currently the most concentrated cultural area in the city. At the same time, it also hosts the countless blue vinyl tents of homeless people.

The main museum building, built in 1937 by Hitoshi Watanabe, is located opposite the main gate. With its oriental-style roof on Western museum architecture, it is the old-

Vinylzelte der Obdachlosen. Gegenüber dem Hauptzugangstor befindet sich das 1937 von Hitoshi Watanabe erbaute Hauptgebäude des Museums. Die westlich geprägte Museums-architektur mit ihrer Dachbekrönung im östlichen Stil ist das älteste Baudokument des westlich-japanischen Mischstils, der als »teikan« bezeichnet wird.

Unser Plan für ein erstes zeitgenössisches Kunstprojekt schien in dem traditionellen Museumsambiente zwar keine realistischen Aussichten zu haben, wurde am Ende aber doch als Kooperation des Museums und des Tokioter Goethe-Instituts verwirklicht. Das National Museum wollte eine neue Richtung einschlagen und seine Struktur für Impulse von außen öffnen. Nachdem Kuball die Örtlichkeiten selbst besichtigt hatte, kam er wider Erwarten sofort auf eine neue Idee, wo seine Installation im Tokyo National Museum auf-gebaut werden sollte. Anstatt die Außenseite des Hauptgebäudes zu nutzen, wählte er den ersten Saal – der japanische Keramik und Töpferarbeiten aufnimmt – für seine zeitlich begrenzte Intervention *Power of Codes – Space for Speech.*

Abb. S. 307

III.

Die Intervention wurde in den weitläufigen Räumlichkeiten des langgestreckten Saals für Dauerausstellungen aufgebaut, in dem die zahlreichen Schaukästen mit historischen Kera-miken und Töpferarbeiten platziert sind. Insgesamt 6 um 360 Grad rotierende Projektoren wurden auf den Vitrinen angebracht. Jeder Projektor warf ständig wechselnde Kombina-tionen aus Buchstaben und grafischen Figuren – minimale abstrakte Elemente – an die

est building to display the mixed Western and Japanese style referred to as "teikan." The plan for the first contemporary art project did not seem realistic in this traditional museum setting, but it was realized as a collaboration between the museum and the Goethe Institute in Tokyo. The National Museum wanted to embark in a new direction, changing its structure into an agency-based one.

Contrary to my expectations, after actually visiting the venue, Kuball immediately had another idea about where to set up his installation in the Tokyo National Museum. Instead of using the outside of the main building, he chose the first space—the space con-taining Japanese ceramics and pottery—for his temporary intervention, *Power of Codes—Space for Speech.*

Fig. p. 307

III.

The intervention was set up in the existing large, long permanent exhibition space with its numerous glass display cases, each holding old ceramics and pottery. A total of six slide projectors were placed on the display cases, rotating horizontally by 360 degrees. Each projector projected constantly changing combinations of letters and graphic figures—minimal, abstract elements—onto the surrounding walls. The images were frequently distorted, because long exhibition space did not allow adjusting the focus. Sometimes, one letter momentarily approached another one, eliciting meaning in the viewers' mind.

umliegenden Wände. Die Lichtbilder waren oft verschwommen, weil der lange Ausstellungs-raum keine Scharfstellung zuließ. Von Zeit zu Zeit ergaben sich Buchstabenkombinationen, die in der Imagination des Betrachters verschiedene Bedeutungen aufscheinen ließen.

Außerdem baute Kuball in 2 einander gegenüberliegenden Ecken des Saals jeweils 2 im 90-Grad-Winkel ausgerichtete Fernsehmonitore auf. Sie zeigten Buchstabennudeln, die in einer verspiegelten Box durcheinander geschüttelt wurden und derart komplexe Muster bildeten, als drehte man an einem Kaleidoskop. Durch den Spiegeleffekt kam es zwischen der Bedeutung der Nudeln (als Buchstaben) und ihren geometrisch-abstrakten Mustern gelegentlich zu Konstellationen, in denen die Grenze zwischen Bedeutung und Nichtbedeu-tung verwischte – mit entsprechenden Effekten auf die Wahrnehmung der Betrachter. Fer-ner reflektierten die Oberflächen von 2 Monitoren die jeweiligen Bilder auf den anderen Monitoren sowie die fortwährend veränderte Lichtsituation im Ausstellungsraum.

In *Power of Codes* brachte der Künstler gegensätzliche Elemente zusammen – fernöst-liche Keramiken und Töpferarbeiten mit dem römischen Alphabet, alte Medien (Keramiken und Töpferarbeiten) mit neuen Medien (Projektoren und Monitoren), Materielles mit Imma-teriellem, die ständige Ausstellung mit der vorübergehenden Intervention et cetera – und sorgte dadurch für eine bis dahin nicht dagewesene Begegnung im Raum. Besucher der Dauerausstellung und solche, die eigens wegen *Power of Codes* gekommen waren, trafen aufeinander und teilten sich den Saal. Durch das Projekt konnten unterschiedliche, in die-ser Art noch nie zusammengestellte Elemente einander kreuzen und auf dem Feld der

In addition, Kuball set up two television monitors each in two corners of the space that faced each other at ninety-degree angles. Each of them showed alphabet noodles forming complex patterns, as if turning a kaleidoscope. The noodles sometimes con-nected due to the mirroring effect between the meaning (as letters) and the geometrical abstract patterns—blurring the border between meaning and non-meaning and having an impact on the viewers' perception. The surfaces of two monitors also kept reflecting the respective image on the other monitors in addition to reflecting the ever-changing light situation inside the exhibition space.

In the *Power of Codes*, the artist brought together contrasting elements—Far Eastern ceramics and pottery and the Roman alphabet, old media (ceramics and pottery) and con-temporary media (projectors and monitors), material and non-material, permanent exhi-bition and temporary intervention, etc.—and arranged them to meet in the space in an unprecedented way. Visitors who came to view the permanent exhibition of ceramics and pottery and those who came for the *Power of Codes* met and shared the space. The project made it possible for different elements that had never been juxtaposed before to meet and interface through meaning, space, and visitor perception. It combined meaning with non-meaning and then allowed the visitors to generate their own meaning depending on their individual physical experience in the space, perception, and memories by freely roaming around inside the space.

327

Bedeutung, des Raumes und der Betrachterwahrnehmung in Austausch treten. Die Arbeit kombinierte durchaus kritisch Bedeutung mit Nicht-Bedeutung und ermöglichte es dadurch den Besuchern, entsprechend der nach ihren beim freien Umhergehen im Saal aufkommenden physischen Erfahrungen, Wahrnehmungen und Erinnerungen ihre eigene Interpretation zu entwickeln.

Glasschaukästen und projizierte Bilder kamen einander nicht in die Quere, weil der Raum so gegliedert war, dass jene die untere und diese die obere Hälfte der Wände belegten. Bewirkt durch das im ganzen Raum verbreitete Licht, entstanden jedoch vielerlei indirekte Interferenzen und Reflexionen. Neben den Projektoren und Monitoren fungierten die vorhandenen Vitrinen dabei zusätzlich als transparente und reflektierende Medien. Die im Innern des Raumes über die Wände gleitenden Buchstaben und geometrischen Formen waren durch die Glaskästen hindurch zu sehen, welche sie gleichzeitig aber auch spiegelten und auf weitere Glaskästen oder Wände übertrugen, und infolge dieser fortgesetzten Kettenreaktion veränderte sich der von einer Vielzahl dynamischer Spiegelungen durchzogene Saal sekündlich. Da die Betrachter sich frei im Raum bewegten, war ihnen eine eindeutige Gesamtansicht des sich stetig verändernden Ortes nicht möglich, bildeten sie doch selbst einen Teil davon: Ihre körperliche Gegenwart in und ihre Bewegungen durch den Raum beeinflussten durch die Überschneidungen mit den Lichtumläufen die Beleuchtung. Dieses Phänomen lässt sich auch dahingehend interpretieren, wie die Information durch die Transparenzen und Reflexionen verändert und die Betrachter zur aktiven Mitwirkung

The glass display cases and the projected images did not directly interfere with one another as the whole room was structured by the former being located in the lower half of the space and the latter on the upper level of the surrounding walls. There were, however, various kinds of indirect interference and reflection caused by the lights extending throughout the space. Here, in addition to the projectors and monitors, the existing display cased began to function as transparent and reflecting media. The letters and geometrical shapes crawling over the walls inside the space were visible through the display cases, which at the same time reflected them, sending them onto other display cases or walls—the chain reaction continued, the entire space filled with dynamic multiple reflections changing second by second. Because they walked freely through the space, visitors were not only capable of perceiving the ever-changing space in a positive way by being a part of it, their physical presence in and movement throughout the space influenced the lighting by interfering with the light circuits. This phenomenon can also be interpreted with respect to how the information was modified by the transparencies and reflections and how it invited visitors to actively participate. The installation also reminds us that the retina of the eye, catching the ever-changing lights, functions as one of the reflectors in the space. In the *Power of Codes*, physical, perceptual, and conscious reflection was generated at the precise moment of the experience.

eingeladen wurden. Ferner erinnert die Installation uns daran, dass die Augennetzhaut, wenn sie von ständig wechselnden Strahlen getroffen wird, selbst als ein Reflektor im Raum fungiert. In *Power of Codes* wurde physikalische, wahrnehmende und bewusste Reflexion im Augenblick des Erlebens erzeugt.

IV.

Man könnte das Projekt als eine immaterielle, vorübergehende »Collage« auffassen, in der Lichter auf komplexe Weise durch den gesamten Raum gesandt und verwirbelt werden. Die Collage ist eine im frühen 20. Jahrhundert, das heißt im Zeitalter der technischen Reproduzierbarkeit entstandene Technik, und wurde besonders von Dadaisten wie Hans Arp oder Kurt Schwitters – um nur zwei Namen zu nennen – experimentell genutzt. Die Kunst der Collage besteht darin, vorhandene Dinge und Informationen aufzudecken, umzuschichten und mit einer neuen Bedeutung zu versehen. Wenn die Collage Bruchstücke aus einem einheitlichen Zusammenhang herausnimmt und sie in einen anderen Kontext verlegt, spielt sie mit der Bedeutung, indem sie die vertraute Syntax verfremdet oder dekonstruiert, den Sinn in die Schwebe rückt oder Widersprüche heraufbeschwört. Sie öffnet die endlosen Kanäle der Informationen oder der Dinge.

Power of Codes erinnert an die durch elektrisches Licht und Glas erzeugten städtischen Collagen des 20. Jahrhunderts. In Walter Ruttmanns Film *Berlin. Die Sinfonie der Großstadt* (1927) spiegeln Schaufensterscheiben die Stadtlandschaft, nachts verwandeln urbane

IV.

The project might be understood as a non-material, ephemeral "collage" in which lights are transferred and stirred in a complex way throughout the whole space. "Collage" is a technique that emerged in the early twentieth century, in the age of mechanical reproduction, and was used in an experimental way especially by Dadaists such as Hans Arp or Kurt Schwitters, to name only a few. The art of collage is to discover and alter existing things and information and lend them new meaning. Taking fragments from a unified context and placing them into a different context, the collage plays with meaning by alienating or deconstructing familiar syntax, by putting meaning in limbo or evoking contradictions. It opens up the endless pathways of information or things.

Power of Codes is reminiscent of the urban collages of the twentieth century created by electric light and glass. In the film *Berlin—The Symphony of the Big City* (1927) by Walter Ruttmann, shop windows reflect the cityscape; at night, urban structures are transformed into light objects; and streetcars serve as dynamic, moving reflectors. The entire city appears to be a single, multi-reflecting light space.

Dan Graham's *Piece for Two Glass Buildings* should also be mentioned in connection with the *Power of Codes*. Graham approaches the possibilities of time and space through the phenomenological aspect of transparency and reflection by using projectors, mirrors, etc. In this particular work, modern twin glass buildings are used for the symmetrical

Strukturen sich in Lichtobjekte, und Straßenbahnen dienen als dynamische, bewegliche Reflektoren. Die ganze Stadt wirkt so, als sei sie ein einziger multireflektorischer Lichtraum.

Dan Grahams *Piece for Two Glass Buildings* gilt es im Zusammenhang mit *Power of Codes* ebenfalls zu nennen. Auch Graham setzt sich anhand des phänomenologischen Aspekts von Transparenz und Reflexion mit den Möglichkeiten von Zeit und Raum auseinander, indem er Projektoren, Spiegel und Ähnliches verwendet. Im genannten Werk werden moderne Zwillingsglasbauten für einen symmetrischen Aufbau genutzt. In auf gleicher Geschosshöhe liegenden Räumen von identischer Größe und identischen Zuschnitts sind 16 mm-Kameras auf die zur Spiegelwand blickenden Fernsehmonitore gerichtet, und die aufgezeichneten Bilder werden jeweils auf dem Monitor im anderen Raum gezeigt. Hier wird die selbstreferentielle Spirale durch die Verzahnung der beiden Räume erzeugt. Die ständig veränderten Tageslichtbedingungen wirken sich auf das Verhältnis von Transparenz und Reflexion im Raum aus, und die Besucher erfahren das Werk aktiv durch ihre Positionswechsel im Raum.

László Moholy-Nagys *Licht-Raum-Modulator* (1922–1930) ist der wichtigste Wegbereiter für *Power of Codes*. Er besteht aus verschiedenartigen Modulen in unterschiedlichen Materialien und Formen, wobei jedes der Module mit einer anderen Geschwindigkeit kreist, sodass eine komplexe Gesamtbewegung entsteht: die immaterielle dynamische Bewegung von Licht und Schatten (Spiegelungen inbegriffen). In *Power of Codes* verwandeln die 360-Grad-Bewegungen der Projektoren den gesamten Ausstellungsraum in ein fortgesetztes

setting. In rooms at corresponding levels and of the same size and format, 16 mm cameras are set up on the television monitors facing the wall, and the recorded images are then shown on the monitor in the other space. Here, the self-referential loop is generated by connecting the two spaces. The ever-changing natural light conditions affect the balance of transparency and reflection in the space, and visitors actively experience the work by changing their position within the space.

Laszlo Moholy-Nagy's *Light-Space Modulator* (1922–30) is the most important precursor to the *Power of Codes*. Consisting of various kinds of modules with distinct materials and forms, each module rotates at a different speed, thus generating the complex movement as a whole—the immaterial, dynamic movement of light and shadow (including reflections). In the *Power of Codes*, the 360-degree movements of the projector transform the whole exhibition space into the perpetual dynamic phenomenon of the multi-reflection of the lights, including the visitors. At the same time, unlike the *Light-Space Modulator*, this project triggers the transformation of the codes and the generation of the meaning by linking the codes with the aid of minimal letters and geometrical shapes that randomly meet or are reversed or extended in real-time. The codes never meet in the same way twice, and meaning is generated by the individual visitor—this is reminiscent of the automatism or automatic poetry of Dada and other avant-garde movements, or of experiments in the 1960s such as Fluxus. But the *Power of Codes* clearly speaks from

dynamisches Phänomen multireflektorischer Lichter, in das auch die Besucher integriert sind. Anders als der *Licht-Raum-Modulator* bewirkt Kuballs Anlage eine Transformation der Codes, indem sie diese mithilfe minimaler Buchstaben und geometrischer Formen verschaltet, die in Echtzeit zufällig aufeinander treffen beziehungsweise zurücktreten und sich ausdehnen. Die Codes begegnen einander nie auf gleiche Weise, und die Bedeutung entsteht im einzelnen Betrachter – dies erinnert an den Automatismus oder die automatische Dichtung bei Dada oder anderen Avantgarde-Bewegungen, aber auch an Experimente aus den Sechzigerjahren wie jene von Fluxus. Allerdings zeugt *Power of Codes* von einem anderen generativen Poesieprinzip, sind es hier doch minimale Elemente (ein Buchstabe oder eine Form), die dem Betrachter den Raum der Interaktion, Imagination und Reflexion bereitstellen – im physischen wie im metaphysischen Sinne.

Das Phänomen der fortwährenden Multireflexion minimaler Buchstaben und Formen ließe sich als Modell eines Kommunikationsnetzwerks auffassen. Durch Reflexion kann jeder Einzelne zum Reflektor werden, indem er eine gewisse Distanz zur Situation, in der er sich befindet, gelten lässt. Und diese Prozesse werden für jeden Besucher in Gang gebracht – vielfältige Informationen treten durch Übertragung oder Verknüpfung mit anderen Informationen in Erscheinung, sodass ein paralleler, distributiver Raum für autonome Erfahrung entsteht. In einer Sphäre, in der Zeit und Raum aus vielschichtiger Reflexion erwachsen, stimuliert *Power of Codes* den kreativen Prozess durch eine Vermischung von Codes, Lichtern, Menschen und öffnet sich dadurch für weitere Interaktionen.

Abb. S. 307

another poetry generation, as the minimal nature of its elements (one letter or one shape) provided the space—in both a physical and metaphysical sense—for visitor interaction, imagination, and reflection.

The phenomenon of the perpetual multi-reflection of the minimal letters and shapes could be understood as a communication network model. Reflection enables each individual to become a reflector by assuming a certain distance to oneself and the situation one is in. And these processes are activated for each visitor—various information appears through the transference of codes or linking up to other information, creating a multi-layered, parallel, generating, decentralized, distributed space for autonomous experience. In the sphere where time and space emerge from multi-layered reflection, *Power of Codes* encourages the creative process by mixing various fragments—codes, lights, people, etc.—thus creating opportunities for further interaction.

Fig. p. 307

PUBLIKUM | PERFORMATIV

PUBLIC | PERFORMATIVE

Tagebau – Raubbau, 1991,
1. Biennale für Landart, Cottbus;
Bauwagen, 25 Kinosessel, 2 Diapro-
jektoren, je 81 Dias, 1 Leinwand
(Foto: Thomas Kläber, Cottbus)

Mischa Kuball entwickelte diese
Arbeit während des Symposiums zur
1. Biennale für Landart. Die Installa-
tion wurde in einem Bauwagen auf-
gebaut, der auf dem Tagebaugelände
in der Niederlausitz stand. Auf einer
Leinwand überlagerten sich Projek-
tionen von einer Weltkarte und über-
dimensionalen Baggern, die für den
Braunkohleabbau genutzt werden.

Tagebau – Raubbau, 1991,
1st Landart Biennale, Cottbus; jobsite
trailer, 25 theater seats, 2 slide pro-
jectors, each containing 81 slides,
1 screen
(photograph: Thomas Kläber, Cottbus)

Kuball developed this work during
a symposium at the first Landart
Biennale. The installation was built
inside a jobsite trailer parked at an
opencast mining site in the Nieder-
lausitz region. Projections of a map
of the world and extra-large bull-
dozers used for brown coal mining
overlapped on a screen.

<<
Tagebau – Raubbau (Detail), 1991,
1. Biennale für Landart, Cottbus
(Foto: Thomas Kläber, Cottbus),
Vgl. Abb. links und diese Seite /
See figs. on the left and on this page

335

Hanauer Kollekte, 1992,
Metzgerei Kober, Altstädter Markt,
Hanau; 12 Leuchtkästen,
je 40 x 60 x 12 cm, 12 Negative
(Foto: Hubertus Birkner, Köln)

Die bemerkenswerte Sammlung
städtischer Beleuchtungskörper in
Hanau konzentriert sich besonders
um den Altstädter Markt. Um diese
Konzentration zu intensivieren, initi-
ierte Mischa Kuball die Idee, in die
Fenster der Bewohner am Altstädter
Markt einen Leuchtkasten zu stellen,
der jeweils am Abend eingeschaltet
wurde. Im Leuchtkasten befand sich
das Negativ einer der Lampen aus
der Städtischen Sammlung. Zum
Abend hin schalteten die Bewohner
die Leuchtkästen an und vervielfäl-
tigten die Lampenvielfalt, transpor-
tierten sie vom öffentlichen in den
privaten Lebensraum und zurück.

Hanauer Kollekte, 1992,
Metzgerei Kober, Altstädter Markt,
Hanau; 12 light boxes, 40 x 60 x 12 cm
each, 12 negatives
(photograph: Hubertus Birkner,
Cologne)

The remarkable collection of city
lights in Hanau is concentrated in
particular around the Altstädter
Markt. In order to intensify the con-
centration, Kuball had the idea of
putting a light box in the windows of
the houses on the Altstädter Markt,
each of which would be turned on
at night. In the light box was a nega-
tive of one of the lamps from the
city collection. At night the inhabi-
tants turned on the light boxes and
multiplied the number of different
lights, transporting them from public
to private living space and back.

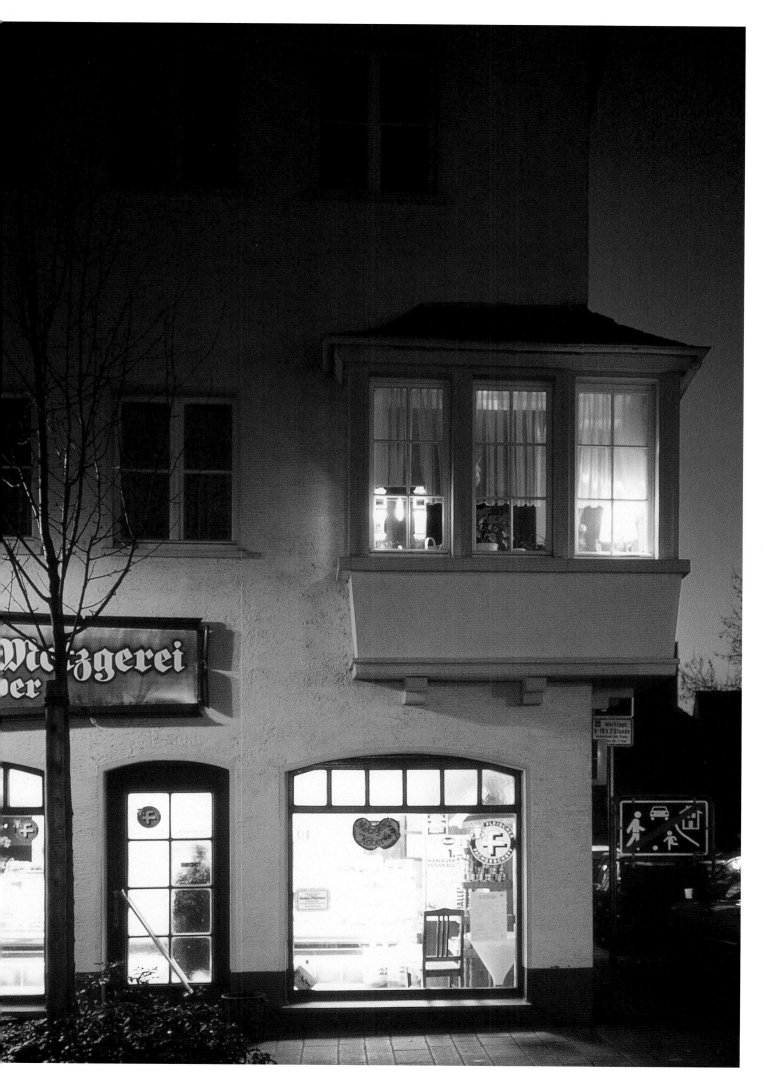

Refraction House, 1994,
Synagoge Stommeln, Pulheim
bei Köln
(Fotos: Hubertus Birkner, Köln)

Die intensive Lichtstrahlung »bezog«
die umliegende Nachbarschaft in die
Arbeit mit ein.
S. S. 38–39

Refraction House, 1994,
Stommeln Synagogue, Pulheim
near Cologne
(photograph: Hubertus Birkner,
Cologne)

The intense rays of light "included"
the surrounding neighborhood in
the work.
See pp. 38–39

Blick aus der Wohnung der Familie
Sauerland
View from the Sauerland family home.

Blick auf die Wohnung der Familie
Sauerland
View of the Sauerland family home.

Blick aus der Wohnung von
Minna Vesen
View from Minna Vesen's home.

Blick auf die Wohnung von
Minna Vesen
View of Minna Vesen's home.

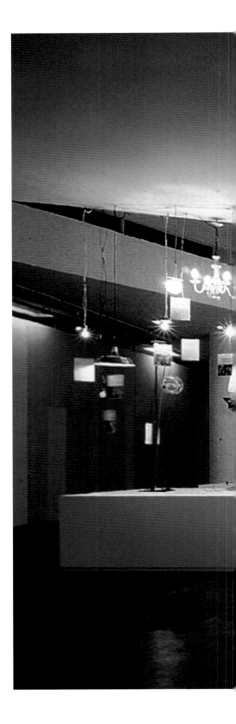

Private Light/Public Light, 1998, Deutscher Beitrag auf der *24. Biennale São Paulo*; 72 Standardleuchten (Foto: Nelson Kon, São Paulo)

72 Familien oder Einzelpersonen aus São Paulo wurden gebeten, eine Lampe aus ihrem Wohnbereich gegen eine von Mischa Kuball entwickelte Standardleuchte auszuwechseln. Die eingetauschten Lampen wurden dicht gedrängt als deutscher Beitrag in dem Ausstellungsraum der *24. Biennale São Paulo* präsentiert.

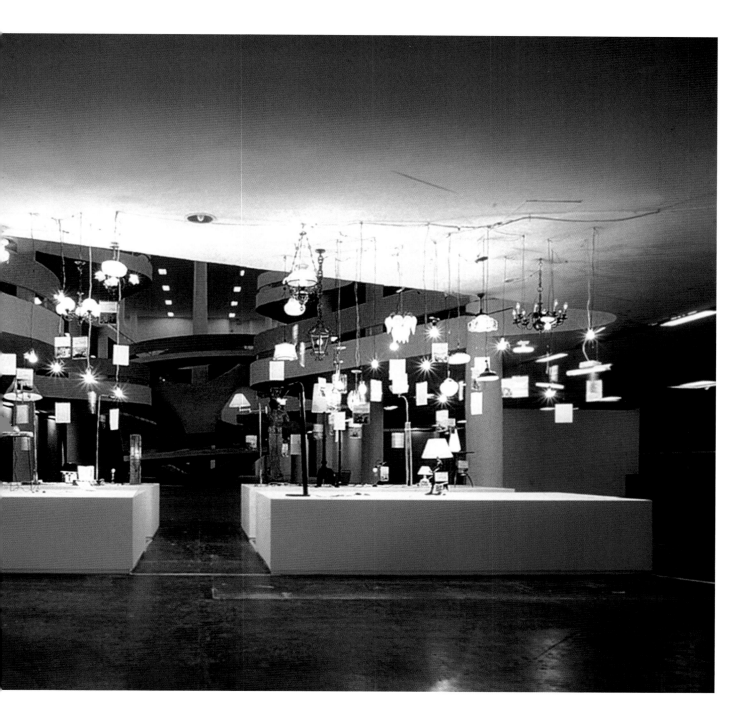

Private Light/Public Light, 1998, German contribution to the 24th São Paulo Biennale; 72 standard lamps (photograph: Nelson Kon, São Paulo)

Seventy-two families or individuals in São Paulo were asked to exchange one lamp from their living space for one developed by Kuball. The lamps he received in exchange were placed closely together in the exhibition space and constituted the German contribution to the 24th Biennale do São Paulo.

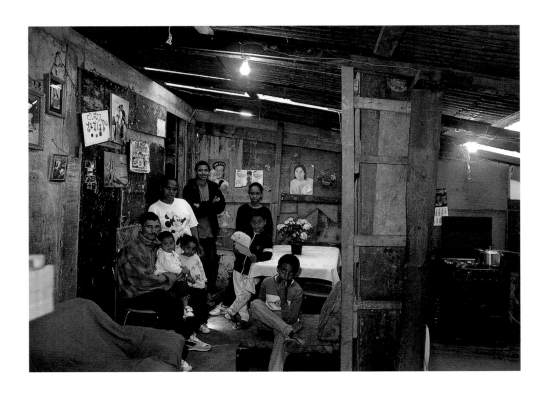

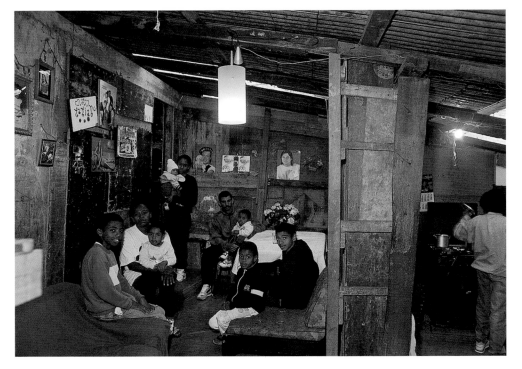

Private Light/Public Light, 1998,
Deutscher Beitrag zur *24. Biennale
São Paulo*; 72 Standardleuchten
(Foto: Kelly Kellerhoff, Berlin)

Maria Lopes & Durwaltercio, Edson,
Tatiane, Talita, Francisco jun., Vanele

Private Light/Public Light, 1998,
German contribution to the 24th São
Paulo Biennale; 72 standard lamps
(photograph: Kelly Kellerhoff, Berlin)

Maria Lopes & Durwaltercio, Edson,
Tatiane, Talita, Francisco, Jr., Vanele

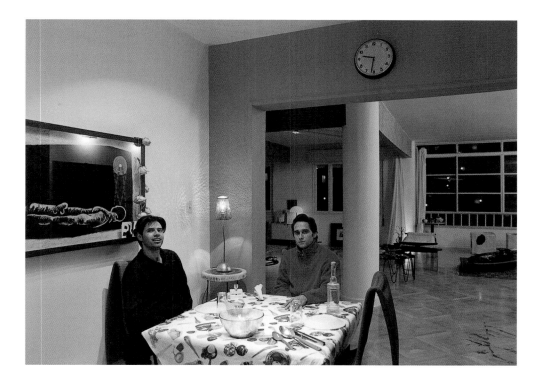

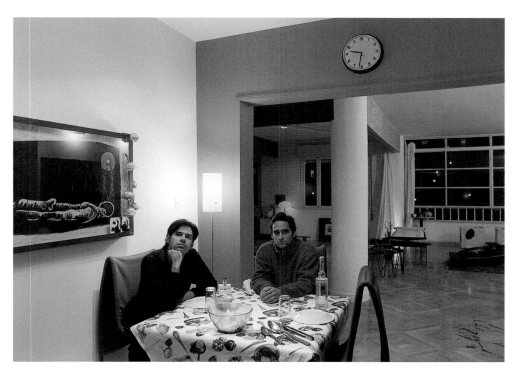

Private Light/Public Light, 1998,
Deutscher Beitrag zur *24. Biennale
São Paulo*; 72 Standardleuchten
(Foto: Kelly Kellerhoff, Berlin)

Marco Donini & Francisco de
Oliveira Zelesnikar

Private Light/Public Light, 1998,
German contribution to the 24th São
Paulo Biennale; 72 standard lamps
(photograph: Kelly Kellerhoff, Berlin)

Marco Donini & Francisco de
Oliveira Zelesnikar

343

Bettina Steinbrügge

Utopie/Black Square/Speed Suprematism, 2003, Halle für Kunst, Lüneburg, 107 Fotografien 21 x 21 cm, 7 Fotografien 1 x 1 m (Fotos: Hans-Jürgen Wege, Lüneburg)

Die Ausstellung war eine Fortsetzung der Bochumer Präsentation S. S. 56–57

Mischa Kuball hat Abbildungen aus dem Ausstellungskatalog der 1992 in der Schirn Kunsthalle gezeigten Suprematismus-Ausstellung mit seinen in die Aufnahmen ragenden Fingerspitzen abfotografiert. Die großformatigen Fotografien wurden in einem musealen Kontext präsentiert, doch die kleinformatigen Fotografien fanden im privaten und teilöffentlichen Stadtraum ihren Platz. Die Bildauswahl war Zufall, die Hängung wurde im privaten Raum ausschließlich oberhalb des bereits vorhandenen persönlichen Wandschmucks – Bilder, Poster, Fotos et cetera – vom Künstler selbst vorgenommen. Die Bedeutung der Platzierung orientierte sich am Konzept der ersten Ausstellung des *Schwarzen Quadrats* von Malewitsch 1915 in St. Petersburg.

Utopie/Black Square/Speed Suprematism, 2003, Halle für Kunst, Lüneburg, 107 photographs 21 x 21 cm, 7 photographs 1 x 1 m (photograph: Hans-Jürgen Wege, Lüneburg)

The exhibition was a continuation of the presentation in Bochum. See pp. 56–57

Kuball took pictures from the 1992 Suprematist exhibition at the Schirn Kunsthalle and rephotographed them so that his fingertips appeared on the pictures. The large photographs were presented in a museum context, however the small prints found their way into private and semi-public urban space. The images were selected at random, and the artist himself hung the prints only above the personal things already decorating the wall, such as paintings, posters, photographs, etc., in private space. The placement was oriented toward the concept of the first exhibition of Malevich's Black Squares in 1915 in St. Petersburg.

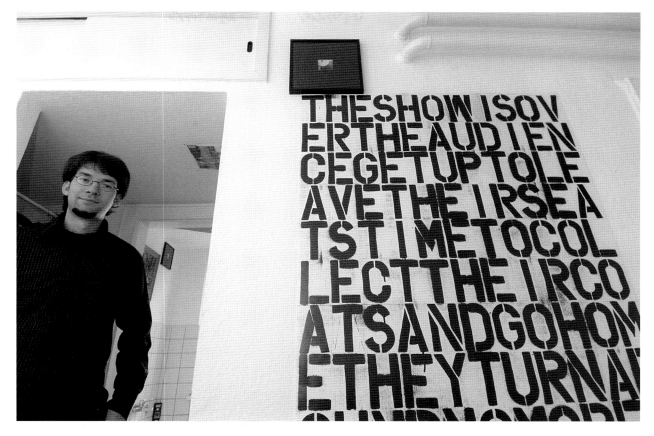

Hilmar Schäfer

Frisör Haarley's, Raymund Schiewek

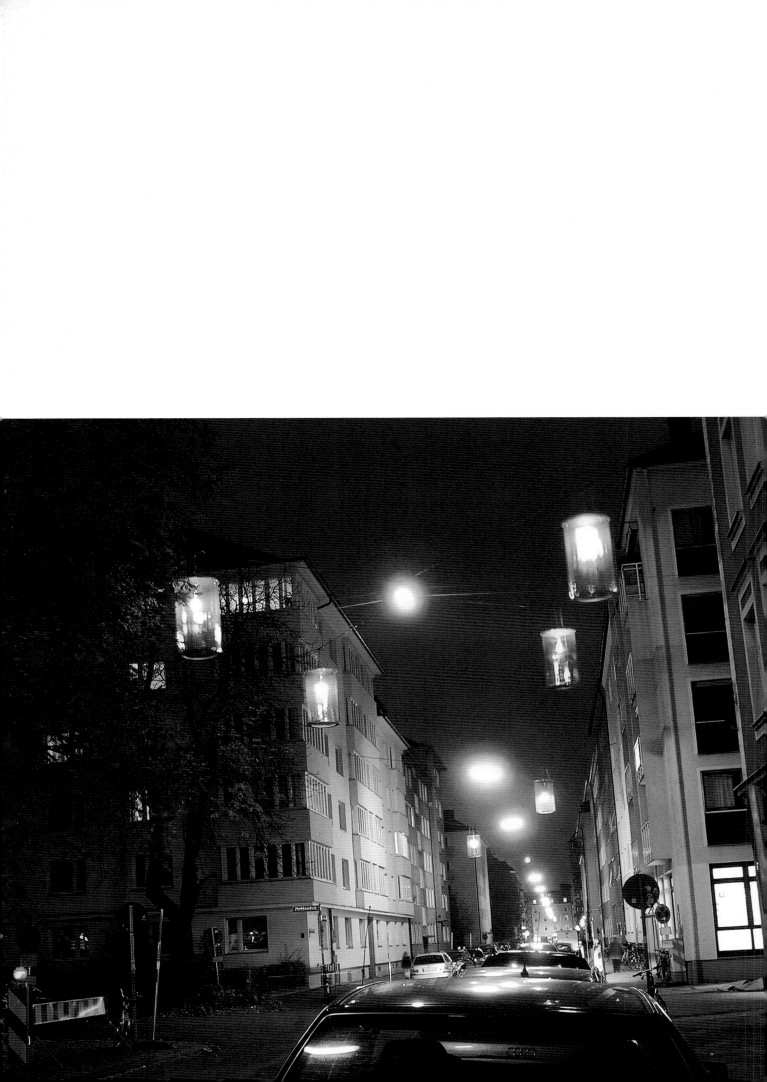

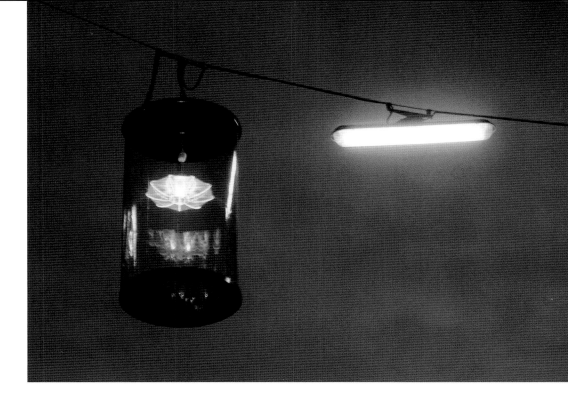

Urban Scans – Public Blend I + II, 2004, Kunstraum München; 12 durchsichtige Gehäuse, transparente Folie, Stahl je 220 x Ø 100 cm, 12 Lampen (Fotos: start.design Ralph Kindel, Essen, und Rüdiger Belter, München)

Im Rahmen des Ausstellungsprojekts *Urban Scans* entwickelte Mischa Kuball die Arbeiten *Public Blend I + II. Public Blend I* dokumentierte fotografisch die Ausstellung *Private Light/Public Light*, São Paulo (S. 340–343). Die dort bereits realisierte Idee des Lampentausches entwickelte er in *Public Blend II* weiter. Der symbolische Tausch wurde allerdings nicht mehr im musealen Kontext gezeigt. In München wurden die getauschten Lampen im öffentlichen Raum platziert.

Urban Scans – Public Blend I + II, 2004, Kunstraum Munich; 12 transparent housings, transparent film, steel, 220 x Ø 100 cm each, 12 lamps (photograph: start.design Ralph Kindel, Essen, and Rüdiger Belter, Munich)

As part of an exhibition project known as *Urban Scans*, Kuball developed the works *Public Blend I + II. Public Blend I* provided photographic documentation of the *Private Light/Public Light* exhibition in São Paulo (pp. 340–343). He continued to develop the idea of exchanging lamps, which was realized in this first project, in *Public Blend II*. However, the symbolic exchange was no longer shown in a museum context. In Munich, the lamps that had been exchanged were placed in public space.

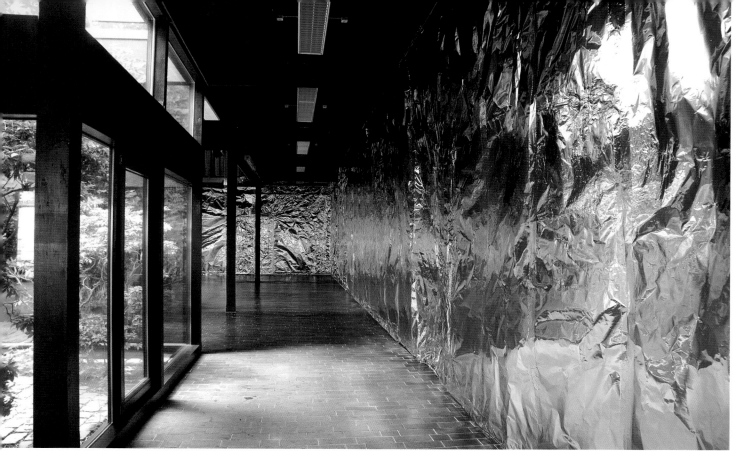

Innenansicht Oldenburger Kunstverein
Interior view of the Oldenburger Kunstverein

Innenansicht Edith-Ruß-Haus für Medienkunst
Interior view of the Edith-Ruß-Haus für Medienkunst

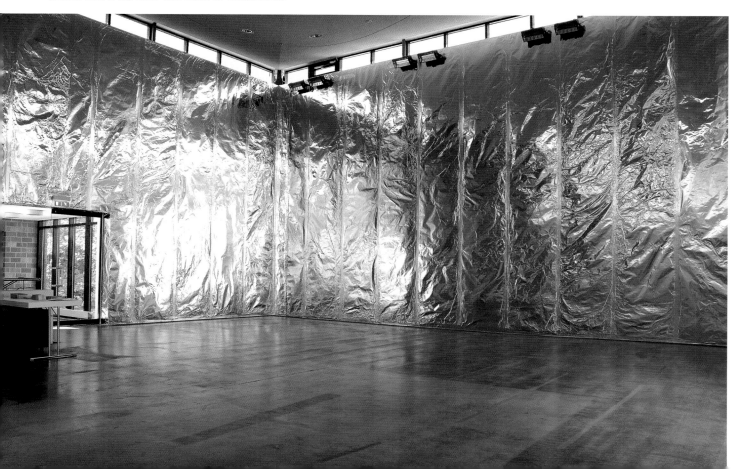

FlashBoxOldenburg, 2005,
Edith-Ruß-Haus für Medienkunst
und Oldenburger Kunstverein, Olden-
burger Innenstadt; ca. 60 Strobo-
skop-Lampen, 2000 m² Aluminium-
folie
(Fotos: Edith-Ruß-Haus für Medien-
kunst, Fotograf: Sven Adelaide,
Oldenburg)

Im Rahmen der Landesausstellung
Jahrhundertschritt 05 suchte Mischa
Kuball in Oldenburg mehr als sechzig
Paten, die sich eine blitzende Stro-
boskop-Lampe temporär an ihre
Hausfassade montieren ließen. Par-
allel inszenierte er im Edith-Ruß-
Haus für Medienkunst und im Olden-
burger Kunstverein 2 sogenannte
FlashBoxes, indem er die Innenräume
mit reflektierender Aluminiumfolie
verkleidete und blitzende Scheinwer-
fer in den Räumen installierte.

FlashBoxOldenburg, 2005,
Edith-Ruß-Haus für Medienkunst and
the Oldenburg Kunstverein, down-
town Oldenburg; approx. 60 strobo-
scopes, 2000 m² of aluminum foil
(photograph: Edith-Ruß-Haus für
Medienkunst, photographer:
Sven Adelaide, Oldenburg)

Within the scope of the *Jahrhundert-
schritt 05* exhibition, Kuball looked
for more than sixty "godparents" in
Oldenburg who would allow a flash-
ing strobe light to be temporarily
mounted on the fronts of their
houses. At the same time, he set up
two so-called *FlashBoxes* in the
Edith-Ruß-Haus für Medienkunst and
the Oldenburg Kunstverein. He cov-
ered the rooms inside with reflective
aluminum foil and installed flashing
spotlights in them, which intensified
the effect of the flashes.

LightSluice, 2001,
Milano Europa 2000, Anteprima
Bovisa, Milano; Lichtinstallation:
5 x 1 kW Scheinwerfer, 2 Beamer,
2 DVDs, Video 8' Loop,
400 x 800 x 500 cm, Stahlgerüst
(Foto: Sergio Anelli, Milano)

Mischa Kuball inszenierte den Ein-
gangsbereich der faschistischen
Architektur des Triennale-Gebäudes
in Mailand durch die Idee der Trans-
formation. Um in die Ausstellung
zu gelangen, mussten die Besucher
eine Treppe erklimmen und dann
durch ein gleißendes Lichttor schrei-
ten. Im Anschluss wurden sie mit
einer Gegenprojektion konfrontiert,
die jedoch keine Objekte oder Bilder
transportierte, sondern nur reines
Licht.

LightSluice, 2001,
Milano Europa 2000, Anteprima
Bovisa, Milan; light installation:
5 1-kW spotlights, 2 projectors,
2 DVDs, video 8' loop,
400 x 800 x 500 cm, steel scaffolding
(photograph: Sergio Anelli, Milan)

Using the idea of transformation,
Mischa Kuball redesigned the entry-
way to a piece of Fascist architecture,
the Triennale building in Milan.
To get into the exhibition, visitors had
to climb a staircase and then walk
through a gleaming gate of light.

Finally, they were confronted with
an opposing projection, which, how-
ever, did not transport any type of
object or image, but simply projected
pure light.

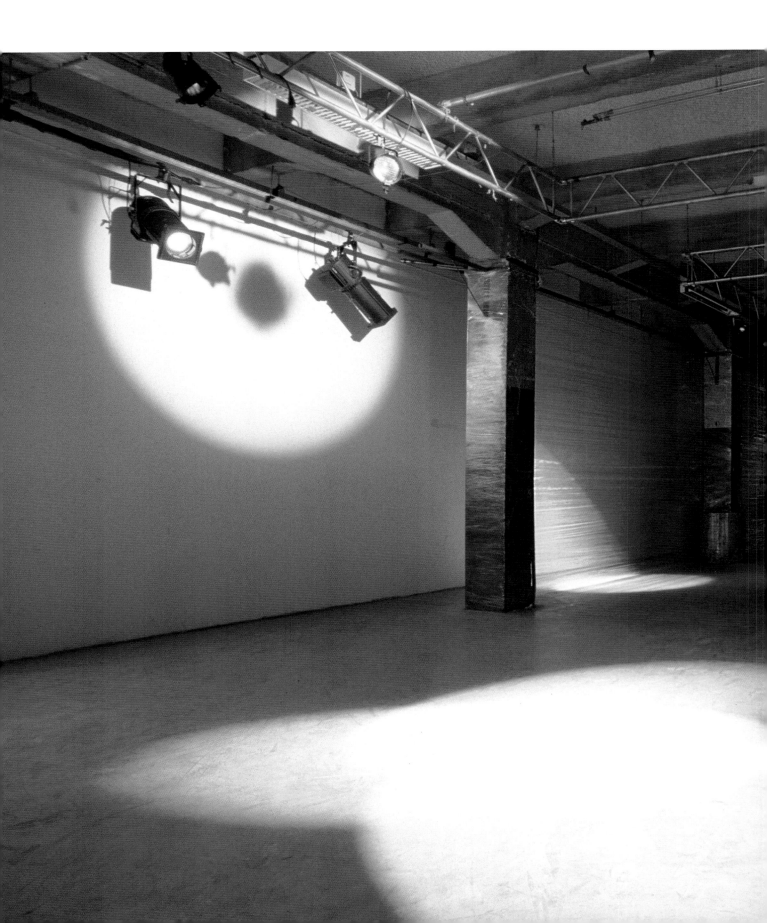

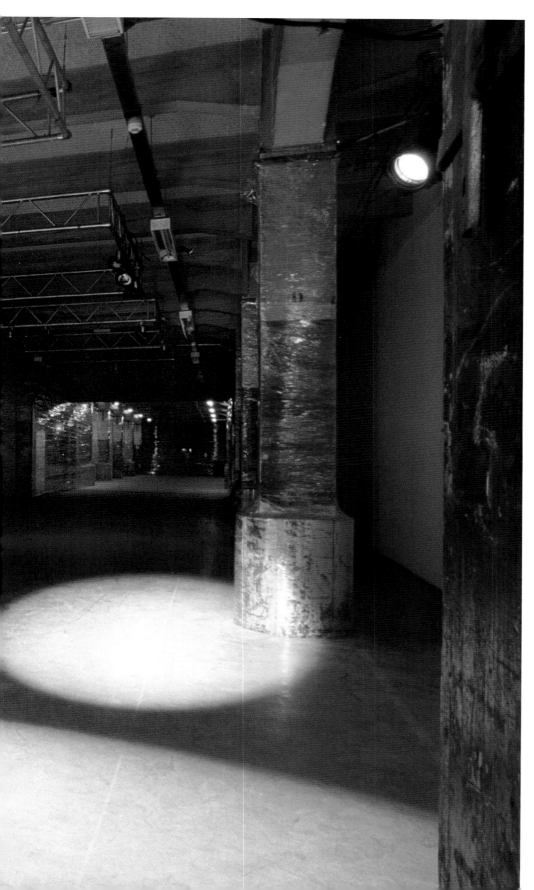

Cargo III, 2002,
Bagaage Hall, Amsterdam;
11 x 1 kw Scheinwerfer
(Foto: Bart Majoor, Amsterdam)

Im Cargo III-Projekt inszenierte
Mischa Kuball die ursprüngliche
Atmosphäre des Reisens in ferne
Länder.

Cargo III, 2002,
Baggage Hall, Amsterdam;
11 1-kW spotlights
(photograph: Bart Majoor, Amsterdam)

In the *Cargo III* project, Mischa Kuball
staged the original atmosphere
of traveling to distant countries.

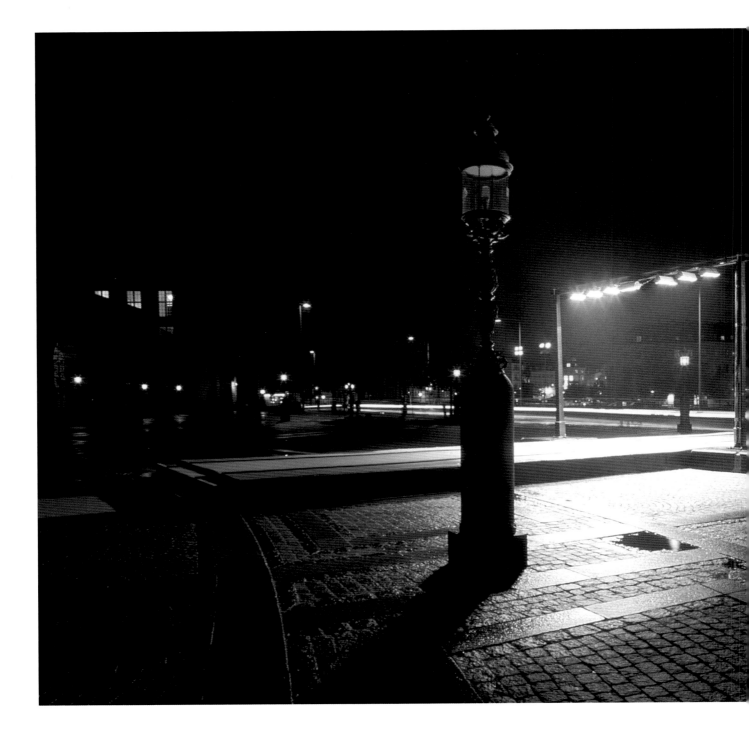

Public Catharsis, 2002,
Copenhagen; stage, red carpet,
scaffolding, Webcam, 7 spotlights
(photograph: Bent Ryberg,
Copenhagen)

The installation was at the parlia-
ment building in Copenhagen and
created a platform, a "red carpet,"
which could be used by anyone for
any type of performance. Alluding to
politicians who are constantly the
focus of public attention, there was
an opportunity here for the "public"
to step into the glare of the "lime-
light." This staged form of attention
was intensified, as the performances
were simultaneously transmitted
on the Internet.

Public Catharsis, 2002,
Kopenhagen; Bühne, roter Teppich,
Gerüst, Webcam, 7 Scheinwerfer
(Foto: Bent Ryberg, Kopenhagen)

Die Installation stand am Parla-
mentsgebäude in Kopenhagen und
schuf eine Plattform, einen »roten
Teppich«, der für jedermann nutzbar
und »performbar« war. In Anlehnung
an die politischen Persönlichkeiten,
die ständig im Licht der Öffentlich-
keit stehen, bot sich hier für die
»Öffentlichkeit« selbst die Möglich-
keit, in den Fokus des »Rampen-
lichts« zu treten. Diese inszenierte
Form der Aufmerksamkeit wurde
durch die parallele Übertragung der
Aktion ins Internet noch verstärkt.

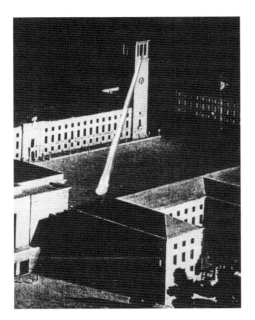

Sprach Platz Sprache, 1999,
nicht realisiert, Weimar
Projektskizzen Sammlung Ulrich
Krempel, Hannover

Ein Scheinwerfer sollte punktuell
zufällig den Hof des ehemaligen
Gauforums in Weimar markieren und
interaktiv auf Passanten reagieren.
Sobald der Scheinwerfer angehalten
hätte, wären auf dem Platz eine nicht
dekodierbare Sprache und Klänge
(konzipiert von Harald Grosskopf) zu
hören gewesen. Das Projekt wurde
in der Vorbereitungsphase aus poli-
tischen Gründen gestoppt. Man
befürchtete, dass Neo-Nazis diese
Installation zum Aufmarsch miss-
brauchen würden.

Sprach Platz Sprache, 1999,
not realized, Weimar
Project sketches Ulrich Krempel
Collection, Hanover

At irregular intervals, a spotlight
would highlight random points of the
former Nazi Gauforum courtyard
in Weimar and react interactively to
passers-by. Whenever the spotlight
stopped in the square, an undeci-
pherable language and sounds (con-
ceived by Harald Grosskopf) would be
heard. This project was halted for
political reasons during the prepara-
tory phase, as it was feared that neo-
Nazis would abuse the installation
by using it as an excuse for a demon-
stration.

KantParkStage, 2004,
mit Kunsu Shim und Gerhard Stäbler,
Wilhelm Lehmbruck-Museum,
Duisburg; 4 Scheinwerfer
(Simulation: start.design, Ralph
Kensmann, Essen)

Die Künstler errichteten zwischen
den Bäumen im Duisburger Kant
Park ein multimediales Ereignis, das
zugleich als temporäre, nächtliche
Bühne genutzt werden sollte. Schein-
werfer reagierten auf Geräusche und
Klänge und beleuchteten so zufällig
vorbeigehende Passanten.

KantParkStage, 2004,
with Kunsu Shim and Gerhard
Stäbler, Wilhelm Lehmbruck-
Museum, Duisburg; 4 spotlights
(simulation: start.design,
Ralph Kensmann, Essen)

The artists set up a multimedia event
among the trees in Duisburg's Kant
Park, which was also supposed to
be used as a temporary stage at
night. Spotlights reacted to sounds
and noises and therefore randomly
illuminated passers-by.

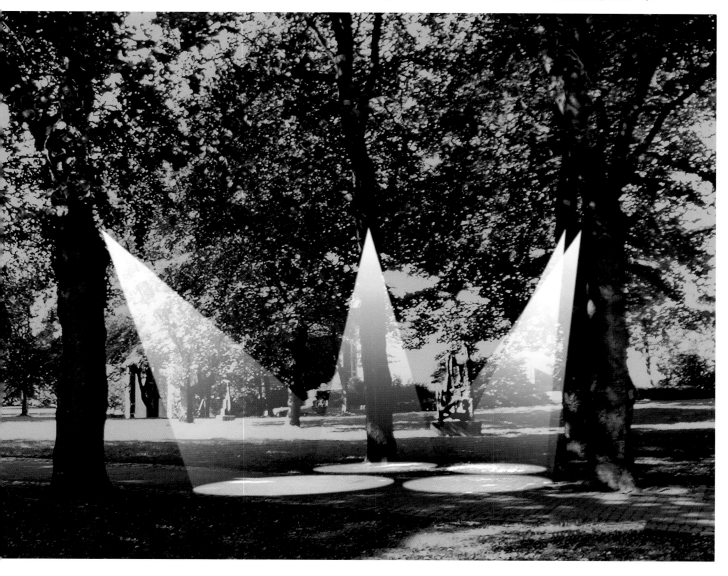

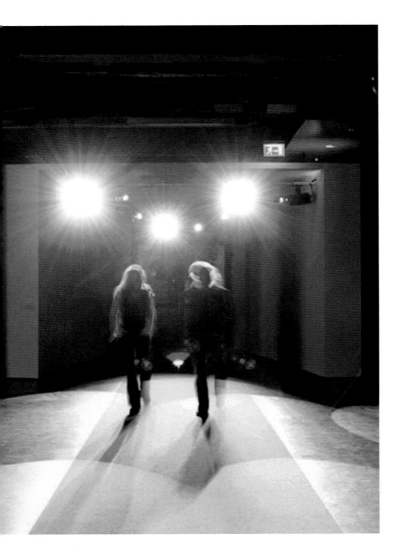
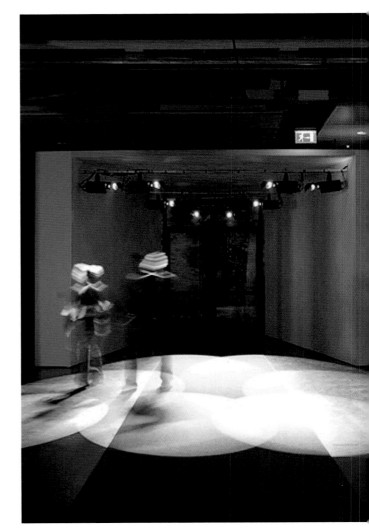

Public Entrance, 2005/06,
ZKM | Museum für Neue Kunst
Karlsruhe; 150 x 4 m roter Teppich,
10 kopfgesteuerte Lampen, DMX-
Programmierung
(Foto: Franz Wamhof, ZKM/MNK,
Karlsruhe)

Die raumspezifische Installation
inszenierte den Eingang zur Ausstel-
lung *Lichtkunst aus Kunstlicht* im
ZKM in Karlsruhe. Die Besucher
betraten durch am Boden und an den
Wänden rotierende Scheinwerfer-
kegel den Ausstellungsbereich.

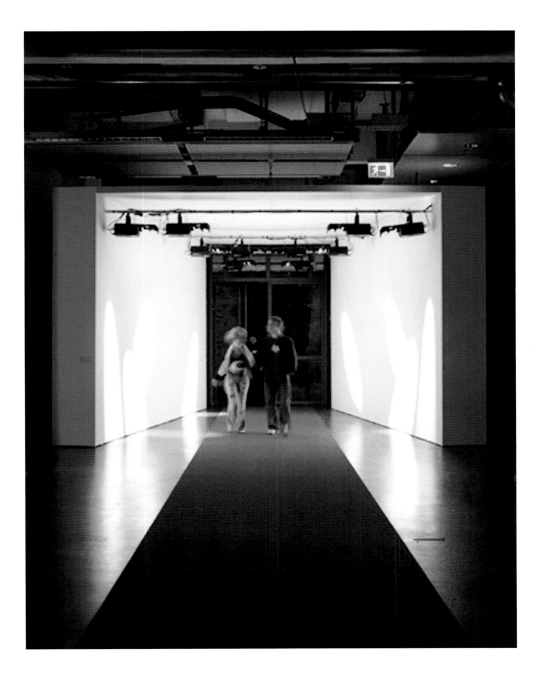

Public Entrance, 2005/06,
ZKM | Museum für Neue Kunst
Karlsruhe; 150 x 4 m red carpet,
10 head-controlled lights,
DMX program
(photograph: Franz Wamhof,
ZKM/MNK, Karlsruhe)

The site-specific installation set up
the entrance to the exhibition *Light
Art from Artificial Light* at the ZKM in
Karlsruhe. In order to enter the exhi-
bition space, visitors had to pass
revolving spotlights attached to the
floor and the walls.

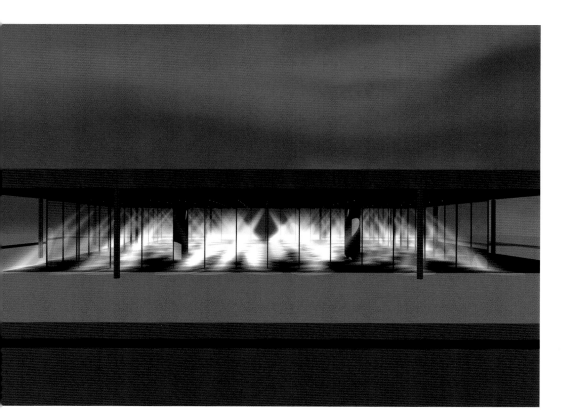

mies-stage, 2004/2005,
nicht realisiert, Nationalgalerie
Berlin (Simulation: Archiv Mischa
Kuball, Düsseldorf in Zusammen-
arbeit mit start.design, Essen)

Die in der Decke angebrachten soge-
nannten »Kopfgesteuerten Leuch-
ten« werfen einen klar konturierten
Lichtkreis auf den Boden der Aus-
stellungshalle und beziehen in steter
Bewegung den Außenraum, auf dem
die Architektur ruht, mit ein. Die
agierenden Besucher geraten in den
Kegel des Lichtes – wobei die Steue-
rungsanlagen in der Lage sind, die
Bewegungen der Besucher zu regi-
strieren und sie gegebenenfalls auch
mit dem Licht zu »verfolgen«.

mies-stage, 2004/05,
not realized, Nationalgalerie Berlin
(simulation: Mischa Kuball Archive,
Düsseldorf, in cooperation with
start.design, Essen)

So-called head-controlled lights
attached to the ceiling projected a
clearly contoured circle of light
onto the floor of the exhibition space,
including in its constant motion the
exterior space, upon which the archi-
tecture is based. Visitors moved into
the cone of light, while the control
system was capable of registering
the motions of the visitors and "pur-
suing" them with the light.

mies-stage, 2004/2005,
nicht realisiert, Nationalgalerie Berlin
(Testfoto: Archiv Mischa Kuball,
Düsseldorf in Zusammenarbeit mit
Elektro Decker, Essen)

mies-stage, 2004/05,
not realized, Nationalgalerie Berlin
(test photograph: Mischa Kuball
Archive, Düsseldorf, in cooperation
with Elektro Decker, Essen)

Megazeichen VI, 1990,
Mannesmann-Hochhaus, Düsseldorf
(Foto: Norbert Faehling, Düsseldorf)

Ansicht von der Oberkasseler
Rheinbrücke
S. S. 166–171

Megazeichen VI, 1990,
Mannesmann High-rise, Düsseldorf
(photograph: Norbert Faehling,
Düsseldorf)

View of the Oberkassel bridge over
the Rhine
See pp. 166–171

Public Stage, 2000,
Staatliche Galerie Moritzburg, Halle;
Bühne 500 x 400 x 50 cm, Banderole,
5 kW Scheinwerfer, Gerüst
500 x 600 x 300 cm

Mischa Kuball installierte eine Licht-
und Bühneninstallation vor dem Tor
der Moritzburg. Über einen Zeitraum
von drei Wochen stand *Public Stage*
für jede mögliche Aktion zur Verfü-
gung. Der Verlauf des Projekts wurde
parallel auf einer Internetseite ver-
öffentlicht. Eine Straße führte zwi-
schen der Lichtinstallation und der
Bühne durch, markierte so eine
Achse zwischen Museum und Stadt-
raum.

Public Stage, 2000,
Staatliche Galerie Moritzburg, Halle;
stage 500 x 400 x 50 cm, banderole,
5-kW spotlight, scaffolding
500 x 600 x 300 cm

Mischa Kuball created a light and
stage installation in front of the gate
of the Moritzburg. Over a period of
about three weeks, *Public Stage* was
available for any type of action. At the
same time, the process of the project
was published on the Web. A street
ran through the light installation and
the stage, marking an axis between
the museum and the urban space.

Eröffnung
(Foto: Klaus Göltz, Halle)
Opening
(photograph: Klaus Göltz, Halle)

24. Juni 2000, Aktion **Öffentlichkeit
ist eine Fiktion** von Joachim Penzel
(Foto: Reinhard Hentze, Halle)
June 24, 2000, **Öffentlichkeit ist eine
Fiktion**, action by Joachim Penzel
(photograph: Reinhard Hentze, Halle)

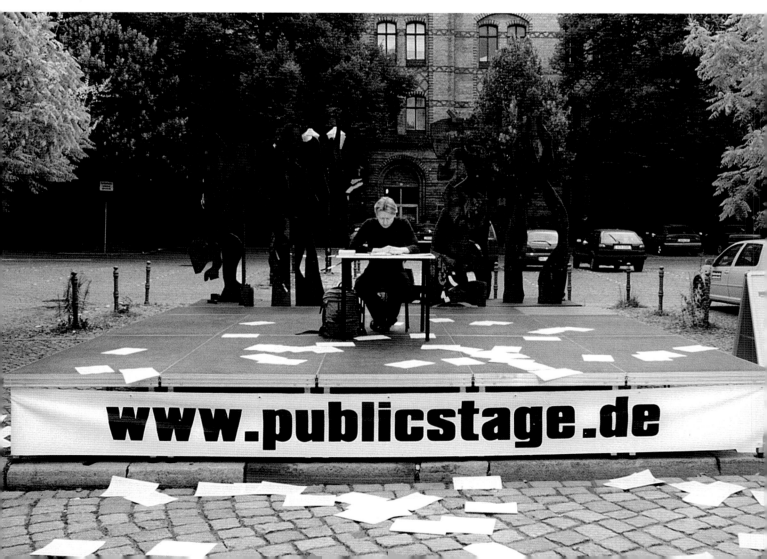

24. Juni 2000, Aktion **Öffentlichkeit ist eine Fiktion** von Joachim Penzel
(Foto: Reinhard Hentze, Halle)
June 24, 2000, **Öffentlichkeit ist eine Fiktion**, performance by Joachim Penzel
(photograph: Reinhard Hentze, Halle)

5. Juni 2000, Aktion **Singen und Reden** von Sandra Spillner und Christiane Schmidt
(Foto: Klaus Göltz, Halle)
June 5, 2000, **Singen und Reden**, performance by Sandra Spillner and Christiane Schmidt
(photograph: Klaus Göltz, Halle)

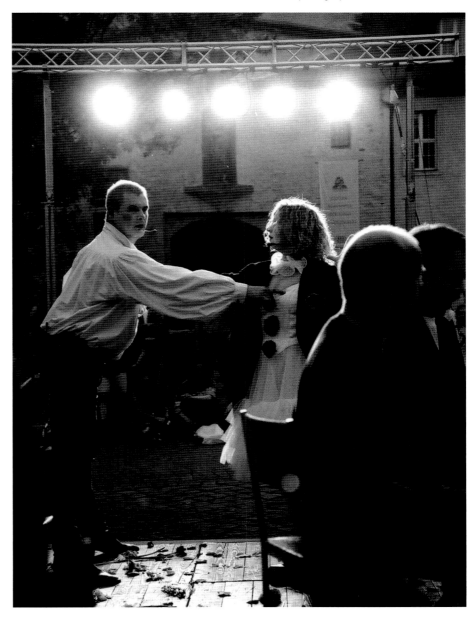

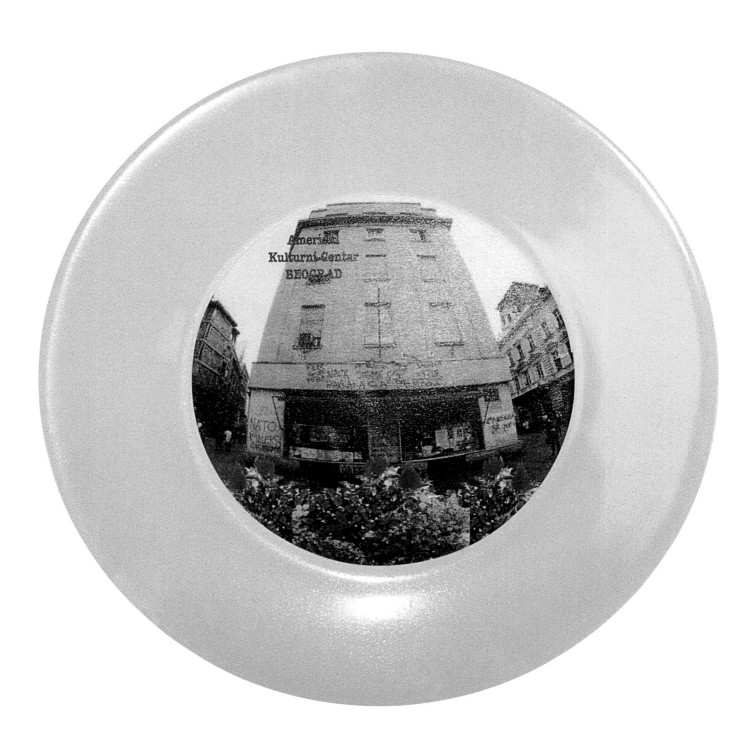

Souvenir for Belgrade/Dysfunctional Places/Displaced Functionalities, 2001, Belgrad; 200 bedruckte Teller (Foto: Archiv: Mischa Kuball, Düsseldorf)

Die urbanen Veränderungen Belgrads in den Fokus nehmend, entwickelte Mischa Kuball einen »Souvenir-Teller« mit dem vandalisierten American Cultural Center als Aufdruck. Diesen Teller verteilte er als Geschenk an Passanten in der Belgrader Innenstadt. Dadurch, dass ein Ausländer den Belgradern ein Souvenir stiftete, kehrte sich der herkömmliche touristische Austausch um.

Souvenir for Belgrade/Dysfunctional
Places/Displaced Functionalities, 2001,
Belgrade; 200 printed plates
(photograph: Mischa Kuball Archive,
Düsseldorf)

Focusing on the changes in urban
Belgrade, Kuball developed a "sou-
venir plate" embossed with an image
of the vandalized American Cultural
Center. He distributed it as a gift to
passers-by in downtown Belgrade.
As a foreigner offering the citizens of
Belgrade a souvenir, Kuball reversed
the usual tourist exchange.

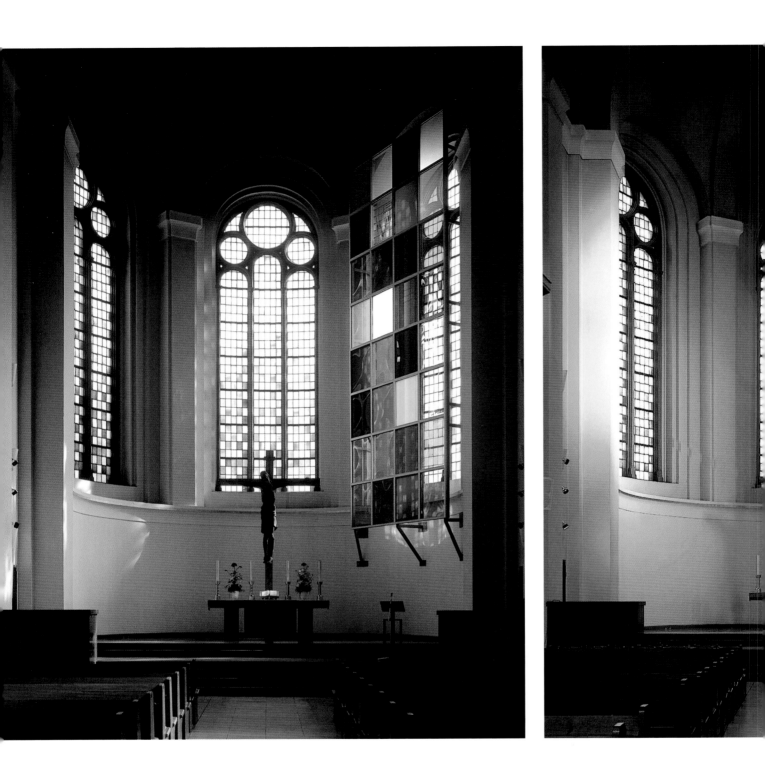

Ein Fenster, 2000/01,
Johanneskirche Düsseldorf; Stahl,
Glas, 4,50 x 9,50 m, 3 x 32 Felder;
1., 2. und 3. Zustand
(Foto: Nic Tenwiggenhorn, Düssel-
dorf)

Mischa Kuball initiierte das inter-
aktive Projekt mit Thorsten Nolting
von der Johanneskirche und gab den
Kirchenbesuchern die Möglichkeit,
eigene Entwürfe für ein Kirchenfen-
ster einzureichen. 96 von 147 Ent-
würfen wurden schließlich über einen
Ausstellungszeitraum von einem

Jahr realisiert. Vor ein Fenster der
Johanneskirche wurde ein Fenster-
gerüst gesetzt, in dessen 32 Feldern
die Entwürfe der Beteiligten ausge-
stellt wurden. Es gab insgesamt
3 verschiedene Fensterversionen.

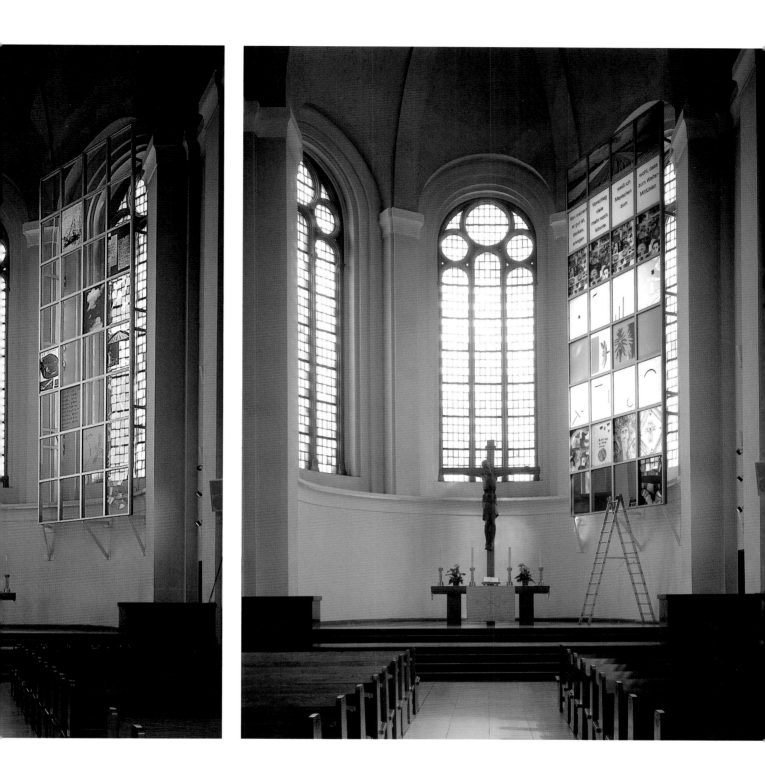

Ein Fenster, 2000/01,
Johanneskirche Düsseldorf; steel,
glass, 4.50 x 9.50 m, 3 x 32 panes;
1st, 2nd, and 3rd version
(photograph: Nic Tenwiggenhorn,
Düsseldorf)

Kuball began the interactive project
with Thorsten Nolting from the
Johanneskirche and gave visitors
to the church the chance to hand in
their own designs for a window for
the church. Ninety-six of 147 designs
were ultimately realized over the
course of the year-long exhibition.

Scaffolding was placed in front of
one of the windows of the church,
and the participants' designs were
displayed in the thirty-two areas
of the window. There were a total of
three different versions of the win-
dow.

Public Square, Frühjahr 2007,
Hamburger Kunsthalle
(Simulation: Archiv Mischa Kuball,
Düsseldorf)

Performance mit circa 625 Personen,
anlässlich der Ausstellung *Das
schwarze Quadrat* in der Hamburger
Kunsthalle.

Public Square, spring 2007,
Hamburg Kunsthalle
(simulation: Mischa Kuball Archive,
Düsseldorf)

Performance with ca. 625 partici-
pants on the occasion of the exhibi-
tion *Das schwarze Quadrat* in the
Hamburg Kunsthalle.

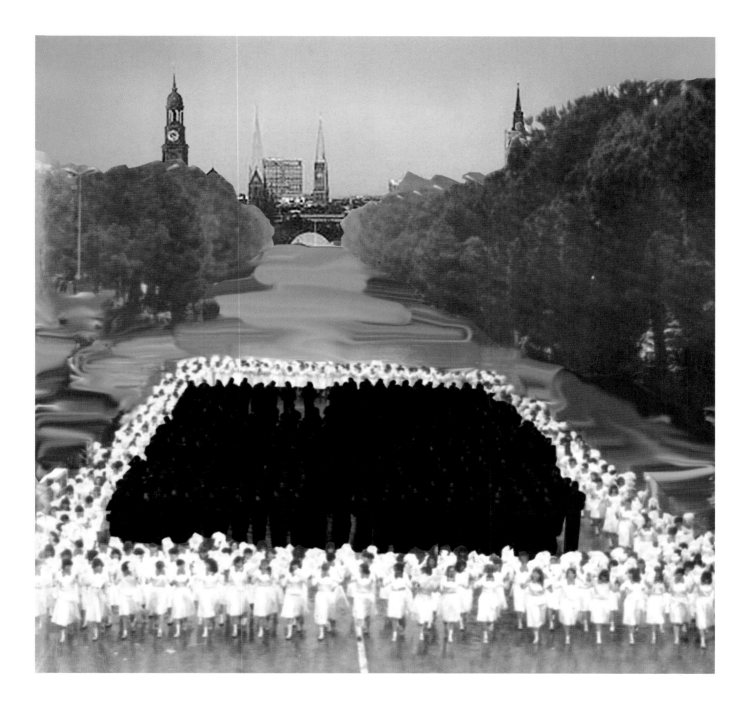

IHOR HOLUBIZKY

DIE INSZENIERUNGEN DES »CITIZEN KUBALL«
THE ENACTMENTS OF "CITIZEN KUBALL"

Mischa Kuballs Werk entfaltet sich in den Schnittflächen von öffentlichem Raum und öffentlichem Handeln – in der Architektur und gebauten Umgebung –, also dort, wo kollektive Erfahrung und persönliche Gedanken entstehen können. Das heißt, er stellt die Mittel zur Verfügung, um das kulturelle Gedächtnis anzuzapfen. Das Gedächtnis prägt sowohl die »Erkenntnis« als auch das Bedürfnis, mit dem Unerkennbaren umzugehen und es zu erforschen: Die Neugier als unsere »zweite Natur« ist hierbei kritische Instanz. Doch Kuballs Werk ist nicht nur darauf angelegt, zu belehren, und seine Verwendung von Technologien ist mehr als bloß ein Kunstgriff zur Bezauberung des Auges. Er erzeugt Wahrnehmungssituationen, in denen viele Elemente miteinander verflochten werden, um dadurch eine »ganzheitliche Kunst« hervorzubringen, die allerdings gleichzeitig einen Kontrapunkt zum »Gesamtkunstwerk« bildet. Das »Ganze« eröffnet sich dem Betrachter mit der Zeit, manchmal langsam und unmerklich. Es ist am Betrachter, das »Ganze« zu vervollständigen, und er mag sogar teilnehmen, ohne es zu wissen.[1] Obwohl auch Kuball zwangsläufig in der Welt der Kunst, im Kontext von deren stetig sich mehrenden, beharrlichen Repräsentanten und Diskursen agiert, lässt er in seinen Arbeiten die Schlussfolgerung offen – und ermöglicht dadurch, dass diese als eine Kunst anderer Ordnung oder überhaupt nicht als Kunst erkannt werden können. Deshalb kann er auch zu dem, was er tut oder in die Wege leitet, eine sachliche Distanz wahren, so als sei er lediglich ein »Bürger«, der an seinem eigenen Werk partizipiert. Seine Recherche mündet im Ergebnis in einer weiteren Form von

Mischa Kuball's work operates within the intersections of public space and activity—architecture and the built environment—where a collective experience and private thoughts can take place. That is to say, he provides the means for cultural memory to be tapped. Memory informs "knowing" and the need to manage and explore the unknowable: curiosity as our "second nature" is a critical ingredient. But Kuball's work is not made simply to teach, and his use of technologies is more than a mere device to enchant the eye. He generates perceptual situations through which many elements are woven together to create a "total art," yet at the same time a counterpoint to the *Gesamtkunstwerk*. The "totality" is revealed to the viewer(s) over time, sometimes slowly and imperceptibly. It is the viewer who must complete the "totality" and may even participate without knowing it.[1] While Kuball also operates within the world of art and its ever-increasing and insistent agents of culture and discourse by necessity, he leaves the conclusion open—and the possibility that this is an art of a different order, or not recognized as art at all. In doing so, he can also stand at an objective distance from what he makes or initiates, as/as if a "citizen" participating in his own work. The outcome of his research becomes another form of research, and I will suggest that both form the enactment. The challenge there-

Public Entrance (Detail), 2005/06,
ZKM | Museum Neue Kunst Karlsruhe
(Foto: Franz Wamhof, ZKM/MNK,
Karlsruhe), Vgl. Abb. S. 358 /
See fig. p. 358

Recherche, und ich möchte dafür plädieren, dass beide zusammen erst die Inszenierung bilden. Zur Frage steht deshalb, wie sich unsere überreizten Sinne im zeitgenössischen urbanen Kontext neu stimulieren lassen, ohne dass dieses Problem weiter verschärft wird. Kuballs Antwort darauf lautet: die einfachsten Mittel zu benutzen, um möglichst viel zu erreichen. Im Blickpunkt dieses Kommentars stehen 4 Werke, die sich in ihrem »Medium« und ihrer Ausführung stark unterscheiden, doch durch ein festes konzeptuelles und empirisches Gewebe miteinander verknüpft sind: *Megazeichen* (1990), *Refraction House* (1994), *Urban Context* (1995–2000) und *Stadt durch Glas* (fortlaufend seit 1995).

Abb. S. 362–363 und 338–339
Abb. S. 40–41 und 248–257

Anstatt einem chronologischen Ablauf zu folgen, möchte ich am Ende – mit *Stadt durch Glas* – beginnen, weil mir die Gelegenheit, mit Kuball an der für das Institute of Modern Art entstandenen Brisbane-Version des Werks zu arbeiten, Einsichten in seine Denkweise und seine Arbeitshaltung in der Welt erlaubte. Dies wiederum führte zu Überlegungen über die Anfänge des Videos als Künstlerinstrument. Unsere Arbeitsbeziehung war nicht als die eines Kurators zum Künstler formalisiert: Ich leistete technische Unterstützung, hörte ihm während der Produktion zu und war »Zeuge« des Prozesses wie auch des Ergebnisses. *Stadt durch Glas* fußte auf einer einfachen Grundidee: Kuball hatte vor, auf einer Autofahrt die Stadt zu filmen. Es gab einen Fahrer, Kuball hielt die Kamera, ich saß auf dem Rücksitz und bestimmte die Strecken, da der Fahrer sich in Brisbane nicht auskannte. Idealerweise war vorgesehen, eine 60-minütige Runde zu drehen und am Ende wieder an den Ausgangspunkt zu gelangen. Wir wollten dieselbe Strecke einmal tags und einmal nachts abfahren. Nun beruht jedoch der Stadtplan von Brisbane nicht auf einem

fore, becomes how to "restimulate" our overstimulated senses in the urban, contemporary environment without adding to the problem. Kuball's answer is using the simplest of means to achieve as much as possible. The focus of this commentary are four works that are vastly different in their "medium" and actualization but have a consistent, conceptual, and experiential connective tissue: *Megazeichen* (1990), *Refraction House* (1994), *Urban Context* (1995–2000), and *Stadt durch Glas* (ongoing since 1995).

Figs. pp. 362–363 and 338–339
Figs. pp. 40–41 and 248–257

Rather than following a chronological path, I will start at the end—*Stadt durch Glas*—as the opportunity to work with Kuball on the Brisbane version for the Institute of Modern Art, provided an insight into his way of thinking and working in the world. In turn, this led to thoughts about the beginning of video as an artist's tool. The working relationship was not formalized as curator-to-artist: I provided technical support, was an eavesdropper during the production, and a "witness" to the process as well as the outcome. The premise of *Stadt durch Glas* Brisbane was simple. Kuball would videotape the city during a car ride. There was a driver; Kuball held the camera; I sat in the back seat selecting the routes, as the driver was unfamiliar with Brisbane. The ideal plan was a circuitous route lasting sixty-minutes duration, ultimately arriving at the departure point. The same route would be taken during the day and night. The Brisbane street plan, however, is not based on a grid because the meandering Brisbane River cuts the city in half, and being situated

Raster, denn der mäandernde Brisbane River zerschneidet die Innenstadt in zwei Hälften, und aufgrund der Flusstal-Lage kann die Topografie sich binnen eines Kilometers dramatisch verändern. Auch erzeugt das System von (zahlreichen) Einbahnstraßen eher eine »natürliche« Schleifenroute als einen typischen »Rundkurs«. Wenngleich wir dieselben Straßen nahmen (nachts kann man sich schwerlich absolut sicher sein, wohin man fährt), unterscheiden sich ganz typisch für eine große Stadt die Verkehrsverläufe – und Staus – am Ende unserer beiden Routen stark. Trotzdem dauerten Tag- und Nachtfahrt wundersamerweise nahezu gleich lang.

Kuball drehte das Video, ohne durch die Linse zu schauen. Das Bild wurde dadurch »kompromittiert«, dass ein mit Klebebändern an der Kamera befestigtes Trinkglas vor dem Objektiv angebracht war (das Glas wurde aus dem Bestand eines örtlichen Discountladens ausgesucht). Dabei entstand ein kreisförmiges/monokulares Bild; durch Verdoppelung bei der Projektion wurde anschließend ein binokularer Effekt erzeugt.[2] Projektionsort war auf Straßenhöhe die einer vorgehängten Fensterfassade gegenüberliegende Galeriewand. Die Projektion lief Tag und Nacht. Kuball hatte angewiesen, dass die Fenster für das Tageslicht »offen« bleiben sollen. Deshalb war das Video »am besten« abends, nach den Öffnungszeiten der Galerie zu sehen, und tagsüber weniger gut wahrnehmbar. Dies bedeutete auch eine Umkehrung der Situation der Videoaufnahme, bei der ja die Strecke am besten tagsüber »erkennbar« war. Kuball und ich saßen am Abend der Vernissage in einiger Entfernung von der Fensterfassade draußen vor der Galerie. Wir schauten auf die Projektion und auf die Besucher in der Galerie, die wiederum auf die Projektion schauten. Kuball

in a river valley, the topography can change dramatically within a kilometer. The system of (many) one-way streets also creates a "natural" looping route rather than a typical "circle road." Although the same routes were followed (at night it is difficult to be absolutely sure where you are going), traffic patterns—and congestion—will differ greatly, which is true of any large city—both day and night trips, miraculously were almost exact in their duration.

Kuball shot the video without looking through the lens. The image itself was "compromised" by taping a drinking glass to the camera, covering the lens (the glass was selected from those available at a local discount store). The result was a circular/monocular image; when doubled in projection, a binocular effect was produced.[2] It was then projected onto a gallery wall, a space with a curtain wall window along the opposite side, facing the street level. The projection was left running day and night: Kuball's instructions were to leave the windows "open" to natural light. Hence, it was "best" seen at night, after gallery public hours, and less visible during the day. This was also a reversal of the videotaping—the route was best "observable" during the daytime.

Kuball and I sat outside the gallery during the evening vernissage and at a distance from the curtain wall/window. We looked at the projection and the people inside the gallery looking at the projection. Kuball noted that this is the best place to see the work. But

bemerkte, dass dies die beste Stelle sei, um seine Arbeit zu betrachten. Doch wie sollte das ein Galeriebesucher, der darauf geeicht ist, Kunst im privilegierten Raum der Galerie zu beäugen, verstehen? Oder würde es den Betrachtern schließlich von selbst »aufgehen«, wenn sie nur lange genug dablieben. Im englischen Volksmund läuft dies unter »Zeit tot-schlagen«. Ein Schlüsselmoment des Werks ist deshalb die Zeit selbst – die Dauer, die dem Betrachter abverlangt wird. Echtzeit vergeht langsamer als filmische Zeit, denn da sorgen entsprechend langjähriger Konvention rasche Schnitte für eine Verdichtung von Zeit und Raum, weil die Erzählung vorangebracht werden soll. Und diese Bildsprache fand im Zuge der Entwicklung der Schnitt-Technik – beziehungsweise einer zunehmend »filmischen« Ästhetik – auch im Video Eingang.[3] Als ich die Galerie noch einmal tagsüber besuchte, war der Kunstkritiker der Tageszeitung zu Besuch, wobei gerade das Sonnenlicht die Projektion verblassen ließ, sodass nichts zu sehen war als der Raum selbst. Ich habe den Kritiker nicht befragt, konnte aber an seiner Unruhe ablesen, dass er glaubte, »es passiere nichts« – dass »keine Kunst« vorhanden sei (Geduld zählt nicht zu den Tugenden von Kriti-kern). Möglicherweise haben viele Betrachter es so erlebt. Die doppelte Ironie liegt freilich darin, dass die »Black Box« – der abgedunkelte, theatralische Raum – ebenso tückisch ist wie der sogenannte »White Cube«. Ich habe noch nie eine reine »White-Cube«-Galerie gesehen, aber schwarze Kästen werden ständig errichtet: Sie machen die neue Konvention für die Präsentation von Videos aus. Was diese eine Arbeit von Kuball betrifft, so sieht man sie sich am besten zu jener Zeit in der Galerie an, wenn »nichts passiert« – wenn die Lumenstärke des Projektors nicht gegen das Tageslicht ankommt.

how would a gallery visitor, trained to inspect art within the privileged gallery space, understand? Or would they come to "realize it" if they lingered there long enough (in Eng-lish vernacular, this is known as "killing time"). A key aspect of the work, therefore, is time itself—the duration—which is demanding of the viewer. Real time moves slower than cinematic time, where the long-standing convention is to cut for rapid edits, to com-press time and space in order to move the narrative along, and a language that has been adapted by video as the editing technology developed, or as video become more "cinema-tic."[3] I visited the gallery during the daytime, and on one occasion the art critic from the daily newspaper was there at a moment when the sunlight bleached out the projection and all that could be seen was the space itself. I did not interrogate the critic but I could see by the fidgeting that they assumed "nothing was happening"—that there was "no art." (Patience is not one of the virtues of art critics.) Perhaps this was the case for many view-ers: the double irony is that the black box—the darkened and theatrical space—is as insi-dious as the so-called white cube. I have never seen a pure white cube gallery, but black boxes are built all the time: it is the new convention of showing video. For Kuball's work, the best time to see it in the gallery is when "nothing is happening"—when the lumen level from the projector cannot compete with daylight.

Die Präsentation von Kuballs Arbeit traf sich mit dem 30-jährigen Bestehen des Insti-
tute of Modern Art, dem der Name anhängt wie ein Bleigewicht. Vor 30 Jahren bedeutete
dieser Name etwas, und wie viele auf zeitgenössische Wechselausstellungen angelegte
Galerien war auch diese Institution von einer kulturellen »Intelligentsia« als Alternative
zum – wie man empfand – wesensmäßigen Konservatismus der State Gallery gegründet wor-
den. Modern zu sein, hieß damals auch zeitgenössisch und radikal zu sein.[4] So schien es
angemessen, dass Kuballs Arbeit an die freche Radikalität der Künstleraktionen in der ersten
Dekade des Videos (1965–1975) erinnerte und doch gleichzeitig eine Grundbedingung des
Mediums zum Ausdruck brachte: und zwar die ewige Wiederkehr der Idee von Inszenierung.[5]

Über vierzig Jahre sind vergangen, seit Video zum Künstlerinstrument wurde, wozu es
1965 mit der Einführung des Sony Portapak kam. Den »mythischen Anfang« machte Nam
June Paik, der angeblich im New Yorker Hafen auf ein Frachtschiff wartete, das mit der
»neuen Technologie« einlaufen sollte: Er filmte an jenem Tag den Besuch Papst Pauls VI.
auf Video und zeigte das Band am selben Abend im Café a Go Go, womit er das »Zeitalter
der Videokunst« einläutete.[6] Es ist durchaus möglich, dass viele Künstler in aller Welt zum
selben Zeitpunkt dieselbe Idee realisierten, schließlich waren keine Regeln zu befolgen –
nur eine Gebrauchsanleitung. Der Portapak in Künstlerhänden ermöglichte die Demokrati-
sierung eines Mediums (Fernsehen), das fest im Griff von Sendeanstalten war. Von Künst-
lern gestaltete Videos waren allerdings nicht wirklich mit dem Fernsehen zu vergleichen –
ein Künstler konnte drehen, schneiden und zeigen (das heißt ausstellen und verbreiten),
ohne irgendwelche Medienmechanismen in Anspruch nehmen zu müssen. Die Definition

The presentation of Kuball's work coincided with the thirtieth anniversary of the Institute
of Modern Art, which carries the name like an albatross around its neck. It meant some-
thing thirty years before, and like many of the temporary-contemporary galleries in
Australia, founded by a cultural intelligentsia as an alternative to what was perceived as
an inherent conservatism of the State gallery. To be modern, then, also meant to be
contemporary and radical.[4] It seemed appropriate that Kuball's work invoked the
fresh radicalism of artists' actions in the first decade of video, from 1965 to 1975, yet at
the same time expressing a fundamental condition of the medium. It is an eternal return
to the idea of enactment.[5]

It has been more than forty years since the advent of video as an artist's tool with the
introduction of the Sony Portapak in 1965. The "mythic origin" begins with Nam June
Paik, who purportedly waited at the New York harbor for a cargo ship to arrive with the
"new technology": he videotaped Pope Paul VI's visit that day and showed it that evening
at the Café à Go Go, thereby ushering in the "age of video art."[6] It is entirely possible that
many artists around the world enacted the same moment-and-idea, as there were no
rules to follow—only an operating manual. The Portapak in the hands of artists offered a
democratization of a medium (television) that was held in the grip of corporations. Video
by artists, however, was not television—an artist could shoot, edit, and show (i.e., exhibit

von Video als Medium blieb deswegen entsprechend unklar, auch wenn es in der Kunst als Bewegung legitimiert war. Die kanadische Kuratorin Peggy Gale schrieb 1974: »Videokunst ist nicht homogen. Sie ist voller Widersprüche und unterschiedlicher Ansätze. Künstler haben sich dem Video wegen seiner Offenheit, seines bislang weder durch bestehende Traditionen noch durch autoritäre Kritik festgelegten Möglichkeitsspektrums zugewandt und haben dessen Funktion ihren eigenen Ausdrucksbedürfnissen angepasst.«[7] Zur gleichen Zeit schrieb der amerikanische Essayist und Videokünstler Douglas Davis: »Beim Betrachten eines Films blickt das Auge auf und zugleich weg; der Geist erlebt hilflos, wie er von sich fortgezerrt wird, in eine überlebensgroße Existenz hinein. Dem Video schenken wir jedoch unsere Aufmerksamkeit, nicht umgekehrt.«[8] Vom eskapistischen Moment der Hollywood-Filme (und des Fernsehens) einmal abgesehen, erkannte Davis eine weitere Besonderheit: »Nam June Paik hat mir einmal erzählt, wenn er sein Werk gesendet sehe, entdecke er stets mehr darin, als er hineingelegt habe.«[9] Davis setzte sich auch dafür ein, dass Video für das allgemeine Publikum ausgestrahlt und nicht wiederum als ein Objekt – als Videoband an sich – auf dem Markt verkauft werden sollte.[10]

Es traf sich, dass Portapak in einer Zeit des gesellschaftlichen Umbruchs aufkam: Es gab einen Sturmangriff auf die Bollwerke des westlichen demokratischen Konservatismus, Studentenaufstände in Europa und auf dem amerikanischen Kontinent, die amerikanische Bürgerrechtsbewegung und ihr »Guerilla«-Flügel – die Black Panthers – und Zeichen des Widerstands in den Staaten des Sowjetblocks. In dieser Zeit trat auch auf, was man als Entmaterialisierung des Kunstobjekts bezeichnen könnte: Land-Art, Interventionen und Per-

and distribute) without the need for any media mechanism. The definition of video as a medium, therefore, remained equally unclear although it was legitimized as if a movement. Canadian curator Peggy Gale wrote, in 1974: "Video Art is not homogenous. It is full of contradictions and diversities. Artists have turned to video for its openness, its range of possibilities still undefined by either established traditions or authoritative criticism, and they have adapted its function for their own expressive needs."[7] At the same time, American essayist and video artist Douglas Davis wrote, "While watching a film, the eye looks up and out; the mind is drawn helplessly away from itself, into a larger-than-life existence. We give video our attention, not the reverse."[8] Davis made a further distinction beyond the escapist aspect of Hollywood films (and television): "Nam June once told me that he always discovers more in his work when he sees it broadcast than he put into it."[9] It was Davis's contention that video had to be broadcast to a general public and not treated as yet another object—the videotape itself—to be sold in the art marketplace.[10]

Coincidentally, the Portapak appeared during a period of social upheaval, an assault on the bastions of Western democratic conservatism—student uprisings in Europe and the Americas—the American Civil Rights movement and its "guerrilla wing," the Black Panthers—and signs of resistance within the Soviet bloc of nations. The period also saw what we could be called a dematerialization of the art object, earthworks, interventions,

formance. Jede radikale Bewegung kann allerdings irgendwann ihre Widersacher haben: Der Prager Frühling Alexander Dubčeks, der »Sozialismus mit menschlichem Antlitz«, wurde im August 1968 durch eine Invasion der Staaten des Warschauer Pakts plattgewalzt; amerikanische Radikale – die sogenannten Chicago Seven – sahen sich wegen ihrer Straßendemonstrationen während des Parteitags der Demokraten vor Gericht gestellt. Die 1960er-Jahre erlebten eine Hyperinflation der Kunst, deren Warencharakter sowie Vermarktung durch Pop und die »Nachfolgebewegungen« Op-Art, Fotorealismus und so weiter.

Oft waren die frühen, von Künstlern gedrehten Videos im buchstäblichen Sinne eine Äußerung in Echtzeit von etwas Inszeniertem, erlaubte diese Technik doch länger dauernde Aufnahmen als die Standard-Filmkamera. Dauer ist ein Aspekt von Video; die Möglichkeit, den Ton mit demselben Medium aufzuzeichnen, ein weiterer (zwar war auch bei manchen Super-8-Kameras eine simultane Bild-Ton-Aufzeichnung möglich, aber eine Super-8-Kassette fasste nur 3 Minuten Film). Zeit, schrieb George Kubler, ist nicht erkennbar: »Wir erkennen Zeit nur indirekt daran, was in ihr geschieht: durch das Beobachten von Wandel und Fortdauer, durch das Registrieren der Ereignisfolge in einem festgefügten Umfeld und durch die Wahrnehmung des Kontrasts wechselnder Tempoveränderung.«[11] Wir sind uns des Vergehens von Zeit in *Stadt durch Glas* bewusst, da die Kamera durch die Stadt, durch die Zeit fährt und dabei gelegentlich einen Blick auf etwas gewährt, was wir in der endlosen Zeit der Wiedergabe als städtischen Ort wiedererkennen. Es gibt zwar einen Anfang und ein Ende, doch spielt dies kaum eine Rolle: Wir können uns jederzeit in die Sichtung einschalten, bei Tag oder bei Nacht – buchstäblich und bildlich gesprochen.

Abb. S. 248–257

and performance. Yet every radical movement at any given time can have its opposite: the Prague Spring of Alexander Dubček, "socialism with a human face," was crushed by an invasion of the Warsaw Pact nations in August 1968; American radicals—the so-called Chicago Seven—were put on trial for the street demonstrations during the 1968 Democratic Party leadership convention. The 1960s saw a hyperinflation of art, its commodification and marketing through Pop and "subsequent "movements," Op, Photorealism, etc.

Much of the early video by artists—in literal terms—was often a real-time expression of something enacted because the technology allowed for recording a longer duration than the standard movie camera. Duration is one unique aspect of video, the ability to record sound on the same medium is another. Even though some Super 8 cameras allowed for a simultaneous optical-sound recording, Super 8 cartridge could only hold three-and-a-half minutes of film. Time, as George Kubler wrote, is unknowable: "We know time only indirectly by what happens in it: by observing change and permanence; by marking the succession of events among stable stetting; and by noting the contrast of varying rates of change."[11] We are conscious of time passing in *Stadt durch Glas* as the camera passes through the city, through time … occasionally providing a glimpse of something that we recognize as urban place in the endless time of its playback. There is a beginning and an end, but it hardly matters: we can enter into the viewing at any time, day or night—literally and metaphorically.

Figs. pp. 248–257

Megazeichen (1990) entstand in einem anderen Medium, hat aber mit Kuballs Video- arbeit die Charakteristik lichterzeugender Projektion gemeinsam. Schauplatz war Düssel- dorf, verwendet und bespielt wurde der Wolkenkratzer, der die Konzernzentrale der Man- nesmann AG beherbergt. Kuball veranlasste, dass die Bürobeleuchtung abends nach Dienstschluss angeschaltet wurde und dabei ein abstrakt-geometrisches Muster bildete. Freilich heißt dies, das ohnehin Augenfällige darzulegen, denn Kuball nutzte sowohl das Potenzial der Lichter als auch die Wege zu deren Erzeugung, um so mit den einfachsten Mitteln und Kunstgriffen eine größtmögliche Wirkung zu erzielen. Das leere Gebäude bekam nachts eine signalhafte Präsenz im städtischen Umfeld, und eine doppelt ikonische dazu (wie bei der Verdoppelung der Projektion von *Stadt durch Glas*): Düsseldorf hatte 1990 keine dicht gedrängte Skyline wie Manhattan, und aus der Ferne verschwand das Gebäude selbst in der Schwärze der Nacht. Der Betrachter als Reisender durch die Stadt konnte die- ser Aktion begegnen, brauchte dabei aber nicht an Kunst zu denken, da ja nachts in der Stadt stets Lichter vorhanden sind. Für jeden Einzelnen konnte das Seherlebnis anders ausfallen, je nach Fahrtstrecke und Abendstunde, Dämmerung oder Dunkelheit. Kuball veränderte die Lichtmuster, sodass ein und demselben Betrachter im Laufe der Zeit die Unterschiede auffallen würden.

Abb. S. 166–171, 362–363

Refraction House (1994) bildete eine Umkehrung zu *Megazeichen*. Kuball baute in der Ortschaft Stommeln in einer ehemaligen Synagoge Flutlichter auf, die zu den Fenster hinausstrahlten. Wie beim Projekt *Megazeichen* wurde keine physische Veränderung vorge- nommen, doch die Flutlichter blieben rund um die Uhr an und erleuchteten sowohl die

Abb. S. 38–39, 338–339

Megazeichen (1990) was a different medium but shares the light-generating-projected characteristics of Kuball's video work. The site was in Düsseldorf, utilizing and inhabiting the skyscraper head office of Mannesmann AG. Kuball arranged for the office lights to be turned on at night, after the workday, to create a geometric-abstract pattern. Although this is to state the obvious: no other pattern could be created, as Kuball inhabited both the potential of the lights and the means by which to create it, as the simplest of means and devices for the maximum effect. The empty building at night was a beacon-like presence in the urban context and a doubled-iconic presence (as in the doubling of the *Stadt durch Glas* projection): Düsseldorf did not have Manhattan-like skyline congestion in 1990, and from a distance the building itself disappears into the blackness of night. The viewer-as- traveler through the city could come across this action yet need not think of art because there is always light in the city at night, and for each person, the experience could be dif- ferent, depending on their driving route and the time of evening, night or dawn, when viewing. Kuball altered the pattern of lights, so it is possible that the same viewer would have noticed the differences over time.

Figs. pp. 166–171, 362–363

Refraction House (1994) was a reversal of *Megazeichen*. Kuball set up floodlights inside a former synagogue, in the small town of Stommeln, directed out through the windows. Like the *Megazeichen* project, no physical change occurred but the floodlights

Figs. pp. 38–39, 338–339

Abb. S. 40–41

unmittelbare Umgebung als auch das Gebäude selbst. Fußgänger – eher als Autofahrer – konnten auf dieses »Wunder« stoßen. Im Unterschied zum *Megazeichen*-Bau hat die Stommelner Synagoge »Geschichte«, und zwar eine Glaubensgeschichte. Der Wolkenkratzer bringt hingegen »nur« seine säkulare Modernität zum Ausdruck.[12] Das Stommelner Licht erzählt uns zwar nichts über die Geschichte, aber es ist für den Betrachter und den Neugierigen »da«, auf dass dieser nachforsche und verstehe. *Urban Context* (1995–2000) umfasste eine tiefer greifende historische Recherche, die über einen Zeitraum von fünf Jahren unternommen wurde – es handelte sich um ein interdisziplinäres Gemeinschaftsprojekt mit Studenten der Universität Lüneburg und der Stadtverwaltung. Das Projekt beinhaltete die »Ausgrabung« eines Bunkers aus dem Zweiten Weltkrieg in der Lüneburger Innenstadt, nicht nur zur Sondierung dessen, was da buchstäblich unter der Hauptstraße verschüttet lag, sondern auch zur Sondierung eines verdrängten kollektiven Bewusstseins. Die verschiedenen Initiativen fanden Eingang in eine Sammelpublikation, doch im Zuge der »Zeichensetzung«, unter die Kuball die Ermittlung stellte, kam das Projekt zurück in den öffentlichen Raum. Er überspannte die Straße mit einer industriellen Brückenkonstruktion, an der lichtstarke Scheinwerfer befestigt wurden, um so die Kontur des Bunkers von oben zu beleuchten. Manfred Schneckenburger schrieb: »Mischa Kuball hat für den unterirdischen Bunker ein Konzept entwickelt, das sich jeder Fixierung im Monument entzieht. Der Diskurs der Erinnerung wird dabei ganz auf die lokale Geschichte gebracht und am authentischen Ort inszeniert. Allerdings weder als Erlebnisarchäologie noch als vage Empathie.«[13] Schneckenburger legte dem Betrachter auch die Frage »Was war da?« in den Sinn. Dass

Figs. pp. 40–41

were left on twenty-four hours a day, illuminating both the immediate surroundings and the building itself. Pedestrians—rather than drivers—would come across this "miracle." In contrast to the *Megazeichen* project, the Stommeln synagogue "has history" and a history of belief, whereas the skyscraper can "only express" its secular modernity.[12] The Stommeln light does not tells us about history, but it is "there" for the viewer and the curious to seek and understand. *Urban Context* (1995–2000) had a deeper historical research aspect that was undertaken over a five-year period—an interdisciplinary and multicollaborator undertaking with students of the university of Lüneburg and the community. The project involved the "excavation" of a Second-World-War bunker in the city of Lüneberg to examine not only what lay buried, literally, under the main street, but also a suppressed collective consciousness (memory). The various initiatives were brought together in the summary publication, but Kuball's "punctuation" to the research returned the project to the streets. He installed industrial rigging that spanned the street and were mounted with high-powered lights to illuminate the outline of the bunker from above. Manfred Schneckenburger wrote, "The bunker project is based on a concept [that] resists every attempt at memorialization … but it operates neither as hands-on archaeology nor as vague empathy."[13] Schneckenburger also posed the question for the viewer—"What used to be there?" It is not necessarily the case, as Kuball recounted an incident in con-

diese nicht unbedingt aufgeworfen wurde, daran erinnerte Kuball im Gespräch mit dem Autor am Beispiel eines Zwischenfalls. Ein »Bürger« klagte nämlich, dass die Lichter einen Autounfall ausgelöst hätten. Darin liegt einige Ironie, ist doch der Zweck einer gut beleuchteten Straße, die Sichtverhältnisse zu verbessern und sie deshalb nachts sicher zu machen.

Die Geschichte wird inszeniert durch Licht und »Erhellung« eines Orts, eines Dokuments oder einer Archivrecherche. Wo dabei die »Kunst« beginnt oder endet, ist nicht wichtig; wichtig ist, wie meistens in Kuballs Arbeit, das »Ganze« des Projekts. Werfen wir noch einmal einen Blick zurück auf die Kommentierung der frühen Videos. 1972 schrieb Patricia Sloan: »Der Aufstieg oder Fall der Videokunst wird sich daran bemessen, ob sie es wert ist oder nicht, angeschaut zu werden, und nicht daran, ob sie Kunst ist oder nicht.«[14] Dieser Gedanke zieht sich wie ein Echo durch Kuballs gesamte Arbeit. Womit nicht angedeutet werden soll, sein Anliegen sei das Wesen der Kunst selbst – was diese ist oder zu sein hat, oder wer das Recht besitzt, sie Kunst zu nennen. Vielmehr ist das Demokratische integraler Bestandteil seiner Arbeitsweise. Douglas Davis sah die demokratischen Möglichkeiten des Videos – »von Natur aus eine revolutionäre Form der Ansprache« –, wobei er jedoch einräumte, dass er als »unsystematisch mit marxistischen Ideen liebäugelnd«[15] oder als Utopist in einer Zeit des pragmatischen Pessimismus missdeutet habe werden können[16]. Wichtiger noch ist Davis' Feststellung: »Die beiden Wörter [Kunst und Politik] sind eins, untrennbar und unveräußerlich, ob wir wollen oder nicht, und sie zu ignorieren oder nachlässig zu definieren, geschieht nicht nur auf unsere eigene Gefahr, sondern auch auf die Gefahr des Kunstwerks selbst, das unvermeidlich in der Welt angesiedelt ist.«[17] Selbstver-

versation with the author. A "citizen" complained that the lights precipitated a car accident. There is irony in this because the purpose of a well-lit street is to make it more visible and therefore safe at night.

History is enacted through light and the "enlightenment" of site, document, and archival research. Where the "art" begins or ends is not important; it is the "totality" of the project, as it is with most of Kuball's work. Returning to commentary on early video, in 1972 Patricia Sloan wrote: "Video art will probably rise or fall according to whether or not it's worth looking at, not according to whether or not it is art."[14] The idea echoes through Kuball's work—and not to suggest that his concern is with the nature of art—what it is or should be—or who owns the right to call it art. The democratic aspect is intrinsic to the way he works. Douglas Davis saw the democratic possibilities of video, "by nature, a revolutionary form of address," yet acknowledged that he may have been misinterpreted as "flirting unsystematically with Marxist ideas"[15] or a Utopia in a period of pragmatic-pessimism.[16] More importantly, Davis states: "The two words [art and politics] are one, whether we like it or not, inseparable and inalienable, to be ignored or carelessly defined not merely at our personal peril, but at the peril of the work of art itself, which is sited inevitably in the world."[17] There are of course degrees of political consciousness—and not all works of art conceived through "democratic" means are equally political. It is difficult to

ständlich gibt es verschiedene Grade politischen Bewusstseins – und nicht alle mit »demokratischen« Mitteln konzipierten Kunstwerke sind gleichermaßen politisch. Ein politischer Aspekt von *Stadt durch Glas* ist schwierig zu begründen oder zu beweisen, aber dieses Werk leitet, wie auch die 3 weiteren beschriebenen Projekte, Absicht und Handeln des Künstlers zurück an deren Quelle: an die Stadt und ihre Bürger als Betrachter ihrer eigenen Lage, von der wir wiederum Zeugnis ablegen können. Davis war sich über dieses (mögliche) Dilemma ebenfalls im Klaren: »Kunst ist nicht Leben [...], sie ist eine Tätigkeit, umstellt vom Leben, auf das sie angewiesen ist.«[18]

»Citizen Kuball« – wie ich ihn genannt habe – wirkt womöglich auch als »sozialer Navigator« – entsprechend Marshall McLuhans Kommentar zur Erörterung der Rolle, die Künstler beim Einsatz neuer Technologien spielen.[19] Der Begriff ist provokativ, die Idee aber entscheidend.

»Kunst ist weder gut noch schlecht für den Menschen. Insofern glaube ich, dass jeder, der sie im Hinblick auf Erlösung betrachtet, enttäuscht sein wird.« Ad Reinhardt, 1966[20]

argue for or prove a political aspect of *Stadt durch Glas,* but it does, as with the other three projects described, return the artists' intent and action to its source—the city and citizens as viewers of their own condition, which we can bear witness to. Davis was aware of this (possible) dilemma as well: "Art is not life ... it is an activity encircled by life, upon which it depends."[18]

"Citizen Kuball"—as I have called him—may also be acting as a social navigator, a comment made by Marshall McLuhan in discussing the role artists play when using new technologies.[19] The term is provocative, but the idea is essential.

"Art is neither good or bad for people. I think at the same that that anyone who looks to it for salvation will be disappointed." Ad Reinhardt, 1966[20]

ANMERKUNGEN

1 Der Betrachter als Erfüllungsgehilfe ist eine viel zitierte Grundannahme Duchamps: »Der schöpferische Akt wird nicht allein vom Künstler vollzogen; der Betrachter bringt das Werk in Berührung mit der Außenwelt, indem er dessen verborgene Voraussetzungen deutet und damit seinen Beitrag zum schöpferischen Akt leistet.« Marcel Duchamp, »The Creative Act«. Referat in der Convention of the American Federation of the Arts, Houston, Texas, April 1957, in: *Art News*, Sommer 1957. Freilich bezog Duchamp sich noch auf Objekte – auf das »Koan«, eine Bedeutung und Existenz sowie »beitragende« Rolle zu beweisen. Wenn es jedoch kein Objekt gibt und, wie in Kuballs Werk, der Galeriekontext verlassen wird, was bringt dann die Präsenz von »Kunst« zur Existenz?

2 In musikalischen Begriffen lässt sich dies als Hi-Fi beschreiben, als ein klangtreues Monosignal im Unterschied zur Stereophonie, wo zwei verschiedene Musikspuren eine Raumwirkung erzeugen und anschließend vom Gehör zusammengeblendet werden.

3 Wie der Cutter Walter S. Murch bemerkt, enthielt *Sunset Boulevard* (1950) typisch für Filme der Zeit in den ersten 20 Minuten 85 Schnitte, *The Sixth Sense* (1999) brachte es im selben Zeitrahmen bereits auf 170 Schnitte, während *Fight Club* (ebenfalls 1999) in den letzten 20 Minuten auf 375 Schnitte kommt. Walter Murch, *In the Blink of an Eye*, 2. Aufl., Los Angeles 2001, S. 119. In der Frühzeit des Videos wurde buchstäblich »unbesehen« geschnitten, da die Magnetbänder keine mit bloßem Auge erkennbaren Informationen enthalten. Bis zum Digitalzeitalter bestand Video aus einem fortlaufenden, analogen elektrischen Signal.

4 Die Ironie der Namensgebung setzt sich fort, eröffnete doch die State Gallery in Brisbane im Dezember 2006 eine lang ersehnte Zweigstelle, die Gallery of Modern Art genannt wurde.

5 Der Ausdruck »ewige Wiederkehr« verweist sowohl auf die philosophische Frage als auch auf die wissenschaftlich-kosmologische Forschung zum Thema Zeit und Zeitpfeil.

6 Zuvor hatte Paik mit Fernsehgeräten gearbeitet, deren Kathodenstrahlröhre er mit einem auf dem Gehäuse angebrachten großen Magneten beeinflusste. Die erste Videoausrüstung für Verbraucher bot 1963 das für seine luxuriösen Weihnachtsgeschenke bekannte Warenhaus Neiman Marcus in Dallas an. Bei einem Verkaufspreis von 30.000 US-$ dürfte dieses Videosystem allerdings nur überaus Wohlhabenden zugedacht gewesen sein.

7 Peggy Gale, in: *Videoscape*, Ausst.-Kat. Art Gallery of Ontario, Toronto 1974, o.S. Die Ausstellung wurde nicht von der eigentlichen »kuratorischen«, sondern von der Öffentlichkeits- und Bildungsabteilung der Galerie organisiert.

8 Douglas Davis, »Filmgoing/Videogoing. Making Distinctions«, in: *Artculture. Essays on the Post-Modern*, New York 1977, S. 80. Erstveröffentlicht wurde der Artikel im *AFI Report* (American Film Institute), Mai 1973.

9 Ebd., S. 83.

10 Douglas Davis, »ArtPolitics. Thoughts Against the Prevailing Fantasies«, in: ebd., S. 20–21.

11 George Kubler, *The Shape of Time. Remarks on the History of Things*, New Haven 1962, S. 13.

12 Die Moderne kann aber auch dazu eingesetzt werden, eine spirituelle Funktion auszudrücken. Schlüsselbeispiele dafür sind Bauwerke wie Le Courbusiers Chapelle Notre Dame du Haut, Ronchamp (1950–54) und Douglas Cardinals St. Mary's Church, Red Deer Alberta (1968).

13 Aus: *Mischa Kuball. Urban Context*, hrsg. von Hartmut Dähnhardt und Ruth Schulenburg, Ausst.-Kat. Projektion Bunker Lüneburg, Lüneburg 2000.

14 Patricia Sloan, in: *Art and Artists,* März 1972, zit. n. Gale 1974 (wie Anm. 7), o. S.

15 Davis › »Artpolitics. Thoughts Against the Prevailing Fantasies«, in: New York 1977 (wie Anm. 8), S. 11.

16 S. ders., »Utopia. Thinking (with Ad Reinhardt) about the End of Art«, in: New York 1977 (wie Anm. 8), S. 125–149.

17 Ders., »Artpolitics«, (wie Anm. 15), S. 25.

18 Ders., »The Size of Non-Size«, in: New York 1977 (wie Anm. 8) S. 35.

19 Aus dem Film *Picnic in Space* von Marshall McLuhan und Harley Parker (1968). Regie: Bruce Bacon, elektronische Musik von Morton Subotnick, Produktion University-at-Large.

20 Zit. n. Davis, »Utopia« (wie Anm. 16), S. 125.

NOTES

1 The viewer as an agent of completion is a much-cited Duchamp assertion: "The creative act is not performed by the artist alone; the spectator brings the work in contact with the external world by deciphering and interpreting its inner qualifications and thus adds his contribution to the creative act." "The Creative Act," a paper presented to the Convention of the American Federation of the Arts, Houston, Texas, April 1957. Published in *Art News* (New York, Summer 1957). Duchamp, however, was still referring to objects—the "koan" of proving meaning and existence, and a "contributing" role. If there is no object, and outside of the gallery-as-context, as in Kuball's work, what brings the presence of "art" into existence?

2 In music terms, this can be described as hi-fi, a high fidelity monaural signal, in contrast to stereo, wherein two different music tracks create a spatial effect, then blended by the ear.

3 Film editor Walter S. Murch noted that the 1950 film *Sunset Boulevard* had eighty-five cuts in the first twenty minutes, typical for films of its time, but that *The Sixth Sense* (1999) had 170 cuts in the first twenty minutes: the *Fight Club* (also 1999) has 375 edits in the last twenty minutes. Walter Murch, *In the Blink of An Eye* (Los Angeles, 2001), p. 119. Early video editing was literally "sight unseen" as there is no visible-to-the-eye information on magnetic tape. Until the digital age, video was a continuous analogue electrical signal.

4 The irony of naming continues, as the State gallery in Brisbane opened a long-awaited second-site museum in December 2006 named the Gallery of Modern Art.

5 Eternal return invokes the philosophical question as well as science-cosmological research on the question of time, the arrow of time.

6 Prior to this Paik had worked with televisions, altering the cathode ray tube signal with a large magnet sitting on top of the cabinet. The first consumer videotape system was offered for sale by the Dallas department store Neiman Marcus, known for their luxury Christmas catalogue gifts, in 1963. The Ampex video system sold for thirty thousand US dollars. Arguably, at that price it was only intended for the very wealthy.

7 Peggy Gale, *Videoscape*, exh. cat. Art Gallery of Ontario (Toronto, 1974), n.p. The exhibition (November 20, 1974–April 1, 1975) was organized by the Education and Extension

department of the Gallery rather than the "curatorial department" proper.

8 Douglas Davis, "Filmgoing/Videogoing: Making Distinctions," *Artculture, Essays on the Post-Modern* (New York, 1977), p. 80. The article was first published in the *AFI Report* (American Film Institute) in May 1973.

9 Davis 1977 (see note 8) p. 83.

10 Douglas Davis, "ArtPolitics: Thoughts Against the Prevailing Fantasies," *Artculture, Essays on the Post-Modern* (New York, 1977), pp. 20–21.

11 George Kubler, *The Shape of Time, Remarks on the History of Things* (New Haven, 1962), p. 13.

12 Modernity can be used to express a spiritual function. The key examples are buildings such as Le Courbusier's Chapelle Notre Dame du Haut, Ronchamp (1950–54), and Douglas Cardinal's St. Mary's Church, Red Deer Alberta (1968).

13 From "Mischa Kuball—urban context," with texts by Ulrich Krempel, Manfred Schneckenburger, Dirk Stegmann, Paul Virilio, and Hartmut Dähnhard (Lüneburg, 2000).

14 From *Art and Artists* (March 1972), cited in Gale 1975 (see note 7), n.p.

15 Davis 1977 (see note 10), p. 11.

16 See Douglas Davis, "Utopia: Thinking (with Ad Reinhardt) about the End of Art," *Artculture, Essays on the Post-Modern* (New York, 1977), pp. 125–149.

17 Davis 1977 (see note 10), p. 25.

18 From Douglas Davis, "The Size of Non-Size," *Artculture, Essays on the Post-Modern* (New York, 1977), p. 35.

19 From the Marshall McLuhan and Harley Parker film *Picnic in Space* (1968). Directed by Bruce Bacon, electronic music by Morton Subotnick. A University-at-Large production.

20 Cited in Davis 1977 (see note 16), p. 125.

Tagebau – Raubbau (Detail), 1991,
1. Biennale für Landart, Cottbus
(Foto: Thomas Kläber, Cottbus),
Vgl. Abb. S. 335 / See fig. p. 335

ANHANG
APPENDIX

BIOGRAFIE | BIOGRAPHY MISCHA KUBALL

1959
Geboren in Düsseldorf, lebt in Düsseldorf

Seit 1984
Raumbezogene Projekte (siehe Ausstellungen)

Seit 1991
Lehraufträge und projektbezogene Arbeiten
an Universitäten und Kunsthochschulen
sowie illustrierte Vorträge

1990
Förderpreis Ars Viva, Kulturkreis der deut-
schen Industrie im BDI, Köln

1991
Stipendium für zeitgenössische Fotografie
der Alfried Krupp von Bohlen und Halbach
Stiftung, Essen

1993
Förderpreis Bildende Kunst des Landes
Nordrhein-Westfalen

1996
Arbeitsstipendium Kunstfonds, Bonn

1997
Arbeitsstipendium in New York der Stiftung
Kunst und Kultur NRW, Düsseldorf
Arbeitsstipendium für Brasilien und Japan
Ministerium für Familie, Stadtentwicklung
und Kultur NRW, Düsseldorf

1998
Deutscher Beitrag auf der *24. Biennale von
São Paulo*
Stipendium der Villa Massimo, Rom

1999/2000
Gastprofessur an der Hochschule für Grafik
und Buchkunst, Leipzig

2004
Vertretungsprofessur an der Hochschule für
Gestaltung, Karlsruhe, Fachbereich Medien-
kunst

Seit 2005
Professur für Medienkunst an der Hochschule
für Gestaltung, Karlsruhe

Seit 2006
Visiting Artist Tutor am Goldsmiths College,
London

1959
Born in Düsseldorf; lives in Düsseldorf,
Germany

1984–present
Spatial projects (see Exhibitions)

1991–present
Temporary lecturer at universities and art
schools; project-related work and illustrated
lectures

1990
Award and grant from Ars Viva, Kulturkreis
der deutschen Industrie im BDI, Cologne

1991
Grant for contemporary photography from
the Alfried Krupp von Bohlen und Halbach
Stiftung, Essen

1993
Award and grant for visual art from the State
of North Rhine-Westphalia

1996
Project grant from Kunstfonds, Bonn

1997
Grant for work in New York from the Stiftung
Kunst und Kultur NRW, Düsseldorf
Grant for work in Brazil and Japan
Ministry for Family Affairs, Urban Develop-
ment, and Culture in North Rhine-Westphalia,
Düsseldorf

1998
German contribution to the 24th Biennale
do São Paulo, Brazil
Grant for work at Villa Massimo, Rome, Italy

1999/2000
Visiting professor at the Hochschule für
Grafik und Buchkunst, Leipzig

2004
Visiting professor at the Hochschule für
Gestaltung, Department of Media Art,
Karlsruhe

Since 2005
Professor of Media Art at the Hochschule für
Gestaltung, Karlsruhe

Since 2006
Visiting Artist Tutor at Goldsmiths College,
London

fläche/spannung/faden /
surface/tension/thread, 1982
Draht, Karton / wire, cardboard 62 x 21 x 12 cm

fläche/spannung / surface/tension, 1982
Draht, Karton / wire, cardboard 62 x 21 x 12 cm

energie I+II / energy I+II, 1982
Karton, Collage / cardboard, collage
68 x 68 x 4 cm

Schnitt I + XVIII/83 / Cut I + XVIII/83, 1983
Collagen / collages 63 x 96 x 7 cm
Sammlung / Collection Meikel Vogt, London

Schnitt III, IV, V, VI, VII, XI, XII, XVI / Cut III, IV,
V, VI, VII, XI, XII, XVI, 1983
Collagen / collages 63 x 96 x 7 cm

Zeichnung III / Drawing III, 1983
Karton / cardboard 50 x 70 cm
Sammlung / Collection Meikel Vogt, London

Zeichnung VI / Drawing VI, 1983
Karton / cardboard 50 x 70 cm
Sammlung / Collection Martha Hentschel,
Düsseldorf

Zeichnung XI / Drawing XI, 1983
Karton / cardboard 50 x 70 cm

Bridge over Manhattan; Lattice on structure;
Construction; Park Ave. Meets Broadway;
City Sculpture – to R. Serra, 1984
5 Collagen / collages je / each 68 x 100 x 8 cm
Sammlung / Collection Alfons Mencke,
Valdemossa

Dia-Cut / Slide cut, 1984
3 Diaprojektoren, je 81 geschnittene Dias,
Esclampsteuerung / 3 slide projectors,
each with 81 cut slides, Esclamp control

space-finger, 1984
Karton, Collage / cardboard, collage
50 x 65 x 5 cm
Sammlung / Collection Luxoom, Berlin

kreis+linien 2b / circle+lines 2b, 1984
Karton, Faden / cardboard, thread
68 x 68 x 4 cm
Sammlung / Collection Thiemo Borchart,
Berlin

Körper I–VIII / Bodies I–VIII, 1986
Papier, 8 Collagen / paper, 8 collages
50 x 70 cm

Doppelprojektion auf Skulptur / Double
projection on sculpture, 1987
Diaprojektor, 81 handgeschnittene Dias,
5 schwarze Holzstäbe / slide projector,
81 hand-cut slides, 5 black wooden sticks
Privatsammlung / Private collection, Kevelaer

Mediendrama / Media drama, 1987
Diaprojektor, Fernseher, Zimmerantenne,
81 handbemalte Dias / slide projector, tele-
vision, indoor aerial, 81 hand-painted slides
ZKM | Zentrum für Kunst und Medientech-
nologie Karlsruhe

Vorläufiges Büro / Temporary Office, 1987
Schreibtisch, Diaprojektor, 81 Dias, Euro-
pallette / desk, slide projector, 81 slides,
wooden pallet

Acht Zeichen / Eight signs, 1987
Regal, 8 Holzkreuze / shelving, 8 wooden
crosses, je / each 10 x 10 cm, 8 Zeichnungen /
8 drawings je / each 21 x 30 cm

Innenraum/Umraum / Interior/surrounding
space, 1987
Holz, Papier / wood, paper 120 x 180 cm

Deutsche Bundespost Paketzustellung
Düsseldorf / German Post package delivery
Düsseldorf, 1987
Collage, Maße variabel / varying dimensions

Viele Teile und kein Ganzes / Many parts and
no whole, 1987
18-teilig / 18 parts: 9 Teile / 9 parts
21 x 30 cm, 9 Holzplatten / 9 wooden boards
50 x 90 cm

Volumen offen / Volumes open, 1987
Holz, Rupfen, Öl / wood, gunny, oil
180 x 90 x 7 cm

Volumen I–III / Volumes I–III, 1987
Holz, Rupfen, Öl / wood, gunny, oil
180 x 60 x 5 cm

Schattenräume I–III / Shadow spaces I–III,
1987
Holz, Öl / wood, oil 50 x 80 x 20 cm

Volumen Rand / Volumes edge, 1987
Holz, Rupfen, Öl / wood, gunny, oil
180 x 60 x 5 cm

Doppelvolumen I–III / Double volumes I–III,
1987
Holz, Öl / wood, oil 154 x 45 x 16 cm

Im Quadrat / In the square, 1987
Rupfen, Öl / gunny, oil 90 x 180 cm
Sammlung / Collection Meikel Vogt, London

Quadrat versetzt / Square shifted, 1987
Rupfen, Öl / gunny, oil 90 x 180 cm
Sammlung / Collection Meikel Vogt, London

Quadrat zu Quadrat / Square to square, 1987
Rupfen, Öl / gunny, oil 90 x 180 cm
Sammlung / Collection Meikel Vogt, London

Quadrat und drei Felder / Square and three
fields, 1987
Rupfen, Öl / gunny, oil 90 x 180 cm
Sammlung / Collection Meikel Vogt, London

Progression I–IV / Progression I–IV, 1988
2-teilig, Holz, Öl, Glas / 2 parts, wood, oil,
glass 170 x 20 x 20 cm
Sammlung / Collection Meikel Vogt, London

Zweifache Drehung / Twofold turn, 1988
Holz, Öl, Glas / wood, oil, glass 60 x 160 x 5 cm

Links-Rechts I–IV / Left-right I–IV, 1988
4-teiliges Wandobjekt, Holz, Öl / four-part
wall object, wood, oil 80 x 70 x 16 cm

Tor / Gate, 1988
2 Diaprojektoren, je 81 Dias, Torkonstruktion
aus Glas und Holz / 2 slide projectors,
each with 81 slides, gate made of glass and
wood 400 x 240 x 60 cm

Deutscher Pavillon I / German pavilion I,
1988/89
Diaprojektor, 81 Dias, Gehäuse aus Pressspan
/ slide projector, 81 slides, pressboard
housing 150 x 160 x 40 cm
Sammlung / Collection Gottfried Hafemann,
Wiesbaden

Deutscher Pavillon II / German pavilion II,
1988/89
Diaprojektor, 81 Dias, Gehäuse aus Press-
span / slide projector, 81 slides, pressboard
housing 150 x 160 x 40 cm

Deutscher Pavillon III + IV / German pavilion III
+ IV, 1988/89
2 Diaprojektoren, je 81 Dias, 2 Gehäuse aus
Pressspan / 2 slide projectors, each with
81 slides, 2 pressboard housings
60 x 400 x ca. 600 cm

Louder-Speaker I + II, 1992
Dispersion auf Rupfen, Keilrahmen /
dispersion paint on gunny, canvas stretchers,
je / each 220 x 120 x 5 cm
Sammlung / Collection Dr. Axel Feldkamp,
Duisburg

Deutsches Haus (sozialer Wohnungsbau) /
German house (public housing), 1989
4 Stelen: Spanplatte, Resopal / 4 steles,
chipboard, Formica, je / each 225 x 40 x 60 cm,
4 Projektoren, je 81 Dias / 4 projectors with
81 slides each
Städtische Galerie im Museum Würzburg

Erfurt 52, 1989/91
7 Tapeziertische je 296 x 50 x 73 cm, Raufaser /
7 trestle tables 296 x 60 x 73 cm, woodchip
paper »Erfurt 52«
1 Erfurt 52 trestle table in the Sammlung /
Collection Lutz Schöbe, Dessau

Magazin des 20. Jahrhunderts / 20th-century
magazine, 1989/90
Metallschrank mit 4 Schubladen, 4 Dia-
projektoren, je 81 Dias / metal filing cabinet
with 4 drawers, 4 slide projectors with
81 slides each
Sammlung / Collection Gottfried Hafemann,
Wiesbaden

Hitler's Kabinett / Hitler's cabinet, 1990
Holzkonstruktion / wooden structure, 4 Dia-
projektoren / 4 slide projectors je / each
81 35-mm Dias / slides, 40.6 x 400.7 x 400.7 cm
The Jewish Museum, New York, Purchase
Fine Arts Acquisitions Committee Fund,
2001-78a-w

Manifest, 1990/91
2 Holzcontainer, MDF, 2 Diaprojektoren,
2 Dias / 2 wooden containers, 2 slide
projectors, insgesamt / total dimensions
275 x 100 x 80 cm

Bauhaus-Los / Bauhaus lottery ticket, 1990–92
20 Tafeln / 20 panels je / each
220 x 140 x 5 cm; je / each 1 Bauhaus-Los /
1 Bauhaus lottery ticket
Sammlung / Collection Luxoom, Berlin, &
Sammlung / Collection SINO AG, Düsseldorf

Bauhaus V. Vorkurs Experiment / Bauhaus V
preparatory course experiment, 1990 Stahl,
Karton, Diaprojektor / steel, cardboard,
slide projector

Megazeichen / Megasign, 1990
Temporäre Installation am Mannesmann-
Hochhaus / temporary installation at the
Mannesmann high-rise, Düsseldorf

Kippfenster I–V / Tilt window I–V, 1990
5-teilig, je / 5 parts, each 80 x 80 x 40 cm, Holz,
Rillenglas / wood, grooved glass

Denkprinzip I / Principle of thought I, 1991
Diaprojektor, 81 Dias, Glas, Stahl, MDF,
ca. je / slide projector, 81 slides, glass, steel,
MDF, each ca. 225 x 246 x 50 cm

Denkprinzip II / Principle of thought II, 1991
Diaprojektor, 81 Dias, Glas, Stahl, MDF,
ca. je / slide projector, 81 slides, glass, steel,
MDF, each ca. 225 x 246 x 50 cm

Deutsches Haus/Reihen und Stapeln I /
German house/rows and piles I, 1990/91
2 Unikat-Fotografien, 2-teilig, MDF /
2 signature photographs, two-part, MDF,
10 x 70 x 16 cm
Sammlung / Collection Heinen, Düsseldorf

Deutsches Haus/Reihen und Stapeln II /
German house/rows and piles II, 1990/91
2 Unikat-Fotografien, 2-teilig, MDF /
2 signature photographs, two-part, MDF
10 x 70 x 16 cm
Sammlung / Collection Dr. Werner Dohmen,
Aachen

Bauhaus I/Lotterie mit einer Klanginstallation
von Heiner Goebbels / Bauhaus I/Lottery with
a sound installation by Heiner Goebbels, 1991
4 Stelen MDF je / 4 steles each
200 x 100 x 50 cm, 4 Diaprojektoren, je 81 Dias,
Audio-Tapes / 4 slide projectors with
81 slides each, audiotapes

Tagebau – Raubbau / Opencast mining –
overexploitation, 1991
Temporäre Installation für die 1. Biennale
für Landart / Temporary installation for the
1st Land Art Biennale, Cottbus
Bauwagen, 25 Kinosessel, 2 Diaprojektoren,
je 81 Dias, 1 Leinwand / jobsite trailer,
25 theater seats, 2 slide projectors with
81 slides each, 1 screen

Robbiehouse / Robbie house, 1991
Modellplan, Glas, Farbe, 16-teilig je / model,
glass, paint, 16 parts each 40 x 30 cm
Sammlung / Collection Dr. Axel Feldkamp,
Duisburg

Projektionsraum 1:1:1 / Projection space 1:1:1,
1991/92
2 Diaprojektoren, je 81 Dias / 2 slide projec-
tors with 81 slides each
Städtische Galerie im Lenbachhaus,
München / Munich

Hanauer Kollekte / Hanau offering, 1992
Temporäre Installation am Altstädter Markt
in Hanau, 12 Familien, 12 Leuchtkästen je
40 x 60 x 12 cm, 12 Negative / temporary
installation at the Altstädter Markt in Hanau,
12 families, 12 light boxes each
40 x 60 x 12 cm, 12 negatives

Ambulantes Aquarium / Itinerant aquarium,
1992
Temporäre Installation in Langenhagen,
3 Diaprojektoren, je 81 Dias, 3 Hocker,
2 x 210, Maße variabel / temporary installation
in Langenhagen, 3 slides projectors
with 81 slides each, 3 stools, 2 x 210, varying
dimensions

Weltklecks/Zustand I + II / World stain/state I
+ II, 1992
Permanente Installation im Eingangsbereich
von IBM, Düsseldorf; 8 Rubons auf trans-
parenten Eingangstüren / permanent installa-
tion in the lobby of the IBM building, Düssel-
dorf, 8 rubons on transparent entrance doors,
3 x 5 x 0,3 m

Luxpowertable, 1992
2 Leuchtkastentische / 2 light-box tables,
je / each 75 x 75 x 75 cm
Sammlung / Collection Meikel Vogt, London

Public Office, 1992
Unikat-Fotografie, Leuchtkasten auf Gerüst /
signature photograph, light box on scaffol-
ding, 3 x 5 x 0.3 m

Chicago, III, 1992/1997
Diaprojektor, 81 Dias, 100 Wassergläser,
Maße variabel / slide projector, 81 slides,
100 tumblers, varying dimensions

Kunstzentrum-Zentrumskunst / Art center-
center art, 1992
Unikat-Fotografie, Leuchtkasten / signature
photograph, light box, 220 x 80 x 20 cm

Rorschachworld I–IV, 1992
Siebdruck, Glas, Fotodiasec, / silk screen,
glass, face-mounted slide, je /
each 120 x 80 cm
Sammlung / Collection Dr. Axel Feldkamp,
Duisburg

Lichtbrücke / Light bridge, 1992
3 Diaprojektoren, je 81 Dias / 3 slide projectors with 81 slides each
Maße der Projektionen / projection dimensions: ca. 40 m, 3 x 4 m

Tagebau/Raubbau / Opencast mining/overexploitation, 1991/92
2 Diaprojektoren, je 81 Dias / 2 slide projectors with 81 slides each, 200 x 300 cm

Vorkurs/Experiment V / Preparatory course/experiment V, 1991/92
Diaprojektor, 81 Dias, 1 Stuhl, Karton / slide projector, 81 slides, 1 chair, cardboard, 70 x 250 x 70 cm

Re-projektion / Re-projection, 1992
Diaprojektor, 1 Dia / slide projector, 1 slide

Vorkurs/Resopal VI / Preparatory course/ Formica VI, 1992
4 Projektoren, je 81 Dias, 4 Resopal Muster / 4 projectors with 81 slides each, 4 Formica samples, je / each 100 x 200 x 16 cm

Apartment, 1992
4 DIN-Türen, je 90 x 200 x 20 cm, 4 Projektoren, je 81 Dias / 4 standard doors, each 200 x 90 x 20 cm, 4 projectors with 81 slides each

Repeat!, 1992
5 Stühle, 3 Diaprojektoren, Leinwand, je 81 Dias, Maße raumabhängig / 5 chairs, 3 slide projectors, screen, 81 slides each, dimensions dependent upon space

Klub / Club, 1992
4 Tische, 4 Stühle, 4 Diaprojektoren, je 81 Dias von s/w Negativen, Maße raumabhängig / 4 tables, 4 chairs, 4 slide projectors each with 81 slides of b/w negatives, dimensions dependent upon space

Gegenbilder / Counterimages, 1993
Temporäre Installation an der Dominikaner Kirche, Münster; 2 Diaprojektoren, je 81 Dias / temporary installation at the Dominican Church in Münster, 2 slide projectors with 81 slides each

Double Standard, 1993
4 Diaprojektoren, je 81 Dias / 4 slide projectors with 81 slides each

Il Duomo, 1993
2 Leuchtkästen / 2 light boxes, je / each 40 x 60 cm
Sammlung / Collection Caren & Rüdiger Czermin, Bad Homburg

Onyx Doré, 1993
Unikat-Fotografie, Leuchtkasten / signature photograph, light box, 160 x 220 x 16 cm
Zentrum für Internationale Lichtkunst, Unna

Projektionsskulptur I–II / Projection sculpture I–II, 1993
je 2 Diaprojektoren, je 2 Dias, je 2 Ständer / 2 slide projectors each, 2 slides each, 2 stands each, 120 x 40 x 40 cm

Liesegang 150 Watt, 1993
Unikat-Fotografie, Leuchtkasten / signature photograph, light box, 60 x 140 x 20 cm

Six-pack I, 1993
2 Leuchtkästen / 2 light boxes, je / each 40 x 60 x 10 cm
Sammlung / Collection Ariel Rogers – Paris, Antwerpen / Antwerp

Six-pack 1–16, 1993
16 Fotografien / 16 photographs, je / each 35 x 50 cm

Triklin I + II / Triclinium I + II, 1993
je 3 Leitern, je 3 Diaprojektoren, je 3 Dias / 3 ladders, 3 slide projectors, 3 slides each

Kunstzentrum-Zentrumskunst I–III / Art center-center art I–III, 1993
3 Unikat-Fotografien, 3 Leuchtkästen / 3 signature photographs, 3 light boxes, je / each 40 x 60 cm
Sammlung / Collection Dr. Axel Feldkamp, Duisburg

Mies-Mies I, 1993
5 Stelen à 4 Leuchtkästen, Metall / 5 steles consisting of 4 light boxes, metal, Maße / dimensions 250 x 330 x 20 cm
Sammlung / Collection Luxoom, Berlin

Mies-Mies II, 1994
Unikat-Fotografie, Leuchtkasten / signature photograph, light box 142 x 220 x 20 cm
Zentrum für Internationale Lichtkunst, Unna

Sunlights I + II, 1994
2 Leuchtkästen / 2 light boxes, 60 x 60 cm
Sammlung / Collection Andreas Grosz, Köln / Cologne

Six-pack-six/spinning space version, 1994
Diaprojektor, Leuchtkasten, Drehbühne / slide projector, light box, revolving stage

Mneme/Mneme, 1994
2 Diaprojektoren, 2 Weingläser, 2 x 81 Dias / 2 slide projectors, 2 wine glasses, 2 sets of 81 slides
Sprengel Museum Hannover

Refraction House, 1994
Temporäre Installation in der Synagoge Stommeln / temporary installation at the Stommeln synagogue, 16 x 1kW Scheinwerfer, 3 Gerüste, je 5 x 3 m / 16 1-kW spotlights, 3 scaffolds, each 5 x 3 m

Le Passage I/94 (für W. B.). Interventionen 1, 1994
Temporäre Installation im Sprengel Museum Hannover / temporary installation at the Sprengel Museum Hannover
4 Diaprojektoren, 4 Drehteller, je 81 Dias / 4 slide projectors, 81 slides each, 4 turntables

Leerstand/Peepout / Vacant/peep out, 1994
Temporäre Installation im Stadtraum von Leipzig / temporary installation in Leipzig
2 Suchscheinwerfer / 2 searchlights

Moderne, rundum II / Modern, all around II, 1994
8 Diaprojektoren, 4 Drehteller, 4 Schubladenschränke, Diamasken, je 81 Dias / 8 slide projectors, 81 slides each, 4 turntables, 4 filing cabinets, slide masks,
Sammlung / Collection Birner & Wittmann, Nürnberg / Nuremberg

Moderne, rundum. No. 5, 6, 8, 11 / Modern, all around. nos. 5, 6, 8, 11, 1994/2002
4 s/w Unikat-Fotografien / 4 b/w signature photographs, 100 x 150 cm
Museum Folkwang, Essen

Moderne, rundum. No. 13 / Modern, all around. no. 13, 1994/2002
s/w Unikat-Fotografie / b/w signature photograph, 100 x 150 cm
Sammlung / Collection Hella & Reiner Bruckhaus, Düsseldorf/Frankfurt am Main

Moderne, rundum. No. 18 / Modern, all around. no. 18, 1994/2002
s/w Unikat-Fotografie / b/w signature photograph, 100 x 150 cm
Sammlung / Collection Katrin & Dr. Barthold Albrecht, Budapest

Moderne, rundum. No. 1, 2, 3, 4, 7, 9, 10, 12, 14, 15, 16, 17 / Modern, all around. nos. 1, 2, 3, 4, 7, 9, 10, 12, 14, 15, 16, 17, 1994/2002
12 s/w Unikat-Fotografien / 12 b/w signature photographs, 100 x 150 cm

Landscapes, 1994–1997
Permanente Installation in der Deutschen Ausgleichsbank Bonn / permanent installation at the Deutsche Ausgleichsbank, Bonn
8-teilig, Spiegelglas mit Fotografie / 8 parts, mirrored glass with photograph, je / each 180 x 134 cm

Die Welt in mir/ich in der Welt / The world in me/me in the world, 1994/96
3 Projektoren, je 81 Dias, 32 Laborkittel, Stahlgerüst: Maße raumabhängig, Deckenmotor / 3 projectors with 81 slides each, 32 laboratory coats, steel scaffold, dimensions dependent on space, ceiling motor

Chamber Piece, 1995
2 Diaprojektoren, je 2 Dias, Glasplatte / 2 slide projectors with 2 slides each, glass plate

Projektion / Reflektion, 1995
Temporäre Installation in der Kunststation St. Peter in Köln / temporary installation in St. Peter Art Station, Cologne
11 x 2 kW Scheinwerfer, Stahlgerüst ca. 60 x 25 m, 11 Spiegel je ca. 250 x 80 cm / 11 2-kW spotlights, steel scaffolding ca. 60 x 23 m, 11 mirrors each ca. 250 x 80 cm

Rotierenderlichtraumhorizont / Rotatinglightspacehorizon, 1995
Temporäre Installation an der Deutzer Brücke in Köln / temporary installation at the Deutzer Bridge in Cologne
12 Diaprojektoren, 12 Drehteller, je 81 Dias / 12 slide projectors, each with 81 slides, 12 turntables

Daylight I + II, 1995
2 Leuchtkästen / 2 light boxes, je / each 260 x 160 cm
Sammlung / Collection Provinzial, Düsseldorf

Landscapes, 1995
Permanente Installation im Deutsch-Japanischen Zentrum, Hamburg / permanent installation at the German-Japanese Center, Hamburg
5 Leuchtkästen und Spiegel, je 80 x 200 x 16 cm, Leuchtkasten und Spiegel, 80 x 240 x 16 cm / 5 light boxes and mirrors, each 80 x 200 x 16 cm, light box and mirror, 80 x 240 x 16 cm

Landscapes, 1995
Permanente Installation an der Gesamthochschule Kassel / permanent installation at the Gesamthochschule Kassel
5 Leuchtkästen und Spiegel je / 5 light boxes and mirrors, each 120 x 240 x 10 cm

Landscapes/glass-view, 1995
Permanente Installation an der Dresdner Bank, Königstein im Taunus / permanent installation at the Dresdner Bank, Königstein im Taunus
Leuchtkasten / light boxes, 134 x 340 x 16 cm

Projektionsraum 1:1:1/Spinning Version / Projection space 1:1:1/Spinning version, 1995
2 Diaprojektoren, je 81 Dias, 2 Glasscheiben 50 x 50 cm, 2 Deckenmotoren / 2 slide projectors with 81 slides each, 2 glass plates 50 x 50 cm, 2 ceiling motors
Stiftung museum kunst palast, Düsseldorf

World-Rorschach/Rorschach-World, 1995
Temporäre Installation im Diözesanmuseum, Köln / temporary installation at the Diözesanmuseum, Cologne
2 Diaprojektoren, 2 Deckenmotoren, je 81 Dias, 2 Glasplatten je 50 x 50 cm, 2 Projektionsständer, 1 Parallelschalter / 2 slide projectors, 2 ceiling motors, 2 sets of 81 slides, 2 glass plates, each 50 x 50 cm, 2 projector stands, 1 parallel connection
Diözesanmuseum, Köln / Cologne

World-Rorschach/Rorschach-World, 1995
16 Unikat-Fotografien, je 70 x 50 cm / 16 signature photographs, 70 x 50 cm each
Sammlung / Collection Caren & Rüdiger Czermin, Bad Homburg

... kneten (Félix Guttari und Gilles Deleuze gewidmet) / ... kneading (dedicated to Felix Guttari and Gilles Deleuze), 1995/96
Video, 60' Loop, mit Audio / 60' video loop with sound

Stadt durch Glas/City through glass, 1995/96
2 Monitore, 2 Videos, 60' Loop, ohne Audio / 2 monitors, 2 60' video loops, silent
Sammlung / Collection Heinen, Düsseldorf

Rotoren / Rotors (Participation by Lawrence Weiner: *SOME THINGS HISTORY DONT SUPPORT* © Foto: Betsy Kaufmann, New York)
1995/96
3 Diaprojektoren, je 2 Dias, Maße raumabhängig / 3 slide projectors with 2 slides each, dimensions dependent on space
Courtesy of Lawrence Weiner & Mischa Kuball

Kaleidoscope, 1996
10 Unikat-Fotografien / 10 signature photographs, je / each 60 x 80 cm

Sprachraum/fragen / Language space/questions, 1996
1 Spiegelkugel, 1 Deckenmotor, 1 Diaprojektor, 1 Rundschablone, 1 Dia / 1 mirrored ball, 1 ceiling motor, 1 slide projector, 1 round template
Sammlung / Collection Dr. Axel Feldkamp, Duisburg

Sprachraum/twin version / Language space/twin version, 1996
2 Spiegelkugeln, 2 Deckenmotoren, 2 Diaprojektoren, 2 Rundschablonen, 2 Dias / 2 mirrored balls, 2 ceiling motors, 2 slide projectors, 2 round templates

Moderne, rundum. Vienna Version / Modern, all around. Vienna version, 1996
8 Diaprojektoren, 4 Drehteller, 4 Schubladenschränke, je 81 Dias / 8 slide projectors with 81 slides each, 4 turntables, 4 filing cabinets

Moderne, rundum I / Modern, all around I, 1996
4 Diaprojektoren, 4 Drehteller, je 81 Dias / 4 slide projectors with 81 slides each, 4 turntables

Doppelhaus I–V / Double house I–V, 1996
5 Zeichnungen, Filzstift auf Papier / 5 drawings, felt marker on paper, 68 x 97 cm
Sammlung / Collection Caren & Rüdiger Czermin, Bad Homburg

Kodak 2050, 1996
Aluminiumguss / aluminum cast, 40 x 40 x 10 cm
Konrad Fischer Galerie, Düsseldorf

In Alphabetical Order, 1997
Temporäre Installation an der Hausfassade des Museums Boijmans van Beuningen, Rotterdam / temporary installation on the facade of the Boijmans van Beuningen Museum, Rotterdam
35 Buchstaben, 2 Videomonitore im Schaufenster / 35 letters, 2 video monitors in display window

Sprachraum/Prisma / Language space/prism, 1997
10 s/w Unikat-Fotografien / 10 b/w signature photographs, je / each 50 x 70 cm

Urban light I + II/Orlando, 1997
2 Unikat-Fotografien / 2 signature photographs, je / each 30 x 40 cm
Sammlung / Collection Simone & Ingo Meyer-Berhorn, Meerbusch

Urban Lights: New Orleans, 1997
4 Unikat-Fotografien, 4 Diasec /
4 signature photographs, 4 slide masks,
je / each 100 x 150 cm
WGZ-Bank, Düsseldorf

Urban Screen I / Vaihingen-Villingen, 1997/2003
Unikat-Fotografie, 90 x 220 cm Sammlung /
Collection Anja & Ingo Hillen, Mönchengladbach

Urban Screen I / Mülheim-Kärlich, 1998/2003
Unikat-Fotografie, 150 x 100 cm Sammlung /
Collection Anja & Ingo Hillen, Mönchengladbach

Urban Screen II / Mülheim-Kärlich, 1998/2003
Unikat-Fotografie, 150 x 100 cm Sammlung /
Collection Dr. Guido Schoenherr, Düsseldorf

space – speech – speed, 1998
3 Spiegelkugeln, 3 Projektoren, 2 Deckenrotoren, 3 Dias / 3 mirrored balls, 3 projectors, 2 ceiling rotors, 3 slides
Zentrum für Internationale Lichtkunst, Unna

Raumspiegel / Space mirror, 1997
Permanente Installation für RWE-Konzernzentrale, Essen / permanent installation
at the RWE headquarters, Essen
4 Monitore, 5 Spiegelkugeln / 4 monitors,
5 mirrored balls, je / each Ø 43 cm

Lichtverbindung / Light connection, 1998
Temporäre Installation am Herrenhäuser
Turm, Hannover / temporary installation
at the Herrenhäuser Turm, Hanover
Diaprojektor, 81 Dias / slide projector,
81 slides

Project Rooms / Kabinett für aktuelle Kunst,
1998
Temporäre Installation im Kabinett für
aktuelle Kunst, Bremerhaven / temporary
installation at the Kabinett für aktuelle Kunst,
Bremerhaven
2 Diaprojektoren, je 81 Dias, 2 Drehscheiben /
2 slide projectors, 2 sets of 81 slides,
2 rotary disks

Public Alphabet, 1998
Video, ca. 12' Loop, mit Audio / ca. 12' video
loop with sound
Edition 1/3 Kunstsammlungen der /
Art Collections of the Ruhr-Universität
Bochum

Private Light/Public Light, 1998
Temporäre Installation auf der *24. Biennale
São Paulo* / temporary installation at the
24th São Paulo Biennale
72 Standardleuchten / 72 standard lamps

Urban Lights/São Paulo, 1998
8 Fotografien / 8 photographs, 120 x 80 cm

Buchstabenfresser / Letter eater, 1998
Video, 12 min Loop, mit Audio / 12' video loop
with sound

Kaleidoscope, 1998
Video, 12' Loop, mit Audio / 12' video loop
with sound

Private Light/Public Light, 1998/2000
72 Unikat-Fotografien / 72 signature
photographs, 50 x 70 cm

material/immaterial, 1999
2 Spiegelkugeln, 2 Deckenmotoren, 2 Diaprojektoren, 2 Rundschablonen, 2 Dias /
2 mirrored balls, 2 ceiling motors, 2 slide
projectors, 2 round templates, 2 slides

Seven Virtues, 1999
7 Spiegelkugeln, 7 Dias, 7 Projektoren,
7 Deckenmotoren, 7 Vario-Objektive /
7 mirrored balls, 7 slides, 7 projectors,
7 ceiling motors, 7 vario lenses
Diözesanmuseum Freising

*Durch das große Glas / Through the
great glass*, 1999
Spiegelschrank / mirror-door wardrobe,
220 x 160 cm, monitor, 25' loop

Greenlight, 1999
Temporäre Installation im Stadtraum von
Montevideo / temporary installation in
Montevideo
ca. 30 Standard-Baulampen mit grünen
Glühlampen / ca. 30 standard building lamps
with green bulbs

Fischer's Loop, 1999
2-teiliges Modell der Galerie, je
35 x 95 x 105 cm, 2 TV-Monitore, 2 VHS-Player,
2 Tapes, je 30' mit Ton / two-part model of
the gallery, each 35 x 95 x 105 cm, 2 TV monitors, 2 VHS players, 2 tapes, each 30' with
sound

*Projektionsraum 1:1:1. Farbraum / Projection
space 1:1:1. Color space*, 1999
2 Projektoren, je 81 Dias, 2 Farbplatten
50 x 50 cm, 2 Deckenmotoren / 2 projectors
with 81 slides each, 2 color plates 50 x 50 cm,
2 ceiling motors
Folkwang Museum, Essen

Chick Lights/Tri-star, 1999
Leuchtkasten / light box 160 x 120 cm,
Fotografie auf Diasec / face-mounted photograph 220 x 160 cm
Sammlung/Collection Helge Achenbach,
Düsseldorf

Oval Light, 1999
Permanente Installation für die Fortbildungsakademie Mont-Cenis, Herne / permanent
installation at the Fortbildungsakademie
Mont-Cenis, Herne
41 Lichtmasten von je 2,20 m bis 17,50 m
Höhe / 41 light masts, each ranging from
2.20 to 17.50 m in height

Stadt durch Glas / City through glass, 1999
6 Unikatfotos mit 6 Kristallspiegeln /
6 signature photographs with 6 crystal
mirrors, 150 x 100 x 5 cm
Sammlung Neurochirurgische Klinik /
Collection Neurosurgical Clinic, Krefeld

*Stadt durch Glas/Night Version NY /
City through glass/Night version NY*, 1999
2 Video-Beamer auf Ausstellungswände,
Projektionsgröße ca. 6 x 18 m, Videoplayer,
Parallelschaltung, Video 60' Loop, ohne
Audio / 2 video projectors on exhibition walls,
projection dimension ca. 6 x 18 m, video
player, parallel connection, 60' video loop,
silent
Edition 1/3 Kunstmuseum Bonn

Red Line, 1999
Video, ca. 30', mit Audio / video, ca. 30',
with sound

393

Gegenlicht / Counterlight, 1999, seit 2000
Antikino tituliert / title changed to *Anticinema*
in 2000
Video 8' Loop, mit Audio / 8' video loop
with sound
1/3 Sammlung / Collection Ursula & Alwin
Lahl, Wiesbaden

Gegenlicht I–III / Counterlight I–III, 1999
3 Unikat-Fotografien, 3 Diasec /
3 signature photographs, 3 face mounts,
je / each 75 x 75 cm
Sammlung / Collection Ursula and Alwin
Lahl, Wiesbaden

Urban light/Leverkusen, 1999
Transparent-Fotografie, Leuchtkasten /
transparent photograph, light box 120 x 160 cm
1/2 Sammlung / Collection Simone &
Ingo Meyer-Berhorn, Meerbusch
& 2/2 Sammlung / Collection Susanne &
Thorsten Nolting, Düsseldorf

*Four flashes – history strikes back
(Chicago/Caen)*, 1999
Fotocollage auf Papier, Original zur Edition
Kunstverein Düsseldorf / photo collage
on paper, original for the Edition Kunstverein
Düsseldorf 19.9 x 35.9 cm on 42 x 59.5 cm
Sammlung / Collection Susanne & Thorsten
Nolting, Düsseldorf

Codes (outdoor), 1999
Temporäre Installation am / temporary
installation at the Museum of Installation,
London
2 Diaprojektoren, je 81 Dias mit Buchstaben /
2 slide projectors, 2 sets of 81 slides with
letters

Power of Codes, 1999
Temporäre Installation im Tokyo National
Museum / temporary installation at the Tokyo
National Museum
6 Diaprojektoren, 6 Drehbühnen, je 81 Dias /
6 slide projectors with 81 slides each,
6 revolving stages

Kompressor / Compressor, 1999
Installiert im Museum für Gegenwartskunst
Siegen / installed in the Museum für Gegen-
wartskunst Siegen
2 Diaprojektoren, je 81 Dias, 4 Glasscheiben,
Maße variabel / 2 slide projectors with
81 slides each, 4 glass plates, varying dimen-
sions
Courtesy of the Sammlung / Collection
Rheingold

Tangential Orange, 1999/2000
Temporäre Installation im Stadtraum von
München / temporary installation in Munich
LED-Leuchtstoffröhre / LED light tubes,
290 m

SIX-PACK-SIX, 2000
Temporäre Installation im RWE-Turm /
temporary installation in the RWE tower
6 einzelne Aluminium-Abgüsse mit 6 Spiegel-
flächen je 40 x 200 cm, 13 s/w, transparente
Fotofolien auf Plexiglas in Alurahmen-
Konstruktion / 6 individual aluminum casts
with 6 mirrored surfaces each 40 x 200 cm,
13 b/w transparent photographs on Plexiglas
in aluminum frame construction,
180 x 240 cm

Horizontal Parallel Structure, 2000
Temporäre Installation an der Fondation
Beyeler, Riehen/Basel / temporary installa-
tion at Fondation Beyeler, Riehen/Basel
2 LED-Leuchtstoffröhren in Orange /
2 orange LED light tubes, 150 m, 60 m

Transformation No. 1, 2000
Temporäre Installation am Gebäude der
Adamsbräu in Innsbruck / temporary installa-
tion on the Adams Brewery building in
Innsbruck
3 Diaprojektoren, je 81 Dias / 3 slide projec-
tors, 3 sets of 81 slides each

(Double-)light-rail, 2000
Temporäre Installation im Stadtraum von
Innsbruck / temporary installation in
Innsbruck
2 Lichterketten / 2 chains of lights,
je / each 150 m

Urban Light I & II, 2000
2 Leuchtkästen / 2 light boxes 160 x 80 cm
Stadtwerke Lüdenscheid

Urban Light Box, 2000
2 Leuchtkästen / 2 light boxes, 80 x 200 x 16 cm
Sammlung / Collection Deutsche Ausgleichs-
bank, Berlin

Red Gate, 2000
Temporäre Installation an der Galerie
Beyeler, Basel / temporary installation at
the Galerie Beyeler, Basel
2 LED-Leuchtstoffröhren / 2 LED light tubes,
je ca. / each ca. 120 m

Urban Context, 2000
Temporäre Installation im Stadtraum
von Lüneburg / temporary installation in
Lüneburg
Stahlgerüst ca. / steel scaffold ca. 5 x 30 m,
11 x 2 kW Scheinwerfer / 11 2-kW spotlights

Schleudertrauma / Sling of Memory, 2000
Temporäre Installation im Kunstverein Ruhr,
ehemalige Synagoge in Essen / temporary
installation in former synagogue in Essen
2 Beamer, 2 DVDs, 8' Loop, mit Audio /
2 projectors, 2 DVDs, 8' loop with sound
Sparkasse Essen

Schleudertrauma / Sling of Memory, 2000
7 Unikat-Fotografien, je 80 x 120 cm /
7 signature photograph, 80 x 120 cm each
Sparkasse Essen

Public Stage, 2000
Temporäre Installation im Stadtraum von
Halle / temporary installation in Halle
Bühne / stage 500 x 400 x 50 cm, Banderole /
banderole, 5 kW Scheinwerfer / spotlight,
Gerüst / scaffolding 500 x 600 x 300 cm

Paracities, 2000
2 Diaprojektoren, je 81 Dias, 2 halbe Spiegel-
kugeln, Glasscherben / 2 slide projectors
with 81 slides each, 2 halves of 2 mirrored
balls, glass shards

Transformator / Transformer, 2000
6 Diaprojektoren, 6 Drehbühnen mit Schleif-
kontakt / 6 slide projectors, 6 revolving stages
with sliding contact

Red Index, 2000/01
Temporäre Installation im Stadtraum von
Potsdam / temporary installation in Potsdam
2 Neonröhren / 2 neon lights, je / each 30 m

Light-over, 2000
2 Diaprojektoren, je 81 Dias, 2 Drehbühnen /
2 slide projectors with 81 slides each,
2 revolving stages

Chicago Sling, 2000
Video, 30' Loop, mit Audio, 3er-Edition /
30' video loop with sound, edition of 3

Metasigns, 2000/01
Permanente Installation am Holzmarkt
in Jena / permanent installation at the
Holzmarkt in Jena
11 Hindernisfeuer-Leuchten / 11 obstruction
lights, Bodenkreis / bottom Ø 18 m,
Dachkreis / top Ø 90 m

Ein Fenster / A window, 2000/01
Temporäre Installation in der Johanneskirche
/ temporary installation at St. John's Church,
Düsseldorf
Stahl, Glas / steel, glass 4.50 x 9.50 m,
3 x 32 Felder, die 3-mal ausgewechselt
wurden / 3 sets of 32 fields that were
changed 3 times

Souvenir for Belgrade/Dysfunctional Places/
Displaced Functionalities, 2001
Performance im Stadtraum von Belgrad /
performance in Belgrade
200 bedruckte Teller / 200 printed plates
Ø 30 cm

LightSluice, 2001
Temporäre Installation für die Ausstellung /
temporary installation for the exhibition
Milano Europa 2000, Mailand / Milan
Stahlgerüst / steel scaffold,
400 x 800 x 500 cm, 5 x 1 kW Scheinwerfer,
2 Beamer, 2 DVDs, Video 8' Loop, mit Audio /
5 1-kW spotlights, 2 projectors, 2 DVDs,
8' video loop with sound

Yellow Marker (Ostpol und Westpol), 2001
Permanente Installation an Fördertürmen /
permanent installation at the shaft towers in
Kamp-Lintfort and Bönen
2 je 87 m lange LEDs, 2 je 124 m lange LEDs /
2 87-m-long LEDs, 2 124-m-long LEDs

M 4,50 Distanz zur Quelle / M 4.50 distance
to the source, 2001
Holz, 40 Watt Glühlampe, Kabel / wood,
40-W bulb, cable
Schenkung des Künstlers an das Museum
der Stadt Lüdenscheid / Gift of the artist to
the Museum of the City of Lüdenscheid

Ohne Titel / Untitled, 2002
Leuchtkasten, C-Print auf Diasec transparent /
light box, face-mounted C-print, transparent,
180 x 270 cm
WGZ Bank, Düsseldorf

Ohne Titel / Untitled, 2002
Permanente Installation im Parkhaus der /
permanent installation in the parking garage
of the WGZ Bank Düsseldorf
4 Leuchtkästen, 4 C-Prints auf Diasec trans-
parent / 4 light boxes, 4 face-mounted
C-prints, transparent, je / each 150 x 560 cm

Public Eye I + II, 2002
Permanente Installation am / permanent
installation at the Kunstmuseum Bonn
2 Videostills, Digitaldruck auf Autoplane /
2 video stills, digital print on tarpulin, je /
each 5 x 5 x 1 m, 2 Dia-Leuchtkästen /
2 slide light boxes
Kunstmuseum Bonn

Broca'sches Areal / Broca's area, 2002
3 Diaprojektoren, 3 Timer, 3 Drehbühnen,
3 x 81 Dias, 2 verspiegelte Kuben
70 x 70 x 70 cm, verspiegeltes Pentagon
120 x 120 x 40 cm / 3 slide projectors, 3 timers,
3 revolving stages, 3 sets of 81 slides,
2 mirrored cubes 70 x 70 x 70 cm, mirrored
pentagon 120 x 120 x 40 cm
ZKM | Zentrum für Kunst und Medientech-
nologie Karlsruhe

Mies-Mies V, 1992/2002
Unikat-Fotografie, Leuchtkasten / signature
photograph, light box 80 x 120 x 16 cm
Sammlung / Collection Dr. Axel Feldkamp,
Duisburg0000

Public Alphabet, 1998/2002
26 Fotoprints, 3 Rahmen / 26 photographic
prints, 3 frames, je / each 30 x 150 cm;
Sammlung des Landes Nordrhein-Westfalen /
Collection of the State of North Rhine-West-
phalia, Düsseldorf

Broca'sches Areal/Collage / Broca's area/
collage, 2002
Collage aus 26 DIN A5 Fotos / collage of
26 DIN A5 photographs 90 x 110 cm
Sammlung / Collection Simone Backhauß &
Dr. Axel Feldkamp, Duisburg

Cargo III, 2002
Temporäre Installation in der / temporary
installation in the Baggage Hall in Amster-
dam
11 x 1 kw Scheinwerfer / 11 1-kW spotlights

Public Catharsis, 2002
Temporäre Installation im Stadtraum von
Kopenhagen / temporary installation in
Copenhagen
Bühne, roter Teppich, Gerüst, Webcam,
7 Scheinwerfer / stage, red carpet, scaffold,
Webcam, 7 spotlights

NetLight, 2002/03
Permanente Installation im Stadtraum und
im Foyer der Oper von Erfurt / permanent
installation in Erfurt and in the foyer of the
Erfurt opera house
4 Stahlmasten à 10 m Höhe / 4 steel masts
each 10 meters high, Ø 10 cm, 4 LED Licht-
linien je 3 m / 4 lines of LED lights, each 3 m

Black Square/Speed Suprematism, 2003
Video, ca. 30' Loop, ohne Audio / ca. 30' video
loop, silent

Utopie/Black Square 2001 ff. / Utopia/Black
square 2001 ff., 2003
107 Fotografien / 107 photographs 21 x 21 cm,
7 Fotografien / 7 photographs 1 x 1 m
Kunstsammlungen der / Art Collections of
the Ruhr-Universität Bochum

Darkroom, 2003
Temporäre Installation im Stadtraum von
Lüdenscheid / temporary installation in
Lüdenscheid
6 Theater-Scheinwerfer, 1 rote Lichtquelle,
Bewegungssensor / 6 theatrical spotlights,
1 source of red light, motion sensor

KUNSTSAMMLUNGENDERRUHRUNIVERSITÄT-
BOCHUM, 2003
Permanente Installation an den Kunstsamm-
lungen der Ruhr-Universität Bochum /
permanent installation at the Kunstsamm-
lungen der Ruhr-Universität Bochum
37 weiße Neonbuchstaben, Versalhöhe
1000 mm, auf 65 m Breite installiert, Zufalls-
steuerung DMX-Programierung / 37 white
neon capital letters, 1000 mm high, installed
over a width of 65 m, random control DMX
programming

Stadt durch Glas/Moskau – Düsseldorf –
Moskau / City through glass/Moscow – Düssel-
dorf – Moscow, 2003
2 Beamer, DVD-Player, DVDs, 60' Loop,
ohne Audio / 2 projectors, DVD player, DVDs,
60' loop, silent
Edition 1/3 Kunstsammlung NRW, Düsseldorf

Lucky Numbers, 2003/2004
3 Projektoren, 3 x 81 Dias, 3 Drehbühnen,
3 schwarze Plexiglaskuben 70 x 70 x 70 cm,
3 transparente Plexiglaskuben / 3 projectors,
3 sets of 81 slides, 3 revolving stages, 3 black
Plexiglas cubes 70 x 70 x 70 cm, 3 transparent
Plexiglas cubes 70 x 70 x 70 cm

Metaphases, 2004
Diaprojektor, 81 Dias, Vergrößerungsschirm
60 x 120 cm / slide projector, 81 slides,
magnifying screen

Lichtbrücke / Lightbridge, in Kooperation mit /
in cooperation with Riken Yamamoto and
Beda Faessler, 2004
Temporäre Installation an der Friedrichs-
brücke in Berlin / temporary installation on
the Friedrichs Bridge in Berlin
Xenonprojektion / Xenon projection

KantParkStage, 2004, mit einer Klanginstalla-
tion von Kunsu Shim und Gerhard Stäbler,
temporäre Installation im Kant Park des
Wilhelm Lehmbruck Museums, Duisburg /
with a sound installation by Kunsu Shim and
Gerhard Stäbler, temporary installation in
the Kant Park of the Wilhelm Lehmbruck
Museum, Duisburg
4 Scheinwerfer / 4 spotlights

Four Light Walls for Weitmar, 2004
Video, 25' Loop, mit Audio / 25' video loop
with sound

Urban Scans – Public Blend I + II, 2004
Temporäre Installation im Stadtraum von
München / temporary installation in Munich
12 durchsichtige Gehäuse, transparente
Folie, Stahl je 220 x Ø 100 cm, 12 Lampen aus
privaten Haushalten / 12 transparent hou-
sings, transparent film, steel, each 220 x
Ø 100 cm, 12 lamps from private households

Reflektor / Reflector, 2004
Temporäre Installation auf einer privaten
Dachterrasse in Köln / temporary installation
on a private roof garden in Cologne
Verkehrsspiegel / traffic mirror

Public Entrance, 2004/06
Temporäre Installation für die *Art Cologne
2004* und ZKM | Museum für Neue Kunst
Karlsruhe / temporary installation for *Art
Cologne 2004* and ZKM | Museum für Neue
Kunst Karlsruhe, 2006
Roter Teppich / red carpet 150 x 4 m;
10 kopfgesteuerte Lampen, DMX-Programm /
10 head-controlled lights, DMX program
Courtesy of ZKM | Zentrum für Kunst und
Medientechnologie Karlsruhe, and 235 media
Köln / Cologne

City thru Glass/Tokyo Day & Night, 2005
7 Beamer, 7 DVD-Player, 7 DVDs, 60' Loop,
ohne Audio / 7 projectors, 7 DVD players,
7 DVDs, 60' loop, silent

*Stadt durch Glas/Düsseldorf / City through
glass/Düsseldorf,* 2005
Printouts, 220 x 80 x 5 cm
Sammlung / Collection Christina &
Philipp Arnold, Düsseldorf

*Stadt durch Glas/New York Day + Night /
City through glass/New York day + night,* 2005
Printouts, 220 x 80 x 5 cm

*Stadt durch Glas/Moskau Day + Night /
City through glass/Moscow day + night,* 2005
Printouts, 220 x 80 x 5 cm

Urban Light Toronto I + II, 2005
Permanente Installation im Eingangsbereich
der Douglas Holding AG Hagen / permanent
installation in the entrance of Douglas
Holding AG, Hagen
2 Leuchtkästen / 2 light boxes,
je / each 340 x 120 cm

FlashPlanet, 2005
Temporäre Installation im Institute of
Modern Art, Brisbane / temporary installation
at the Institute of Modern Art, Brisbane
4 runde Papierlampen, 4 Stroboskop-
Lampen, 4 Diaprojektoren, je 81 Dias /
4 round paper lampshades, 4 stroboscopes,
4 slide projectors with 81 slides each

Crosses, 2005
Permanente Installation in der Johannes-
kirche in Freising / permanent installation
at St. John's Church, Freising
LED-Blitzprojektion / LED flash projection,
250 x 250 cm

UNIVERSITÄTSBIBLIOTHEKBOCHUM, 2005
Permanente Installation an der Universitäts-
bibliothek der Ruhr-Universität, Bochum /
permanent installation at the university
library of the Ruhr University, Bochum
28 weiße Neonbuchstaben, Versalhöhe
1000 mm, auf 65 m Breite installiert, Zufalls-
steuerung DMX-Programmierung FS / 28 white
neon capital letters, 1000 mm high, installed
over a width of 65 m, random control DMX
programming
Kunstsammlungen der / Art Collections of
the Ruhr-Universität Bochum

Pont lumière, in Kooperation mit Riken Yama-
moto und Beda Faessler / in cooperation
with Riken Yamamoto and Beda Faessler,
2005
Temporäre Installation im Stadtraum von
Genf / temporary installation in Geneva;
Beamer, DVD, Programm / DVD projector,
DVD, program

*Bridge over Manhattan; Lattice on structure;
Construction; Park Ave. Meets Broadway;
City Sculpture – to R. Serra,* 1984/2005
5 Unikat-Fotografien / 5 signature photo-
graphs, je / each 68 x 100 x 8 cm
Sammlung / Collection Hanno Haniel,
Köln / Cologne

Stage II, 2005
Video, 18' Loop, ohne Audio, schwarze
Plexiglas-Maske für den Monitor / 18' video
loop, silent, black Plexiglas mask for the
monitor, 40 x 30 x 80 cm

FlashBoxOldenburg, 2005
Temporäre Installation im Edith-Ruß-Haus
für Medienkunst, im Oldenburger Kunstverein
und in der Oldenburger Innenstadt / tempo-
rary installation in the Edith Russ House
for Media Art, the Oldenburg Kunstverein,
and downtown Oldenburg
Ca. 60 Stroboskop-Lampen, 2000 m² Alumi-
niumfolie / ca. 60 stroboscopes, 2000 m²
aluminum foil

Lichtprojekt am/im Hochhaus der Schwei-
zer National / Light project on/in the
Schweizer National high-rise, 2006
Permanente Installation / permanent
installation, Frankfurt am Main
5 umlaufende LED-Lichtlinien je 160 m sowie
5 LED-Linien im Innenraum, Gesamtlänge
ca. 120 m / 5 continuous lines of LED lights,
each 160 m, 5 LED lines in the interior,
entire length ca. 120 m

Pacemaker, 2006 ff.
Permanente Installation im Außenraum der
Stadtwerke Düsseldorf / permanent installa-
tion outside the Stadtwerke Düsseldorf
Lichtstele 12 m, 17 Scheinwerfer, Timer/
Programmierung / light stele 12 m,
17 spotlights, timer/programming

WERKVERZEICHNIS | LIST OF WORKS

Silver Tunnel, 2006
Temporäre Installation in einem Tunnel
im Riverside Park, Manhattan/New York /
Temporary installation in a tunnel in
Riverside Park, New York
1200 m² reflektierende Aluminiumfolie,
4 x 500-Watt-Leuchten / 1200 m² reflecting
aluminum foil, 4 500-W lights

*Zwei Abendräume für Köln / Two evening
spaces for Cologne*, 2006
Temporäre Installation in/an St. Peter,
in/an St. Cäcilien, Köln; 6 Diaprojektoren,
je 1 Paper-Cut-Dia, 6 Drehbühnen, 2 Strobo-
skop-Lichter / temporary installation in/at
St. Peter, in/at St. Cecilia's, Cologne; 6 slide
projectors with 1 paper-cut slide each,
6 revolving stages, 2 stroboscopes

Numbers, 2006
DVD, 8' Loop, mit Audio, 3er-Edition /
8' loop with sound, edition of 3

Numbers/Digits, 2006
Unikat-Fotografie, Diasec / face-mounted
signature photograph, 180 x 60 cm
2/12 SINO AG, Düsseldorf

Flash-Bridge-Flash, 2006
Temporäre Installation an einer Brücke in
Luxemburg, ca. 250 Glühlampen / temporary
installation on a bridge in Luxembourg,
ca. 250 lightbulbs, DMX Programm /
program

Editionen | Editions

Megazeichen / Megasigns, 1991
5 Unikat-Fotografien, 5 Leuchtkästen /
5 signature photographs, 5 light boxes
40 x 60 cm
Datiert, nummeriert und signiert, Auflage:
4 (+ AP) / dated, numbered, and signed,
edition of 4, plus artist's print
Herausgeber / published by: Mischa Kuball
Sammlung / Collection Dr. Axel Feldkamp,
Duisburg, Sammlung / Collection Hiltrud
Neumann, Mönchengladbach, and Sammlung /
Collection Dr. Werner Dohmen, Aachen

Denkprinzip / Principle of thought, 1993
Objektkasten / object box, 30 x 21 cm
Datiert, nummeriert und signiert, Auflage:
10 (+ 2 AP) / dated, numbered, and signed,
edition of 10, plus 2 artist's prints
Herausgeber / published by: Kunstverein
Düsseldorf

Kaleidoscope, 1998
Fotoprint / photo print, 120 x 80 cm
Datiert, nummeriert und signiert, Auflage:
20 / dated, numbered, signed, edition of
20
Herausgeber / published by: Kölnischer
Kunstverein

*Four flashes – history strikes back
(Chicago/Caen)*, 1999
Fotocollage auf Papier / photo collage on
paper, 19.9 x 35.9 cm on 42 x 59.5 cm
Datiert, nummeriert und signiert, Auflage: 11 /
dated, numbered, and signed, edition of 11
Herausgeber / published by: Kunstverein
Düsseldorf

*Utopie/Black Square 2001ff. / Utopia/Black
square 2001ff.*, 2003
Fotografie auf Aludibond, 50 x 50 cm, Datiert,
nummeriert und signiert, Auflage: 20 /
numbered on the back, signed, and dated,
edition of 20
Herausgeber / published by: Halle für Kunst,
Lüneburg

FlashBoxOldenburg, 2005
Fotoprint auf Aluminium / print mounted
on aluminum, 42 x 59.4 cm
Datiert, nummeriert und signiert, Auflage:
20 / dated, numbered, and signed, edition
of 20
Herausgeber / published by: Kunstverein
Oldenburg

Licht und Luft / Light and air, 2006
Fotografie auf Aludibond / photograph
mounted on aluminum dibond, 22.5 x 50 cm
Datiert, nummeriert und signiert, Auflage: 10
(+2 AP) / dated, numbered, signed, edition
of 10, plus 2 artist's prints)
Herausgeber / published by: Kunstverein
Bonn

Künstlerbücher | Artist's Books

Mischa Kuball, *Todesfuge. Paul Celan /
Death fuge. Paul Celan*, Originalschnitte /
original cuts, Kaldewey Press New York, 1984

Mischa Kuball, *Leipzig!*, s/w Originalfotos,
Originalstanzen / b/w original photographs,
original stencils, Mönchengladbach, 1999

Mischa Kuball, *Paul Celan. Sand aus den
Urnen / Paul Celan. Sand from the urns*
Originalzeichnungen und »Braille«-Schrift /
original drawings and text in Braille,
Kaldewey Press New York, 2004

BIBLIOGRAFIE | BIBLIOGRAPHY

**Monografien und Kataloge zu Einzelaus-
stellungen von Mischa Kuball | Monographs
and Catalogues of Solo Exhibitions by
Mischa Kuball**

Mischa Kuball. Zwei Abendräume für Köln, hrsg.
von/ed. Friedhelm Mennekes SJ, Ausst.-
Kat./exh. cat. Kunststation St. Peter/Schnüt-
genmuseum St. Cäcilien Köln, Köln/Cologne
2007

*Mischa Kuball. … in progress. Projekte/Projects
1980–2007*, hrsg. von/ed. Florian Matzner, Ost-
fildern 2007

kuball@sino, hrsg. von/eds. Ingo Hillen &
Matthias Hocke, Ausst.-Kat./exh. cat. SINO AG
Düsseldorf, Düsseldorf 2007

Mischa Kuball. Public Blend, hrsg. von/ed.
Rüdiger Belter, Ausst.-Kat./exh. cat. Kunstraum
München, München/Munich 2006 (German/
English)

Mischa Kuball. Flash Planet 2005, Ausst.-Kat./
exh. cat. Institute of Modern Art, Brisbane,
Brisbane 2005 (English)

FlashBoxOldenburg. Mischa Kuball, Ausst.-
Kat./exh. cat. Oldenburger Kunstverein &
Edith-Ruß-Haus für Medienkunst, Oldenburg,
Oldenburg 2005

Mischa Kuball. Utopie/Black Square 2001ff.,
hrsg. von/ed. Kai-Uwe Hemken & Monika
Steinhauser, Ausst.-Kat./exh. cat. für das/
for the Kunstgeschichtliche Institut der Ruhr-
Universität Bochum, Frankfurt 2004
(German/English)

*Mischa Kuball. Stadt durch Glas. Moskau –
Düsseldorf – Moskau. Utopie/Black Square
2001ff.*, hrsg. von/ed. Pia Müller-Tamm, Ausst.-
Kat./exh. cat. State Tretyakov Gallery & K20/
Kunstsammlung Nordrhein-Westfalen,
Düsseldorf, Düsseldorf 2003 (Russian/German)

*Mischa Kuball. Stadt durch Glas. Moskau –
Düsseldorf – Moskau*, Ausst.-Kat./exh. cat.
K20/Kunstsammlung Nordrhein-Westfalen,
Düsseldorf, Düsseldorf 2003 (German/
English)

Mischa Kuball. Public Stage, hrsg. von/ed.
Cornelia Wieg, Ausst.-Kat./exh. cat. Staat-
liche Galerie Moritzburg, Halle, Köln/Cologne
2001

*Mischa Kuball. Ein Fenster. Eine Dokumen-
tation*, hrsg. von/ed. Thorsten Nolting, Ausst.-
Kat./exh. cat. Projekt in der/project in the
Johanneskirche, Düsseldorf, Köln/Cologne
2001

Mischa Kuball. SIX-PACK-SIX, Ausst.-Kat./
exh. cat. Museum Folkwang & RWE AG,
Essen, Essen 2000

Mischa Kuball. Urban Context, hrsg. von/ed.
Hartmut Dähnhardt & Ruth Schulenburg,
Ausst.-Kat./exh. cat. Projekt/project Bunker
Lüneburg, Lüneburg 2000 (German/English)

Schleudertrauma. Mischa Kuball, hrsg. von/
ed. Friederike Wappler, Ausst.-Kat./exh. cat.
Kunstverein Ruhr, Essen, Düsseldorf 2000
(German/English)

Mischa Kuball. Greenlight, hrsg. von/ed. Hans-
Georg Thoenges, Ausst.-Kat./exh. cat. Goethe
Institut, Montevideo, Montevideo 1999
(German/English/Spanish)

*Mischa Kuball. Sieh' durch meine Augen/Stadt
durch Glas*, hrsg. von/ed. Frank Ulrich, Ausst.-
Kat./exh. cat. Neurochirurgische Klinik,
Krefeld, Düsseldorf 1999 (German/English)

Mischa Kuball. Sprach Platz Sprache, hrsg.
von/ed. Bernd Kauffmann & Ulrich Krempel,
Ostfildern 1999 (German/English)

Mischa Kuball. Project Rooms, Ausst.-Kat./
exh. cat. Museum of Installation, London,
London 1999 (English)

Johannes Stahl, *Karl-Marx-Kopf. Chemnitz*,
Düsseldorf 1998 (German/English)

Private Light/Public Light. Mischa Kuball,
hrsg. von/ed. Karin Stempel, Ausst.-Kat./exh.
cat. *24. Biennale von São Paulo*, Ostfildern
1998 (German/English/Portuguese)

Tower of Power. Mischa Kuball, hrsg. von/
ed. Manfred Middendorff, Ausst.-Kat./exh.
cat. Herrenhäuser Turm & Sprengel Museum,
Hannover, Düsseldorf 1998 (German/
English)

SIX-PACK-SIX. Mischa Kuball, hrsg. von/
ed. Reiner Speck & Gerhard Theewen, Köln/
Cologne 1997

Project Rooms. Mischa Kuball, hrsg. von/
ed. Gérard A. Goodrow & Hans Ulrich Reck,
Köln/Cologne 1997 (German/English)

fragen/perguntar/asking. Material/Immaterial,
hrsg. von/ed. Karin Stempel, Casa das Rosas,
São Paulo, Düsseldorf 1997 (German/
English/Portuguese)

*World-Rorschach/Rorschach-World. Mischa
Kuball*, hrsg. von/ed. Katharina Winnekes,
Ausst.-Kat./exh. cat. Diözesan-Museum Köln/
Cologne, Köln/Cologne 1996

*Moderne, rundum. Vienna Version. Mischa
Kuball*, hrsg. von/ed. Karl Irsigler, Ausst.-
Kat./exh. cat. Museum moderner Kunst
Stiftung Ludwig, Wien/Vienna, Wien/Vienna
1996 (German/English)

PROJEKTION/REFLEKTION. Mischa Kuball,
hrsg. von/ed. Kurt Danach & Mariana
Hanstein, Ausst.-Kat./exh. cat. Kunststation
St. Peter, Köln/Cologne, Köln/Cologne &
Berlin 1995 (German/English)

*Rotierenderlichtraumhorizont. Mischa Kuball:
Deutzer Brücke*, hrsg. von/ed. Petra Stilper,
Ausst.-Kat./exh. cat. Wandelhalle Köln/
Cologne, Köln/Cologne 1995 (German/
English)

*No-Place. Mischa Kuball (eine Intervention)
im Sprengel Museum Hannover*, hrsg. von/
ed. Ulrich Krempel, Ausst.-Kat./exh. cat.
Sprengel Museum Hannover, Düsseldorf 1994
(German/English)

1994. Mischa Kuball, hrsg. von/ed. Martin
Bochynek & Raimund Stecker, Ausst.-Kat./
exh. cat. Kunstverein für die Rheinlande und
Westfalen, Düsseldorf, Düsseldorf 1994

Refraction House. Mischa Kuball, hrsg. von/
ed. Gerhard Dornseifer & Armin Zweite,
Düsseldorf 1994

Double Standard. Mischa Kuball, Ausst.-
Kat./exh. cat. Stichting de Appel, Amsterdam,
Amsterdam 1993 (Dutch/English)

Bauhaus-Block. Mischa Kuball, hrsg. von/
ed. Lutz Schöbe, Ausst.-Kat./exh. cat.
Bauhaus Dessau, Ostfildern 1992 (German/
English)

World/Fall. Mischa Kuball, Ausst.-Kat./
exh. cat. Haus Wittgenstein, Wien/Vienna,
Bensheim 1992 (German/English)

B(l)aupause. Mischa Kuball, hrsg. von/ed.
Karin Stempel, Ausst.-Kat./exh. cat.

Städtisches Museum, Mülheim an der Ruhr, Oberhausen 1991

Welt/Fall. Mischa Kuball, Ausst.-Kat./exh. cat. Haus Wittgenstein, Wien/Vienna, Mönchengladbach 1991 (German/English)

Ulrich Krempel, *Megazeichen. Mischa Kuball,* Düsseldorf 1990 (German/English)

Kabinett/Cabinet. Mischa Kuball, Ausst.-Kat./exh. cat. Nassauischer Kunstverein, Wiesbaden u. a./et al., Düsseldorf 1990 (German/English)

Dieter Bartetzko, *Mischa Kuball. Die Rede/The Speech,* Düsseldorf 1990 (German/English)

Deutsches Haus. Mischa Kuball, Ausst.-Kat./exh. cat. Städtische Galerie Würzburg, Würzburg 1989

Deutscher Pavillon. Mischa Kuball: Exploration I, Ausst.-Kat./exh. cat. Galerie Hafemann, Wiesbaden, Wiesbaden 1989

Mischa Kuball. Körper, Ausst.-Kat./exh. cat. Galerie Schröder, Mönchengladbach, Mönchengladbach 1988

Mischa Kuball. Projektion – Installation, Ausst.-Kat./exh. cat. Neuer Berliner Kunstverein, Berlin 1988 (German/English)

Installation 1987. Mischa Kuball, Ausst.-Kat./exh. cat. Museum Folkwang, Essen, TiBor de Nagy Gallery, New York, Essen 1987 (German/English)

Mischa Kuball. Ausst.-Kat./exh. cat. Städtische Galerie Düsseldorf, Düsseldorf 1984

Publikationen zu Mischa Kuball in Gruppenkatalogen (Auswahl) | Publications on Mischa Kuball in Group-Exhibition Catalogues (Selection)

»Urban Lab. Stiller Autor im öffentlichen Kommunikationsprozess. Mischa Kuball im Gespräch mit Söke Dinkla«, in: *Constructing the Truth. Kunst im öffentlichen Raum,* hrsg. von/ed. Söke Dinkla, Ausst.-Kat./exh. cat. Stadt Duisburg, Nürnberg/Nuremberg 2006

Lichtkunst aus Kunstlicht. Licht als Mediun im 20. und 21. Jahrhundert/Light Art from Artificial Light. Light as a Medium in 20th an 21st Century Art, hrsg. von/eds. Peter Weibel, Gregor Jansen, Ausst.-Kat./exh. cat. ZKM | Museum für Neue Kunst Karlsruhe, Ostfildern 2006

Eléonore Espargilière, »Mischa Kuball«, in: *On/Off,* Ausst.-Kat./exh. cat. Casino Luxembourg; Fonds régional d´art contemporain de Lorraine, Metz; Saarlandmuseum, Saarbrücken, Luxemburg/Luxembourg 2006

Studio in the Park, Ausst.-Kat./exh. cat. BravinLee Programs, New York 2006

Alexa Riederer, »Mischa Kuball. Licht ist das zentrale Medium meiner Arbeit«, in: *Kunstwerke,* Ausst.-Kat./exh. cat. Stadtwerke Düsseldorf, Düsseldorf 2006

Traces de Parcours. 1996–2006, hrsg. von/ed. Casino Luxembourg, Luxemburg/Luxembourg 2006

Kunstsammlung WGZ Bank, hrsg. von/ed. Ralf Hartweg, Dokumentation der Sammlung WGZ Bank Düsseldorf, Neuwied 2006

Katja Heckes, »Mischa Kuball«, in: *Videonale 10,* hrsg. von/ed. Georg Elben, Ausst.-Kat./exh. cat. Videonale Bonn, Köln/Cologne 2005

Kunstsammlung WGZ Bank, hrsg. von Ralf Hartweg Sammlungskatalog/coll. cat. WGZ Bank Düsseldorf, Neuwied 2006

Peter B. Steiner, »XII. Johanneskirche«, in: *Kreuz und Kruzifix. Zeichen und Bild,* Ausst.-Kat./exh. cat. Diözesanmuseum Freising, Lindenberg im Allgäu 2005

If Walls had Ears. Als muren oren hadden 1994–2005, hrsg. von/ed. Edna van Duyn, Stichting de Appel, Amsterdam 2005

Broken Glass. Glas in Kunst und Architektur, hrsg. von/ed. Wolfgang Becker, Ausst.-Kat./exh. cat. Glaspalast Heerlen, Köln/Cologne 2005

Uwe Rüth, »Raum – Rede – Geschwindigkeit/Space – Speech – Speed«, in: *Shadow Play,* Ausst.-Kat./exh. cat. Kunsthallen Brandts Klædefabrik, Heidelberg 2005

Mischa Kuball, »Four Light Walls for Weimar«, in: *Deutsche Videokunst 2002–2004. Deutsche Video-Installations-Kunst 2002–2004. MEDIEN Raum-Wettbewerb 2004,* hrsg. von/ed. Uwe Rüth, Ausst.-Kat./exh. cat. Skulpturenmuseum Glaskasten Marl, Essen 2004

»Mischa Kuball und Beda Faessler im Gespräch mit Heike Catherina Müller«, in: *Con-Con. Constructed Connections 2004,* München/Munich 2004

Guido Boulboullé & Nina Tatter, »Mischa Kuball. Schleudertrauma«, in: *After Images. Kunst als soziales Gedächtnis,* hrsg. von/ed. Peter Friese, Ausst.-Kat./exh. cat. Neues Museum Weserburg, Bremen, Frankfurt am Main 2004

Karin Stempel, »Mischa Kuball. Space – Speech – Speed«, in: *Paradise. Moscow,* Ausst.-Kat./exh. cat. International Forum of Art Initiatives, Moscow, Moskau 2004

Privatgrün 2004. Kunst im privaten Raum, hrsg. von/ed. Nikola Doll & Jochen Heufelder, Ausst.-Kat./exh. cat. Fuhrwerkswaage Kunstraum e. V., Köln/Cologne 2004

New Art. 38th International Fair for Modern and Contemporary Art, Ausst.-Kat./exh. cat. Art Cologne, Köln/Cologne 2004

Diözesanmuseum Freising 1974–2004, hrsg. von/ed. Norbert Jocher, Freising 2004

Carolyn J. Dean, *The Fragility of Empathy. After the Holocaust,* New York 2004

graublaugrün. Der Emscher Landschaftspark, Ausst.-Kat./exh. cat. Stiftung Schloss und Park Benrath, Düsseldorf 2004

Am Rande des Lichts. Inmitten des Lichts. Lichtkunst und Lichtprojekte im öffentlichen Raum Nordrhein-Westfalens, hrsg. von/ed. Söke Dinkla, Zentrum für internationale Lichtkunst, Unna, Köln/Cologne 2004

Uwe Rüth, »Mischa Kuball«, in: *Die Samm-lung*. hrsg. vom/ed. Zentrum für internatio-nale Lichtkunst, Unna, Köln/Cologne 2004

Stadtlicht – Lichtkunst, hrsg. von/ed. Christoph Brockhaus, Ausst.-Kat./exh. cat. Wilhelm Lehmbruck Museum, Duisburg, Köln/Cologne 2004

Rituale in der zeitgenössischen Kunst, hrsg. von/ed. Nina Muecke & Angelika Sommer, Ausst.-Kat./exh. cat. Akademie der Künste, Berlin, Berlin 2003

Lichtrouten 2003, hrsg. von/ed. Jörg Marré & Andreas Preuß, Ausst.-Kat./exh. cat. Licht-routen Lüdenscheid, Lüdenscheid 2004

Sammlung Sparkasse Essen, Essen 2003

Zeitgenössische Deutsche Fotografie. Stipendiaten der Alfried Krupp von Bohlen und Halbach Stiftung, hrsg. von/ed. Ute Eskildsen & Esther Ruelfs, Ausst.-Kat./exh. cat. Museum Folkwang, Essen, Göttingen 2003

Peter Steiner, »Licht Raum Sprache«, in: *Unaussprechlich schön. Das mystische Para-doxon in der Kunst des 20. Jahrhunderts*, hrsg. von/ed. Kai Uwe Schierz & Silke Opitz, Ausst.-Kat./exh. cat. Kunsthalle Erfurt, Köln/Cologne 2003

Ein Lichtkonzept für die Schwebebahn. Dokumentation des Wettbewerbsverfahrens, Wuppertal 2003

Con-Con. Constructed Connections 2003, Ausst.-Kat./exh. cat. Stadtkunstprojekte e. V., Berlin 2003

Plan Camp 02. Reader Stadtlicht, Ausst.-Kat./exh. cat. Plan Project Köln, Köln/Cologne 2003

Mischa Kuball, »StattUtopie//:Instead of Utopia«, in: *No Art = No City! Stadtutopien in der zeitgenössischen Kunst*, hrsg. von/ed. Florian Matzner, Ostfildern 2003

Heute bis jetzt. Zeitgenössische Fotografie aus Düsseldorf, Ausst.-Kat./exh. cat. Museum Kunst Palast, Düsseldorf, München/Munich 2002

Stadtlicht. Ein Farb-Licht-Projekt für Basel, hrsg. von/ed. Simon Baur, Luzern 2002

Kugeln (bitte die weiße Kugel nicht versenken), Ausst.-Kat./exh. cat. Schloß Plüschow, Meck-lenburgisches Künstlerhaus, Plüschow 2002

Norman L. Kleeblatt, »Transforming Images into Symbols«, in: *Mirroring Evil, Nazi Imagery/ Recent Art*, hrsg. von/ed. Norman L. Kleeblatt, Ausst.-Kat./exh. cat. The Jewish Museum, New York, New Brunswick u. a./et al. 2002

Lux Europae 2002 Copenhagen, hrsg. von/ed. Finn Andersen, Ausst.-Kat./exh. cat. Det Danske Kulturinstitut, Kopenhagen/ Copenhagen 2002

Adachiara Zevi, *ARTEINMEMORIA*, Rome 2002

Renate Puvogel, »Mischa Kuball. Überlage-rungen«, in: Renate Puvogel, *Über Künstler unserer Zeit*, Köln/Cologne 2002

Künstler – Knöpfe II, hrsg. von/ed. Uwe Obier, Ausst.-Kat./exh. cat. Kulturdezernat und Museen der Stadt Lüdenscheid, Bönen 2002

Mischa Kuball: »›And it's a pleasure . . .‹. Öffentlichkeit als Labor«, in: *Public Art. Kunst im öffentlichen Raum*, hrsg. von/ed. Florian Matzner, Ostfildern 2001

Intermedia – Dialog der Medien. Museum für Gegenwartskunst Siegen, hrsg. von/ed. Klaus Bußmann u. a./et al., Siegen 2001

ARTlight, Ausst.-Kat./exh. cat. Galerie Beyeler, Basel 2001

Die baupolitischen Ziele des Landes Nordrhein-Westfalen, hrsg. vom/ed. Ministerium für Städtebau und Wohnen, Kultur und Sport, Paderborn 2001

Kunst setzt Zeichen. Landmarken-Kunst, hrsg. von/ed. Bernhard Mensch & Peter Pachnicke, Ausst.-Kat./exh. cat. Ludwig Gale-rie, Schloss Oberhausen, Oberhausen 2001

Lichtzeichen und Landmarken im Ruhrgebiet, hrsg. von/ed. Bernhard Mensch & Peter Pachnicke, Ausst.-Kat./exh. cat. Ludwig Gale-rie, Schloss Oberhausen, Oberhausen 2001

Milano Europa 2000. Fine secolo. I semi del futuro, Ausst.-Kat./exh. cat. Palazzo della Triennale di Milano, Mailand 2001

Licht und Raum. Erstes mehrjähriges inter-disziplinäres Projekt mit wechselnder Gast-professur, hrsg. von/ed. der Hochschule für Grafik und Buchkunst, Leipzig 2001

Stefan Wimmer, »Mischa Kuball. Soziogramm der brasilianischen Gesellschaft«, in: *Personal Light*, hrsg. von/ed. Reinhard Spieler, Ausst.-Kat./exh. cat. Kunsthaus Hamburg, Düsseldorf 2001

München im Kunstlicht, Ausst.-Kat./exh. cat. Landeshauptstadt München, München/ Munich 2000

Armin Zweite, »Mischa Kuball. Refraction House«, in: *Art Projects. Synagoge Stommeln*, hrsg. von/ed. Gerhard Dornseifer & Angelika Schallenberg, Ostfildern 2000

HausSchau. Das Haus in der Kunst, Ausst.-Kat./ exh. cat. Deichtorhallen, Hamburg, Ostfildern 2000

Internationaler Medien Kunstpreis 2000. ciTy/ Urbanismus, hrsg. von/ed. Rudolf Frieling, Ausst.-Kat./exh. cat. ZKM | Zentrum für Kunst und Medientechnologie Karlsruhe, Karlsruhe 2000

Dia/Slide/Transparency, Ausst.-Kat./exh. cat. Neue Gesellschaft für Bildende Kunst, Berlin 2000

Strange Paradises, Ausst.-Kat./exh. cat. Casino Luxembourg, Luxemburg/Luxembourg 2000

Farbe zu Licht, Ausst.-Kat./exh. cat. Fondation Beyeler, Ostfildern 2000

Vision Ruhr. Kunst-Medien-Interaktion auf der Zeche Zollern, Ausst.-Kat./exh. cat. West-fälisches Industriemuseum Zeche Zollern II/IV, Dortmund, Ostfildern 2000

Chausseestraße 23. Die Medienfassade der VEAG, Vereinigte Energiewerke AG, Berlin 2000

Light Pieces, Ausst.-Kat./exh. cat. Casino Luxembourg, Luxemburg/Luxembourg 2000

Projekte zum Lichtparcours. Braunschweig 2000, Ausst.-Kat./exh. cat. Kunstverein Braunschweig, Dresden 1999

Daniel Delhaes & Andreas Grosz, *Die Kultur AG. Neue Allianzen zwischen Wirtschaft und Kultur*, München/Munich & Wien/Vienna 1999

Licht auf Weimar. Die ephemeren Medien, Ausst.-Kat./exh. cat. Kulturhauptstadt Weimar, Weimar 1999

Schöpfung, hrsg. von/ed. Petra Giloy-Hirtz & Peter B. Steiner, Ausst.-Kat./exh. cat. Diözesanmuseum Freising, Ostfildern 1999

Licht und Raum, hrsg. von/ed. Michael Schwarz, Köln/Cologne 1998

Kunst-Stücke, hrsg. von/ed. Georg Elben, Sammlungskatalog/coll. cat. Deutsche Ausgleichsbank Bonn, Köln/Cologne 1998

Licht – das Material des Bildhauers, hrsg. von/ed. Gottfried Hafemann, Ausst.-Kat./exh. cat. Nassauischer Kunstverein, Wiesbaden, Wiesbaden 1998

Threshold, hrsg. von/ed. Louise Dompierre, Ausst.-Kat./exh. cat. The Power Plant, Temporary Art Gallery Toronto, Toronto 1998

Der Fuchs und die Trauben. Dokumentation 1991–1996, Kunstraum Wuppertal, Ostfildern 1998

Crossing Borders. The Kaldewey Press, New York, hrsg. von/ed. Mindell Dubansky & Monica J. Strauss, Ostfildern 1997

Licht, Farbe, Raum. Künstlerisch-wissenschaftliches Symposium, hrsg. von/ed. Michael Schwarz, Braunschweig 1997

Märkisches Stipendium für Bildende Kunst 1997, Märkische Kulturkonferenz e. V., Iserlohn 1997

Farbe am Bauhaus, Stiftung Bauhaus Dessau, Dessau 1996

Jedes gemalte Bild verkündet: Dies wurde gesehen. Dokumentation der Sammlung Provinzial Versicherungsanstalten, Bremen 1996

Project 8, Ausst.-Kat./exh. cat. Total Museum of Contemporary Art, Seoul, Seoul 1996

Die Alchemie der Gegensätze, hrsg. von/ed. Karl A. Irsigler, Bruck an der Mur 1996

?Bakunin – !ein Denkmal! Kunst Anarchismus, Ausst.-Kat./exh. cat. Neue Gesellschaft für Bildende Kunst, Berlin 1996

En helvetes förfandling. Tysk konst från Nordrhein Westfalen, hrsg. von/ed. Gerhard Engelking & Jost Reinert, Ausst.-Kat./exh. cat. Düsseldorf 1996

Das letzte Haus/The Last House, Ausst.-Kat./exh. cat. Haus der Architektur, Steirischer Herbst, Ostfildern 1995

László Moholy-Nagy. Idee und Wirkung, hrsg. von/ed. Jutta Hülsewig-Jonen & Gottfried Jäger, Ausst.-Kat./exh. cat. Kunsthalle Bielefeld, Bielefeld 1995

Minima Media. Medienbiennale Leipzig 1994, hrsg. von/ed. Dieter Daniels, Leipzig & Oberhausen 1995

Axel Wirths u. a./et al., »Mischa Kuball. A Discussion«, in: *Matthew McCaslin*, Ausst.-Kat./exh. cat. Wandelhalle, Köln/Cologne 1995

Harald Weltzer, »Mischa Kuball. Refraction House«, in: *Das Gedächtnis der Bilder*, hrsg. von/ed. Harald Weltzer, Tübingen 1995

Leerstand. Comfortable Conceptions, Ausst.-Kat./exh. cat. Förderkreis der Leipziger Galerie für Zeitgenössische Kunst, Leipzig 1994

»Marc Mer in einem Interview mit Mischa Kuball«, in: *Translokation. Der ver-rückte Ort. Kunst zwischen Architektur*, hrsg. von/ed. Marc Mer u. a./et al., Ausst. Kat./exh. cat. Haus der Kunst, Graz, Wien/Vienna 1994

Förderpreis Bildende Kunst 1994, Unternehmensgruppe Melitta, Minden 1994

Bildende Kunst und Denk-Mahnmal. Eine aktuelle Herausforderung. Dokumentation der Podiumsdiskussion vom 15. April 1994 zu Mischa Kuballs *Refraction House* in der Synagoge Stommeln, Düsseldorf 1994

Gegenbilder, Katholische und Evangelische Kirche Münster, Münster 1993

Lichträume, hrsg. von/ed. Gerhard Finckh, Ausst.-Kat./exh. cat. Museum Folkwang, Essen; Bauhaus Dessau, Oberhausen 1993

Connecting Things, hrsg. von/ed. Dieter Daniels u. a./et al., Leipzig 1993

Mischa Kuball, »Bauhaus-Block. Projektionen 1988–1992«, in: *Leben am Bauhaus. Die Meisterhäuser in Dessau*, Buchendorf 1993

Arbeitsheft. Neue Kunst im Hagenbucher, hrsg. von/ed. Mechthild Bauer-Babel, Neckarsulm 1993

Ulrich Krempel, »Laudatio. Förderpreis NRW 1992«, in: *Förderpreis des Landes NRW für junge Künstlerinnen und Künstler '92*, Düsseldorf 1993

Nel corso del tempo/Im Laufe der Zeit, hrsg. von/ed. Gilberto Pellizzola, Ausst.-Kat./exh. cat. Goethe Institut Genua, Genua/Genoa 1993

Stipendiaten der Alfried Krupp von Bohlen und Halbach Stiftung, hrsg. von/ed. Ute Eskildsen, Ausst.-Kat./exh. cat. Fotografische Sammlung, Museum Folkwang, Essen, Düsseldorf 1993

Think, hrsg. von/ed. Ulrich Krempel, Ausst.-Kat./exh. cat. IBM Deutschland, Düsseldorf 1992

Achim Könnecke & Michael Stephan, »vor Ort-Kunst in städtischen Situationen«, in: *Vor Ort*, Ausst.-Kat./exh. cat. Kulturamt Stadt Langenhagen, Langenhagen 1992

Medienbiennale Leipzig 92, hrsg. von/ed. Benedikt Forster, Ausst.-Kat./exh. cat. Museum der Bildenden Künste, Leipzig, Berlin 1992

Lux Europae, hrsg. von/ed. Isabel Vasseur, Ausst.-Kat./exh. cat. The European Arts Festival Edinburgh, Edinburgh 1992

Reflex Ost-West. Symposium im Alten Rathaus Potsdam, Bundesverband Bildender Künstler Bonn, Mainz 1992

Kunstszene Tagebau, Ausst.-Kat./exh. cat. Förderverein Kulturlandschaft Niederlausitz, Heidelberg 1992

Marianne Hoffmann, »Mischa Kuball«, in: *Geistesgegenwart. Freiräume-Kultur zum Kirchentag*, Ausst.-Kat./exh. cat. Museum Bochum, Bochum 1991

De Ambiguiteit van de Herinnering, Ausst.-Kat./exh. cat. Museum van Hedendaagse Kunst, Antwerpen, Antwerpen/Antwerp 1991

Ulrich Bohnen, *Transparenz/Transzendenz*, Köln/Cologne 1991

Stephan Schmidt-Wulfen, »Mischa Kuball. Projektionen«, in: *Ars Viva 90/91*, Kulturkreis der deutschen Industrie im BDI, Köln/Cologne 1990

Meine Zeit – Mein Raubtier, Ausst.-Kat./exh. cat. Museum Kunst Palast, Düsseldorf, Düsseldorf 1988

Figurationen, Ausst.-Kat./exh. cat. Museum Herne, Herne 1988

36. Jahresausstellung, Ausst.-Kat./exh. cat. Deutscher Künstlerbund, Berlin, Hannover 1988

Medien Mafia präsentiert, Ausst.-Kat./exh. cat. Medien Mafia Düsseldorf, Düsseldorf 1987

Zeitschrift für alles. Nr. 10, hrsg. von/ed. Dieter Roth, Basel 1988

Forum junger Kunst, Ausst.-Kat./exh. cat. Würtembergischer Kunstverein, Stuttgart, Ostfildern 1984

Große Kunstausstellung Düsseldorf 83, Ausst.-Kat./exh. cat. Museum Kunst Palast, Düsseldorf, Düsseldorf 1983

Beiträge in Zeitschriften (Auswahl)
Articles in Periodicals (Selection)

»Das Nicht-Zeigen ist eine absichtsvolle Entscheidung. Mischa Kuball im Gespräch mit Carmela Thiele«, in: *Juni*, 9, Juli/July 2005, S./pp. 40–44

Corinna Otto & Paula von Sydow: »Kunst und Medien an der Wende zum 21. Jahrhundert«, in: *Vernissage*, 13, 9, 2005, S./pp. 52–54

Manuel Falkenberg, »Mehr Licht«, in: *K. West*, September 2004, S./pp. 7–9

Hans-Ulrich Reck, »Licht, Ort, Zeit. Aspekte zur Kunst von Mischa Kuball«, in: *Diagonal*, 24, 1, 2002, S./pp. 80–99

Anita Shah, »Light as a Tool for the Artist«, in: *Professional Lighting*, 25, 5/6 2002, S./pp. 40–43

Georg Elben, »Mischa Kuball. Konzepte und Projekte für den urbanen Raum« sowie ein Gespräch mit/as well as a conversation with Mischa Kuball, in: *Kunstforum*, 144, März/April/March/April 1999, S./pp. 258–271

Marianne Hoffmann, »Lichte Augenblicke«, in: *about. Magazin für Design und Business*, 1, 2, 1999 S./pp. 25–27

Thomas Fechner-Smarsly, »Licht und Kannibalismus«, in: *Neue Bildende Kunst*, 5, Oktober/October 1998

Hajo Schiff, »Kunst als Verdauungsproblem«, in: *Neue Bildende Kunst*, 6, Dezember/Januar/December/January 1998, S./pp. 72–73

Jörg Restorff »Lichter der Großstadt«, in: *Kunstzeitung*, 26, Oktober/October 1998

Petra Giloy-Hirtz, »Mischa Kuball. Die Sprache des Lichts«, in: *Kritisches Lexikon der Gegenwartskunst*, 42, 12, 2. Quartal/2nd quarter 1998

»Lichtkunst-Wasser auf der Brücke«, in: *Professional Lighting Design*, 37, 5, 1997, S./p. 13

Cornel Bierens, »Letter Art by Mischa Kuball«, in: *Archis*, 7, 1997

Andrea Jonas-Edel, »Schwingende Lichträume. Ein Interview mit Mischa Kuball«, in: *Kunst-Bulletin*, 12, Dezember/December 1997, S./pp. 8–15

Anita Shah, »Mischa Kuball«, in: *Texte zur Kunst*, 14, 1994, S./pp. 183–185

Friedwart Maria Rudel, »Kunstgedenkstätte. Erinnerungsarbeiten in der Stommelner Synagoge«, in: *Kunst + Kultur*, 9, 1994, S./pp. 32–33

Gérard A. Goodrow, »Mischa Kuball. Stommeln Synagogue«, in: *ARTnews*, Summer 1994, S./p. 190

Thomas Fechner-Smarsly, »Eine Synagoge im Licht«, in: *Kulturchronik*, 4, 1994, S./pp. 13–14

Mischa Kuball, »Architekturraum/Kunstraum/Sozialraum«, in: *Medien. Kunst. Passagen*, 2, 1993, S./pp. 25–32

Antje von Graevenitz, »The double standards of Mischa Kuball«, in: *Archis*, 4, 1993

Friedwart Maria Rudel, »Mischa Kuball«, in: *artist Kunstmagazin*, 17/18, März/April/March/April 1993, S./pp. 51–53

Heinz-Norbert Jocks, »Wenn Häuser Zeichen zeugen«, in: *Kunstforum*, 118, April/Mai/Juni/April/May/June 1992, S./pp. 306–317

Christiane Vielhaber, »Mischa Kuball. ›Der Letzte macht das Licht aus‹«, in: *Kunst Köln*, 1, 1991, S./pp. 32–36

Suri-Roja Kassimi, »Mischa Kuball« in: *Apex*, 11, 1990, S./pp. 62–73

Ulrich Krempel: »Mischa Kuball. Megazeichen«, in: *Apex*, 11, 1990 S./pp. 152–159

Johannes Stahl, »Im Sog der Megazeichen«, in: *Kunstforum*, 110, November/Dezember/November/December 1990, S./pp. 420–421

Film

Lichtkünstler Mischa Kuball. Ein Film von/A film by Werner Raeune, 8.12.2003/December 8, 2003, ZDF, 15′

AUSGEWÄHLTE EINZELAUSSTELLUNGEN
SELECTED SOLO EXHIBITIONS

2007

BrocaRemix, ZKM | Museum für Neue Kunst Karlsruhe

Mies-Mies, Zentrum für Internationale Lichtkunst, Unna

Mischa Kuball, Kunstbygning/Kunsthal Århus

Mischa Kuball, Neue Galerie am Landesmuseum Joanneum Graz

2006

Zwei Abendräume für Köln, Kunststation St. Peter/St. Cäcilien, Köln/Cologne

kuball@sino, SINO AG, Düsseldorf

Pacemaker, Stadtwerke Düsseldorf

2005

Shelterprojekt mit Wohnungslosen, Diakonie in Düsseldorf, bis 2006

Space – Speed – Speech, Gallery of Modern Art, Glasgow

Projektionsraum 1:1:1/Spinning Version, Ostpol, Förderturm Bönen, Bönen

FlashPlanet 2005, IMA, Institute of Modern Art, Brisbane

Lucky Number. Neue Projektionen, Museum für Gegenwartskunst Siegen

FlashBoxOldenburg, Oldenburger Kunstverein und Edith-Ruß-Haus für Medienkunst, Oldenburg

UNIVERSITÄTSBIBLIOTHEKBOCHUM, permanente Neon-Installation, Ruhr-Universität Bochum, Bochum

2004

City thru Glas. Düsseldorf – Moscow – Düsseldorf, VC6xMAM – Virgin Cinemas Roppongi Hills/Mori Art Museum Collaboration, Tokio/Tokyo

Stadt durch Glas. Düsseldorf – Moscow – Düsseldorf, Museumsnacht Bern, Kornhaus Bern

Public Blend I + II, Kunstraum München, München/Munich

Public Entrance, Art Cologne 2004 in Kooperation mit 235 Media, Köln/Cologne

Lucky Number, Museum für Gegenwartskunst Siegen

2003

Utopie/Black Square/Speed Suprematism, Projektraum Rosenthaler Straße, Berlin

Stadt durch Glas. Düsseldorf – Moscow – Düsseldorf, Staatliche Tretjakov Galerie, Moskau/Moscow

Utopie/Black Square 2001 ff., Kunstsammlungen der Ruhr-Universität, Bochum

Utopie/Square/Speed Suprematism, Halle für Kunst, Lüneburg

Stadt durch Glas, K20/Kunstsammlung Nordrhein-Westfalen, Düsseldorf

2002

Public Eye, Kunstmuseum Bonn, Bonn

Broca'sches Areal, Konrad Fischer Galerie, Düsseldorf

2001

Yellow Marker, Kamp-Lintfort & Bönen

Metasigns, Holzmarkt, Jena

Ein Fenster, Johanneskirche Düsseldorf

2000

Schleudertrauma, Kunstverein Ruhr, Essen

Urban Context, Projektion Bunker Lüneburg, Lüneburg

Chicago Sling, Vedanta Gallery, Chicago

Public Stage, Staatliche Galerie Moritzburg, Halle

SIX-PACK-SIX, Museum Folkwang at RWE-Tower, Essen

Projektionsraum 1:1:1/Farbraum, Museum Folkwang, Essen

1999

… vers le langage, Passages centre d'art contemporain, Troyes

Project Rooms, Chicago Cultural Center, Chicago

Project Rooms, Vedanta Gallery, Chicago

Sieh' durch meine Augen/Stadt durch Glas, Neurochirurgische Klinik, Krefeld

Project Rooms, Galerie für Zeitgenössische Kunst, Leipzig

Kaleidoscope, Hochschule für Grafik und Buchkunst, Leipzig

Project Rooms, Museum of Installation, London

Moderne, rundum, Birner & Wittmann, Nürnberg/Nuremberg

Power of Codes, Tokyo National Museum, Tokio/Tokyo

Greenlight, Montevideo (Public Project), Montevideo

Light Traps, The Wood Street Galleries, Pittsburgh

Fischer's Loop, Konrad Fischer Galerie, Düsseldorf

1998

Project Rooms, Kabinett für aktuelle Kunst, Bremerhaven

Tower of Power, Herrenhäuser Turm, in Kooperation mit dem Sprengel Museum, Hannover/Hanover

Project Rooms, Kölnischer Kunstverein, Köln/Cologne

Project Rooms, Stadtgalerie Saarbrücken in der Stiftung Saarländischer Kulturbesitz, Saarbrücken

Private Light/Public Light, Deutscher Beitrag auf der 24. Biennale São Paulo, São Paulo

1997

In Alphabetical Order, Museum Boijmans van Beuningen, Rotterdam

Chicago III, Karin Sachs, München/Munich

fragen/perguntar/asking. Material/Immaterial, Casa das Rosas, São Paulo

Project Rooms, BM Contemporary Art Center, Istanbul

1996

Moderne, rundum. Vienna Version, Museum Moderner Kunst Stiftung Ludwig, Wien/Vienna

Installationen/Projektionen/Videos, Konrad Fischer Galerie, Düsseldorf

Sprachraum, Kunstraum Wuppertal, Wuppertal

1995

Rotierenderlichtraumhorizont, Wandelhalle, Deutzer Brücke, Köln/Cologne

Chamber-Piece, B.+J. Simmen, München/Munich

PROJEKTION/REFLEKTION, Kunststation St. Peter, Köln/Cologne

World-Rorschach/Rorschach-World, Diözesan-Museum, Köln/Cologne

1994

Refraction House, Synagoge Stommeln, bei Köln/near Cologne

Projektionen, Konrad Fischer Galerie, Düsseldorf

1994, Kunstverein für die Rheinlande und Westfalen, Düsseldorf

No-Place, Sprengel Museum, Hannover/Hanover

Bauhaus-Block, Heidelberger Kunstverein, Heidelberg

1993

Double Standard, Stichting de Appel, Amsterdam

Bauhaus-Block, Museum Folkwang, Essen

1992

Projektionsraum 1:1:1, Konrad Fischer Galerie, Düsseldorf

Bauhaus-Block, Bauhaus Dessau, Dessau

1991

Bauhaus I, Neue Kunst im Hagenbucher, Heilbronn

B(l)aupause, Städtisches Museum, Mülheim an der Ruhr

Welt/Fall, Haus Wittgenstein (mit Vilém Flusser), Wien/Vienna

AUSGEWÄHLTE GRUPPENAUSSTELLUNGEN
SELECTED GROUP EXHIBITIONS

1990
Kabinett/Cabinet, Nassauischer Kunstverein, Wiesbaden
Kabinett/Cabinet, Kunsthalle Köln, Köln
Megazeichen, Mannesmann-Hochhaus, Düsseldorf

1989
Deutsches Haus, Städtische Galerie Würzburg, Würzburg
Tibor de Nagy Gallery, New York

1988
Projektion – Reflektion, Neuer Berliner Kunstverein, Berlin

1987
Installation 1987, Städtische Galerie im Museum Folkwang, Essen
Tibor de Nagy Gallery, New York

1984
DIA-Cut, Städtische Galerie Düsseldorf

2007
Videonale 11, Kunstmuseum Bonn
Das schwarze Quadrat, Hamburger Kunsthalle
European Media Art Festival 2007, Osnabrück

2006
Visual Sound – Klang Vision, Automata, Ljubljana
Gegenstände, Badischer Kunstverein Karlsruhe, Karlsruhe
40jahrevideokunst.de, Projektraum Deutscher Künstlerbund, Berlin
Auswahl 3 – Daylight, Kunstmuseum Bonn
Summertime, Galerie m, Bochum
Silver Tunnel, BravinLee Programs/Riverside Park Fund, New York
Kontexte der Fotografie, Museum für Gegenwartskunst Siegen
Totalschaden, Kunstverein Bonn
Schattenspiel, Landesgalerie Linz

2005
Lichtkunst aus Kunstlicht, ZKM | Zentrum für Kunst und Medientechnologie Karlsruhe
Stadtlicht – Lichtkunst, Wilhelm Lehmbruck Museum, Duisburg
Videonale 10 – Festival für zeitgenössische Videokunst, Kunstmuseum Bonn
Kreuz und Kruzifix, Dombergmuseum Freising
Schattenspiel. Kunsthalle zu Kiel
Broken Glass, Glaspalais Heerlen
Schattenspiel, Brandts Klæderfabriken, Odense
Les yeux de la nuit: Projekt *Lichtbrücke,* in Kooperation mit Riken Yamamoto und Beda Faessler, Genf/Geneva

2004
Sammlung Uschi + Alwin Lahl Teil Vl, Wiesbaden
Con-Con – Constructed Connections: Projekt *Lichtbrücke,* in Kooperation mit Riken Yamamoto und Beda Faessler, Friedrichbrücke, Museumsinsel, Berlin
4. Marler Video-Installations-Preis für Deutschland: 2002–2004, Skulpturenmuseum Glaskasten Marl
After Images. Kunst als soziales Gedächtnis, Neues Museum Weserburg, Bremen
Paradise. Moscow. International Forum of Art Initiatives, Russian Art Today, Moskau/Moscow
Privatgrün, Dachterrasse H. W. Pausch
Projekt *Reflektor,* Fuhrwerkswaage Kunstraum e.V., Köln/Cologne

2003
Zeitgenössische Fotografie in Deutschland: Stipendiaten der Alfred Krupp von Bohlen und Halbach Stiftung 1982–2002, Museum Folkwang, Essen
Rituale in der zeitgenössischen Kunst, Akademie der Künste, Berlin
Unaussprechlich schön. Das mystische Paradoxon in der Kunst des 20. Jahrhunderts, Kunsthalle Erfurt
Lichtparcours Lüdenscheid: Project *Darkroom,* Sternplatz-Pavillon, Lüdenscheid
Con-Con – Constructed Connections, Aedes East/Extension Pavillon, Hackesche Höfe, Hof III, Berlin
NO ART=No City!, Städtische Galerie im Buntentor, Bremen

2002
Heute bis jetzt. Zeitgenössische Fotografie aus Düsseldorf, Stiftung museum kunst palast, Düsseldorf
Mirroring Evil. Nazi Imagery/Recent Art, The Jewish Museum, New York
Kugeln (bitte die weiße Kugel nicht versenken), Schloß Plüschow, Mecklenburgisches Künstlerhaus, Plüschow
Cargo III, Cargo Series, Bagaage Hall, Amsterdam
Lux Europae 2002 Copenhagen, Det Danske Kulturinstitut, Kopenhagen/Copenhagen
Von ZERO bis 2002, ZKM | Museum für Neue Kunst Karlsruhe

2001
ARTlight, Galerie Beyeler, Basel
Milano Europa 2000, Anteprima Bovisa, Palazzo della Triennale, Mailand/Milan
Zentrum für Internationale Lichtkunst, Unna
Dysfunctional Places, Belgrade Art Festival, Belgrad
Personal Light, Kunsthaus Hamburg, Hamburg

2000
München im Kunstlicht: Projekt *Tangential Orange,* München/Munich
Light Pieces, Casino Luxembourg, Luxemburg
Invisible Touch, Kunstraum Innsbruck, Innsbruck
Strange Paradises, Casino Luxembourg, Luxemburg
Farbe > Licht, Fondation Beyeler, Riehen, Basel
HausSchau. Das Haus in der Kunst, Deichtorhallen, Hamburg
Vision Ruhr, Westfälisches Industriemuseum Zeche Zollern II/IV, Dortmund

Auf zu den Sternen, Brandenburgischer
Kunstverein, Potsdam
Dia/Slide/Transparency, Neue Gesellschaft
für bildende Kunst, Berlin

1999
Lichtparcours 2000, Kunstverein Braun-
schweig, Braunschweig
*Mehr Licht. Internationale Beiträge zur Licht-
kunst*, Galerie Friebe, Lüdenscheid
Licht auf Weimar. Die ephemeren Medien,
Kulturhauptstadt Weimar 1999, Weimar
Schöpfung. Seven Virtues, Karmelitenkirche,
München/Munich
*Das XX. Jahrhundert. Ein Jahrhundert Kunst in
Deutschland*, Neue Nationalgalerie, Berlin

1998
Licht – das Material des Bildhauers,
Nassauischer Kunstverein, Wiesbaden
Threshold, The Power Plant, Temporary Art
Gallery, Toronto

1997
Farbe am Bauhaus, Bauhaus Dessau

1996
*15 Lux MAXIMUM/new impulses in light sculp-
ting*, Eight Floor Inc., New York
Project 8, Total Art Museum of Contemporary
Art, Seoul
En helvetes förvandling, Kulturhuset Stock-
holm
Ein Haus voller Häuser, Lindinger+Schmid,
Regensburg

1995
László Moholy-Nagy. Idee und Wirkung,
Städtische Kunsthalle Bielefeld

1994
*Stipendiaten der Alfried Krupp von Bohlen und
Halbach Stiftung*, Nancy
Translokation, Haus der Architektur, Graz
2. Medienbiennale Leipzig, Leipzig
Leerstand, Förderkreis für zeitgenössische
Kunst, Leipzig
Lichträume, Bauhaus Dessau, Dessau
Steirischer Herbst, Vilém Flusser Symposium,
Graz

1993
Nel Corso del Tempo, Leonardi V–Idea,
Genua/Genoa
Gegenbilder, Dominikaner Kirche, Münster
Facetten und Fassaden, Deutsches Architektur
Museum, Frankfurt am Main
Lichträume, Museum Folkwang, Essen

*Stipendiaten der Alfried Krupp von Bohlen und
Halbach Stiftung*, Fotografische Sammlung,
Museum Folkwang, Essen

1992
The USF Art Museum, Tampa
Centre for Fine Arts, Miami
Geistesgegenwart, Museum Bochum, Bochum
1. Biennale für Landart, Cottbus
The Ambiguity of Memory, Museum van
Hedendaagse Kunst, Antwerpen/Antwerp
1. Medienbiennale, Leipzig
Avantgarde Reflex Ost/West, Potsdam
Lux Europae, Edinburgh
Vor Ort, ambulantes Aquarium, Stadt Langen-
hagen

1991
Ars Viva, Nassauischer Kunstverein,
Wiesbaden
Transparenz/Transzendenz, Ludwig Forum für
Internationale Kunst, Aachen

1990
De Collectie als noch, Provinciaal Museum,
Hasselt
Ars Viva, Kunstverein Heidelberg, Heidelberg
Ars Viva, Hochschule für Grafik und Buch-
kunst, Leipzig

1988
Meine Zeit – Mein Raubtier, Kunstmuseum
Düsseldorf
Good Art, Museum of Modern Art, Kyoto
Figurationen, Museum Herne
Internationale Fotoszene, Museum Ludwig,
Köln/Cologne

1985
Impulse 6, Galerie Löhrl, Mönchengladbach
ArtWare, Inter Media Hamburg

1983
Protetch-McNeill, New York

Walter Grasskamp (1950) Kunstkritiker und Professor für Kunstgeschichte an der Akademie der Bildenden Künste München. Letzte Publikationen *Das Cover von Sgt.Pepper. Eine Momentaufnahme der Popkultur*, Berlin 2004; *Sonderbare Museumsbesuche. Von Goethe bis Gernhardt* (Hrsg.), München 2006. / Art critic and professor of art history at the Akademie der Bildenden Künste in Munich. Most recent publications *Das Cover von Sgt.Pepper. Eine Momentaufnahme der Popkultur*, Berlin 2004; *Sonderbare Museumsbesuche. Von Goethe bis Gernhardt* (ed.), Munich 2006.

Boris Groys (1947) Philosoph, 1971 bis 1981 Lehrtätigkeit in Leningrad und Moskau. Seit 1994 Professor für Ästhetik, Kunstgeschichte und Medientheorie an der Hochschule für Gestaltung in Karlsruhe und seit 2005 Global Distinguished Professor at the Faculty of Arts and Science, NYU, New York. / Philosopher, taught from 1971 to 1981 in Leningrad and Moscow. Professor of aesthetics, art history, and media theory at the Hochschule für Gestaltung in Karlsruhe since 1994; Global Distinguished Professor at the Faculty of Arts and Science, NYU, New York, since 2005.

Ihor Holubizky (1952) Schriftsteller, Kunsthistoriker, Musiker und Komponist. Er arbeitet als Ausstellungskurator in Kanada und Australien und schließt zur Zeit seine Doktorarbeit in Kunstgeschichte an der Universität von Queensland ab. / Author, art historian, musician, and composer. He is an exhibition curator in Canada and Australia and is currently finishing his doctorate in art history at the University of Queensland.

Nina Hülsmeier (1974) Studium der Kunstgeschichte, Romanistik und Medienwissenschaften. Projektleitung künstlerischer Wettbewerbe, Projektmitarbeit an zahlreichen Ausstellungen und Symposien zur zeitgenössischen Kunst. Freiberufliche Kunsthistorikerin, lebt in Bochum. / Studied art history, Romance languages, and media sciences. Project director for art competitions, has worked on many exhibitions and symposia for contemporary art. Independent art historian; lives in Bochum.

Doris Krystof (1961) Studium der Kunstgeschichte, Literaturwissenschaft und Geschichte, Kuratorin für Sammlung und Wechselausstellungen im K21/Kunstsammlung Nordrhein-Westfalen, Düsseldorf. Zahlreiche Ausstellungen und Veröffentlichungen zur Kunst der Gegenwart. / Studied art history, literary theory, and history; curator for the collection and exhibitions at the K21/Kunstsammlung North Rhine-Westphalia, Düsseldorf. Many exhibitions and publications on contemporary art.

Florian Matzner (1961) Kunsthistoriker und Kurator, 1991–1998 Kurator am Landesmuseum Münster, seit 1998 Professor für Kunstgeschichte an der Akademie der Bildenden Künste München. Zahlreiche Publikationen und Ausstellungen zur zeitgenössischen Kunst mit dem Schwerpunkt Kunst im öffentlichen Raum. / Art historian and curator, was curator from 1991 to 1998 at the Landesmuseum Münster. Has been professor for art history at the Akademie der Bildenden Künste in Munich since 1998. Numerous publications and exhibition on contemporary art, with a focus on public art in particular.

Yukiko Shikata (1958) Freiberufliche Medienkunstkuratorin und -kritikerin in Tokio, arbeitet als Kuratorin am NTT InterCommunication Center, Tokio, Professorin einer eigens für sie eingerichteten Stelle an der Tokyo Zokei University, Gastprofessorin an der Tama Art University und der Kyoto University of Art and Design. / Independent media art curator and critic based in Tokyo, works as a curator at the NTT InterCommunication Center, adjunct professor at Tokyo Zokei University; guest professor at Tama Art University and Kyoto University of Art and Design.

Peter Sloterdijk (1947) Philosoph, Schriftsteller und Essayist. Rektor der Hochschule für Gestaltung in Karlruhe und Professor für Philosophie und Ästhetik in Wien. / Philosopher, author, essayist. Rector of the Hochschule für Gestaltung in Karlruhe and professor of philosophy and aesthetics in Vienna.

Peter Weibel (1944) Künstler, Ausstellungskurator, Kunst- und Medientheoretiker. Nach Professuren in Wien, Buffalo/New York und Frankfurt 1993 Berufung zum Chefkurator der Neuen Galerie am Landesmuseum Joanneum, Graz. Seit 1999 Vorstand des ZKM | Zentrum für Kunst und Medientechnologie in Karlsruhe. / Artist, exhibition curator, art and media theorist. After professorships in Vienna, Buffalo, NY, and Frankfurt am Main, became chief curator of the Neue Galerie am Landesmuseum Joanneum in Graz. Has been chairman of the ZKM | Zentrum für Kunst und Medientechnologie in Karlsruhe since 1999.

Armin Zweite (1941) Kunsthistoriker, 1974–1990 Direktor der Städtischen Galerie im Lenbachhaus, München. 1983, 1985 und 1987 Kommissar der Bundesrepublik Deutschland für die *Biennale São Paulo*. Seit 1990 Direktor der Kunstsammlung Nordrhein-Westfalen, Düsseldorf. / Art historian. Between 1974 and 1990 Director of the Städtische Galerie im Lenbachhaus in Munich. In 1983, 1985, and 1987 commissioner for Germany for the Bienal de São Paulo. Director of the Kunstsammlung Nordrhein-Westfalen, Düsseldorf since 1990.

IMPRESSUM
COLOPHON

Diese Publikation erscheint anlässlich der
Ausstellungen / This book is published in
conjunction with the exhibition tour
Mischa Kuball. . . . in progress.
Projekte/Projects 1980–2007

ZKM | Museum für Neue Kunst Karlsruhe

Kunstbygning/Kunsthal Århus – Neue Galerie
am Landesmuseum Joanneum Graz –
Kunstverein Hannover– Stiftung Wilhelm
Lehmbruck Museum Duisburg – Museum of
Contemporary Art Belgrade – Sarajevo Center
for Contemporary Art – Beijing Royal Art
Museum – Toyota Municipal Museum of Art,
Toyota – Pori Art Museum, Pori – Museum für
Gegenwartskunst Siegen – Kunsthalle Bern –
Tong JI University Shanghai – Centre d'Art
Contemporain Passerelle, Brest

www.mischakuball.com

Herausgeber/Editor:
Florian Matzner

Redaktion/Editing:
Nina Hülsmeier, Mischa Kuball, Florian Matzner

Verlagslektorat/Proofreading:
Birgit Sonna (Deutsch/German),
Rebecca van Dyck (Englisch/English)

Koordination/Coordination:
Tas Skorupa

Übersetzungen/Translations:
Stefan Barmann, Brigitta Merschmann,
Nicola Morris, Allison Plath-Moseley,
John Southard, Rebecca van Dyck

Grafische Gestaltung/Graphic design:
Saskia Helena Kruse, München

Satz/Typesetting:
Setzerei Max Vornehm GmbH, München/Munich

Schrift/Typeface:
DIN

Papier/Paper:
Galaxi Supermat 170 g/m^2

Reproduktion/Reproductions:
ReproLine Genceller GmbH, München

Buchbinderei/Binding:
Verlagsbuchbinderei Dieringer, Gerlingen

Gesamtherstellung/Printing:
Dr. Cantz'sche Druckerei, Ostfildern

© 2007 ZKM | Museum für Neue Kunst,
Karlsruhe, Hatje Cantz Verlag, Ostfildern
und Autoren/and authors

© 2007 für die abgebildeten Werke von/
for the reproduced works by Mischa Kuball:
VG Bild-Kunst, Bonn

Erschienen im/Published by
Hatje Cantz Verlag
Zeppelinstraße 32
73760 Ostfildern
Deutschland Germany
Tel. +49 711 4405–200
Fax +49 711 4405–220
www.hatjecantz.com

Hatje Cantz books are available internatio-
nally at selected bookstores and from the
following distribution partners:

USA/North America – D. A. P., Distributed Art
Publishers, New York, www.artbook.com
UK – Art Books International, London,
www.art-bks.com
Australia – Tower Books, Frenchs Forest
(Sydney), www.towerbooks.com.au
France – Interart, Paris, www.interart.fr
Belgium – Exhibitions International, Leuven,
www.exhibitionsinternational.be
Switzerland – Scheidegger, Affoltern am
Albis, www.ava.ch

For Asia, Japan, South America, and Africa,
as well as for general questions, please
contact Hatje Cantz directly at sales

ISBN 978–3–7757–1926–1

Printed in Germany

Umschlagabbildung/Cover illustration:
Stadt durch Glas/Night Version NY, 1999,
Das XX. Jahrhundert, Neue Nationalgalerie,
Berlin (Foto: Arwed Messmer, Berlin)

Abbildung Seite 408/Illustration page 408:
Vilém Flusser & Mischa Kuball, 1991
(Foto: Stefan Bollmann, Düsseldorf)

R54079
12/11/07
LRC
735.29
KUB
LEEDS COLLEGE OF ART & DESIGN

Vilém Flusser 1920–1991